Photography: A Critical Introduction Third Edition

This fully revised and updated third edition of *Photography: A Critical Introduction* retains its position as the only introductory textbook to examine the key debates in photographic theory and place them in their social and political contexts. It thus uniquely integrates photographic theory with photographic history and critically engages with debates about the nature of photographic seeing. The third edition retains the thematic structure and text features of previous editions but also expands coverage on photojournalism and digital imaging.

Especially designed to be accessible and user-friendly, it includes:

- Key concepts, short biographies of major thinkers and seminal references
- Updated international and contemporary case studies and examples
- A full glossary of terms and a comprehensive bibliography
- Resource information, including guides to public archives and useful websites

Individual chapters cover:

- Issues and debates in photographic theory and history
- Documentary photography and photojournalism
- Personal and popular photography, historically and now
- The body in photography
- Commodity culture, and representation
- Photography as art
- The photodigital

Lavishly illustrated with 100 black and white photographs and 16 pages of colour plates, it includes images from Bill Brandt, Susan Derges, Rineke Dijkstra, Lee Friedlander, Fran Herbello, Hannah Höch, Dorothea Lange, Lee Miller, Martin Parr, Ingrid Pollard, Jacob Riis, Alexander Rodchenko, Sebastião Salgado and Andres Serrano.

The editor: Liz Wells is Principal Lecturer in Media Arts in the Faculty of Arts, University of Plymouth

Contributors: Michelle Henning, Patricia Holland, Martin Lister, Derrick Price, Anandi Ramamurthy, Liz Wells.

Comments on previous editions:

'Bravo to Liz Wells for putting together such a comprehensive critical introduction. Lucid, smart and well illustrated, this will be a "must read" for every serious student of the medium.'

Deborah Bright, Professor of Photography and Art History, Rhode Island School of Design

'An essential purchase. It raises awareness of the main contemporary issues related to photographic practice.'

Howard Riley, Swansea Institute of Higher Education

'A timely revision of a great book. It is invaluable in setting the stage for critical research in photography. . . . A substantial contribution to the critical study of photography.'

Professor Lynne Bentley-Kemp, Rochester
Institute of Technology

'Precisely the kind of book I have been yearning to see appear for a long time. Carefully structured, it fulfils the need for a critical theory text for FE, HE and introductory college courses.'

Nicky West, University of Northumbria at Newcastle

'Ideal for stimulating discussions on the critical use of photographic images and their evaluation. It is ideal for teaching this part of my BTEC Media and BTEC Art and Design courses.'

Ken Absalom, Gwent Tertiary College

'Well structured – each chapter is thorough and relevant. The quality of the finish is superb – lovely photos and good use of margin notes.'

Richard Swales, Roade School, Northampton

Photography: A Critical Introduction

Third Edition

EDITED BY LIZ WELLS

First published in 1996 by Routledge

11 New Fetter Lane, London EC4P 4EE

Simultaneously published in the USA and Canada by Routledge 29 West 35th Street, New York, NY 10001

Reprinted 1998

Second edition published 2000 by Routledge

Reprinted 2001, 2002, 2003

Third edition published 2004 by Routledge

Routledge is an imprint of the Taylor & Francis Group

© 2004 Liz Wells and contributors

Typeset in Bembo and Frutiger by Florence Production Ltd, Stoodleigh, Devon Printed and bound in Great Britain by Bell & Bain Ltd, Glasgow

All rights reserved. No part of this book may be reprinted or reproduced or utilised in any form or by any electronic, mechanical, or other means, now known or hereafter invented, including photocopying and recording, or in any information storage or retrieval system, without permission in writing from the publishers.

British Library Cataloguing in Publication Data
A catalogue record for this book is available from the
British Library

Library of Congress Cataloging in Publication Data A catalogue record for this book has been requested

ISBN 0-415-30703-1 (hbk) ISBN 0-415-30704-X (pbk)

Contents

	Notes on contributors	x
	Editor's preface	xi
	Acknowledgements	xiii
	Illustration acknowledgements	xiv
	Introduction	1
1	Thinking about photography: debates,	
	historically and now	9
	DERRICK PRICE AND LIZ WELLS	
	Introduction 11	
	Aesthetics and technologies 12	
	The impact of new technologies 12	
	Art or technology? 13	
	The photograph as document 17	
	Photography and the modern 18	
	The postmodern 21	
	Contemporary debates 24	
	What is theory? 24	
	Photography theory 25	
	Critical reflections on realism 26	
	Reading the image 29	
	Photography reconsidered 33	
	Theory, criticism, practice 35	
	Case study: Image analysis: the example of Migrant Mothe	r 37

	Social history and photography 55	
	The photograph as testament 56	
	Categorical photography 58	
	Institutions and contexts 60	
	The museum 61	
	The archive 62	
2	Surveyors and surveyed: photography	
	out and about	65
	DERRICK PRICE	
	Introduction 67	
	Documentary and photojournalism: issues and	
	definitions 69	
	Documentary photography 69	
	Photojournalism 70	
	Documentary and authenticity 71	
	The real and the digital 73	
	Surveys and social facts 75	
	Victorian surveys and investigations 75	
	Photographing workers 79	
	Photography within colonialism 82	
	Photography and war 86	
	The construction of documentary 89	
	Picturing ourselves 90	
	The Farm Security Administration (FSA) 94	
	Discussion: Drum 97	
	Documentary: New cultures, new spaces 99	
	Theory and the critique of documentary 103	
	Cultural politics and everyday life 106	
	Documentary and photojournalism in the global age 109	
3	'Sweet it is to scan': personal photographs	
	and popular photography	113
	PATRICIA HOLLAND	
	Introduction 115	
	In and beyond the charmed circle of home 120	
	The public and the private in personal photography 120	
	Beyond the domestic 123	
	Fiction and fantasy 125	

Histories of photography 48Which founding father? 49
The photograph as image 50

Photography and social history 55

History in focus 52

4

5

Portraits and albums 126 Informality and intimacy 132 The working classes picture themselves 133 Kodak and the mass market 138 The supersnap in Kodaland 144 Paths unholy and deeds without a name? 148 Twenty-first-century contemplations 148 Post-family and post-photography? 157 Acknowledgements 158	
The subject as object: photography and	
the human body	159
MICHELLE HENNING	
Introduction 161	
The photographic body in crisis 161	
Embodying social difference 164	
Objects of desire 168	
Objectification and images of women 168	
Fetishism, voyeurism and pleasure 170	
Class and representations of the body 172	
The anti-pornography campaigns 174	
Photography and homoerotic desire 176	
Case study: La Cicciolina 177	
Technological bodies 180	
The camera as mechanical eye 180	
Interventions and scientific images 183	
The body as machine 185	
Digital imaging and the malleable body 187	
Photography, birth and death 189	
Summary 192	
Spectacles and illusions: photography and	
commodity culture	193
ANANDI RAMAMURTHY	
Introduction: the society of the spectacle 195	
Photographic portraiture and commodity culture 196	
Photojournalism, glamour and the paparrazzi 198	
Commercial photography, image banks and corporate media 201	
Commodity spectacles in advertising photography 204	
The grammar of the ad 208	
Case study: The commodification of human relations and	
experience – 'Omega and Cindy: time together' 208	
The photographic message 210	

The transfer of meaning 211

The creation of meaning through context and photographic

styles 212

Hegemony in photographic representation 214

Photomontage: concealing social relations 215

Concealing labour relations 216 Gendered representations 218

Fashion photography 220

Case study: Tourism, fashion and 'the Other' 223

The context of the image 235

Image worlds 236

Case study: Benetton, Toscanini and the limits of

advertising 239

6 On and beyond the white walls: photography as art

245

LIZ WELLS

Introduction 247

The status of the photograph as art 248

Early debates and practices 251

The complex relations between photography and art 251

Realism and systems of representation 252

Photography extending art 253

Photography claiming a place in the gallery 256

The modern era 259

Modernism and Modern Art 259

Modern photography 262

Photo-eye: new ways of seeing 264

Case study: Art, design, politics: Soviet Constructivism 265

American formalism 267

Case study: Art movements and intellectual currencies:

Surrealism 269

Late twentieth-century perspectives 273

Conceptual art and the photographic 273

Photography and the postmodern 276

New constructions 278

Women's photography 280

Questions of identity 282

Identity and the multi-cultural 283

Photography within the institution 284

Appraising the contemporary 285

Curators and collectors 287

Internationalism: festivals and publishing 288

The gallery as context 289

Case study: Landscape as genre 290

7	Photography in the age of electronic imaging	295
	MARTIN LISTER	
	Introduction 297	
	Box A: Digital encoding 299	
	Box B: Digital simulation 300	
	Box C : Digitising photographs: the initial implications 301	
	Box D: Analogue and digital 303	
	A 'post-photographic' era? 304	
	A new way of seeing and the end of the 'Cartesian	
	dream'? 305	
	Walter Benjamin and the precedent of the age	
	of mechanical reproduction 308	
	The end of photography as we know it? 310	
	Digitisation and the commodification of images 313	
	Post-photography, postmodernity and language 316	
	Technological change and cultural continuity 317	
	Photography's promiscuity: its historical interface with	
	other technologies, sign systems and images 318	
	Case study: War and surveillance 322	
	Case study: Popular entertainment 326	
	Photodigital: taking stock 327	
	Remembering photography's nature 328	
	Our belief in photography's realism 329	
	The force of the indexical image 331	
	The reception of digital images 332	
	Does digital photography exist? 333	
	Photo-realism versus post-human vision 334	
	Glossary	337
	Photography archives	344
	Bibliography	350
	Index	369

Contributors

Michelle Henning is Senior Lecturer in the School of Cultural Studies at the University of the West of England, Bristol. She has written on representations of the body in J. Arthurs and J. Grimshaw, *Women's Bodies* (Cassell 1999) and on digital images in M. Lister (ed.), *The Photographic Image in Digital Culture* (Routledge 1995), and is currently writing books on digital photography and on museums and cultural theory. She also works as a multimedia artist.

Patricia Holland is a writer, lecturer and film-maker. She has written about popular photography in *Picturing Childhood* (I.B.Tauris, 2004), *What is a Child?* (Virago 1992), and *Family Snaps* (Virago 1991, co-edited with Jo Spence). She has contributed to several readers on photography, television and cultural studies and is author of *The Television Handbook* (Routledge 1997; second edition 2000).

Martin Lister is Professor of Visual Culture and Head of the School of Cultural Studies at the University of the West of England, Bristol. His publications include: Youth, Culture and Photography (Macmillan 1988), The Photographic Image in Digital Culture (Routledge 1995), From Silver to Silicon: a CD Rom about photography, culture and new technologies (ARTEC, London, 1995), and New Media: A Critical Introduction (Routledge, 2003).

Derrick Price is a freelance writer and researcher who has published articles on photography, film and literature. A Senior Visiting Research Fellow at the University of the West of England, Bristol, he is a co-ordinator of the group, Creative Urban Space Projects (CUSP). He works extensively with arts organisations and is Chair of the Council of Management of Watershed Media Centre.

Anandi Ramamurthy is Senior Lecturer in the Department of Historical and Critical Studies, University of Central Lancashire. She is author of *Imperial Persuaders: Images of Africa and Asia in British Advertising* (Manchester University Press, 2003) and is co-editor of *Visual Culture in Britain at the End of Empire* (Ashgate, 2005). Between 2003 and 2005 she is establishing a web-based digitised archive of the visual and ephemeral culture of the South Asian struggle for social and political rights in Britain.

Liz Wells is Principal Lecturer in Media Arts, Faculty of Arts, University of Plymouth. She edited *The Photography Reader* (Routledge, 2003), co-edited and co-curated *Shifting Horizons: Women's Landscape Photography Now* (I.B. Tauris, 2000). She is curator of *Facing East, contemporary landscape photography from Baltic areas*, touring 2004 to 2006, and is researching a book on land, landscape, photography and identity.

Editor's preface

This book aims to remedy the absence of a good, coherent introduction to issues in photography theory, and results from the frustrations of teaching without the benefit of a succinct introductory textbook. There are a number of published histories of photography which define the field according to various agendas, although almost invariably with an emphasis upon great photographers, historically and now. Fewer publications critically engage with debates about the nature of photographic seeing. Most are collections of essays pitched at a level that assumes familiarity with contemporary cultural issues and debates which students new to this field of enquiry may not yet have.

The genesis of this book was complex. The first edition resulted initially from a discussion between myself and Rebecca Barden of Routledge, in which she solicited suggestions for publications which would support the current curriculum. Responding subsequently to her invitation to put forward a developed book proposal, two factors were immediately clear: first, that the attempt to be relatively comprehensive could best be tackled through a collective approach. Thus, a team of writers was assembled right from the start of the project. Second, it quickly became apparent that the project was, in effect, impossible. Photography is ubiquitous. As a result, there are no clear boundaries. It follows that there cannot be precise agreement as to what a 'comprehensive' introduction and overview should encompass, prioritise or exclude. After much consideration, we focused on issues and areas of practice which, given our experience as lecturers in a number of different university institutions, we know feature frequently. That we worked to a large extent in relation to an established curriculum did not mean that the project has been either straightforward or easy. On the contrary, the intention to introduce and explore issues reasonably fully, taking account of what critics have had to say on various aspects of photographic practices, involved investigating and drawing upon a wide and diverse range of resources.

The overall response to the first edition was positive. Comments included some useful suggestions, many of which we incorporated within the second, revised edition which, in response to feedback, included a new chapter on the body in photography. This chapter, taken as a whole, stands as an example of the range of debates that may become engaged when the content or subject matter of images is taken as a starting point. In this respect it contrasts in particular with chapters 2 and 6, in which the focus is on a specific genre, or an arena, of practice. The third edition is updated and, for the first time, includes colour plates. (Lecturers – note that the order of chapters has been slightly amended to take account of this.)

As editor, researching this book led to further questions, as well as to engaging discoveries. The tension between looking, thinking, investigation and discovery is one of the pleasures of academic research. Revising the book again has offered an opportunity to revisit and further clarify several points and issues. (In respect of this please note that section and page numbers have changed.)

This book aims to be relevant, and of interest, to students of photography, graphics, fine art, art and design history, journalism, media studies, communication and cultural studies. We hope that it proves both useful and enjoyable.

Acknowledgements

This book could not have been produced without the support of a number of people. First and foremost I should like to thank Michelle Henning, Patricia Holland, Martin Lister, Derrick Price and Anandi Ramamurthy, without whom the book would not have been possible. The project has been a difficult one but nonetheless a happy one, due to the quality of the team which I have had the good fortune to be in a position to assemble. I should like to thank Rebecca Barden, Moira Taylor and others at Routledge for their support.

I should like to thank colleagues and students who, in some instances without realising, contributed to the final shaping. I should also like to thank staff at various archives, including MOMA, New York and CCP, Tucson, for their help in introducing me to their study collections. Many people have read and commented on the earlier editions of this book, and offered advice on this new edition. Needless to state, the book could not have been further developed without this extensive feedback for which we are all very grateful.

Liz Wells July 2003

Illustration acknowledgements

We are indebted to the people and archives below for permission to reproduce photographs. Every effort has been made to trace copyright-holders but in a few cases this has not been possible. Any omissions brought to our attention, will be remedied in future editions.

	page
Frontispiece Herbert Bayer, Lonely Metropolitan, 1932, courtesy of Denver Art Museum. © DACS 2003	XX
1.1 Dorothea Lange , <i>Migrant Mother</i> , 1936, FSA Collection, courtesy of the Library of Congress, Washington, LCUSF341–9058C	38
1.2–1.5 Dorothea Lange , <i>Migrant Mother</i> , 1936, alternative versions, FSA Collection, courtesy of the Library of Congress, Washington	40
1.6 Reference to 'Migrant Mother', <i>Bohemia Venezolana</i> , 10 May 1964 ssue, courtesy of the Library of Congress, Washington	47
1.7 Reference to 'Migrant Mother', <i>Black Panther</i> magazine, 7 Decembe 1972, copyright Huey P.P. Newton, courtesy of the Alderman Library, University of Virginia	r 47
2.1 Sebastião Salgado , <i>Sao Paulo Construction</i> , 1996, from <i>Terra:</i> Struggles of the Landless, Phaidon, 1997, courtesy of Network, London	66
2.2 Thomas Annan , <i>Close No. 118 High Street</i> , 1868, courtesy of the Glasgow City Council Libraries Department	76
2.3 Jacob Riis , Lodgers in a Crowded Tenement – 'five cents a spot', 1880s, courtesy of the Museum of the City of New York	79
2.4 Frank Meadow Sutcliffe , <i>A Fish Stall</i> , c. 1882, courtesy of the Royal Photographic Society	81
2.5 William Thomas, Mrs Lewis Waller with a Kaffir Boy, 1903, courtesy of the Public Record Office, London, 517 Copy 1 464	84
2.6 Humphrey Spender , <i>Men Greeting in a Pub</i> , Worktown Series, 1937, courtesy of the Mass Observation Archive, Bolton Museum and Art Gallery	92
2.7 Arthur Rothstein, Dust Storm, Cimarron County, Oklahoma, 1936, courtesy of the Library of Congress, Washington	96
2.8 Drum , March 1952, courtesy of Nasionale Pers Beperk and the Bailey Trust, South Africa	98

2.9 Helen Levitt , <i>New York</i> , <i>c</i> . 1940, courtesy of the Laurence Miller Gallery, New York	101
2.10 Lee Friedlander , <i>1 Lafayette, Louisiana</i> , 1970, courtesy of the Fraenkel Gallery, San Francisco	102
2.11 Edith Tudor Hart , <i>Poverty in London</i> , c. 1930, courtesy of Wolfgang Suschitsky	104
3.1 Studio photograph of Lily Peapell in peasant dress on roller skates, USA Studios, Peckham, South London, c. 1912, courtesy of her grandson, Colin Aggett	114
3.2a From the album of Sir Arnold Wilson (No. 3 Persian scenes), 1909, courtesy of the Royal Photographic Society	121
3.2b From the album of Sir Arnold Wilson (No. 7), 1900, also courtesy of the Royal Photographic Society	122
3.3 'The photographic craze', Amateur Photographer, 10 June 1887	124
3.4 Stereoscopic slide from the late nineteenth century, courtesy of the National Museum of Photography, Film and Television, Bradford, uncatalogued	125
3.5 Earliest known daguerrotype of a photographer at work. Jabez Hogg photographs Mr Johnson, c. 1843, courtesy of the National Museum of Photography, Film and Television, Bradford	127
3.6 A page from the album of R. Foley Onslow, c. 1860, courtesy of Arthur Lockwood	129
3.7 Illustration from Cuthbert Bede, Photographic Pleasures, 1855	131
3.8 Pupils at St Mary's School, Moss Lane, Manchester, c. 1910, courtesy of the Manchester Documentary Photography Archive	134
3.9 Holiday postcard from a Blackpool studio, 1910, courtesy of Martin Parr	135
3.10 Mobile sales tent for Bailey's photographers, Bournemouth, c. 1910, courtesy of Martin Parr	135
3.11 Edward and May Bond taken by a street photographer outside their home in Manchester, c. 1912, courtesy of the Manchester Documentary Photography Archive	136
3.12 Studio photograph of Edward and May Bond, <i>c.</i> 1910, courtesy of the Manchester Documentary Photography Archive	137
3.13 Black Country chain-makers, postcard, 7 August 1911, courtesy of Jack Stasiak	138
3.14 Kodak advertisement, 1920, courtesy of the Punch Picture Library, London	141

3.15 A page from a Kodak 'Brownie' album, c. 1900, courtesy of Guillermo Marin Martinez	143
3.16 A page from the album of Frank Lockwood, 1927, courtesy of his son, watercolourist and designer Arthur Lockwood	145
3.17 From the album of Ursula Kocharian, courtesy of Ursula Kocharian	152
3.18 Valerie Walkerdine as the Bluebell Fairy, courtesy of Valerie Walkerdine	155
4.1 Physique image from <i>Physique Pictorial</i> , 4(3), Fall 1954, from <i>The Complete Reprint of Physique Pictorial</i> , Taschen, 1997	160
4.2 Fran Herbello , <i>Untitled</i> , from A Imaxe e Semellanza, 2000, courtesy of Fran Herbello	162
4.3 Filing card using Bertillon's 'anthropometric' system, 1898, from 'Anthropometrical Signalment' from the McDade Collection, reproduced in Suren Lalvani (1996), <i>Photography, Vision, and the Production of Modern Bodies</i> , Albany: State University of New York, fig. 22, p. 111	165
4.4 Francis Galton , <i>The Jewish Type</i> , composite photographs, 1883, plate 35 from Pearson, reproduced on p. 361 of Allan Sekula, 'The Body and the Archive', in Richard Bolton (ed.) (1989) <i>The Contest of Meaning: Critical Histories of Photography</i> , Cambridge: MA: The MIT Press	167
4.5 Nancy Burson , with Richard Carling and David Kramlich, Warhead I, composite image, 1982, courtesy of Nancy Burson	168
4.6 Anonymous stereoscope photograph from around 1895, from the collection of Serge Nazarieff, reproduced from the Stereoscopic Nude 1850–1930 (1933), Cologne: Benedikt Taschen Verlag GmBH	169
4.7 Riccardo Schicchi <i>La Cicciolina</i> (original in colour), courtesy of Illona Steller Koons	178
4.8 L.L. Roger-Viollet , Women Using Stereoscopes, c. Second Empire, courtesy L.L. Roger-Viollet Agency, Paris	181
4.9 Etienne-Jules Marey , images reproduced from Marta Braun (1992), <i>Picturing Time: The Work of Etienne-Jules Marey</i> (1830–1904), p. 111, Chicago: CT: University of Chicago Press	182
4.10 Hannah Höch, Das schöne Mädchen (The Beautiful Girl),	
photomontage, private collection, reproduced from Maud Lavin (1993), Cut With the Kitchen Knife: The Weimar Photomontages of Hannah Höch, New Haven, CT: Yale University Press, plate 4	185
4.11 Hans Bellmer , <i>Hans Bellmer with first Doll</i> , 1934, copyright ADAGP, Paris and DACS, London	187
4.12 Advertisement for Saab, 1998, courtesy of Lowe & Partners	188
4.13 Post-mortem daguerreotype of child, Boston, c. 1850, courtesy of George Eastman House, International Museum of Photography and Film	190

5.1 Victor Burgin , What does Possession mean to you?, 1974, courtesy of the artist	194
5.2 H.S. Wong , Chinese baby, 1937, courtesy of Associated Press	199
5.3 Stock sheet W1910783 from the Photographic Advertising Archive, courtesy of the National Museum of Photography, Film and Television (Photographic Advertising Archive), supplied by the Science and Society Picture Libary	207
5.4 South African miners demonstrating outside the office of the organisation of South African mine owners. <i>Independent</i> 26 August 1987, and used in the Anglo-American Corporation of South Africa advertisement published in <i>The Guardian</i> , 2 April 1990.	213
5.5 Illustration from Mrs Christine Frederick's The New Housekeeping,1913	215
5.6 Carte D'Or icecream advertisement, <i>Good Housekeeping</i> , June 1998, supplied by Asset, London	217
5.7 'Billy Durm', Jack Daniel's Whiskey advertisement, as it appeared in <i>FHM</i> magazine, August 1995	219
5.8 French Colonial postcard <i>c</i> . 1910, from Malek Alloula (1985) <i>The Colonial Harem</i> , Manchester: Manchester University Press, p. 26, courtesy of Malek Alloula	225
5.9 'Morocco 1990'	226
5.10 Paul Wombell , Montage, 1979, courtesy of the artist.	227
5.11 Tourist photograph, courtesy of Sita Ramamurthy	228
5.12 'Arabia behind the veil', <i>Marie Claire</i> , September 1988, no. 1, pp. 14–15. Photographers: Pascal and Maria Marechaux. Courtesy of <i>Marie Claire</i> /IPC	230
5.13 French Colonial postcard <i>c</i> . 1910, from Malek Alloula (1985) op. cit., p. 82, courtesy of Malek Alloula	232
5.14 Afternoon Dream from 'Indian Summer' Marie Claire June 1994. Photographer: Christian Moser. Courtesy of Marie Claire/IPC	233
5.15 From 'The Golden Age of Hollywood' <i>Marie Claire</i> June 1994 Photographer: Matthew Ralston. Courtesy of <i>Marie Claire</i> /IPC	234
5.16 <i>Schenectady Works News</i> , General Electric, 2 November 1923, courtesy of the Schenectady Museum's Hall of Electrical History, Schenectady, New York	238
5.17a & b USSR Benetton and America, Benetton, 1987	241
6.1 Karen Knorr , Analytical Inquiry into the Principles of Taste, from Country Life, courtesy of the artist	246

6.2 Camille Silvy , <i>River Scene, France</i> , 1858, courtesy of the Victoria and Albert Picture Library, London	255
6.3 Henry Peach Robinson , <i>The Lady of Shalott</i> , 1860–1, courtesy of the Royal Photographic Society, Bath	257
6.4 Thurston Thompson , <i>Exhibition Installation</i> , 1858, courtesy of the Victoria and Albert Picture Library, London	258
6.5 Bill Brandt , <i>Prior Park</i> , <i>near Bath</i> , 1936, copyright Bill Brandt, courtesy of John-Paul Kernot, London (await letter of reply)	261
6.6 Alexander Rodchenko , <i>White Sea Canal</i> , from <i>USSR in Construction</i> 12, 1933, copyright A. Lavrentiev/Rodchenko Family Archive, courtesy of the Slavic and Baltic Division, The New York Public Library, Astor, Lenox and Tilden Foundation	266
6.7 Edward Weston , <i>Dunes, Oceano</i> , courtesy of the Victoria and Albert Picture Library, London	268
6.8 Lee Miller , <i>Portrait of Space</i> , near Siwa, Egypt, 1937, courtesy of the Lee Miller Archive, Chiddingly, East Sussex	271
6.9 Keith Arnatt , <i>Self Burial</i> , TV Interference Project, 1969, copyright Keith Arnatt, courtesy of Tate Publishing	275
7.1 David Bate , Six Simulations of Liberty, 2003, courtesy of the artist	296
7.2 A three-stage illustration of the principle of digitising a photograph, from Richard Mark Friedhoff and William Benzon (1989), <i>The Second Computer Revolution: Visualisation</i> , New York: Harry N. Abrams Inc., p. 49	299
7.3 Diagrammatic representation of the concept of a 'virtual camera', from T. Binkley (1993), 'Refiguring Culture' in B. Hayward and T. Wollen (eds) <i>Future Visions: New Technologies of the Screen</i> , London: BFI Publishing, p. 104	301
7.4 Computer-generated image of billiard balls, from Richard Mark Friedhoff and William Benzon (1989) <i>The Second Computer Revolution: Visualisation,</i> New York: Harry N. Abrams Inc. p. 102. Copyright 1984, Thomas Porter, Pixar	301
7.5 Albrecht Dürer , <i>Draughtsman drawing a nud</i> e, 1538, courtesy of the Trustees of the British Museum	307
7.6 Front page of the <i>Daily Mirror</i> , 22 April 1912, Historic Newspapers, Wigtownshire, Scotland	321
7.7 Nadar (Gaspard Felix Tournachon) The Arc de Triomphe and the Grand Boulevards, Paris, from a balloon, 1868, courtesy of Cliché Félix Nadar, Arch. photo © Centre des monuments nationaux, Paris	323

7.8 NASA, Johnson Space Center, Houston, Texas. STS-52 Earth View (Sinai Peninsula), no. 93-HC-232 STS-052, courtesy of NASA	324
7.9 Press photographer photographing the Gulf War in progress, from <i>TEN</i> 8 (2): 18	324
7.10 Sophie Ristelhuber, Fait, 1992, courtesy of the artist	325
7.11 Viewers at a Panorama, from S. Buck Morss (1991) <i>The Dialectics of Seeing: Walter Benjamin and the Arcades Project</i> , Cambridge, MA: The MIT Press, p. 82	326
7.12 Photograph of a contemporary games arcade, courtesy of the Last Resort Picture Library, Tuxford, Nottingham	326

Colour plates between pages 148 and 149, and pages 292 and 293

- 1 Roshini Kempadoo, from Sweetness and Light, 1996. Courtesy of the artist
- 2 Martin Parr, from Last Resort, 1986 New Brighton. Courtesy Magnum
- **3 Paul Seawright**, Room 1, from the book and exhibition, Hidden, 2003. Courtesy of the artist
- 4 Nick Saunders, Eve, Karen and Nick, 2003. Digital image courtesy of the artist
- **5** Jo Spence/Tim Sheard, Greedy I recreate my journey into emotional eating, a rebellion against parental disapproval, 1989. Courtesy of Terry Dennett, the Jo Spence Archive, London
- **6 Rineke Dijkstra**, *Julie*, *Den Haag, Netherlands*, 1994. Courtesy of the Marian Goodman Gallery, New York
- **7 Andres Serrano**, *The Morgue (Fatal Meningitis II)*, 1992. Courtesy of the Paula Cooper Gallery, New York
- **8** Advertisement for Omega watches, 'Omega and Cindy, time together', 1999. Courtesy of Omega SA, Zurich
- 9 Stock image of woman floating, no. bf0378-001. Courtesy of Getty Images
- **10** A page from 'Night Diva', *Marie Claire*, July 2003, photographer Darren Feist. Courtesy *Marie Claire*/IPC Syndication
- **11 Jeff Wall**, A Sudden Gust of Wind (after Hokusai), 1993. Courtesy of the artist and Tate Publishing © Tate, London 2003
- 12 Ingrid Pollard, from Pastoral Interludes, 1987. Courtesy of the artist
- **13** Marte Aas, from the series *Common Green, no. 7,* 1999. Courtesy of the artist
- 14 Susan Derges, 'Larch', from The Streens, 2002. Courtesy of the artist

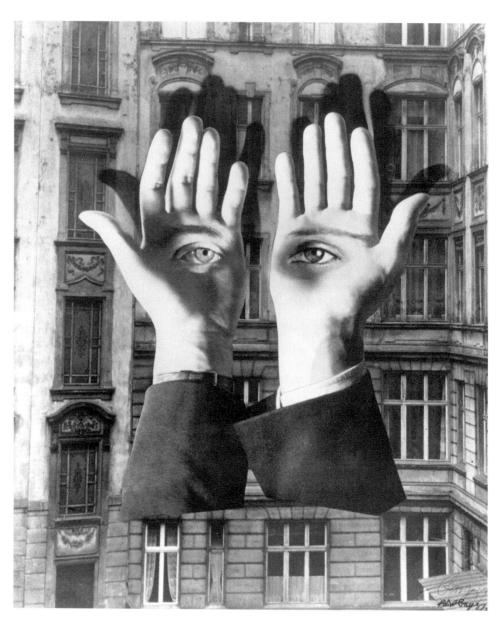

Herbert Bayer, Lonely Metropolitan, 1932

Introduction

LIZ WELLS

- 3 The purpose of this book
- 4 How to use this book
- 6 Chapter by chapter

Introduction

THE PURPOSE OF THIS BOOK

This book introduces and offers an overview of conceptual issues relating to photography and to ways of thinking about photographs. It considers the photograph as an artefact used in a range of different ways and circumstances, and photography as a set of practices which take place in particular contexts. Thus it is essentially about reading photographic images rather than about their making. The principal purpose is to introduce key debates, and to indicate sources and resources so students (and other readers) can further develop lines of enquiry relevant to them. The book primarily examines debates and developments in Britain, other parts of Europe and in North America. The perspective is informed by the British base of the team of writers, particularly showing the influence of cultural studies within British academia in the 1990s. Our writing thus reflects a specific point of departure and context for debates. There is no chronological history. Rather, we discuss past attitudes and understandings, technological limitations, and sociopolitical contexts through focus on issues pertinent to contemporary practices. In other words, we consider how ideas about photography have developed in relation to the specific focus, or field of practice, which forms the theme of each chapter. We cannot render theory easy, but we can contribute to clarifying key issues by pointing to ways in which debates have been framed.

Why study theory? As will become clear, theory informs practice. Essentially there are two choices. You can disregard theoretical debates, taking no account of ways in which images become meaningful, thereby limiting critical understanding and, if you are a photographer, restricting the depth

of understanding supporting your own work. The alternative is to engage consciously with questions of photographic meaning in order to develop critical perceptions which can be brought to bear upon photographic practices, historically and now, or upon your own photography.

HOW TO USE THIS BOOK

This book introduces a range of debates pertaining to specific fields of photographic practice. We identify key reading and other resources, in order to illuminate critical debates about photography itself, and to place such debates in relation to broader theoretical and critical discussions. Our aim is to mediate such discussions, indicating key intellectual influences within the debates and alerting you to core reading and other resources. In some instances, our recommendations are highly directive. Thus, we summarise and appraise different critical positions, and point to books and articles in which these positions have been outlined. In most cases the literature which we discuss offers clear priorities and quite explicit points of view in relation to photographic cultures. One part of our task is to draw attention to implicit, underlying assumptions which inform the theoretical stances adopted.

Since the purpose of the book is to introduce issues and ideas which may not yet be familiar, design elements have been incorporated to help. Some chapters include specific case studies, and summary diagrams, which are separated from the main flow of text. This is so that they can be seen in relation to the main argument, but also considered relatively autonomously. Likewise, photographs are sometimes used to illustrate points of discussion. However, images may also be viewed as a specific line of development within each chapter. In order to facilitate visual connections we have limited the range of topics or genres in each chapter. Thus, for instance, chapter 2, on documentary practices, concentrates primarily upon street photography. Comparison of images of similar content should help you to see some of the ways in which forms and styles of documentary and photojournalism have changed over time. It should be added that, in order to keep the size (and price) of the book reasonably manageable, we have used fewer photographs than is really desirable in a book about photography. You will need to use other visual sources, books and archives, alongside this book, in order to pursue visual analysis in proper detail.

There is a margin for notes throughout the book. Key references to core reading, and also to archive sources, appear in the margin so you can follow up the issues and ideas which have been introduced. References are repeated in a consolidated bibliography at the end. The margins are also used for technical definitions and for mini-biographies of key theorists. Terms which may be new to you are printed in bold on their first occurrence in each chapter, and there is a glossary at the end of the book. We also list principal magazines and journals published in English, and some key archives.

The book is in seven chapters, each of which may be read separately, although there are points of connection between them. We have indicated some of these links between chapters, but it is up to you to think them through in detail. A summary of the principal content of each chapter follows at the end of this introduction. This will help you to map your route through the book.

Discussion cannot be fully comprehensive. Photographic practices are diverse, and it is not possible to focus upon every possible issue and field of activity of interest, historically and now. Furthermore, since the book is reliant on the existence of other source material to which it acts as a guide, it is largely restricted to issues and debates which have been already documented and discussed. Some areas of practice have not had the full focus they might be deemed to deserve. For example, there are many collections of fashion photographs, and there have been numerous articles and books written in recent years on questions of gender, representation, fashion, style and popular culture. But there has been relatively little critical writing on fashion photography. This is an omission which we could not rectify here. Thus, fashion photography forms one section of the more general chapter on commodity culture rather than attracting a chapter to itself. Likewise, a number of more technical practices within medical and scientific imaging fall beyond the scope of this book because relevant philosophical and critical writing to date is insufficiently developed.

In some respects the chapters seem quite different from one another. There are a number of reasons for this, of which the first – and most obvious – is that each is written by a different author, and writers each have their own style. The specific tasks allotted to each chapter, and the material included, also lead to different approaches. Two chapters, concerning photography in relation to commodity culture, and to digital imaging, both broadly concentrate upon the contemporary. The chapter on the body in photography takes image content as the starting point for discussion. Three chapters, in appraising the specific fields of documentary and photojournalism, photography as art, and personal photography, are more obviously historical in their approach. Each takes it as axiomatic that the exploration of the history of debates and practices is a means to better understanding how we have arrived at present ways of thinking and operating.

Finally, of course, writing is not interest-free. You should not take the discussion in any of the chapters as representing everything that could be said on its subject. Aside from the limitations of length, authors have their own priorities. Each chapter is written from a considered viewpoint, and each of the authors has studied their subject in depth over many years. As a result of their expertise, and their broader political and social affiliations, they have arrived at particular conclusions. These contribute to determining which issues and examples they have selected for central focus and, indeed, the way they have structured the exposition and argument in their chapter. Whilst

each offers you the opportunity to consider key issues and debates, you should not view them as either comprehensive or objectively 'true'. Rather, you should see the book as a guide to what is at stake within particular debates, bearing in mind that the writer, too, has something at stake. You should also remember that this is essentially only an introduction to issues and ideas.

CHAPTER BY CHAPTER

- In chapter 1 we introduce key debates relating to photography and, most particularly, identify some of the positions within these debates taken by established theorists. The chapter focuses initially on a number of debates which have characterised theoretical and critical discussions of the photograph and of photographic practices starting with the interrelation between aesthetics and technologies. We then summarise and discuss historical accounts of photography. Finally we consider sites of practice, institutions and the audience for photography. Central to the chapter is a case study of ways in which one single image, Dorothea Lange's Migrant Mother, has been discussed. It acts as a model of how particular attitudes and assumptions can be illuminated through considering a specific example. The chapter is designed as a foundation for discussions, many of which will be picked up again for more detailed examination later in the book.
- Chapter 2 focuses upon the documentary role of the camera, especially in relation to recording everyday life. There is also some discussion of travel photography and of photojournalism, especially the expanding journalistic role for photography in the early twentieth century. Claims have been made for the authenticity or 'truth' of photography used within surveys or viewed as evidence. The chapter considers disputes that have arisen in relation to such claims in the nineteenth century, in the early twentieth century especially in the 1920s and 1930s when the term 'documentary' was coined and in relation to contemporary practices in documentary and reportage.

The chapter is concerned throughout with the multiple discourses through which the nature of photography and its social project has been constructed and understood. By concentrating on particular periods it offers a critical history of documentary which problematises and clarifies the relationship of a specific form of representation to other debates and movements.

• Chapter 3 focuses upon the popular and the personal, developing an historical overview of leisure and domestic uses of photography as a medium through which individual lives and fantasies have been recorded. Particular attention is paid to the family album, which both documents social histories and stands as a talisman of personal experience. The chapter also considers the strategies by which a mass market for photography was constructed, in particular by Kodak, and notes contemporary developments in digital imaging for domestic use. Finally the chapter comments upon recent research on the family photograph, considering what is concealed, as much as what

is revealed, in family relationships, gender and sexuality. Attention throughout is drawn to the role of women as photographers and keepers of the photograph album.

In keeping with the style of this book, this chapter signals key texts and further reading. However, the history of popular photography to date has attracted less critical attention than has been directed to other fields of photographic practice; for instance, documentary. In contrast to other parts of the book, this chapter draws upon original research and little-known materials.

- Chapter 4 focuses upon the photographic body, discussing the extent to which the body image came under scrutiny at the end of the twentieth century. Here a history of attitudes to photography and the body is traced, noting ways in which the photograph has been taken to embody social difference. Taking as its starting point the proposal that there is a crisis of confidence in the body consequent upon new technological developments, along with a crisis of representation of the body, the chapter explores questions of desire, pornography, the grotesque and images of the dead, in relation to different modes of representing the body familiar from media imagery as well as within art history.
- Chapter 5 continues the focus upon everyday uses of photography through considering commodity culture, spectacle and advertising. Photography is a cultural tool which is itself a commodity as well as a key expressive medium used to promote commercial interests. These links are examined through a series of case studies offering examples of analysis of the single image tourism, fashion and the exotic. Within commodity culture, that which is specific to photography interacts extensively with broader political and cultural issues. Thus we note references both to commercial photography and, more generally, to questions of the politics of representation, paying particular attention to gender and ethnicity. The chapter employs semiotics within the context of socioeconomic analysis to point to ways in which photography is implicated in the concealing of international social and economic relations.
- Chapter 6 considers photographic practices in relation to art and art institutions, discussing claims made for the status of photography as a fine art practice, historically and now. The chapter is organised chronologically in three sections: the nineteenth century; modern art movements; postmodern and contemporary practices. This historical division is intended not as a sort of chart of progress so much as a method of identifying different moments and shifting terms of reference relating to photography as an art practice. Attention is paid to forms of work and to themes which feature frequently in contemporary practice, including questions of gender, ethnicity and identity. The principal concern is to trace shifting terms of debate as to the status of the photograph as art and to map historical changes in the situation of the photographic within the museum and art gallery. Particular attention is paid to land and landscape imagery.

• Chapter 7 explores photodigital imaging. New means of electronic and digital imaging have emerged within societies that are undergoing significant economic, technological and political change. How can these developments be understood? How are these technologies being used? What effect have they had on historically established practices of photography? The chapter is based on two key ideas. First, amidst dramatic developments in electronic communications and digital image technologies, it no longer seems possible to take the cultural dominance of the photographic for granted. Second, given that the photographic image has shaped the way the world is seen and represented, it is clear that the history of photographic codes, practices and uses has contributed to shaping new media. It is argued that older debates, for instance, relating to photography and realism, have persisted through new technological developments, and that, increasingly, such arguments can be conceived not so much in terms of 'post-photography' but in terms of 'post-human' vision.

CHAPTER 1

Thinking about photography

Debates, historically and now

DERRICK PRICE LIZ WELLS

11 Introduction

12 Aesthetics and technologies

The impact of new technologies Art or technology? The photograph as document Photography and the modern The postmodern

24 Contemporary debates

What is theory?
Photography theory
Critical reflections on realism
Reading the image
Photography reconsidered
Theory, criticism, practice
Case study: Image analysis: the example of
Migrant Mother

48 Histories of photography

Which founding father? The photograph as image History in focus

55 Photography and social history

Social history and photography The photograph as testament Categorical photography Institutions and contexts The museum The archive A knowledge of photography is just as important as that of the alphabet. The illiterate of the future will be ignorant of the use of camera and pen alike.

László Moholy-Nagy 1923

Thinking about photography

Debates, historically and now

INTRODUCTION

This chapter introduces and discusses key writings on photography. The references are to relatively recent publications, and to current debates about photography; however, these books often refer back to earlier writings, so a history of changing ideas can be discerned. This history focuses on photography itself as well as considering photography alongside art history and theory, and cultural history and theory more generally.

The chapter is in four sections: Aesthetics and technologies, Contemporary debates, Histories of photography, and Photography and social history. The principal aim is to locate writings about photography both in terms of its own history, as a specific medium and set of practices, and in relation to broader historical, theoretical and political considerations. Thus we introduce and consider some of the different approaches – and difficulties – which emerge in relation to the project of theorising photography.

E.H. Carr has observed that history is a construct consequent upon the questions asked by the historian (Carr 1964). Thus, he suggests, histories tell us as much about the historian as about the period or subject under interrogation. Stories told reflect what the historian hopes to find, and where information is sought. In contemporary terms, fact gathering may be influenced by the particular networks used by web-based search engines. Furthermore, the historian's selection and organisation of material is to some extent

predetermined by the purpose and intellectual parameters of any particular project. Such parameters reflect particular institutional constraints as well as the interests of the historian (for instance, academics may be expected to complete research within a set period of time). Projects are also framed by underpinning ideological and political assumptions and priorities.

Such observations are obviously pertinent when considering the history of photography. They are also relevant to investigating ways in which photography has been implicated in the construction of history. As the French cultural critic, Roland Barthes, has pointed out, the nineteenth century gave us both history and photography. He distinguishes between history which he describes as 'memory fabricated according to positive formulas', and the photograph defined as 'but fugitive testimony' (Barthes 1984: 93). It is attitudes to photography, its contexts, usages and critiques of its nature that we explore in this chapter.

AESTHETICS AND TECHNOLOGIES

The impact of new technologies

The late twentieth-century convergence of audio-visual technologies with computing has led to a profound and ongoing transformation in the ways in which we record, interpret and interact with the world. This is marked both by the astonishing speed of innovation and by a rapid extension of technologies to new social, cultural, political and economic domains. We see this ferment of activity as a defining feature of the twenty-first century and, perhaps, think of it as a unique moment in human history. But, in the 1850s, many people also thought of themselves as living in the forefront of a technological revolution. From this historical distance, it is hard to recapture the extraordinary excitement that was generated 150 years ago by a cluster of new technologies. These included inventions in the electrical industries and new discoveries in optics and in chemistry, which led to the development of the new means of communication that was to become so important to so many spheres of life - photography. Hailed as a great technological invention, photography immediately became the subject of debates concerning its aesthetic status and social uses.

The excitement generated by the announcement, or marketing, of innovations tends to distract us from the fact that technologies are researched and developed in human societies. New machinery is normally presented as the agent of social change, not as the outcome of a desire for such change, i.e. as a cause rather than a consequence of culture. However, it can be argued that particular cultures invest in and develop new machines and technologies in order to satisfy previously foreseen social needs. Photography is one such example. A number of theorists have identified precursors of photography in the late eighteenth century. For instance, an expanding middle-class

demand for portraiture which outstripped available (painted) means led to the development of the mechanical physiognotrace¹ and to the practice of silhouette cutting (Freund 1980). Geoffrey Batchen also points out that photography had been a 'widespread social imperative' long before Daguerre and Fox Talbot's official announcements in 1839. He lists 24 names of people who had 'felt the hitherto strange and unfamiliar desire to have images formed by light spontaneously fix themselves' from as early as 1782 (Batchen 1990: 9). Since most of the necessary elements of technological knowledge were in place well before 1839, the significant question is not so much who invented photography but rather why it became an active field of research and discovery at that particular point in time (Punt 1995).

Once a technology exists, it may become adapted and introduced into social use in a variety of both foreseen and unforeseen ways. As cultural theorist Raymond Williams has argued, there is nothing in a technology itself which determines its cultural location or usage (Williams 1974). If technology is viewed as determining cultural uses, much remains to be explained. Not the least of this is the extent to which people subvert technologies or invent new uses which had never originally been intended or envisaged. In addition, new technologies become incorporated within established relations of production and consumption, contributing to articulating – but not causing – shifts and changes in such relations and patterns of behaviour.

Art or technology?

Central to the nineteenth-century debate about the nature of photography as a new technology was the question as to how far it could be considered to be art. Given the contemporary ubiquity of photography, to ask such a categorical question now seems quite odd. But in its early years photography was celebrated for its putative ability to produce accurate images of what was in front of its lens; images which were seen as being mechanically produced and thus free of the selective discriminations of the human eye and hand. On precisely the same grounds, the medium was often regarded as falling outside the realm of art, as its assumed power of accurate, dispassionate recording appeared to displace the artist's compositional creativity. Debates concerning the status of photography as art took place in periodicals throughout the nineteenth century. The French journal, La Lumière, published writings on photography both as a science and as an art.2 Baudelaire linked 'the invasion of photography and the great industrial madness of today' and asserted that 'if photography is allowed to deputize for art in some of art's activities, it will not be long before it has supplanted or corrupted art altogether' (Baudelaire 1859: 297). In his view photography's only function was to support intellectual enquiry:

Photography must, therefore, return to its true duty which is that of handmaid of the arts and sciences, but their very humble handmaid,

1 For definitions see Gordon Baldwin (1991) Looking at Photographs: A Guide to Technical Terms, California: The J. Paul Getty Museum and London: British Museum Press.

2 Lemagny and Rouille (1987: 44) point out that the subtitle for the journal was 'Review of photography: fine artsheliography-sciences, non-political magazine published every Saturday'.

CHARLES BAUDELAIRE

(1821 - 1867)Paris-based poet and critic whose writings on French art and literature embraced modernity; he stressed the fluidity of modern life, especially in the metropolitan city, and extolled painting for its ability to express - through style as well as subject-matter - the constant change central to the experience of modernity. In keeping with attitudes of the era, he dismissed photography as technical transcription, perhaps oddly so given that photography was a product of the era which so fascinated

like printing and shorthand, which have neither created nor supplemented literature. Let photography quickly enrich the traveller's album and restore to his eyes the precision his memory may lack; let it adorn the library of the naturalist, magnify microscopic insects, even strengthen, with a few facts, the hypotheses of the astronomer; let it, in short, be the secretary and record-keeper of whomsoever needs absolute material accuracy for professional reasons.

(Baudelaire 1859: 297)

'Absolute material accuracy' was seen as the hallmark of photography because most people at the time accepted that the medium rendered a complete and faithful image of its subjects. Moreover, the nineteenth-century desire to explore, record and catalogue human experience, both home and abroad, encouraged people to emphasise photography as a method of naturalistic documentation. Baudelaire, who was among the more prominent French critics of the time, not only accepts its veracity but adds: 'if once it be allowed to impinge on the sphere of the intangible and the imaginary, on anything that has value solely because man adds something to it from his soul, then woe betide us!' (1859: 297). Here he is opposing industry (seen as mechanical, soulless and repetitive) with art, which he considered to be the most important sphere of existential life. Thus Baudelaire is evoking the irrational, the spiritual and the imaginary as an antidote to the positivist interest in measurement and statistical accuracy which, as we have noted, characterised much nineteenth-century investigation. From this point of view the mechanical nature of the camera militated against its use for anything other than mundane purposes.

Photographers responded to criticisms of this kind in two main ways: either they accepted that photography was something different from art and sought to discover what the intrinsic properties of the medium were; or they pointed out that photography was more than a mechanical form of image-making, that it could be worked on and contrived so as to produce pictures which in some ways resembled paintings. 'Pictorial' photography, from the 1850s onwards, sought to overcome the problems of photography by careful arrangement of all the elements of the composition and by reducing the signifiers of technological production within the photograph. For example, they ensured that the image was out of focus, slightly blurred and fuzzy; they made pictures of allegorical subjects, including religious scenes; and those who worked with the gum bichromate process scratched and marked their prints in an effort to imitate something of the appearance of a canvas.

In the other camp were those photographers who celebrated the qualities of **straight photography** and did not want to treat the medium as a kind of monochrome painting. They were interested in photography's ability to provide apparently accurate records of the visual world and tried to give their

See ch. 6 for discussion of Pictorialism as a specific photographic movement.

straight photography Emphasis upon direct documentary typical of the Modern period in American photography. images the formal status and finish of paintings while concentrating their attention on its intrinsic qualities.

Most of these photographs were displayed on gallery walls – this was a world of exhibition salons, juries, competitions and medals. In the journals of the time (which already included the *British Journal of Photography*), tips about technique coexisted with articles on the rules of composition. If the photographs aspired to be art, their makers aspired to be artists, and they emulated the characteristic institutions of the art world. However, away from the salon, in the high streets of most towns, jobbing photographers earned a living by making simple photographic portraits of people, many of whom could not have afforded any other record of their own appearance. This did not please the painters:

The cheap portrait painter, whose efforts were principally devoted to giving a strongly marked diagram of the face, in the shortest possible time and at the lowest possible price, has been to a great extent superseded. Even those who are better entitled to take the rank of artists have been greatly interfered with. The rapidity of execution, dispensing with the fatigue and trouble of rigorous sittings, together with the supposed certainty of accuracy in likeness in photography, incline many persons to try their luck in Daguerreotype, a Talbotype, Heliotype, or some method of sun or light-painting, instead of trusting to what is considered the greater uncertainty of artistic skill.

(Howard 1853: 154)

The industrial process, so despised by Baudelaire and other like-minded critics, is here seen as offering mechanical accuracy combined with a degree of quality control. Photography thus begins to emerge as the most commonly used and important means of communication for the industrial age.³

Writing at about the same time as Baudelaire, Lady Elizabeth Eastlake agreed that photography was not an art but emphasised this as its strength.⁴ She argued that:

She is made for the present age, in which the desire for art resides in a small minority, but the craving, or rather the necessity for cheap, prompt, and correct facts in the public at large. Photography is the purveyor of such knowledge to the world. She is the sworn witness of everything presented to her view . . . (her studies are 'facts') . . . facts which are neither the province of art nor of description, but of that new form of communication between man and man – neither letter, message, nor picture – which now happily fills the space between them.

(Eastlake 1857: 93)

- 3 For an interesting account of debates and discourses on realism and photography in the nineteenth century see Jennifer Green-Lewis (1996) Framing the Victorians, Photography and the Culture of Realism, Ithaca and London: Cornell University Press.
- 4 Lady Eastlake, a photographer in her own right, was married to Sir Charles Eastlake, first President of the London Photographic Society (later the Royal Photographic Society).

In this account, photography is not so much concerned with the development of a new aesthetic as with the construction of new kinds of knowledge as the carrier of 'facts'. These facts are connected to new forms of communication for which there is a demand among all social groups; they are neither arcane nor specialist, but belong in the sphere of everyday life. In this respect, Eastlake is one of the first writers to argue that photography is a democratic means of representation and that the new facts will be available to everyone.

Photography does not merely transmit these facts, it creates them, but Eastlake sees photography as the 'sworn witness' of the appearance of things. This juridical phrase strikingly captures what, for many years, was considered to be the inevitable function of photography — that it showed the world without contrivance or prejudice. For Eastlake, such facts came from the recording without selection of whatever was before the lens. It is photography's inability to choose and select the objects within the frame that locates it in a factual world and prevents it from becoming art:

Every form which is traced by light is the impress of one great moment, or one hour, or one age in the great passage of time. Though the faces of our children may not be modelled and rounded with that truth and beauty which art attains, yet *minor* things – the very shoes of the one, the inseparable toy of the other – are given with a strength of identity which art does not even seek.

(Eastlake 1857: 94; emphasis in original)

The old hierarchies of art have broken down. Photography bears witness to the passage of time, but it cannot make statements as to the importance of things at any time, nor is it concerned with 'truth and beauty' or with teasing out what underlies appearances. Rather, it voraciously records anything in view; in other words it is firmly in the realm of the contingent.

Photography, then, is concerned with facts that are 'necessary', but may also be contingent, may draw our attention to what formerly went unnoticed or ignored. Writing within 15 years of its invention Eastlake points to the many social uses to which photography has already been put:

photography has become a household word and a household want; it is used alike by art and science, by love, business and justice; is found in the most sumptuous saloon and the dingiest attic – in the solitude of the Highland cottage, and in the glare of the London gin palace – in the pocket of the detective, in the cell of the convict, in the folio of the painter and architect, among the papers and patterns of the mill owner and manufacturer and on the cold breast of the battle field.

(Eastlake 1857: 81)

For Eastlake, photography is ubiquitous and classless; it is a popular means of communication. Of course, it was not true that people of all classes and conditions could commission photographs as a necessary 'household want' – she anticipates that state by several decades, during which time the use of photography was also spreading from its original practitioners (relatively affluent people who saw themselves as experimenters or hobbyists) to those who undertook it as a business and began to extend the repertoire of conventions of the 'correct' way to photograph people and scenes.

Eastlake's facts are produced, she claims, by a new form of communication, which she is unable to define very clearly. But for all her vagueness, she does identify an important constituent in the making of modernity: the rise of previously unknown forms of communication which had a dislocating effect on traditional technologies and practices. She is writing at an historical moment marked by a cluster of technical inventions and changes and she places photography at the centre of them. The notion that the camera should aspire to the status of the printing press – a mechanical tool which exercises no effect upon the medium which it supports – is here seriously challenged. For Eastlake calmly accepts that photography is not art, but hints at the displacing effect the medium will have on the old structures of art; photography, she says, bears witness to the passage of time, but it cannot select or order the relative importance of things at any time. It does not tease out what underlies appearances, but records voraciously whatever is in its view. By the first decade of the twentieth century the Pictorialists had all but retreated from the field and it was the qualities of straight photography that were subsequently prized. Moreover, modernism argued for a photography that was in opposition to the traditional claims of art.

The photograph as document

In Britain, as elsewhere, the idea of documentary has underpinned most photographic practices since the 1930s. The terminology is indicative: the Oxford English Dictionary definition of 'documentary' is 'to document or record'. The simultaneous 'it was there' (the pro-photographic event) and 'I was there' (the photographer) effect of the photographic record of people and circumstances contributes to the authority of the photographic image. Photographic aesthetics commonly accord with the dominant modes and traditions of Western two-dimensional art, including perspective and the idea of a vanishing point. Indeed, as a number of critics have suggested, photography not only echoes post-Renaissance painterly conventions, but also achieves visual renderings of scenes and situations with what seems to be a higher degree of accuracy than was possible in painting. Photography can, in this respect, be seen as effectively substituting for the representational task previously accorded to painting. In addition, as Walter Benjamin argued in 1936, changes brought about by the introduction of mechanical means of reproduction which produced and circulated multiple copies of an image

WALTER BENJAMIN

(1892-1940) Born in Berlin, Benjamin studied philosophy and literature in a number of German universities. In the 1920s he met the playwright, Bertolt Brecht, who exercised a decisive influence on his work. Fleeing the Nazis in 1940, Benjamin found himself trapped in occupied France and committed suicide on the Spanish border. During the 1970s his work began to be translated into English and exercised a great critical influence. His critical essays on Brecht were published in English under the title Understanding Brecht in 1973. Benjamin was an influential figure in the exploration of the nature of modernity through essays such as his study of Baudelaire. published as Charles Baudelaire: A Lyric Poet in the Era of High Capitalism (London: Verso, 1973). He is acclaimed as one of the major thinkers of the twentieth century, particularly for his historically situated interrogations of modern culture. Two highly important essays for the student of photography are 'A Short History of Photography' (1931) and 'The Work of Art in the Age of Mechanical Reproduction' (1936). The latter essay and 'Theses on the Philosophy of History' are frequently drawn upon in discussion of the cultural implications of new technological developments.

SIEGFRIED KRACAUER

(1889-1966) German critic, emigrated to America in 1941. His first major essay on photography was published in 1927 in the Frankfurter Zeitung. The sub-title of his best known work Theory of Film: The Redemption of Physical Reality indicates his focus on images as sources of historical information. Benjamin's renowned 'Short History of Photography' (1931), along with his 'artworks' essay (1936), was, in effect, a response to Kracauer's 1927 essay.

WALTER BENJAMIN (1931)
'A Short History of Photography'
in (1979) **One Way Street,**London: New Left Books.

See ch. 2 and 7 for further discussion.

shifted attitudes to art (Benjamin 1936). Formerly unique objects, located in a particular place, lost their singularity as they became accessible to many people in diverse places. Lost too was the 'aura' that was attached to a work of Art which was now open to many different readings and interpretations. For Benjamin, photography was therefore inherently more democratic. Yet established attitudes persist. In Western art the artist is accorded the status of someone endowed with particular sensitivities and vision. That the photographer as artist, viewed as a special kind of seer, chose to make a particular photograph lends extra authority and credibility to the picture.

In the twentieth century, photography continued to be ascribed the task of 'realistically' reproducing impressions of actuality. Writing after the Second World War in Europe, German critic, **Siegfried Kracauer** and French critic, André Bazin, both stressed the ontological relation of the photograph to reality (Bazin 1967; Kracauer 1960). Walter Benjamin was among those who had disputed the efficacy of the photograph in this respect, arguing that the reproduction of the surface appearance of places tells us little about the sociopolitical circumstances which influence and circumscribe actual human experience (**Benjamin 1931**).

The photograph, technically and aesthetically, has a unique and distinctive relation with that which is/was in front of the camera. Analogical theories of the photograph have been abandoned; we no longer believe that the photograph directly replicates circumstances. But it remains the case that, technologically, the chemically produced image is an indexical effect caused by a particular conjuncture of circumstances (including subject-matter, framing, light, characteristics of the lens, chemical properties and darkroom decisions). This basis in the observable lends a sense of authenticity to the photograph. Italian semiotician, Umberto Eco, has commented that the photograph reproduces the conditions of optical perception, but only some of them (see Eco in Burgin 1982). That the photograph appears iconic not only contributes an aura of authenticity, it also seems reassuringly familiar. The articulation of familiar-looking subjects through established aesthetic conventions further fuels realist notions associated with photography. Thus philosophical, technical and aesthetic issues - along with the role accorded to the artist - all feature within ontological debates relating to the photograph.

In recent years, developments in computer-based image production and the possibilities of digitisation and reworking of the photographic image have increasingly called into question the idea of documentary realism. The authority attributed to the photograph is at stake. That this has led to a reopening of debates about 'photographic truth' in itself shows that, in everyday parlance, photographs are still viewed as realistic.

Photography and the modern

Photography was born into a critical age, and much of the discussion of the medium has been concerned to define it and to distinguish it from other practices. There has never, at any one time, been a single object, practice or form that is photography; rather, it has always consisted of different kinds of work and types of image which in turn served different material and social uses. Yet discussion of the nature of the medium has often been either reductionist – looking for an essence which transcends its social or aesthetic forms – or highly descriptive and not theorised.

Photography was a major carrier and shaper of **modernism**. Not only did it *dislocate* time and space, but it also undermined the linear structure of conventional narrative in a number of respects. These included access to visual information about the past carried by the photo, and detail over and above that normally noted by the human eye. Writing in 1931, Walter Benjamin proposed that the photograph records the 'optical unconscious',

It is indeed a different nature that speaks to the camera from the one which addresses the eye; different above all in the sense that instead of a space worked through by a human consciousness there appears one which is affected unconsciously. It is possible, for example, however roughly, to describe the way somebody walks, but it is impossible to say anything about that fraction of a second when a person starts to walk. Photography with its various aids (lenses, enlargement) can reveal this moment. Photography makes aware for the first time the optical unconscious, just as psychoanalysis discloses the instinctual unconscious.

(Benjamin 1972: 7)

Benjamin was writing at a time when the idea that photography offered a particular way of seeing took on particular emphasis; in the 1920s and 1930s both the putative political power of photography and its status as the most important modern form of communication were at their height. Modernism aimed to produce a new kind of world and new kinds of human beings to people it. The old world would be put under the spotlight of modern technology and the old evasions and concealments revealed. The photo-eye was seen as revelatory, dragging 'facts', however distasteful or deleterious to those in power, into the light of day. As a number of photographers in Europe and North America stressed, albeit somewhat differently, another of its functions was to show us the world as it had never been seen before. Photographers sought to offer new perceptions founded in an emphasis upon the formal 'geometry' of the image, both literally and metaphorically offering new angles of vision. The stress on form in photographic seeing typical of American modern photography parallels the stress on photography, and on cinematography, as a particular kind of vision in European art movements of the 1920s. Our vision will be changed because we can see the world from unfamiliar viewpoints, for instance, through a microscope, from the top of high buildings, from under the sea. Moreover, photography validated our experience of 'being there', which is not merely one of visiting an unfamiliar place,

but of capturing the authentic experience of a strange place. Photographs are records and documents which pin down the changing world of appearance. In this respect the close kinship between the still image and the movie is relevant; photography and film were both implicated in the modern stress on seeing as revelation. Indeed, artists and documentarians frequently used both media.

European modernism, with its contempt for the aesthetic forms of the past and its celebration of the machine, endorsed photography's claim to be the most important form of representation. Moholy-Nagy, writing in the 1920s, argued that now our vision will be corrected and the weight of the old cultural forms removed from our shoulders:

Everyone will be compelled to see that which is optically true, is explicable in its own terms, is objective, before he can arrive at any possible subjective position. This will abolish that pictorial and imaginative association pattern which has remained unsuperseded for centuries and which has been stamped upon our vision by great individual painters.

(Moholy-Nagy 1967: 28)

A world cleansed of traditional forms and hierarchies of values would be established, one in which we would be free to see clearly without the distorting aesthetics of the past. This new world had already been named by Paul Strand in describing American photographic practice, which he saw as indigenous, and viewed as being as revolutionary as the skyscraper. As he put it in a famous article in the last issue of *Camera Work*:

America has been expressed in terms of America without the outside influence of Paris art schools or their dilute offspring here . . . [photography] found its highest esthetic achievement in America, where a small group of men and women worked with honest and sincere purpose, some instinctively and a few consciously, but without any background of photographic or graphic formulae much less any cut and dried ideas of what is Art and what isn't: this innocence was their real strength. Everything they wanted to say had to be worked out by their own experiments: it was born of actual living. In the same way the creators of our skyscrapers had to face the similar circumstances of no precedent and it was through that very necessity of evolving a new form, both in architecture and photography that the resulting expression was vitalised.

(Strand 1917: 220)

Here, in a distinctively American formulation, photography is seen as having been developed outside history. Strand is claiming that a new frontier of vision was established by hard work and a kind of innocence, that it was a product of human experience rather than of cultural inheritance.

The postmodern

Postmodernism is an important, and much contested philosophical term, which emerged in the mid 1980s. It is difficult to define, not least because it was applied to very many spheres of activity and disciplines. Briefly, writers on postmodernism postulated the idea that modernity had run its course, and was being replaced by new forms of social organisation with a transforming influence on many aspects of existence. Central to the growth of this kind of social formation was the development of information networks on a global scale which allowed capital, ideas, information and images to flow freely around the world, weakening national boundaries and profoundly changing the ways in which we experience the world.

Among the key concepts of postmodernism were the claims that we are at the 'end of history' and that as Jean-François Lyotard suggested, we are no longer governed by, so called, 'grand' or 'master' narratives - the underpinning framework of ideas by means of which we had formerly made sense of our existence. For instance, Marxism in emphasising class conflict as the dialectical motor of history, provides a material philosophical position which can be drawn upon to account for any number of sociopolitical phenomena or circumstances (Lyotard 1985). This critique was accompanied by the assertion that there has been a major shift in the nature of our identity. Eighteenth century 'Enlightenment' philosophy saw humans as stable, rational subjects. Postmodernism shares with modernism the idea that we are, on the contrary, 'decentered' subjects. The word 'subjects', here, is not really concerned with us as individuals, but refers to the ways in which we embody and act out the practices of our culture. Some postmodernist critics have argued that we are cut loose from the grand narratives provided by history, philosophy or science; so that we live in fragmented and volatile cultures. This view is supported by the postmodern idea that we inhabit a world of dislocated signs, a world in which the appearance of things has been separated from authentic originals.

Writing over a century earlier in 1859, the American jurist and writer, Oliver Wendell Holmes, had considered the power of photography to change our relationship to original, single and remarkable works:

There is only one Coliseum or Pantheon; but how many millions of potential negatives have they shed – representatives of billions of pictures – since they were erected! Matter in large masses must always be fixed and dear; form is cheap and transportable. We have got the fruit of creation now and need not trouble ourselves with the core. Every conceivable object of Nature and Art will soon scale off its surface for us. We will hunt all curious, beautiful grand objects, as they hunt the

cattle in South America, for their skins, and leave the carcasses as of little worth.

(Holmes 1859: 60)

Holmes did conceive of some essential difference between originals and copies. Nevertheless, he realised that the mass trade in images would change our relationship to originals; making them, indeed, little more than the source of representation.

The postmodern is not concerned with the aura of authenticity. For example, in Las Vegas hotels are designed to reference places such as New York or Venice, featuring 'Coney Island' or 'The Grand Canal'. Superficially the resemblance is impressive in its grasp of iconography and semiotics, specifically, in understanding that, say, Paris, can be conjured up in a condensed way through copying traditional (kitsch) characteristics of Montmartre. Actual histories, geographies and human experiences are not only obscured, they are irrelevant, as these reconstructions are essentially décor for commercialism: gambling, shopping, eating and drinking. Indeed, communications increasingly featured what the French philosopher Jean Baudrillard called 'simulacra': copies for which there was no original.

In a world overwhelmed by signs, what status is there for photography's celebrated ability to reproduce the real appearance of things? Fredric Jameson argues that photography is:

renouncing reference as such in order to elaborate an autonomous vision which has no external equivalent. Internal differentiation now stands as the mark and moment of a decisive displacement in which the older relationship of image to reference is superseded by an inner or interiorized one . . . the attention of the viewer is now engaged by a differential opposition within the image itself, so that he or she has little energy left over for intentness to that older 'likeness' or 'matching' operation which compared the image to some putative thing outside.

(Jameson 1991: 179)

He is among a number of contemporary critics who argue that photography has given up attempting to provide depictions of things which have an autonomous existence outside the image and that we spectators no longer possess the psychic energy needed to compare the photograph with objects, persons or events in the world external to the frame of the camera. If a simulacrum is a copy for which there is no original; it is, as it were, a copy in its own right. Thus, in postmodernity it may be that the photograph has no referent in the wider world and can be understood or critiqued only in terms of its own internal aesthetic organisation. Yet, as Roland Barthes argued, the photograph is always and necessarily of something (Barthes 1984: 28).

JEAN BAUDRILLARD (b.1929) French philosopher, Jean Baudrillard, has theorised across a very wide terrain of political, social and cultural life. In his early work he attempted to move Marxist thought away from a preoccupation with production and labour to a concern with consumption and culture. His later work looks at the production and exchange of signs in a spectacular society. His notions of the hyperreal and of the simulacrum are of great interest to those interested in theorising photography, and were among the core concepts of postmodernism.

Some photography does not traffic in multiple images but, rather, is constructed for the gallery. Cultural theorist, Rosalind Krauss, has described photography's relationship to the world of aesthetic distinction and judgement in the following terms:

Within the aesthetic universe of differentiation – which is to say; 'this is good, this is bad, this, in its absolute originality, is different from that' – within this universe photography raises the specter of nondifferentiation at the level of qualitative difference and introduces instead the condition of a merely quantitative array of difference, as in series. The possibility of aesthetic difference is collapsed from within and the originality that is dependent on this idea of difference collapses with it.

(Krauss 1981: 21)

Like Benjamin she is noting the loss of aura introduced by the mass reproducability of photographs, but here she draws attention to the impact of this inherent characteristic within the gallery and the art market. The 'collapse of difference' has had an enormous effect on painting and sculpture, for photography's failure of singularity undermined the very ground on which the aesthetic rules that validated originality was established. Multiple, reproducible, repetitive images destabilised the very notion of 'originality' and blurred the difference between original and copy. The 'great masters' approach to the analysis of images becomes increasingly irrelevant, for in the world of the simulacrum what is called into question is the originality of authorship, the uniqueness of the art object and the nature of self-expression.

Indeed, in a world wherein images, which appear increasingly mutable, circulate electronically, such issues may seem irrelevant. In chapter 7 we discuss digital technologies in detail, look at their impact on photography, and consider ways in which we can critically analyse them. Here, we merely want to note that we can now all see some of the effects of the ongoing digital revolution. Many of us receive photographs on e-mail, send them via mobile phones, store them in electronic archives, combine them with text to create brochures, or manipulate them to enhance their quality.

Photography has always been caught up in new technologies and played a central part in the making of the modern world. However, one feature of the digitisation of many parts of our life is that potential new technologies are discussed in detail long before they become an everyday reality. In terms of photography many people anticipated a loss of confidence in the medium because of the ease with which images could be seamlessly altered and presented as accurate records. That this does not appear to have happened is testimony to the complex ways in which we use and interpret photographs. Nevertheless, these technologies are having a decided impact on the nature of the medium and are changing the ways in which it is used in all spheres

of life. These changes continue to be made as the complex mix of technologies leads to the production of new products, stimulates new desires and evolves new forms of communication.

CONTEMPORARY DEBATES

What is theory?

The role of any theory is to explain. But as recent critical debate has taught us, systems of discourse are themselves implicated in real social and political relationships of power. Explanations inevitably privilege one set of interests over others, and today few of those engaged in critical work would claim to speak from a neutral or objective place. Theoreticians now aspire less to the erection of alternative global systems and more to the questioning and challenging of existing patterns of cultural power. In the current climate, any smooth and unambiguous unity of theory is likely to arouse suspicion. The most insidious explanations are those which see no need to explain themselves.

(Ferguson 1992: 5)

All discussions of photographs rest upon some notion of the nature of the photograph and how it acquires meaning. The issue is not whether theory is in play but, rather, whether theory is acknowledged. Two strands of theoretical discussion have featured in recent debates about photography: first, theoretical approaches premised on the relationship of the image to reality; second, those which stress the importance of the interpretation of the image by focusing upon the reading, rather than the taking, of photographic representations. In so far as there has been crossover between these two strands, this is found in the recent interest in the contexts and uses of photographs (whether chemical or digital).

'Theory' refers to a coherent set of understandings about a particular issue which have been, or potentially can be, appropriately verified. It emerges from the quest for explanation, offers a system of explanation and reflects specific intellectual and cultural circumstances. Theoretical developments occur within established paradigms, or manners of thinking, which frame and structure the academic imagination. On the whole, modern Western philosophy, from the eighteenth century onwards, has stressed rational thought and posited a distinction between subjective experience and the objective, observable or external. One consequence of this has been positivist approaches to research both in the sciences and the social sciences and, as we have already indicated, photography has been centrally implicated within the empirical as a recording tool. Positivism has not only influenced uses of photography; it has also framed attitudes towards the status of the photograph.

Academic interrogation of photography employs a range of different types of theoretical understandings: scientific, social scientific and aesthetic. Historically, there has been a marked difference between scientific expectations of theory, and the role of theory within the humanities. Debates within the social sciences have occupied an intellectual space which has drawn upon both scientific models and the humanities. In the early/mid-twentieth century literary criticism centred upon a canon of key texts deemed worthy of study. Similarly, art history was devoted to a core line of works of 'great' artists, and much time was given to discussion of their subject-matter, techniques, and the provenance of the image. The academic framework was one of sustaining a particular set of critical standards and, perhaps, extending the canon by advocating the inclusion of new or newly rediscovered works. A number of major exhibitions and publications on photography have taken this as their model, offering exposition of the work of selected photographers as 'masters' in the field. This approach, in literature, art history and aesthetic philosophy, has been critiqued for its esoteric basis. It has also been criticised for reflecting white, male interests and, indeed, for blinkering the academic from a range of potential alternative visual and other pleasures. For instance, within photography the fascination of domestic or popular imagery, in its own right as well as within social history, was long overlooked, largely because such images do not necessarily accord with the aesthetic expectations of the medium and because they tend to be anonymous.

A more systematic critical approach, associated with mainland European intellectual debates, penetrated the Anglo-American tradition in some areas of the humanities, especially philosophy and literary studies, in the 1970s. The parallel influence on visual studies came slightly later. This impact was most pronounced in the relatively new – and therefore receptive – discipline of film studies. But there was also a significant displacement of older, established preoccupations and methods within art history and criticism, from which emerged what has come to be termed *new art history*. Increasingly, methodologically more eclectic visual cultural studies have superseded the more limited focus of traditional art history and aesthetic philosophy.

Photography theory

One of the central difficulties in the establishment of photography theory, and of priorities within debates relating to the photographic image, is that photography lies at the cusp of the scientific, the social scientific and the humanities. Thus, contemporary ontological debates relating to the photograph are divergent. One approach centres on analysis of the rhetoric of the image in relation to looking, and the desire to look. This is premised on models of visual communication which draw upon linguistics and, in particular, **psychoanalysis**. This approach locates photographic imagery within broader **poststructuralist** concerns to understand meaning-producing processes.

VICTOR BURGIN (ed.) (1982) Thinking Photography, London: Macmillan. A collection of eight essays, including three by Burgin himself, which, although varying in theoretical stance and focus, all aim to contribute to developing a materially grounded analysis of photographic practices.

SUSAN SONTAG (2002) On Photography, Harmondsworth: Penguin, new edition with introduction by John Berger. A collection of six essays on various aspects of photography which, despite seeming slightly out of date in its concern with realism, still offers many key insights. Her programme on photography, It's Stolen Your Face, produced for the BBC in 1978, was based on this collection.

ROLAND BARTHES (1984)

Camera Lucida, London:
Fontana. First published in
French in 1980 as La Chambre
Claire. In this, his final book,
Barthes offers a quite complex,
rhetorical, but nonetheless
interesting and significant set of
comments on how we respond
to photographs.

Up until the 1980s 'photography theory' within education had been taken to refer to technologies and techniques as in optics, colour temperature, optimum developer heat, etc. 'Theory' related to the craft base of photography. In introducing the collection of essays Thinking Photography, artist/critic Victor Burgin argued that photography theory must be interdisciplinary and must engage not only with techniques but, more particularly, with processes of signification (Burgin 1982). Writing in the context of the 1970s/80s, and drawing on work from a range of disciplines, he commented that photography theory does not exist in any adequately developed form. Rather, we have photography criticism which, as currently practised, was evaluative and normative, authoritative and opinionated, reflecting what he terms an 'uneasy and contradictory amalgam' of Romantic, Realist and Modernist aesthetic theories and traditions. We might ask to what extent this is different now, over 20 years on. He also suggested that photography history, as written up until the 1980s, reflects the same ideological positions and assumptions; that is to say, it uncritically accepts the dominant paradigms of aesthetic theory. Burgin warns against confusing photography theory with a general theory of culture, arguing for the specificity of the still, photographic image.

In relation to this, as we have already seen, a number of critics have focused on the realist properties of the image. Film critic André Bazin, in the 1950s, in his key essay on the subject, emphasised the truth-to-appearances characteristics of the photographic (Bazin 1967). Albeit within wider-ranging terms, **Susan Sontag**, in her 1970s series of essays collected as *On Photography*, also discussed photographs as traces of reality and interrogated photography in terms of the extent to which the image reproduces reality. Similarly, Roland Barthes emphasised the referential characteristics of the photograph in his final book *Camera Lucida* (**Barthes 1984**).

Critical reflections on realism

Photographing is essentially an act of non-intervention.

(Sontag 1979: 11)

Because of the disjunction between the thinking, seeing photographer and the camera that is the instrument of recording, the viewer finds it more difficult than with other visual artifacts to attribute creativity to any photographer.

(Price 1994: 4)

In philosophical terms, any concern with truth-to-appearances or traces of reality presupposes 'reality' as a given, external entity. Notions of the photograph as empirical proof, or the photograph as witness offering descriptive testimony, ultimately rest upon the view of reality as external to the human individual and objectively appraisable. If reality is somehow there, present,

external, and available for objective recording, then the extent to which the photograph offers accurate reference, and the significance of the desire to take photographs or to look at images of particular places or events, become pertinent.

Susan Sontag defined the photograph as a 'trace' directly stencilled off reality, like a footprint or a death mask. On Photography offered a series of interconnected essays, essentially based on a realist view of photography. Her concern was with the extent to which the image adequately represents the moment of actuality from which it is taken. She emphasised the idea of the photograph as a means of freezing a moment in time. If the photograph misleads the viewer, she argued this is because the photographer has not found an adequate means of conveying what he or she wishes to communicate about a particular set of circumstances. Her focus was on the photograph as document, as a report, or as evidence of activities such as tourism. She commented that the use of a camera satisfies the work ethic and stands in when we are unsure of our responses to unfamiliar circumstances, but can also reduce travel and other experiences to a search for the photogenic. Sontag also discussed the ethics of the relationship between the photographer as reporter and the person, place or circumstances recorded. The photographer, especially the photojournalist, is relatively powerful within this relationship, and thus may be seen as predatory. She pointed out that the language of military manoeuvre – 'load', 'shoot' – is central to photographic practices. Given this relative power, in her view it is even more important to emphasise the necessity of accurate reporting or relating of events. Photographs are not necessarily sentimental, or candid; they may be used for a variety of purposes including policing or incrimination.

Sontag's discussion veers between the reasons for taking photographs and the uses to which they are put. It is marked by a sense of the elusiveness of the photo-image itself. She noted our reluctance to tear up photos of relatives, and the rejection of politicians through symbolically burning images. She describes photographs as relics of people as they once were, suggesting that the still camera embalms (by contrast with the movie camera, which savours mobility). Thus she drew attention to the fascination of looking at photographs in terms of what we think they may reveal of that which we cannot otherwise have any sense of knowing, characterising photographs as a catalogue of acquired images which stand in for memories. Photographs can also, she suggests, give us an unearned sense of understanding things, past and present, having both the potential to move us emotionally, but also the possibility of holding us at a distance through aestheticising images of events. Photographs can also exhaust experiences, using up the beautiful through rendering it into cliché. For instance, she notes that sunsets may now look corny, too much like photographs of sunsets. The overall impact of her essays is rhetorical in that she makes grand claims for photography as a route to seeing, and, by extension, understanding more about the world of experience. Throughout, we have the sense that meaning may be sought within the photograph, providing it has been well composed and therefore accurately traces a relic of a person, place or event. Yet the collection does not include examples of actual photographs and there is no detailed analysis and discussion of specific images.

In her book *The Photograph: A Strange, Confined Space* (1994), American critic, Mary Price, argues that the meaning of the photographic image is primarily determined through associated verbal description and the context in which the photograph is *used*. By contrast with Sontag's emphasis on the relation between the image and its source in the actual historical world, Price starts from questions of viewing and the context of reception. Thus, she suggests, in principle there is no single meaning for a photograph, but rather an emergent meaning, within which the subject-matter of the image is but one element. Her analysis is practical in its approach. She takes a number of specific examples, aiming to demonstrate the extent to which usage and contextualisation determine meaning.

Realist theories of photography can take a number of different starting points: first, the photograph itself as an aesthetic artefact; second, the institutions of photography and the position and behaviour of photographers; third, the viewer or audience and the context in which the image is used, encountered, consumed. The particular starting point organises investigative priorities. For instance, ethical questions relating to who has the right to represent whom are central when considering the photographer and institutions such as the press.

Sontag takes a particular position within debates about realism, stressing the referential nature of the photographic image both in terms of its iconic properties and in terms of its **indexical** nature. For Sontag, the fact that a photograph exists testifies to the actuality of how something, someone or somewhere once appeared. Max Kozloff challenged Sontag's conceptual model, criticising her proposition that the photograph 'traces' reality, and arguing instead for a view of the photograph as 'witness' with all the possibilities of misunderstanding, partial information or false testament that the term 'witness' may be taken to imply (Kozloff 1987: 237). In his earlier collection of essays, *Photography and Fascination*, Kozloff starts from the question of the enticement of the photograph. He concludes that:

Though infested with many bewildering anomalies, photographs are considered our best arbiters between our visual perceptions and the memory of them. It is not only their apparent 'objectivity' that grants photographs their high status in this regard, but our belief that in them, fugitive sensation has been laid to rest. The presence of photographs reveals how circumscribed we are in the throes of sensing. We perceive and interpret the outer world through a set of incredibly fine internal receptors. But we are incapable, by ourselves, of grasping or

tweezing out any permanent, sharable figment of it. Practically speaking, we ritually verify what is there, and are disposed to call it reality. But, with photographs, we have concrete proof that we have not been hallucinating all our lives.

(Kozloff 1979: 101)

However the relation between the image and the social world is conceptualised, it is worth noting that the authority which emanates from the sense of authenticity or 'truth to actuality' conferred by photography is a fundamental element within photographic language and aesthetics. This authority, founded in realism, has come to be taken for granted in the interpretation of images made through the lens. It is precisely this which sets lens-based imagery apart from other media of visual communication. Again, to quote Kozloff, 'A main distinction between a painting and a photograph is that the painting alludes to its content, whereas the photograph summons it, from wherever and whenever, to us' (1987: 236). The photographic is distinct from the autographic, or from the digital, in that it seems to emanate directly from the external. Inherent within the photographic is the particular requirement for the physical presence of the referent. This has led to photographs (along with film and video) being viewed as realist in ways that, say, technical drawing or portrait painting are not (although they are also based upon observation). That this is the case needs to be clearly acknowledged and addressed, in order to develop theory adequate and specific to photography.

Reading the image

It is seeing which establishes our place in the surrounding world, we explain that world with words, but words can never undo the fact that we are surrounded by it. The relationship between what we see and what we know is never settled.

(Berger 1972a: 7)

Two key theoretical developments, semiotics and psychoanalysis, have significantly contributed to changes within the humanities and both have figured in debates relating to the constitution of photographic meaning. Semiotics (or **Semiology**), the idea of a science of signs, originates from comments in Ferdinand de Saussure's *General Theory of Linguistics* (1916) but was not further developed until after the Second World War. Essentially, semiotics proposed the systematic analysis of cultural behaviour. At its extremes it aimed at establishing an empirically verifiable method of analysis of human communication systems. Thus, **codes** of dress, music, advertising – and other forms of communication – are conceptualised as logical systems. The focus is upon clues which together constitute a *text* ready for reading and interpretation. American semiotician, C.S. Pierce, further distinguished between iconic,

indexical and symbolic codes. Iconic codes are based upon resemblance, for instance, a picture of someone or something; indexical codes are effects with specific causes, for example, footprints indicate human presence; symbolic codes are arbitrary, for instance, there is no necessary link between the sound of a word and that to which it refers.

The key limitation of semiotics as first proposed, with its focus upon systems of signification, was that it failed to address how particular *readers* of signs interpreted communications, made them meaningful to themselves within their specific context of experience. It is currently common to use the term 'semiology' to refer to the earlier, relatively inflexible approach based upon structuralist linguistics, and to use 'semiotics' to indicate later, more fluid models, incorporating psychoanalysis, wherein the focus is more upon meaning-producing processes than upon textual systems. Social semiotics, taking account of questions of interpretation and context, inflects the emphasis specifically towards cultural artefacts and social behaviour.

Italian semiotician Umberto Eco specifically discussed the codification of the photograph as text (Eco, 'Critique of the Image' in Burgin 1982). He argues that, despite the appearance of resemblance between the image and its referent, the iconic sign is, nonetheless, like other sign systems, 'completely arbitrary, conventional and unmotivated'. Thus he focuses on the conventions of perception and the cultural understandings which inform interpretation. He offers a ten-point summary of the range of codes implicated in photographic communication. The codes are presented with relatively little elaboration, and with no ascription of hierarchy within the overall model. This thus stands as a starting point for exploring the potential of complex semiotics as a mode of analysis of the photographic.

Roland Barthes is known for his contribution to the semiological analysis of visual culture, in particular from his early work, Mythologies. Working inductively from his observations of differing cultural phenomena, he proposed that everyday culture can be analysed in terms of language of communication (visual and verbal) and integrally associated myths or culturally specific discourses. The central objective of this early work was the development of all-encompassing models of analysis of meaning-production processes. This was conceptualised both generally and in terms which could take account of particular cultural characteristics. Thus, for example, his analysis of the codification of a short story S/Z (1970) was intended to identify, test and demonstrate the explanatory potential of a set of five codes which, he was then suggesting, were potentially applicable to a range of storytelling media (the novel, film, oral narratives). This is the point at which his work is most characterised by strict structuralist methodology. Later works, including The Pleasure of the Text (1973) and Camera Lucida (1984), are no longer primarily text-focused and less strictly 'scientific' (i.e. seeking to objectively classify significatory phenomena) in their approach. These works

ROLAND BARTHES

(1915-1980) Studied French Literature and Classics at the University of Paris, and taught French abroad in Rumania and Egypt before returning to Paris for a research post in sociology and semiotics. He taught a course on the sociology of signs, symbols and collective representations at the École Pratique des Hautes Études, and became known for his contribution to the development of semiology, the science of signs, first proposed by linguist Ferdinand de Saussure in 1916 but not fully explored until after the Second World War. Barthes' publications include Mythologies (1957), Elements of Semiology (1964), The Empire of Signs (1970) and Image, Music, Text (1977), which includes his wellknown essay on 'The Rhetoric of the Image'. Camera Lucida, originally titled La Chambre Claire (1980), was his last work, and the only publication devoted entirely to photography.

take more account of the individual reader, of processes of interpretation, of psychoanalytic factors, and of what we might term cultural 'slippages' – thereby implicitly accepting a degree of unpredictability in human agency or response.

Camera Lucida is motivated by an ontological desire to understand the nature of the photograph 'in itself'. In semiotic terms, the photograph is disorderly because its ubiquity renders it unclassifiable: 'photography evades us' (Barthes 1984: 4). The style of writing is narrative and rhetorical, the tone is personal: he starts from discussion of himself as reader of the photographic image, asking why photos move him emotionally. In Part One he develops a commentary upon the nature and impact of the photograph using examples from documentary and photojournalism. In Part Two he focuses upon his own family photographs, particularly images of his mother - some of which date from 'history'; that is, a time before his birth - in order to contemplate more subjective meanings (this discussion is not illustrated). However, the objective is not to do with specific genres. For instance, there is no discussion of commercial imagery; nor of fine art uses of the medium. His purpose is essentialist in that he seeks to define that which is specific to the photograph as a means of representation. He is not concerned with the taker of a photograph (the photographer or, as he terms it, 'operator') and the act of taking but, rather, with the act of looking (the spectator) and with the 'target' of the photograph; that is, the object or person represented within the 'spectrum' of the photograph. Thus he observes that the knowing portraitee adopts a pose which anticipates the representational image, and takes account of the fact that this piece of paper will outlast the actual person who is the subject of the portrait becoming the 'flat death', which both exposes that which has been and precedes actual death.

Barthes concludes that it is 'reference' rather than art, or communication, which is fundamental to photography. Central to his exploration is the contention that, unlike in any other medium, in photography the referent uniquely sticks to the image. In painting, for instance, it is not necessary for the referent to be present. Painting can be achieved from memory, (chemical) photography cannot. From this emerges the time-specific characteristic of the photograph. It deals with what was, regardless of whether the terms or conditions continue to obtain. For Barthes, photography is never about the present, although the act of looking occurs in the present. In addition, the photograph is indescribable: words cannot substitute for the weight or impact of the resemblance of the image. The photograph is always about looking, and seeing. Furthermore, the photograph itself – that is, the chemically treated and processed paper – is invisible. It is not it that we see. Rather, through it we see that which is represented. (This, he suggests, is one source of the difficulty in analysing photography ontologically.)

What, then, is the attraction of certain (but never all) photographs for the spectator? As writer-lecturer Philip Stokes has pointed out in relation to the

potentially boring experience of looking at other people's family albums, 'in every dreary litany there is an instant when a window opens onto a scene of fascination that stops the eye and seizes the mind, filling it with questions or simply joy' (Stokes 1992: 194). Why do some images arrest attention, animating the viewer, while others fail to 'speak' to the particular spectator? Barthes proposes that photographs arrest attention when they encompass a duality of elements - two (or more) discontinuous, and not logically connected, elements which form the 'puzzle' (our term, not his) of the image. Here he distinguishes between *studium*, general enthusiasm for images and. indeed, the polite interest which may be expressed when confronted with any particular photograph, and the punctum (prick, sting or wound) which arrests attention. Previously, in an essay entitled 'The Third Meaning', he had suggested that photographs encompass the obvious and the obtuse, implying play of meaning within the photograph as text (Barthes 1977c). This leads him to explore why, when so many images are noted as a matter of routine, only some images make an impact on us. Here, again, he makes a detailed distinction between the photograph which captures attention through 'shouting' or because of the shock of revelation of subject-matter (for instance, a particularly startling photojournalistic image), and the punctum of recognition which transcends mere surprise, or rarity value, to inflict a poignancy of recognition for the particular spectator. This, he proposes, emanates more often from some detail within the image which stands out, rather than from the unity of the content as a whole. He sees this effect as essentially a product of the photograph itself. This, we would suggest, limits his discussion. The noticing of detail is also a consequence of the particular spectator's history and interests - even a relatively insignificant detail might offer a key point of focus for a person. In other words, the poignancy or joy of recognition is founded in the act of engagement, the act of looking at a particular image, the relation between the spectator and the photograph.

Barthes goes on to suggest that the photograph in itself, through being contingent upon its referent, is outside meaning. In this sense he views it as 'a message without a code' (to use a phrase drawn from his earlier essay on the rhetoric of the image). Thus he suggests that it is the fact of social observation which is immediate rather than the photograph. For Barthes, photography is at its most powerful not because of what it can reveal, but because it is, as he terms it, 'pensive'. It thinks. Of course Barthes does know that a photograph is not a thinking subject: the photograph itself is an inanimate piece of paper. The photographer thinks, the portraitee poses, and the spectator may respond reflectively. Animation occurs only through the act of looking.

Barthes' precise use of words (which, in the French, offers careful nuancing but, in translation, may seem over-precious), and the personal tone, to some extent obscure the general argument which is more **phenomenological** than

semiotic in its method. His discussion is useful in reminding us of the essential contingency of the photograph. Like Sontag, he draws attention to its referential characteristics; unlike Sontag, who relates this to a range of practices, he defines this as that which characterises the medium, but it does not necessarily follow that this is a representation without a code. On the contrary, it is impossible to contemplate the image without operationalising a range of aesthetic and cultural codes. Ultimately, he also takes relatively little account of the specificity of the spectator and reasons and contexts of viewing. Despite his emphasis upon looking, and seeing, he focuses centrally on the image as text rather than upon the relation between image and spectatorship. This does limit his ontological conclusions.

Photography reconsidered

The individual as spectator, the reception and usage of photographs, and the nature of processes whereby photographs become meaningful subjectively and collectively have remained central to contemporary debates. Here the influence of psychoanalysis has to be taken into account alongside semiotics, together with the concerns of **social history**.

Psychoanalysis, founded in Freud's investigations of the human psyche (from the 1880s onwards), centres upon the individual in ways which are now taken for granted but which, at the time, reflected certain revolutionary strands of political and philosophical thought. For political theorists the individual became viewed as the basic social unit; also, as someone expected to take personal responsibility for social and economic survival. Philosophers such as Nietzsche, regarded by many as the father figure of individualism, emphasised personal moral responsibility, engaging, in particular, with what he conceptualised as the enslaving influence of Christianity. Individualism is a taken-for-granted feature of twentieth-century Western experience. We talk of the individual consumer, individual professional responsibilities, individual responsibilities within the family, and so on. Yet this emphasis is relatively new. Psychoanalytic understandings of individual subjective responses to social experience have offered new models of insight into human behaviour in ways which have been challenging academically (as well as offering therapeutic means of coming to terms with personal trauma).

As already noted, Victor Burgin's *Thinking Photography* (1982) focused on debates within the theory, practice and criticism of photography. The book's authors set out to challenge the notion of the autonomous creative artist, to question the idea of documentary 'truth' and to interrogate the notion of purely visual languages. The intention was to situate photography within broader theoretical debates and understandings pertaining to meaning and communication, visual culture and the politics of representation.⁵ The history of theories of art as they relate to – or 'position' – photography is also a key

SIGMUND FREUD

(1856-1939) Freud's copious writings and his work with patients form the basis of the discipline of psychoanalysis, used both as a therapeutic method and as a tool to understand interpersonal relations and cultural activities. Psychoanalysis has irrevocably changed the way we understand the world and ourselves. Possibly Freud's most important contribution to modern thought is the concept of the unconscious, which insists that human action always derives from mental processes of which we cannot be aware. Many photographers have used the ideas of Freud as the basis of their work.

5 At this time Burgin lectured in photography at the Polytechnic of Central London (now the University of Westminster). His other publications include Between (1986), The End of Art Theory (1986), and Formations of Fantasy (co-edited 1989). He was based at the University of California throughout the 1990s, and is now at Goldsmiths College, University of London.

theme. The eight essays (including three by Burgin himself), while they vary in their theoretical stance and critical style, share 'the project of developing a materialist analysis of photography'. What Burgin is concerned with is photography 'considered as a practice of *signification*'; that is, specific materials worked on for specified purposes within a particular social and historical context. Semiotics is one starting point for this theoretical project, but, as Burgin states, semiotics is not sufficient to account for 'the complex articulations of the moments of institution, text, distribution and consumption of photography' (Burgin 1982: 2).

In effect, this collection of essays traces a particular trajectory through Left debates of the 1970s, centring on questions of class, revolutionary struggle and the role of the artist, through semiotics, to questions of realism, to psychoanalysis and spectatorship. (Questions of gender are addressed, although, notably, no essays by women theorists are included.) The book posits two key theoretical starting points: materialist analysis, as represented in the reprinting of Frankfurt School theorist Walter Benjamin's essay on 'The Author as Producer' (first published in German in 1966) and the semiotic, represented in Italian semiotician Umberto Eco's essay, 'Critique of the Image'. The other central historical reference is that of Russian Futurism and the formalist–constructivist theoretical debates which followed.

Classic Marxist models of artistic production are addressed, critically, in the penultimate essay of the book, 'Making Strange: The Shattered Mirror', by Simon Watney. Focusing on seeing, vision and the social nature of perception, Watney discusses various 1920s/1930s manifestations - in Russian aesthetic debates and in Brecht - of the proposal that through alienation, or 'making strange', new ways of 'seeing', politically and aesthetically, may be forged. The subtitle, 'The Shattered Mirror', refers to the rupturing of any notion of the photograph as a mirror or transparent recorder of reality. (It does not carry the psychoanalytic implications which, as we shall see, characterise Burgin's contributions.) The essay situates ideas of defamiliarisation in relation to past practices in order to reflect upon modern European and American work which he exemplifies, briefly, through reference to French photographer Atget; Bauhaus theorist-photographer Moholy-Nagy; and American documentarian Berenice Abbott. He argues that the project of defamiliarisation in photography rested upon acceptance of the fallacy of the transparency of the photograph. In other words, if we relinquish realist theories of the photograph, the problem of employing effective techniques for defamiliarisation dissolves.

Semiotics, in conjunction with psychoanalysis, informs Burgin's own three essays which, respectively, develop a series of related points about: the nature of the photograph as conceptualised in the context of new art theory; the experience of 'looking at photographs' from the point of view of the spectator; and exploring the psychological nature of the pleasurable response

to the image. Thus he is concerned to trace links between the image, interpretation and ideological discourses. The model is most fully developed in 'Photography, Phantasy, Function', wherein the main part of the essay draws upon Freud to discuss psychological aspects of the act of looking, noting that looking is not indifferent. Thus he draws our attention to the voyeuristic and fetishistic investment in looking, arguing that to look is to become sutured within ideological discourse(s). He further argues that the photograph, like the fetish, is the result of an isolated fragment or frozen moment, and describes the fetishistic nature of the photograph as one source of its fascination.

Theory, criticism, practice

What has all this got to do with making photographs? Visual methods of communication are, of course, embedded in particular cultural circumstances and therefore reflect specific assumptions and expectations. For instance, as has been argued, given the nineteenth-century desire for empirical evidence, photography was hailed for its apparent ability to represent events accurately. This desire or expectation persists in fields such as photojournalism. Furthermore, theoretical concepts interact. For instance, criteria based upon established visual aesthetics inform the assessment of what makes a 'good' photograph, photojournalistic or otherwise. Similarly, questions of representation pertaining to, for example, gender or race, which have contributed to the challenge to the canon within literary studies and art history, are relevant to photography.

The key point is that theoretical assumptions founded in varying academic fields, from the scientific to the philosophic and the aesthetic, intersect to inform both the making and the interpretation of visual imagery. One consequence of the postmodern is a change in type of theoretical endeavour and, consequently, a change in style of publications concerning photography which, in recent years, have become more eclectic in their theoretical sources and less all-embracing in terms of questions posed and projects pursued. Books of essays on a diversity of subjects, adopting a range of differing theoretical concerns and conjunctions, are increasingly common.

Yet, in common with other fields of the arts, photography criticism still tends to be normative, evaluating work in relation to established traditions and practices. At its worst, criticism masks personal opinion, dressed up as objective or authoritative with the aim of impressing, for example, the readers of review articles in order to generate respect and support for the reviewer. At its best, criticism helps to locate particular work in relation to specific debates about practice through elucidating appreciation of the effect, meaning, context and import of the imagery under question.

In order to think about photographic communication, we need to take account of communication theory in broad terms as well as focusing

specifically on photographs as a particular type of visual sign, produced and used in specific, but differing, contexts. The photograph, therefore, might be conceptualised as a site of intersection of various orders of theoretical understanding relating to its production, publication and consumption or reading. Central to the project of theorising photography is the issue of the relation between that which particularly characterises the photographic (which, as we have seen, is its referential qualities), and theoretical discourses which pertain to the making and reading of the image but whose purchase is broader, for instance, aesthetic theory or sexual politics. What is crucially at stake is how we think about the tension between the referential characteristics of the photograph and the contexts of usage and interpretation.

The key characteristic of photography – as opposed to digital imaging – is its ultimate dependence upon, and therefore reference to, a physical person or object present at the moment of making the original exposure. This physical presence is the origin or source of the possibility of an image and, consequently, the image stands as an index of the once physical presence. It is this indexical status which is the source of the authority of the image and, thus, of central theoretical debates relating to realism and 'truth'.

Photography theory cannot rest simply on optics and chemistry (or, indeed, the binary mathematical systems which underpin digital imaging). Given the ubiquity of photographic practices, a twofold problem emerges: first, to analyse ways in which clusters of theoretical discourses intersect, or acquire priority, in particular fields of practice; and second, to define and analyse that which is peculiar to photography. If we take Barthes' final words on the subject, it is primarily its referential characteristic which variously lends it particular credibility, force or significance. If we start from the greater diversity of positions – semiotic, psychoanalytic and social-historical – outlined in Burgin's edited collection, then the focus must be upon the political and **ideological**. The project of theorising photography thus relies upon the development of complex models of analysis which can take account of these rather different starting points.

Within this conceptual approach it is not the objective presence of the image which is at stake, but rather the force-field within which it generates meaning. This contrasts with semiological stress on systems of signification. In effect we are invited to consider not only the text, its production and its reading, but also to take account of the social relations within which meaning is produced and operates. Here, the semblance of the real underpins processes of interpretation. Photography is reassuringly familiar, not least because it seems to reproduce that which we see, or might see. In so far as visual representations contribute to constructing and reaffirming our sense of identity, this familiarity, and the apparent realism of the photographic image, render it a particularly powerful discursive force.

6 For a good general discussion of questions of representation, semiotics and discursive practices see Stuart Hall (1997) 'The Work of Representation', Chapter 1 in Stuart Hall (ed.) (1997) Representation, Cultural Representations and Signifying Practices, London: Sage/Open University.

CASE STUDY: IMAGE ANALYSIS: THE EXAMPLE OF MIGRANT MOTHER

In 1936 the documentary photographer, Dorothea Lange, was working for a government-run project known as the Farm Security Administration (FSA). Lange has recounted the story of how she stopped one night on the road – although she was already exhausted by the work of the day – to investigate a group of people who were employed to pick peas. In less than a quarter of an hour she was back on the road having taken several shots of the woman with her children. One of these photographs, *Migrant Mother* (Figure 1.1), became the most reproduced image in the history of photography and is known to many people who could not name its author.

In the subsequent 60 years this photograph has been used and contextualised in a number of ways. This, not only as a photograph; it has appeared on a USA postage stamp (illustrating the decade of the 1930s) and has acted as a source for cartoons. The picture has had a history beyond its original context within the FSA and it is regularly referred to as one of the world's greatest news photographs. Many critics have commented on this, noting various moments of appropriation of the image.

A number of differing approaches may be used to analyse photographs. Each model reflects its own particular concerns and priorities. For instance, any single photograph might be:

- viewed primarily as social or historical evidence
- investigated in relation to the intentions of the photographer and the particular context of its making
- related to politics and ideology
- assessed through reference to process and technique
- considered in terms of aesthetics and traditions of representation in art
- discussed in relation to class, race and gender
- analysed through reference to psychoanalysis
- decoded as a semiotic text.

Here we take the example of Dorothea Lange's *Migrant Mother* in order to illustrate and comment upon some of the ways in which this photograph has been discussed, and to draw attention to assumptions which underpin particular remarks about it.

The photograph as testament

Given that Lange took a number of shots of the woman and children, why is it this image which has become so famous? A number of critics have commented upon this: See, for instance, Martha Rosler's celebrated essay 'In, around, and afterthoughts (on documentary photography)' (reprinted variously), or the opening section of Judith Fryer Davidov (1998) Women's Camera Work, Durham and London: Duke University Press.

Commonly, discussion of images draws upon two or three analytic approaches. For instance, those concerned with the status of a photograph as evidence may also be interested in the intentions of the photographer and the context of making; semiotic analysis makes reference to aesthetic coding and to cultural contexts.

In order to avoid emphasising artificial boundaries between academic disciplines, and to demonstrate the extent to which we operate in an interdisciplinary manner, this case study is organised under a series of headings which allow us to indicate the range of concerns that may be implicated simultaneously in writing about a photograph.

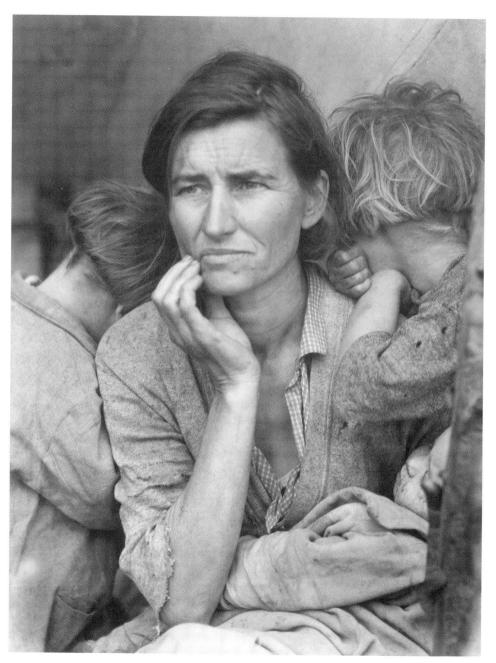

1.1 Dorothea Lange, Migrant Mother, 1936

The woman is used purely as subject. She is appropriated within a symbolic framework of significance as declared and determined by Lange. Indeed, the other images taken by Lange at this 'session' add to the sense of construction and direction. They remain distant, though, and lack the compelling presence which Lange achieves in the Migrant Mother image. In this Lange creates a highly charged emotional text dependent upon her use of children and the mother. The central position of the mother, the absence of the father, the direction of the mother's 'look', all add to the emotional and sentimental register through which the image works. The woman is viewed as a symbol larger than the actuality in which she exists. As Lange admitted, she wasn't interested in 'her name or her history'.

(Clarke 1997: 153)

Lange made five exposures of the woman and children in a tent (see figures 1.2–1.5). One image was selected for publication and this became one of the most famous photographs of the twentieth century. We can see that this image excludes literal detail (reference to the whole tent and the woodlands beyond, or to domestic objects) which might anchor the image to a particular place and time.

That the image was in accordance with the intentions of the photographer, and, indeed, of the FSA project, is confirmed by Roy Stryker, director of the project, in an interview:

STRYKER: I still think it's a great picture. I think it's one of America's great pictures . . .

INTERVIEWER: Would you want to say anything about what that picture means to you personally?

STRYKER: I can, in two words. Mother and child. What more do I need to say? A great, great picture of the mother and child. She happens to be badly dressed. It was bad conditions. But she's still a mother and she had children. We'd found a wonderful family.

(Stryker 1972: 154)

Clearly the potential for the image to transcend its particular location and socioeconomic context was recognised by those involved in this project. In this sense, the image reflects a humanitarian notion of universal similarities in the condition of humankind. Many critics have noted this, for instance:

For Lange, a compelling photograph presented an engaging human drama that addressed questions larger than the immediate subject. Her subjects gained importance from external value systems. . . . 'We were after the truth', she wrote, 'not just making effective pictures'. She was concerned with the human condition, and the value of a fact was measured in terms of its own consequences. . . . Today, the subjects of Lange's picture are, as

Looking at the picture alongside the others allows us to explore the criteria by which photographers select shape and organise images, and to consider why none of the other images could have acquired the same status in terms of documentary aesthetics and its iconic status.

Clarke does not discuss the specific history and context of the making of the image, or of its immediate use. By excluding detail, Lange made it possible for the picture to be seen as a universal symbol of motherhood, poverty and survival. Clarke seems to go along with this. His approach emphasises the notion of the good photograph, but the criteria whereby an image might be considered 'good' are taken for granted. Emotional empathy is clearly one element, but this is assumed rather than treated as something for critical discussion.

Stryker's emphasis on the drama of the photograph reflects his drive to use pictures for emotional impact.

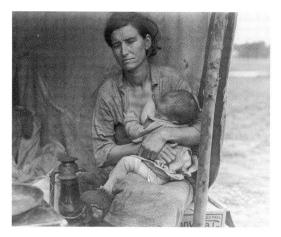

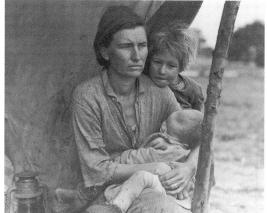

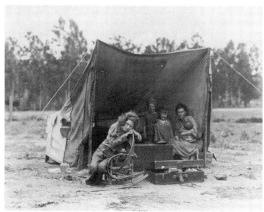

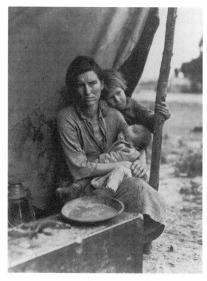

1.2-1.5 Migrant Mother, alternative versions

Therese Heyman has observed, 'figures in history whose hardship the present viewer is incapable of healing – symbols of timeless sorrow'.

(Tucker 1984: 50-1)

7 Family of Man, facsimile catalogue, p. 151.

Here Tucker is taking a critical stance, discussing the impact of the picture in terms both of culture and ideology and of the reception of the image, acknowledging differences between now and then.

Indeed, this picture was included in the exhibition, 'Family of Man' (organised by the American curator, Edward Steichen, in 1955 as a sort of indirect response to the Second World War). The exhibition set out to emphasise all that humanity has in common. Roland Barthes commented on the 'ambiguous myth' of community whereby diversity between peoples and cultures was brought into focus in order to forge a sense of unity from this pluralism.

(Barthes 1973)

The photographer's account

In an essay written almost 30 years after the event, entitled 'The Assignment I'll Never Forget', Dorothea Lange gave us her story of how she made the photograph.

I saw and approached the hungry and desperate mother, as if drawn by a magnet. I do not remember how I explained my presence or my camera to her, but I do remember she asked me no questions. I made five exposures, working closer and closer from the same direction. I did not ask her name or her history. She told me her age, that she was thirty-two. She said that they had been living on frozen vegetables from the surrounding fields, and birds that the children killed. She had just sold the tires from her car to buy food. There she sat in that lean-to tent with her children huddled around her, and seemed to know that my pictures might help her, and so she helped me. There was a sort of equality about it.

(Lange 1960: 264)

In relation to the alleged 'equality' between the photographer and her subject it is worth noting that in 1978, the 'Migrant Mother' herself, Florence Thompson, was tracked down to their trailer home in Modesto, California. One of the twentieth century's most familiar and telling images was recuperated as an ordinary, aged woman who was poor in a humdrum way and no longer able to function as an icon of nobility and sadness in the face of destitution.

Her image has appeared in many forms and in many settings, and has been multiply copied millions of times. She was a most familiar figure, but not until 50 years after the event did she get to comment on it publicly. She told United Press that she was proud to be the subject of the photograph, but that she had never made a penny out of it and that it had done her no good (Rosler 1989).

Genre and usage

The FSA project was essentially documentary. However, control of the reproduction of images did not lie in the hands of the photographers. As photohistorian, Naomi Rosenblum notes, the FSA in effect acted as a photo agency supplying pictures for photojournalistic use:

In common with other government agencies that embraced photographic projects, the F.S.A. supplied prints for reproduction in the daily and periodical press. In that project photographers were given shooting scripts from which to work, did not own their negatives, and had no control over how the pictures might be cropped, arranged, and captioned. Their position was similar to that of photojournalists working for the commercial press – a situation that both Evans and Lange found particularly distasteful. (Rosenblum 1997: 366–9)

Note also that she credits her source. This allows us to find the original context of the Heyman quote to check whether we agree with Tucker's interpretation. Crediting sources is a part of good academic practice, as it acknowledges previous critical contributions and helps the reader to find further information.

This essay by Barthes is included in his early collection, *Mythologies*. He draws our attention to, and questions, the fundamental premise of the exhibition. See general discussion of Barthes (pp. 30–1).

The fact that Lange's story was reprinted in a major collection suggests that a photographer's account is of particular interest in considering the image. The intention of the photographer and her memory of the occasion are in some way assumed to add to our appreciation of the image and our understanding of its significance. We have to ask ourselves, 60 years on, why this should be relevant to our reading of the image now, in different circumstances.

For discussion of the concept of documentary see ch. 1, pp. 17–18 and ch. 2, pp. 69–73.

In this account, the significance of the question of who retains control of the image rests upon an unspoken notion of the integrity of the image in terms of its original composition. For those concerned with a notion of documentary authenticity, there are ethical implications relating to the use of images. These ideas are not brought into question here. If, however, we take the more contemporary view that photographic meaning shifts according to usage or, indeed, that the photograph, once in circulation, stands apart from its maker, this is less a matter of concern.

One of the central principles of the documentary aesthetic was that a photograph should be untouched, so that its veracity, its genuineness, might be maintained. Even minor violations of this principle were frowned upon:

Lange's great *Migrant Mother* photograph had always bothered her a little. Just at the instant that she had taken the picture, a hand had reached out to draw the tent flap back a bit further and the photograph had caught a disembodied thumb in the foreground. That thumb had worried Lange. So, when she prepared the picture for *American Exodus*, the thumb was retouched out of the negative.

This was a simple technique that she had employed hundreds of times during her career as a portrait photographer. For Stryker it was a lapse of taste. He was quite bitter over the incident.

(Hurley 1972: 142)

Image in context

The FSA project was a response to the economic crisis of 1929 and the ensuing economic depression of the 1930s together with the collapse of sharecropping agriculture in a number of the south-west states of the USA. It aimed to document and record statistically the position of the rural poor, but the photographers it employed eschewed a mere photography of record in favour of works that stressed the depiction of human destitution and distress. Such images had a clear political purpose, but one that has been criticised for individualising what were collective problems with potentially collective solutions. Abigail Solomon-Godeau:

Commenting on the works of Dorothea Lange, the film maker Pare Lorentz noted the following: 'She has selected with an unerring eye. You do not find in her portrait gallery the bindle-stiffs, the drifters, the tramps, the unfortunate, the aimless dregs of a country.' In other words, the appeal made to the viewer was premised on the assertion that the victims of the Depression were to be judged as the deserving poor, and thus the claim for redress hinged on individual misfortune rather than on systematic failure in the political, economic, and social spheres.

(Solomon-Godeau 1991a: 179)

Here Solomon-Godeau is concerned with the political implications of that to which the image testifies.

Image-text

The image is titled *Migrant Mother*. This caption, together with the formal organisation of the photograph, are key elements of its appeal. Yet in *A Concise History of Photography* by Helmut and Alison Gernsheim, published in 1965, the same picture is captioned *Seasonal Farm Labourer's Family*, a title which seems

This quote reminds us of rules that functioned as indicators of authenticity. It seems to be concerned with realism. However, implicit within this is a very literal notion of realism viewed as pictures true to appearance. A number of critics, among whom Brecht and Benjamin were prominent, have argued that realism goes beyond a mere matter of appearances and, indeed, that the photograph, in its apparent literal veracity, is limited in its ability to convey information about socioeconomic and political relations.

In analysing this quote, we want to ask whether Lorentz is accurate in his comment - are there examples of photographs by Lange which might contradict his view? (Several other photographs by Lange are included in Andrea Fisher (1987) Let Us Now Praise Famous Women, London: Pandora). Furthermore, do we agree with Solomon-Godeau's interpretation of his comment? Finally, what distinction is being made here between 'individual misfortune' and 'systematic failure' and what political positions underpin each of these phrases?

(Pare Lorentz was head of the short-lived US Film Service, formed by Roosevelt, and director of documentary films including *The Plow That Broke the Plains*, 1936 and *The River*, 1937.)

less potent since it implies the presence of a working father. The original title and date are given by Andrea Fisher as 'Destitute pea pickers in California, a 32 year old mother of seven children. February 1936'.

Aesthetics and art history

Western aesthetic philosophy is concerned to examine principles of taste and systems for the appreciation of that which is deemed beautiful. Thus the aesthetics of photography have been concerned with formal matters such as composition, subject-matter, and the organisation of pictorial elements within the frame. It has also encompassed questions of technique – sharpness of image, exposure values, print quality, etc. Karin Becker Ohrn tells us that:

Many of Lange's prints were poor. She made them according to no formula, and they varied widely in density, making it a challenge to print them.

(Ohrn 1980: 228)

These failures of technique were unimportant when the photographs were reproduced in books and journals, but towards the end of her life, Lange presented her work in a number of major exhibitions, and this required careful technical work to take place:

The prints were processed to archival standards and placed on white mounts. The final result was superb; the print quality was commended by several reviewers of the exhibition.

(ibid.)

The context of viewing is also influential. Naomi Rosenblum comments:

The images were transformed into photographic works of art when they were exhibited under the auspices of the Museum of Modern Art. For the first time, photographs made to document social conditions were accorded the kind of recognition formerly reserved for aesthetically conceived camera images.

(Rosenblum 1997: 369)

If the photograph is in a book or magazine concerned with social conditions, its status as evidence is foregrounded. Lange's photographs were published by the FSA in 1939 as a book titled *An American Exodus: A Record of Human Erosion*. The title directs the reader to consider the group of photographs sociologically; the focus is upon the implications of the content. By contrast, when exhibited in the art gallery the context invites us to look at the picture in aesthetic and symbolic terms. For instance, art historians have observed that

Titles contribute to holding the meaning of pictures, to limiting the potential range of interpretations or responses on the part of the audience or reader. Examining – or imagining – alternative titles for an image can help us understand how the title lends resonance to the picture.

This concern with print quality is often seen as excessively formal, privileging matters of technique at the expense of content, meaning and context, However, different contexts require differing levels of attention to print quality. While a mediocre print may be adequate for newspapers given their low-quality reproduction, gallery exhibition demands high-quality visual resolution. Shift in usage of the image required a different degree of precision.

In traditional art history, questions of genre, form and technique, as well as subject-matter deemed appropriate for artistic expression, are central. When photographs are reappropriated within the gallery context, specific art-historical traditions associated with them come into play, becoming, as it were, laid over the picture.

Lange's photograph is related – in terms of both subject-matter and framing – to the many paintings of the Madonna and Child in Western art.

As gendered image

A number of feminist photohistorians have looked at the FSA in terms of the participation of women photographers and the gendering of the image. Lange has been cast as 'mother' of documentary. Thus, for instance, Andrea Fisher in Let us Now Praise Famous Women discusses her contribution:

Dorothea Lange became a key figure in securing the humanism of documentary. She was repeatedly represented in popular journals as the 'mother' of documentary: the little woman who would cut through ideas by evoking personal feeling. Through her pathos for destitute rural migrants, the New Deal's programs of rural reform might be legitimized, not as power, but as the exercise of care. Her place in the construction of documentary rhetoric was thus crucially different but every bit as important as Walker Evans', more widely recognized as the paradigmatic figure of documentary. Where Evans was thought of as the guarantor of honest observation, with his flat-lit frontal shots, Lange was lauded as the keeper of documentary's compassion.

(Fisher 1987: 131)

Fisher argues that Stryker over-edited the FSA work and in so doing obscured the work and the role played by women in the project. She particularly argues that representations of femininity played a crucial role in the rhetoric of the FSA photographs, both in terms of the gender of the photographer and subject-matter.

In hailing Lange as the 'Mother', Stryker placed her as the mirror of immutable motherhood that many of her photographs would subsequently suggest. Her consuming empathy for her subjects became synonymous with her subjects' caring for their children. Though only a fraction of her images conformed to the transcendent ideal of mother and child, it was the image of the Migrant Mother which soared to the status of icon, and became the hallmark of Lange herself:

The naming of Lange as 'Mother' folded across the reading of her images. It not only prioritized certain images, but became intimately embedded in the sense that could be made of them.

(Fisher 1987: 140-1)

Photography critic John Roberts has summarised her argument thus:

Fisher argues that one of the principal ideological props of the way FSA photographs were used to construct an American community under

Here Fisher draws attention to the centrality of 'motherhood', a concept which was brought under scrutiny in feminist critiques of the 1970s. threat was the image of the maternal. She cites Dorothea Lange's *Migrant Mother* (1937) as a primary example of this, one of the most reproduced photographs of the period, so much so in fact that it could be said to stand in iconically *for* the Depression. For Fisher the way the image was cropped and contextualised reveals how much the image of a damaged femininity came to symbolise the crisis of community for the American public. Anxious and in obvious poverty, the woman holds on to her two children, suggesting the power of maternal values to overcome the most dire of circumstances. Here is a woman who has lost everything, yet heroically, stoically keeps her family together. Here in essence was what the magazine editors were waiting for: an image of tragedy AND resistance. That this image became so successful reflects how great a part gender played in the symbolic management of the Depression.

(Roberts 1998: 85)

Fisher herself offers a slightly different account:

The incessant picturing of women with their children was never prioritized by Stryker for his photographers; it was not a conscious political device. But perhaps it arose, like the whole of Stryker's enterprise, as part of that widely felt nostalgia for a mythic American past: an American essence as natural as the land, and so located in an immutable rural family. But only for an urban audience could the land achieve this mythic status, and the rural mother the status of universal touchstone. Perhaps, too, that desire for lost plenitude found in the image of the Mother its most appropriate analogue.

(Fisher 1987: 138; our emphasis)

Here, questions of gender are seen as interrelating with other sets of ideas about Americanness. Fisher points to the power of this interaction.

Semiotics focuses on the formal components of the image, emphasising the centrality of sign systems. Sign systems are viewed as largely conventional; that is, primarily consequent not upon 'natural' relations between images and that to which they refer but upon cultural understandings. As noted, (pp. 29–30) for American semiotician C.S. Pierce, signs may be iconic (based upon resemblance to that represented), indexical (based upon a trace or indicator, for instance, smoke indicates fire) or symbolic (based upon conventional associations). Chemically produced photographs incorporate all three constituents: images resemble the person or place or object re-presented; they are indexical in that the subject had to be present for the photograph to be made, which means that the image is essentially a 'trace'; and images circulate in specific cultural contexts within which differing symbolic meanings and values may adhere.

Ouestions of gender have been discussed both in relation to the photographer and to the content of the image as a particular representation of, in this instance, maternity. But Roberts takes this up in terms which contain overtones of conspiracy, seeing the gendering in terms of political rhetoric. When we look back to Fisher herself we find a different emphasis. This illustrates, once again, the importance of checking original sources. As we see, Roberts has imposed a specific inflection on Fisher's original research.

Reading the photograph

As we have noted, the 1960s and 1970s witnessed a shift in photography theory whereby images became viewed as complexly coded artefacts to be read as cultural, psychoanalytic and ideological signs. For Barthes, in his later writings, specifically *Camera Lucida*, the photograph signifies reality, rather than reflecting or representing it. The emphasis is upon what the viewer as 'reader' of the image takes as the principal cues and clues for use as the basis of interpretation.

In reading photographs we may choose to concentrate on the formal qualities of the image; for example, its arrangement within the frame, or the dispositions, stances and gestures of its subjects. Alternatively, or additionally, we may seek to locate the work within the history of image-making, noting similarities and differences from other works of the same kind. Or we may want to explore the way in which the image may be examined from the standpoint of a number of disciplines or discourses which exist outside the photographic.

John Pultz begins his analysis of *Migrant Mother* by referring to these ideas in the context of a reading of the gestural system at work within the image. He then moves to consider the woman's body within the tradition of painting; and concludes by commenting on the gendered nature of the space within which the image is set:

Migrant Mother . . . centers on the female body, the body that is socially constructed through the gaze, and has the quality 'to be looked at'. In Migrant Mother, Lange builds a narrative around a woman and her three children, centered on the single gesture of an upraised arm. As the two older children turn their heads away from the photographer (out of shame or shyness?) and an infant child sleeps, the mother alone remains awake and vigilant. Her arm is upraised, not to support her head but to finger her chin in tentative thought. The picture is created around certain notions of the female body, including the idea of the nurturing mother. Lange drew on traditional, such as Renaissance depictions of the Virgin and Child and the secularised versions of these that began to appear in the mid nineteenth century with the rise of the Victorian cult of domesticity. Moreover, even though Migrant Mother was made in a public space, the close cropping of the image creates within the frame itself a protected, interior, feminised space.

(Pultz 1995a: 93)

Image as icon

Halla Beloff wants to grant the image an iconic status that takes it out of the realm of representation altogether:

Such is the power of the camera that we can easily think of photographs as having a kind of independent reality. Dorothea Lange's Migrant Mother

Freudian theory has been acknowledged in Western academia, especially in the latter part of the twentieth century. Within photography criticism, two influential ideas derived from psychoanalytic theory have been that of the function of the gaze, and of analysis of the way in which what might be thought of as 'abstractions' may be inscribed upon the body - literally embodied. These ideas form the background to Pultz's discussion of how we look at this image. Note that in this instance it is the interrelation of gender and of aesthetics which is woven into his analysis. However, we might ask whether Pultz believes Lange's reference to the virgin and child was conscious on her part.

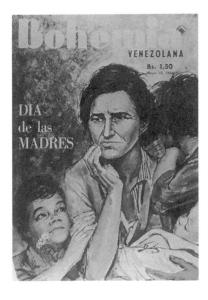

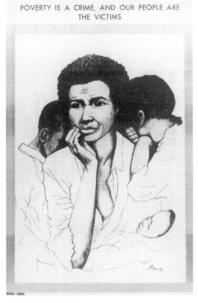

1.6 Reference to 'Migrant Mother', Bohemia Venezolana

1.7 Reference to 'Migrant Mother', Black Panther magazine

is a picture that has entered Western consciousness. She is not a mere representation.

(Beloff 1985: 15)

Part of the iconic power of the work derives from its multiple appearances over the years, in many contexts and forms. For instance, in 1964 it appeared on the cover of the Hispanic magazine, *Bohemia Venezolana*, and in 1973 was referenced in *Black Panther* magazine (figures 1.6 and 1.7). Paula Rabinowitz comments on this aspect of the photograph in the following terms:

I do not need to remind my readers of the power of images – a power that includes their ability to exceed the original impulse of their creation. For instance, the troubling story of Lange's 'Migrant Mother', told and retold, offers with acute poignancy an example of discourse as repository of meaning – the photograph as much as its checkered history includes a woman and her children, a photographer, a government bureau, popular magazines, museums, scholars, and a changing public – an image and tale composed, revised, circulated, and reissued in various venues until whatever reality its subject first possessed has been drained away and the image becomes icon.

(Rabinowitz 1994: 86)

'Icon' here refers not so much to the verisimilitude of the image but to the symbolic value invested in it.

Here, there is a notion of photographs as containing 'reality' – a commodity that, as it were, leaches out over time, so that the initial complexity gives way to the merely iconic. Do we agree with this? Or does the image continue to be 'troubling'?

See ch. 4 for further examples of analysis of specific images.

In summary, critical writings appropriate and 're-frame' images in relation to particular sets of concerns. This image has attracted extensive discussion from a range of perspectives, reflecting many differing concerns. Our procedure here was to seek out, select and analyse specific quotes as examples of different 'takes' on the picture.

HISTORIES OF PHOTOGRAPHY

Inventions – the name by which we call devices that seem fundamentally new – are almost always born out of a process that is more like farming than magic. From a complex ecology of ideas and circumstance that includes the condition of the intellectual soil, the political climate, the state of technical competence, and the sophistication of the seed, the suggestion of new possibilities arises.

(Szarkowski 1989: 11)

Typically, histories of photography offer a series of histories of photographers illustrated with examples from their work. In the twentieth century, in common with other areas of the arts, such as painting or the novel, there has been a tendency to conflate the history of the subject with the work of particular practitioners. The central purpose of this opening section is to compare key books, published in English in recent years, most of which are variously titled *The History*... or *A Concise History*....

What is the story of photography? It was invented in 1839, or so we have commonly been led to believe, but this apparently simple statement masks a complex set of factors. It is true that it was in 1839 that both Fox Talbot in England and Daguerre in France announced the processes whereby they had succeeded in making and fixing a photo-graphic image. But the idea of photography long precedes that date.

To a large extent the history of photography prior to 1938, when **Beaumont Newhall** first published his commentary, then entitled *Photography, A Short Critical History*, has been represented as a history of techniques. The focus was not on what sort of images were made, but on how they were made. This approach is to some extent reflected in museum collections wherein it is the instruments of photography which are prioritised for display, with photographs acting as examples of particular printing methods, detailed in accompanying descriptions. The subject-matter of such photographs (and associated aesthetic and social implications), if acknowledged at all, is presented as being of secondary importance.

So, was the story of photography always an account of changing technologies? Martin Gasser suggests that this history is more complicated (Gasser 1992). Considering German, French, British and American publications written between 1839 and 1939, he identifies three emphases: first, what is

BEAUMONT NEWHALL (1982)
The History of Photography,
New York: MOMA, fifth edition,
revised and enlarged. This
remains a key text, although, as
a number of critics have
commented, it is limited in its
compass by its foundations in
the MOMA collection which is
primarily American in
orientation and idiosyncratic in
its holdings, having been built
up over the years according to
the interests and tastes of its
particular curators.

Key archives in Britain for equipment and techniques:

- The National Museum of Photography, Film and Television, Bradford
- The Fox Talbot Museum, Lacock, Wiltshire (National Trust)

termed 'the priority debate'; second, histories of the development of photography written primarily as handbooks detailing methods and techniques and also potential uses for photography; third, histories of the photograph as image. It is worth noting that it is the proliferation of material in the second of these categories which has led to the false assumption that the first hundred years of publication were largely devoted to technologies and techniques. Aside from any other consideration, a number of the papers published in the early years of photography made assertions about the intrinsic nature of the medium and speculated on its potential uses.

Which founding father?

Before considering histories of the photograph as image, the priority debate deserves brief comment. This debate is concerned with who first achieved the fixing of the photographic image. A number of historical accounts exist whose primary purpose is to argue - usually through a combination of biography and discussion of photographic techniques - that someone other than Fox Talbot in Britain or Daguerre in France 'invented' photography. These two men were the first to announce their findings publicly (in the appropriate scientific journals of the time, in Britain and France) in 1839. But it is also clear, from contemporary correspondence, that Fox Talbot was not alone in Britain in his experimentation. Similarly, in France, Nicephore Nièpce was responsible in the early 1820s for key discoveries leading up to the daguerreotype. As every history of early photography emphasises, the challenge did not lie with the development of camera and lens technology. The principle of concentrating light through a small hole in order to create reflection on the wall of a dark chamber was known to Aristotle (384-322 BC). The photographic camera was based on the camera obscura, described as early as the tenth century AD, of which the first illustration was published in 1545. The problem which preoccupied experimentation in the late eighteenth and early nineteenth centuries was how to fix the image once it had been obtained.

The credit for discovering practical chemical processes lies with no single person, nor, indeed, with any particular nation, although the ascription of credit has always had nationalistic overtones with, for example, the French, keen to downgrade British claims (1839 was within a generation of the Battle of Trafalgar). Likewise, strenuous rewritings of history allowed the German photohistorian, Stenger, writing in the 1930s during the ascendance of Hitler, to claim German experiments of the eighteenth century as fundamental for photography. Re-examining the prehistory, Mary Warner Marien urges caution in two respects: first, she warns against too uncritical an acceptance of the work of early photohistorians. She notes the extent to which the burgeoning of research in the field since the Second World War has both uncovered new findings and suggested new ways of thinking about previously known facts within the history of photography; recent research represents

daguerreotype Photographic image made by the process launched by Louis-Jacques-Mandé Daguerre in France in 1839. It is a positive image on a metal plate with a mirror-like silvered surface, characterised by very fine detail. Each one is unique and fragile and needs to be protected by a padded case. It became the dominant portrait mode for the first decades of photography, especially in the United States.

only the beginning of a much needed archaeology of early photography. In addition, she emphasises the broader historical context of political, technological and cultural change within which photography developed. The overall point is that, in considering the origins of photography, a stance which is both cautious and critical should be adopted (Warner Marien 1991). Geoffrey Batchen offers a more detailed discussion which points to the complexities involved in reappraising early photography in terms of who founded it, where, and for what purposes (Batchen 1997).

The photograph as image

While earlier writing on photography had not exclusively focused on technology and techniques, since the Second World War art-historical concerns have become more central, together with a new stress on connoisseurship of the photograph as a privileged object. A number of the books which we now take as key texts on the history of photography were first written as exhibition catalogues for works collected and shown in institutions. For instance, Beaumont Newhall's The History of Photography stems from a catalogue written to accompany 'Photography 1839-1937' at the Museum of Modern Art (MOMA) in New York in 1937. The broader context for the introduction of art-historical methods and concerns into photography collection and exhibition includes the development of art history as an academic discipline and, more particularly, the increasing influence of art criticism within modern art in the first half of the twentieth century. Here it is relevant to remember the emphasis upon art as a set of special practices which informed modernist thinking. A central feature of modernist criticism was that of maintaining a clear distinction between high and low culture, a differentiation which was equally evident in the writings of some Marxist critics as it was among conservative critics. If photographs were to take their place in the gallery, they inevitably became caught up within more general intellectual trends and discourses.

Since the Second World War, then, the predominant approach to writing the history of photography has been to focus on the photograph as image. Two classic histories, still consulted, are Beaumont Newhall's *The History of Photography* (now in its fifth, revised edition); and **Helmut and Alison Gernsheim**'s *History of Photography*, which, as we have seen, was organised in its earliest form in relation to developing technologies but has subsequently been rewritten to take fuller account of photographs as specific types of image. It is worth pausing to consider and compare these two publications; together they established a specific canon for the history of photography which has been the basis for further development – or taken as a starting point for challenge – ever since.

Educated as an art historian, and appointed on to the library staff at New York's Museum of Modern Art, Newhall was invited to research its first major photography exhibition. His historical overview, which formed the principal

HELMUT AND ALISON
GERNSHEIM (1969) The
History of Photography
from the Earliest Use of the
Camera Obscura in the
Eleventh Century up to
1914, 2 vols, London and New
York (first edition, 1955). One
of the two classic histories. It is
interesting to compare later
editions with the first edition in
order to see how their interests
and research developed.

essay in the exhibition catalogue, described changing techniques, but also included comments on specific photographers and particular periods of aesthetic development. Newhall was one of the first to introduce aesthetic judgements into the discussion of photographs, but, at this stage, as he has noted himself, he avoided the identification of artists, thereby refusing MOMA's expectations of what an exhibition catalogue should be. It was only in the third edition of his *History of Photography* that emphasis on photographers and an account of the work of practitioners emerges. In this edition he also, for the first time, introduced chapters on straight photography, documentary and 'instant vision', thereby acknowledging characteristics specific to photography. The third edition thus represents the beginning of an engagement with the idea of photography theory as distinct from art theory.⁸

Similarly, it is only in later editions that Helmut Gernsheim refocuses the history to comment more extensively upon particular practitioners. His contribution to the history, developed in collaboration with Alison Gernsheim, was founded in the study of their collection of nineteenthcentury photographs. The full title of their research, first published in 1955 and dedicated to Beaumont Newhall, is The History of Photography from the Earliest Use of the Camera Obscura in the Eleventh Century up to 1914. The second edition, in 1969, was divided into two volumes, with considerably more emphasis on illustration than previously. The third, revised edition appeared in the 1980s, by then under the single authorship of Helmut Gernsheim (since the death of his wife). The first volume of The History of Photography focuses on the origins of photography in France, America, Great Britain and Germany. 10 A chapter on Italy was added later, in the third edition, which was published in 1982. A summary version of the research was published in 1965 as A Concise History of Photography, offering a shorter, and thus easier entry into his work. This version includes a brief, and highly selective, discussion of modern photography up to the 1950s. (For purposes of studying the nineteenth century, the two-volume edition which is in large format, with good quality picture reproduction, is recommended for the detail of observation and the range of imagery.)

Both Newhall and Gernsheim focus upon Western Europe and the United States (with no comment, for instance, on Soviet Russia or South America). The key difference between Newhall and Gernsheim lies in Gernsheim's relative concentration on the nineteenth century, and his greater emphasis on technical aspects of photography. His study is more lengthy and less literary in approach than Newhall's. This may reflect the origins of Newhall's essay as an exhibition catalogue, which meant that he had to take account of the problem of succinct communication to a diverse audience. Further differences may stem from nationality: Newhall was American; Gernsheim was born in Germany but was naturalised British. As has already been noted, they were working in relation to particular archive collections, the former drawing upon the collection at MOMA with, inevitably, a central focus upon

8 All editions are credited to Newhall, but a number of commentators have noted the research contribution of his wife, Nancy Newhall.

9 The Gernsheim collection is now at the University of Texas in Austin.

10 The chapter is in fact entitled 'The Daguerreotype in German-Speaking Countries'. He refers to what is now Germany and Austria. PAUL HILL AND THOMAS COOPER (1992) **Dialogue** with Photography, Manchester: Cornerhouse Publications.

Also see: VICKI GOLDBERG (ed.) (1981) **Photography in Print**, Albuquerque: University of New Mexico Press.

NATHAN LYONS (1966) **Photographers on Photography**, Englewood Cliffs: Prentice-Hall.

CHRISTOPHER PHILLIPS (ed.) (1989) **Photography in the Modern Era**, New York: Metropolitan Museum/Aperture.

MARY WARNER MARIEN (2002) **Photography, A Cultural History** London: Laurence King Publishing Ltd. developments in America, as well as upon the research in Europe conducted prior to the 1937 exhibition. The Gernsheim collection focused on the nineteenth century, and was centred upon British photography.

Both publications proceed to a greater or lesser extent by way of discussion of great photographers. Gernsheim notes that their collection was organised not only in files about photographic processes, apparatus, exhibitions, but also folders on important photographers (see Hill and Cooper 1992). Newhall, as an art historian, was accustomed to emphasis on the contribution of the individual artist, and by the fifth edition of his work, the contribution of individual photographers and the authority of their work is clearly a priority. This has the effect of raising the profile of certain 'masters' of photography, thereby defining a canon, or authoritative list, of great practitioners. It also renders history as a relatively simple chronological account, devoid of broader social context. The canonisation of photographers as artists, in line with the emphasis on individual practitioners in other art fields in the Modern period, characterises many contemporary publications. For instance, Photo Poche publish a three-part 'history' organised as brief biographies with comments on photographers, accompanied by one image selected from their lifetime's work. Similarly, The Photography Book, published by Phaidon, includes 500 photographs by 500 different photographers (presented alphabetically by surname). Such collections offer useful starting points for identifying the style of particular photographers, but the socio-historical contextualisation is strictly limited. By selecting known practitioners, rather than sets of ideas or types of practice, such books have the effect of reinforcing the canon of acclaimed photographers and marginalising practices which cannot be illustrated through reference to specific names.

History in focus

There are several consequences of canonisation: first, changing attitudes to photography as a set of practices have tended to become obscured behind the eulogisation of particular photographers, their photographs and their contribution. Second, the focus (led by male historians) has been upon male photographers, with the consequence that the participation of women has been overlooked or obscured. Third, there has been relatively extensive discussion of professional and serious commercial practices, but relatively few accounts of popular photography or of more specialist areas of practice, such as architecture or medicine. Fourth, as has already been mentioned, photography history has tended to prioritise aesthetic concerns over broader and more diverse forms of involvement of photography in all aspects of social experience, including personal photography, publishing and everyday portraiture.

More recent histories published in English have offered broader perspectives. Of these, the most comprehensive is **Mary Warner Marien**'s *Photography, A Cultural History* which considers a range of amateur and professional uses of photography, from art and travel, to fashion and the mass media.

Although organised broadly chronologically, it is structured primarily in terms of discussion of particular practices rather than technologies or practitioners, although both the latter are acknowledged in mini case studies which feature throughout; the book is clearly written and amply illustrated. The central focus is upon developments in Europe and North America, but it also takes advantage of recent research into non-Western photography. **Naomi Rosenblum**'s *A World History of Photography* likewise offers an excellent, well written account which is thorough and markedly international in its compass. The device of including three separate sections on technical history allows her to focus on images and movements in the main body of the text, which is extensively illustrated.

Mark Haworth-Booth's discussion of *Photography: An Independent Art* offers an eminently readable account of the development of the photography archive at the Victoria and Albert Museum in London. While focusing upon images in that particular collection, his discussion is informed and informative about more general developments in photography as both art and technology. Likewise, **Ian Jeffrey**'s account *Photography, A Concise History* is purposeful and generally clearly written. This book set out to be a radical reappraisal of the history of photography as written to date, although Stevie Bezencenet has argued that it was less than successful in its re-evaluation on the grounds that to produce a history of photography now requires a diversity of academic approaches (Bezencenet 1982b). She also notes that Jeffrey offers another history overwhelmingly concerned with male practitioners, making the point that, however radical his declared intentions, his work mirrors the established formula of a chronological account of changes and focuses on dominant modes of photography and particular practitioners.

Lemagny and Rouille's account is of interest to the English reader, for its central starting point is within French culture which, in effect, recentres France within photography history. While discussion of photography in Britain is more limited than in some of the other accounts, the references to Europe as a whole are more comprehensive. This book is an edited collection. Despite the editors' stated intention of holding a balance between discussion of photography as a field in itself, and discussion of the broader context within which it functions, some chapters succeed in being more analytic than others. While expressing strong criticisms, in reviewing the book, Warner Marien suggests that its strengths lie in two chapters on photography as art, and she adds that in general this collection takes more account of contemporary theoretical ideas than do most works of this kind (Warner Marien 1988). Likewise, Michel Frizot's A New History of Photography is written from a French perspective, as indicated, for instance, in its emphasis in early chapters on the spread of the daguerreotype. Organised chronologically, it offers groups of images juxtaposed with specific thematic discussions which range from the technical to particular fields of practice. In similar vein, Graham Clarke explores how we understand a photograph through a brief NAOMI ROSENBLUM (1997) A World History of Photography New York, London, and Paris: Abbeville Press. Previous editions, 1984, 1989

MARK HAWORTH-BOOTH (1997) **Photography: An Independent Art**, London: V&A publications. Haworth-Booth is Curator of Photography at the V&A. This book was published to coincide with the establishment, in May 1998, of a permanent photography gallery at the V&A for showing works from the museum's collection.

IAN JEFFREY (1981) **Photography, A Concise History**, London: Thames and Hudson.

JEAN-CLAUDE LEMAGNY AND ANDRÉ ROUILLE (1987) A History of Photography, Cambridge: Cambridge University Press.

MICHEL FRIZOT (ed.) (1998) **A New History of Photography**, Cologne: Könemann.

GRAHAM CLARKE (1997) **The Photograph**, Oxford:
Oxford University Press.

introductory historical overview of practices in terms of genres: landscape, the city, the portrait, the body, documentary, fine art, and photographic manipulations.

The year 1989 saw the publication of two major historical overviews, both designed to accompany retrospective exhibitions celebrating 150 years of photography. The title of Mike Weaver's The Art of Photography (1989) reflects the location of this exhibition at the Royal Academy in Piccadilly, London. This was the first ever exhibition of photographs to be held there and, as such, both the show and the accompanying publication emphasise the image as art and the status of the photographer as artist. Similarly, John Szarkowski's Photography Until Now (1989) - which accompanied the MOMA celebration of 150 years of photography - in relying primarily on the MOMA collection reinforces the American canon (which includes a number of European photographers). Szarkowski trained both as an art historian and as a photographer before working in the MOMA collection for 30 years. His interests centred upon the formal and technical properties which distinguish photographs from other visual media, and in the status of the unauthored or vernacular photograph. However, the production values of both of these publications are high, which makes each a useful source for visual reference and research.

If you are coming to the story of photography for the first time, Rosenblum offers a good, clearly written starting point for engaging with this history. Alternatively, Szarkowski and Jeffrey complement one another in taking America, or Europe, as central starting points. Indeed, Szarkowski specifically comments on the difference in the situation of photography in the US, as opposed to Europe, at the turn of the century. He suggests that American (he specifies 'Yankee') photographers were more inclined towards reportage than their European counterparts, having invested less in claims for the status of the photograph as art, since America lacked the depth of artistic tradition that was central to post-Renaissance Europe.

Each of the histories reviewed above reflects, to a greater or lesser degree, an established selection of photographers and their images. The 'great masters' approach has been challenged variously. Anne Tucker, in *The Woman's Eye* (1973) was among the first to draw attention to the considerable participation of women as photographers historically. As the title implies, she suggests that what we see photographically – that is, subject-matter and treatment – to some extent reflects gender. This question of gender has been pursued by **Val Williams** in her discussion of British women's participation in a range of practices, including the local (studio) and the domestic (the family album), and, like Mary Warner Marien, her historical account takes stock of commercial practices. By contrast, Naomi Rosenbaum, in reappraising photohistories, focuses primarily upon work by American women photographers. Likewise, Jeanne Montoussamy-Ashe (1985) reinstates black women into the history of

JOHN SZARKOWSKI (1989) **Photography Until Now,**New York: MOMA, Published to
coincide with the exhibition of
the same name on the occasion
of the 150 years' celebration.

VAL WILLIAMS (1986) Women Photographers: The Other Observers, 1900 to the Present, London: Virago. Revised edition (1991) The Other Observers: Women Photographers from 1900 to the Present. American photography, noting, for instance, documentation for the 1866 Houston city directory which lists 'col' against the name of a female photographic printer. (Some women are also listed in D. Willis Thomas' Black Photographers bio-bibliography (1985), again American.) In all instances, what is at stake is to note the presence of women within a particular field and to consider ways in which gender, positively or negatively, contributed to constructing or limiting the roles played. By contrast, Constance Sullivan's Woman Photographers (1990), considering European (including British) and American examples, has stressed women's participation as artists, arguing that women's work historically has demonstrated equivalent aesthetic values to those which characterise the work of their better-known male contemporaries, while often bringing different subject-matter into focus. This book is particularly useful for its quality reproduction of images. But the fundamental point is that each author focuses on putting women back into the picture even if, ultimately, they challenge the canon rather than canonisation.

NAOMI ROSENBLUM (1994) A History of Women Photographers, New York, London and Paris: Abbeville Press.

Also see: LIZ HERON AND VAL WILLIAMS (1996) Illuminations, Women Writing on Photography from the 1850s to the Present, London: I B Tauris.

PHOTOGRAPHY AND SOCIAL HISTORY

Social history and photography

A further challenge to the dominance of the 'great masters' history of photography has been made by those who have re-examined the status and significance of popular photography. By 'popular' we refer to personal photography, or to photographs which may have been commissioned from professional photographers, but were intended for personal use (see chapter 3). The term also extends to include postcards exchanged between individuals, and pictures made to record events or membership of clubs and societies. The high street portrait studio is also a legacy of Victorian photography, and was by no means confined to major cities. Such studios were often family enterprises, or were run by women photographers.

The contribution of particular photographers, and the economic circumstances within which Victorian and Edwardian photography was pursued, has become a focus of much recent research. But one of the points about reviewing popular photography and rethinking its significance is that concern with the authoring of images is related to questions of provenance (establishing where and when a photograph was taken) rather than to questions of artistic significance. This is because popular photography is increasingly used as social-historical evidence. Personal albums, and other materials, are viewed as a form of visual anthropology and are catalogued within a number of archives, of differing scale and thematic concern. Public museums and libraries may have photographic collections within their local or regional archive; and there are many independent collections.¹¹ Such rich collections offer myriad research possibilities. They also contribute to the fast-expanding 'Heritage'

11 See the Royal Photographic Society (1977) Directory of British Photographic Collections, London: Heinemann. industry in Britain wherein photographs play a high profile as 'evidence' from the past. As such, they are displayed, or used as reference for the design of reconstructions of buildings or machinery, or republished as postcards.

The photograph as testament

Photographs are commonly used as evidence. They are among the material marshalled by the historian in order to investigate the past. Over the past 30 years they have become a major source of information by which we picture or imagine the nineteenth century. Historians have for the most part had an uneasy relationship with the medium, as their professional training did not introduce them to an analysis of visual images. It was television that first raided the many photographic archives for images of historical interest; this necessarily led to some difficulties, not least of which was that of an archive used in a general way to illustrate commentary, with scant regard for the purposes for which the photographs were made. The social historian may be interested in changing modes of dress, or agricultural and industrial machinery. Photographs are used as evidence of such changes, which means that the detailing of the source and date of the photograph – that is, its provenance – becomes especially important. Hence we come across titles of publications such as 'The Camera as Historian' or 'The Camera as Witness'. 12

Popular education also led to a growth in the use of photographs for the analysis of local or community history.¹³ There are a number of reasons why people are interested in using old photographs: some have an ethnographic curiosity about the kinds of clothes or tools that were common at a particular period, while others are fascinated by the characteristic stance and gait of workers in particular trades. Social and labour historians who wanted to gain some idea of ordinary life and work in the Victorian era have also been drawn to the examination of visual material; not merely for the information provided by photographs, but also to begin to recognise in the faces and stances of the subjects something of the real people in the scenes that have been the subject of so many accounts and narratives.

Photography was used throughout the nineteenth century in the service of political and industrial change. One reason for landscape photography was governmental employment of photographers for civil and military mapping purposes. For instance, the British government used photographers for a military survey of the Highlands of Scotland in order to help quell anti-English rebellion (Christian 1990). Similarly, in America, early landscape photography in the West was often commercial in origin: Carleton Watkins' employers included the California State Geological Survey and the Pacific Railroad Company (Snyder 1994). These photographs, along with others made for less systematic purposes, are used as a form of social-historical evidence. Examples range widely: for instance, Alison Gernsheim used photographs as a basis for a survey of changing fashions (Gernsheim 1981). The status of the

- 12 Tagg (1988) remarks on the publication in London as early as 1916 of a handbook entitled *The Camera as Historian* aimed at those who used the camera for survey and record societies.
- 13 See 'The Pencil of History' in Patrice Petro (ed.) Fugitive Images, Bloomington: Indiana University Press, 1995.

photograph as evidence is not questioned. Likewise, books based on past photojournalism are common.¹⁴ Such books purport to present the past 'as it was', taking for granted that this is what photographs do. As is asserted on the inside cover of one such book presenting pictures of Britain and Ireland, 'More than words, more than paintings or prints, old photographs convey an immediate, undistorted impression of the past' (Minto 1970).

Such use of photographs reflects a broader set of academic assumptions. Until recently, British historical, scientific and social scientific method was characterised by empiricism. The nineteenth century was a period of extensive technological and social change, characterised by faith in progress and 'modernity'. Modernity has to be distinguished from modernism. Historians argue constantly about when 'modernity' begins, but it much pre-dates the twentieth-century art movements - aesthetic and philosophical developments in art and design - that are called modernism. Modernity is usually dated from the middle of the eighteenth century. Important changes included the transformation of the economy through new techniques of production; the development of new materials and commodities; the growth of industrialisation and, related to this, the expansion of towns and cities as people moved to live in centres of employment; the creation of new kinds of communication systems and forms of display. In Britain, France and elsewhere, such changes were underpinned economically through imperialism (which made available raw materials and cheap labour from other parts of the world) and through the low pay and poor working conditions experienced by industrial and agrarian labour at home. All these factors contributed to the increasingly public and urban nature of modern life, and to emphasising the separation of the aristocracy (in Britain), the professional and entrepreneurial middle classes, and the workers.

Photography not only developed in the Victorian era but was also implicitly caught up in nineteenth-century interests and attitudes. The Victorians invested considerable faith in the power of the camera to record, classify and witness. This meant that the camera was also entrusted with delineating social appearance, classifying the face of criminality and lunacy, offering racial and social stereotypes. In one of few histories to investigate the photograph neither primarily as image nor as technology, Alan Thomas in The Expanding Eye considers ways in which early uses of photography reflect and reinforce nineteenth-century concerns. Centred upon Victorian Britain, his account focuses on the popularisation of photography both in terms of uses of photographs (it is one of the first accounts to give a whole chapter to photography as family chronicler) and in terms of representation of the everyday. Thus he includes discussion of personal uses of photography in, for instance, the family album; portraiture (including theatre portraits); and photographs which investigate rural and urban working and living conditions. Likewise, Mary Warner Marien, in the publication which preceded her comprehensive cultural history, critically considers the history of the idea of photography,

14 There are too many examples to enumerate, but many draw upon pictures from the *Illustrated London* News or Picture Post.

ALAN THOMAS (1978) **The Expanding Eye**, London: Croom Helm.

MARY WARNER MARIEN (1997) Photography and Its Critics, A Cultural History, 1839–1900, Cambridge: Cambridge University Press. 15 It is interesting to note that in 1851, 51 people recorded themselves by occupation as photographers, and in 1961 there were 2,879 (Gernsheim and Gernsheim 1969: 234).

JOHN TAGG (1988) The Burden of Representation: Essays on Photographies and Histories, London: Macmillan.

MICHEL FOUCAULT

(1926-1984) One of the most influential of French philosophers of recent times. He enjoyed a distinguished career as a scholar and academic which culminated in his appointment as Professor in the History of Systems of Thought at the Collège de France. In the 1960s Foucault rejected humanism and philosophies of consciousness and set about the construction of a new kind of critical theory. His concerns were with the way in which specific social institutions and practices construct the objects and forms of knowledge and help to determine our human subjectivity. Some key works in this project are, in English translation: The Order of Things: An Archeology of the Human Sciences (1970): The Archeology of Knowledge (1972); The Birth of the Clinic (1973); Discipline and Punish (1977); The History of Sexuality (1978).

ELIZABETH EDWARDS (ed.) (1992) Photography and Anthropology, New Haven: Yale University Press. An impressive collection of essays on the subject which takes advantage of access to key archives including the Pitt River Museum, Oxford, where Edwards is Curator of Photography.

its cultural impact and implications in the nineteenth and early twentieth century, including discussion of the photograph within mass culture.

One of the consequences of extensive social change was a series of social surveys, which were designed to try to understand further how different social groups responded to the changing times and sought explanation through the quantitative assembly of information. In 1851 The Great Exhibition celebrated industrial and technological achievement. In that same year, the British Census recorded differences in work status and living circumstances. The motivation for the Victorian survey was not simply academic. Also in 1851 Henry Mayhew published his *London Labour and London Poor*. This first survey of living conditions was illustrated with wood engravings based upon photographs, and therefore stands as an early example of the photograph being used as documentation. It became common for authenticity to be stressed through using such phrases as 'drawn from an original photograph'. The photographic image was already being mobilised as witness.

Categorical photography

John Tagg has written extensively on the uses of photography within power relations, noting that photographs became implicated in surveillance very early on. He employs the genealogical method typical of the work of French philosopher, Michel Foucault. In The Burden of Representation Tagg traces intersecting ways in which photography was involved in maintaining social class hierarchies through delineation of, for instance, prisoners or the poor. He insists on the need to trace the complex relations between representation, knowledge and ideology in terms which take account of fundamental class interests at stake. In his essay 'The Currency of the Photograph' (Burgin 1982) Tagg focuses on what he terms 'the prerequisites of realism'. His title metaphorically references the notion of the photograph as symbolic exchange, while simultaneously referring to the values implicated in such an exchange. Thus he discusses the relationship of the photograph to reality, the constitution of photographic meaning, the social utility of photographs, and the institutional frameworks within which they are produced and consumed.

Likewise, recent reappraisals of uses of photography within social anthropology, and within the records of colonial travellers implicated in European imperialism, have drawn attention to the political and ideological implications of using photography to define social types viewed as different or **Other**. As a number of critics have variously observed, such definitional uses of the image contribute to legitimating colonial rule (**Edwards 1992**). Furthermore, as Sarah Graham-Brown has argued, there is a complex interplay between imperialism and patriarchy, within which women become particular sorts of exoticised victims of the stereotyping of the colonial Other (Graham-Brown 1988).

In his 'The Archive and the Body' (1986), photographer and critic Allan Sekula traces the attempts of Victorian men of science to delineate, record and classify particular 'types' of human being (Sekula 1991). They used physiognomy and phrenology to show that it was possible to read from the surface of the body the inner delineation and moral character of the subject being studied. They employed the developing science of statistics in order to demonstrate that science – aided by one of its new tools, the seemingly impartial eye of the camera – would reveal and systematically record the varieties of criminal faces.

In this complex article Sekula is particularly interested in photography's relation to police procedures, but mad people and native peoples from other cultures were similarly subjected to processes of measurement and scentific appraisal. In 1869 T.H. Huxley was asked to make a photographic record of people from a number of races:

Huxley . . . was asked . . . by the Colonial Office to devise instructions for the 'formation of a series of photographs of the various races of men comprehended within the British Empire'. The system he conceived called for unclothed subjects to be photographed full- and half-length, frontally and in profile, standing in each exposure beside a clearly marked measuring stick. Such photographs reproduced the hierarchical structures of domination and subordination inherent in the institutions of colonialism.

(Pultz 1995: 25)

But a number of further issues beg attention in considering surveillance, social survey and other 'mapping' usages of photography. In referring to the photograph as 'fugitive testimony', Barthes draws our attention to the fleeting nature of the moment captured in the photograph and the extent to which contemporary experience (we are looking back with eyes informed by circumstances and ways of thinking of the 1990s), along with limited knowledge of the specific context within which – and purpose for which – the photograph was taken, make the image an unreliable witness. Photography is involved in the construction of history. But when photographs are presented as 'evidence' of past events and circumstances, a set of assumptions about their accuracy as documents is being made. Such assumptions are usually acknowledged through statements of provenance: dates, sources, and so on. But this is to ignore wider questions relating to visual communication and ways in which we interpret photographs.

Photography has been used by those who want to construct history around the notion of 'popular memory'. Here the photographs are often of a personal nature, through which communities might begin the process of establishing their own non-formal history; accounts which might well challenge or be oppositional to more official versions. One problem with this is that

[See ch. 4, pp. 164-8].

photographs have often been treated as though they really were a source of disinterested facts, rather than as densely coded cultural objects:

Ultimately, then, when photographs are uncritically presented as historical documents, they are transformed into aesthetic objects. Accordingly, the pretence to historical understanding remains although that understanding has been replaced by aesthetic experience.

(Sekula 1991: 123)

The history of photography is to a large extent shaped by the characteristic ways in which photographs have been collected, stored, used and displayed. With the passage of time the original motive for the making of a photograph may disappear, leaving it accessible to being 're-framed' within new contexts.

Institutions and contexts

Let us assume that a photograph of a homeless, unemployed man, published in a 1930s magazine to advance some philanthropic cause, is shown, massively enlarged, on the walls of a gallery 50 years after it was first made. Originally tied to the page with a caption and an explanatory text, it now stands alone as some kind of art object. How are we to read such an image? As an example of a genre? For its technical qualities? As part of the oeuvre of a distinguished practitioner? As a work of art, or as an historical object which conveys specific information or exemplifies 'pastness'? Do we try to make sense of it in terms of its distance from our own lives, or because there are many similarities to prevailing conditions? Do we try to read through the image some notion of human nature, of how, regardless of political context or the specificity of time, it would feel to be destitute and suffering? Or do we see it merely as a photograph, one among many and to be distinguished in terms of its formal, aesthetic qualities rather than its relationship to a world outside itself?

The very ubiquity of the medium has meant that photographs have always circulated in contexts for which they were not made. It is also important to remember that there is no single, intrinsic, aboriginal meaning locked up within them. Rather, there are many ways in which photographs can be read and understood, but in 'reading' photographs we rely on many contextual clues which lie outside the photography itself. We rarely encounter photographs in their original state, for we normally see them on hoardings, in magazines and newspapers, as book covers, on the walls of galleries or on the sides of buses. Their social meanings are already indicated to us and they are designed into a space, often accompanied by a text that gives us the preferred readings of their producers and allows us to make sense of what might otherwise be puzzling or ambiguous images. Indeed, commercial uses of photography, especially in advertising, often play on the multiple possible connotations that are provoked by the image.

One determinant of the way in which we understand photographs, then, is the context within which we view them, and key institutions shape the nature of photography by the way they provide this context. This approach to understanding photography was particularly influential in Britain in the 1970s and 1980s and was central to the concerns of a number of magazines at that time, pre-eminently Ten/8 and Camerawork (Evans 1997). As was argued, photographs are weak at the level of imminent meaning and depend for their decoding on text, surrounding, organisation, and so on. Although collections of photographs have always been assembled, photography's ambiguous status with regard to Art has often meant that they were not displayed in museums as objects in themselves, but rather, used as a source of supplementary information to some more valued objects.

JESSICA EVANS (ed.) (1997) The Camerawork Essays, London: Rivers Oram. Includes 15 essays originally printed in Camerawork between 1976 and

The museum

Douglas Crimp has argued that the entry of photographs into the privileged space of the museum stripped them of the multiple potential meanings with which they are invested. They were removed from the many realms within which they made sense, in order to stress their status as separate objects - as photographs. Crimp is particularly interested in the work of the Museum of Modern Art, New York, in transforming photographs into objects of merely aesthetic attention. He is not alone in drawing attention to the way in which MOMA embraced photographs as art objects, brought them into the privileged space of the gallery and surrounded them with the apparatus of scholarship, appreciation and connoisseurship formerly reserved for paintings and sculptures.

But Crimp also examined the practice of the New York Public Library which, becoming aware of the number of photographs it possessed and of their historic and financial value, created a Department of Photography. They scoured all sections of the huge library for a trawl of photographs, which were removed from multitudinous subject areas and reclassified as photographs, often under the individual photographer. 16 Crimp comments of photography that:

Thus ghettoized it will no longer primarily be useful within other discursive practices; it will no longer serve the purposes of information, documentation, evidence, illustration, reportage. The formerly plural field of photography will henceforth be reduced to the single, allencompassing aesthetic.

What is lost in this process is the ability of photography to create information and knowledge through its interaction with other discourses. Photographs, doomed to the visual solitude of the art object, lose their plurality

(Crimp 1995: 75)

DOUGLAS CRIMP (1995) On the Museum's Ruins, Cambridge, MA: MIT Press. A collection of key essays originally published in October and other journals.

16 Likewise, the collection of photographs at the V&A, London, was established through bringing together photographs from a number of different sections of the museum

and their ability to traverse fields of meaning. They are treated as though they are unique and singular, rather than as the kind of industrial object – capable of being multiply reproduced – that constitutes their real existence.

The archive

Allan Sekula, in his article 'Reading an Archive' (1991), draws our attention to the power of the photographic archive. There are, of course, many different kinds of archive, from those held in museums to commercial or historical collections or family albums. They are found in libraries, commercial firms, museums and private collections. What they have in common is the fact that they heap together images of very different kinds and impose upon them a homogeneity that is a product of their very existence within an archive. The unity of an archive, he argues, is imposed by ownership of the objects themselves and of the principles of classification and organisation by which they are structured.¹⁷

Photographs of many kinds, which may have been taken for different – perhaps even antagonistic – purposes, are brought together: 'in an archive, the possibility of meaning is "liberated" from the actual contingencies of use. But this liberation is also a loss, an *abstraction* from the complexity and richness of use, a loss of context' (Sekula 1991: 116). But archives play an important function in the creation of knowledge. Characteristically, an archive seeks to grow; it aspires to completeness and through this process of mass acquisition a kind of knowledge emerges:

And so archives are contradictory in character. Within their confines meaning is liberated from use, and yet at a more general level an empiricist model of truth prevails. Pictures are atomized, isolated in one way and homogenized in another.

(Sekula 1991: 118)

But if serious historians have sometimes neglected to read photographs in the complex way they deserve, the heritage industry has used photography as a central tool in its attempt to reconstruct the past as a site of tourist pleasure. Here, photography becomes a direct way through which our experience of the past is structured.

Many critics have been worried by, or contemptuous of, the touristic use of historical materials and of the function of the visual. For example, Donald Horne claims that photography is an essential part of the tourist experience because it allows us to convert the places we visit into signs which we can then possess. Photography, he suggests:

offers us the joys of possession: by taking photographs of famous sites and then, at home, putting them into albums or showing them as slides, we gain some kind of possession of them. For some of us this can be

17 See Chrissie Iles and Russell Roberts (eds) (1997) In Visible Light, Oxford: Museum of Modern Art. This exhibition catalogue includes four key essays on photography and classification in art, science and the everyday.

the main reason for our tourism. Between them, the camera and tourism are two of the uniquely modern ways of defining reality.

(Horne 1984: 12)

Similarly, Robert Hewison argues:

Heritage is gradually effacing history, by substituting an image of the past for its reality. At a time when Britain is obsessed by the past, we have a fading sense of continuity and change, which is being replaced by a fragmented and piecemeal idea of the past constructed out of costume drama on television, re-enactments of civil war battles and mendacious celebrations of events such as the Glorious Revolution, which was neither glorious nor a revolution.

(Hewison, in Corner and Harvey 1990: 175)

Now the archive is raided not for photographs as aesthetic objects, but for photographs as signifiers of past times. Blown up from their original proportions, sepia-toned and hung on gallery walls, or recycled as advertising imagery, photographs retain their implicit claim to authenticity. This kind of commodification of the image continues to raise complex questions about how history is constructed and photographs employed to visualise the past. This is brought into particular focus in chapter 2, on documentary, and chapter 3, on personal photography.

JOHN TAYLOR (1994) A Dream of England: Landscape, Photography and the Tourist's Imagination, Manchester: Manchester University Press.

CHAPTER 2

Surveyors and surveyed

Photography out and about

DERRICK PRICE

- 67 Introduction
- 69 **Documentary and photojournalism: issues**and definitions
 Documentary photography
 Photojournalism
 Documentary and authenticity
 The real and the digital
- 75 **Surveys and social facts**Victorian surveys and investigations
 Photographing workers
 Photography within colonialism
 Photography and war
- 89 **The construction of documentary**Picturing ourselves
 The Farm Security Administration (FSA)
 Discussion: *Drum*
- 99 **Documentary: New cultures, new spaces**Theory and the critique of documentary
 Cultural politics and everyday life
 Documentary and photojournalism in the
 global age

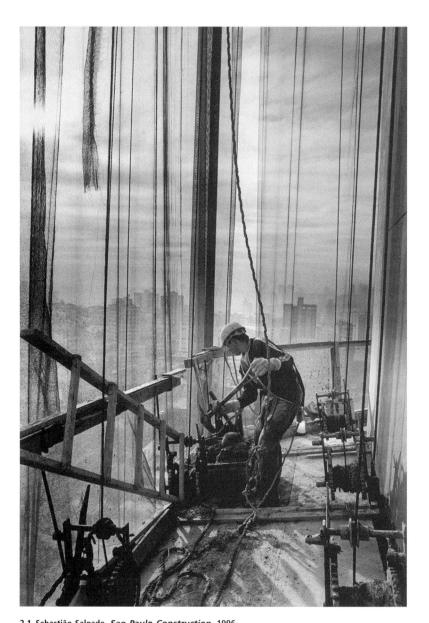

2.1 Sebastião Salgado, Sao Paulo Construction, 1996Brazilian-born, Salgado is one of the most important contemporary photographers. He has photographed workers, the poor and the dispossessed around the world

Surveyors and surveyed

Photography out and about

INTRODUCTION

Within a decade or two of its invention, photography was used to chronicle wars, to survey remote regions of the world and to make scientific observations. Life on the streets of great cities was recorded, but so were the monuments of Egypt and Syria, the vast ranges of the Himalayas, the USA railroad as it moved West, the fishing village of Whitby and the architecture of Paris. Pornographic images were soon in circulation, as were charity shots of the poor and homeless. **Montage** techniques were used to produce pictures of fairies, ghosts and elves. Less sensationally, the dead were recorded as they lay in their coffins (photography was hailed as an excellent substitute for the death mask), while all the living seemed appropriate subjects for the camera's gaze.

In this chapter we examine some of the ways photography has been used in order to bring us images of the wider world. We are essentially concerned with documentary photographs and with the history through which they were shaped and developed, but documentary is closely associated with other kinds of photography, especially those of war, travel, and photojournalism. There are often no clear lines of demarcation between these genres, nor is it possible to find exclusive descriptions of them. They cannot be defined simply by studying the intrinsic characteristics of the photographs themselves,

montage or photomontage
The use of two or more
originals, perhaps also including
written text, to make a
combined image. A montaged
image may be imaginative,
artistic, comic or deliberately
satirical.

but have to be understood through an examination of the history of their practices and social uses in particular places at determinate times. In this sense the chapter is centrally concerned with questions of history, but it does not aspire to provide a chronicle of events around the world, or a register of great practitioners over the last 150 years. Indeed, so all-pervasive has been documentary, and its associated forms, that such a chronicle would need to include many of the major figures in the history of photography. We discuss particular photographers in order to illustrate some aspect of the documentary project, rather than to provide a description or evaluation of their work

As elsewhere in the book, our concern is with *critical* questions about the nature of documentary realism and the way in which debates about its form, status and characteristic practices change over time in response to social, political, economic and technological pressures and opportunities. Our approach has been to explore the connections between documentary, social investigation, modes of **representation** and forms of reportage at particular times.

In the first section we look at the relationship of documentary to photo-journalism and explore the ways in which both may be said to offer authentic images of life. This question is made particularly pertinent by the development of increasingly sophisticated forms of digital imaging. We then examine the ways in which nineteenth-century debates and preoccupations often prefigure our contemporary concerns and we look at the archetypal subjects of documentary – workers, the poor, the colonised and victims of war.

The following section focuses on the 1930s as the decade in which most of our ideas about documentary, together with its characteristic social and political objectives, were formed. To illustrate this we discuss the work of the US Farm Security Administration Project.

Next, we consider the way documentary loses its stable identity and is dispersed through a variety of other, related, practices, for example, American street photography and new kinds of work in Britain.

We then examine the ways in which documentary has been critiqued and consider its ability to reveal significant features of everyday life before, finally, looking briefly at what the future may hold for documentary and photo-journalism.

We begin by noting photography's inexhaustible ability to provide us with pictures of the world; images which we are asked to accept as faithful to the real appearance of things. We want to examine the medium's putative capability to furnish us with accurate transcriptions of reality, an ability once thought to be guaranteed by the technology itself. Later this naive view was challenged and, as we shall see, the relationship of photography to reality was problematised and contested.

DOCUMENTARY AND PHOTOJOURNALISM: ISSUES AND DEFINITIONS

Documentary photography

Documentary has been described as a form, a genre, a tradition, a style, a movement and a practice; it is not useful to try to offer a single definition of the word. John Grierson coined it in 1926 to describe the kind of cinema that he wanted to replace what he saw as the dream factory of Hollywood, and it quickly gained currency within photography. The word had an imperialist tendency, and rather different kinds of photography were soon being subsumed within it. Some nineteenth-century photographers had regarded their work as 'documents', but many more were innocent of the fact that they were documentary photographers. Indeed, **Abigail Solomon-Godeau** (1991) has pointed out that in the nineteenth century almost all photography was what would later be described as 'documentary'.

But, if most photographs are a *kind* of documentary, how can we make distinctions between them? Historians and critics have frequently drawn attention to the difficulty of defining documentary that cannot be recognised as possessing a unique style, method or body of techniques. One answer to the question is to define documentary in terms of its connection with particular kinds of social investigation. Karin Becker Ohrn argues:

The cluster of characteristics defining the documentary style incorporates all aspects of the making and use of photographs. Although not rigid, these characteristics serve as referents for comparing photographers working within . . . the documentary tradition – a tradition that includes aspects of journalism, art, education, sociology and history. Primarily, documentary was thought of as having a goal beyond the production of a fine print. The photographer's goal was to bring the attention of an audience to the subject of his or her work and, in many cases, to pave the way for social change.

(Ohrn 1980: 36)

Our concern in this chapter will be to unpick some of the components of this tradition and examine ways in which we can distinguish documentary from other kinds of **straight photography**. Certainly the nature of an image itself is not enough to classify a particular photograph as in some essential way 'documentary'; rather we need to look at the contexts, practices, institutional forms within which the work is set. Documentary work may be seen to belong to the history of a particular kind of social investigation, although it employed its own forms, conventions and tropes. **Martha Rosler** (1989) tells us that to understand it we need to look to history, and she characterises documentary as 'a practice with a past'. A past, we might add, which, despite changing technologies, practices and fashions, was always concerned to claim

ABIGAIL SOLOMON-GODEAU (1991) **Photography at the Dock**, Minneapolis: University of Minnesota Press.

straight photography Emphasis upon direct documentary typical of the Modern period in American photography.

MARTHA ROSLER (1989)

'In, Around and Afterthoughts
(on Documentary Photography)'
in R. Bolton (ed.) The Contest
of Meaning: Critical
Histories of Photography,
Cambridge, MA: The MIT
Press.

for documentary a special relationship to real life and a singular status with regard to notions of truth and authenticity.

Photojournalism

Documentary and photojournalism are intimately linked, and many practitioners of straight photography are interchangeably described as either photojournalists or documentary photographers. However, photojournalism does, as the name indicates, have a special relationship to other texts and is seen, in its classic form, as a way of narrating current events or illustrating written news stories. While announcements of the news have existed since antiquity, and newspapers for hundreds of years, the word 'journalism' enters the language only in the 1830s, so that journalism as a modern profession grew up at the same time as photography. A modern press catering to the needs of a newly literate, urban population sought easy, graphic ways of spelling out the news while, at the same time, seeking to validate the truth and objectivity of their publications. Photographs seemed able to satisfy both these demands - although print technology made it impossible to reproduce them until the 1880s. Nevertheless, magazines that told stories with the help of pictures were extremely popular. The Illustrated London News sold 26,000 copies of its first issue in 1842, and by 1863 had a weekly print run of 310,000. The illustrations were in the form of wood engravings that were produced with machine-like speed and precision through the use of a complex division of technical and artistic labour.

The spread and new excitement of photojournalism from the 1930s also owed much to the fact that there were many outlets through which such work could be shown and for which it could be commissioned. These magazines, which were based on the extensive use of photographs to tell stories, constitute the start of the modern movement of photojournalism. They include Look and Life in the USA, Vu in France, and Illustrated and Picture Post in Britain. There was also a host of new or revitalised publications in Germany where the movement began and most of the rhetorical devices of presentation were established – devices that allowed picture editors and designers to create powerful stories through the juxtaposition of image and text. Many of the German Illustrierte disappeared after Hitler came to power in 1933 and the editors and photographers who had worked for them went into exile, taking their skills with them to their adopted countries. Within a few years photojournalism became a worldwide phenomenon and attracted very large readerships, however, the spread of television, and changes in the patterns of newspaper ownership and financing, put pressure on the illustrated magazines. By the 1960s readerships had fallen and several wellknown magazines had ceased to exist. At the same time, new kinds of newspaper supplements appeared. These were full colour productions and contained many photographs, but they were advertising-led and their primary purpose was to sell goods rather than to report the news. Photojournalists

had to find new outlets for their work and new strategies in order to continue their practice.

Almost every aspect of social, political and personal life has been told through photojournalism and, despite the fact that television and video have become the dominant means of reportage, it is still an important source of news. However, the lack of photo magazines, the development of online reporting and the decline of photo stories in newspapers (in favour of single shots to illustrate the news) together with a new interest in personality based stories, have all led to a growing crisis in photojournalism, which can only flourish where there are editors to commission work and outlets in which to publish them.

Documentary and authenticity

Photojournalism and documentary are linked by the fact that they claim to have a special relationship to the real; that they give us an accurate and authentic view of the world. This claim has often been challenged on a number of grounds. Perhaps the simplest and most obvious test of authenticity is to ask whether what is in front of the lens to be photographed has been tampered with, set up or altered by the photographer.

Early in its history photography had been presented with many cases of fraud, as, for example, when the French photographer E. Appert published his book *Les Crimes de la Commune* in 1871. This purported to be a record of the vile behaviour of those who took part in the rising of the Paris Commune and was received with relish by many bourgeois commentators of the time. It consists, for the most part, of crudely montaged and retouched photographs, but was convincing enough for a public who were confident that the camera could not lie. It would, however, be incorrect to deduce that in the nineteenth century only outright deception was commented upon. Many sophisticated arguments about the ability of photographs to be true to appearances were rehearsed at that time. Indeed the Victorians were to stage a dramatic debate on the relationship between truth and representation in the public trial of Dr Barnardo.

In 1876 the philanthropist Dr T.J. Barnardo appeared at a hearing, having been charged with deceiving the public. His detractors claimed, and Barnardo finally conceded, that he had misled the public in his use of 'before and after' photographs of the orphans in his care. He had produced a series of cards which purported to reveal the transformative power of his project: one card was of dirty, ragged children lounging about against a background of urban decay; a second card showed one of these children cleaned up and neatly dressed, undertaking some useful task. Dr Barnardo used child models for these cards and one, Katie Smith, is pictured in several of them, posing as a crossing-sweeper or a match-seller. At the hearing Barnardo agreed that Katie had never sold matches, but he pointed out that she was a child of the streets who might well have ended up as a beggar and that, in any case,

she represented the appearance and state of a match-girl in an honest manner. Moreover, Katie could easily have stumbled into that kind of life had she not been saved by his mission.

As a result of the public hearing Barnardo gave up using photographs in this way, but his case raises questions that were to recur throughout the next century. Why should we trust the camera to be true-to-appearances? What is the relationship between the accurate portrayal of a single case and a general truth about the nature of things? Cannot something arranged or set up offer us an authentic insight into reality? It was questions of this kind that were rehearsed, long after Barnardo, in the furore that broke out over a photograph made in the USA.

In 1936 the American photographer Arthur Rothstein photographed a steer's skull that had been bleached by the sun and left lying on the earth. This was a simple still life, then, but one that was clearly intended to exemplify the contemporary crisis in agriculture. Rothstein took two photographs of this object, the most famous of which shows it lying on cracked, baked, waterless earth. The second, however, revealed it as resting on the less symbolically charged ground of a stretch of grass. The photographer acknowledged that he had moved the skull a few metres in order to obtain a more dramatic pictorial effect. When the presence of these two rather different images was discovered there was an outcry from Republican politicians, who claimed that the public had a right to see photographs that were objectively true rather than those that had been manipulated in order to make a rhetorical point. Two kinds of truth were in play; for, while the right-wing politicians demanded a truth at the denotative level, the photographer, like Dr Barnardo, laid claim to a greater truth at the connotative level. Nevertheless, Rothstein was at pains to draw attention to the smallness of his intervention in the 'real' state of things and would certainly have subscribed to the view that the authentic could only be guaranteed by a relatively unmediated representation of things as they are.

So, the practice of documentary was and is problematic and, over time, a number of conventions and practices evolved to mark 'authentic documentary' from other kinds of work. These included, for example, printing the whole of the image with a black border around it to demonstrate that everything the camera recorded was shown to the viewer. At another time, scenes lit by flash were deemed illegitimate, as only the natural light that fell on the scene should be used. A kind of rudimentary technical ethic of documentary work emerged which 'guaranteed' the authenticity of the photograph. We may note that studio-based photography, whether for commercial purposes or as art, was made by suppressing what was contingent within the photographic frame. The scene was designed in such a way that all aspects of the image were controlled and carefully placed. We have already observed that any attempt to arrange and structure the location by a documentary

photographer would be regarded as illegitimate behaviour, yet the aesthetic demand for well-composed shots remained.

Documentary photographers, too, took considerable pains to control the nature of a scene without making any obvious change to it. Thus, the celebrated French photographer Henri Cartier-Bresson lay in wait for all the messy contingency of the world to compose itself into an image that he judged to be both productive of visual information and aesthetically pleasing. This he called 'the decisive moment', a formal flash of time when all the right elements were in place before the scene fell back into its quotidian disorder. Increasingly, documentary turned away from attempting to record what would formerly have been seen as its major subjects. Instead, it began to concentrate on exploring cultural life and popular experience, and this often led to representations that celebrated the transitory or the fragmentary. The endeavour to make great statements gave way to the recording of little, dislocated moments which merely insinuated that some greater meaning might be at stake (Cartier-Bresson 1952). Cartier-Bresson's humanist work is often regarded as documentary or as photojournalism but he is also seen as working outside the constraints of labels of this kind. As photographer and theorist Allan Sekula has pointed out,

Documentary is thought to be art when it transcends its reference to the world, when the work can be regarded, first and foremost, as an act of self-expression on the part of the artist.

(Sekula 1978: 236)

The problem, then, becomes how we define 'reference to the world' and how documentary photographers can demonstrate their fidelity to the social world. To have to engage with particular conventions, technical processes and rhetorical forms in order to authenticate documentary undermines the notion of the objective camera and with it, one might imagine, any claim of documentary to be any more truthful to appearances than other forms of representation.

The real and the digital

The convergence between computing and audio-visual technologies has, as we all know, produced new kinds of digital media which are transforming the means of image making together with its social, commercial and aesthetic practices. A detailed study of digital imaging is given in chapter 7. Here, we need to note that digital media – with its ability to create, manipulate and edit images – has given new prominence to arguments about the nature of photography and taken them into the popular domain. These may briefly be summarised as: questions about the nature of the photographic image; about new ways of defining and understanding 'the real' that are brought about by

ALLAN SEKULA (1978)
'Dismantling Modernism,
Reinventing Documentary
(Notes on the Politics of
Representation)' in J. Liebling
(ed.) Photography: Current
Perspectives, Rochester,
New York: Light Impressions Co.

processes of globalisation and postmodern philosophical positions, and, finally, questions about the relationship of photography to other media.

It is now clear that images with all the appearance of 'real' photographs may have been created from scratch on a computer, montaged from many sources, altered in some respects, or radically transformed. Figures may be added or removed and the main constituents of the picture rearranged to suggest new relationships or bizarre conjunctions. Does all this not destroy the claim of photography to have a special ability to show things as they are and raise serious doubts about those genres with a particular investment in the 'real' – documentary and photojournalism?

We can, of course, observe that, as we have already seen, the manipulation of images is nothing new and that photographs have been changed, touched-up or distorted since the earliest days. But we are not looking here merely at a technically sophisticated way of altering images, but at much more profound changes that challenge the ontological status of the photograph itself. If a photograph is not of something already existing in the world, how can we regard it as an accurate record of how things are? Roland Barthes' influential conception of the nature of the photograph, is that it is the result of an event in the world, evidence of the passing of a moment of time that once was and is no more, which left a kind of trace of the event on the photograph. It is this trace, which has been considered to give photographs their special relationship to the real. That is that they function, in the typology of signs offered by the American semiotician, C.S. Pierce, as **indexical** signs.

The nature of the sign within semiological systems is important, but it is interesting to note that we have always known that photographs are malleable, contrived and slippery, but have, simultaneously, been prepared to believe them to be evidential and more 'real' than other kinds of images. It is possible to argue that the authenticity of the photograph was validated less by the nature of the image itself than through the structure of discursive, social and professional practices which constituted *photography*. Any radical transformation in this structure makes us uneasy about the status of the photograph. Not only do we know that individual photographs could have been manipulated, but our reception and understanding of the world of signs may have been transformed.

Writing in the French newspaper *Liberation*, in 1991 the social theorist, Jean Baudrillard famously remarked that 'the gulf war did not take place' (Baudrillard 1995). He was commenting on the nature of the real and the authentic in our time and suggesting that in the world of the spectacle, it is pointless to posit an external reality that is then pictured, described and represented. In his view everything is constructed and our sense of the world is mediated by complex technologies that are themselves a major constituent of our reality. What took place, then, was not the first Gulf War but a whole sequence of political, social and military actions that were acted out in a new

kind of social and technical space. While this may be an extreme way of formulating the argument, it is clear that a complex of technical, political, social and cultural changes has transformed not just photography, but the whole of visual culture. For example, David Campany points out that 'almost a third of all news "photographs" are frame grabs from video or digital sources' and he comments that:

The definition of a medium, particularly photography, is not autonomous or self-governing, but heteronymous, dependent on other media. It derives less from what it is *technologically* than what it is *culturally*. Photography is what we do with it. And what we do with it depends on what we do with other image technologies.

(Campany 2003: 130; emphasis in original)

One significant consequence of this has been a new merging and lack of definition between photographic genres. It is increasingly difficult to distinguish one kind of photograph practice from another. As we shall see later, titles, such as 'documentary' are of little use as labels for the new kind of work that is being produced. Indeed, all descriptive titles have been freely appropriated and find themselves used in curious couplings, for example, one sub-genre of photography now well established in the USA is that of 'wedding photojournalism'.

SURVEYS AND SOCIAL FACTS

Victorian surveys and investigations

Photography has always had to take its place within a range of discourses and visual practices. One reason why the veracity of the camera was readily accepted in the nineteenth century was that photographs appeared to confirm ideas about the world that had been the subject of other artistic and cultural forms. The camera reinforced journalistic and literary accounts of aspects of social life that had rarely been seen or experienced by middle-class people. Moreover, we may argue that Victorian actuality photographs were regarded as 'authentic' precisely because they were images of the poor and the dispossessed; people whose lives had about them (to the middle-class spectator) an air of being simple, real and untrammelled by the overt complexity of middleclass existence. Photography's subjects were those that had already been the topic of examination in reports, surveys, philanthropy and literature. It established itself as part of a tradition of enquiry into the health, housing, education, economic condition and moral state of the poor. Enquiries emanated from government departments, newspapers, independent scholars, medical practitioners, religious leaders and philanthropic bodies.

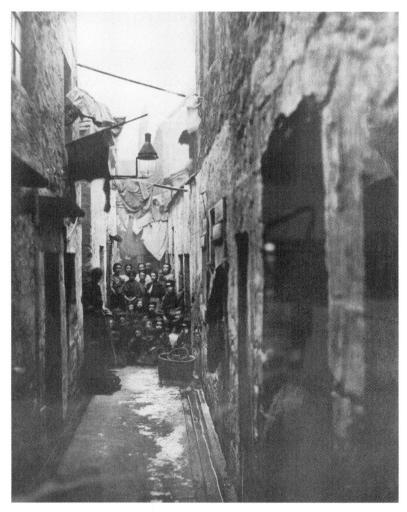

2.2 Thomas Annan, Close No. 118 High Street, 1868
One of Annan's evocative studies of the Glasgow slums. The inhabitants of Close No. 118 huddle together as they are recorded for posterity

Photography also became a mode of surveying the unknown and apparently mysterious and threatening city streets were being visually inspected and hauled into the light of day. Describing the anonymous photographers of the time, the historian **Alan Thomas** comments that:

They entered the back streets, it appears, in the same spirit as expeditionary cameramen journeying in strange lands, for one of the commonest documentary photographs of the century shows a line of back street dwellers, generally women and children, with perhaps a man

ALAN THOMAS (1978)
The Expanding Eye:
Photography and the
Nineteenth Century Mind,
London: Croom Helm.

lurking in the rear, who are ranged across the middle of the composition, gazing expectantly into the camera. From the 1860s to the end of the century, and from every great city comes this photograph; it always seems worth looking at because of the candid directness with which the subjects give themselves to the camera – like those foreign aboriginals photographed for the first time by expeditionary photographers.

(Thomas 1978: 136)

If the professional reporter journeyed to the dark places of the city, an army of amateur photographers snapped away in the more salubrious areas, but here the presence of photographers was considered to be undesirable, and by the 1880s they had been defined as a public nuisance. In London, licences were required to film in many places, while the photographic press carried articles deploring the activities of those who photographed respectable people without their specific consent.

Codes of conduct were beginning to emerge and a range of permissible and impermissible subjects was being informally drawn up. If the photographers were middle class, the posed *anonymous* subjects were likely to be poor or working class. What distinguished documentary photographers within this ferment of picture-making was that they worked with some notion of improving or ameliorating the lot of their subjects. But this, in turn, led to some curious social interactions. To illustrate this point it is worth looking at the work of the photographer who is generally taken to be the first of the American documentary photographers, Jacob Riis.

Danish-born Riis emigrated to the USA in the 1860s. He worked as a police reporter firstly for *Tribune* and later for the *Evening Sun* and began to concentrate on reporting the conditions of life in the East Side slums of New York City. Like many philanthropists and reporters before him, Riis was frustrated by his inability to convince people of the nature of the poverty, overcrowding, sweated labour and sheer misery that existed at the heart of a prosperous city.

He produced a picture of social conditions that is of considerable interest, despite the lack of formal aesthetic qualities in his images. In a typical Riis picture a crude flash of light in an otherwise dark room illuminates a scene of woeful overcrowding, with ragged people huddled on wooden benches or asleep on the floor. Others show garment-workers at their trade and, of course, children sleeping in doorways or labouring alongside their parents in tiny rooms. Riis worked at a time when the conventions of documentary photography had yet to be established, and he certainly wasted no time by seeking the cooperation of his subjects. Perhaps inevitably, his photographs provide us with ethnographic detail of material life and social conditions rather than more complex subjective readings of the nature of poverty and destitution. Work of that kind was left to his successors, but Riis is important

as a forerunner, and as a figure who directly connected photography to the journalistic enterprise. He was in no doubt of the power of photography to be a witness to the true nature of things. Describing a case of gross over-crowding, he writes:

When the report was submitted to the Health Board the next day, it did not make much of an impression – these things rarely do, put in mere words – until my negatives, still dripping from the dark-room, came to re-enforce them. From them there was no appeal. It was not the only instance of the kind by a good many. Neither the landlord's protests nor the tenant's plea 'went' in the face of the camera's evidence, and I was satisfied.

(Riis 1918: 273)

'Mere words' were to give way, in Riis' opinion, to the irrefutable veracity of the camera, and he saw his contribution as being that of bringing evidence to bear on what might otherwise be problematic. But he would not have seen his own personal vision as being of importance: the facts would speak for themselves and the people of the slums had, through the power and authority of the camera, been converted into 'facts' whose function was to exemplify and embody social problems. If complex and difficult lives are simplified into iconic statements of social deprivation, this is a problem not merely for Riis, but for the documentary project itself. Riis captured his photographs as if he were shooting game; he inscribed 'objectivity' into his images by refusing to allow his subjects to negotiate in any way the manner in which they might be recorded. Sally Stein has commented perceptively on this:

We can indeed marvel at the consistency of Riis's photography in which so few of the exposures presented a subject sufficiently composed to return the glance of the photographer. That he rejected those rare photographs in which the subject did happen to look back suggests how premeditated the effect was. . . . The averted gaze, the appearance of unconsciousness or stupefaction, were only a few of the recurring features which gave Riis's pictorial documents stylistic unity and ideological coherence in relation to the text.

(Stein 1983: 14)

A history of documentary could be structured around an account of the association between photographer and subject, and of the power relationships that are mediated between them. In the ostensible interest of revealing (and subsequently ameliorating) harsh conditions of life, photographers often rendered those they recorded into passive sufferers of poverty, rather than active agents in their own lives.

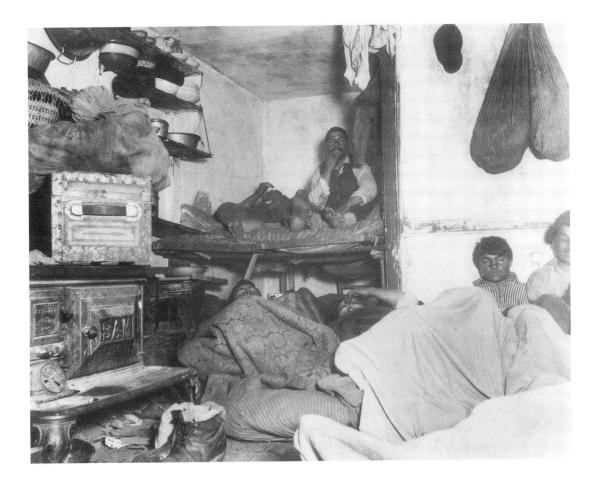

Photographing workers

Constituted as 'the **Other**', workers, poor, lumpen-proletariat, criminals, were often ill-distinguished in the middle-class mind, despite the efforts of people such as the social observer and writer, Henry Mayhew, to provide detailed typologies of the 'labouring poor'. Mayhew's approach to his investigations – a mixture of interview, statistics and descriptive writing – was to be one of the dominant modes through which working people were surveyed. Nor is it any accident that his monumental study of London life was illustrated with engravings that were based on photographs (Mayhew 1861).

In the last decades of the nineteenth century a number of significant British photographers recorded the life of the poor in great cities: John Thomson and Paul Martin in London, and Thomas Annan in Glasgow are three examples. Working several decades before Jacob Riis, they were influenced by the

2.3 Jacob Riis, Lodgers in a Crowded Tenement – 'five cents a spot', 1880s A typical scene of poverty and overcrowding is revealed in the harsh light of Riis' flash gun.

studies of the poor being carried out in literature and by philanthropists and social investigators. John Thomson directly cites the work of James Greenwood, the journalist, and Mayhew's monumental study, *London Labour and the London Poor*. Thomson is anxious to demonstrate that photography was a guarantor of authenticity and that his studies transcended the casual illustration of idiosyncratic types. He asserts that he is:

bringing to bear the precision of photography in the illustration of our subject. The unquestionable accuracy of this testimony will enable us to present true types of the London Poor and shield us from the accusation of either underrating or exaggerating individual peculiarities of appearance.

(Thomson 1877: n.p.)

Thomson may also have been attempting to distinguish his work from the staged productions of other photographers. In the 1860s and 1870s the poor were seen as suitable subjects for art. Notable photographers, such as Oscar Gustav Rejlander, produced picturesque studies of ragged street children that were much admired and, indeed, were used by Dr Barnardo to justify his own practices.

This preoccupation with the poor was not matched by a similar concern with capturing images of the world of work. Photography came into existence at a dynamic period in the development of capitalism, a time of technical innovation and of major engineering feats. Little of this energy is represented in the photographic archives; nor is the sheer drudgery of work and the army of labourers who carried it out made visible. Where there are shots of workers they tend to be inadvertently caught in a corner of the frame, or deliberately placed so as to give a sense of scale to some major building scheme.

There are many reasons for the absence of portraits of workers, not least that photographers tended not to live in the sites where industrial work was carried out. Moreover, notions of what made a good subject for a photograph were determined by convention, and also by such factors as the subjects set by the juries of photographic competitions. In the 1890s many clubs established 'street characters' or 'city trades' as subjects for competition, but they would have been very unlikely to establish categories based on industrial labour or domestic work.

Photographers were deeply influenced by conventional subjects and ways of treating the poor, and there are some examples of sustained and careful recording of working life. For example, Frank Meadow Sutcliffe diligently documented the village of Whitby as both a fishing village and a holiday resort over a long period of time. This work drew on the picturesque qualities of much of the labour involved, but also added new qualities of directness and close observation.

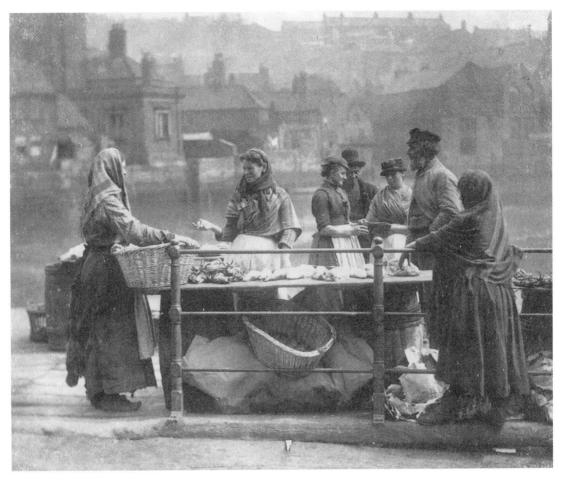

2.4 Frank Meadow Sutcliffe, A Fish Stall, c. 1882
Sutcliffe's long study of Whitby, Yorkshire, yielded hundreds of photographs that reveal the pattern of work and leisure in a Victorian fishing village

But such detailed, long studies were rare, and confined to one or two trades. Other workers passed without any great notice; of the vast army of clerks and domestic workers there is scarcely a sign, and those photographs of workers that do exist are usually of male labourers engaged in heavy, manual tasks. There are few images of women carrying out any kind of work and they are absent from the ranks of manual labourers. Indeed, if it were not for the curious obsession of **Arthur Munby**, women manual workers would have disappeared with scarcely a trace (Hudson 1972).¹

Of course, some documentary photographers were able to undertake sustained studies of labour, as did Lewis Hine in the United States from the turn of the nineteenth century. Hine was a most committed and subtle 1 Arthur Joseph Munby (1828–1910) Munby was a barrister and minor poet who is now best known for his diaries and notebooks which tell us something about the fashionable and artistic life of the time, and also reveal his obsession with working women. In journeying round England and Wales, he sought out women working in coalmining, fishing and farming and commissioned

local photographers to make portraits of them. A collection of these photographs at Trinity College, Cambridge, provides an invaluable historical resource for anyone exploring the way in which labour has been depicted. Munby did not confine his passion to organising these pictures; he also secretly married his maidservant, Hannah Cullwick, and they lived together for many years. A useful book on Munby is Derek Hudson's Munby: Man of Two Worlds, London: John Murray, 1972.

ALAN TRACHTENBERG (1989) Reading American Photographs, New York: Hill and Wang.

2 For an account of the connections between photography and other kinds of social investigation in the nineteenth and twentieth centuries see Derrick Price, 'Photographing the Poor and the Working Class', Framework 22(22), Autumn 1983.

photographer of people at work and was dedicated to the cause of using his images in the service of social reform. His output spans the time from Jacob Riis to the Farm Security Administration project of the 1930s. An excellent account of the work of Lewis Hine is given in **Trachtenberg**'s *Reading American Photographs* (1989).²

Photography within colonialism

Despite the physical difficulties of transporting large, unwieldy cameras and portable darkrooms, photographers covered the world in search of images of historic sites, sacred places and curious people. Photography developed in Europe at the height of the British Empire and amongst the first subjects of the lens were colonised peoples around the world. There has been a great deal of scholarly and critical work that explores the way in which the camera was used as an instrument of symbolic control. Indeed, Thomas Richards has pointed out that the British ruled huge parts of the world with little military presence and that its control was exercised through its extraordinary grasp of systems of information – its passion for inventories, lists, maps and pictures.

From all over the globe the British collected information about the countries they were adding to their map. They surveyed and they mapped. They took censuses, produced statistics. They made vast lists of birds. Then they shoved the data they had collected into a shifting series of classifications. In fact they often could do little other than collect and collate information, for any exact civil control, of the kind possible in England, was out of the question. The Empire was too far away, and the bureaucrats of Empire had to be content to shuffle papers.

(Richards 1993: 3)

While photographs are an important part of these archives they derive their importance from their relationship to other kinds of material and from the body of scientific ideas by which they were validated. So great was this passion that some critics have argued that it was the driving force behind the collection of a diverse range of material:

Colonial exploitation opened up vast new populations as much to scientific study as to economic exploitation, and although the need to organize and control was clearly important to the task of classification of racial and other types, the 'taxonomic imperative' of Victorian science appears to have been sufficient motivation in itself to promote anthropological photography.

(Hamilton and Hargreaves 2001: 87)

The Victorian fervour for classification, then, extended to whole peoples, who were categorised and ranked according to 'anthropological type'. Supported by theories of physiognomy, these sought to demonstrate the 'objective'

differences between peoples, races, castes and social categories. Those who were subjected to the coloniser's gaze were often seen as merely representative of racial or social groups, and were usually posed so as to embody particular kinds of dress, social roles and material cultures. Peter Quartermaine, in his discussion of the photographs of Johannes Lindt of the native peoples of Australia and New Guinea, comments that:

These people were photographed as 'other': the white settler population was interested in learning *about* them, a quasi-scientific attitude, which presupposed a controlling, position. The photographic images produced by Australian photographers sold to a metropolitan and international consumer market. Such prints doubly privileged the purchasers since, although reflecting their own aesthetic (natives clothed and posed with decorative artefacts), they also supposedly granted direct access to the culture depicted; their use as raw evidence by anthropologists and ethnographers certainly assumed this.

(Quartermaine 1992: 85)

The concept of the Other is of central importance to this argument. The phrase is used in feminist, **psychoanalytic** theory to indicate that men construct women as 'the Other'; that is, as an opposite, in reaction to which their own maleness can be defined. Similarly, European culture was defined *against* 'the Other' of colonised peoples:

Photography is here no mere handmaid of empire, but a shaping dimension of it: formal imperial power structures institutionalised the attitudes and assumptions necessarily entailed in viewing another individual as a subject for photography

(Quartermaine 1992: 85)

We must remember that, unlike the body of painting and engravings of 'exotic' peoples that had been popular Victorian subjects, photography claimed to be able to create objective, 'scientific' records that were free from the bias of human imagination. Carefully contrived and constructed photographs were consumed as though they were unmediated and offered a neutral reflection of the world. They were, however, far from being transparent and dispassionate images, for, as Jill Lloyd puts it: 'both photography as a medium and anthropology as a discipline masked their ideological standpoints and connotative potential with the appearance of scientific objectivity' (Lloyd 1985: 13). What were returned to the Western spectator were images of native peoples that established them as primitive, bizarre, barbaric or simply picturesque. In the service of these images, people were photographed in what appeared to be archetypal ways. While 'primitive' dress was sometimes stressed, there was also a great emphasis on nudity:

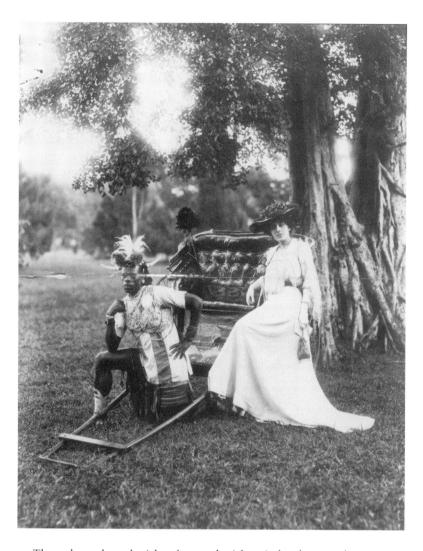

2.5 William Thomas,
Mrs Lewis Waller with a
Kaffir Boy, 1903
The relationship between
coloniser and colonised is
sharply focused in this portrait
of Mrs Waller and her African

servant.

Throughout the colonial and postcolonial periods, photography was a major tool in the framing of a confrontation between local and external cultural styles. In this confrontation, nudity was used as a visual marker of specific, but contradictory, local characteristics. It stood variously for primitivity, underdevelopment, indecency and indigeneity.

(Van Schendel 2002: 34)

While nudity was employed as an indicator of particular kinds of subjectivity, this quotation from Van Schendel also reminds us that control of the body is central to colonial modes of power, including the processes of representation. Much of the critical work in the study of colonialism and

postcolonialism has been concerned with the body, and, at the symbolic level, photography was, as we have noted, of central importance in mediating the relationship between the colonised and coloniser. John Urry tells us that:

To photograph is in some ways to appropriate the object being photographed. It is a power/knowledge relationship. To have visual knowledge of an object is in part to have power, even if only momentarily over it. Photography tames the object of the gaze, the most striking examples being of exotic cultures. In the USA the railway companies did much to create 'Indian' attractions to be photographed, carefully selecting those tribes with a particularly 'picturesque and ancient' appearance.

(Urry 1990: 139)

Victorian notions of progress allowed colonised people to be seen as occupying a lower scale of human existence than Europeans, but it was a stage from which, it was imagined, they would evolve in the long march to civilization. A cluster of ideas such as these underpin the colonial enterprise, so that James R. Ryan has argued that:

Despite claims for its accuracy and trustworthiness, however, photography did not so much record the real as signify and construct it. Through various rhetorical and pictorial devices, from ideas of the picturesque to schemes of scientific classification, and different visual themes, from landscapes to 'racial types', photographers represented the imaginative geographies of Empire. Indeed, as a practice of representation, photography did more than merely familiarise Victorians with foreign views: it enabled them symbolically to travel through, explore and even possess those spaces.

(Ryan 1997: 214)

It is this 'imaginative geography of empire' with which we are concerned and which has absorbed the attention of critics working on questions of post-colonialism. We need to remember here the scale of modern empire and understand that the structures of power established by colonialism are still active in our globalised world, albeit often disguised in a variety of social and cultural practices. We can, to take just one example, see many of the tropes through which colonised peoples were pictured, drawn on in modern tourist photography. Like colonial photographers they stress the indigenous nature of people, their settled lives, picturesque or exotic appearance and timeless existence. In contrast to this, postcolonial commentators draw attention to the vast diasporic movement of peoples around the globe; examine the sets of appropriations and relations of hybridity between coloniser and colonised, and problematise questions of identity and subjectivity. Work of this kind is

being made in many places by very different kinds of artists and photographers. We have illustrated it with a piece by Roshini Kempadoo who works within the documentary tradition but digitally reworks the photographs to construct new images that seek to reinforce or undermine particular ideas about race and colonial history. (See Plate 1.)

While a number of important critical and analytical concepts have emerged from postcolonial work, we need to remember that each society was very different in terms of its history, its indigenous forms of image making and its cultural practices. Critically informed photography often works across the terrain of the local, as that has been constructed, reflected, transformed or employed in the imaginative geography of Empire. Ryan investigates the range of work which collectively produced the geography of imperialism and he looks at a number of individuals, places and activities – from African explorers, travellers in India, commercial photographers, military campaigns and the study of racial types – all of which helped to construct an archive of the achievements of the Victorian colonial and imperial project.

The public appetite for images of native peoples was accompanied by a demand for photographs of historic sites, many of which were familiar from paintings and engravings, but which were given a new authenticity by the camera. It is difficult now to gain any idea of just how many travel photographs were made and sold, but the market for them was certainly vast. In addition to the beautifully mounted and bound albums that are now preserved in archives and museums, the new commercial photography firms that were established in the years after 1850 sold thousands of cheap postcards and single prints. For example, in 1865 the London Stereoscopic Company sold half a million pictures, many of them scenes from foreign places. At the same time we see the emergence of the professional travel photographer of whom Francis Frith is probably the best known. In addition to his own work, he established a company bearing his name that was to become the largest publisher of photographs in its time. The camera and travel became linked together and, as tourism slowly developed into a mass industry, photography functioned both to set the scene in advance of a trip and to provide a record of the journey when it was over. Soon there were few places in the world that had not been surveyed by the camera and few people who had not been subjected to the photo-eye; wildernesses gave up their seclusion as surely as cities yielded their secret places to the new image makers.

Photography and war

One major factor in the development of photography around the world was the desire to record wars. Even today most people's understanding of the nature of war comes from photographic images rather than literary accounts. It was, however, the highly critical reports of the London *Times* reporter, William Russell, on the progress of the Crimean War that led to Roger

Fenton being sent to take photographs that would reassure the public. Fenton used the newly invented wet **collodion** process to produce more than 350 photographs which did, indeed, show scenes of calm and disciplined order. He produced a number of handsome albums with original photographs 'tipped in', but his images were also used as the basis of illustrations in the *Illustrated London News*. Illustrated newspapers produced hundreds of woodcuts, often laid out to create a narrative of events. It seems that an added sense of realism was given to the piece if it was 'based on photographs' rather than being the work of an artist or illustrator, even though the engraver would omit or add material in order to make a visual point or a more pleasing aesthetic effect.

Fenton spent only a short time in the Crimea and his work did little to reveal the hardships or horrors of war. The American Civil War (1861–5) was the first to be photographed extensively throughout its duration, and in which photography was seen not only as providing realistic images of the struggle, but also as 'news'. In this sense, it also provided one of the foundation stones for the development of photojournalism. Michael L. Carlebach comments that:

Two weekly newspapers that were established in America in the years just preceding the Civil War made photographs and other visual materials equal partners of the printed word in the reporting of news. These new publications would provide the public, or at least the northern public, with accurate and timely illustrations of the war. The pictures they published, many based on photographs, offered vivid, graphic and reliable glimpses into all aspects of the conflict. For the first time, Americans would see through the eyes of a score of photographers, exactly what was going on at the front.

(Carlebach 1992: 63)

But, as Carlebach makes plain, these significant images were not the most numerous of the photographs produced in the war. A boom was experienced by photographic studios trying to deal with the demand for portraits of those who were going into battle. In addition, photographs of the commanders of the Federal army were turned out by the hundred; purchased by people anxious to support the cause and made the subject of a special tax.

The most important photographer of the Civil War was Matthew Brady. Already celebrated for his portraits, 'Brady of Broadway' produced photographs that showed scenes of action, together with shots of the dead on the battlefield, and more tranquil views of soldiers relaxing at their camps. Brady put teams of photographers into the field of battle, including Alexander Gardner, Timothy O'Sullivan and George Barnard, and published this work under his own imprint. Alan Trachtenberg describes his function in the following terms:

collodion This process, known as wet collodion (or Ambrotype), invented by English photographer Frederick Scott Archer in 1851, increased the speed of photography as the glass plate was treated and exposed while stiel 'wet' (i.e. gummy) but it had the drawback of involving bulky equipment. It became one of the major processes until the invention in the 1870s of gelatin-coated plates known as dry plates.

'Brady's pictures' did not mean pictures made by Brady himself but those he displayed or published. . . . Organiser of one of several corps of private photographers, collector of images made by others, a kind of archivist or curator of the entire photographic campaign of the war, Brady played many roles, swarmed with ambiguities, in the war.

(Trachtenberg 1989: 72)

Since Brady's time, no war or violent conflict has lacked its photographic record and interpreters. For example, hundreds of thousands of images of the First World War were made, most of which have been rendered anonymous by the system of classification and archiving that was subsequently employed. Despite the sheer number of photographs of that conflict, there is little work that really gives us a sense of the nature of trench warfare, and the poetry, films and paintings of the time are often more moving and revealing.

Photography was considerably more important as a means of depicting the Spanish Civil War (1936-9). The many illustrated journals of the day carried photographs and these images were influential in shaping people's view of the war. The single most famous photograph was Robert Capa's Death of a Loyalist Soldier which later became the subject of speculation as to its authenticity. Capa was also one of the photographers of the Second World War whose work became very familiar to the public, along with that of Bert Hardy, W. Eugene Smith, Carl Mydans and Life photographer David Douglas Duncan, who went on to produce heroic images of American soldiers in Korea and Vietnam. After the Spanish Civil War, Capa was one of the founders of the photo agency, Magnum, which has enrolled many distinguished photographers over the years.3 Many histories of documentary and photojournalism in the last half century are written essentially around the work of members of the agency. Photo agencies are vital to the work of independent photographers and the archives they establish and support are a most important resource.

The Second World War (1939–45) blurred the distinction between combatant and civilian and, thereafter, war photographers concentrated as much attention on those caught up in conflict as on the soldiers themselves. This is, of course, also true for violent conflict which is not defined as a 'war', as in Cyprus or Northern Ireland.

Jorge Lewinski has commented that:

It is only in the post-war period, starting with the Korean war, that the immediacy of war photographs begins to have a significant effect. Since then, a stream of authentic images has overwhelmed us with cumulative power. The images from Korea, Cyprus, Israel, the Congo, Biafra and Vietnam have left their indelible mark on our imaginations.

(Lewinski 1978: 12)

3 Magnum Photos is one of the world's most prestigious photographic agencies. It was founded in 1947 by four photographers: Robert Capa, Henri Cartier-Bresson, George Rodger and David (Chim) Seymour. Its membership now reflects a range of different styles and practices and includes in its distinguished list: Eve Arnold, David Hurn, Josef Koudelka and Susan Meiselas.

Certainly, it is often said that the stream of images revealing the death, injury and sorrows of the people of Vietnam was a major factor in the public's eventual repugnance for that war. In the sophisticated photographic work of the time the themes of martial conflict and civilian anguish are intertwined. An excellent example is given in the work of Philip Jones Griffiths, who produced one of the most important photographic records of the war (Griffiths 1971).

War has been seen as an important subject for photography for a number of reasons: the photographer might reveal scenes and actions which would not otherwise come to the attention of the public; war inevitably throws up scenes of great emotional force which can best be captured by the camera; it has a dark psychic fascination for us, which coexists with our feelings of revulsion. The person who has most mused on this ambivalence is the English photographer, Don McCullin, who has documented many wars and violent uprisings since the early 1960s (McCullin 2003).

So powerful has been the influence of war reporting, that military authorities make every effort to control journalists and photographers working in scenes of conflict. The unattached freelance reporter has all but disappeared and photographers increasingly find themselves working at a distance from violent action. For some photojournalists, war reporting has, in consequence, taken on new forms that are more akin to meditations on the nature of war than direct reportage. This new kind of retrospective work may be exemplified by the pictures the Irish photographer Paul Seawright took in Afghanistan for the Imperial War Museum, London. These are large, colour works, that have no images of direct conflict, but show the traces of war, the scarred buildings and furrowed earth, together with the characteristic debris of battle. They have none of the busy activity of war photography, but are contemplative works through which we can explore the nature of violent conflict (Plate 3).

THE CONSTRUCTION OF DOCUMENTARY

During the 1930s the paradigmatic form of documentary was produced: one which cast its subjects within a 'social problem' framework, and which argued for a politics of reform, and social education. Describing photographs produced much earlier as 'documentary' was not a simple act of labelling, but meant that we were invited to reconsider this work within the framework of the 1930s documentary project.

Photography in the 1930s was influenced by a number of factors. Technically the development of new, lightweight 35mm cameras made the act of photographing people less obtrusive and increased the range of possible camera angles. There was a growth in the number of illustrated magazines and, within these, an increasingly sophisticated approach to the role of photo editors and the construction of photo-essays. Not least, there was a new and vast public with a hunger to see images drawn from real life. Following

WILLIAM STOTT (1973)

Documentary Expression
and Thirties America,
London: Oxford University Press

Grierson, documentary was regarded as a tool of education that would militate against foolish distractions and anchor people in a rational world of work and social obligation. It would offer, in an exciting form, facts about the social order that everyone would need in order to play a part in modern society. But how would documentary function in order to achieve these objectives? In an influential book on documentary, **William Stott** (1973) writes:

This is how documentary works. . . . It defies comment; it imposes its meaning. It confronts us, the audience, with empirical evidence of such nature as to render dispute impossible and interpretation superfluous. All emphasis is on the evidence; the facts themselves speak . . . since just the fact matters, it can be transmitted in any plausible medium. . . . The heart of documentary is not form or style or medium, but always content.

(Stott 1973: 14)

On this reading the documentary genre is held to be able to transcend the discursive structures of any particular form: imposing rather than creating meaning; disempowering the reader or spectator from any acts of interpretation *vis-à-vis* the text. Documentary, on this definition, becomes a kind of ideologically charged common sense that is inaccessible to critical engagement. It is a fascinating definition because it spells out, 40 years after the time, what lies at the heart of 1930s notions of documentary. There was an assumption that the world was productive of facts and that those facts could be communicated to others in a transparent way, free of the complex codes through which narratives are structured.

Picturing ourselves

In the 1930s a plethora of conventional and novel means of investigation were employed by a variety of people. In addition to formal reports based on statistical investigation, there were varieties of journalistic reportage, travel books, diaries, films, photographs and newsreels. The study of the exotic was now accompanied by an attempt to look at ordinary life through objective eyes.

The best known organisation that set out to make an anthropological survey of British life in the 1930s is *Mass Observation* which was founded early in 1937 by Tom Harrison and Charles Madge. Harrison was an anthropologist newly returned from Borneo, and Madge a poet. What their project has in common with the documentary movement is the sense that the world could no longer be taken for granted and understood; that ordinary day-to-day lives needed to be made strange by being examined with the supposedly 'impartial' eye of the social scientist. *Mass Observation* recruited many respondents

who, through the use of diaries and formal reports, would scrutinise and record their own day-to-day actions and behaviour, together with that of other people. The organisation was particularly interested in examining what happened on buses, in pubs, at the seaside and other areas where collective behaviour in public places could be observed.

Mass Observation used respondents, editors, painters and photographers in its attempt to build up an accurate picture of everyday life. Photographers adopted a range of techniques in order to capture their subjects; while some sought cooperation, most were concerned not to be observed and to work without the knowledge of the photographed. One characteristic response of photographers to the political and moral debates of the time was to see themselves as part of the camera, merely recording what was in front of them. Bert Hardy, who worked his way up from being a delivery boy to becoming a major photographer on Picture Post, described his practice in Camerawork:

I didn't think of it politically. I was never a political animal. I mean the journalists had that sort of job to do. I think I just photographed what I saw. I never angled anything.

(Hardy 1977: 9)

However, Humphrey Spender (in a later issue of the same journal) comments on the work he did in Bolton for *Mass Observation* and makes clear his desire to work voyeuristically:

My main anxiety, purpose, was to become invisible and to make my equipment invisible, which is one of the reasons I carried around an absolute minimum of equipment. . . . Summing up the relics of feelings toward *Mass Observation* I think I can remember the main enemy being boredom and tedium and embarrassment.

(Spender 1978: 7)

Working for a number of magazines and newspapers as well as for *Mass Observation*, Humphrey Spender made many of the pictures of working-class life which were later thought to be exemplary images of the time. In one account of this work he described his procedure as allowing 'things to speak for themselves and not to impose any kind of theory'. The difficulty of his journey was that:

I had to be an invisible spy – an impossibility which I didn't particularly enjoy trying to achieve . . . I was somebody from another planet intruding on another way of life. . . . A constant feature of taking the kind of photograph we're talking about even when people were unaware

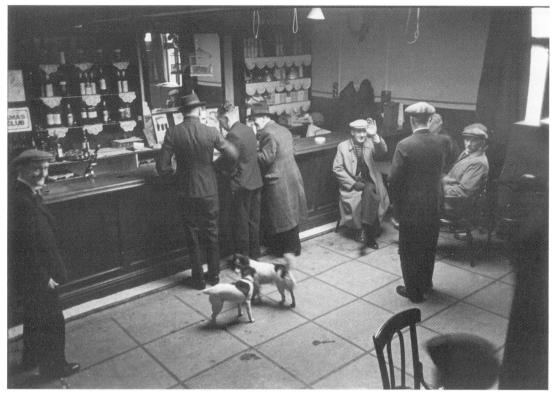

2.6 Humphrey Spender, *Men Greeting in a Pub*, **Worktown Series, 1937**This carefully composed, gentle and humorous photograph reveals the influence of both realist photography and Surrealism on Spender's work

that they were actually being photographed – was a feeling that I was exploiting the people I was photographing, even when . . . the aim explicitly was to help them.

(Spender 1978: 16)

Spender's description of himself as an alien and a spy is a dramatic way of emphasising social distance, and in his account of his own feelings he points up the fact that 'our way of life' might also be seen as distinct and separate 'ways of life'. The notion of the workers as productive of useful facts gives way to a consideration of the subjects of representation as potentially exploited by the encounter. Spender worked for *Mass Observation*, but his photographs also appeared in the *Daily Mirror* and in *Picture Post*, and by the 1930s the market for actuality photographs had grown to very large proportions. While the styles and approaches of photographers differed one from another, it is also possible to see continuities and influences from the past as well as gender

differences in the way in which documentary photographers carried out their work. Val Williams has argued that women photographers did not adopt

candid photography as exemplified in the discreet, detached observation of photographers like Frank Meadow Sutcliffe and Paul Martin. Both Sutcliffe and Martin had pictured the world as full of vitality, as a kaleidoscopic spectacle of trades and crafts and distinguishing costume. . . . The style which they evolved affected the production of British documentary photography enormously, and reverberated through to *Picture Post* and beyond. For many of those who later took up photography – the stance became obligatory, particularly for war photographers working from the late thirties onwards. It indicated not only a kind of political detachment, allowing photographers to see themselves as reporters rather than participants, but also a particular machismo.

(Williams 1986: 25)

Williams describes women photographers as using the medium for 'diverse and often very personal reasons' while 'women documentarists usually set out to record rather than to captivate and the avoidance of the dramatic and the candid was a primary influence upon each of them' (Williams 1986: 26).

Together with these gender differences in the approach to photography, we might also consider uses of the medium that were influenced by considerations of social class. We have seen that the documentary movement was part of a reformist political project and we should remember that, politically, it was concerned with the promulgation of liberal social values rather than with the revolutionary politics to which so many people in the 1930s subscribed. Closely associated with this is the charge that the political project implicit in much documentary work was unlikely to succeed given that documentary can, at best, show suffering, degradation, despair, but can do nothing to illuminate the causes of these woes. Power and causality are difficult to express through photographic images, as are collective struggle and resistance. Martha Rosler has critiqued this political stance in the following terms:

In contrast to the pure sensationalism of much of the journalistic attention to working-class, immigrant and slum life, the meliorism of Riis, Lewis Hine, and others involved in social work propagandizing argued, through the presentation of images combined with other forms of discourse, for the rectification of wrongs. It did not perceive those wrongs as fundamental to the social system that tolerated them – the assumption that they were tolerated rather than *bred* marks a basic fallacy of social work.

(Rosler 1989: 304)

Of course, many people in the 1930s did see poverty and dispossession as consequences of the prevailing social system and this belief gave rise to a vibrant left oppositional practice of radical theatre, film and photography. Workers' film and photo leagues were established in both Britain and the USA and opened up the medium of photography so that workers could make their own records of their lives and struggles. This was an important principle, but there is little evidence that the results challenged the nature of documentary reportage or established new kinds of image making. Perhaps more interesting were those groups who maintained that questions of representation were a central part of political struggle, and developed an alternative photographic practice to exemplify those ideas. Their intention was not to reveal how things looked in the 'real world', but to disrupt the surface appearance of the image in order to construct new meanings out of the old pictorial elements. The painter, sculptor and photographer, Alexander Rodchenko in the USSR, and the German Dadaists at the end of the First World War, elaborated this practice. Working against the central tenets of documentary, these artists argued that, in order to arrive at the meaning that lies below the surface of a photograph, it was necessary to contrive and manipulate the image. John Heartfield's incisive, politically charged photomontages, which developed from his work with the Berlin Dadaists, are the best-known constructions of this kind.

The Farm Security Administration (FSA)

The function of documentary in the service of radical politics was affected not only by the beliefs of individual photographers, but also by the uses for which pictures were commissioned; the professional practices through which they were produced, and the source of the finance that made them possible. In this respect the Farm Security Administration project is of considerable interest.

This was a government agency established in 1935 as part of the Roosevelt administration's attempt to rebuild the economy of the United States. A young social scientist, Roy Stryker, was appointed to head the photography section of the FSA. His main responsibility was to provide contemporary images to illustrate and support the written accounts of conditions in agriculture that were published in official reports.

The enterprise became the most important example of a major state-funded documentary project in the world and many of its participants have entered into the pantheon of 'great photographers': Walker Evans, Dorothea Lange, Russell Lee, Arthur Rothstein, Ben Shahn, Marion Post Walcott. We saw in chapter 1 how Dorothea Lange's *Migrant Mother* became an iconic work, but many other photographs from the project have been reproduced extensively on book jackets, as illustrations, on gallery walls, even in advertisements. They are often described in histories of photography as having revealed the human face of Depression Day America.

Their initial task, however, was to show America at work and to provide images of workers rather than the displaced poor. Once on the road, though, the photographers were free from the constraints of Washington and often returned very different kinds of photographs to those that were expected. Some critics claim that their genius as visual artists allowed them to go beyond the mundane business of recording labour to penetrate to the secret heart of things. In fact, among the many thousands of negatives of the project there are very many which concern themselves with human toil.

But the huge archive has been used as a resource from which some photographs have been selected more often than others, so that our social and political sense of the project is constructed from the editing that has taken place over the years. In some ways this body of work does present us with an apparently coherent critique of American life. The most famous photographs are those of the sharecroppers of the southwest and their migration west out of the 'dustbowl' to the orange groves and fruit farms of California in search of work as itinerant labourers. This is a familiar story and was the subject of one of the most celebrated 'social' novels and movies of the time, John Steinbeck's *The Grapes of Wrath*.

Through the interest shown in them by photographers, writers and painters, these people were to become emblematic of the US Depression. What we remember about them is that the winds eroded their fields, destroying their livelihood, and that they were forced, though desperately poor, to travel long distances to try to find work in the low-wage fruit and cotton fields. The FSA photographs are almost always of individuals and families, and often show them as weary and defenceless. They evoke images of strain, of mental fatigue, but they also tease out the bonds of affection and connection between people, especially between mothers and children. And, of course, they show people on the road, moving out; their possessions packed away, their furniture roped to the tops of cars or heaped on to a rickety truck. In these images the solid elements of domestic life are often dissolved and relocated in strange, outdoor spaces. Objects do service as carriers of emotion; objects that are stranded, dislocated, treasured though cheap. For instance, Russell Lee shows us a harmonium upright, ready to be played, out in a field, all by itself, surrounded by mud. Walker Evans records a roughly piled grave of loose earth topped with the impermanent and unstable memorial of a dinner plate. Nothing appears to be anchored or solid, instead dust is everywhere; a friable earth is heaped against the walls of houses, has shawled over the gas pumps and the Coca-Cola signs, and is etched into the lines of faces and hands.

These documentary photographs, like all others, are densely constructed works which use certain techniques and forms to produce a desired response in the spectator. They do contain 'facts' in a simple sense: a woman wears a dress made from a flour sack, a family lives under a hastily constructed tent of twigs and tarpaulin. There is, in other words, plenty of evidence of poverty indicated by the traditional markers of lack of material prosperity. But, in

their more complex versions, they are photographs of the (literally) dispossessed, carefully constructed to produce a meaning that transcends what is shown.

These people were not chosen merely for their 'representative' qualities: they are not simple icons of dispossession. Although they are anonymous subjects of the camera, their singularity is often stressed and their individual gestures carefully recorded. This is emphasised by the closeness of the camera and the informal stances people are allowed to take up in front of it. We feel that we are not in the presence of representatives of a class, but of ordinary people, much like us, who have fallen on hard times and are doing the best they can in the circumstances. Poverty and misery thus cease to be possessions of particular social groups living at a particular time in determinate conditions, and become a kind of dislocation or breakdown into which any one of us might stumble. In other words, we are asked to accept that we can make immediate connections between this body of work and our own life and condition; but also that these are photographs which sum up the specific experience of the migrant workers in the USA. We are invited to accept that

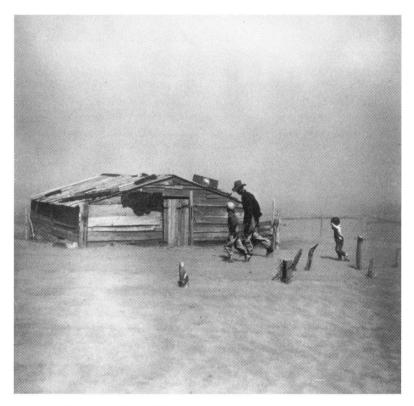

2.7 Arthur Rothstein, *Dust Storm*, 1936
One of the original FSA photographers, Rothstein contributed many striking images to the archive

these are 'honest' images drawn from life, but are also the product of extraordinarily gifted photographers. Some of the central contradictions of the social project of documentary photography are revealed here, for these photographs are treated as historical, but timeless; densely coded, but transparent; highly specific, but universal. And these various readings militated against the idea that the photographs should have been immediately accessible as evidence against the social and political system

DISCUSSION: DRUM

The illustrated magazine *Drum* was founded in South Africa in 1951 at the beginning of a decade that was to see an extension of the powers of the apartheid state. At the same time, the African National Congress launched its *Defence Campaign* and the anti-racist *Freedom Charter* was produced. This political ferment was encouraged by the growth of a sophisticated, urban black population that formed the core of *Drum's* readership.

Despite its justly deserved reputation for investigative journalism, *Drum* was not an overtly political magazine. Rather it embraced popular culture and was a heady mix of sport, jazz, fiction, gangsters and glamour. It also ran a famous Lonely Hearts column and, of course, told stories in pictures as well as words. Soon after it grew out of a short lived magazine, *African Drum*, it was selling close to 200,000 copies a month and it was to spread, through the energy and ambition of its most important founder, Jim Bailey, the son of a mining millionaire, to many other African countries including, Nigeria, Ghana, Sierra Leone, Kenya, Uganda, Tanzania, Zambia and Zimbabwe. Produced and circulated with great difficulty, it was often banned, but is now remembered as one of the most influential of illustrated magazines.

It was important because of the writers it found and encouraged, several of whom have become well known journalists, novelists and critics. Included among them are Henry Nxumbolo, Lewis Nkosi, Bloke Modisane, Can Themba, Arthur Maimaine, Todd Matshikiza. Influential, too, because of its ability to train and nurture excellent photographers: people such as Bob Gosani, Peter Magubane, and the German photographer, Jürgen Schadeberg who was for many years the senior figure in the group. Also working for the magazine were Ernest Cole, whose photographic book *House of Bondage* became essential reading for anyone interested in life in South Africa, and the white photographer Ian Berry who later joined *Magnum* and whose photographs for *Drum* of the Sharpeville massacre (21 March 1960) circulated around the world.

This extraordinary array of talented individuals was led in the first years by an English editor, Anthony Sampson, who had no experience of magazine editing, but was a friend of Jim Bailey's from their time together at Oxford. Sampson established the characteristic content of the magazine, its relaxed way

DRUM, MARCH, 1952

ALL NAMES MENTIONED IN THIS ARTICLE ARE NECESSARILY FICTITIOUS, BUT MR. DRUM KNOWS, AND CAN PROVIDE, THE ACTUAL NAME AND ADDRESS IN EACH INSTANCE.

CAGED AFRICANS being taken to a farm from the Johannesburg Fort. Farmers drive into Johannesburg in lorries to collect convicts to serve their sentences on farms. This picture was taken by the photographer of a Johannesburg daily paper, while the farmer was away on business in the city. The convict labour system accounts for a good deal of labour in the Bethal Area.

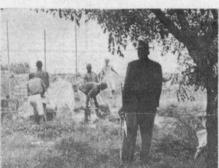

PRISONERS FROM BETHAL PRISON at work on building. In the foreground is the boss-boy, and the man with the cap is a prison supervisor running towards Mr. Drum to prevent the picture-being taken. Officials describe the farm prison system as the "ideal rehabilitation scheme," but when farmers can use prison labour, there is obviously less incentive to attract voluntary labour by hatter conditions and nave and previously less incentive to attract voluntary labour by better conditions and pay.

THE STORY OF BETH

USUALLY in South Africa a farm labourer's life, poor and simple though it is, has the same pleasant easy-going nature as is found in the countryside throughout much of the rest of the world. His is a skilled job and he has much of the natural independence of the skilled worker. If he grew up on the farm, he quite possibly became the playmate of the farmer's son and a happy association might well start that way which will last for the rest of their lives. On top of that, the rapid industrialisation of South Africa, by drawing off labour from the countryside with the offer of higher wages and a more gaudy life in the towns, puts increasing pressure on the farmer to imlife in the towns, puts increasing pressure on the farmer to im-prove working conditions if he wishes to keep his labour. BUT BETHAL IS DIFFERENT.

EVIL RECORD

FOR MANY TEARS BETHAL together for the night; and only a HASS BEEN N970RIOUS for the Bi-treatment of the African 13.847), a farm foreman was found as April 12, 1929, there was a case (Rex v. Nafte, at the Circuit Court at Helial) of a farmer who was a lease of the Helial) of a farmer who was located the Helial) of a farmer who was located to death, posuring scalding water into his mouth when he cried for 18.747; another foreman was found water. In January, 1944 (Rex v. Mariera) the Mahlangu), a labourer by similar case appeared in Withauk and the Mahlangu), a labourer strength of the Mahlangu, and the Mahlangu, an

WE publish this impor-tant and revealing story or and revealing story or and revealing to provide the story of the our readers, and add-ships and dangers they may suffer as a result of signing a contract they do not fully understand. It is our intention to assist the authorities by making clear to would-be recruits

the workings of the contract system, and by pre-centing the tree fact of the cose. We are all to ware of the domage to ware of the domage to good relations between the races that the condi-tions at Bethal have brought about, and we wish to do all we can to prevent such happenings in the future.

SYSTEM 'A GREAT SCANDAL'

uses and by private investigations, some action has been taken to preent similar cases, and the Government, particularly the Department sent, particularly the Department I I Native Labour, has shown itself extons to resouve the injustices and bases of the contract system. It seems clear, however, that it is in-sessible to prevent abuses of the implement of contract labour with employ model of contract labour with the accompanying composition of system, and this has been emphasized by many althorities. In 1944 Mr. AUNTICE MARITZ in Rex. v. Isaac Stetship pointed out-that the com-pound labour system was "some-cially guite new in agricultural economy," and combinined the whole system as responsible for eneally guid injustice. In October, 1944 the DIOCESAN SYNOD OF THE

SINCE the publishy given to ANGLICAN CHURCH issued a Bethal by these and other court measurements stating that "it must be clear that the extension of the mass and by private investigations, nine community system to fine

The following is a typical account of the workings of the contract system, as told by a relative of Mr. DRUM's who was sent to Bethal early in 1949:

Continued on page 7

2.8 Drum, March 1952

Drum, Africa's most famous illustrated magazine, offered a unique blend of investigative journalism, sport, and crime to a new, urban readership

of working and its central concerns. His book *Drum*, published in 1956 and updated in the 1980s, gives a fascinating account of the early years of the magazine (Sampson: 1983). Sampson was succeeded as editor first by Sylvester Stein then by Tom Hopkinson who had developed and inspired the famous British illustrated magazine, *Picture Post*. Hopkinson has also given an account of his years with the magazine as it developed in a number of African countries (Hopkinson, 1962).

Although *Drum* found a ready readership for its social and entertainment content it is as a crusading magazine that its early years will be remembered. It is not too extravagant to claim that a single story established *Drum* on its first anniversary. The story was an exposé of the brutal conditions of life and work suffered by black people arrested for failing to carry a pass and sentenced to work on a white owned potato farm. In the persona of Mr. Drum, Henry Nxamalo infiltrated the farm together with the writer Arthur Maimane and photographer Jürgen Schadeberg. The success of the piece meant that exposés became the order of the day and over the years Mr. Drum went, with great success, on trips to many sites of oppression and injustice.

Despite this investigative work, *Drum* could only exist because it did not directly challenge the government of the day, or overtly proselytise for any political party. This lack of direct political struggle was criticised by some people on the left in Africa. Graeme Addison sums up the position in the following terms:

The Magazine remains a problem for the critic because it sprang from a matrix of white entrepreneurship, editorial opportunism, and non-militant black talents, none of whom had a prime interest in the liberation of the masses. *Drum* did not aim to mobilise these masses, but it did educate and inform them, perhaps better than any other medium.

(Addison: 1978)

We might add that *Drum* was witty, caustic, brash and knowing. It provided its early readers with an irreplaceable mix of ideas, fashions, insights and information that was conveyed through a mix of pictures and text. The magazine continued with varied journalistic success through the 1960s and 1970s until in 1984, to everyone's surprise, Jim Bailey sold it to the pro-government Afrikaaner group, Nasionale Pers. It became a weekly in 1996 and now describes itself, with its mix of fashion, advertising and leisure interest features as 'a vibrant magazine for the young, upwardly socially mobile South African'.

DOCUMENTARY: NEW CULTURES, NEW SPACES

The archetypal documentary project was concerned to draw the attention of an audience to particular subjects, often with a view to changing the existing social or political situation. To achieve this goal, documentary photographs were rarely seen as single, independent images. They were usually accompanied by or incorporated into written texts. Within this context the images functioned both to provide information about the nature of things and to confirm the authenticity of a written account. Individual photographers were rarely credited for their work in magazines, and photographs were treated as though they were anonymous productions. The postwar consumer boom, exemplified in the introduction of television and the growth of car ownership, produced a very different society to that of the 1930s. In commenting on this new social scene some photographers produced work that was to transform the nature of documentary photography. Especially in the USA, documentary began to be concerned with new kinds of cultural spaces, in particular those that were encountered in everyday life, rather than places that were exemplary of grinding poverty or social injustice.

In his collection *The Americans*, Robert Frank offered his own version of American life in which he eschewed the usual subjects of documentary investigation and presented us instead with cool and ironic images of the fleeting moments of ordinary life. Significantly enough, the introduction to the book was written by the Beat writer, Jack Kerouac, who said: 'After seeing these pictures you end up finally not knowing any more whether a juke box is sadder than a coffin' (Frank 1959: 5).

Born in Switzerland, Robert Frank brought an outsider's eye to bear on the USA of the 1950s. He went on the road with a camera, an old car and a Guggenheim scholarship and photographed not only juke-boxes and coffins, but cowboys, long empty roads, tract houses on lonely fields, flags and bikers, drive-in movies and barbers' chairs. Frank caught America at the point where commonplace life was about to be turned into myth; where even the banal and the prosaic were soon to be commodified into spectacle. People in these photographs are not constituted as 'poor' or 'workers' or, indeed, as any particular kind of social being. They exist as spectators, gazing out at some invisible scene: other people, the road ahead, a movie screen, a parade going by. In these closed, watchful faces we can read no significant facts, and if we have a sense of 'being there', it is as a witness to nothing of any great importance. Frank refused a documentary project that saw life as productive of weighty events that the photographer might chronicle and analyse. He seems to be saying that none of the many scenes that happen in the world are invested with any special meaning, although some may be made distinctive by the very act of being photographed. It is important to notice that coffins are no sadder than juke boxes precisely because an old hierarchy of importance has been abolished; hereafter the subject matter of documentary is both dispersed and expanded to include whatever engages or fascinates the photographer. Facts now matter less than appearances. The old documentary project is fractured into work that explores the world in terms of particular subjectivities, identities and pleasures.

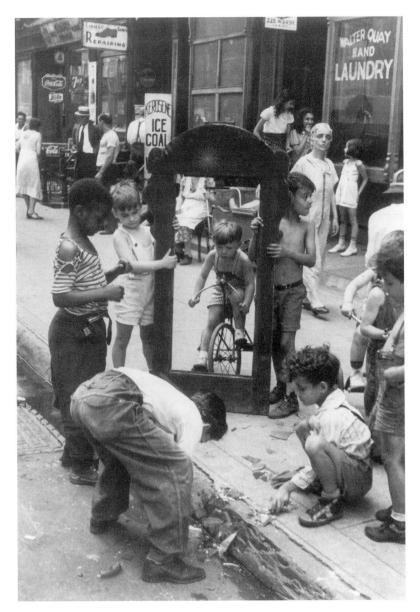

2.9 Helen Levitt, *New York*, c. 1940
Levitt photographed New York as a place of community and neighbourhood as in this wartime shot of children playing cheerfully in a lively street

2.10 Lee Friedlander, *1 Lafayette*, *Louisiana*, 1970
In the 1970s, Friedlander was one of the major 'new' documentarists. His images are intricate, ambiguous, sometimes difficult to read, and tell us something about the complexity of modern life

Frank was not alone in offering new, less monumental images of America in the 1950s. Around the same time William Klein was photographing New York in a manner that stressed the disorder and randomness of life in great cities. Halla Beloff comments on them in the following terms:

It is the truth value of American street photographs . . . that gives them their special artistic and psychological interest. Their style and their subject matter in a state of consonance, they randomly sample their subject matter. They show fragments, *randomly* set out, *arbitrarily* cut off, with *bizarre* juxtapositions, and these epithets invite us to move from the photographs to the culture and people in them.

(Beloff 1985: 99)

In Klein's crowded streets the point of photographic interest may lie in a half-concealed detail somewhere in the background of a shot. His city is restless, crowded, neurotic and alienating, and was to become one dominant version of how cities were perceived and represented by later commentators. A

different version of urban life was created by some French or British photographers; for example, Roger Mayne's photographs of street life in West London provided a portrait of the lives of people in a particular place that was relaxed, incisive, intimate and very different from earlier British documentary work (Mayne 1986).

Documentary was changing and apparently presenting new subject matter or old themes treated in new ways. Often called 'subjective' documentary, this work was very influential in both the USA and Britain. It liberated documentary from the political project with which it had formerly been associated, and allowed photographers to move away from both the traditional subjects of documentary and the conventions of documentary representation. Now, Lee Friedlander could make a series of photographs full of visual ambiguity and allow his own silhouette to fall across his subjects to celebrate his shadowy presence on the scene. Gradually, there was an extension of the subjects that were deemed suitable for documentary. For example, Tony Ray-Jones' A Day Off: An English Journal (1974) attempted to cover a spectrum of social class in looking at the English at play, from Glyndebourne and Eton to Butlins and Brighton's Palace Pier. In the 1930s, perhaps the most famous photographer of British life, Bill Brandt, had compared photographs of rich and poor; for example, putting maids and mistresses into a double-page spread so that we could observe difference and privilege. By the 1960s, however, photographers were concerned to offer more personal versions of the nature of social existence.

Theory and the critique of documentary

From the 1970s, a stream of critical work began to reject the notion that acts of looking and recording can ever be neutral, disinterested or innocent, and described them instead as containing and expressing relations of power and control. Perhaps the single most important influence on British documentary after 1970 came from the new ways in which photography was theorised and the functions it was considered to be able to play in cultural politics. Semiological analysis treated films and photographs as texts in order to investigate the components of sign systems through which meaning is structured and encoded within a work. The point of concern was not whether the work adequately revealed or reflected a pre-existing reality, but the way particular signifying systems imposed order and created particular sets of meaning. Inscribed within the photograph, then, was not some little likeness to reality, but a complex set of technical and cultural forms that needed to be decoded. Far from being innocent transcriptions of the real, photographs were treated as complex material objects with the ability to create, articulate and sustain meaning. Using theoretical tools that often derived from Film Studies or Literary Studies, critics began to explore the way in which photography functioned as a signifying system. One of the characteristics of photography is, as we have seen, the fact that it appears to have a special

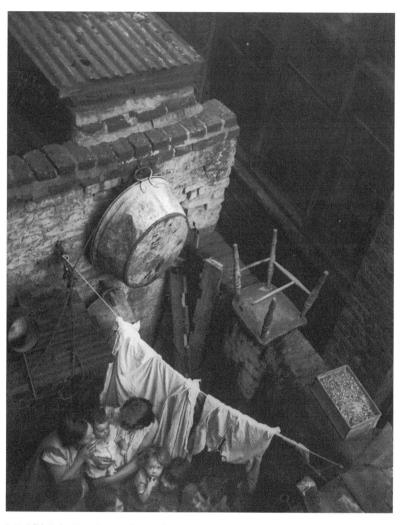

4 In the 1970s, magazines such as Camerawork and Ten.8 re-appraised the documentary movement and displayed the work of photographers such as Edith Tudor Hart who had been half forgotten.

2.11 Edith Tudor Hart, *Poverty in London, c.* **1930**Austrian-born Edith Tudor Hart photographed workers in London, Tyneside and South Wales in the 1930s. She worked with a reforming zeal and a sympathetic attention to the plight of the poor ⁴

relationship to reality. We speak of *taking* photographs rather than *making* them, because the marks of their **construction** are not immediately visible; they have the appearance of having come about as traces from the scene itself, rather than as carefully fabricated cultural objects. As spectators we are positioned as the eye of the camera and we gaze upon an apparently natural and unmediated scene. Our acts of looking were no longer considered to be disinterestedly innocent, but were analysed in order to distinguish the kinds of psychic pleasure and relations of power that are invested in the process. The

concept of power which is being used in this analysis owes much to the work of the French philosopher, **Michel Foucault**. (See also note p. 58.)

Power is not seen by Foucault as a force held by a particular social group that enables it to coerce another, but is located within all parts of the social system. Power resides in all aspects of a knowledge system including the construction of archives, the codification of information and the communication chains through which it is disseminated. Nor is 'truth' a special kind of knowledge that allows us to escape the pervasive reach of power: truth and power are also intertwined. Each society has constructed its own 'regime of truth', elaborating frameworks, institutions and discourses which validate particular procedures and permit us to distinguish true from false statements.

Power, on this account, flows through the processes of science; through discourses, and the apparently trivial encounters of everyday life. Nor is power an abstract force that is only occasionally employed in order to enforce obedience, but, within a disciplinary society, it is inscribed on the body through the processes whereby the body is objectified as a source of knowledge. Photography's obsessive concern to record, catalogue, explore, reveal, compare and measure the human body was one way in which it could be seen to be an important form within the disciplinary process (see ch. 4, pp. 164–8).

In his collection of essays The Burden of Representation (1988), John Tagg analyses the vast increase in the power of photography in the latter half of the nineteenth century and traces the 'complicity' of photography in the articulation of particular kinds of surveillance and observation. Documentary is seen as part of the process of examination described by Foucault as 'a procedure of objectification and subjection', in which ordinary lives are turned into accounts - into writing or, for that matter, into photographs. Such an analysis of the function of documentary clearly cast considerable doubts on the reformist social and political project with which it had been identified for so long. Its overt or implicit use as a means of surveillance and control was now being stressed, rather than its ability to reveal the nature of suffering or destitution in the service of social reform. Photography is seen as being complicit in the discourses which function to exert social control. 'Documentation' cannot act to reveal inequalities in social life, for there can be no document that is merely a transcription of reality. Rather, as part of a discursive system, it constructs the reality that it purports to reveal. But this is not a random creation, for it is made within the ideological positions framed by the discourses which are themselves part of the system of power. Cultural critic Julian Stallabrass has commented on Tagg's analysis in the following terms:

Tagg presents 'documentary' – which includes documentary photography – as 'a liberal, corporatist plan to negotiate economic, political and cultural crises through a linked programme of structural reforms, relief measures, and a cultural intervention aimed at

JOHN TAGG (1988) The Burden of Representation: Essays on Photographies and Histories, London: Macmillan. restructuring the order of discourse, appropriating dissent, and rescuing the threatened bonds of social consent'. In this retrospective view which entirely discounts the beliefs of those individuals involved – including some who were committed to overthrowing capitalism – the complex and diverse currents of documentary photography serve the conspiracy by which the system survives.

(Stallabrass 1997: 136)

Cultural politics and everyday life

Documentary was grounded in the recording and delineation of commonplace life, but the idea of 'ordinary, everyday life' was itself now understood to be a problematic concept. Rather than being seen simply as a method of recording, photography begins to be regarded as a means through which we can express and articulate our own particularity and difference. We can move, as Don Slater has put it, from being consumers of images to becoming active producers:

The camera as an *active* mass tool of representation is a vehicle for documenting one's conditions (of living, working and sociality; for creating alternative representations of oneself and one's sex, class, agegroup, race, etc; of gaining power of analysis and visual literacy) over one's image; of presenting arguments and demands; of stimulating action; of experiencing visual pleasure as a producer, not consumer of images; of relating to, by objectifying, one's personal and political environment.

(Slater 1983: 246)

If we can actively work on 'representations of ourselves', it seems that documentary, with its historic weight of practice and ostensible claim to transparency, might not be the perfect photographic form by which this could be achieved. Documentary began to be deserted in favour of contrivance and artifice. Work of this kind came from community groups and feminist collectives, and was to be found in certain kinds of gallery practice. For example, the East London community group, Hackney Flashers, used their photographic project to politicise activities and concepts such as motherhood, housework and child-care. They used a variety of montage techniques, together with text and slogans, to overcome the perceived limitations of documentary photography, a limitation that was outlined by Angela Kelly when making her 1979 selection of feminist photographs:

The 'analytical' approach sees conventional documentary as problematic in the sense that the medium itself is a complex signifying process. Photographic images are presented as constructs and the viewer is forced to read the system of signs and to become aware of being actively involved in the process of the creation of meaning. This approach stands

in opposition to the notion of the photograph as a transparent 'window on the world'.

(Kelly 1979: 42)

Kelly makes it clear that she does not endorse the documentary project, which she considers to confirm, at least implicitly, photography's claim to be 'true to appearances'. Similarly, more than a decade later, Tessa Boffin and Jean Fraser introduced their book of lesbian photography with an explanation that, since sexuality is socially constructed, documentary realism might be an inappropriate form for its representation:

Lesbianism exists in a complex relation to many other identities; concerns with sexuality intersect with those of race, class and the body ... we looked for work which concentrated on constructed, staged or self-consciously manipulated imagery which might mirror the socially constructed nature of sexuality. We have not included much documentary work as the realism of documentary has often been used ideologically to reinforce notions of naturalness. We do not want this book to claim a natural status for lesbianism but rather to celebrate that there is no natural sexuality at all.

(Boffin and Fraser 1991: 10)

Photography has been used in projects of this kind in order to explore subjectivity, but, while working-class life has been surveyed through documentary, it seems that gender, race and sexuality have been analysed in terms of other kinds of photographic discourses and practices – those which stress a Brechtian concern with construction and fabrication in photography. Called into question was the ability of realist practices adequately to unmask the nature of the prevailing social conditions or to explore the social and political nature of our subjective lives. John Roberts has suggested that the movement away from documentary is associated with the 'downgrading of class within cultural politics' and a retreat from class politics itself. Rather than simply endorse the documentary movement, however, he argues:

There can be no representation of class subjectivities without the photographer intervening *in* the process of the production of meaning. Whether you are studio-based or working with conventional documentary images then, work on the representation of class cannot proceed without a recognition of those symbolic processes that shape and determine the construction of class identity.

(Roberts 1993: 13)

Of course, there were documentary photographers who were still concerned to represent the nature of work and the lives of working people in a style that owes a great deal to classic forms of documentary photography. For example, in very different ways, the work of UK photographers Chris Killip, Nick Hedges and the Exit Photography Group (Nicholas Battye, Chris Steele-Perkins and Paul Trevor) were all recognisably in the tradition of documentary, although they were more concerned with exploring class subjectivity than with aspiring to discover the 'facts' of working-class life.

Not only were themes changing, but the very technical and aesthetic basis on which documentary photography was founded was being challenged. In the 1960s colour photography was largely confined to advertising and the publicity industry until the American William Eggleston started to use it in his work. With the support of John Szarkowski he mounted a now famous exhibition at the Museum of Modern Art in New York. The colour photographs had been made using the dye-transfer process, which gave them intense colour saturation, and became the subject of great debate as to their validity and artistic merit. His subjects were mundane, everyday, often trivial, so that the real subject was often seen to be colour itself. Thomas Weski describes it in the following way:

Eggleston's particular interpretation of pictorial colour is largely responsible for the fact that his photographs often induce the feeling that we have never before consciously seen the situations and objects depicted, or that we are discovering a side of them that has hitherto been hidden from us. This was the first time that colour had been used in art-photography not simply to replicate reality but to express and induce feelings.

(Weski 2003: 25)

Important as Eggleston is in making colour an acceptable part of art and documentary photography, he was not, of course, alone in employing it. Paul Outerbridge, Stephen Shore, John Divola and Alex Harris all worked in different ways with colour. This American led innovation spread to Britain where, in very different ways, a number of photographers moved from monochrome work to the expressive use of colour photography. Writing in *Creative Camera*, Susan Butler saw the use of colour by British photographers as a way of making visible aspects of life that had been largely ignored in the struggle to reveal class positions and social problems:

But one can shift the perspective yet again to make the case that in the area of new colour work in Britain, many 'straight' photographers are expanding documentary concerns to include a broader range of social and, in effect, anthropological readings as opposed to a more overtly political but rather confined range of social issues based mostly in class and work, although these concerns as well have begun to figure in colour work, and are being revitalised by it.

(Butler 1985: 122)

Indeed, many British-based photographers were being influenced by the demands and possibilities of colour at the time. They include Paul Graham, Anita Corbin, Jem Southam, Martin Parr, John Podpadec and Peter Fraser, and many others who clearly did not share a common practice or approach to photography in other respects. An example of Martin Parr's work from his collection of photographs of New Brighton is reproduced in this book. (Plate 2) (Parr 1986). It is important to realise that the use of black and white film and, in the case of documentary, a particular kind of subject matter, were considered to be the necessary markers of a serious photographer. Colour not only belonged to the world of commerce, but was regarded as lacking the technical control and aesthetic order of black and white photography. The effect of colour was to push new subjects (drawn from the whole range of everyday life) and new expressive approaches to those subjects from many photographers. Black and white may not have died in 1985, but its time as a hegemonic technology and practice was coming to an end.

Documentary and photojournalism in the global age

All over the world people continue to make documentary photographs, which are shown in journals, books and newspapers, but the practice has become largely dislocated from its former social and political project. Moreover, much documentary work is now to be seen on gallery walls and the archetypal small, monochrome print has frequently given way to large colour images. Even that most rigorous practitioner, Sebastião Salgado exhibits his photographs in gallery settings before reproducing them as books, while photographers increasingly seek out new kinds of commercial and cultural spaces in which to show photographs. The conditions of reception, then, have changed dramatically and the gallery has become an important space not only for documentary, but also for photojournalism. It may seem strange that works created to comment on current events are shown, divorced from any serious text, in the contemplative space of the gallery. Certainly, this has been partly a response to the decline in outlets for print based photojournalists, but it is also a consequence of a change in intention on the part of photographers in response to the pressures of the structure of contemporary communications. The globalisation of news and the demand for information around the clock has changed the organisational structure of magazines and newspapers and brought about a new division of labour. For example, it has been noted that the growth of digital photography means that photographers tend to select images and edit in camera. Not only are potential archives (formerly built around retaining negatives) lost, but fewer photographers are employed on the staff, and the availability of digital cameras has made it possible for print journalists to send images directly to the picture desk. (Burgess: 2001) David Bate has pointed out that manipulation of press images by the computer has transferred power away from the photographer and to the picture editor who,

increasingly, controls the nature of what is seen (Bate: 2001). In response to this apparent lack of either immediate relevancy or control of their own work, some photographers have chosen to adopt (at least in some respects) the condition of the artist; to organise their images in a gallery setting, and to sell them in the growing commercial market for photographs. Inevitably, this has led to an abandonment of the well worn tropes of photojournalism in favour of work that is allusive rather than direct and that cannot be seen and understood in an instant.

This blending of genres is leading to new kinds of extremely interesting work, but we ought to remember that there are still many photojournalists working in a more traditional way and contributing to newspapers and magazines around the world, and that long established debates on the ethics, efficacy, political bias, or objectivity of realist photography are still vigorously conducted.

The development of a consumer culture displaced photography from its more traditional functions and sent out images in vast numbers to sell goods. In the 1980s and 1990s, postmodernists questioned the nature of 'originals' and 'copies', and regarded images as transmutable objects that are involved in endless, complex acts of circulation and exchange. Such objects have no necessary context, so that documentary photographs of the 1930s unemployed might be massively enlarged and used as part of the decor of restaurants; images of the dispossessed could be used to sell jeans, while the homeless of earlier generations might find themselves presented as picturesque urban characters on gallery walls. The growth of the heritage industry has led to a great demand for pictures that show us something of the world as it was. Indeed, in many of the new sites that celebrate older forms of life and labour, it is the 'original' black and white photographs that act as guarantors of authenticity. These multiple uses of documentary photography, and the lack of demarcating boundaries between them, were explored by theorists of postmodernity. Postmodernist movements existed at many levels, from serious philosophical reflection to particular kinds of surface style and fashions. Linking them all was a concern with the nature of images and their circulation; an elision between high and popular culture; a scepticism about the nature of 'the real' or 'the authentic' (for the 'simulacrum' was held to have taken over from the original); and a suggestion that the discourses which once bounded and structured knowledge (such as history or science) had broken down.

Under these conditions, what future might there be for documentary; is it a practice that has run out of history? In this context it is useful to look at the output of practising photographers whose work is of a kind that would formerly have been labelled 'documentary'. A good example is the 1990s exhibition and book by Martin Parr, *Small World*, which has a commentary by Simon Winchester (Parr 1995). Parr returns us to the world of travel photography, for his images were taken in several places around the world.

Like any good Victorian photographer, he visits Egypt and the Far East, Switzerland and Rome. What he returned with, however, are not carefully composed shots of temples and pyramids, nor artfully posed portraits of picturesque native peoples, but images of other tourists; those who form part of the movement of mass tourism. Photographed in rich colour, the tourists struggle with maps, follow the raised umbrellas of guides, buy beads in Goa, take photographs and pose for photographs. What connects the world in this exhibition is the multiple presence of the camera. Images are intertwined with what would once have been called the 'original' object; signs have broken loose from their former anchorages and float freely around a world that has been constituted as a site of spectacle. Can we consider work of this kind, with its multiple references to other images and its unwillingness to make authoritative statements, to be documentary? Certainly it fulfils a minimal condition of documentary: that it provide an account of events that have their own existence outside the frame of the photograph or the confines of the studio walls. We are no longer asked to accept that such images are impartial or disinterested; instead we inhabit a space between scepticism, pleasure and trust, from which we can read documentary images in more complex ways.

It would be unwise, however, to assume that documentary was once an easily understood practice, which has only lately been made more complex. Regis Durand reminds us that:

... the question is and will remain: in documentary photography, what is it that is really documented? Not only is it not usually what is supposed to be the document's obvious object ... but that object can be shifted and reconstituted again and again during the course of our historical perception of it. And this still leaves the essential question of the subject (what the photograph is about, what is recorded and done when it is taken) and even more the problem of reception.

(Durand 1999: 38)

These are central questions that have been at the heart of enquiries into documentary throughout its history and ones that in a world of constantly changing technologies and photographic practices will become increasingly pertinent.

CHAPTER 3

'Sweet it is to scan ...'

Personal photographs and popular photography

PATRICIA HOLLAND

115 Introduction

120 In and beyond the charmed circle of home

The public and the private in personal photography
Beyond the domestic
Fiction and fantasy
Portraits and albums
Informality and intimacy
The working classes picture themselves
Kodak and the mass market
The supersnap in Kodaland

148 Paths unholy and deeds without a name?

Twenty-first-century contemplations Post-family and post-photography?

158 Acknowledgements

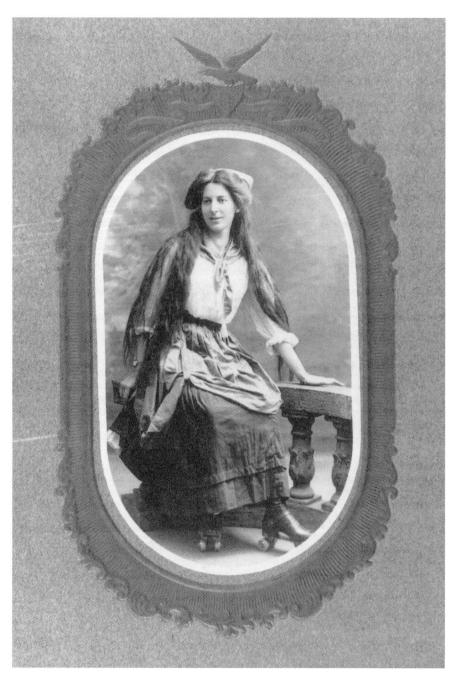

3.1 Studio photograph of Lily Peapell in peasant dress on roller skates, c. 1912

'Sweet it is to scan ...'

Personal photographs and popular photography

'When amid life's surging battle Reverie its solace lends Sweet it is to scan the faces – Picture faces – of old friends

. . .

Some have passed the mystic portals Where the usher Death presides Some to distant climes have wandered Borne on Time's relentless tides; Some, perchance, to paths unholy; Some to deeds without a name But the faces in the album Are for aye and aye the same.

. . .

Picture faces! Oh what volumes Of unwritten life ye hold: Youthful faces! pure, sweet faces! Dearly prized as we grow old'

> M.C. DUNCAN Frontispiece to Richard Penlake Home Portraits for Amateur Photographers (1899)

INTRODUCTION

The doggerel, couched in the language of late Victorian sentiment, with its yearning for purity and sense of the closeness of death, fronted a book of advice for 'amateur photographers' just at the time when home photography was undergoing a dramatic transformation. The crafted work of the 'gentleman amateur' or hobbyist, whose proliferating equipment involved tripods, black cloths, glass plate negatives, special backdrops, darkrooms and a cocktail of chemicals, was giving way to an instant push-button affair, in which the film could be sent off for processing and no special skills were required. By 1899 George Eastman had already marketed his revolutionary hand-held Kodak with the cheery slogan 'You press the button, we do the rest' and was about to launch the 'Box Brownie' - the camera he claimed that everyone could afford and was easy enough for children to use. 'Kodak's advertising purged domestic photography of all traces of sorrow and death' writes Nancy Martha West (2000: 1). This was the beginning of an era when the 'amateur' photographer is likely to be a woman, interested in 'home portraits', records of family life and much else beside. The new technology of the day was bringing a revolution in ways of perceiving the immediate domestic world, and in redefining who had the right to record that world.

NANCY MARTHA WEST (2000) Kodak and the Lens of Nostalgia Virginia: University of Virginia Press. DON SLATER (1995b) 'Domestic Photography and Digital Culture' in M. Lister (ed.) *The Photographic Image in Digital Culture*, London: Routledge

A hundred years later, the new technology of the day has created a different revolution in domestic imagery - more interactive, more interventionist, and potentially even more inclusive. Photography now takes its place within a new configuration of home-based media, part of an 'integrated home entertainment unit' (Slater 1995b). While digital technology means that huge numbers of domestic scenes can be recorded with unparalleled ease, it has, more importantly, put an even wider range of controls in the hands of the home photographer. 'Doing the rest' is now as easy as 'pressing the button'. Sophisticated procedures that continued to be reserved for the professional or the dedicated amateur are now available to a broad swathe of the population. There is an infinity of playful ways of organising and rearranging personal pictures using simple computer programmes, and of distributing them instantaneously via e-mail, the Internet and mobile phones. Pictures are less likely to be precious one-offs. They are more malleable, more disposable. Digital technology has broadened perception beyond the immediate and the contemporary. Websites which specialise in family history have fuelled an increasing appetite for tracing ancestors and rediscovering pictures from the past. And the past can be reconstituted, too. Dead relatives can be scanned into contemporary pictures; family groups can be constructed which never existed in real life. When M.C. Duncan wrote 'sweet it is to scan . . .' he was thinking of the poignant experience of gazing at the present image of those who have 'passed the mystic portals' or 'wandered to distant climes'. Little did he imagine the unique pleasure of digitally scanning such images to construct a more fluid perception of the gap between present and past.

But the history of personal photography is more than a simple story of technological development. The desire to scan the picture faces of old friends has been expressed in a multitude of different ways over the last century and a half. Social and cultural changes are intertwined with the history of photographic techniques and practices, as are the interpretive meanings we bring to the pictures. This chapter will outline that history, in which taking pictures is both a leisure pursuit and an increasingly flexible medium for the construction of ordinary people's accounts of their lives and fantasies. The history of the medium and the separate history of the discourse of which photography forms a part, interact with the social and economic history of an era. We will begin in the 1840s, imagining how it must have been when, for the first time, people could hold in their hands the marvel of a photographic likeness. The final section of the chapter will start from the other end, as it were, and will look back from where we stand today, finding ways to make sense of personal pictures from the recent and distant past. The meanings brought by the browser in the album both meet up with, and part company from, the external realities of the historical world, particularly when pictures are associated with major trauma or historical displacement.¹

We have chosen to speak here of 'private' or 'personal' pictures rather than the more usual 'family' pictures, because our private lives cover so much

discuss the significance of certain family photographs for survivors of the Holocaust in *Testimony* (1992), which deals with memory and the possibility of witness.

1 Literary theorist

Shoshanna Felman and

psychoanalyst Dori Laub

more than our family lives. The equation between 'the family' and private experience is too easily made and excludes too much.² The evolution of private photography has indeed been family based but that link is historically contingent, not, as is often assumed, the consequence of 'natural' necessity. In 1899 it was the picture faces of 'old friends' that were apostrophised in M.C. Duncan's verse. The point has been made by writers such as Terry Dennett, who compare family albums to other sorts of albums that record the lives of clubs, political groups and other networks of support and obligation (**Spence and Holland 1991: 72**).

That private photography has become *family* photography is itself an indication of the domestication of everyday life and the expansion of 'the family' as the pivot of a century-long shift to a consumer-led, home-based economy. Personal photography has evolved as part of the interleaving of leisure and the domestic, whose development runs parallel to the history of photography itself.

In Britain and the West, the gradual expansion of domesticity from the respectable middle classes through to all but the very poorest has drawn women, children and finally even men into the 'charmed circle of home'.³ Such activities as child-care, the preparation of meals and work on improving the house and garden have come to be seen as pleasures rather than duties, and the family has become the main resource for close relationships and expressive emotion. Now, at the beginning of the twenty-first century, taking snapshots is among a plethora of leisure pursuits which underpin that specific form of family life. However, photography occupies a peculiar place among those activities, as pictures are themselves carriers of meanings and interpretations. They record and reflect on daily activities, delicately holding within the innocent-seeming image much that is intimate. Here are M.C. Duncan's 'volumes of unwritten life' for which we must scan beyond the edges of the frame.

Personal photographs are embedded in the lives of those who own or make use of them. Even when they are professionally taken, there is a contract between photographer and subject quite different from other types of photography. Personal pictures are made specifically to portray the individual or the group to which they belong as they would wish to be seen and as they have chosen to show themselves to one another. Even so, the conventions of the group inevitably overrule the preferences of individual members. Children, especially, have very little say over how they are pictured, and this discrepancy is the source of many of the conflicting emotions analysed by writers on family photography.

The photographs we keep for ourselves are treasured less for their quality than for their *context*, and for the part they play in confirming and challenging the identity and history of their users. In this discussion it will be useful to distinguish between *users* and *readers* of personal pictures, whether family snaps, school photos or the portraits in the high street photographer's

2 See Michèle Barrett and Mary McIntosh (1982) for a development of this argument.

JO SPENCE AND PATRICIA HOLLAND (eds) (1991) Family Snaps: The Meanings of Domestic Photography, London: Virago.

3 For an account of the evolution of 'domesticity' as a concept and a way of living, see Hall (1979) and Davidoff and Hall (1976). For an exploration of the cultural rituals which have sustained family life, see Gillis (1997).

4 The distinction between users and readers derives from Basil Bernstein's analysis of elaborated and restricted codes. A restricted code is one that depends on its context to be understood (see Bernstein 1971: 76–7). See also Eco (1979).

ROLAND BARTHES (1982) **Camera Lucida**, London: Jonathan Cape.

BRIAN COE AND PAUL GATES (1977) The Snapshot Photograph: The Rise of Popular Photography 1888–1939, London: Ash and Grant.

COLIN FORD (1989) The Story of Popular Photography, Bradford: Century Hutchinson Ltd/National Museum of Photography, Film and Television.

AUDREY LINKMAN AND CAROLINE WARHURST (1982) Family Albums, Manchester: Manchester Polytechnic. A fully illustrated exhibition catalogue with an introduction.

AUDREY LINKMAN (1993) The Victorians: Photographic Portraits, London: Tauris Parke Books.

SUE ISHERWOOD (1988) **The Family Album**, London: Broadcasting Support Services.

window.4 Users bring to the images a wealth of surrounding knowledge. Their own private pictures are part of the complex network of memories and meanings with which they make sense of their daily lives. For readers, on the other hand, a hazy snapshot or a smiling portrait from the 1950s is a mysterious text whose meanings must be teased out in an act of decoding or historical detective work. Users of personal pictures have access to the world in which they make sense; readers must translate those private meanings into a more public realm. Private photographs, taken alone, are a 'restricted code' in the sense described by Basil Bernstein, dependent for their specific meanings on knowledge of the rich soil of meanings that holds them in place (Bernstein 1971). Wrenched from that context, they appear thin and ephemeral, offering little in the way of either aesthetic pleasure or historical documentation. But, although such ghostly hints of other lives may tempt the reader to engage in the detective project and to construct stories from these tentative clues, the empirical historian would do well to treat them with extreme caution. The peculiar fascination of personal photographs comes from this contrast between an almost unbearable richness and the inconsequentiality and triviality of the medium. Roland Barthes, writing on photography and memory, could not bear to reproduce the snapshot of his recently deceased mother, even though it gave rise to his essay (Barthes 1982).

Private pictures, offering up so little to the critic and art historian, have tended to feature in histories of photography chiefly as examples of technological improvement. Historians have noted the increasing lightness of cameras, the invention of colour film and similar developments (Coe and Gates 1977; Ford 1989). Twentieth-century snapshots have been seen as slight and unimportant, of poor quality and of value only to those who make use of them. However, over the last 25 years or so, personal pictures have become the centre of a different sort of interest as the study of history itself has changed, and as working photographers, particularly women, have re-evaluated photographic practice. A concern with local and family histories, women's history, the history of everyday life and history from below has given a new significance to personal pictures as historical documents (Linkman and Warhurst 1982; Linkman 1993; Drake and Finnegan 1994). Nancy Martha West's Kodak and the Lens of Nostalgia (2000) traces the development of Kodak through its advertising, and places snapshot photography within the new leisure-based society of the United States in the early twentieth century. When scrutinised under the detective's magnifying glass, it seems that private pictures offer up many public meanings, some superficial, some historically illuminating. They tell us about the style of crinoline fashionable in the 1860s and about the donkeys used by beach photographers in the 1910s. But they also display public ideologies - stories and ideas about how things are and how they ought to be (Isherwood 1988).

Historically, personal pictures are deeply unreliable, but it is in this very unreliability that their interest lies. It has led to a new set of questions – for

whom are these pictures? who sees them? to whom do they communicate? In making an effort to *reread* private pictures, there has been a move to revalue the undervalued and to bring into public discourse meanings which have hitherto been concealed in the most secret parts of the private sphere. Writers, photographers and curators (Jo Spence, Val Williams and Marianne Hirsch among them), are concerned to read history through autobiography. While drawing attention to the importance of this most popular of the uses of photography, they have insisted that the *privacy* of its meanings should not be dispersed (Spence and Holland 1991; **Spence 1987, 1995; Williams 1986; Hirsch 1997**).

The increasing self-consciousness of the modern world has been explored and reworked in many different ways since the mid-nineteenth century. It has been argued that photography is itself a central feature of modernity – not just in its modernist moment, when photographers such as Rodchenko and Moholy-Nagy indulged in formalist abstractions and celebrations of machine culture – but as a *technology*, contributing to the control of the external world with its mechanical eye and potential for scientific neutrality (**Tagg 1988**; Slater 1995a).

Personal photography has played a different but equally important role in the **modernisation** of Western culture. It has developed as a medium through which individuals confirm and explore their identity, that sense of selfhood which is an indispensable feature of a modern sensibility - for in Western urban culture it is as individuals that people have come to experience themselves, independently of their role as family members or as occupying a recognised social position. The twentieth-century consumer-led economy has shifted these new individuals away from a culture based on work and selfdiscipline to one based on libidinous gratification which encourages us all to identify our pleasures in order to develop and refine them. In a parallel move, the century of Freud became an age of inwardness and self-scrutiny. These changes are reflected in the images we produce of ourselves, the uses we make of them, and our search through the Internet for material relevant to ourselves. Scanning personal pictures has become part of that act of selfcontemplation (Spence and Martin in Spence and Holland 1991; Spence 1987; Spence 1995; Slater 1995b).

Despite the intensity of such a project, in one of those many paradoxes that makes its study so fascinating, private photography insists on being a non-serious practice. Cuthbert Bede, writing in 1855 in the facetiously punning style enjoyed by the mid-nineteenth century, reminded his readers that photography was 'essentially a *light* subject and should be treated in a light manner' (Bede 1855). And so it has continued over its history, seeking the playful and celebrating the trivial. Personal photography sets out to be photography without pretensions, and that is how we intend to approach it. In the spirit of other work by feminist writers on women's culture (for example, Geraghty 1991), we will not be arguing that these forms of photography

JO SPENCE (1987) Putting Myself in the Picture, London: Camden Press; (1995) Cultural Sniping, London: Routledge.

VAL WILLIAMS (1986) Women Photographers: The Other Observers 1900 to the Present, London: Virago.

MARIANNE HIRSCH (1997)
Family Frames:
Photography, Narrative and
Postmemory, Cambridge, MA:
Harvard University Press.

JOHN TAGG (1988) The Burden of Representation: Essays on Photographies and Histories, London: Macmillan, especially ch. 1, 'A Democracy of the Image: Photographic Portraiture and Commodity Production'. should be captured for 'art' or 'high culture', but that what is needed is to understand them on their own terms.

IN AND BEYOND THE CHARMED CIRCLE OF HOME

The public and the private in personal photography

At its beginnings in the 1840s, popular photography tended to look outwards as well as being home based. During the nineteenth century, images of the strange and exotic were marvels which enhanced the comfortable home and became as much part of home entertainment as television is today. In some family albums, preserved by prosperous patriarchs before the turn of the twentieth century, we can see how the middle-class home, even as it became increasingly separated from political and economic activity, depended on the world outside. The feminine domesticity of the extended family was visibly sustained by masculine adventure, both military and entrepreneurial.⁵ The copious albums preserved by Sir Arnold Wilson dramatically illustrate the point. Sir Arnold was a well-connected army officer serving in India and Persia in the early years of the twentieth century. He worked with the Anglo-Persian Oil Company in the 1920s and became a Conservative MP in the 1930s. His family albums cover a period from 1870 to 1920, recording holiday trips, afternoons in the vicarage garden and regimental postings. Set-piece photographs of India and the Middle East are juxtaposed with gentle family groups and intimate portraits in the gardens and drawing-rooms of the family's homes at Leighton Park Estate and in the countryside near Rochdale. In India the regimental tug-of-war team and the local Gurkha regiment present themselves proudly to the camera. In the Middle East, British officers pose one by one with local sheikhs. Tourism overlaps with colonial rule as spectacular views of the Himalayan hill station at Muree are followed by annotated pages showing the complex decoration of local mosques. In the Persian album, alongside the purchased images of silversmiths and weavers at work, Sir Arnold included pictures of executioners and torturers demonstrating their craft.

Discussing the colonialist imagery of advertising at the turn of the century, Anne McClintock argues that 'the cult of domesticity became indispensable to the consolidation of British imperial identity' (McClintock 1995: 207). The starkness of the contrast in Sir Arnold Wilson's albums makes visible the tensions on which domestic photography has continued to be based. They look inwards at an increasingly privatised and protected domestic haven and outwards at a world of political violence, re-presented as spectacular and exotic. The pictures in Sir Arnold's albums present this outside world with great confidence, gazing with the eyes of those who would control it and claim to civilise it.

5 I am using mainly British (or rather British-based) examples here. For a discussion of the US experience see Hirsch (1997) and Langford (2001).

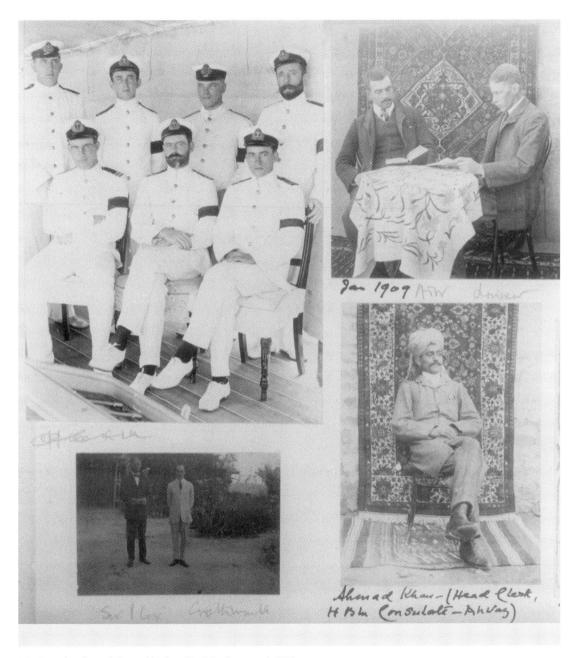

3.2a From the album of Sir Arnold Wilson (No. 3 Persian scenes), 1909

3.2b From the album of Sir Arnold Wilson (No. 7), 1900

As the twentieth century progressed, and as photography became available to the ruled as well as the rulers, the politics of the world beyond the family group has come to be **repressed** in the domestic image. The *consequences* of colonial domination and the ever possible presence of violence must be read beyond the limits of the frame (Hall 1991: 152). The two sides of popular photography have remained, but the imperial aspiration of this vision, and the celebration of commerce and military adventure of the Victorian era, have long since been replaced by a tamer record of travel and tourism.

Beyond the domestic

From the very early days through to the unflagging popularity of posters and postcards in the twenty-first century, popular photography has continued to include purchased pictures of unknown people and places. William Henry Fox Talbot, who first developed a negative/positive **calotype** process in Britain in 1839, hastened to patent his invention and turn it to financial advantage. In 1843 he set up the first printing workshop to reproduce photographs for sale. His book, *The Pencil of Nature*, was amongst the earliest to be photographically illustrated.

Within 20 years there was a thriving industry in photographic prints, which included impressive landscapes, views and still lifes. If Sir Arnold Wilson's turn-of-the-century collection carries the confidence of those who seek to control what they see, these pictures marketed from the 1850s onwards had the more modest aim of entertainment. However, what John Urry described as 'the tourist gaze' (Urry 1990) itself ensures a separation between the one who does the looking, assumed to be familiar and like 'us', and that which is looked at, assumed to be different and strange. A taste for the exotic was already well established in the mid-nineteenth century and photography gave it a new boost. Francis Frith set up a highly profitable company which produced saleable photographs of parts of the world which up till that time had only been seen through the eyes of artists or the imaginative descriptions of travellers. From 1856 he made three expeditions to the Bible lands of the Middle East and The Times called his resulting photographs 'the most important ever published' (Macdonald 1979). His photographers travelled the length of the British Isles and at the height of his business his firm claimed to have one million available prints, including photographs of every city, town and beauty spot in Britain. By the later years of the nineteenth century, photographs of parts of the world, impressive because of their distance, their strangeness or the difficulty experienced in reaching them - from the high Alps to remote areas of China and Japan - were published as prints, lantern slides and stereoscopic views.

The coming of photography gave rise to a new set of dilemmas around the production of the exotic. On the one hand it displayed images of hitherto unknown and remarkable places and people, but at the same time it had to be recognised that these were *real* places and people. The veneer calotype Photographic print made by the process launched by William Henry Fox Tallbot in England in 1840. It involved the exposure of sensitised paper in the camera from which, after processing, positive paper prints could be made. Not much used in England in the early days because it was protected by Fox Talbot's own patents, but its use was developed in Scotland, especially by David Octavius Hill and Robert Adamson.

of exoticism may be confirmed or challenged by the photograph itself. We should not forget that photography was also developing in those very places that seemed exotic to the untravelled British. By the end of the nineteenth century in China, Japan and India, local photographers were making pictures for local use (Falconer 2001). Pictures which would be seen as exotica in the metropolitan West are someone else's family photos.

Popular photography has rarely been a medium of record. Foreign views 1994).

claimed, ruined the very views they had come to discover. But from the turn of the century, a new generation of tourists took their cameras in search of scenic beauties previously seen only on postcards and in travelogues. At first they went by train or bicycle, but by the 1920s many were travelling by car. In the United States the publicity-conscious Kodak company pointed out scenic views with road signs reading 'Picture ahead! Kodak as you go!' (West 2000: 65). With each wave of visitors the possibility of an undiscovered rural scene or an unspoilt village seemed ever more elusive. A photograph was a

exaggerated the exotic and the strange, and a fashion developed for the quaint and the traditional (for example, George Washington Wilson's pictures of gnarled old Scottish fishermen and other local types). With hindsight this fashion can be seen as the beginnings of a heritage industry in which the imagery was threaded through with nostalgia brought about by photography itself, already capturing a disappearing past. Groups such as the Society for Photographing Relics of Old London set up in 1875 contributed to an archive of the past which itself became part of a tourist view of the world (Taylor Middle-class artistic travellers came to deplore 'vulgar' sightseers, who, they

JUNE 10, 1887. THE AMATEUR PHOTOGRAPHER

THE PROTOGRAPHIC CRAZE: A VILLAGE BESIEGED

3.3 'The photographic craze', Amateur Photographer, 10 June 1887

JOHN TAYLOR (1994) A Dream of England: Landscape, Photography and the Tourist's Imagination, Manchester: Manchester University Press.

nostalgic compensation for the loss of a world that appeared to be uncorrupted by industry and urbanisation. By the twenty-first century, that historical world itself had been preserved and packaged. The heritage industry and the tourist trade between them had provided renovated antique buildings and tidied up picturesque views to create ready-made photo opportunities. It is no longer surprising to find 'viewpoints' clearly marked on roads and maps. Taking a picture is an intrinsic part of the tourist experience and 'places of interest' dominate the albums of many a modest traveller just as they did those of Sir Arnold Wilson.

Fiction and fantasy

Fiction and fantasy have long been more attractive than the mundanities of everyday life, and this was certainly true of one of the most popular of nine-teenth-century domestic media, the stereoscopic view. From 1854 the London Stereoscopic Company produced double pictures which gave a 3D effect when peered at through a binocular viewer. This could be a small hand-held affair or a grand piece of drawing-room furniture. By 1858 there were 100,000 different views on offer and the company's slogan was 'No home without a stereoscope'.

Many stereoscopic scenes exploited the Victorians' love of theatrical tableaux and aimed for a style and subject-matter suited to the taste of their middle-brow purchasers. Such 'stereoscopic trash' outraged the proponents of

3.4 Stereoscopic slide from the late nineteenth century

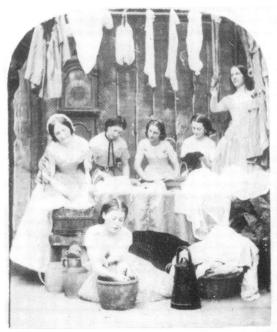

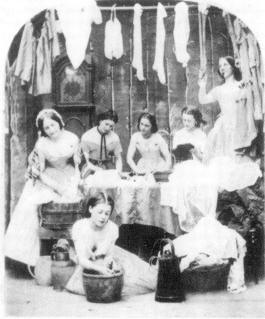

photography as art (see ch. 6 pp. 256–9). The Photographic Society (later to become Royal), founded in 1853 to protect artistic standards, deplored the debasement of the medium. In 1858 its journal fumed,

To see that noble instrument prostituted as it is by those sentimental 'Weddings', 'Christenings', 'Distressed Seamstresses', 'Crinolines' and 'Ghosts' is enough to disgust anyone of refined taste. We are sorry to say that recently some slides have been published which are, to say the least, questionable in point of view of delicacy.

(Macdonald 1979)

Sentiment, jokes, horror, melodrama and material which verged on pornography – this was the stuff of nineteenth-century photographic entertainment. Some stereoscopes even came with a locked drawer for a gentleman to keep his risqué pictures away from his family (see ch. 4 p. 169 on the reputation of laundresses as sexually loose women). In those days before the cinema, magic lantern shows were also popular. Impressive views could be watched in a darkened room, enhanced by exciting optical effects – from a sunset over the Alps to lifelike thunderstorms (Chanan 1996). The making of personal portraits was part of this popular aesthetic, firmly embedded in commercial practices.

Portraits and albums

Louis-Jacques-Mandé Daguerre's invention of positive images on silvered metal, each one unique, was, from the 1840s, the dominant format for personal portraits. Enterprising daguerreotypists learned the new skills and tried to interest customers in towns across Europe and the New World. In those very early days, sittings for 15-20 minutes in as bright a sunlight as possible led to extreme discomfort for the sitter and some fairly unflattering pictures which could be difficult to discern on the highly reflective surface. Even so, within a few years, huge numbers of people of middling income wanted their portraits taken, and 'daguerreomania' had taken hold. Photographic 'glasshouses' - so called because of the wide expanse of window needed to maximise daylight - were established in urban centres across Europe and the United States. In Britain, Antoine Claudet had a 'temple of photography' designed by Sir Charles Barry, who built the Houses of Parliament. In Leicester Square in London there was a 'Panopticon of science and art' with a room 54 feet long (approximately 16.5 metres) 'enabling family groups of 18 persons to be taken at once', which also offered lessons in daguerreotyping and studios for hire. Studio portraitists introduced painted backdrops so that the customers, whatever their social standing, could choose to place themselves within dignified parklands, seascapes, conservatories or palm houses. Many were extremely successful: Richard Beard was said to be

daguerreotype Photographic image made by the process launched by Louis-Jacques-Mandé Daguerre in France in 1839. It is a positive image on a metal plate with a mirror-like silvered surface, characterised by very fine detail. Each one is unique and fragile and needs to be protected by a padded case. It became the dominant portrait mode for the first decades of photography, especially in the United States.

photography's first millionaire (Macdonald 1979; Tagg 1988; Ford 1989; **Kenyon 1992: 11–12**).

The 'cheap and common establishments' in the less fashionable parts of town got a bad name for aggressive touting for trade. Someone stood outside shouting, 'Have your picture taken', and virtually 'dragging customers in by the collar' (Werge 1890: 202). Most of these early portraits were carefully posed and touched up so as to produce as flattering an image as possible under difficult circumstances. A headrest kept that most important feature, the face, static for the lengthy exposures needed, or the posing individual was asked to lean on a table or a mock-classical pillar which also served decorative and symbolic functions. The head resting on the hand achieved the popular Victorian soulful look, as well as helping the sitter to keep still. Smiles were difficult to sustain under such circumstances: the modern ubiquitous snapshot smile should be seen as a technological achievement as well as a change in social mores.

DAVE KENYON (1992) **Inside Amateur Photography**, London: Batsford.

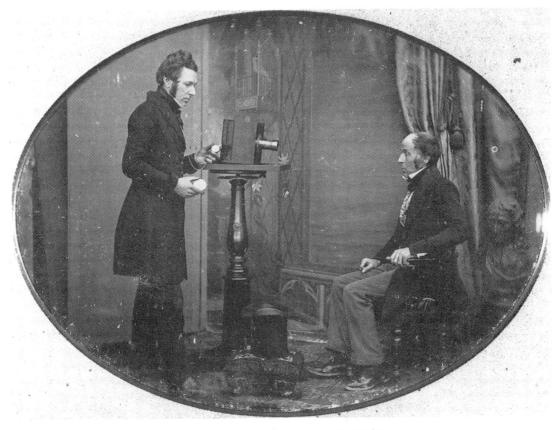

3.5 Earliest known daguerrotype of a photographer at work. Jabez Hogg photographs Mr Johnson, c. 1843

carte-de-visite A small paper print (2½–4½) mounted on a card with the photographer's details on the reverse. This way of producing photographs for sale was developed by André-Adolphe Disdéri in France in 1854. Eight or more images were made on the same glass negative by a special camera with several lenses and a moving plate-holder. The prints were then cut up to size. Such prints could be produced in very large numbers.

Every innovation was hailed as spreading photography more widely across the classes. 'Such portraits are to be found in everybody's hands', wrote André-Adolphe Disdéri, who invented the 'carte-de-visite' in 1854 (Lemagny and Rouille 1987: 38). Named after the leisured classes' 'visiting cards', these were small paper prints mounted on the photographer's own decorated card. Several poses could be produced on a single negative so that the process was speeded up and multiple copies were easily available. This was the first attempt at a form of mass production of popular photographs, and certainly class differences were far less visible in such pictures than they were in everyday life. Shopkeepers, minor officials and small traders all took themselves and their children to pose stiffly in their best clothes in front of one of these early cameras.

A craze for collecting *cartes-de-visite* of the famous developed. Some of the earliest photographic albums were not 'family albums' at all, but handsomely bound volumes filled with pictures of royalty, celebrities and politicians. As pressure increased on middle-class women to make their lives within the confines of the home environment, useless but suitably decorative hobbies such as collecting *cartes-de-visite* fitted in well with other genteel activities such as sketching and pressing flowers (Davidoff and Hall 1976; Warner 1999; Swingler 2000).

Queen Victoria's family was presented as a model of the new respectable domesticity, but published photographs of the Royal Family remained strictly formal. When the celebrated photographer Roger Fenton was invited to photograph the Queen's children dressing up and presenting tableaux, the pictures were felt to lack dignity and were never released to the public (Hannavy 1975). Even so, it was the more relaxed picture of Princess Alexandra giving her daughter Louise a piggyback that became the best-selling *carte-de-visite*. Among their many hobbies and pastimes, women members of the Royal Family took up photography themselves, and Queen Victoria's and later Queen Alexandra's own copious albums were filled with views of family picnics and hunting parties (Williams 1986: 75).

Home photography was not for public display, but for fun with friends. In 1855 Cuthbert Bede described, for the benefit of 'all the light-hearted friends of light painting', many such social activities, including 'visiting country houses and calotyping all the eligible daughters' (Bede 1855: 44). The light-hearted uses of photographs, part of the Victorian fascination for fads and fancies, included mounting dainty miniatures into brooches and lockets, decorating jewel cases, or even setting them into the spines of a fan. A Victorian album was itself a series of visual novelties, with the portraits often cut up and arranged in decorative shapes and incorporating drawings and other scrapbook items. Mary Queen of Scots going to her execution was a favourite. And there were the mottoes: 'Love me, love my dog' heads a page of pets squatting smugly on their cushions. The interest is not just in

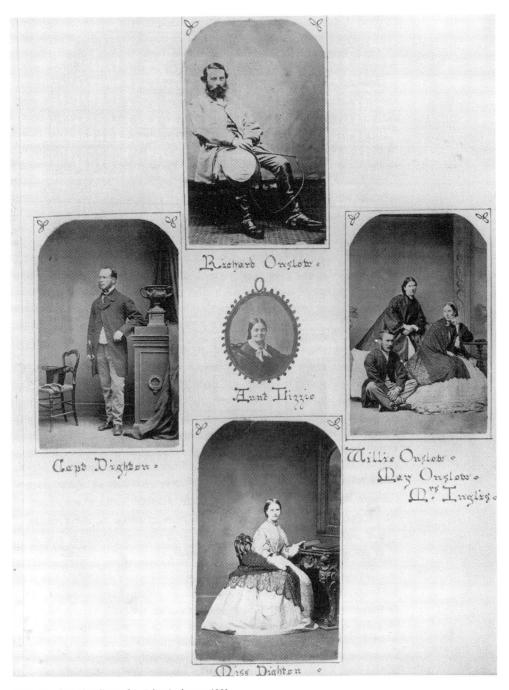

3.6 A page from the album of R. Foley Onslow, c. 1860

6 It is relatively new for photographic historians to recognise the album's importance as a complete entity. Collectors have frequently purchased an album simply to remove one or two remarkable prints. Curator Pam Roberts of the Royal Photographic Society is preserving and cataloguing albums in their own right. She makes the point that the way photographs have been selected and put together is an important part of the personal meaning of the pictures in an album.

the individual pictures but in the arrangement as a decorative collection (Smith 1998: 57).⁶

The family-based albums of the nineteenth century are those of prosperous dynasties whose members had both the leisure and the money to take up photography, as well as to buy commercially produced pictures. The life of the Helm family, in their spacious mansion in Walthamstow, elegantly photographed by James Helm and preserved in a set of albums put together in the early 1860s, demonstrates not so much the luxury and overt enjoyment of a free-spending leisure class, but the decency and quiet respectability of the middle-class suburb (Cunningham in Thompson 1990). The group is large and diverse, with aunts and other relatives and friends as regular members, in striking contrast to today's pictures of tight-knit families in which parents and young children predominate. The leisurely lifestyle included croquet on the lawn, amateur dramatics, young men posing with their musical instruments and dignified ladies in layered crinolines taking tea. These are scenes from everyday life, carefully organised and staged in the tableau manner. In the 1840s, Fox Talbot had written, 'when a group of persons has been artistically arranged and trained by a little practice to maintain an absolute immobility for a few seconds of time, many delightful pictures are easily obtained. I have observed that family groups are especial favourites' (Ford 1989). The tableau was a pleasing artistic picture as much as a family record. Pictures such as these were marking out the evolving domestic sensibility of the nineteenth century, which made the home environment the centre of decent living. It was a model which the lower-middle and working classes were to emulate in the coming century.

If the home was becoming a site of leisure, the creation of the 'hobbyist', and its more elevated relative the 'amateur', meant that leisure time could be used both for scientific experiment and the creation of works of art. Although one aspect of the evolution of domesticity meant that 'the feminine ideal was to be weak and childlike' (Davidoff in Thompson 1990: 84), women could become home-based hobbyists. 'Photography is the science for amateurs, equally adapted for ladies and gentlemen, which cannot be said of the generality of sciences', wrote Bede. Among the most celebrated photographers of the nineteenth century were comfortably off women with plenty of leisure and domestic help, who made use of their family and immediate surroundings as raw material for their photographic works, rather than as family record. Julia Margaret Cameron's misty portraits and visions of cupids and angels embraced and transcended Victorian romanticism (ch. 6 pp. 254-5). Workingclass women were needed as servants and helpers to service the middle-class domestic haven. Indeed, Julia Margaret Cameron's own favourite model was her assistant and maid, Mary Hillier (Mavor 1996). There were women working portraitists, too. John Werge remembers a 'Miss Wigley from London' who came to his home town in the North of England to practise daguerreotyping as early as the mid-1840s (Werge 1890).

A PHOTOGRAPHIC POSITIVE.

LADY MOTHER (LAQUITUR)" / SHALL FEEL OBLIGED TO YOU, MR. SQUILLS, IF YOU WOULD REMOVE THESE STAIMS FROM MY DAUGHTER'S FACE. I CANNOT PERSUADE HER TO BE SUFFICIENTLY CAREFUL WITH HER PHOTOGRAPHIC CHEMICALS AND SHE HAS WAD A MISSON:
-TUNE WITH HER NITRATE OF SLYER, UNLESS YOU CAN DO SOMETHING FOR HER, SHE WILL MOTHER FIT TO BE SEEN AT LADY MAYFAIR'S TO NIGHT. "

LOPUON . PUBLISHED BY T. MC.LEAN .

3.7 Illustration from Cuthbert Bede, Photographic Pleasures, 1855

Informality and intimacy

The repertoire of personal imagery was changing. There had been an elegiac tone to much Victorian personal photography, evoked by the solemnity of middle-class portraiture and by the awareness that so many died young. Death was a central part of family life, and memorial pictures of the dead and dying were common. Babies who had died were dressed in their best and photographed in their mother's arms (Williams 1994; West 2000; ch. 4, p. 190). By the end of the century the emphasis was changing to a more present celebration of life and a taste for informality.

Photographic portraits had long been valued not only for their likeness to the sitter but also for the apparent escape from convention and the greater naturalness offered by the mechanical process. Bede had written that a calotype is a step beyond a painted portrait, for a painting has 'the artist's conventional face, his conventional attitude, his conventional background' (Bede 1855: 45). In 1899 Richard Penlake advised amateur photographers how to avoid 'perfect' pictures like those of a celebrity, who is so carefully made up and posed as to seem like a wax model, or of royalty, in which the very best pose is selected from many exposures and even then 'so worked up that scarcely a single part of the original negative prints at all' (Penlake 1899: 16).

Penlake also offered advice on tricks and optical effects, such as making double images - so that the sitter magically appears twice in the same picture - and montaging photographed heads on to caricatured bodies, but with the coming of hand-held cameras such conceits were on the way out. Albums of the 1880s, compared with those of the 1860s, show a much more relaxed style and closeness to the subjects. The movement and visual interest was now in the picture itself rather than in the decoration and arrangement of the pictures on the page. On one page in Sir Arnold Wilson's album, girls and boys in sailor suits and boaters are trying out a bicycle. They are 'captured' with their backs to the viewer; in mid-conversation with each other; pointing their own hand-held cameras and playing up to the photographer, in a sequence of images which have much in common with the new 'candid' work by photographers such as Paul Martin and Frank Meadow Sutcliffe. At the time 'detective cameras' were all the rage. They were tiny, unobtrusive or concealed so that pictures could be taken without the knowledge of the subject. There was a growing taste for a different sort of personal picture, one where the contract between photographer and subject is brought into question. Secret observation was not always welcome to the observed. One local paper wrote in 1893:

Several decent young men are forming themselves into a Vigilance Association with the purpose of thrashing cads with cameras who go around seaside places taking pictures of ladies emerging from the deep in

montage or photomontage
The use of two or more
originals, perhaps also including
written text, to make a
combined image. A montaged
image may be imaginative,
artistic, comic or deliberately
satirical.

the mournful garments peculiar to the British female bather . . . I wish the new society stout cudgels and much success.

(Coe and Gates 1977: 18)

The working classes picture themselves

From the mid-nineteenth century in Britain and the US the middle classes began to move away from the city centres to the newly built suburbs. Behind their privet hedges they were able to protect themselves from the grime of industry and the potential immorality of the streets. But the working classes remained confined to the inner cities, in areas that were filthy and unhygienic. Their homes were not places of pleasurable relaxation and they could rarely afford the cost of representing themselves through photography. We twentyfirst century seekers for the past may look at the family of Sir Arnold Wilson and see its members as they would like to be seen, but the image of the working classes which we have inherited has been produced either by those, like Oscar Rejlander, who aestheticised and sentimentalised it, or those, like Thomas Annan, who documented it for the benefit of various official projects. A sense of working-class identity is largely absent. Middle-class concern frequently took the form of outrage at the state of the less salubrious areas, often describing the people who lived there as distasteful, smelly and unhealthy like their dwellings. Photographer Willie Swift, who published Leeds Slumdom in 1897, turned his pictures into lantern slides and 'with the help of my daughters who sang suitable solos for us, we went up and down showing the dark places of the city, helping to create that healthy public opinion which eventually demanded clearance of the places shown' (Tagg 1988: 225). In New York city, the photographer Jacob Riis was spectacularly successful, both with his dramatic photographs of slum dwellings, and his successful campaign for the demolition of 'these sewers'. The area that was Mulberry Bend is now Jacob Riis Park (Tagg 1988: 152; see ch. 2 pp. 75-8).

Against this background, middle-class intervention became the context for another kind of personal photograph, often valued by those it represents although not necessarily made for their sake. Following the Education Acts of 1870 and 1893 which introduced universal schooling in England and Wales, some of the earliest photographs kept by working-class families are those depicting their children ranked behind wooden desks. In 1891 and 1893 respectively, the Church Lads' Brigade and the Boys' Brigade were launched to tidy up disorderly youngsters and get them off the streets. Photographs of clubs and bands present a disciplined image, modelled on those produced by the likes of Arnold Wilson and his regiment out in the hill stations of Muree.

However, the shortening of the working week and the coming of the Saturday day off led to new sporting and leisure activities, which working-class people could organise for themselves and which they were beginning to record for their own pleasure (West 2000: ch. 2, on the links between

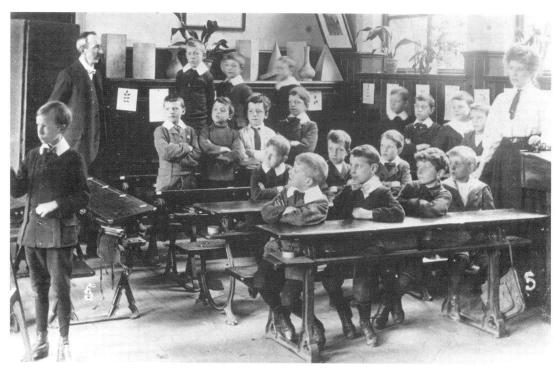

3.8 Pupils at St Mary's School, Moss Lane, Manchester, c. 1910

polaroid The Polaroid Land camera, producing instant black and white positives, was first marketed in 1947, but produced poor-quality images. Polaroid instant colour prints and slides were launched in 1963.

tintype or ferrotype Tintypes, instant positive images on enamelled iron plates, were produced from 1852 to around 1946. As one of the cheapest methods, they were especially favoured by seaside photographers.

Kodak marketing and leisure, especially in the US). Modest photographs from the 1890s onwards show the cycling group, the football supporters and, above all, the trip to the seaside, made possible by the expanding railway network. Opportunist photographers were now on hand for trippers who wanted their picture taken. Long before the **polaroid**, the **tintype** (or **ferrotype**) could produce an instant metal positive showing little boys with buckets and spades, toddlers perched on the photographer's donkey, and young women holding up their voluminous skirts as they paddle in the shallows. Photographers working in the new postcard format were ready with cheeky devices: 'The subject's head would join a monstrously fat body holding countless bottles of beer, or he would sit in a wooden aeroplane among painted stars' (Parr and Stasiak 1986: 13).

By 1910 postcard sales were averaging 860 million per year (Pryce 1994: 143). As well as the usual repertoire of views, royalty, celebrities and tableaux, travelling photographers would set up their stall at a fair or a local beauty spot and offer to put *your* picture on a postcard. When people couldn't afford the threepence (1.5p) or so for a picture, clubs were set up to pay in instalments. These jobbing photographers came from a class background similar to those whom they served. Photography was fast becoming a medium in

3.9 Holiday postcard from a Blackpool studio, 1910

which working-class people could present themselves to each other, creating a confident working-class identity.

Not surprisingly, many of the poorer people continued to choose studio portraits where dignified or exotic backdrops would remove them from their pokey homes. However, when the travelling photographer came by to set up

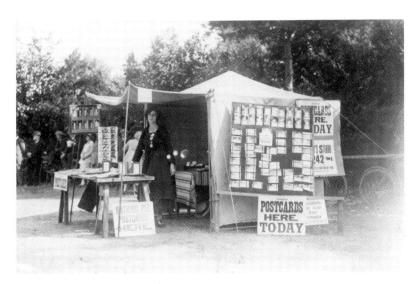

3.10 Mobile sales tent for Bailey's photographers, Bournemouth, c. 1910

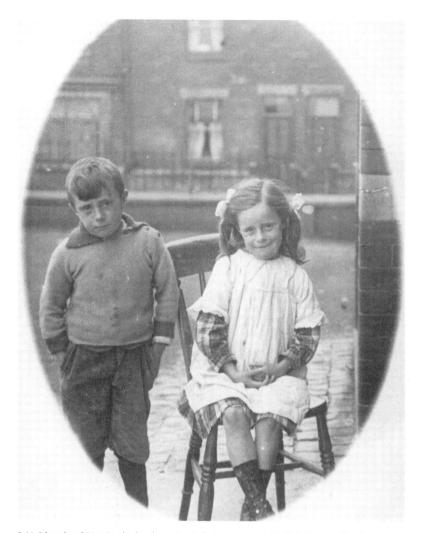

3.11 Edward and May Bond taken by a street photographer outside their home in Manchester, c. 1912

his equipment in a local street, all the children of the neighbourhood ran after him to get in the picture. 'Do not take too much notice of how they are taken', wrote Edward and May Bond's mother when she sent such a picture to her eldest son, 'for they look a bit untidy but I did not know they were having their likenesses taken, but I thought I would buy one to let you have a look at their dear little faces'.

Enterprising postcard photographers would visit local collieries, docks or mills, often producing the only photographic record of such workplaces that

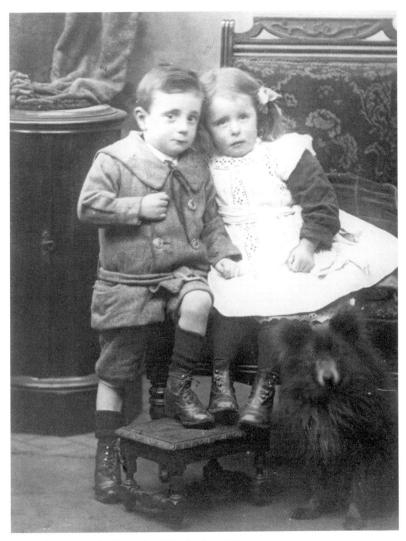

3.12 Studio photograph of Edward and May Bond, c. 1910

exist. Others specialised in local events, such as strikes, lockouts or disasters. In 1910, John Leach, a Whitehaven photographer, put together a montage of 124 of those killed in the appalling explosion and fire in the Wellington pit, as a memorial for the traumatised local community (Hiley 1983). Pictures of festivities were especially important to local people. At the Manchester Whit Walks, 'the working class was on display and they knew it' (Linkman and Warhurst 1982). Children who were untidy or had no clean clothes were kept well out of sight by their parents, and such pictures gave a very different

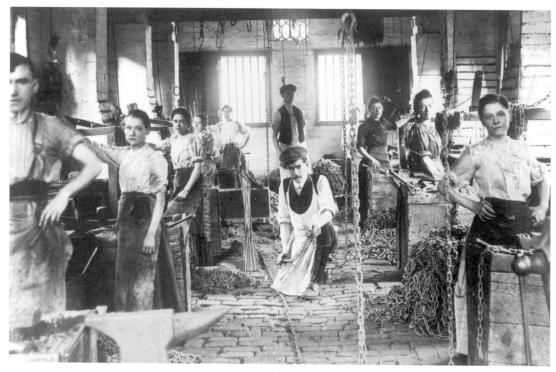

3.13 Black Country chain-makers, postcard, 7 August 1911

impression of life in the inner city from the documentarist's view of picturesque misery. Photographs made for the benefit of the photographer, whether as artist or concerned reporter, stand in striking contrast to those made for the eyes of the people whom they represent.

Kodak and the mass market

It was not until George Eastman, an American photographic plate manufacturer, successfully produced sensitised paper in 1884, and followed it up with his hand-held camera in 1888, that the paraphernalia of tripods and glass plates could finally be put aside and home photography for all became a possibility. Eastman was an entrepreneur with a flair for publicity, who sought to dominate the world market with a camera simple enough to be used by anyone. His crucial move was the separation of the *taking* of an image from the other stages involved in making a photograph. The smelly and difficult business of processing and printing was placed, conveniently out of sight, in a factory. This leisure activity for the home was supported by mass production and an army of employees – mostly women. Hence, in a single gesture, photography was both domesticated and industrialised. The first celebrated

Kodak camera was a lumpish wooden box with a hole at one end for the lens. When all the exposures had been made, and they amounted to about a hundred on a single film, the whole thing was sent back to the Eastman factory for processing and reloading. The slogan 'You press the button, we do the rest' was to form the basis of personal photography for the next century (West 2000).

Don Slater has argued that this drastic simplification amounted to depriving the new users of photography both of skills they might have put to more radical effect and a practical understanding of how photography creates meanings:

Being separated from a knowledge of process, we have no sense of photography as manipulation, as a form of action, as a making sense through the manipulation of tools of representation and meaning.

(Slater 1991: 54)

However, looking back with the hindsight of the twenty-first century, it is clear that such an analysis underestimates the scale on which a *new* skill was introduced at the end of the nineteenth. Selecting, framing and achieving the content of a photographic image was now a possibility for those who would not otherwise have had the time, the money nor the inclination to engage in the complex processes of amateur photography. Don Slater's arguments also disregard Cuthbert Bede's reminder that personal photography is a *light* art. Photographic manipulation had long been part of the games people played with their cameras. Producing joke pictures and clowning in front of the lens are activities which have turned taking pictures into a pastime that secures friendship and insists on interaction between photographer and subject. This *is* collaboration in 'manipulating the tools of representation and meaning', even when it's just for fun.

The more individualist activities which the full photographic process demands became part of a separate movement known as 'amateur photography'. The population in general, with little distinction of sex or even age, had become regular snapshooters, whereas amateur photography remained a more masculine pastime, scornful of the snapshot's cheery refusal to concern itself with the complexities of the medium. Serious amateur practice has retained its fascination with technology and its striving for aesthetic control. It has its own magazines, competitions and standards, and has retained its long-lived aspiration to the sort of pictorialism fashionable among artist-photographers at the turn of the twentieth century.

Meanwhile, George Eastman's commercial operations rapidly reached from Rochester, New York State to Harrow in Middlesex, and across the world. Developments followed each other in quick succession. Daylight loading, where the celluloid film came in light-tight cartons, was an advance that meant there was no longer a need to send the whole camera back to the

factory. 'Anybody can use it. Everybody will use it' ran the publicity, listing some of those possible users:

Travellers and tourists: Use it to obtain a picturesque diary of their travels. . . . Bicyclists and boating men: Can carry it where a larger camera would be too burdensome. . . . Ocean travellers: Use it to photograph their fellow passengers on the steamship deck. . . . Sportsmen and camping parties: Use it to recall pleasant times spent in camp and wilderness . . . and Lovers of fine animals: use it to photograph their pets.

(Coe and Gates 1977: 18)

The first theme was looking outwards. Novice photographers should make the most of expanding facilities for travelling – the train and the bicycle – and point their cameras at the picturesque and the unusual.

Looking inwards towards the domestic and creating an exclusive record of your family was an increasingly important message, directed largely at the women of the middle classes. This new technology was gendered. Its simplicity of operation indicated that the woman of the house could use it, while the chemicals and other technical paraphernalia could be left to the men. And what activity could be more suitable for a woman than to photograph her children. 'Do you think baby will be quiet long enough to take her picture mama?' asks a cartoon-style advertisement from 1889, as a mother lines up her camera on her toddler and replies, 'The Kodak will catch her whether she moves or not. It is as quick as a wink.' The prosperity of those late decades of the nineteenth century had brought women a new sense of independence. The passive 'angel in the house' was being superseded by the 'new woman', and those who took up their cameras were not just housebound mothers. 'Thousands of Birmingham girls are scattered about the holiday resorts of Britain this month, and a very large percentage of them are armed with cameras', wrote Photographic News in September 1905. 'It is as much a feminine as a masculine hobby these days, perhaps more so' (Coe and Gates 1977: 28).

Kodak advertisements overwhelmingly showed women carrying the camera, very often out together with other women (West 2000: 53). The 'Kodak girl' was introduced in 1893 – as an independent, stylish and youthful amateur who would typify the new brand. In 1910 she gained her smart but comfortable blue and white striped dress, easily adapted to changing fashions in skirt length and outline, which always seemed to be blowing in some breeze or other. Variously drawn by a number of well-known artists, she balanced her camera casually in her hand in Kodak advertisements for nearly 80 years. Always out of doors, she may be perched on a rock pointing out to sea, leaning on a jetty watching the yachts come in, celebrating the Paris World Fair in 1934, or picturing children romping on the beach, or a rustic cottage, or a modern young woman in a car, urging purchasers to 'Make Kodak snapshots of every happy scene' (Figure 3.14). As time went on, even

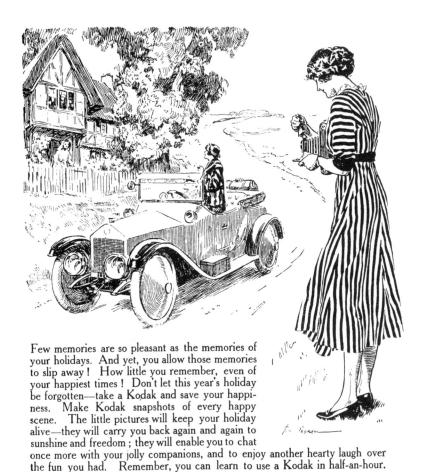

The only holiday that lasts forever is the holiday with a

Kodak

Ask your nearest Kodak dealer to show you the latest models.

Kodak Ltd., Kingsway, London, W.C. 2.

7 Kenyon (1992) has a detailed discussion of income relative to price of cameras and film.

the cameras were feminised. In the late 1920s, Kodaks were produced in fashion colours – pinks, blues and greens – and 'Vanity Kodaks' came with a matching lipstick, mirror and compact holder.

The 'Box Brownie', launched in 1900, cost five shillings, a quarter of an average week's wages, which brought it into the reach of all but the poorest. Now the advertisements were directed at children, too. The Brownie was a camera for little folk and could, the advertisements claimed, 'be operated by any school boy or girl'. Like the other Kodaks, it was not only easy to use but was guaranteed to be successful. However inept the operator, its pictures will always come out. Brownie albums were provided, with spaces ready prepared for slotting in a sequence of the snapshots (Figure 3.15).

Photography was not the only medium to shift from small-scale craft production to industrial production for a mass market in the last decades of the nineteenth century. Universal literacy, new printing techniques and the entrepreneurial ambitions of such men as Northcliffe and Rothermere meant that popular newspapers were launched for an unprecedentedly large readership. The advertising industry was rapidly expanding, since the mass production of all sorts of goods for domestic consumption required wider and more innovative marketing. Photography was at the centre of these developments and was to become the heart of the intensely visual popular culture of the twentieth century (see ch. 5 on photography and commodity culture). After the Daily Illustrated Mirror (today's Daily Mirror) was launched in 1903 as the first British newspaper to use photographic illustrations, the popular press came to depend on photography as an indispensable part of news reporting, and even more importantly, as central to their entertainment role (Holland 1997). Pictures of celebrities and royalty, which in the mid-nineteenth century had found their way into carte-de-visite albums, were now to be found in newspapers and later in the burgeoning consumer magazines. From the latter half of the twentieth century, the coming of high quality fullcolour printing, first in magazines, then in newspapers, meant that a huge range of topics - fashion, gardening, cookery, travel and tourism, entertainment, celebrities and music - have become part of a light-hearted and pleasurable lifestyle created by high-quality photographic imagery. Popular photography is all around us and it exerts its influence on contemporary private photography.

In the early years of the century the new domestic photographers had fewer models to imitate. As municipal housing became available for the less well-off, the working classes were beginning to follow the familial ideal established – and indeed enforced – by the Victorian middle classes (Davidoff in Thompson 1990: 106). With the coming of gas lighting and piped water, working-class homes were both more comfortable and more consciously 'respectable'. The elaborately furnished and scrupulously protected front parlour was 'not for relaxation, but a controlled and formal social environment' (Daunton in Thompson 1990: 207). As the lifestyles of the different

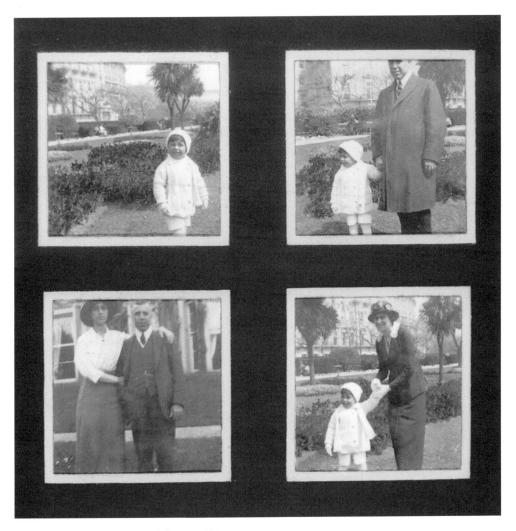

3.15 A page from a Kodak 'Brownie' album, c. 1900

classes grew closer together, the snapshot style could indicate a casual and informal mode which gave a democratic veneer to social divisions. Val Williams describes the relaxed pictures of the little Princesses, Margaret and Elizabeth, taken in the 1930s, as a studied model to which the whole nation could aspire (Williams 1986: 72). The poorer the community, the less directly are their daily activities reflected in the pictures they keep. Those who lived in the inner city tenements remained anxious to record the formality and dignity of their life, not its more distressing moments.

With the coming of the First World War there was a boom in camera sales, which reached its peak in 1917 as families bought cameras to record soldiers leaving for the war (Coe and Gates 1977: 34). Portraits of young men in uniform, many of whom never returned, make a poignant moment in most twentieth-century family collections. The increase in working-class incomes paradoxically brought about by the war meant that, by 1916, the *Kodak Trade Circular* could advise retailers that:

the people of the working class could be looked on as a likely buyer . . . it may even be said that they are better able to appreciate the Kodak than some of the people who usually buy it. The craftsman who works a high speed tool and who has to work to very fine measurements is just the right type of man to admire the mechanical excellence of the Kodak . . . If your shop is near a working class neighbourhood, think this over.

(Coe 1989: 69)

The supersnap in Kodaland

Following each of the major upheavals of the twentieth century, 'the family' was reasserted as a force for reconstruction and social cohesion. During the Second World War, for a brief period, popular photography had included high-quality photojournalism developed by *Picture Post*, which concerned itself with the 'home front', with public life and communal responsibility as well as with military campaigns; but in the postwar period, just as in the years following the First World War, a reconstructed economy was based on domestic consumption and the domestic ideal. This required, in particular, women's willing return to the home to become the pivot of family life, relinquishing their public presence in the workplace and revaluing the ideal of a private sphere where political forces appear irrelevant. Twentieth-century family photography, with its resolute insistence on the creation of *happy* memories, has determinedly reflected this mood, in which politics and world affairs, even the most disruptive, are pushed to the background of public consciousness (Taylor 1994: 141).

Despite the depression, it was during the inter-war years of the 1920s and 1930s that a home-based family idyll took hold in the mock Tudor, semi-detached suburbs of English towns. Here the rising working class found for the first time 'such homes of which thousands have only dreamed' (Holland 1991). The stiff front parlour became a living room designed for leisure use and rigid gender and age divisions gave way to companionate marriage and demonstrative parenting (Davidoff in Thompson 1990: 116). The domestic ideal, built up over the nineteenth century as a space that would be calmer and morally superior to the turbulent world outside, was being narrowed down to a much smaller family, made up of two parents and their younger children, who aimed to lead a pleasurable rather than dutiful life. A state of mind was coming about in which the satisfaction of each *individual's* desire for comfort and satisfaction would not seem incompatible with the mutual

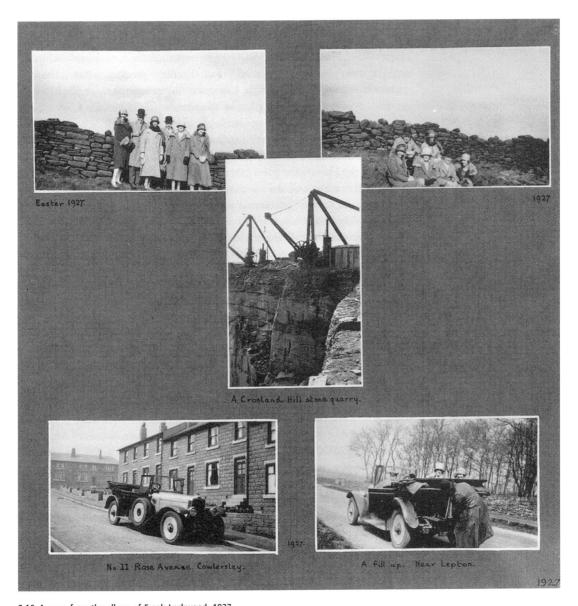

3.16 A page from the album of Frank Lockwood, 1927

Frank Lockwood was a Birmingham watercolourist and designer for Cadbury Brothers

obligations demanded by family groups. The increasing relaxation and informality appearing in family snapshots echoed that change.

The image of the child became the central icon of family life. By the 1930s the two- or three-child family was the norm, which meant that individual attention could be given to each child and there was more time for birthday celebrations, Christmas trees and the snapshots which accompany these ceremonies. The domestic camera was confirmed as a ritualised element in joint celebrations (Musello 1979). As well as the visible markers for home-centred values, children signified the aspirational optimism of a century dominated by the newly prosperous working and lower-middle classes, whose horizons seemed to be ever widening. The modest pictures of the period between the wars give off a sense of hope, a belief in progress and in the possibility of a comfortable life for all.

Despite the ideology of 'home' as a warm, familial centre, most collections of personal pictures are, in fact, dominated by time spent away from the home. As well as becoming closer and more inward-looking, the family was also becoming mobile (Slater 1995b: 132). The gradual spread of motorcar ownership meant that holidays and days out could be more private, enjoyed by the couple or the young family or the noisy, gregarious group. The domestication of the unfamiliar, by capturing it on film, has remained one of the most important uses of snapshot cameras since Kodak's first appeal to tourists and travellers. A site is not a sight until we've snapped it and made it ours, often by placing a familiar face – whether travelling companion or family member - in an unfamiliar place. Many of Kodak's early advertisements addressed themselves to those who set out in search of the impressive and the educational, but these adult activities take second place to trips and holidays which have become an indispensable element of family pleasures. Sightseeing may be for adults alone, but the centre of Kodak's advertising, from the Kodak girl on the windswept British beach to the sunsaturated images from the Costa del Sol, has been the child-centred family holiday.

In the second half of the twentieth century, increasing prosperity, together with the introduction of package tours and the establishment of an energetic tourist industry, meant that overseas holidays were to become the norm. But, while personal collections became filled with photos of Mum, Dad and the kids in ever more distant locations, pictures of *home*-based daily life emerged in *commercial* imagery. The expansion of packaged foods and branded goods brought new outlets for visual images which showed what a happily consuming family *should* be like. Commercial photographers studied how to create ever more convincing pictures of appetising food consumed by ecstatic and grateful youngsters and of well-groomed mothers delighting in their newly technologised kitchens. Such images, perfected for advertisements and promotional design, were routinely delivered to the breakfast table on cornflakes packages and baby food jars, and greeted shoppers with their

serried ranks on the shelves of the early supermarkets. The 1960s burst into commercial colour as the burgeoning products for domestic use were promoted by advertising-based supplements to the Sunday papers and an expanding range of consumer magazines which drew on the new, high-quality colour printing techniques (Crawley 1989). The lush photography on their feature pages came to cover every aspect of domestic life – from *Home and Garden* to *Mother and Baby* (Holland 1992). Snapshots and consumer imagery were fast becoming two sides of the same coin.

In 1963 Kodak produced 'a complete new system of snapshot photography' when it brought out its 'Instamatic' series of small reliable cameras (Ford 1989: 141). It was the result of ten years of research which sought to make snapshooting even easier. Cheap colour printing and faster film stocks made it increasingly possible for home photographers to emulate the sophisticated images they were seeing all around them. Snapshot photographs now came in 'bright, beautiful colours and subtle shades – like life', in the words of a Kodak advertisement from 1969. Once more, women were the target purchasers. Unlike the 'male jewellery' of massive lenses and proliferating accessories, the 'Instamatic' removed the technological mystique. Cartridge loading and fixed focus made it so simple that 'even Mum could use it'.

Advertisements encouraged a wider range of subject-matter and ever more casual and informal pictures, catching 'the moment as it happens'. Automatic built-in flash meant that colour pictures could be taken indoors, in dull weather or in the rain. 'Memories are made of this', was the slogan. Through hundreds of glowing, full-colour pictures, a couple could now confidently record every precious moment, from the birth of their first baby to their grandchildren and beyond. The last quarter of the twentieth century became the age of the 'supersnap in Kodaland'.

Those are the words of Jennifer Ransom Carter, advertising photographer for Kodak Ltd from 1970 to 1984. She produced many of those joyful images which offer themselves in advertisements and on print wallets for snapshooters to emulate. She 'tried to get pictures which were as close as possible to those that people would have liked to take for themselves'. In Majorca she photographed holiday-makers as well as models. Promotional pictures 'had to have a universal appeal, so that people would say "I want to take a picture like that . . .". We aimed to tread a line between reality and unreality as we produced a professional interpretation of the family snap.'8 And, of course, the pictures people want to keep are those that record the 'happy memories', not the messy reality. It is hardly surprising that family collections include annual pictures of Christmas dinners and birthday teas, but hardly any of the daily meal or the act of peeling the potatoes or washing up. No children's party is complete without snapshots, but crying, bullying or sulky children are definitely not for posterity.

As Leonore Davidoff has pointed out, as the family became more inward-looking, it came to contain 'the most immediate experience of love and hate,

8 Information from conversations with Jennifer Ransom Carter.

power and dependence, interpersonal attention and interpersonal violence that most people would experience in their lifetime' (Davidoff in Thompson 1990: 129). It was that gap between the enrichment and proliferation of ideal images of family life and the complexity of its lived reality which led to the damning critiques of the 1970s, particularly from the youthful and energetic women's movement. Unhappy childhoods, broken families, child abuse, disgruntled teenagers and the persistence of poverty are only a few of the all too common experiences *not* recorded in domestic pictures. The family image came to be seen as riven with fractures and contradictions. Divided, individualised, hypocritical, it was argued that 'the family' itself was coming up against its limits.

Many commentators have stressed the cohesive function of family photography, but the use of snapshots to celebrate time out and time off has meant that fun in Kodaland, seeking individual pleasures, may well be at odds with family obligations. A hint of disruption hovers nervously just below the surface of so many personal pictures. Holidays are a time for throwing off constraints, a time of sexual adventure and illicit indulgence, and in the snapshots many such moments are for ever preserved. Pictures of leisure activities increasingly include the carnivalesque - cross-dressing for the last-night party, sidling up to the Greek waiter, the work outing when everyone was impossibly drunk, the risqué nude image, the scantily clad teenage clubbers. Just as Mediterranean food and street cafés have spilled back on to previously drab British streets, the holiday mood of these snapshots remains as a reproach to dutiful lifestyles. Local pubs now cover their walls with beery pictures which verge on the lewd, where skirts are raised, the wrong husbands kiss the wrong wives, and family values are playfully - and sometimes really - put to the test. Don Slater notes that, by the end of the twentieth century, the increasing pressures from consumerism and the commercialisation of leisure - within which family photography is marketed and experienced - have meant that the use of self-representation as a form of empowerment and demystification has become even less possible (Slater 1995b: 144).

PATHS UNHOLY AND DEEDS WITHOUT A NAME?

Twenty-first-century contemplations

Giving an account of recent personal photography is a complex task. Nineteenth-century pictures are beyond living memory. They can be treated on their own terms – as documents, as aesthetic creations or as someone else's story. Twentieth and twenty-first century pictures are part of our lived experience and hint at meanings which are tantalisingly within our grasp. Almost everyone has their own collection of pictures – sometimes in albums, sometimes digitally stored on a computer, sometimes organised in packets or drawers, sometimes just scattered around in a disorderly fashion but impossible

9 Marianne Hirsch refers to our relationship with pictures of our ancestors as 'postmemory'. 'postmemory is distinguished from memory by generational distance, and from history by deep personal connection' (Hirsch 1997:

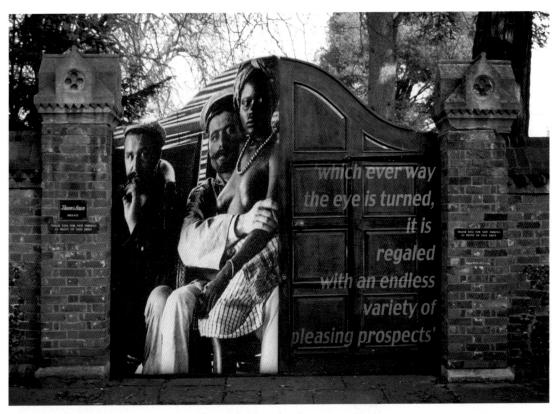

Plate 1 Roshini Kempadoo, from *Sweetness and Light*, 1996. Roshini Kempadoo's work is grounded in the documentary tradition, but she digitally manipulates images to make particular points and counter historical stereotypes

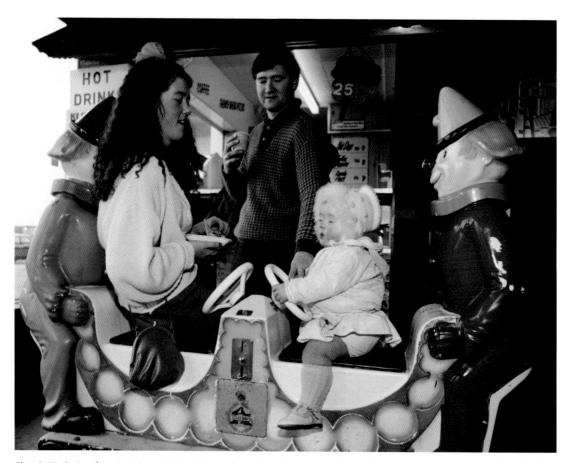

Plate 2 Martin Parr, from Last Resort, 1986. This image from Martin Parr's study of the English seaside resort of New Brighton is exemplary of his colour work and particular vision of everyday life

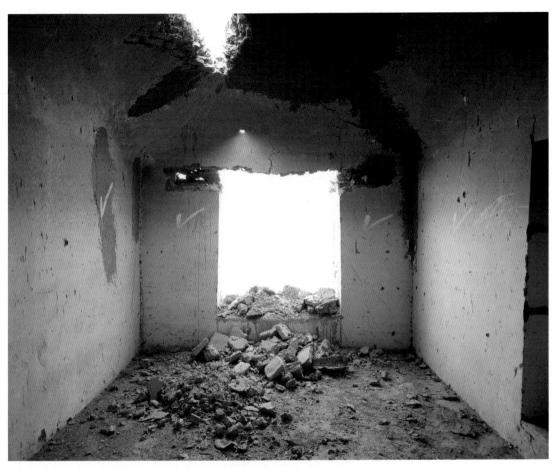

Plate 3 Paul Seawright, Room 1, 2003, 50 x 60 in. The Irish photographer was commissioned by the Imperial War Museum to photograph the aftermath of conflict in Afghanistan. This haunting image is from the collection, Hidden

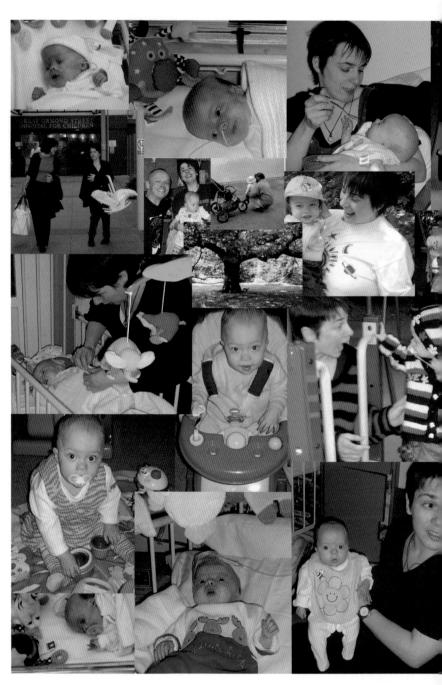

Plate 4 Nick Saunders, Eve, Karen and Nick, 2003. Digital image courtesy of the photographer

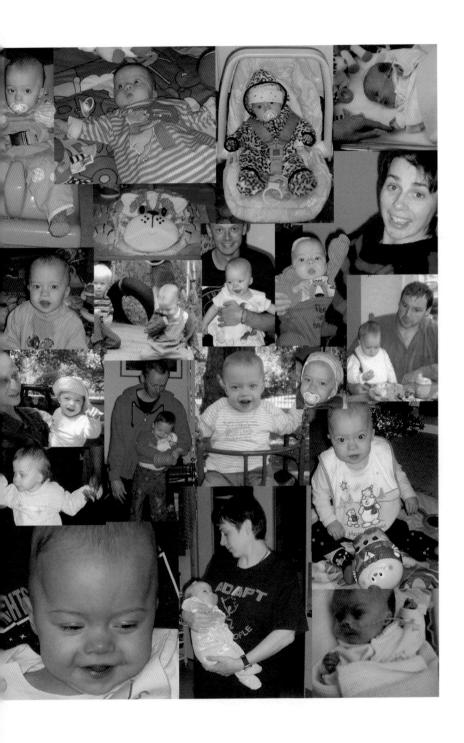

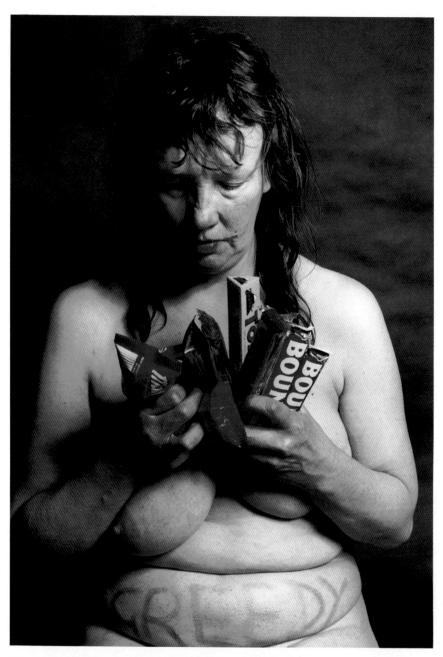

Plate 5 Jo Spence/Tim Sheard, *Greedy – I recreate my journey into emotional eating, a rebellion against parental disapproval*, 1989. Courtesy of Terry Dennett, the Jo Spence Archive, London

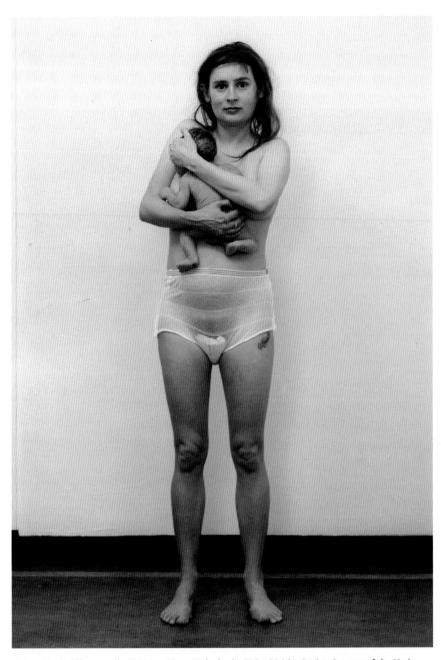

Plate 6 Rineke Dijkstra, *Julie*, 1994 Den Haag, Netherlands, 60.2 x 50.8 in. C print. Courtesy of the Marian Goodman Gallery, New York. Dijkstra's naturalistic photos represent people after or on the verge of lifechanging experiences. This image is one of a series depicting women and their new babies

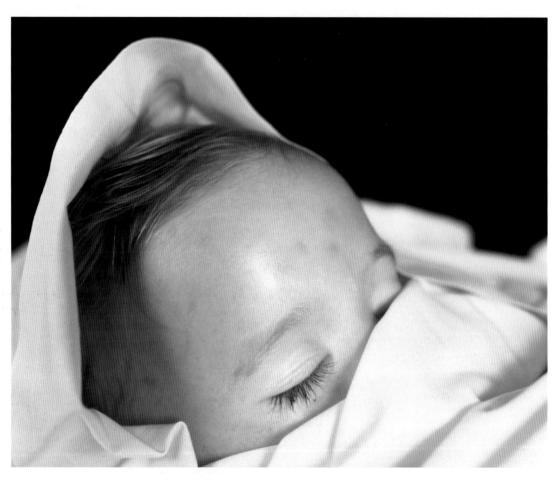

Plate 7 Andres Serrano, *The Morgue (Fatal Meningitis II)*, 1992. Serrano's morgue photographs draw on the nineteenth-century tradition, blurring the line between sleep and death

to throw away. Every collection is different, every example unique. It is no longer enough to outline a social history of such images, since any history must now include interpretations and contextual information brought by their owners and users. 10 These pictures do not stand alone but are enriched by memory, conversation, anecdote and whispered scandal. They are truly personal because they are part of the accumulated history of people currently alive, who know all too well that memories are not exclusively happy ones. Above all, they include pictures of oneself as a child and at earlier periods of one's life, pictures which carry a burden of significance that only their subjects can comprehend. It is hardly surprising that collections of such photographs hold great personal importance. In an American study of people's 'most cherished objects', many respondents broke down when describing those pictures they felt they could never part with (Csikszentmihalyi and Rochberg-Halton 1992: 68). Yet for writer Teshome Gabriel, a snapshot of himself as a young man, given to him by his mother when he returned to his birthplace in Ethiopia after an absence of 32 years, proved to be an 'intolerable gift' (Gabriel 1995). Because photography in all its forms holds the past before our eyes with unprecedented verisimilitude, a sense of the recent past, including one's own, is more vividly present to those now living than to any previous generation. Yet no photograph can give a clear and straightforward insight into the past. Personal photography, as we have seen, has a history of its own which meets up with and overlaps with social history but needs to be explored on its own terms. While many individuals bring to their personal collection the sort of emotional investment shown by those elderly Americans in the 'cherished objects' study, these are their responses as users of the images. To make sense of pictures which are not our own, we must change gear to become readers of the pictures and engage in a textual and semiotic exploration, paying attention to cultural as well as photographic codes. As we will see, many writers have argued that one may become a reader of one's own pictures, too; teasing out meanings that go beyond questions of factual memory and emotional response, giving a different sort of understanding to the history they represent.

Possibly the most frequent – and most important – image in anyone's snapshot collection is the simple shot of a subject presenting themselves to the camera, standing, perhaps in front of a famous monument or beside a car or house, but basically just being there. Yet this is the least readable of images, depending heavily on knowledge of the subject, on why the picture was taken and on its context. As Stuart Hall pointed out in relation to portraits of black Britons from the 1950s – dressed in their best and presenting themselves with great dignity – such innocence will always be deceptive, subject as it is to pressures from outside the frame (Hall 1991). The calmest portrait may offer evidence of recovery from illness or survival against the odds, and the most conventional of snaps may conceal dreadful abuse (Williams 1994: 31). Discrimination, persecution and social injustice are rarely explicit. 'How

10 At the Documentary Photography Archive, Manchester, curator Audrey Linkman creates a context for the collection of about 70,000 photographs copied from local family albums by supporting them with detailed information about the subject and the photographer.

11 *Tango of Slaves* written and directed by Ilan Ziv, *TX 31* January 1994, Channel Four Television.

JULIA HIRSCH (1981) Family Photography: Context, Meaning and Effect, New

York: Oxford University Press.

will you understand your past when all you have is photographs?' asks Ilan Ziv in his film about memories of the Holocaust.¹¹

A rereading and re-viewing of family pictures came with the radical history movements of the 1970s, which brought different ways of understanding history, more sensitive to the type of information carried by everyday documents, including personal snaps. Not only academic historians, but also reminiscence groups, women's groups and local historians, set out to challenge the politics of traditional history writing by looking at the past from a different perspective. There was a desire to write history from below, to listen to ordinary people's accounts and to recapture the texture of ordinary lives. Those who had been hidden from history - women, black people, workingclass people and many minorities - insisted on writing their own histories that ran counter to the dominant view of events, and they used personal photographs as part of the process. Arguing that women's stories have been concealed by the conventional ways of recording history, women writers drew on personal pictures to fill those absences. Projects included getting elderly women to recall their times at work, and tracing female ancestors (Stanley 1991; Grey 1991). Radical photographic movements - Camerawork, Hackney Flashers and others - joined in a campaigning attack which took on convention, capitalism and the ideology of the family.

To look back at personal pictures and tease out their meanings has meant that various different approaches to history have been brought into play. First, community histories have been recognised; histories of specific groups of many different kinds, say, the working class from the North-east of England; recent immigrants from Afghanistan; those with an Oxbridge education; second generation British Asians. Personal photographs expect to be understood within an interpretive community, a group of users who share the same understandings of pictures which record and confirm valued rites of passage and culturally significant moments (Bhabha 1990: 17). Pictures of events such as anniversaries, religious holidays and weddings are symbols of social integration. They have different significations for different cultural groups, who bring an instant recognition to the details by which the meaning of the event 'subtly overwhelms the personal aspect of the picture and fills it with allusions to tribe and ritual' (Hirsch 1981: 59).

Even while acknowledging such visible community cues, family stories may cut across communal meanings. Julia Hirsch discusses wedding photographs of mixed marriages which must find a way of dealing with two sets of cultural conventions. Family histories often tell of conflict with a community or marginality to it, of migration and mobility across the generations, so that the photographs which accompany family members shift in and out of different contexts of understanding (Solanke 1991). On investigation, many people find that their stories tell of hybridity and cultural mixing, of post-colonial guilt or resentment. Ursula Kocharian put together an album to show the complex ancestry of her sons, born in Bradford because 'so many

families were uprooted from their countries of origin due to political events'. ¹² By 'reading' the pictures, and referring to influences from popular culture, she produced a document in which cultural, political and family changes are displayed. Ursula's husband, Serge, comes from Iran, where his Armenian family fled from the Turkish massacres of 1915. Her own father came from Poland to fight alongside the British during the Second World War; his album, which he had published at his own cost, was a record of the Polish regiment's campaigns across Germany. The long pressure of political history, invisible in the simplicity of the family photographs of the two boys, has shaped the family's movements, through wars, revolutions and enforced migration (Figure 3.17).

Just as family histories fit uneasily with histories of communities, *personal* histories remain part of, yet often at odds with, the histories of families. These three different modes rub up against each other, each one important in its own right, but questioned and often invalidated by the others in a recurring dissonance that frequently underlies discussions of personal photographs.

The more ceremonial the occasion, confirming familial and communal rituals, the more important it is that certain rules are followed in the production of the photographs that mark the event. Weddings must provide pictures of the bride and groom together, dressed in the clothes that make the occasion special. 'We do not care whether it was taken, like so many other ceremonial photographs, the day before the wedding or three hours later; we care only that the man and woman look like bride and groom and uphold the decorum of formal weddings' writes Julia Hirsch (1981: 62). This is one occasion for which a professional photographer (who knows the photographic rules and will abide by them) is usually engaged, for the power of such photographs is precisely in their embrace of convention.

Nevertheless, recognising their role in creating cohesion often goes along with resisting that cohesion at a personal level. Family photographs tend to be constructed with the aid of what Marianne Hirsch describes as a 'screen made up of dominant mythologies and preconceptions', nevertheless, she adds, they 'can more easily show us what we wish our family to be, and therefore what, most frequently, it is not' (Hirsch 1997: 7–8). Pictures which live up to expectations give enormous pleasure precisely because their familiar structure is able to contain the tension between an ideal image and the ambivalence of lived experience. They can offer a framework within which understandings of the various realities we inhabit may come into play. While the historian is looking for the truths of the past, the user of a personal collection is engaging in acts of recognition, reconstructing their own past and setting a personal narrative against more public accounts (Walkerdine 1991; Watney 1991; Kuhn 2002).

While family pictures may, on the surface, act as social documents, a closer examination reveals the complex of interrelations and scandals that weave

12 Information from conversations with Ursula

The influence of Holywood even got to Iran in the 1950s Serges Unde, Haroot in striking pose on the right!

Below, Serge's father Samuel Approx. 1940.

The adventurer" with rifle and ammunition leady to go Tiger hunting in Northson Ivan and gold prospecting.

Didu't get a tiger - orany gold!

Above and right. Galipse. Serge's aunt on his mothers side.

The influence of Wallis Simpson obviously reached Ivan in the 1940's!

Galipse was, single, educated and a career woman (Matron of a large hospital in the capital Tehran)
How sad that 40 years after the first picture was taken one was forced to wear the Muslim "chador" Cefter Khomeinis Islamic revolution.
Even though, in fairness. They are allowed to remain Chistians (Armenian Ofthoda) They must conform to the Muslim dress code.

My father (standing, left.) 1942 Fighting with the BRITS after fleeing Poland.

Photo above - one of the many Army Photos taken by my, fother during the war. This one is the English Cromwell Tanks 1944-145

Afterwards he settled in England with his Smiss bride and had Barbara (my sister) in 1951.

And here they are, our children Alex & Joe (both named after Great Grandfathers) with Serge. Both born in Bradford, W. Yorks and only here as a result of so many of our family being uprosted from their countries of origin because of political events. World War II on my family's side and the 1914 Armenian Massacre and 1979 Iranian revolution on serge's

through the soap opera of personal life (Isherwood 1988; Martin 1991; Spence 1991). The placing of divorced spouses, children from a previous marriage, disgraced relatives, gay relationships, even awkward and sulky teenagers, poses problems for those who want their pictures to abide by the conventions. The very hints and puzzles they contain have enticed both detectives of family history and those who want to explore the ways in which their present identity carries the weight of the past. Personal pictures may act as an emotional centre for individual self-exploration. Autobiography, 'memory work' and forms of self-expression based on settling accounts with the past have become central to feminist approaches. The disjunction between image and remembered experience, the uncertain borderline between fantasy and memory, the tracing of identity and a sense of self back through one's parents and their sense of themselves, the opportunity to relive or re-enact the past – these have all been ways in which family photographs have been used to recapture personal history and make sense of individual lives (Spence 1987; Hirsch 1997; Langford 2001; Kuhn 2002).

During the 1980s, photographer and writer Jo Spence shed new light on the construction of complex identities, drawing on domestic photographs and family albums for her own, intensely personal work. She began by using the snapshots of her childhood to draw attention to the codes of domestic photography. At the age of five, her mother photographed her with her bubble curls and coy smile to look just like Shirley Temple. When she became a teenager she instinctively took up the pose of the glamorous pin-ups of 1950s cinema. In her exhibition *Beyond the Family Album* at the Hayward Gallery in London in 1979, she offered her awareness of the sickness, shame and struggles of everyday life as a commentary on the conventional smiles of the snapshots themselves. Annette Kuhn has written that they seemed 'conspicuous by their ordinariness . . . but in aggregate the work felt utterly out of the ordinary' (Spence 1995: 20). It contributed to a revaluation of photographic genres, so that snapshots could no longer be ignored as trivial and irrelevant.

Jo Spence went on to explore her childhood experience within her own photographic work (Plate 5). In collaboration with Rosy Martin she staged possible family pictures in a dramatic performance of concealed relationships and submerged emotion. The work developed into a practice she described as a form of therapy, working through traumatic moments and reliving the intensities of childhood usually accessible only through **psychoanalysis** (Spence 1987). Her work was embattled and engaged, determined to explore the taboos and hidden truths which bedevil family histories. She dealt with class, as she reflected on her working-class upbringing and the half-articulated exclusions that implied; she dealt with gender, approaching the world from an uncompromising feminist perspective with a campaigning edge; and she dealt with subjectivity, always 'putting myself in the picture' in a form of 'politicised exhibitionism' (Spence 1987; Spence 1995: 94). Her most striking images represent her struggles with illness as she faced an operation for

breast cancer in 1981. In a series of pictures that were also an ironic commentary on the process of photography itself, she asserted her right to define her own body. Ten years later she faced the ultimate taboo with her approaching death from leukaemia, but the project of photography remained with her until the last. In one of the few pictures which show her in the hospice where she died, she is lying to one side of the bed, almost pushed off its edge by the dozens of photographic prints spread across it. Her revelation of inner pain and her dialogue with her own body proved an inspiration for many and gave an impetus to a new generation of women photographers.

Other writers, including Annette Kuhn and Valerie Walkerdine, have also used the snapshots of their childhood to tease out the ways in which personal memory and childhood fantasy overlap, and how both interleave with the social and with popular culture. Such memories are rarely comfortable. Looking at pictures of oneself as a child can be a disturbing experience, recognising in the calm exterior of an image the traces of a turbulent inner world. In a series of articles using the insights of psychoanalysis, Valerie Walkerdine writes of an obsession with sickness, death and incestuous sexuality as she repeatedly re-contextualises a snapshot of herself in carnival dress as the

3.18 Valerie Walkerdine as the Bluebell Fairy

'Bluebell Fairy': 'Even when the images of myself present me as the feminised object of the male gaze, as a pretty little girl who smiles for the camera, there is a terrible rage underneath' (Walkerdine 1991: 40). Critical work like that of Jo Spence and Valerie Walkerdine lays bare the trauma of an ordinary childhood. Revelations about child abuse and family discord indicate that worse horrors may underlie the aspirational surface of the innocent family snapshot. Family secrecy can give way to family horror story.

Yet late twentieth-century traumas did not only come from within. With the expansion of poverty and the decay of inner city neighbourhoods, the happy memories promised by the Kodak snapshot remained a remote possibility for the disaffected youngsters and struggling single parents living on desolate estates that seemed to have been abandoned by a shrinking welfare state. The privatised pleasure-loving family began to look increasingly defensive as the gap widened between the comfortably off and the dispossessed. Family images which came to epitomise 1990s Britain were the school photos of the 11-year-old boys who murdered toddler James Bulger, and the fuzzy image from a surveillance camera which failed to prevent that atrocity (Kember 1995b; Holland 2003).

Despite the privacy of family discourse, the public narratives of community, religion, ethnicity and nation cannot be put aside. As the twentieth century ended, the public media themselves began to look back on personal upheavals. Millions now watch television programmes that trace the secret histories of ordinary people, often using their personal snapshots. It has become common for hitherto unspoken memories to be given public expression, be they of childhood distress or of global traumas, like those undergone by survivors of the Holocaust or Hiroshima. Often, such dreadful memories can only be given voice many years after the event, and the pictures treasured by those who tell their story have been used not to remember but to forget.

As Ursula Kocharian's snapshots illustrate, for huge numbers of people migration and dispossession are part of recent history. Journeys always disrupt borders, and more journeys are made from economic pressure or are enforced by war or political rupture than are made purely for pleasure. Increasing disparity between the rich and the poor nations has given rise to increasing numbers of asylum seekers in the prosperous West. Where do family albums record such present distress and memories of atrocities past? Only in sudden disappearances and truncated lives. Violence is only hinted at in the pictures of 'the old country' kept by immigrants and refugees. Whether from former Czechoslovakia, Hungary and Poland, or from Somalia, Sri Lanka, Colombia or Kosovo, the previous generations who seem so composed in their portraits have so often perished in violent conflict, famines or concentration camps. And yet the second generation of immigrants is often ashamed of its parents: they speak with an accent, their clothes are different, they cling to the past and their memories are a burden to their children. Their parents look like other people's postcards (Kalogeraki 1991: 40).

Yet, snapshots can be objects which enable the ego to 'bear the difference between now and then', ¹³ and more distant generations are able for the first time to look back at traumas suffered by their relatives, such as the sole survivor from a cultured Jewish family in Slovakia, who set about making a 'family album' which attempted to piece together obliterated family histories. ¹⁴ Andrew Dewdney launched an investigation into hybridity and mixing with a group of teachers and students in Sydney. They were the children of immigrants to Australia from Greece (driven by economic necessity) and Vietnam (driven by war). He himself is from the English port of Bristol, made rich by the slave trade. In the resulting 'extended and shared family albums', the experiences of the native Australians proved as alienating as those first generation white Australians (Dewdney 1991).

Post-family and post-photography?

At the turn of the twenty-first century, there is a public acceptance that the Western two parent, two child family which the snapshot tradition had yearned to reflect, is no longer the dominant family form - if it ever was. Second marriages, step-children, re-constructed families, single parents, same sex couples - infinite variations on the family form have become visible as never before. Arguably this is partly due to the popular exploitation of domestic imagery in new and very public contexts. Celebrity magazines, such as Hello! and OK reveal the indiscretions and private moments of the well-known and not so well-known with an appealing gloss, using photographic styles which range from the captured paparazzi shot to the formal portrait, as well as the constructed hyperrealism of contemporary fashion photography. Something of this luscious, colourful imagery can be seen reflected in family pictures of the 'post-photography' era. Digital photographic culture creates fluidity and malleability of the image, as well as instant access across continents via the Internet. Colours may be digitally heightened, imperfections erased and juxtapositions carefully arranged between the casual and the formal. Nick Saunders's richly detailed digitally-generated montage celebrates such a 'post-family' as it charts the progress of his daughter, Eve (Plate 4). Both Eve and her mother, Karen are disabled. Karen and Nick are split up and Karen has support from the local authority to help look after Eve. Nick, who lives in a shared house, is also disabled and remains a devoted and supportive father. Despite its visual complexity, the image barely hints at the complexity of the lives it reflects. Instead it focuses on Eve and her world. It is not the job of post-photography to challenge the traditional values of family photography. At the same time, irregularity and non-conformity are hardly noticed in a contemporary mood in which the mobility and changeability of family life are taken for granted.

In recent years, a fascination with the personal has brought family photography into the galleries in new ways. Some photographers have taken the world of inner experience as their subject-matter, incorporating snapshots or imitating their style (Williams 1994). Some, including Christian Boltanski,

- 13 Quoted from a lecture given by Mark Cousins at the Architectural Association, London 1994.
- 14 See also Serge Klarsfeld's meticulous collection of photographs of thousands of Jewish children deported from France, mostly to Auschwitz between 27 March 1942 and 22 August 1944, in French Children of the Holocaust: A Memorial, New York: New York University Press, 1997

have exploited the public and political dimension of personal photography (Brittain 1999: 213). Others have developed a form of domestic hyperrealism, seeking out the squalor of everyday life, peeling off the conventions of the family snapshot. Notable are Richard Billingham's painful yet hilarious images which relentlessly record, in huge and garishly coloured panels, the chaos of his parents' home, and Nan Goldin's intense yet casual pictures of the New York drug culture of which she was part. Women photographers, including Sally Mann and Nancy Honey, have photographed their children with an intimacy which questions easy judgements about childhood sensuality. Art historian Anne Higonnet comments that 'mothers know more than they used to' and argues that a maternal view of children and domestic life is for the first time validated both in art and in private photography (Higonnet 1998: 197; Mann 1992; Honey 1992; Hirsch 1997 chs 5 and 8).

But these remain the public works of photographic artists, produced and distributed within a context which is very different from that of the mundane family snapshot. However strongly they challenge the boundaries between the public and the private, they are designed to be read by the world at large. Personal photography remains a minor discourse, a knowledge without authority, designed to be used by a limited number of individuals. 15 It is precisely because of this special quality, this everyday unimportance, that we would do well to attend to what it has to tell us. The work of the German artist Joachim Schmidt, makes the point. Schmidt collects snapshots, millions of them, sent to him from all over the world. His project is to display them in new contexts; sometimes compared with the work of prestigious photographers, sometimes as multiples of images that have an uncanny resemblance to each other - a reminder of the powerful codes of personal photography which cause us to recreate the same image over and over again. These are the 'picture faces' of someone else's old friends, unfamiliar people in familiar poses, slight but powerful images whose meanings are for ever lost, because their context has been lost. Their touching anonymity reminds us that personal pictures conceal as well as reveal; they are also about forgetting.

15 French sociologist Pierre Bourdieu, in his classic 1965 study, described photography as a 'middlebrow art'.

ACKNOWLEDGEMENTS

I should like to thank Liz Wells for her invaluable editorial comments; Sue Isherwood for her early input into this article; also Barry Lane, Pam Roberts, Kate Rousse and Debbie Ireland at the Royal Photographic Society; Guillermo Marin and Arthur Lockwood for bringing me albums and other material; and Arthur for his help in rephotographing the albums; Jenny Ransom for discussing her work at Kodak; Marian and Jeanette Covington, Paula Fascht, Ursula Kocharian, Colin Aggett, Nick Saunders and Karen Smith and many others for discussing their family histories with me, lending me their very personal photographs, and in some cases allowing me to reproduce their pictures here.

CHAPTER 4

The subject as object

Photography and the human body

MICHELLE HENNING

- 161 **Introduction**The photographic body in crisis
- 164 Embodying social difference
- Objects of desire
 Objectification and images of women
 Fetishism, voyeurism and pleasure
 Class and representations of the body
 The anti-pornography campaigns
 Photography and homoerotic desire
 Case study: La Cicciolina
- 180 **Technological bodies**The camera as mechanical eye

Interventions and scientific images
The body as machine
Digital imaging and the malleable body

- 189 Photography, birth and death
- 192 Summary

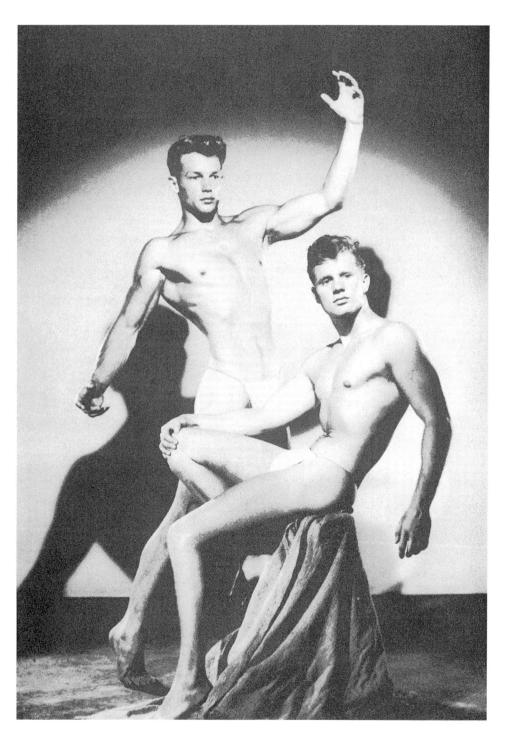

4.1 Physique image from Physique Pictorial, 4(3), Fall 1954

The subject as object

Photography and the human body

INTRODUCTION

The photographic body in crisis

Since the late 1980s, an extraordinary number of photographic practices and critical texts have taken the human body as their central subject. For instance, the work of artists as diverse as Jo Spence, Cindy Sherman, and Annette Messager reflects on the ways photography contributes to perceptions of gender and ageing. And photography is used by, for example, the installation artists Mona Hatoum and Adrian Piper to critique ideas of racial difference. Other photographers such as Fran Herbello and Inez Van Lamsweerde have used digital techniques to produce unlikely and illusionistic images, drawing analogies between image manipulation and actual body altering practices and producing unsettling composite bodies. These and many other photographers are concerned not simply with how to represent bodies, or what kinds of bodies should be represented, but with the emergence of specifically photographic ways of seeing the body, and with the role of photography in the production of desire.¹

In the 1990s, photography historians and theorists suggested that the new interest in the body in photography was linked to the emergence of new critical theories and 'body politics'. They also argued that social crises, notably the AIDS epidemic, had politicised these photographic practices (**Pultz** 1995b: 7–10, Foster 1996: 122–3). Official representations of the AIDS crisis were opposed by agitational graphics groups such as Gran Fury, and artists

1 The work of some of these artists is reproduced in widely available monographs and exhibition catalogues. It has not been possible to include full publication references for all of them. Fran Herbello's work can be found at www.zonezero.com.

JOHN PULTZ (1995) **Photography and the Body**,
London: Weidenfeld & Nicolson.

4.2 Fran Herbello, *Untitled,* from A Imaxe e Semellanza, 2000

Herbello's digital images represent the body as a kind of attire, and deal with the transformation of identity in the digital era, and the changes this may produce in our relationship with our bodies.

such as Nan Goldin documented the impact of the epidemic on actual communities and individuals (Dubin 1992: 197–225; Crimp and Rolston 1990; Kotz 1998). The fascination with the body has also been linked to the advent of new technologies and technical knowledges and new means of rapidly reproducing and distributing photographic images. At the beginning of the twenty-first century, media and art world attention has turned away

from AIDS (increasingly viewed as a 'third world' problem), but anxieties about the scientific manipulation of the human body are heightened: with fears about 'designer babies', stem cell research, cloning, and the possible effects on our bodies of genetically modified food. Developments in genetics and medicine appear to offer the possibility of radically transformed bodies (Ewing 1994: 9). In the early 1990s, many cultural theorists and writers viewed the prospect of a technologically altered 'posthuman' or cyborg body as exciting, even liberating. In the early twenty-first century, as this seems an ever more plausible reality, it is increasingly viewed in dystopian, rather than utopian terms (on the 'posthuman' see Deitch 1992; Hayles 1999; Badmington 2000).

The writer Chris Townsend argued that there have been two separate crises: first, a crisis of 'the body and social despair' and second, a crisis relating to looking, 'to the cultural uses of photography, and to disintegrating myths about the medium' which leads to conflicting views over how photography should be used to represent the human body (Townsend 1998: 8). However, the anthropologist Carole S. Vance, writing on photography and censorship in the US, shows how ideas about bodies and ideas about the meanings and uses of photographs are deeply interconnected (Vance 1990). Unlike Townsend, she sees the 'crisis of looking' and the 'crisis of the body' as closely related. Instances of censorship bring to light the way that conflict between different interest groups relates to conflicting interpretations of photography.² Vance's analysis shows how certain ways of reading photographs are used to challenge the legitimacy of different sexual practices and identities (see the section on antiporn campaigns p. 174). Her work offers one demonstration of how photographs of human bodies are caught up in social struggles, and how different views about the meanings and uses of photographs have political implications. These struggles are as old as photography, but they became particularly vivid in the late twentieth century and early twenty-first century with the rise of both sexual politics and religious fundamentalism. At the same time, the globalisation and diversification of media and the targeting of specialised interest groups has made the range of photographic representations of the body more visible than ever. In this chapter, we consider not just this recent history but also older examples which show the social significance of photographs of and about bodies.

This chapter is organised thematically rather than chronologically, to allow discussion of a number of current and historical photographic practices and debates. There are, inevitably, some important issues not discussed here, such as the representation of disability or the controversies over the photographing of children. However, the ideas and theories introduced in this chapter may be applied to a wider range of examples than those specifically considered here.

In the first section we look at how photography has been used historically as part of a broader attempt to 'read' people's bodies: especially in relation to racial and ethnic classifications and the description and analysis of social

CAROLE S. VANCE (1990) 'The Pleasures of Looking: The Attorney General's Commission on Pornography versus Visual Images' in Carol Squiers (ed.) The Critical Image: Essays on Contemporary Photography, Seattle: Bay Press.

2 This was vividly demonstrated in the reactions to Robert Mapplethorpe's touring photographic exhibition *The Perfect Moment* (1989) and to Andres Serrano's 1987 photograph *Piss Christ*. See Dubin 1992.

deviancy. The next section considers how gender and sexuality are visually coded in certain photographs, focusing particularly on erotic or 'soft porn' photographs. The third section attends to the ways in which the camera as a technology intervenes in the body, and also how it represents the body's relationship with technology, through a consideration of medical imaging, early avant–garde photography and contemporary advertising images. It also addresses how digital manipulation participates in new ways of seeing and conceptualising the human body. The final section explores the view that photography is a practice deeply associated with death, and considers photographs relating to both birth and death.

EMBODYING SOCIAL DIFFERENCE

By the end of the nineteenth century, photography was being used to classify people into 'types', illustrating and extending the Victorian sciences of phrenology and physiognomy. The success of these popular sciences in the late nineteenth century has been described as part of a 'vast attempt at deciphering the body' in which the desire to classify bodies according to visual appearance is justified by the belief that the surface reveals hidden depths; in other words, that the outer surfaces of the body could be read as a series of signs or codes revealing or expressing inner character (Magli 1989: 124). Both phrenology and physiognomy appealed to a popular enthusiasm for classification according to 'type', and both became popular in the 1840s and 1850s at the same time as photography. 'Typological' classification was reassuring to the urban middle classes because its convenient generalisations helped make the mass of strangers in the city seem more familiar. As the sociologist Simmel noted, visual appearances were particularly important in a period when new means of public transport meant that many social encounters were primarily visual encounters:

Before the development of buses, railroads and trams in the nineteenth century, people had never been in a position of having to look at one another for long minutes or even hours without speaking to one another.

(Simmel quoted in Benjamin 1938: 38)

Simplified, popularised versions of physiognomy and phrenology could be used to counteract the anonymity of urban life, and provided 'a method of quickly assessing the characters of strangers in the dangerous and congested spaces of the nineteenth century city' (Sekula 1989: 348). These 'sciences' are not, however, as harmless as they first appear. Whilst they may have reassured the dominant class, physiognomy and phrenology were also deployed as a means of social control via photography. Because it shows us only surfaces, photography is ideally suited to physiognomic and phreno-

phrenology was developed at the end of the eighteenth century by Franz Josef Gall. It was based on the idea that the contours of the skull could give clues to the mental functioning of the brain.

physiognomy was an ancient science, systematised in the 1770s by Johann Caspar Lavater, which claimed to read the character of a person through the classification of the features of head and face. Lavater saw a 'correspondence between the external and the internal man, the visible superficies and invisible contents' (Lavater 1789 quoted in Lalvani 1996: 48).

logical interpretation, and it became part of an increasingly professionalised and systematic police force.

The photographer and theorist **Allan Sekula** argues that the photographs taken for police and prison records should be seen alongside the portrait photographs that flourished at the same time. People were encouraged to read portraits using physiognomy, so the portrait of the respectable citizen emphasised facial characteristics associated in physiognomy with moral character and citizenship. The photographic police archives also relied on a physiognomic norm: the 'average man' was the physical and social ideal against which the criminal body was measured (Sekula 1989: 347, 354–6).

Photography historian **John Tagg** has also discussed photographs of criminals, using the work of the French social historian **Michel Foucault** (see

Height Head, l'gth 1m. 74 7 Circle Sel Age, 32 years Stoop width 15.4 Periph Z. S. E. M. Duts. A 1m. 84 Born in Ant 道(ligth Trunk 95.4 Fore A 48. æ wdth Pecul. 3 Remarks incident to Measurements. Inol. The Ridge, Rest (Und) Hair, Sx. Ch Beard. W. ch Base, ELLO Root, Hight. The Width M. narrow Pecul. m. long Chin, 78/ 1898 Measured

4.3 Filing card using Bertillon's 'anthropometric' system, 1898

The standardised police records initiated by Bertillon produce 'a portrait of the product of the disciplinary method: the body made object' (Tagg 1988: 76)

ALLAN SEKULA (1989) 'The Body and the Archive' in Richard Bolton (ed.) The Contest of Meaning: Critical Histories of Photography, Cambridge, MA: MIT Press.

JOHN TAGG (1988) The Burden of Representation: Essays on Photographies and Histories, London: Macmillan. also margin note p. 58) to understand how photography is used to 'discipline' people. Discipline in Foucault's sense refers to processes of surveillance, identification, classification, labelling, analysis and correction - as opposed to older regimes of punishment which did not seek to understand the deviant/deviation but rather to eliminate it. According to Foucault, in modern society, power is dispersed through social institutions (such as schools, asylums, prisons) and exists in insidious ways in everyday practices. The construction of archives is crucial to the everyday ways in which disciplinary power is exercised. Tagg quotes texts from the 1850s through to the 1970s which lay down strictures for photographing social deviants for the purpose of police, prison, asylum and legal archives. At first the photographic archive was a vast accumulation of unclassified and often unrecognisable photographic portraits, but in the 1880s a French bureaucrat, Alphonse Bertillon, developed techniques to standardise police records and enable identification of repeat offenders. He used photography as a means to train police in the classification and recognition of different facial features. His filing card system involved detailed measurements of the criminal, description of identifying marks, and use of two photos - front view and profile - which were taken using standardised focal length and lighting (Lalvani 1996: 109; Sekula 1989: 357-63, Kemp and Wallace 2000: 144-7).

To study the disciplinary uses of photography means considering the ways in which people are represented, arranged for the camera, made available to be gazed at, and placed in a system of signification which codes and classifies them. As Tagg notes, we can see

a repetitive pattern, the body isolated; the narrow space; the subjection to an unreturnable gaze; the scrutiny of gestures, faces and features; the clarity of illumination and sharpness of focus; the names and number boards. These are the traces of power, repeated countless times, whenever the photographer prepared an exposure, in police cell, prison, consultation room, home or school.

(Tagg 1988: 85)

Perhaps one of the most striking photographic techniques derived from physiognomy and phrenology is composite portraiture. This was introduced by Francis Galton in the 1880s. Galton developed a technique for superimposing a number of photographed faces of people with shared characteristics or circumstances. The composite image produced in this way supposedly revealed hereditary physical characteristics, the surface 'symptoms' of innate biology. At first he presented his technique as useful in the diagnosis of disease, but he also attempted to use composite portraiture to reveal the characteristic physiognomy of different 'types': the faces superimposed may all have committed the same crimes, or belong to the same ethnic groups. Galton's method is centred around a concept of race: using phrenology and

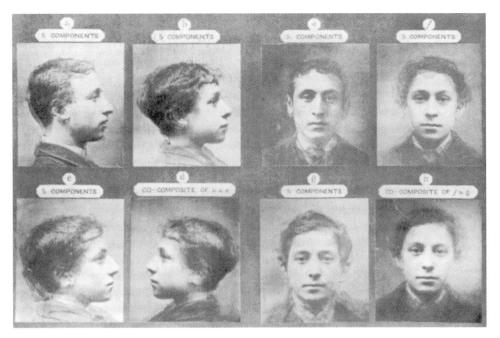

4.4 Francis Galton, *The Jewish Type*, composite photographs, 1883
Joseph Jacobs, the Jewish man who commissioned these images, saw them as validating Jewish identity, but they also reinforced Galton's own anti-Semitic views

physiognomy, he naturalised social differences by describing social 'types' in terms of biology, that is, along the lines of race. In his work, different cultural groups or social classes appear as separate races with definite and visible physical characteristics.

So the popular sciences of phrenology and physiognomy, combined with new photographic techniques, produced a new and fundamentally racist vision of society. It is perhaps not surprising to learn that the racial classificatory system that Galton developed was later embraced by Nazism. It was Galton, the pioneer of composite photography, who introduced the 'science' of eugenics. Eugenics proposed that intellectual and moral qualities were hereditary and that some races were therefore superior to others. As well as conveniently providing a justification for European colonialism, eugenics represented class differences as biological, viewing the inclination of the lower social classes towards deviance as the result of a lack of hereditary good qualities.

These photographic practices are not confined to the nineteenth century. For instance, Sekula compares Galton's work to the recent use of composite (digital) photography by the American artist Nancy Burson, challenging the social and political implications of Burson's practice (Sekula 1989: 377). Burson's work questions nuclear weapons policies, advocates social welfare

4.5 Nancy Burson, Warhead I, composite image, 1982

Using computer imaging to superimpose faces, Nancy Burson updates the composite photography technique invented in the nineteenth century.

3 However, it could be argued that finding missing children is a different kind of activity from establishing the criminal 'type'. There are also problems with regarding all uses of composite imagery as leading us to physiognomy or eugenics. The photographer Gerhard Lang also uses Galton's techniques, but with closer attention to their social and historical significance and in more precise ways than Burson. See Kemp and Wallace 2000, pp. 190-9.

4 'I had Bill Clinton's Baby', Marie Claire 104, April 1997, p. 92. Even this mechanised composite uses racial typology - as well as programming in the preferred sex of your child you can choose your child's racial characteristics from 'Asian, Afro-Caribbean, Hispanic or Caucasian'. Chapter 5 gives a contemporary example of the way this works: some of Benetton's ads, while ostensibly about global harmony, use visual signifiers of racial and ethnic identity which reproduce ideas of absolute racial difference.

and tackles the conventions of feminine beauty, but like phrenology, it emphasises surface appearances. It has also been argued that the fact that Burson has used her methods to help find missing children 'returns the art of composite portraiture to the purposes for which Galton originally designed it', for police detective work (Taylor 1997: 57).³

Computer-generated composites have also become a form of entertainment: 'Foto Morphosis' photo-booths combine the faces of two individuals to produce their 'virtual reality' child.⁴ Composite imaging of a different sort, the 'photo fit', is regularly used by the police to attempt to identify criminals, and is based on classifying facial features according to type (this kind of mouth . . . or this kind?). Aspects of physiognomy and phrenology also exist today in market research attempts to identify and classify the consumer, just as the nineteenth century attempted to characterise strangers in the urban crowd. Most advertising today is too sophisticated to simply provide visual representation of the 'ideal consumer', but it still frequently deploys images of individuals as 'types'.

OBJECTS OF DESIRE

Objectification and images of women

Even erotic imagery depended on the classification of social types, though not primarily through physiognomy. Clothing and props act as signifiers of class and occupation in Victorian pornography. These images represented social types considered to be sexually available: for example, the laundress. The art historian Eunice Lipton has shown how, in Paris, the laundresses' low pay, visibility (the laundries were open on to the street), and tendency to drink wine to counteract the heat of the laundry, led to their reputation as sexually 'loose' women (Lipton 1980). Other Victorian pornographic images showed women and couples in clearly middle-class domestic surroundings.⁵

Today, erotica also works through classifying its subjects into recognisable types – in this way it makes different women appear sexually available to a presumed heterosexual male viewer. And, just as the criminal photograph reduces the depicted person to a series of signifiers, so pornographic images offer women as available objects of fantasy by attaching certain meanings to a narrow set of signifiers.

In the 1970s and 1980s, such representations of women became a focus of feminist criticism. Feminists questioned the existing distinctions between legitimate and illegitimate images (such as 'hardcore' pornography) which were based on degrees of explicitness of nudity and/or sexual activity.⁶ They criticised advertising and publicity images as well as erotica for eroticising the female body in a way which turned women into mere objects for a male gaze, a process usually termed **objectification**.⁷

The concept of objectification has special relevance to photography. In one sense photography inadvertently objectifies people by turning them into

- See figure 3.4 in chapter 3 which hints at this reputation, though more explicitly sexualised images of laundresses were also common.
- 5 Detailed discussion of Victorian erotic and pornographic photography can be found in Solomon-Godeau (1991c); Kendrick (1987), and Williams (1995),
- 6 The argument against the traditional 'hard'/'soft' distinction is put by Brown (1981).
- 7 Solomon-Godeau concludes that 'it may well be that the most insidious and instrumental forms of domination, subjugation and objectification are produced by mainstream images of women rather than by juridically criminal or obscene ones' (Solomon-Godeau 1991c: 237).

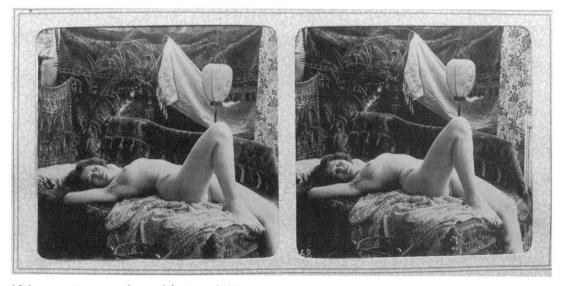

4.6 Anonymous stereoscope photograph from around 1895
The plants, fabrics and lamp in this image are used to suggest an exot

The plants, fabrics and lamp in this image are used to suggest an exotic interior associated with the Orient and with the harem

things to be looked at (Solomon-Godeau 1991c: 221–2). But it has also been suggested that in everyday life women are already constituted as objects to be looked at and men as 'possessing the **gaze**'. According to this argument, women internalise the male gaze to the point that they survey themselves. This relationship has been expressed by the critic John Berger:

Men look at women. Women watch themselves being looked at. This determines not only most relations between men and women but also the relation of women to themselves. The surveyor of woman in herself is male: the surveyed female. Thus she turns herself into an object – and most particularly an object of vision: a sight.

(Berger 1972a: 47)

If women are already objectified by the male gaze, and if objectification is in any case what photography does, then photographic images of women are doubly 'objectifying' (see Solomon-Godeau 1991: 221–2). We need to consider not only how photographs present women's bodies for a male viewer but also how this process spills over into everyday life and into how men view actual women, and how women view themselves. In relation to this 'spilling over', the everyday cultural objects, domestic settings and familiar poses used in soft porn and advertising are significant, because, as feminist theorist Beverley Brown has argued, this limited visual vocabulary operates as a 'short-cut' to sexual fantasy and in turn, leaves everyday life with a 'certain afterglow' (Brown 1981: 138–40). In advertising, this process is part of the attempt to eroticise commodities (see ch. 5).

Fetishism, voyeurism and pleasure

Photography theorists have made use of psychoanalytic theory to analyse how photographic images construct women as objects for a male gaze, and how the visual pleasures of looking at such images are implicated in the exercise of power. In particular the concepts of **voyeurism** and **fetishism** have been influential. These concepts were most famously formulated by Sigmund Freud, and have been developed by more recent psychoanalysts, notably Jacques Lacan, Melanie Klein and Luce Irigaray (see Gamman and Makinen 1994: ch. 3). However, we will focus here on the terms as they were initially developed by Sigmund Freud (Freud 1905, 1927). (See also note p. 33.)

A Freudian approach considers the spectator's experience of visual pleasure in terms of his or her subjectivity which is shaped from early childhood. This visual pleasure or 'scopophilia' is usually understood as an erotic pleasure gained in looking at another person or at images of other bodies. This pleasure is voyeuristic when it is dependent on the object of this gaze being unaware, not looking back. Voyeurism is a form of objectification which Freud saw as originating in childhood curiosity. At its extreme, it becomes an obsessive

sexual practice. Voyeurism describes a mode of looking related to the exercise of power in which a body becomes a spectacle for someone else's pleasure, a world divided into the active 'lookers' and the passive 'looked at'. To some extent photography, by the very nature of the medium, invites voyeuristic looking, although some photographs, such as those which depict a normally private or taboo activity and a subject apparently unaware that they are being photographed, are more explicitly voyeuristic (Sontag 1979: 11–14). The concept of voyeurism is applicable not only to sexualised or erotic images, but also in relation to the depiction of colonised peoples and of disability as spectacle.

Another concept which has been central to Freudian analyses of photography is fetishism (see Burgin 1982: p. 177ff). In Freudian psychoanalytic theory an important moment in the shaping of the self is the point at which the child becomes aware of sexual difference and moves away from its early close relationship with its mother: this process of entry into sexuality is what produces, in some people, sexual fetishism. Freud's definition of fetishism is derived from older anthropological definitions, in which an inanimate object takes on special powers such as warding off danger and misfortune and is the centre of religious rituals. In Freud's interpretation, an object becomes a fetish when it becomes the focus of (usually male) sexual desire. The male child develops an unconscious fear of castration at the sight of a woman's body, and fetishism is one means of allaying this anxiety: in a process termed 'disavowal' the fetishist knows but suppresses his knowledge of her 'lack' (of a penis) and idealises objects associated with the woman (for example, shoes).

The use of Freud's concept of fetishism to explain visual pleasure is controversial because it relies on the theory of male castration anxiety which implies that the fetishist is by definition male (Gamman and Makinen 1994: chs 3 and 6). Nevertheless, it is useful for thinking about the ways in which certain photographic styles and techniques are linked to objectification. For instance, the film theorist **Christian Metz** argued that a photograph works like a fetish because it freezes a fragment of reality, 'cutting off a piece of space and time . . . keeping it unchanged while the world around continues to change' (Metz 1985: 85).

In the same way, fetishism, in Freud's interpretation, involves freezing a moment (the moment before the trauma of recognition) and fixating on a fragment, an object associated with the woman. Most of all, the photograph can be a fetish because of its physicality – we can touch and hold a photograph: 'The familiar photographs that many people carry with them always obviously belong to the order of fetishes in the ordinary sense of the word' (Metz 1985: 87).

But perhaps the reason why the theory of fetishism has been so important in analysing film and photography is that it helps to account for the ways in which visual images seem so often to objectify and fragment women's bodies in a way that is not common in representations of the male body.

8 In particular, it is a useful corrective to the tendency towards a literal interpretation in which a pornographic image which does not include a woman's head has 'decapitated her', or flattening lighting made for a 'one-dimensional' representation. Instead, a reading based in the concept of fetishism suggests flattening and fragmentation are part of the process by which the pleasures of looking at the image, or handling the object (a magazine page, a photograph), are translated into the pleasure of looking at (or imagining touching) the depicted body.

CHRISTIAN METZ (1985) 'Photography and Fetish', **October** 34, Autumn.

LAURA MULVEY (1975) 'Visual Pleasure and Narrative Cinema' Reprinted 1989 in **Visual and Other Pleasures**, London:

9 In 1957 Roland Barthes observed similar qualities in the cinematic representation of the face of Greta Garbo (Barthes 1986: 56–7).

10 However, an advertisement such as this is clearly intended for a female readership. Even taking into account Berger's argument that women internalise the male gaze, the Freudian theory of fetishism is inadequate in explaining the fetishistic qualities of these advertisements (Gamman and Makinen 1994: 37–44, 95–105).

Freud's definition of fetishism can be understood in relation to the Marxist explanation of commodity fetishism: in which goods exchanged in a market appear to have value independent of the human labour that produced them, and independent of their usefulness. What a commodity is worth comes to seem 'natural' or inherent, comparable to the value of other commodities in the same way that their weight or size might be compared. It is this mystification of commodity value which Marx refers to as fetishism.

LAURA KIPNIS (1992) '(Male) Desire and (Female) Disgust: Reading Hustler' in Lawrence Grossberg et al. (eds) **Cultural Studies**, London and New York: Routledge

11 Hustler had been used by Andrea Dworkin to demonstrate the misogyny she believes to be central to pornography (Dworkin 1981: 29–30). Kipnis' argument is a critique of approaches such as Dworkin's, which focus exclusively on gender in their discussions of pornography.

In a well-known essay, the film theorist and filmmaker **Laura Mulvey** used the theory of fetishism to explain ways in which certain films objectify the female star. She suggested that the female figure on screen is potentially troubling to male spectators: 'the woman as icon, displayed for the gaze and enjoyment of men, the active controllers of the look, always threatens to evoke the anxiety it originally signified' (Mulvey 1989: 21).

Mulvey contended that the male spectator is unconsciously reminded of the traumatic moment when he recognised sexual difference. One way he can deal with this is by disavowing it through fetishism. Mulvey suggests that certain films turn the represented figure of a female star (such as Marlene Dietrich) into a fetish by bringing together the beauty of the film as spectacle, the play of light and shadows, with the beauty of the woman as object. Close-ups, lighting and make-up fragment, flatten and render the female face one-dimensional (Mulvey 1989: 21-3). The formal qualities of the projected image are the reassuring substitute object which distracts the male spectator from the threat that the woman poses. 10 Although Mulvey is discussing motion film, we can see similar qualities in the representation of the female face in current cosmetic advertisements in women's magazines. Here, a blank space in the image stands in for flesh: the faces are flattened with no shadows visible, reduced to a set of facial features arranged on a smooth and atonal expanse of skin. In this way the medium and image are conflated, the glossy, smooth feel of the magazine page stands in for the woman's skin (see Burgin 1986: 19).

In most accounts of fetishism (not just psychoanalytic accounts), the desirability of objects is related to a conflation of the human and the object world, so that things appear to be inherently desirable or valuable, even animated. (Leslie 2002: 6–8). Reciprocally, human beings become perceived and represented as objects. The rise of fetishistic representations of women in both pornography and advertising photographs is connected to the development of a capitalist economy, and to the fetishising of commodities. Fetishism describes not just a sexual preference of a minority (classified by Freud as one of the 'perversions') but a culturally dominant way of seeing both the object world and ourselves.

Class and representations of the body

One useful question raised by the debates around photographic images of women is how we distinguish a feminist political opposition to these images from a more conservative disgust at the portrayal of aspects of the body that are normally kept hidden from public view (Rodgerson and Wilson 1991: 28). The cultural theorist **Laura Kipnis** uses the example of the pornographic magazine *Hustler*. It Kipnis argues that *Hustler* needs to be understood in terms of class as well as gender, since it sets out primarily to provoke and disgust the 'establishment' (Kipnis 1992: 373–91).

To understand what disgust has to do with class, we need to look briefly at the history of attitudes towards the body. The historian Norbert Elias has described the change in attitudes that occurred as part of a shift from feudal society to a capitalist system in Europe. He suggested that, as a new class becomes dominant, it transforms the dominant ideas about the body and bodily decorum that had prevailed in the old social order (Elias 1994).

Medieval, feudal society was rigidly hierarchical, and control of bodies was a central part of social control of the population. But, as the Russian literary theorist **Mikhail Bakhtin** pointed out, in the medieval carnival these hierarchies were disrupted, and ideas of bodily decorum ridiculed or ignored. Carnival was the legitimate space where bodily excess was celebrated, where the lower body, orifices, reproduction, eating, defecation and copulation, pregnancy, birth and death were openly represented (Stallybrass and White 1986: 13; Dentith 1995: ch. 3). 12

Bakhtin referred to this carnivalesque body as the 'grotesque' body. In the grotesque conception of the world, birth and death are cyclically related, and bodies are understood in collective terms, linked to one another and the world and continually growing and changing. Gradually, the grotesque body of the carnival was displaced by the dominant representation of the body, epitomised by the classical nude. The classical body is a smooth, orifice-less and self-sufficient body. While the grotesque tradition represents the body as ever-changing, from birth to death, and connected to the earth and to other bodies, 'classical' representations of the body omit these aspects: 'The ever unfinished nature of the body was hidden, kept secret; conception, pregnancy, childbirth, death throes, were almost never shown' (Bakhtin 1984: 29).

One way the merchant classes in the sixteenth century and the industrial bourgeoisie in the eighteenth century maintained their political **hegemony** was through strictures about bodily control and decorum. Capitalist society places enormous emphasis on individualism, constructing a strict separation between the 'private' and the 'public'. Increasingly, the classical body became the publicly acceptable representation of the body in modern society, while those aspects associated with the lower body and the body's connection with the world were banished to the realm of the private, seen as disgusting and shameful, displaced into illicit and secret representations which were unmentionable and invisible in 'polite society' (Stallybrass and White 1986: 188). However, the advent of photography as mass reproduction made this division increasingly hard to control and the representation of the disgusting, the base, the distasteful became a means of challenging social hierarchies.

Kipnis sees *Hustler* in this light. She contrasts *Hustler*'s use of photography with the more 'tasteful' images of *Playboy* and *Penthouse*:

The Hustler body is an unromanticized body – no vaselined lens or soft focus: this is neither the airbrushed top-heavy fantasy body of Playboy,

12 Other writers argue that it was legitimate precisely because it made it easier for those hierarchies to remain in place the rest of the time. See Stallybrass and White 1986: 13; Dentith 1995: 73–4.

MIKHAIL MIKHAILOVICH BAKHTIN (1895-1975) Bakhtin was a Soviet literary theorist. In 1929 he was arrested by Stalin's regime and until his death in 1975 worked in internal exile in the Soviet Union. His work focused on culture as a reciprocal process, and especially on the relationship between representation and social conflict, in which subordinate groups modify and reinterpret the representations produced by the dominant social class. His work was controversial and subject to censorship, since it defended the idea of multiple and conflicting perspectives ('heteroglossia') at a time when the Stalinist government was attempting to impose one ideological worldview. Bakhtin's most famous writings include the essays written in the 1930s and early 1940s, published in The Dialogic Imagination (trans. Caryl Emerson and Michael Holquist, University of Texas, 1981).

Bakhtin wrote about carnival and the grotesque in relation to the work of Rabelais and Dostoevsky in books eventually published in the mid-1960s: Rabelais and his World (trans. Hèiëne Iswolsky, Indiana University Press, 1984) and Problems of Dostoevsky's Poetics (trans. Caryl Emerson, University of Manchester Press, 1984).

nor the ersatz opulence, the lingeried and sensitive crotch shots of Penthouse, transforming female genitals into *objets d'art*. It's a body, not a surface or a suntan: insistently material, defiantly vulgar, corporeal.

(Kipnis 1992: 375)

But being insistently 'grotesque' does not necessarily make an image politically radical. The targets of carnivalesque ridicule and attack were just as often social outsiders or those considered inferior, such as women. To understand a reaction of shock or disgust at a photograph may mean paying attention to complicated intersections of categories such as class and gender. Middle-class women's disgust at the explicit representation of women's bodies for a male audience is inseparable from their own relationship to images of women's bodies and to their own bodies. Attempts to legally restrict the distribution of explicit photographs of women's bodies or of sexual activity were made to protect 'ladies' against seeing such representations, though the film historian Linda Williams suggests that they saw them nevertheless (Williams 1995: 25). This attitude to middle-class women as (potential) viewers of sexually explicit imagery is part of a wider ideology which incited in middle-class women a disgust at their own bodies. 'Ladies' were encouraged to develop a delicate 'feminine' sensibility premised on the repression and unmentionability of bodily experiences such as menstruation, excretion, and even childbirth: 'Since "respectable women" were defined precisely by their selfdistancing from such indecent domains they were the social group most remote from any access to available symbolic articulations of the lower body' (Stallybrass and White 1986: 188-9).

By the late nineteenth century these 'symbolic articulations' included photographs. Even today, a middle-class woman's first encounter with a pornographic magazine may be an encounter with carnivalesque pleasures from which she knows she is excluded; she is not the intended viewer of these images, though she may be the object of the fantasies. Her disgust at these images may be a combination of her learned disgust at the lower body, her horror at the knowledge of her own exclusion (a body like hers is offered up for the pleasure of the readers, while she has had so little access to such representation) as well as feminist outrage at the ways in which the conventions of pornographic imagery construct the woman as an object of male sexual fantasy.¹³

The anti-pornography campaigns

Although, as Kipnis argues, feminist analyses of pornography have tended to underestimate the significance of class, they have effectively drawn attention to its often extreme misogyny and its role in women's subordination. In the 1980s, a number of feminist campaigns against pornographic imagery gained momentum, such as the 'Off the Shelf' campaign organised by the Campaign

LINDA WILLIAMS (1995)
'Corporealized Observers: Visual Pornographies and the Carnal Density of Vision' in Patrice Petro **Fugitive Images**, Bloomington: Indiana University Press.

13 Disgust and desire are not necessarily mutually exclusive: 'disgust always bears the imprint of desire. These low domains, apparently expelled as "Other", return as the object of nostalgia, longing and fascination' (Stallybrass and White 1986: 191).

Against Pornography in the UK.¹⁴ These campaigns were influenced by the American Radical Feminists, such as Robin Morgan, who argued that 'Pornography is the theory – rape is the practice' and Andrea Dworkin, who famously stated: 'Pornography *is* violence against women' (Rodgerson and Wilson 1991: 26; Dworkin 1981). Dworkin's critique of pornography is passionate and almost evangelical in style, and has been very influential. It differs from previous forms of feminism in seeing texts (both visual and written) rather than social discrimination, as central to male dominance. However, it depends on a very narrow interpretive approach to photographs, and offers little evidence for the view that a photograph can be a *cause* of violence against women (Kendrick 1996: 231).

Other feminists, such as the group Feminists Against Censorship, argued that the anti-pornography campaigns risked undermining women's right to enjoy sexual and erotic imagery (Chester and Dickey 1988; Rodgerson and Wilson 1991; Segal and Macintosh 1992). A number of writers have pointed out how the category 'pornography' is a misleading one, and that we should pay attention to the range of images and audiences for whom 'pornography' has widely differing meanings and uses. As the critic Katherine Enos puts it:

For conservative feminists and the religious right, pornography is the theory, the rape and murder of women the practice. For queer culture, the production of their own pornographies can be a self-affirming form of representation in a straight culture where a 'lesbian kiss' on TV is so unheard of as to be a matter of public debate.

(Enos 1997/1998)

As the above quote implies, anti-pornography feminism found allies in political groups which were usually opposed to feminism. Whilst left-wing political parties were happier to support feminists on this issue than on many other feminist arguments, the religious Right also found it acceptable, even taking on board aspects of feminist arguments, such as the objectification argument. 15 However, as the artist and writer Deborah Bright argues, the right wing, particularly in the United States, was primarily interested in responding to the new-found visibility of many minority communities and tackling what they saw as 'enemies within', such as 'immigrants, those on public assistance, young unemployed black men, unwed mothers, and gay men and lesbians' (Bright 1998: 1). State-funded arts agencies in the United States were relatively supportive of community-based art in the 1970s and 1980s. Right-wing groups responded by attacking state funding of photographic images which dealt with issues related to minorities, and especially to homosexuality. In particular they questioned the funding by the National Endowment for the Arts (NEA) of exhibitions of photographs which they saw as undermining norms of decency. They considered images which could be read as pornographic, sacrilegious or blasphemous as unsuitable for state funding; this

14 Previously, attention had focused on writing rather than images. One explanation for feminism's new focus on the visual image is that most visual erotica seemed to be of women and for men, while written erotica more frequently addressed a female audience. The Kinsey report research of the 1940s suggested that women are less sexually aroused by images than by literature, and this view is still commonly held. Walter Kendrick points out that attitudes to pornography in America (and Britain) have now shifted so much that "Pornography" now means pictures, preferably, moving pictures' (Kendrick 1996:

15 The feminist lawyer Catherine MacKinnon drafted anti-pornography legislation in Minneapolis which was then adopted by right-wing legislators in Indianapolis and New York (legislation subsequently declared unconstitutional).

DEBORAH BRIGHT (1998)
The Passionate Camera:
Photography and Bodies of
Desire, London and New York:
Routledge.

usually meant photographic representations of bodies, body parts, bodily fluids or sexual practices. Most notorious were the 1989 attacks on exhibitions of the photographs of Robert Mapplethorpe and Andres Serrano, both funded by the NEA, leading to (self-) censorship of this work by museums and galleries, and to legislation restricting the NEA's grant-giving powers (Bright 1998: 6–7).

Photography and homoerotic desire

Whereas feminist writers have pointed to photography's role in naturalising or reinforcing gender hierarchy, Christian fundamentalists see certain kinds of photographs (or photographs of certain subjects) as naturalising and endorsing improper or illegitimate activities and identities. They attribute particular power to photographs because of their immediacy, tending to treat the photograph as directly reflecting reality, and somehow capable of causing deviant behaviour. Carole S. Vance has argued that, because it is very easy to change a photograph's meaning through recontextualising it, campaigners could elicit support through exposing unfamiliar audiences to, for instance, decontextualised images of naked children or sadomasochistic sex (Vance 1990).

The New Right objected to the visibility of forms of sexual 'deviance' – in particular, homosexuality – and their aim was to suppress this visibility through legislative measures. The conservative tendency to idealise an earlier America, of the 1950s, is partly based in a belief that images appealing to such deviant desires were a more recent phenomenon.

While it is true that in the 1950s gay men and lesbians had little access to images or media representations which represented homosexuality, and those which were available usually portrayed it in a negative light, some writers have argued that homoerotic desire was addressed by certain images and texts, but in highly coded ways to avoid censorship. The art historian **Emmanuel Cooper** explains how the American 'physique' magazines of the 1950s, which were primarily photographic magazines depicting toned and muscular male bodies for a male readership, legitimated their male readership's interest through the use of visual references to classical antiquity (Cooper 1990: 100–1). These classical references work in a dual way: legitimating the images by emphasising their aesthetic (rather than erotic) nature; and simultaneously working as coded references for the readership, drawing on the homoerotic associations of ancient Greek art and culture.

However, the art historian Gavin Butt argues that the repressive culture of 1950s America meant that readings were fragile, based in connotations and associations dependent on the viewer's own homoerotic desire. The heavily coded nature of the image is evidence of the illegitimate and unspoken nature of such desire at the time, rather than of a thriving 'gay' identity (Butt 1998: 280). As well as references to classical art, the physique photos included certain 'campy' references. For instance, in Figure 4.1, (p. 160) the use of studio

EMMANUEL COOPER (1990) Fully Exposed: The Male Nude in Photography, London: Unwin Hyman. props emphasises the contrived nature of the image, avoiding any attempt to make the image appear naturalistic. In addition, the poses struck by the models are not so much accurate copies of classical poses but a 'kitsch approximation' which emphasises the image's own artifice (Butt 1998: 279; Cooper 1990: 102) (for a discussion of kitsch and camp, see p. 180). Even the models' carefully developed bodies had homoerotic associations, displaying developed torsos yet 'slim-hipped, with the legs of ballet dancers' (Michael Bronski, quoted in Butt 1998: 280). These images pre-date the 1970s, when male homosexual identity became more visible and distinct, and specifically gay cultural forms were constructed.

In the 1980s, a new sexual politics, partly developed in response to government policies regarding HIV and AIDS, rejected older gay and lesbian attempts to be accepted within the status quo and instead challenged the dominant construction of 'normal' versus 'deviant' through a revival and reinflection of the category 'queer'. Queer activists demanded public visibility for people and practices deemed 'abnormal' or 'unnatural' in the face of a history of social invisibility and repression.

Part of this new sexual politics was a re-evaluation of the cross-dressing which was an important part of working-class 'butch/femme' lesbian culture in the early twentieth century. Previously, this had been dismissed by lesbian feminists as a sign of repression, and as reinforcing old 'inversion' theories of homosexuality (in which lesbians are 'mannish' women). Queer politics shed a different light on this history, celebrating cross-dressing as undermining fixed gender roles. Whilst lesbian photographers challenged anti-pornography feminism by producing lesbian erotica, including SM images, queer photographers emphasise role-playing and cross-dressing, questioning the stability and naturalness of gender.

CASE STUDY: LA CICCIOLINA (FIGURE 4.7)

This chapter has outlined a number of different arguments and theories related to the photographic representation of the human body. Using a case study we can explore how these general arguments might be applied to a specific image: a photograph of the Hungarian-Italian 'porn star' Ilona Staller, known as La Cicciolina.

Earlier in the chapter, I looked at how erotic imagery uses props and settings to classify bodies as social types. This tendency impinges on people's everyday lives, insofar as this typology is then applied to actual people: affecting, for instance, how men view women, and how women view themselves. Yet Schicchi's photographs of *La Cicciolina* suggest that photographs do not have to use this vocabulary to 'count' within the porn/erotica industry. The props in the photograph shown here – (painted) bubbles, a gold waistcoat, a goose, and broken

4.7 La Cicciolina (original in colour)
In Italy, Ilona Staller is a well-known porn star who performs in hardcore stage shows and films, as well as modelling for softcore magazines. In June 1987 she was elected to the Italian Parliament as an MP for the Italian Radical Party. This photograph is taken by Riccardo Schicchi, with whom she usually works

classical columns – do not add up to any recognisable everyday situation, nor are they readable signifiers of class or social position. The only obvious connotations are of fairy-tales, signified by the goose (and its fairy-tale connection with gold). *La Cicciolina* herself is clearly situated as a figure of fantasy, not a real social type or 'girl next door'.

The lack of realism in pornographic colour photography was noted in the 1950s by one of the founders of Cultural Studies in Britain, Richard Hoggart. He commented on the new 'technicolour cheesecake' magazines which he saw as part of the Americanisation and de-politicisation of British working-class culture.

Everything has been stripped to a limited range of visual suggestions – can one imagine a musky body-smell, un-artificially disordered hair, an uneven texture to the skin, hair on the arms and legs, beads of perspiration on the upper-lip, on one of these neatly-packaged creatures?

(Hoggart 1957: 191)

Hoggart then goes on to imply that this lack of realism might encourage 'sexual immorality'. ¹⁶ His view contrasts interestingly with the way the right-wing anti-pornography campaigners of the 1980s read photographs as direct, scarcely mediated, reflections of real situations (Vance 1990).

In fact Hoggart's description could apply to the *Cicciolina* image, with its absence of shadows and three-dimensional space. As noted above, this flattening is particularly common in photographs of women, making the pleasure of looking at the person depicted inseparable from the visual and tactile pleasure provided by the picture. It turns the photograph into a fetishistic substitute, defusing the threat suggested by the female body. The same visual qualities produce what Bakhtin characterises as the classical body. The classical body represses or conceals aspects of real existence in favour of an idealised norm. As Kipnis argued, more 'respectable' softcore magazines such as *Playboy* and *Penthouse* tend towards smooth, unblemished classical bodies. Schicchi and Staller take this to an extreme, so that even in the more explicit images *La Cicciolina*'s body is decidedly un-corporeal, with atonal expanses of skin and often lacking any body hair.

However, the more typical photographic spreads of *Penthouse* and *Playboy* are naturalistic; that is, they attempt to pass as reality through invoking 'everyday' situations and settings. In contrast, the images of *La Cicciolina* have become increasingly anti-naturalistic over the course of her career. Whilst early images present her in conventional erotic poses with honey-blonde hair and little make-up, by the mid-1980s she sports white-blonde hair, startling ginger eyebrows, scarlet lips and bright blue eyelashes, and poses with increasingly bizarre props in front of painted backdrops. Staller and Schicchi's approach can be compared to the tactics of the Radical Party, for whom Staller stood as candidate. This minority party achieves its political ends by disrupting Parliament from within, its playful humour standing in contrast to the seriousness of the main political parties. Similarly, these photographs could be seen as disrupting the naturalism of softcore pornography, taking up and exaggerating existing tendencies such as the lack of perspectival depth and the use of props.

It is interesting to compare this explicitly staged quality with the emphasis on artifice which characterised the 1950s physique photographs discussed above, and also with the use of studio photography and role-playing in recent 'queer' photography. Although the *Cicciolina* pictures have very little in common with the work of queer photographers such as Del LaGrace Volcano, the use of colour, painted surfaces and playful quotation of styles and settings resemble the work of the French photographers Pierre et Gilles. These qualities could be

16 'Are such things likely to increase sexual immorality among young people? I find it hard to imagine much connexion between them and heterosexual activity. They may encourage masturbation: in their symbolic way they may promote that kind of sealed-off sexual response' (Hoggart 1957: 191–2).

17 'Neo-kitsch is intentional, and it capitalises on an acquired taste for tackiness. It is a popularisation of the camp sensibility, a perspective wherein appreciation of the "ugly" conveys to the spectator an aura of refined decadence, an ironic enjoyment from a position of enlightened superiority' (Olalquiaga 1992: 45).

18 Williams argues that understanding photography in relation to the body is particularly crucial for erotic images since the observer engages with them by touching their own body as well as the machine through which they are viewing or the paper of the image (Williams 1995: 14).

JONATHAN CRARY (1993) Techniques of the Observer: On Vision and Modernity in the Nineteenth Century, Cambridge, MA: The MIT Press.

The **mutoscope** was one of many entertainment devices developed as a result of the Victorian fascination with the phenomenon of persistence of vision, in which the human brain retains an image for a fraction of a second longer than the eye actually sees it. The mutoscope was an arcade machine invented in 1895 by Thomas Edison. It was basically a mechanised version of a flipbook, in which a person looked through a viewer and cranked a handle to flip the photographs inside, which gave the images the illusion of continuous movement.

The **stereoscope** was a form of entertainment popular from the 1850s. It consisted of either a hand-held or a cabinet-style viewer and pairs of photographs on cards. The pictures were taken from different viewpoints corresponding to the spacing of the eyes. The stereoscope was constructed so that each eye only sees one photograph, giving the impression of a

understood in terms of 'camp' which is characterised by humorous artifice and flamboyance. Yet 'camp' has been defined as a 'queer aesthetic', which loses its political significance if applied to 'straight' culture (Meyer 1994: Introduction). Thus the visual style of Schicchi's photographs of *La Cicciolina* could be read as a heterosexual appropriation of the camp aesthetic. However those very same qualities could be understood in terms of 'kitsch'. This was originally a derogatory term applied to forms of popular culture considered as cheap, garish, sentimental or vulgar (Greenberg 1939). More recently the term has taken on other associations, so that 'kitsch' taste also refers to the knowing, ironic preference of an educated middle class for objects and images usually dismissed as 'low' culture.¹⁷ The wide availability of the *Cicciolina* photographs, as postcards and poster-books, could be seen as evidence that even softcore porn, seen as one of the lowest and most irredeemable forms of popular culture in the late 1970s and early 1980s, became by the 1990s capable of being rehabilitated through irony.

TECHNOLOGICAL BODIES

The camera as mechanical eye

Recent writers have considered photography in terms both of the bodies depicted and of its relationship to the bodies of the viewer and of the photographer (Crary 1993; Jay 1993). They suggest that photographs should not be thought of in terms of a single, centred and disembodied 'gaze' but as part of a new visual practice which presumes an embodied observer. **Jonathan Crary** places photography in the context of a range of popular nineteenth-century toys and devices which produce illusions of movement or depth. Devices such as **mutoscopes** and **stereoscopes** were enjoyed precisely because they 'tricked the eye' and, as Linda Williams has suggested, because of the tactile bodily sensations they provided since the observer engaged with them by holding the eyepiece of the machine or cranking a handle (Williams 1995: 14).¹⁸

Early scientific uses of photography give us an idea of its significance for understanding the human body. In the 1880s, the French scientist Etienne-Jules Marey used photography to explore human and animal physiology. As the photography theorist **Marta Braun** explains, Marey developed special cameras and photographic techniques to study human and animal locomotion (Braun 1992: ch. 3). His contemporary, the American artist Eadweard Muybridge, performed similar experiments. His images of a horse in motion, published in 1878, were sensational because they showed for the first time that horses ran in a different way than was usually pictured.

Through their photography, Marey and Muybridge opened up to vision things that the human eye could not perceive. This ability of photographic

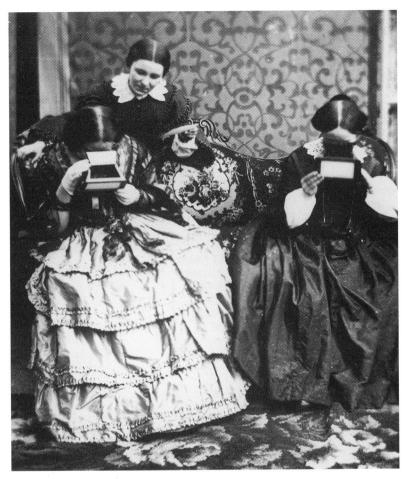

4.8 Women using stereoscopes in late nineteenth-century FranceThis photograph is a reminder that women, as well as men, enjoyed optical toys and the pleasures of spectatorship

technology to expand the capabilities of the eye was noted by writers, photographers and filmmakers in the early part of the twentieth century. In the 1920s and 1930s, the camera (both the still and the motion camera) was understood as a kind of mechanical eye. As the Soviet film-maker, Dziga Vertov, expressed it:

I'm an eye. A mechanical eye. I, the machine, show you a world the way only I can see it. I free myself for today and forever from human immobility. . . . My way leads towards the creation of a fresh perception of the world. Thus I explain in a new way the world unknown to you.

(Vertov 1923 quoted in Berger 1972a: 7)

three-dimensional image. Sometimes tinted tissue paper was used as a backing, adding colour to the image when seen through a backlit viewer; or pinpricks included to simulate sparkling jewels or streetlamps; or objects painted on the tissues so that they would suddenly appear when held to the light.

MARTA BRAUN (1992)
Picturing Time: The Work
of Etienne-Jules Marey
(1830–1904), Chicago:
University of Chicago Press.

See ch. 3, pp. 125–6 for more discussion of stereoscopes.

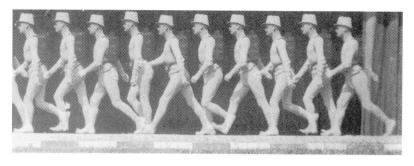

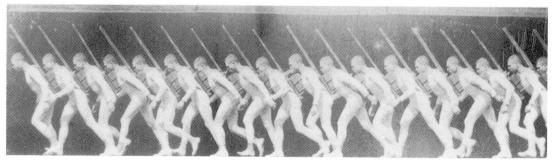

4.9 Etienne-Jules Marev

Marey's 'chronophotographic' studies can be understood as part of the drive to increase the efficiency of human motion in the military, in industry and in sport

The literary critic and philosopher Walter Benjamin also commented on the ability of photography and film to expand perception. For Benjamin, this was part of their utopian, liberatory potential: in enabling people to see the world in new ways, it offered them the possibility of questioning and ultimately changing their everyday lives (Benjamin 1936: 229-30). A number of theorists have argued that cinema produced an expanded gaze at the cost of an increasing immobility of the body (Manovich 2001: 107-9; Friedberg 1993: 28). Early photography required its subjects to be static, even using an apparatus to clamp the 'sitter' still for the duration of the exposure. However, photography quickly became a relatively mobile practice, and now the incorporation of cameras into mobile phones (cellphones) that can also be used to transmit and view images, gives photography a different relation to the body. If film let our vision go wandering while rendering our physical bodies increasingly immobile, now 'mobile' technologies travel with us: the expanded gaze locks our bodies to the technology, we move, but 'hooked up', 'plugged in', 'online' (Manovich 2001: 114). Thus, the technology which gives us this bigger perceptual world also changes the ways we inhabit the physical world which surrounds us. The camera is one of a number of machines (including telephones and computers) which appear to be like

prosthetics in that we treat them as extensions of our own bodies but which change the ways we physically engage with the world. The very presence of the camera transforms the scene, it *intervenes* in reality. The camera threatens to take over and displace the eye: it gets between the viewer and the viewed and 'shapes reality according to *its* terms' (Krauss 1986: 116). The experience of looking through the camera, and the conventions surrounding photographic practice, affect the way we see. Seeing through the camera is different from seeing without it and, since photography, seeing is a changed practice.

The camera and other technologies for seeing also affect the way we value our own sense of sight. The cultural theorist **Lisa Cartwright** has argued that in medicine, photography and cinematography 'supplanted or replaced sensory perception', since the data produced via these techniques came to be seen as having more authority than the doctor's or technician's own observations (Cartwright 1995: 34). Indeed, these images not only affect our understanding of our own vision, but also fit with understandings of what counts as authoritative forms of knowledge. In the case of foetal ultrasound scans, the images allow obstetricians to depend less on the pregnant woman's account of her own pregnancy. Yet while doctors may view sonograms as a source of information and means of diagnosis, these images are popularly understood (like early X-rays were) as a kind of photograph, a portrait of the unborn child. They shape our perception of life before birth, and seem to support the view that the foetus is a person, hence the use of such images in anti-abortion campaigns (Taylor 2000).

Non-photographic media such as X-rays (radiography), ultrasound (sono-grams) and magnetic resonance imaging, new techniques such as tomography (which allows cross-sections or slices through the body to be imaged) together with microscopic photography (micrography), enable us to see aspects of the body not visible to the naked eye (Ewing 1996). Yet these photographic and non-photographic imaging techniques actively transform the body in the process of representing it. Nineteenth-century surgical experiments combined photography and cinematography with vivisection, as in the 1898 film of a dog's beating heart (Cartwright 1995: 20). Other medical imaging techniques had inadvertent and unexpected effects on bodies, producing tumour and cancers (notably radiography; see Cartwright 1995: chs 5 and 6).

Interventions and scientific images

Many techniques for visualising the interior of bodies are intended to prevent extreme forms of intervention. Intervention is associated with loss of objectivity. By surgically entering the body, the scientist disturbs its natural order or normal functions. Yet even Marey's techniques for picturing motion, which developed out of his rejection of animal vivisection, produced a selective representation of the body. Marey attempted to remove from the picture all features of the body not connected to its motion, all the 'readable' signs which the physiognomist is anxious to record. Through his photographic

LISA CARTWRIGHT (1995)
Screening the Body: Tracing
Medicine's Visual Culture,
Minneapolis and London:
University of Minnesota Press.

technique, 'Marey effectively reorganised the body to make it embody its own status as an object subject to laws of temporality and duration' (Cartwright 1995: 36).

Marey was involved in the 'science of work', the European equivalent of the 'scientific management' techniques of the American Frederick Winslow Taylor. From 1911, Frank Gilbreth, a follower of Taylor, used Marey's chronophotographic techniques to break down, analyse and reorganise the movements of a person at work (Braun 1992: 340–8; Lalvani 1996: 139–68). The shift from the analysis and classification of bodies, as in physiognomy, towards their corrective transformation is described by Michel Foucault, as part of a general shift in the exercise of power in the modern period.

The Visible Human Project demonstrates the relationship between the exercise of power and the project of making the body the subject of knowledge. This project, commissioned in 1993 by the United States government. involved making images of two human cadavers (one male, one female) using computed axial tomography (CAT) and magnetic resonance imaging (MRI), then dissecting them into thousands of slices, and photographing each slice to produce a detailed 'atlas' of the body - a complete digital/photographic anatomy (Waldby 2000). The images are used by companies and institutions for research purposes and in the production of, for instance, crash test dummies and prosthetic body parts. This project is similar in intention to Bertillon's development of a police archiving sytem, only here the filing cards are replaced by the electronic database, and the knowledge produced for primarily medical purposes. As with Bertillon, the project aims to make bodies intelligible. In doing so, it represses the singularity of the bodies used and the diversity of human bodies. The male body is presented to us as a 'complete' 'normal' and 'representative', yet it is also the body of a 39-yearold man called Joseph Jernigan, who was convicted of murder and donated his body to science before being executed by lethal injection in Texas. This is the cadaver of a criminal killed by the State, dissected and turned into a representation by the Federal Government. The particular history of this singular corpse points to the violence and policing involved in the production of rational scientific knowledge via photography. The representation which circulates as the Visible Human Male is not Joseph Jernigan but a body as object, isolated from its social and physical context and its sensory entanglement with the world.

The Visible Human Project necessarily omits the ways in which the body is already culturally inscribed, meaningful and historical. In becoming the object of rational, scientific knowledge, the body becomes instead the representation of a "techno-scientific ideal", reaffirming the scientific and rationalist view of the body which informed the project in the first place (Curtis 1999: 263). The body itself becomes subordinate to the technological apparatus which represents it, (and reduces it to slices) and the instrumental purposes it will serve.

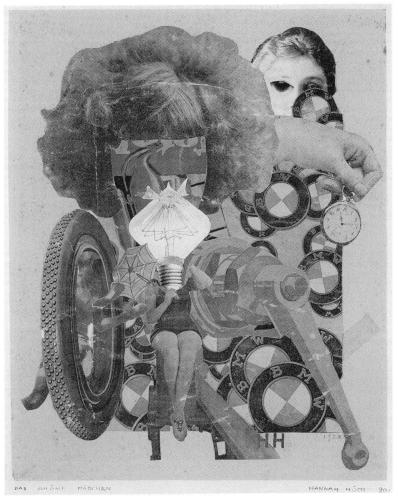

4.10 Hannah Höch, *Das schöne Mädchen* (The Beautiful Girl), photomontage (original in colour) The photomontages of the Dada artist Hannah Höch celebrate the 'New Woman', playfully juxtaposing magazine images of women with photographs of machine parts, but also seem critical of the uniform, idealised and machine-like mannequins depicted in the same magazines

The body as machine

The reduction of a human being to a 'data set' is a new development in an historical tradition of thinking and representing the body in mechanistic and technological terms. Almost a century before the Visible Human Project, the photographs and films of Marey and Gilbreth were among a large number (including industrial, commercial, medical and art photographs) which contributed to the perception of the human body as a machine. This perception depended on a highly idealised and utopian concept of the efficient,

smooth-running machine, which ignored the ways in which certain kinds of machines mutilate bodies (for example, in factories and war).

In popular culture, an uneasy mixture of traditional ideas of femininity and the new image of the disciplined, machine-like body informed the representation of women. In 1920s Germany, women's magazines enthusiastically showed female aviators and female celebrities beside their cars, while advertising photographs depicted women as automaton-like mannequins (Lavin 1993: 3, 59 and 132).

Avant-garde artists used new photographic techniques both to celebrate technology and to critique it.¹⁹ The political stakes of this became clear in the late 1930s, as Nazi ideology embraced a version of the machine body. This combined ideas of classical perfection from ancient Greek art with the racial classifications of nineteenth-century physiognomy, and Fordist/Taylorist ideas of the ideally machine-like, efficient and uniform worker. The ideal male body was a self-contained, muscular, armoured machine.

Some avant-garde photography challenged the image of the body as machine favoured by Taylorism and the Nazi emphasis on the male body as a disciplined fighting machine. The art historian **Hal Foster** shows how Hans Bellmer's Surrealist photographs of dismembered and mutilated dolls, which can be read as deeply misogynistic and paedophiliac, have different connotations in this historical context. Bellmer's photographs of distorted bodies, complete with prosthetic limbs, are simultaneously a rebuke to the militaristic ambitions of Fascism and Fascist ideas of bodily (and racial) purity, and a reminder of the real mutilations produced by technological warfare (Foster 1993: 114–20).

The relationship between technology and the body continues to be ambivalently and uneasily represented. In a 1998 advertisement for the Saab 9-3 car (see Figure 4.12), the photographic/digital montage blending car seat and human torso recalls the avant-garde use of **photomontage**. However, avant-garde montage depended on the incongruous and violent juxtaposition of bodies and machine parts. Here, the seamless blend of chair and torso suggests a painless transition from human to technological. The seat seems more human than the torso, its headrest becomes a kind of head, and it has wrinkles, while the torso has no hairs or irregularities, its flesh a polite shade of beige, smooth as a mannequin. The head is missing but not severed; instead, the neck discreetly fades into shadow. Thus the advertisement humanises technology, presenting the merging of technology and the body as desirable but also as inherently safe. The text confirms this: 'you actually feel like part of the car itself. Joined at the hip, as it were.'

The ad has the task of picturing the intermingling of body and machine without reminding us of the violent collision of flesh and metal which happens in a car crash. To tread over this line would undermine the ideology of the harmlessness of technology which it is promoting, and make the image disturbingly suggestive of death.

19 Maud Lavin notes that 'the Berlin Dadaists prided themselves on both affirming and negating their principal themes. While they were applauding the newly rationalized man associated in their minds with the machine, the engineer, and the Soviet artist Vladimir Tatlin they were also satirizing man-as-machine idealism, particularly as it had been played out in the carnage of World War I' (Lavin 1993: 16).

HAL FOSTER (1993)

Compulsive Beauty,
Cambridge, MA, and London:
The MIT Press, chs 4 and 5.

photomontage The use of two or more originals, perhaps also including written text, to make a combined image. A montaged image may be imaginative, artistic, comic or deliberately satirical.

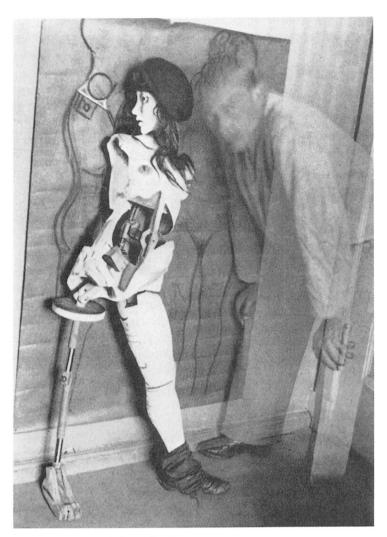

4.11 Hans Bellmer with first Doll, 1934

Digital imaging and the malleable body

The Saab ad is a good example of digital compositing. As the new media theorist Lev Manovich says,

Compositing in the 1990s supports a different aesthetic characterized by smoothness and continuity, Elements are now blended together, and boundaries erased rather than emphasised . . . where old media relied on montage, new media substitutes the aesthetics of continuity.

(Manovich 2001: 142)

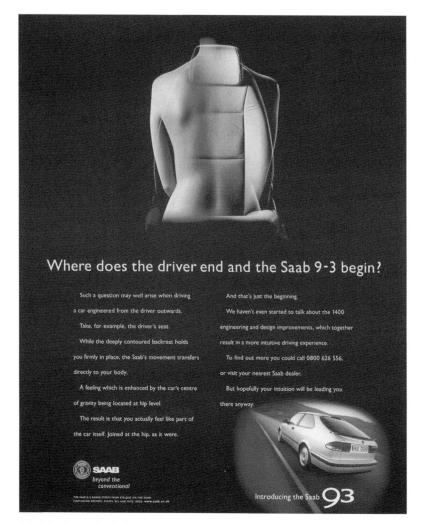

4.12 Advertisement for Saab, 1998

One of the themes central to current representations of the body is the merging of the corporeal and the technological, and the potential displacement of the body by the machine. By presenting a seamless merging of human and machine, this advertisement reassures us of the harmlessness of the car, and conceals the fact that technology can pierce and shatter bodies

More recently, advertising has gone further, manipulating human bodies in illusionistic ways, to give flesh and skin a plasticity beyond that of actual human flesh. A simple, and relatively restrained example can be found in advertisements for the confectionary Toblerone, which show people's faces with one cheek implausibly stretched to reveal Toblerone's 'trademark' triangular shape. Distorted bodies are not new to photography: the photographers André Kertész and Bill Brandt are well known for their optically distorted

nudes. In their work, the distortions are achieved using lenses and mirrors. However, the distortions produced using digital image manipulation software (such as Adobe Photoshop) are not optical but painterly, made by retouching the image. In this respect, they have more in common with drawn and painted animated cartoons than the photographs of Kertész and Brandt. Animation uses techniques of distortion, including 'squash and stretch' to give an illusion of realistic motion. This was at its height in Disney animations of the 1920s and 1930s. The filmmaker Sergei Eisenstein gave the term 'plasmatic' to that elastic quality of animation that allows bodies in cartoons to metamorph into other bodies, objects to come alive. Eisenstein saw this in Utopian terms, as expressing the potential of humans to change themselves and their world, rejecting the idea of static form in favour of a return to 'primal protoplasm' (Leslie 2002: 231-7) By the late 1930s, though, other writers were noting the loss of this playful shapeshifting in favour of more sanitised cartoons in which, in the view of the theorists, the physical violence meted out on the pliable cartoon bodies disciplined the audience and encouraged a submissive masochism. (Leslie 2002: 171-7). This raises the interesting question of how to read the digitally 'morphed' bodies of contemporary culture. Digital manipulation of photographs gives the body a photo-real malleability related to the fluidity given by film special effects, most famously the liquid metal body of the T-1000 in the film Terminator 2 (dir. James Cameron, 1991). As with the plasmatic character of animation, this can be understood in Utopian terms, as enabling us to imagine a new and liberating cyborg, 'posthuman' body; or in Dystopian terms, as part of the continued objectification of the human body, in a culture where body parts are increasingly understood as commodities (as in the trading of human organs for medical use).

PHOTOGRAPHY, BIRTH AND DEATH

Photography's particular ability to objectify the body associates it with death – this is expressed by **Susan Sontag**: 'All photographs are *memento mori*. To take a photograph is to participate in another person's (or thing's) mortality, vulnerability, mutability. Precisely by slicing out this moment and freezing it, all photographs testify to time's relentless melt' (Sontag 1979: 15).

The qualities which make a photograph work as a fetish – its immobility and silence, its ability to freeze a past moment – are deathly qualities (Metz 1985: 83–4) **Roland Barthes** has argued that our horror at photographs of corpses is related to our faith in photographic realism. Since, according to Barthes, we tend to conflate the real and the live, a photograph of a corpse seems to attest 'that the corpse is alive, as *corpse*: it is the living image of a dead thing'; in other words, the corpse appears to have been live at the moment of its encounter with the camera (Barthes 1984: 78). Photography renders the living immobile, frozen: the living person photographed may subsequently die, but remains preserved in the photograph, while the dead body

SUSAN SONTAG (1979) **On Photography**, Harmondsworth: Penguin.

ROLAND BARTHES (1984) **Camera Lucida**, London: Fontana in 1981 by Hill and Wang. photographed is 'horrible' since it is given the same 'immortality'. According to Barthes, photography 'produces Death while trying to preserve life' (Barthes 1981/1984: 92; Jay 1993: 450–6).

Current attitudes to post-mortem photography are related to the tendency to accept photographs as reflections of the real as well as to contemporary attitudes toward death (Rosler 1991). Everyday (as opposed to sensational or exceptional) death is among those aspects openly represented in medieval carnival but is increasingly relegated to the private realm in the modern era. The practice of photographing dead relatives or friends was a publicly acceptable practice until about 1880, with photographs of corpses displayed openly in American homes, and professional photography studios advertising the services. It is usually assumed that the practice stopped, particularly in Englishspeaking countries. Anthropologist Jay Ruby has challenged this perception, showing that it continues in present-day America, but has come to be seen as shameful, or highly private, and is seldom discussed, and the photographs are seldom displayed publicly (Ruby 1995: 161). Originally, the significance of corpse photography was to preserve a likeness. For many bereaved people, photographs still privately serve this function, but a new public unease has grown around photographing the dead. Ruby suggests that the fact that nineteenth-century photographers were frequently commissioned to produce post-mortem photographs does not necessarily mean that theirs was a

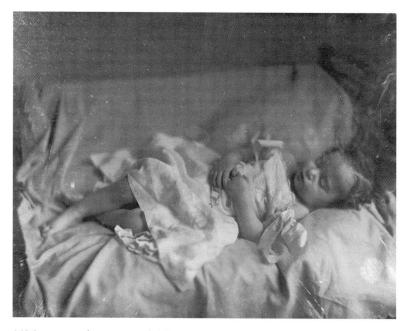

4.13 Post-mortem daguerreotype of child, Boston, c. 1850s
An example of the mid-nineteenth-century tendency to photograph the dead as if they were asleep

culture much more comfortable with death than our own. Great effort was made in early post-mortem photography to present the corpse as merely asleep, in keeping with funerary practices and cultural representations which represent death as a deep sleep (a notion still present in the modern 'chapel of rest') (Ruby 1995: 63–72). However, this representation of death as sleep derives from the Christian belief in the afterlife of the soul: the image complies with the notion that the soul of the person continues to live after bodily death.

Though nowadays commercial photography studios do not photograph corpses, a number of art photographers have done so – notably Andres Serrano and Sue Fox. Sue Fox's mortuary photographs perhaps seem more 'horrific' than Serrano's because their documentary-style composition has the effect which Barthes noted: of making the dead seem alive. 20 Yet Fox also depicts the corpse dissected, as meat, stripped of personality, However, Serrano's photographs continue the Victorian religious tradition of making the dead appear asleep. In some of the Morgue series, the wounds and marks on the flesh operate also as references to Christian religious iconography (in one entitled Rat Poison Suicide II a wound on a foot recalls the stigmata, the crucifixion wounds of Christ which appear miraculously on believers). Serrano's morgue series, like his series depicting body fluids, including the (in)famous Piss Christ, draws on a Roman Catholic tradition of representing the bloodied bodies of martyrs and the dead Christ. Transposed to photography and expanded to include the representation of bodily fluids such as urine and semen, and deaths by suicide and illness, this becomes a very heretical version of Catholicism.

Serrano's photographs are lush, large scale, and highly staged (using studio lighting techniques) (Plate 7). The combination of this high artifice and the Catholic references gives the images a kitsch quality. As with the kitsch of Cicciolina or the camp aesthetic of the 1950s Physique photos, the bodies here have much in common with Bakhtin's characterisation of the classical body. The composition and sumptuous colour conflicts with the horror of the subject matter. Serrano's photographs hint at a social world through small but poignant details such as the mark left on a child's flesh by the elastic of its sock.

The Dutch photographer Rineke Dijkstra also uses the body to speak of a world of experience beyond that depicted in the photograph. She too makes monumental photographs of people, shot with a large format camera and exhibited in an art gallery context. A set of three naturalistic photographs of mothers depict them naked, or almost naked, in front of a plain white wall, clutching their tiny newborn babies. In one photograph a woman named Julie stands before the camera wearing only the disposable pants commonly used after childbirth, her hand protecting the baby's face from the camera flash (Plate 6). What she has been through only an hour before seems to show in her eyes and her ambiguous expression. In common with many of

20 For reproductions and discussion of Sue Fox's photographs see Townsend

Dijkstra's subjects, she has a dazed look. This may be the result of the physiological changes associated with natural childbirth (the surge of adrenalin and hormones), since the baby was born at home. Dijkstra paired this series with another series of photographs of male bullfighters just out of the ring, and they also look in a state of shock, pupils dilated, seemingly unaware of their blood-spattered and dishevelled appearance. The subjects of both series have been transformed though experience. In *Julie*, the act of birth is still present, traced on the bodies of both mother and child. Dijkstra's photographs point to the animal aspect of the body at the same time as they depict bodies as social and changeable, transformed by experience. Although they are displayed to us, these bodies are not frozen, not easily objectified. They are bodies in transition.

SUMMARY

As the examples in this chapter demonstrate, campaigns and conflicts over photographs of the body hinge on the relationship between photography and reality and the extent to which the photograph is understood as a reflection of reality. Yet it is also clear that photography is one of the means by which individuals are constructed as social subjects: the use of photographs in medicine, policing and in scientific studies of work shows how photography participates in the disciplining of the body. In disciplining the body, these photographic practices also exclude (or attempt to exclude) those sensory and social aspects of bodies and bodily experience which do not conform to the particular understanding of the body on which the practice is premised. A photograph constructs different meanings for human bodies through the way it represents them, and some photographs may conform to and reproduce dominant ideas about sex, about race, about what it is to be human, male or female, whilst other photographs challenge these ideas. However, these meanings are not firmly attached to particular methods, techniques or styles; instead, the significance of particular ways of photographing bodies changes with its context. For instance, the composite photos of Francis Galton, Nancy Burson, and those produced by a photo-booth all depend on viewing people as 'types', but all serve different social purposes. Similarly, the muscled male body and the classical aesthetic could be associated with either a coded homoeroticism (in American physique magazines of the 1950s) or the deeply homophobic culture of Fascism. In all instances, photographs do not simply speak of 'the body' but of particular bodies, of social groups and the relationships of power between them.

CHAPTER 5

Spectacles and illusions

Photography and commodity culture

ANANDI RAMAMURTHY

195 **Introduction: the society of the spectacle**Photographic portraiture and commodity culture

Photojournalism, glamour and the paparazzi
Commercial photography, image banks and
corporate media

Commodity spectacles in advertising photography

208 The grammar of the ad

Case Study: The commodification of human relations and experience – 'Omega and Cindy: time together'

The photographic message
The transfer of meaning
The creation of meaning through context and
photographic styles

214 Hegemony in photographic representation

Photomontage: concealing social relations Concealing labour relations Gendered representations

220 Fashion photography

Case study: Tourism, fashion and 'the Other'

235 The context of the image

Image worlds
Case study: Benetton, Toscanini and the limits
of advertising

What does possession mean to you?

7% of our population own 84% of our wealth

The Economist, 15 January, 1966

Spectacles and illusions

Photography and commodity culture

INTRODUCTION: THE SOCIETY OF THE SPECTACLE

In societies dominated by modern conditions of production, life is presented as an immense accumulation of spectacles. Everything that was directly lived has receded into a representation.

(Debord 1967 section 1)

In the twenty-first century, commodity relations rule our lives to such an extent that we are often unaware of them as a specific set of historical, social and economic relations which human beings have constructed. Like any cultural and technical development, the development of photography has been influenced by its social and economic context. The photograph is both a cultural tool which has been commodified as well as a tool that has been used to express **commodity culture** through advertisements and other marketing material. Capitalism's exploitation of the mass media and visual imagery to create an array of spectacles and illusions that promote commodity culture can be explored by considering some of the ideas that the French Situationist Guy Debord discussed in his book *Society of the Spectacle* (Debord 1967).¹

In this book Debord outlines the way in which modern industrial capitalist society has created a world in which the majority of people are increasingly passive and depoliticised as a society of spectacles both media and otherwise absorb us into a world of illusions and false consciousness. He describes these

1 Debord was a leading member of the Situationist International who was influenced both by Marxist and anarchist thought. Their main aim was to encourage ordinary workers to become involved in the transformation of everyday life immediately and not wait for a distant revolution. They were involved in the French student protests of 1968. Through Debord's writings, the ideas of the Situationists gained longevity.

spectacles as 'a permanent opium war' and discusses the way in which 'the spectacle presents itself as a vast inaccessible reality that can never be questioned. Its sole message is: "what appears is good; what is good appears". Debord's concern is with the endless proliferation of media messages - frequently visual and usually photographic - that saturate our existence both inside and outside our homes, through billboards, television, films, magazines, newspapers, the Internet, commodity packaging and ephemera. These media messages are predominantly focused on a world of glamour and entertainment where issues of conflict (when addressed) are usually packaged around an array of feel-good factor articles and presentations to remove the sting from conflict and contradiction and to present these as a distant 'other' world. Debord's key argument is that ordinary people as spectators of spectacle remain passive, uncreative and therefore powerless in the running of society. Baudriallard and other postmodernists have also recognised the impact of spectacles and media messages in the late twentieth and twentyfirst century. They have described the world of spectacle as a hyperreality, but they have not used their analysis in an attempt to expose exploitation and oppression as Debord did (Baudriallard 1983; Eco 1987). Debord wished to expose the way in which this world hid reality. Douglas Kellner has recently applied these ideas to discuss media spectacles in the late twentieth century (Kellner 2003). Kellner discusses the way in which global mega-spectacles such as the O.J. Simpson murder trial are given so much space and time on television and in the rest of the mass media that these events are elevated in the minds of media consumers in the West to positions of greater or parallel importance to those of wars or other atrocities.² The photographic image – both still and moving – is crucial in supporting the society of spectacle. 'Cameras define reality in two ways essential to the workings of an advanced industrial society: as a spectacle (for masses) and as an object of surveillance (for rulers). The production of images also furnishes a ruling ideology. Social change is replaced by a change in images. The freedom to consume a plurality of images and goods is equated with freedom itself' (Sontag 1979: 178-9).

2 I am using the term West to indicate those countries benefiting most from the exploitations of imperialism.

This chapter will consider examples of the photograph as a commodity and its role in representing commodity culture. It will explore the way in which capitalist ideology has impacted on forms and styles of photography which we see today and the way in which photographic use and practise is organised. This first section on the society of the spectacle concentrates on exploring examples of commercial photography which are outside of the field of advertising and marketing, the kind of photography which needs to be understood commercially but is not created to sell commodities, but to sell itself.

JOHN TAGG (1988) 'A Democracy of the Image: Photographic Portraiture and Commodity Production' in The Burden of Representation: Essays on Photographies and Histories, London: Macmillan

Photographic portraiture and commodity culture

John Tagg has described the development of photography as 'a model of capitalist growth in the nineteenth century' (Tagg 1988: 37). The rise

of commodity culture in the nineteenth century was a key influence on the way in which this technology was developed and used. The way in which photographic genres were affected by capitalism is illustrated in Tagg's essay by the demand for photographic portraits in the nineteenth century by the rising middle and lower-middle classes, keen for objects symbolic of high social status. The photographic portraits were affordable in price, yet were reminiscent of aristocratic social ascendancy signified by 'having one's portrait done'. Tagg describes how the daguerreotype and later the carte-de-visite established an industry that had a vast clientele and was ruled by this clientele's 'taste and acceptance of the conventional devices and genres of official art' (Tagg 1988: 50). The commodification of the photograph dulled the possible creativity of the new technology, by the desire to reproduce a set of conventions already established within painted portraiture. It was not, however, simply the perspectives and desires of the clients visiting photographic studios that encouraged the adherence to convention, but also the attempt, as McCauley has highlighted in her study of mid-nineteenth-century commercial photography in Paris, of the small business owners of these photographic studios both to establish themselves as part of a bourgeois class, as well as to assert the claim of photography as a highbrow art (McCauley 1994).

Suren Lalvani has also highlighted the way in which nineteenth-century photographic portraiture was a powerful expression of bourgeois culture through the conventions of display in both dress and the arrangement of the body. Lalvani gives examples of the way in which these portraits upheld capitalist values about the nation-state, the family and the individual. 'In bourgeois portraiture, it is especially the arrangement of heads, shoulders and hands -'as if those parts of our body were our "truth"' that act to furnish evidence of the individual as though 'the world may be civilized by the domestication of the hand by the head' (Lalvani 1996: 52). Photography was not acting independently in the development of the bourgeois ideal, but borrowed from and was influenced by other disciplines such as physiognomy and phrenology (see ch. 4 pp. 164-8). Lalvani also points out the way in which these images, frequently produced for public consumption as the craze for cartes-de-visite developed, represent the development of a spectacular economy of images. He notes how political leaders of the time as well as royalty exploited the craze for collecting and exchanging the cartes-de-visite to promote their own popularity (see ch. 3, p. 128). President Lincoln for example is said to have believed that the carte which Brady produced of him helped him to win the presidency. Photographic portraiture in the nineteenth century therefore acts as an example of the influence of bourgeois thought both on the form and style of portraiture as well as an example of the development of - 'a regime of the spectacle' (Lalvani 1996: 82).

Today the portraiture of the high street studio adheres to similar conventions of display. Just as photographic genres have been affected by commerce,

daguerreotype Photographic image made by the process launched by Louis-Jacques-Mandé Daguerre in France in 1839. It is a positive image on a metal plate with a mirror-like silvered surface, characterised by very fine detail. Each one is unique and fragile and needs to be protected by a padded case. It became the dominant portrait mode for the first decades of photography, especially in the United States.

carte-de-visite A small paper print (2½–4½°) mounted on a card with the photographer's details on the reverse. This way of producing photographs for sale was developed by André-Adolphe Disdéri in France in 1854. Eight or more images were made on the same glass negative by a special camera with several lenses and a moving plate-holder. The prints were then cut upt os ize. Such prints could be produced in very large numbers.

ELIZABETH ANNE McCAULEY (1994) Industrial Madness: Commercial Photography in Paris 1848–1871, New Haven, CT, and London: Yale University Press. DON SLATER (1983) 'Marketing Mass Photography' in H. Davis and P. Walton (eds) **Language, Image, Media,** Oxford: Blackwell so has the development of photographic technology. The 'Instamatic' for instance was clearly developed in order to expand camera use and camera ownership. In turn, this technology limited the kind of photographs people could take (**Slater 1983**).

Photojournalism, glamour and the paparazzi

Another area in which we can observe the operations of spectacle is that of photojournalism. Although a documentary form of photography which has been used to highlight atrocities and deliver information and news, the photojournalist is keenly aware of the need for spectacular images that will draw attention on the news stand and encourage sales above those of rival newspapers. In Britain and America in the 1930s, the establishment of publications such as Life and Picture Post saw the photographic image begin to command what was considered newsworthy. Dramatic and sensational images meant newsworthiness. In wars and situations of conflict photojournalists have frequently intervened to create more dramatic images. In 1937 for example, H.S. Wong placed a baby on to the railway line of the bombed out Shanghai railway station to create an image which could captivate the despair and devastation of the Japanese bombing (Figure 5.2). The frequent adjustment of scenes by photographers creates a demand in the viewer for a constant spectacle and drama to be presented. Such drama does not always exist in life. Stories without it are ignored by the papers. On some occasions, people have used their knowledge of the newspapers' need for photographs of high drama to get their perspective heard. With the publication in 1988 of the Satanic Verses by Salman Rushdie, quiet protests by Muslim organisations against the book did not make the news. It was only when one group in Bradford, UK, provided the cameras with a dramatic image of book burning that their voice and position was heard. The image of people acting as extremists could sell papers.

Although individuals have sometimes intervened in the production of the spectacle, it has been primarily produced by those with the financial clout to do so. The first Gulf War saw a major PR company, Hill & Knowlton, promote the need for war after being hired for the princely sum of \$5.64 million by an organisation of 13 members (Citizens for a Free Kuwait). Their PR strategies included Kuwait Student Information days, countless press conferences and the production of documentary images that they distributed of Iraq's invasion of Kuwait and of human rights abuses there. As Mark Miller writes, 'indeed, throughout these crucial months [September to December] there was, on TV, no other footage of or about Kuwait: every single documentary image that was telecast had been prepared by Hill & Knowlton' (Miller 1994). In the recent invasion of Iraq, Freimut Duve, the expert on media freedom for the Organisation of Security and Cooperation in Europe argued: 'We are entering a historic phase where war is turned into a spectacle. A high percentage of people are watching without realising that it is a war'. During the first days of the war, it was presented as a real media spectacle

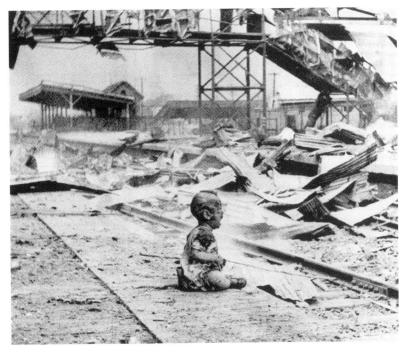

5.2 H.S. Wong, Chinese baby, 1937

to be followed around the clock. The viewer was led to believe that he 'was very close' to the action, 'but it was in fact a form of reportage, especially on US television, that avoided the reality of war. It was extremely far away from the realities in the cities, in the region' (Rahir 2003).

The development of the spectacle has also spawned a journalism of the sensational. The tabloid newspapers such as the Sun, Daily Star, Daily Mirror and News of the World in Britain, and the Globe, Star and Enquirer in the US focus entirely on the production of a journalism of the spectacle which promotes and destroys stars and celebrities to provide a treadmill of stories of sex and scandal. Photographs play a major role in these stories. Two styles and forms of photography dominate this journalism, the official photographs provided by the stars and their media machines, and the 'stolen' paparazzi photographs that often tell a different story. Carol Squiers has discussed the photography of stars, the origins of paparazzi photography and the exploitation of the image of Princess Diana by the tabloid press. In her essay she outlines how, the posed images of stars taken for editorial and advertising purposes place a high value on the stars ability to control and manipulate every aspect of the image - lighting, makeup, costume, hairstyle, facial expression, posture, and gesture. 'Big stars usually demand and receive blanket control over who takes the pictures, how they will be constructed, where in

a publication they will be used, and which images will be reproduced' (Squiers 2003: 274). The effect is to construct the stars as individuals in a spectacularly perfect world, with perfect clothes, perfect hair, perfect bodies, perfect lips and perfect lives. These, usually high gloss photographs are akin to the photographic world of advertising by their creation of technically perfect images of dreams and images of desire. By contrast, the paparazzi photographs are the opposite of this. They are images of individuals caught unaware – stripped of their luxury and dazzle.

Rather than molding a celebrity as a uniquely magical creature the way posed pictures do, paparazzi images show celebrities as more mundane figures who sometimes inhabit the same space (a city sidewalk, a parking lot), perform similar tasks (shopping, jogging) and wear same clothing (blue jeans, sloppy sweaters) that the non celebrity does.

(Squiers 2003: 274)

These images are sometimes blurred and of poor quality, but this simply adds a mark of their authenticity - their 'truth'. These photographs however, while seemingly reporting on the 'real' star and therefore apparently concerning itself with issues of the 'truth', channel the tabloid into focusing on the truth about stars as opposed to issues of the truth about how society operates. Paparazzi photography is also often a play between the celebrity and the photographer, with celebrities using photographers at particular moments to construct their image. Witness Diana's use of photographers on an official visit to India when her marriage with Charles was failing. She visited the Taj Mahal by herself and allowed herself to be photographed alone, against a backdrop of one of the most ornate monuments to love (Squiers 2003: 300). Her image captivated the journalists and she upstaged her husband in the news coverage. The production of photography for this journalism of the spectacle has no moral consciousness and is not intended to encourage the viewer/consumer to reflect on the deeper conflicts in society. It is entirely geared towards profit. Stars and celebrities can make large sums of money from official photographs. Anthea Turner for example, a British television presenter, probably best known for being the first presenter of the National Lottery, made £250,000 for selling her wedding photographs to OK magazine for an exclusive feature in August 2000. The 'stolen' photographs of the paparazzi and others also bring wealth. Club Manager Bryce Taylor is reported to have received between £150,000 and £1.5 million from the sale of the Diana photos at his health club.

The photographs of Anthea Turner's wedding for *OK* magazine add another dimension to the whole notion of the stolen image in commercial photography. On negotiating exclusive rights for her marriage photographs with *OK* magazine, Anthea claims that she was duped when asked to eat a new chocolate bar that Cadbury's were launching. As part of the agreement

with OK, Anthea had agreed to supply one picture of her wedding to the press in general. She left OK to choose the image. OK magazine chose to sell a photograph of Anthea and her husband eating the new chocolate to all the tabloid newspapers, requesting them to mention the chocolate by name in the caption. An image of Anthea in her wedding dress was also displayed on the cover of OK magazine with a free Snowflake chocolate on the lefthand side. Inside were images of Anthea, her new husband Grant and celebrity guests eating the chocolate bar. The wedding appeared to be sponsored by Cadbury's, and with the free chocolate on the magazine cover, all readers could join in the celebrity wedding. The tabloids used the opportunity to condemn Anthea for what they do everyday - exploit all opportunities for profit. They themselves obviously secured profit by condemning Anthea Turner. As Kevin O'Sullivan the showbiz editor of the Daily Mirror said '[Anthea] certainly became the whipping girl, but you know, I think we all felt it was selling papers' (Tabloid Tales 3/6/2003 BBC1). The photograph in this incident was pivotal, and what was on one level an official wedding photograph turned into a stolen, almost paparazzi style image which destroyed her celebrity status. The incident indicates the depths of exploitation at all levels in the field of tabloid journalism - the journalism of the spectacle.

Commercial photography, image banks and corporate media

The spectacle is the stage at which the commodity has succeeded in totally colonizing social life. Commodification is not only visible, we no longer see anything else; the world we see is the world of the commodity.

(Debord 1967 Section 42)

The photojournalism discussed above is of real events even if they are events of the spectacle. They clearly mark occasions of interaction and experience between groups and individuals. In the growing world of colour supplement and glossy magazine culture, there is another vast area of photography, which does not mark the existence of an event and does not constitute advertising – stock photography. These images fill increasingly vast digital image banks, where they can be bought and sold right across the world. Generally as Machin writes, 'they can be spotted easily: they are those bright, airy images showing attractive models, flat, rich colour, and a blank background. And they are recognisably less than realistic' (Machin 2004). The main reason for this is that the more multi-purpose and generic they are the more re-usable they are, and therefore the more they will sell. The blank or reduced background, by de-contextualising the subject enables the images to act as generic types. The settings that do exist are generic – a window, the sea, the mountains, an ocean or a non-descript city street. Where attributes or props do

exist, they are symbolic – a computer to signify office, or a hard hat to highlight construction. The models too adhere to the mood of the generic image: 'the models are clearly attractive, but they are not remarkable, because a striking face, an easily recognisable face, will be less easy to re-use' (Machin 2004). Machin argues that these images are changing the way in which we use and understand photography. The photograph is no longer witness here, its use is symbolic. What is interesting about these images is that they speak very little. The context provides meaning, just as the context in advertising provides meaning to those images (see below the section The grammar of the ad). The balance between denotation and connotation which Barthes discussed is no longer apparent (Barthes 1977b). This is a photography in which there is only connotation.

This shift, Machin argues, is partly due to the culture of branding consumerism where products are represented by concepts such as friendship, romance or adventure. The control by multinationals of image banks and the licensing of digitised images has also affected the development of stock photography. This two billion dollar industry has transformed the world's media. Getty Images www.gettyimages.com and Corbis www.corbis.com (owned by Bill Gates) are the largest of these enterprises and are used by magazines world wide. Getty Images is the larger of the two organisations with 40 per cent of its revenue coming from outside of the US. It owns over 25 per cent of the market share in some countries and while part of its vast digital image bank contains historical archives such as the Eastman Kodak Image Bank, the Hulton Picture archive and the National Geographic image collection, the biggest earners for Getty are the stock images of the kind described above. Geoffrey Batchen has highlighted the impact of image banks such as Corbis on our understanding of traditional photography and the role of photography in the recording of history (Batchen 2003).

Colour supplements cannot afford to pay photographers to shoot appropriate images for all their articles, so these stock images are a cheap way of brightening up a page. Getty has now started to search out these stock images and informs photographers of the kinds of images that they are looking for. Getty is clearly interested in being 'a leading force in building the world's visual language' as their promotional material asserts. Morrish has highlighted how these stock images must be 'striking, technically superb yet meaningless' so that they will 'never conflict with the clients message' (Morrish 2001). Machin argues that while these images may appear to be meaningless, in the sense that they are able to absorb radically different meanings from their context, it is not helpful to see them in this way, since what these images are doing is reasserting the concepts of branding in a non-branding context. It is obviously of interest for a major multinational to promote and encourage this kind of photography.

Let us look at two examples. The first is an image from Corbis that was used on the cover of *Sunday Times Magazine* (22 June 2003). It depicts five

babies sleeping in clear hospital cots. The magazine cover advertises a key feature called 'Birth Defects' that highlights addiction to be an inherited disease. The Sunday Times digitally alter the image by adding alarming labels to the cots such as 'smoker', sex addict, alcoholic, etc. to catch our attention. Here we can see the way in which the magazine uses a tranquil image of five sleeping babies to highlight a medical feature about inherited conditions. The photograph could just as easily have been inserted into an editorial about an overcrowded NHS or designer babies. The photograph is a good example of an image which is generic enough to be able to absorb meanings easily from the context of its use. This is a documentary image of sorts, but not one that furnishes much evidence. We do not know where these babies were born, when they were born or any other piece of information which may anchor the image to specific meanings. The range of possible meanings that could be applied can be seen by the variety of key words that Corbis associate with the image: 'asleep, babies, birth, calm, cute, delicate, exhaustion, fragile, future, health, health care facility, hospitals, human culture, indoors, infants, innocence, maternity, medical, peacefulness, rest, science, serene, sleep, tranquillity, youth' (there are 72 keywords in all).

Let us look at another example of a stock image. It is an image which is probably more common than the last one. It depicts a woman floating in the sea in tranquillity (Plate 9). In searching for this image in the Getty archive, there were 94 pages of images that depicted a woman floating in the sea connoting tranquillity or relaxation. This image was used on a supplement to the independent magazine for 14-20 June 2003. The image acts to highlight a feature about the best beaches in Europe. The image, however, is typical of generic images that can be used in a variety of contexts. It could just as easily have been used to illustrate an article which asked whether our seas were polluted or not or to talk about dealing with stress. This woman floats in a sea which may not even be European. In fact this same image has been used in a 2003 travel brochure by British Airways for tropical beaches. Here she visualises a section on 'well being', as the copy beside the image indicates: 'Ever imagined lazing around in your own pavilion on an isolated patch of white-sand beach, listening to the sound of waves on the turquoise sea, as the warm breeze and the touch of healing hands pass quietly by.' She is an indistinctive model, wearing an indistinct bikini in an indistinctive sea. The photograph is striking because of the slightly peculiar angle, which emphasises her forearm and the fairly bold swathes of colour in the blue sky and what appears to be a digitally retouched green sea. The image acts perfectly to represent concepts important to the process of branding, such as contemplation, enjoyment, well being and relaxation. In fact, just in case you are in need of other similar images when you do click on to such an image which interests you, Getty lists subjects and concepts which you may wish to explore to find similar images. The concepts are the descriptive labels, the moods which Getty perceives that the image contains. For this image they list 'contemplation, enjoyment, getting away from it all, heat, leisure activity, relaxation, serene people, vacations and well being'. The list of concepts to indicate various types of enjoyment and calm are detailed.

If we search the Getty archive for images of labour conflict however, the term gets re-interpreted as 'working and conflict' and three pages of images showing pictures of the difficulties of juggling home and work or of individuals in strenuous discussions with one another in an office environment are listed. The conflicts of labour are reduced to personal office rivalries and differences, as opposed to major issues of class conflict. The term class conflict fares even worse in the archive, with three photographs depicting conflicts in classrooms listed. If we look for images of trade unions under the subject headings, there are three pages of images; all but two however are historical images from the Hulton Picture library in black and white. Of the two colour images available, one is a banal concept type image with the words 'blue collar' stamped across a scratched and graffitied surface and the other is an image of a boss shaking hands with a worker in a staged shot reminiscent of the corporate photography of the annual report. The image of workers struggling for their rights is completely washed out of existence. The stock photography of branded concepts only visualise the world that the corporate media wish us to see - 'the society of the spectacle', the society of the banal and a society in which contemporary labour is rarely visualised and exploitation never.

Commodity spectacles in advertising photography

The range of contexts within which photographs have been used to sell products or services is so enormous that we are almost unaware of the medium of photography and the language which has been created to convey commercial messages. Photographs for commerce appear on everything from the glossy, high-quality billboard and magazine advertisements to small, cheap flyers on estate agents' blurbs. Between these two areas there is a breadth of usage, including the mundane images in mail-order information and catalogues, the seemingly matter-of-fact but high-quality documentary-style images of company annual reports, the varied quality of commodity packaging, and of course the photography on marketing materials such as calendars, produced by companies to enhance their status. Within the traditional histories of photography, advertising photography has largely been ignored, despite the fact that photography produced for advertising and marketing constitutes the largest quantity of photographic production. One possible reason for the lack of documentation and history-writing in this area is that commercial photography, for the most part, has not sought to stretch the medium of photography, since one of the key characteristics of all commercial photography is its parasitism. Advertising photography cannot be seen to constitute any kind of photographic genre; rather, it borrows and mimics from every existing genre of photographic and cultural practice to enhance and alter the meaning of lifeless objects - commodities.

By reading the opinions of advertising photographers for the students of commercial advertising, we can explore the way in which this photography has developed the commodity spectacle. One of the first instances suggesting the power of photography for advertisers dates back to the mid-nineteenth century, when the photographer Disdéri wrote an article offering 'indispensable advice' to exhibitors in the 1855 Exposition Universelle in Paris, emphasising the speed, exactitude and economy of photographic reproductions and suggesting 'wouldn't the propagation of a model of furniture appreciated by all the visitors to the exposition attract numerous orders to the manufacturer?' (McCauley 1994: 196). It is clear that as forms of mass production began to develop, the photograph, which constituted one of these forms, was also seen as a medium through which these commodities could be popularised and marketed. In this sense, from the very beginning, photographs were employed to induce desire and promote the spectacle of commodities. Thomas Richards discusses the display of commodities at the Great Exhibition of 1851 as a spectacle of goods, a spectacle which was soon taken up by advertisers as they moved from advertising products to brands (Richards 1990).

By the inter-war period, photographs began to be used more regularly within advertisements. This was partly due to the increased production of illustrated papers during the period, but also due to the development of a visually literate British public during the 1930s, the result of the dissemination of photography through the illustrated newspaper. Two comments by those working in the industry highlight the shifting concerns for photographers during this period:

The advertisement photographer visualises his work . . . holding its own . . . where it will not be looked at deliberately unless it has the power to arrest and intrigue the casual eye of the reader.

(Stapely and Sharpe 1937)

now, the leading London dailies devote whole pages to photography, while the Sunday and Provincial press freely scatter photographs throughout their editorial columns. Photographic news brought photographic advertising and a public that had been educated to visualise the world's events soon began to visualise its own needs.

(George Mewes of Photographic Advertising Limited 1926–60 quoted in Wilkinson 1997: 28)

It is clear that while the simple use of arresting photography was enough in the early period, as the century progressed and the regime of spectacle developed, advertising photography has sought to develop dreams and desires in the images that they create. The period of the 1930s was one of flux, while some simply interpreted the role of the advertising photographer as one who would create a striking and arresting image; George Mewes of Photographic Advertising Limited understood the role of the photographer as one who would create needs and desires. In doing this, they did not create new forms of photography, but borrowed forms of photography popularised through the new illustrated papers and through the developing film industry.

Helen Wilkinson notes how advertising photography began to appropriate first, journalistic methods of a seemingly 'realistic' style as well as the conveyance of narrative through a combination of image and text; and second, commercial cinematic conventions. For example, deep shadows to convey emotions were employed along with the close-up for a more naturalistic style of portraiture, which still retained an element of glamour. Some of the cinematic conventions of photography can be seen in stock photography sheets belonging to Photographic Advertising Ltd. One sheet represents head-andshoulder portraits of women (Figure 5.3). All the women have been shot in dramatic studio lighting and wear make-up, conventions which adhere to an image of cinematic glamour. All are photographed in a relatively relaxed manner and seem to reflect moments within a narrative. Some of the women are even involved in mundane activities like eating and drinking, actions which would not have been recorded in conventional portraiture. Thus they all appear to have a degree of naturalism which could be misconstrued as 'realism' despite their obvious glamour. The relationship between glamour and naturalism is a key aspect of 1930s advertising photography, as Wilkinson describes in relation to a 1930s Horlicks advertisement which depicts a closeup shot of a glamorous and attractive woman in a relaxed image of Horlicks-induced sleep. The degree of naturalism allowed the ordinary consumer to identify with the model and, combined with an image of glamour, provided a route to encourage desire that was transmuted to the product through the advertisement.

Glamorising mundane activities and commodities is part of the process through which photography has helped to imbue products with meanings and characteristics to which the commodity has no relationship. As Karl Marx noted, commodities are objects - usually inert - that have been imbued with all kinds of social characteristics in the marketplace. Marx called this process the fetishism of commodities, since in the marketplace (which means every place where things have been bought and sold) the social character of people's labour was no longer apparent, and it was the products of their labour instead that interacted and were prominent. Advertising photography is pivotal in acting to further fetishise commodities by investing products with what Marxists have described as false meanings (see Williams 1980; Richards 1990). As Robert Goldman remarked in a study of 1980s advertising imagery: 'ads offer a unique window for observing how commodity interests conceptualise social relations' (Goldman 1992: 2). The role of the advertising photographer has been central to the fetishism of commodities and since the 1960s to the development of lifestyle culture. As Giebelhausen writes in 1963, 'The

ROBERT GOLDMAN (1992) Reading Ads Socially, London: Routledge.

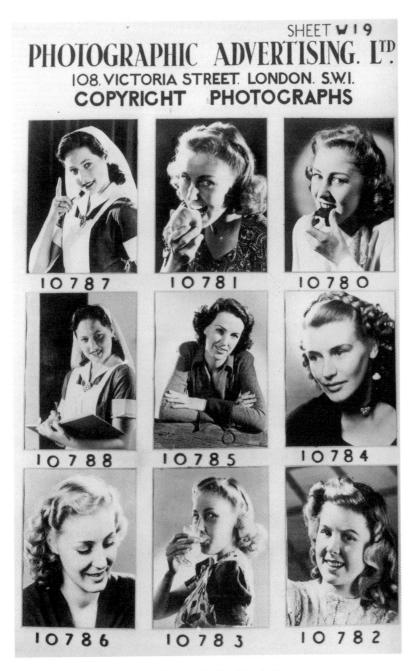

5.3 Stock sheet W1910783 from the Photographic Advertising Archive

camera has long been the favourite medium of the advertiser. It convinces with its realism even as it fascinates as with the magic of a dream so that even the people of our time are cajoled into worshipping the idols it creates' (Giebelhausen 1963).

More recently text books have emphasised, not simply the creation of dreams, but the open-ended meanings within images, and the role of the viewer in creating meanings:

The essence of advertising generally and advertising photography in particular, is to turn something which is ostensibly mundane into an exciting and arresting image. The advertising photographer is selling dreams and aspirations – sometimes his own. Commercial photography of this nature means painstakingly creating an elaborate yet intimate image that invites the viewer to almost imagine a story rather than just see the objects in the shot.

(Ward 1990)

This last statement also indicates how commercial practitioners have understood what scholars and critics of advertising have highlighted – our own role in the creation of meaning in advertisements. Through semiotic and cultural analyses of commercial imagery, Barthes and others suggested ways in which we can decode advertising images as well as appreciate our own role in the interpretation of photographs as part and parcel of the making and maintenance of **ideologies** and the hegemony of commodity culture (**Barthes 1973**; **Barthes 1977b**; **Hall 1993**, **Williamson 1978**). The next two sections: The grammar of the ad and Hegemony in photographic representation, will use some of the ideas by scholars writing about advertising and mass culture to explore how we can read and interpret these messages in detail.

THE GRAMMAR OF THE AD

CASE STUDY: THE COMMODIFICATION OF HUMAN RELATIONS AND EXPERIENCE – 'OMEGA AND CINDY: TIME TOGETHER'

The advertisement for Omega watches in the February 1999 issue of *Elle* magazine uses a traditional image of an attractive and glamorous woman – here Cindy Crawford – wearing an Omega watch (Plate 8). Cindy is photographed in a surprisingly similar way to the women in the 1930s stock photography sheet discussed above, and indicates the endurance of this kind of glamour-girl image within commercial photography. Like many of the 1930s glamour girls, she is photographed isolated from any specific location, with heavy make-up, looking

ROLAND BARTHES (1973)
Mythologies, London: Granada;
(1977b) 'The Rhetoric of the
Image' in Image, Music, Text,
London: Fontana.

STUART HALL (1993) 'Encoding/Decoding' in S. During (ed.) *The Cultural Studies Reader*, London: Routledge (first published 1980).

JUDITH WILLIAMSON (1978)
Decoding Advertisements:
Ideology and Meaning in
Advertising, London: Marion
Boyars.

engagingly out at the viewer, with a half-open mouth suggesting sexual availability. She, like the 1930s girls, also appears in a relatively relaxed, candid pose. There are of course differences between the 1930s and late twentieth-century interpretations of the glamour girl. Cindy's loose hair and sporty tank top are used to suggest a late twentieth-century femininity which is supposedly more liberated. Although there are similarities between the stock photography sheets and the Omega image, we know that Cindy's photograph was taken specifically for this advertisement, not only because a supermodel has given her name to a product, but also because Cindy is depicted leaning her chin on her right arm on which she wears an Omega watch. The watch is given enormous focus in the image through its central position and its location next to Cindy's open mouth. The image of sensual desire which Cindy exudes is thereby transferred to desire for the watch. The notion of the watch carrying human characteristics is further encouraged through the text below, which reads 'Omega and Cindy: time together'. It is as though the watch is a human being with a personality with whom we can have a relationship. This feeling is further encouraged by the subsequent three pages of the ad, which present a diary of Cindy's day with Omega. Each page is captioned with a quotation from a classic text - Horace, K. Gibran, Keats - which suggests that the relationship and the watch are both as stimulating and enduring as the literature.

In advertising, photography and montage play a crucial role in the production of meaning and the commodification of human relations and experience. Here, the juxtaposition of text and image, and the construction of the photograph, transmutes our desire for human relationships into a relationship between a person and a thing. This is represented as both attractive and satisfying. The commodification of human emotions and relations is one of the most pervasive influences of modern advertising. In the Omega advertisement, our cultural associations with Cindy Crawford as an enduring supermodel who has proved herself to be capable and intelligent through her journalistic career and charity work are also transferred to the image of the watch. Just as Cindy has endured as a model so, it is suggested, will the watch and the so-called 'relationship' it can provide. The power of the meanings created through both montage and the photographic image not only leads us to be unaware of a process, which when considered rationally appears absurd, but also enhances these surface meanings above those of other product meanings which may exist through manufacture. We know nothing of how Omega watches are made. How much were the factory workers who produced and packaged the watches paid? Were they allowed to join a union? What were the health and safety conditions like for the workers? Could the workers afford to buy and wear these watches? Advertisements provide an alluring image, the constructed meanings of which are enhanced by photographic techniques to create a culture in which it appears natural not to even want to know the context of production. These constructed meanings are not just simply illusions, rather 'they accurately portray social relations which are illusory' (Goldman 1992: 35).

ROLAND BARTHES (1977a)
'The Photographic Image' in
S. Heath (ed.) Image, Music,
Text, London: Fontana.

The photographic message

In unravelling the meanings of images, Roland Barthes and others have tried to find systems which could be applied to help decode any photographic message. In his essay 'The Photographic Message', Barthes described photographs as containing both a denoted and a connoted message (Barthes 1977a). By the denoted message Barthes meant the literal reality which the photograph portrayed. In the case of the ad for Omega, this would be the image of Cindy Crawford wearing a watch (see case study). The second message, the connoted message, is one which he described as making use of social and cultural references. The connoted message is the inferred message. It is symbolic. It is a message with a code - i.e. Cindy Crawford signifies enduring beauty and glamour. When we look at documentary photography, the denoted image appears dominant. We believe the photograph to be 'fact', although, as Tagg has pointed out, it is impossible to have a simple 'denoted' message – all messages are 'constructed' (Tagg 1988: 1-5). The image for use in advertising, however, is different. We know from the start that it is highly structured. The discussion on the Omega ad has already mentioned how the codes of glamour photography are employed in the image, as well as how the structuring of the watch in line with Cindy's mouth suggests a symbolic desire for Omega watches. The commercial photograph is therefore not perceived as primarily documenting real life. In this sense we are unconsciously aware when reading the image that the connoted message is the crucial one. We have also seen the focus on the connoted message in commercial stock photography.

In trying to find systems for reading images, many scholars have adopted semiological methods first used in linguistics to decode visual signs:

A sign is quite simply a thing – whether object, word or thing – which has a particular meaning to a person or group of people. It is neither the thing nor the meaning alone, but the two together. The sign consists of the signifier, the material object, and the signified, which is its meaning. These are only divided for analytical purposes; in practice a sign is always thing-plus-meaning.

(Williamson 1978: 17)

If we use this system to analyse the Omega watch ad, we can read Cindy Crawford as a signifier of glamour and beauty which is the meaning signified. There are also many other signifiers in the image, for example, the black and white photograph, Cindy's half-open mouth, her loose hair and tank top, which all combine to signify a specific kind of femininity, glamour and beauty.

So what does the watch signify? To disentangle its meanings in the advertisement, it is useful to consider Roland Barthes' notion of a second-order semiological system, which he asserts exists in all texts. In the second-order semiological system, the sign from the first level of signification becomes the

signifier of the second level. In the ad for Omega, therefore, Cindy Crawford as a sign of enduring beauty and glamour acts as a signifier of Omega. The human characteristics of Cindy are interpreted as characteristics of an Omega watch. Second, the signifier of Cindy wearing an Omega watch in the context of the statement 'Cindy and Omega: time together' acts to signify an enduring and glamorous relationship. Barthes perceives this second level of signification as a form of myth, since in this second level of signification the production of ideology is paramount (Barthes 1973). In the case of advertisements such as this one it emphasises the ideological power of ads to commodify human relations.

In understanding the transfer of meaning between signs in an image, Judith Williamson and, later, Robert Goldman have suggested that the formal structure of an ad is significant (Williamson 1978: 24–6; Goldman 1992: 61–85). In one of the most widely adopted conventions of commodity advertising, an illustrative image of the product is montaged on to what could be described as the main mood image of the advertisement. Through this juxtaposition we are encouraged to transfer meaning. This convention is still applied in the Omega ad, although in a more sophisticated way. Cindy actually wears the watch, but the watch is photographed clearly and in hard focus – similar to most illustrative insets. The convention of montage is even more apparent on the subsequent diary pages of the advertisement, where the watch is highlighted from the rest of the black and white mood photograph by being in colour.

Apart from drawing our attention to the way in which formal structures create meaning, Judith Williamson also made an important point about the active involvement of the viewer in the production of meanings. She describes the viewer's role in producing meaning as 'advertising work' (Williamson 1978: 15–19). In describing this process, Williamson wished to emphasise our involvement in the maintenance and production of ideology. Later critics have also emphasised the way in which viewers interpret advertisements differently, depending on their experiences and cultural knowledge.

The transfer of meaning

In his essay 'Encoding/Decoding', Stuart Hall considered our involvement in the production of meaning (Hall 1993). He discusses how images are first 'encoded' by the producer, and then 'decoded' by the viewer. The transfer of meaning in this process only works if there are compatible systems of signs and symbols which the encoder and decoder use within their cultural life. Our background – i.e. our gender, class, ethnic origin, sexuality, religion, etc. – all affect our interpretation of signs and symbols. Our relationship and understanding of various forms of photography are part of those signs and symbols. Hall points to the fact that messages are not always read as they were intended, because our various cultural backgrounds lead to different interpretations. He suggests that there are three possible readings of an image:

a dominant or preferred reading, a negotiated reading, and an oppositional reading. The dominant reading would comply with the meaning intended by the producer of the image. The importance of readers interpreting images as they were intended is obviously crucial for commercial messages, and is one of the reasons why advertisers use text and montage to restrict the ways in which we may interpret their images. Hall describes the negotiated reading as one which only partly conforms to the intended, dominant meaning. Finally the oppositional reading is one which is in total conflict with the meaning intended by the image-producer. Examples of ordinary people producing oppositional readings through graffiti were collected by Jill Posner in Spray it Loud (Posner 1982). In Reading Ads Socially, Robert Goldman cites an example of a cigarette advertisement which was misinterpreted by many readers to create an oppositional meaning. In 1986, Kent cigarettes launched an ad campaign which depicted two people flying a kite on a page. In order to involve the viewer in the advertisement, the advertiser emptied the figures of content so that readers could literally place themselves in the ad. Viewers, however, interpreted the silhouetted figures as ghosts because of the health warnings about smoking to which we have become accustomed (Goldman 1992: 80-1). The question of reception brings into doubt the notion of global advertising which companies such as Coca-Cola and Benetton have tried to create. Can there really be worldwide advertising campaigns? People across the world will surely find different symbolic meanings in the same signifiers.

The creation of meaning through context and photographic styles

All photographs will be viewed by different people in different ways, whether in commercial contexts or not. The same photograph can also mean different things in different contexts, even different styles of photography will carry different messages. Let us look at an advertisement which does not use a style of photography normally associated with advertising. Because advertisers have traditionally been concerned with creating glamorous, fantasy worlds of desire for their products, they have tended to shy away from the stark, grainy, black and white imagery traditionally associated with documentary images and photojournalism. They have gone instead for glossy, high-colour photography to enhance their images of desire. Yet, at times of company crisis, or when companies have wanted to deliberately foster an image of no-nonsense frankness, they have used black and white imagery. In 1990, a short while after Nelson Mandela was released from jail by the South African authorities, the Anglo-American Corporation of South Africa brought out an advertisement entitled 'Do we sometimes wish we had not fought to have Black trade unions recognised?' Underneath this title was a documentary photograph of a Black South African miner, in a show of victory (Figure 5.4). At a moment when Anglo-American foresaw massive economic and political change, they attempted to distance themselves from the apartheid regime. Yet Anglo-

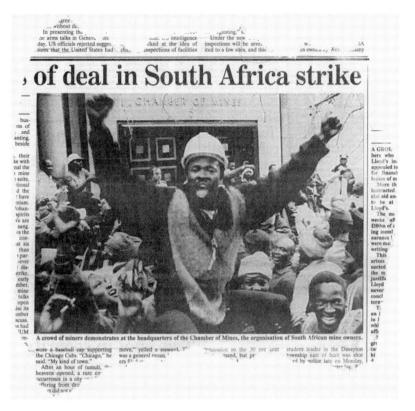

5.4 South African miners demonstrating outside the office of the organisation of South African mine owners. *Independent* 26 August 1987

This photograph was used, torn from the newspaper page as it is here, by the Anglo American Corporation of South Africa in their advertisement DO WE SOMETIMES WISH WE HAD NOT FOUGHT TO HAVE BLACK TRADE UNIONS RECOGNISED?, published in *The Guardian* 2 April 1990

American was by far the largest company in South Africa, 'with a near total grip over large sectors of the apartheid economy'. While presenting this advertisement to the public, De Beers – Anglo's sister company, in which they had a 35 per cent stake – also cancelled their recognition agreement with the NUM at the Premier Diamond Mines, despite 90 per cent of workers belonging to the union. The frank and honest style of address which black and white photography provided hid the reality for black workers in South Africa. The miner depicted was in fact celebrating his victory against Anglo-American in 1987. Here, at another moment of crisis, Anglo-American has appropriated this image of resistance. The parasitism of advertising enables it to use and discard any style and content for its own ends. Anglo-American are no longer interested in fostering this image (they declined permission to have the advertisement reproduced here). There is an added irony in Anglo-

3 As stated in anti-Apartheid campaign literature of the time. American's use of this image, since it is not strictly speaking a documentary image at all, but a montage of two images used to capture the mood of the strike as the *Independent* saw it.

Black and white imagery has been used in other company contexts at moments of crisis. Carol Squiers has discussed the way in which they have been used in annual reports. Black and white, she notes, 'looks more modest and costs less to print'. As Arnold Saks, a corporate designer, said: 'There's an honesty about black and white, a reality. . . . Black and white is the only reality' (Squiers 1992: 208).

Apart from specific ways in which certain forms of black and white photography have been used to signify specific characteristics of a company, advertisements that have tried to encourage the idea of rational consumer choice have adopted a kind of factual illustrative photography, which suggests an attention to scientific detail. An advertisement for Halfords children's bikes uses this kind of image to emphasise the inappropriateness of other manufacturers' children's handlebars. It is an interesting advertisement since the photograph does not actually represent their product, but a design fault in their rivals'. The advertisement also highlights the way in which the text of advertisements is crucial in anchoring their meaning. Angela Goddard discusses the way in which texts frame meanings in her recent book *The Language of Advertising* (Goddard 1998).

The symbolic value of using or not using a photograph has also been important for advertisers. Kathy Myers has explored the moments when advertisers have chosen to use and not use photographic images in an attempt to find symbols of ecological awareness (**Myers 1990**).

HEGEMONY IN PHOTOGRAPHIC REPRESENTATION

Commercial photography constantly borrows ideas and images from the wider cultural domain. It is clear that when we point the camera we frame it in a thousand and one ways through our own cultural conditioning. Photographs, like other cultural products, have therefore tended to perpetuate ideas which are dominant in society. Commercial photographs, because of their profuse nature and because they have never sought to challenge the status quo within society (since they are only produced to sell products or promote commodity culture, have also aided in the construction and perpetuation of stereotypes, to the point at which they have appeared natural and eternal (see Barthes 1977b; Williamson 1978, part 2). Through commercial photography we can therefore explore hegemonic constructs of, for example, race, gender and class. Below, consider examples from advertisements. It is just as possible to use examples from the wider gambit of commercial photography as has been highlighted above in discussing stock photography and as raised below in discussing fashion photography.

CAROL SQUIERS 'The Corporate Year in Pictures' in R. Bolton (ed.) **The Contest of Meaning: Critical Histories of Photography**, Cambridge, MA: MIT Press.

KATHY MYERS (1990) 'Selling Green' in C. Squiers (ed.) The Critical Image: Essays on Contemporary Photography, Seattle: Bay Press.

Photomontage: concealing social relations

One of the key ways in which commercial photography has sought to determine particular readings of images and products has been through photomontage. Advertisements are in fact simple photomontages produced for commercial purposes, although most books on the technique seem to ignore this expansive area. While socialist photographers like Heartfield use photomontage to make invisible social relations visible, 4 advertisers have used montage to conceal 'reality'. One of the peculiar advantages of photomontage, as John Berger wrote in his essay 'The Political Uses of Photomontage', is the fact that 'everything which has been cut out keeps its familiar photographic appearance. We are still looking first at things and only afterwards at symbols' (Berger 1972b: 185). This creates a sense of naturalness about an image or message which is in fact constructed. An early example of the photomontage naturalising social relations has been discussed by Sally Stein, who considers 'the reception of photography within the larger matrix of socially organised communication', and looks at the rise of Taylor's ideas of 'scientific management' in the factory, and the way these ideas were also applied to domestic work (Stein 1981: 42-4). She also notes how expensive it was to have photomechanical reproductions within a book in the early part of the century.

Yet in Mrs Christine Frederick's 1913 tract, *The New Housekeeping*, there were eight pages of glossy photographic images. This must have impressed the average reader. In her chapter on the new efficiency as applied to cooking, an image was provided which affirmed this ideology as the answer to women's work. The image consisted of a line drawing of an open card file, organised into types of dishes, and an example of a recipe card with a photograph of an elaborate lamb dish (Figure 5.5). Despite Frederick's interest in precision, the card, which would logically be delineated by a black rectangular frame, does not match the dimensions of the file, nor does it contain practical information such as cost, number of servings, etc. which Frederick suggests in her text. As Stein points out, however, most readers must have overlooked this point when confronted with this luscious photographic image, which they would have accepted at face value.

Because the page is not clearly divided between the file in one half and the recipe card in the other but instead flows uninterruptedly between drawing below, text of recipe, and photograph of the final dish, the meticulous organisation of the file alone seems responsible for the full flowering of the dish. As a symbolic representation of modern house work, what you have in short order is a strict hierarchy, with an emblem of the family feast at its pinnacle.

(Stein 1981: 43)

4 John Heartfield was a German artist who used his talent to further both the anti-Nazi and socialist cause. His most celebrated work was produced for the Communist Party's illustrated newspaper Arbeiter Illustrierte Zeitung which included montages that exposed the rhetoric of Hitler's speeches, his sources of funding and the tragic impotence of organisations such as the League of Nations.

SALLY STEIN (1981) 'The Composite Photographic Image and the Composition of Consumer Ideology', Art Journal, Spring.

5.5 Illustration from Mrs Christine Frederick's The New Housekeeping 1913

The more down-to-earth questions of time and money are ignored and almost banished. In response to those who believed that her reading was too contrived, Stein wrote: 'If it seems that I am reading too much into this composite image, one need only note the title of Frederick's subsequent publication – *Meals that Cook Themselves*' (Stein 1992).

There are two key issues we can draw from Stein's analysis. First, the example highlights the power of the photographic image to foster desire. While a rather ordinary photograph of a cake or a roast may have impressed an early twentieth-century audience, in the twenty-first century we are also seduced by the use of the latest technology and luscious photography. The photography of food continues to produce tantalising images through the play of colour and texture. Dishes are often painted or glazed to highlight colours and textures in order to produce more mouth-watering images. Roland Barthes also discussed food advertising in his essay 'The Rhetoric of the Image' (Barthes 1977b). Using an advertisement for Panzani pasta he highlighted the sense of natural abundance that is often focused on in food advertising and photography, to encourage the notion of the naturalness of prepacked produce. The constant juxtaposition of uncooked fruit or vegetables with prepared food also conceals and thereby in effect dismisses the labour process. The total metamorphosis of a coconut into Carte D'Or's coconut ice cream (Figure 5.6) is an extreme example of the ability of the latest technology - here digital photography - to deny the labour of cooking. The concealing of social and economic relations in advertising led Victor Burgin to create the image 'Possession' which I use as the frontispiece of this chapter (Figure 5.1). It is worth noting that photographers today appear not be making work of this kind. The collapse of the Soviet Union and the rise of American imperialism as the only superpower have also impacted on the work of academics. There are only a few that have been concerned with exposing the illusions of advertising photography which is why many of the writings referred to in this text are from the 1970s and 1980s. It was left to a journalist to write the most critical analysis of branding in the new century (Klein 2001).

Concealing labour relations

This brings us to the second issue in Stein's analysis – the power of photomontage in the commercial context to conceal labour relations. Judith Williamson has also discussed this with regard to a Lancia car advertisement from around 1978. The image depicts the Lancia Beta in an Italian vineyard. It shows a man who appears to be the owner, standing on the far side of the car with his back towards us, looking over a vineyard in which a number of peasants are working happily. In the distance, on a hill, is an old castle (this image is illustrated in **Williamson 1979**). Williamson asks a series of questions:

JUDITH WILLIAMSON (1979) 'Great History that Photographs Mislaid' in Photography Workshop (ed.) **Photography/ Politics One**, London: Comedia.

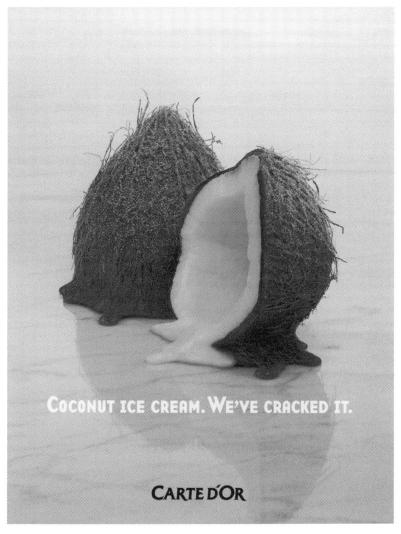

5.6 Carte D'Or icecream advertisement, Good Housekeeping, June 1998

Who made this car? Has it just emerged new and gleaming from the soil, its finished form as much a product of nature as the grapes on the vine? . . . Who are these peasants? Have they made the car out in this most Italian field? . . . How can a car even exist in these feudal relations, how can such a contradiction be carried off? . . . What is this, if not a complete slipping over of the capitalist mode of production, as we survey a set of feudal class relations represented by the surveying gaze of possession, the look of the landlord with his back to us?

(Williamson 1979: 53)

Williamson also notes how the feudal Italian owner's gaze does not encompass both car (the product of industrial capitalism) and the owner's field of vision (the relations of Italian feudalism). She discusses the structure of the advertisement in order to understand why we don't question the contradictions of the image. The ad uses the traditional grammar of car advertisements with the showroom-effect camera angle, which intersects with the representation of 'Italianness'. The positioning of the car seems so casual that the man leaning against it could have just stopped to have a break and look at this Italian view. Maybe he is not Italian? Perhaps he will drive on and leave the 'most Italian' scene behind. The narrative of chance on the horizontal axis of the photograph naturalises the vertical axis of Italian castle, feudal relations and commodity ownership.

Many contemporary advertisements also adopt romanticised and non-industrial working environments to give their products an image of quality and historicity. Hovis and other wholemeal bread producers have often used the image of the family bakery. Whiskey distillers have also used this image to represent their brand as one which has been produced with special attention and one that has the experience of time behind it. Jack Daniel's whiskey has produced advertisements since the 1990s which present a labour environment that could not possibly exist today (Figure 5.7). One individual worker is highlighted and named, almost as a family friend. Their work is represented as individualised (the opposite of factory production). The black and white photograph of a romanticised work environment seems to represent both the past and present. There is a reassuring sense of stability. The photograph also seems to elude us into believing that this is a 'real' world, especially since the whiskey bottle at the bottom of the ad, which we know to exist, is only engraved.

Gendered representations

While the concealing of class relations and the representation of commodity culture as natural and eternal is the most overwhelming construct of advertising, capitalism has also exploited racist and sexist ideologies. Much of the literature which considers racist and sexist imagery, however, while using commercial photography for examples, has tended to discuss broader cultural readings rather than the commercial or photographic context. (For the most recent and lucid example of these critiques see **Hall 1997**.) This section will discuss gendered representations. (For explorations of 'race' and racism in commercial photography see case studies on pages 223–35 and 239–44.)

The stereotypical and highly coded representations of women in popular culture have been given attention by many critics (**Berger 1972a; Winship 1987a**, 1987b; Williamson 1978). One of the key criticisms has been the way in which ads always represent women as objects to be surveyed. This has tended to increase the representation of women as both passive and objects of sexual desire. In his book, *Gender Advertisements*, Erving Goffman has

STUART HALL (1997) **Cultural Representations and Signifying Practice**, London: Sage

JOHN BERGER (1972a) Ways of Seeing, London: BBC.

JANICE WINSHIP (1987a)
'Handling Sex' in R. Betterton
(ed.) Looking On: Images of
Femininity in the Visual
Arts and Media, London:
Pandora.

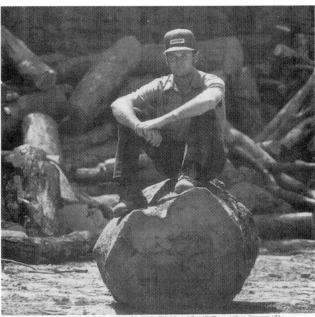

If you'd like to irrow more about our virigue whoskey, whe to us for a fine bookket at the lack Dawld Distillery, Lyrchburg, Itemas TENNESSEE MEN and Tennessee maple account for the smoothness of Jack Daniel's Tennessee Whiskey.

We get these big chunks of hard maple from the hills around here. They're taken from high ground when the sap is low. Then, men like Billy Durm cut them in strips; stack them in ricks; and burn them to charcoal for smoothing our whiskey. Sometimes we joke about who's more important—the man or the maple? But after a sip of charcoal mellowed Jack Daniel's, you'll know that both are doing good jobs.

5.7 'Billy Durm', Jack Daniel's Whiskey advertisement

A romanticised labour environment appears more real by its representation as a photograph

explored the way in which men and women's body language has been photographed to perpetuate gender roles (Goffman 1979). It is important to remember that the photographer always surveys his or her subject and personally selects what is believed to be worth photographing. The photographic process can also, therefore, exacerbate the voyeuristic gaze. Analyses of popular film and the scopophilic nature of mainstream film products is also useful in reading and interpreting advertising (see Mulvey 1975). In understanding the role of photographs in representing stereotypical images of women, Janice Winship has explored the contrasting ways in which men's and women's hands have been photographed in advertisements (see Winship 1987a). While male

hands are usually photographed as active and controlling, female hands are invariably represented as decorative and caressing.

Winship's essay also draws attention to the increasing fragmentation of the body within recent commercial photography. It makes the body more easily commodified and packaged. In a content analysis of lipstick advertisements, Robert Goldman has pointed out that while most lipstick ads in 1946 depicted the whole body of a woman, by 1977 most ads only showed a part of the body. A Marks & Spencer make-up ad from Marie Claire, November 1998, highlights the continual fragmentation of women's bodies, with a series of women's lips montaged into the ad to express the range of lipsticks available. It is as though each part is like a commodity to be worn and discarded at will.5 There are countless examples of women's make-up ads that fragment the women's bodies. As Pollock indicates, it was only 'after Picasso had visually hacked up the body, [that] we have been gradually accustomed to the cutting up of specifically feminine bodies: indeed, their cut-up-ness has come to be seen as a sign of that femininity'. Significantly, Pollock adds that this 'came to be naturalised by photographic representation in film, advertising, and pornography, all of which are discourses about desire that utilise the dialectic of fantasy and reality effects associated with the hegemonic modes of photographic representation' (Pollock 1990: 218). One of the most famous examples of the fragmentation of women's bodies was an advertisement for Pretty Polly tights, which depicted a woman's legs emerging from an egg. This objectification and fragmentation received criticism at the time. Oppositional graffiti included one that read 'born kicking'. Today, opposition to commercial photography's abuse of women is articulated through web sites such as www.about-face.org or www.adbusters.org.

Recent commercial photography has undoubtedly objectified both male and female bodies in the constant drive for commodification. Yet women's bodies continue to be the more powerful object of the gaze. New technology such as digital imaging has been used repeatedly to heighten the display of women's sexual availability. Women's bodies can now be contorted into impossible positions. *Marie Claire's* fashion spread 'Night Diva' from March 2003 shows such a manipulation (Plate 10).

FASHION PHOTOGRAPHY

Here, it is worth considering the genre of fashion photography, since this area of commercial photography has been particularly targeted with regard to discussions on the construction of femininity and gendered representations. The fashion industry is another tool through which we can see the development of a society of the spectacle.

In *The Face of Fashion*, Jennifer Craik provides an historical account of the techniques of fashion photography from early photographic pictorialism of the nineteenth century, through the gendered constructions of the 1920s and

5 It is worth noting. however, that despite the anonymity and objectification of the women's bodies in the image, the models used for the advertisement command much higher economic benefit from their work than the photographer. On asking Marks & Spencer for reproduction rights for this book, the company asked for £,300 to be paid to each model and only f.100 to be paid to the photographer.

1930s which increasingly represented women as commodities, to the increasing dominance of the fashion photographer in the 1960s and the influence of filmatic techniques which led to clothes becoming more and more incidental within the fashion photograph. Craik also draws our attention to the spectacle of eroticism of 1970s and 1980s fashion photography. Most importantly she notes that the conventions of fashion photography are 'neither fixed nor purposeful' (Craik 1994: 114). This comment could be applied to that of all commercial photography. It is perhaps for this reason that critical literature on fashion photography is sparse. Most of what has been written does not provide a critique of the genre as a whole, but tends to consider the constructions of gender and sexuality within these images. Femininity, as Craik notes, 'became co-extensive with the fashion photograph' by the 1930s. The heightened sexuality of the fashion image in the 1970s and 1980s, with the work of photographers such as Helmut Newton, has been discussed by Rosetta Brookes (Brookes 1992: 17–24).

The way in which women read fashion images of women has also been explored (see Evans and Thornton 1989: ch. 5). As Berger commented: 'Men look at women. Women watch themselves being looked at' (Berger 1972a: 47). As far as the photographic quality of the fashion spread is concerned, these have tended to be discussed in books, often commissioned by commercial enterprises such as Vogue, which eulogise these images and their relationship to 'art' photography. In this process the work of individual photographers has been discussed, rather than the genre itself. It is worth noting that even in their discussions of the fashion image and sexuality, Brookes, as well as Evans and Thornton, discussed the issue through key examples of work by particular photographers. Their essays provide critical case studies of fashion images from the 1960s, 1970s and 1980s by photographers such as Helmut Newton, Guy Bourdin and Deborah Turbeville. In marking out fashion photography as an area for discussion, it seems clear that the glossy images which are mostly discussed contrast to the fashion photographs of the average mail-order catalogue, which could be described as fashion illustration.

Several signs or features of the fashion image which have been pointed out by various writers are worth considering together in order to understand the genre. First, the transitory nature of fashion has impacted on the fashion image. Evans and Thornton have discussed this in terms of the ability of the fashion image to take 'extraordinary liberties' and get away with images which are unduly violent, pornographic or outrageous. Polly Devlin has pointed out the contradictory nature of the fashion image's transitoriness, since it aims to be both timely and timeless: 'Its subject is a product with built-in obsolescence, and the result may be an amusing, ephemeral picture or a monumental statement' (Devlin 1979: 113).

There are other contradictions apparent within the fashion image. Rosetta Brookes has suggested that in fashion photography 'we see the typical instead JENNIFER CRAIK (1994) 'Soft Focus: Techniques of Fashion Photography', **The Face of Fashion**, London: Routledge, ch. 5.

ROSETTA BROOKES (1992)
'Fashion Photography' in J. Ash and E. Wilson (eds) Chic Thrills: A Fashion Reader, London: Pandora

C. EVANS AND M. THORNTON (1989) Women and Fashion: A New Look, London: Quartet, especially ch. 5.

of the unique moment or event' (Brookes 1992: 17). Yet, at the same time as producing the typical, fashion photographers have aimed to construct a sense of what is original and unique within a particular fashion. They have also tried to produce images which stand their ground beyond the transitory space of the magazine and the transitory nature of fashion, and for example enter the gallery or the coffee-table book. The Vogue Book of Fashion Photography and the major Victoria and Albert Museum exhibition and its accompanying catalogue Appearances: Fashion Photography since 1945 are testament to this conflict (Devlin 1979; Harrison 1991). Both provide a good collection of images of the classical fashion photograph, although the historical essays tend to be uncritical of the genre. It is clear that there are tensions in the relationship between fashion photography and both advertising photography and art photography. The fashion image attempts to stand aloof from the undiluted commercial context of advertising, since most fashion spreads are commissioned by magazines which are not directly selling clothes. Yet the undeniable commercial angle has separated it from the art photograph, despite the inevitable commercial context of the latter.

The relationship of the fashion spread to magazines rather than the manufacturers also emphasises the importance of the images' ability to project 'a look, an image, a world' (Evans and Thornton 1989: 82) These images in the 1990s and in the new millennium promote the world of concept branding. Val Williams' Look at Me: Fashion and Photography in Britain highlights the crucial role that particular magazines such as Nova in the 1960s and later I-D and The Face in the 1980s have played in developing conventions of challenge within certain areas of fashion photography, that encompassed discussions of race, sexuality and class within fashion and style. In constructing these multiple identities fashion photography enables us to view the social attitudes of a period.

Despite providing 'conventions of challenge', however, these magazines and the photographs within them are still subsumed within a culture of commodification in which identities, whether traditional or not, form part of a vast reservoir of appearances that can be packaged and sold. As Steve Edwards wrote, with regard to the *Next Directory*:

As we flip the pages multiple identities whizz past our eyes. Distance and depth collapse into the intricate and exquisite surface of the image. What is there now to prevent us switching back and forth between these marvellous identities? She: now sipping tea on the lawn of the country seat, bathed in golden light, 'well-dressed, well-bred,' in that 'endless summer'. Now the belle of the southern states, young and raw, perhaps with an illicit negro lover. Now the cultured woman, on her travels through Europe in search of adventure. He: from the big city gentleman, to the rugged biker, to the fictions of Havana. These are the worlds that the photograph has to offer. . . . Our only choice is

between its choices, we have no choice but to consume . . . or so the argument goes.

(Edwards 1989: 5)

In creating worlds of illusion, fashion photography has been influenced by all other areas of photographic practice. Early portrait photography and the carte-de-visite had already established ways of photographing people in fashionable or dramatic clothing, which were adopted by early fashion photographers (Ewing 1991: 6-10). Fashion photographers such as André Barre, Irving Penn and Erwin Blumenfield have been influenced by art movements such as Surrealism. Bruce Weber's photographs for Calvin Klein have been influenced by the work of Leni Riefenstahl. The power of photojournalism and documentary photography in the 1930s also affected fashion images, especially as photographers moved between the genres. Yet, the concentration on what is contrived and stylised rather than the 'captured' moment, so revered in documentary, continues to set it apart. Films have also influenced fashion photography, both in terms of content and the creation of looks and styles and the way in which we are able to read what would otherwise appear as fragmentary and disjointed image sequences in the fashion spread. In creating images and 'looks', the fashion photograph - in its attempts to always find something new, different, glamorous and often 'exotic' - has also been influenced by the increasing experience of international travel. In the following case study we will therefore explore fashion and travel images together. This should indicate the impossibility of considering various commercial imagemaking forms in isolation. We live in a world dominated by lifestyle culture, whose conventions are 'neither fixed nor purposeful'.

CASE STUDY: TOURISM, FASHION AND 'THE OTHER'

In this case study we will consider a particular hegemonic construction from the nineteenth century – that of the exotic/primitive 'Other' – and explore the way in which it has been exploited in the commercial world. Some of the most dominant ideological and photographic constructs were developed during the nineteenth century, a period of European imperial expansion. This history has affected the representation of black people in all forms of photographic practice (see Gupta 1986; Bailey 1988; Ten/8 16; Ten/8 2(3)). During the nineteenth century, the camera joined the gun in the process of colonisation. The camera was used to record and define those who were colonised according to the interests of the West. This unequal relationship of power between the white photographer and the colonised subject has been discussed by many (Freedman 1990; Prochaska 1991; Schildkrout 1991; Edwards 1992; Bate 1993). These early anthropological and geographical photographers were sometimes paid

employees of companies who organised campaigns to explore new markets. Emile Torday, for example – an anthropologist who used photography as a research aid – was paid by the Belgian Kasai Company to explore the Congo.

This history of photography is integrally linked to colonial and economic exploitation. A sense of submission, exoticism and the 'primitive' were key feelings, which these photographers documented and catalogued. Through these images, the European photographer and viewer could perceive their own superiority. Europe was defined as 'the norm' upon which all other cultures should be judged. That which was different was disempowered by its very 'Otherness'.

During this period, the sense of 'Otherness' and exoticism was not only captured 'in the field' but was also exploited by photographers working in commercial enterprises. Malek Alloula has documented the genre of exotic/ erotic colonial postcards which were sent back to France by French colonists. In his book *The Colonial Harem* he discusses images of Algerian women taken by French studio photographers in Algeria (**Alloula 1987**). In the confines of the studio, French photographers constructed visions of exoticism which suited their own colonial fantasies and those of the European consumers of these images. The paid Algerian models could only remain silent to the colonisers' abuse of their bodies (Figures 5.8 and 5.13). These images encapsulate Edward Said's description of Flaubert's Egyptian courtesan:

MALEK ALLOULA (1987) **The Colonial Harem**, Manchester: Manchester University Press.

She never spoke of herself, she never represented her emotions, her presence or history. He spoke for and represented her. He was foreign, comparatively wealthy, male, and these were historical facts of domination that allowed him not only to possess Kuchuk Hanem physically but to speak for her and tell his readers in what way she was typically oriental.

(Said 1985: 6)

The dominance of photographs of women in these commercial images is not by chance. Colonial power could be more emphatically represented through gendered relations - the white, wealthy male photographer versus the nonwhite, poor female subject. These images, bought and sold in their thousands, reflect the commodification of women's bodies generally in society. They are also part of the development of postcard culture which enabled the consumption of photographs by millions. The production of exotic postcards also brought photographs of the 'Empire' and the non-European world into every European home. It was not only the photographs of non-European women which were sold: landscape photographs, which constructed Europe as developed and the non-European world as underdeveloped, were also popular (Prochaska 1991). Gen Doy has developed this discussion of Algerian postcards arguing that those produced in the European studio and those produced in Algeria sometimes present conflicting images of this stereotype, because the sitters in Algeria were not always aware nor did they always adhere to the constructed codes with which the European artist wished to frame them (Doy 1996: 30-1). Colonial

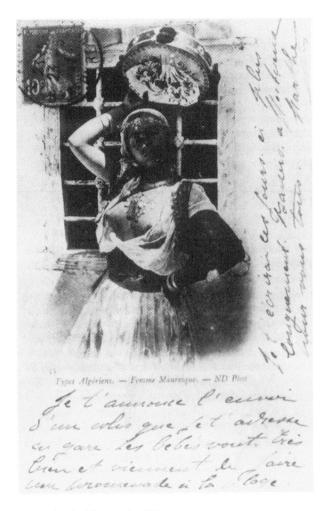

5.8 French Colonial postcard c. 1910

White French photographers constructed their own colonial fantasies, which were sent by colonial officers in Algeria to relatives and friends in France

visions continue to pervade contemporary travel photography, not only through postcards, but also in travel brochures and tourist ephemera.

Tourism

Today, many areas of commercial photography exploit exoticism and 'Otherness', along with the ingredient of glamour to invite and entice viewers and consumers. In this way, some of the ideological constructs of colonial domination have become so naturalised that we hardly notice them. In the tourist industry, images of exoticised women and children in traditional garb are used

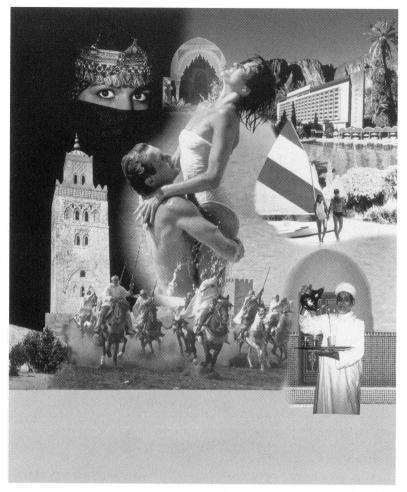

5.9 'Morocco 1990'

to encourage travel through tourist brochures, posters and TV campaigns. Many of these images have echoes to those discussed by Alloula. The East continues to be constructed as the submissive female and the West usually as the authoritative male. A recent brochure advertising Dubai recycles the image of Arab women dancing for the white spectator. A montage of images from a 1990 advertisement serves up Morocco as a location for pleasure (Figure 5.9). The non-European world is represented as a playground for the West. The bombardment of these images denies the reality of resourcefulness and intense physical work which actually constitutes most women's lives in the Third World. In the 1970s, Paul Wombell commented on this construct in a photomontage, which contrasted the fantasy tourist world with the reality for many Asian women

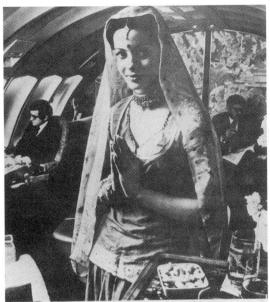

Rajput windows and the ethereal voice of the sitar. Murals of the legends of Krishna and silks and brocades from Rajasthan. A glimpse of India on your way to New York.

Ash trays and the extensive dirty floors of the airport.

The arrivals and departure board of Heathrow and the overalls from Acme.

A glimpse of exploitation on your way to New York.

IMMIGRANT-LABOUR

5.10 Montage, Paul Wombell, 1979

workers in Britain (Figure 5.10). In many tourist advertisements, the image of work is so glamorised that we cannot perceive the reality.

The dominant photographic language of the tourist brochure has also affected how tourists construct their own photographs. These snapshots tend to reinforce the constructed and commodified experience of travel: what is photographed is that which is different and out of the ordinary. Most tourist snapshots also use a vocabulary of photographic practice which is embedded in power relations. Let us look at the photographs by Western tourists in the non-Western world. Tourism within Europe produces a slightly different set of relations. In the non-Western world, the majority of tourists who travel abroad are Western. Automatically a relationship of economic power is established, both generally and in terms of camera ownership.

While Don Slater (Slater 1983) has discussed the contradictory way in which the expansion of camera ownership has not led to new or challenging photographic practices, in the non-Western world this contradiction between ownership and practice is less evident. Tourists, having already consumed an array of exotic and glamorised photographs of the place before arrival, search out these very images and sites to visit and photograph in order to feel that their trip is complete. While many of the experiences revolve around architectural

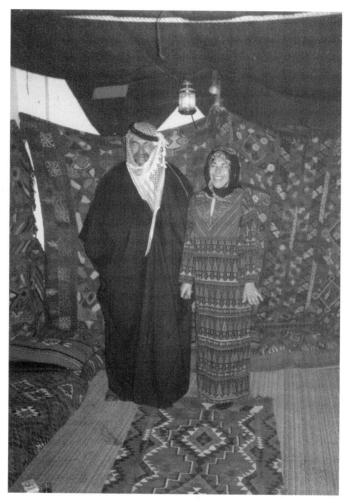

5.11 Tourist photographThis photograph was taken in a carpet shop where tourists could dress up and role-play in a mock bedouin tent

monuments, the desire to consume exotic/anthropological images of people has found a new trade, which has its parallel in the earlier studio-anthropological photography. In many tourist locations – in India, Morocco and Algeria, for example – men and women sit in elaborate garb which the tourist can recognise as traditional and, more importantly, exotic. These people wait for those willing to pay to have their photograph taken with them. Tourism creates its own culture for consumption. Just like the model in the studio, he or she is also paid by the photographer to conform to an image which has already been constructed. Alternatively, at other sites, tourists can dress up as part of the exotic experience, and photograph themselves (Figure 5.11). The trade in these

new 'anthropological' images may have expanded to include the unknown snap-shooter, but their purpose is not to encourage an understanding of a culture, but rather to commodify and consume yet another aspect of a place through the photographic image – the people.

Fashion

In fashion photography the consumption of 'Other' worlds is domesticated through the familiar context of the fashion magazine and the (more-often-thannot) white model. In some cases it is hard to know where one genre ends and the other begins. Within fashion, the ordinary is made to appear extraordinary, and vice versa. Fashion photography, as I have already mentioned, is blatantly concerned with the constructed photograph. It is also concerned with what is exotic, dramatic, glamorous and different. Therefore, it is easy to see how some photographers have moved between areas of anthropological and fashion photography. Irving Penn's Worlds in a Small Room is a series of constructed images of peoples from around the world, whom Penn photographed while on assignments for Vogue (Penn 1974). In these images the genres of fashion and visual anthropology seem to collapse. The images tell us little about the people, but say a lot about Penn's construction of these people as primitive and exotic. As with the fashion shoot, these images are contrived and stylised, and Penn is at pains to find what is extraordinary and to create the dramatic. The isolated space of the studio removes the subjects from their own time and space, in a similar way to the French colonial postcards discussed above (p. 224), and gives the photographer free rein to create every aspect of the image. Interestingly, Penn described this studio space as 'a sort of neutral area' (Penn 1974: 9). Yet, as we look through his book and peruse the photographs of Penn constructing his shots, the unequal relationship of power makes a mockery of the notion of neutrality.

The latent relationship between fashion and popular anthropological photography explains why the fashion magazine *Marie Claire* could include articles about ethnography without losing the tone of the fashion magazine. In their first issue, the article 'Arabia behind the veil' represented the jewellery and make-up of Arab women in a series of plates, like fashion ideas (Figure 5.12). If we look closely at the images it is clear that the photographer has used just two or three models and dressed them differently to represent a series of styles, just like a fashion shoot.

In fashion photography we can see the continued use of the 'harem' image, for example, as the site of colonial fantasy and as being oppositional to the white 'norm'. In the November 1988 issue of *Company* magazine, a fashion spread titled 'Arabesque: Rock the Casbah – This is Evening Wear to Smoulder in' features non-white women in brocaded clothes, sitting and lying indoors on heavily ornamented fabrics, while pining over black and white photographs of men. The photographs of the women are bathed in an orangey, rich light. By contrasting colour and black and white photography, the men seem to appear

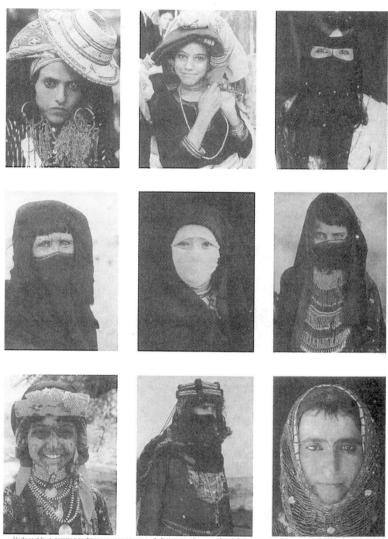

Veils and face-pateting techniques vary enormously between urban, rural and desert regions. Some girls start with make-up and 'graduate' to veils; women may combine the two, adding ornate jewellery or besidwork, head rings and, occasionally, hats

5.12 (a) and (b) 'Arabia behind the veil', *Marie Claire*, September 1988

women, then, adopted the veil with the same intention as the Arab women of today, as a shield against the visual aggression and intrusion of men. The most well-documented, archaic function of the veil, therefore, remains simply to protect and preserve.

Sustaining a certain ambiguity of dentity is vital in the battle against destructive forces. Moslems often change their names when they enter a strange village or when they fall ill, to avoid tempting fate (understandably making the administration of health centres undly complicated), and people here do not kiss due to the belief that an open mouth allows had spirits to enter and the soul to escape Voiling, make-up and name-changing are all different methods of separating the individual from the malevolent force, whether human or spiritual, of the cutistide world.

In the strength of the division in Arabia between public life, at work, and private life, at home. This is hard for the outward coloning Westerner to grapping the most voiling maintaining the extreme seclusion of the domestic sphere has, particularly in Saudi, developed over the centuries and become a kind of congenital male obsession. A woman who emerges from the confines of the home unveiled goes beyond inviting the advances of strangers she is in fact, exposing the most vehericant ly guarded element, prize oven, of private life.

Moslems are burdonod with an inescapable pressure that comes from constant social surveillance. Each indivision are constant social surveillance.

ly guarded element, prize even, of private life.

Moslems are burdoned with an inescapable pressure that comes from constant social surveillance. Each individual is considered responsible for the actions of his neighbours, so a form of secred critizen's arrest exists where by people can successfully become their brother's keoper. In Riyadh, even driving through an amber light might lead to the person being followed, detained and denounced by a complete stranger.

It may seem like a distorted view of independance, but the veil can actually serve to reloase women from the stress of the domestic hind the thick sphere has make-up of developed over black curtain, many Arab women feel liberated by their anonymity.

And the veil obsession does not in Its self prevent women from educating themselves or working and can actually co-exist with a surprising amount of freedom. For instance, in a region to the cast of Yemen, women reven though they accept the vetil - still practise the custom of femporary marriage't a woman can, extremely easily.

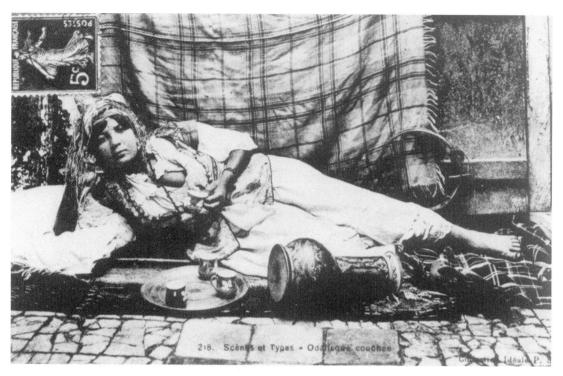

5.13 French Colonial postcard c. 1910

During the nineteenth century and today, the harem has remained a site for colonial fantasy and a space which ensures the representation of the 'orient' as the opposite of the 'West'

more distant and further unobtainable. The representation of sexuality here is of an unhealthy obsession. In contrast, the fashion spread following it, 'Cold Comfort', features a white couple together, in a relationship of relative equality. Blue and brown predominate, in contrast to the previous spread, and the much more standard photographic lighting contrasts with the previous yellow haze, to present images which seem much more matter-of-fact, like the denim clothing advertised. Here, however, matter-of-factness acts to represent Europe as rational in opposition to the irrational East.

In Marie Claire's June 1994 issue, another pair of fashion spreads also provides an example of the oppositional way in which East and West are presented, not just through content, but also through photographic codes. In 'Indian Summer', the image of an exotic woman in physical and sexual abandon predominates the pages (Figure 5.14), as in the previous spread and the colonial postcards already discussed (Figures 5.8 and 5.13). The pages of this photo-story are almost like a film sequence with rapid cuts. As in the last 'Orientalist' sequence, this woman is alone, but the themes of physical and sexual desire are paramount. Many of the shots use wide angles to enhance their depth and, along with rich

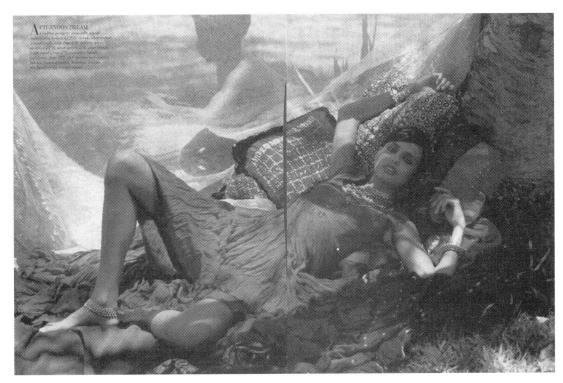

5.14 'Afternoon Dream' from 'Indian Summer' Marie Claire June 1994Rich reds and oranges dominate this scene in which the mood of sexual abandon that is created is more important than the display of clothes

oranges and blues, it gives the sequence a heightened sense of physicality. The spread which follows this, entitled 'The Golden Age of Hollywood', contrasts by representing white men and women together, in relative harmony (Figure 5.15). This sequence is much more about glamour than 'Cold Comfort', yet here again the notion of rationality is also encouraged by the style of clothing as well as the standard photographic lens used. There is also an almost colonial feel to this fashion spread, through the sepia tones of the photographs and the 1930s styling. The other important difference between the two fashion spreads is that, while the latter concentrates on the clothing, the former concentrates on atmosphere. The context of these images within the fashion magazine leaves the predominantly white women as the surveyors of 'Other' women.

While I have discussed the use of colonial and exotic photographic messages in tourist and fashion photography separately, within the recent dominance of lifestyle culture there is little difference between these forms. In the late 1980s and early 1990s particularly these genres were repeatedly elided. Sisley's photo 'magazine' from Spring/Summer 1990 visualised a Moroccan caravan tour. Along with the series of travel photographs of a European man and woman,

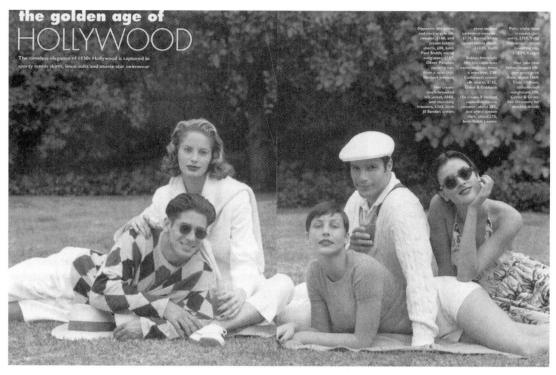

5.15 from 'The Golden Age of Hollywood' *Marie Claire* June 1994 In contrast to the 'East', Europe is represented as more rational and restrained

presumably in Sisley clothes, is the male traveller's diary. There is no written information on the clothes, and they are clearly not the main subject of the photographs, which concentrate on building up an atmosphere of unhindered travel. It is not just the fashion advertiser that has manipulated 'the exotic' into a lifestyle and a fashion statement. Fashion magazines such as *Elle* and *Vogue* created similar fashion spreads. *Elle*'s fashion spread from November 1987 entitled 'Weave a Winter's Tale of Fashion's Bright New Folklore' was shot in Peru, and combined photographs of the season's clothes with tourist brochure images. The main text is of a travel diary, with a subtext of photo titles which combine tourist descriptions and clothing details that include prices. Here, Peru is turned into the flavour of the month for fashion influence and tourism, which are not distinguished between in layout and photographic format. In a similar vein, *Vogue* focused on Egypt in their May 1989 issue in a fashion spread called 'Letter to Luxor'.

Images and photographs for both these magazines are the key to their commercial success. Here, there is also no distinct line between the advertisement and editorial photograph. Today it is common practice for fashion magazines to advertise the places where they stayed on photo shoots in the

fashion pages of the journal. The dominance of commercial interests in all these photographic images are 'positioned on a threshold between two worlds: the consumer public and a mythic elite created in the utopia of the photograph as well as in the reality of a social group maintained by the fashion industry' (Brooks 1992: 18–19).

THE CONTEXT OF THE IMAGE

Don Slater has criticised the semiotic critique of advertisements (characterised by writers such as Roland Barthes and Judith Williamson) for taking as assumed precisely what needs to be explained – 'the relations and practices within which discourses are formed and operated' (Slater 1983: 258). Barthes' and Williamson's readings of advertisements have provided a very limited social and historical context. Often even simple pieces of information, such as the magazine from which the images have been extracted and the date of advertisements, have not been mentioned. Liz Wells has commented on some of the limitations of *Decoding Advertisements*, especially Williamson's lack of consideration of multiple readings (Wells 1992).

While scholars have devoted some space to the understanding of a broad cultural context, the exploration of political and economic contexts is more rare. The vast array of commercial messages has also made their contextualisation increasingly difficult. It would be impossible to contextualise them all. Information about processes of production is not always easily available, and this increases the reality of consumption over that of production:

What commodities fail to communicate to consumers is information about the process of production. Unlike goods in earlier societies, they do not bear the signature of their makers, whose motives and actions we might access because we knew who they were. . . . The real and full meaning of production is hidden beneath the empty appearance in exchange. Only once the real meaning has been systematically emptied out of commodities does advertising then refill this void with its own symbols. Production empties. Advertising fills. The real is hidden by the imaginary.

(Ihally 1990: 50)

To decode photographs and advertising images more effectively, it is essential for us to understand their context. Let us take, for example, Williamson's reading of the Lancia car advertisement (1979). Would a discussion of Lancia manufacturing and car production in the late 1970s reveal more about the image?

Since the founding of the Lancia firm in 1907, Lancia had been known for their production of quality cars for gentlemen, as one writer described it. With increasing conglomeration in all industries throughout the twentieth century, Lancia, as a family firm, ran into trouble and was eventually taken over by Fiat in 1969 (Weernink 1979). The Beta saloon was the first car to be produced by Lancia after the merger. Fiat, which was known for producing smaller, cheaper cars, needed to distinguish the Beta from its own cars. Style and quality needed to be suggested, and 'Lancia – the Most Italian Car' was the slogan used to enhance the sense of stylishness of the Lancia range generally. It is this slogan which has been visualised in the 1979 advertisement discussed by Williamson.

Apart from asserting a sense of style and quality, why has Lancia chosen to represent any form of labour relations in the advertisement? Most car advertisements of this period tended to talk about the car itself and its features - for example, its economical use of petrol or the size of its boot. This advertisement does not discuss the car's actual features at all. In the late 1970s strikes took place in many major industries in Britain and Europe. In September 1978, for example, the Ford car workers at Dagenham went on strike for nine weeks. Car manufacturers generally must have wanted to maintain an image of good industrial relations. The illusion of the contented happy peasant worker in the vineyards depicted by the ad discussed earlier (see pp. 216-18) glosses over the general unrest that was present during this period. Finally, the image of the peasant worker could carry another function. During the mid-1970s, the car industry began to introduce microprocessors into production for increased automation. The peasant workers depicted in the ad, outside of industrial production, also acted to represent Lancia as a quality hand-crafted, gentleman's car. A growing number of scholars have researched into the context of production for marketing photography. Below we discuss David Nye's account of General Electric photography. Another example of the value of research into the context of photographic production can be seen in Brian Osborne's essay on the Canadian state and the Canadian National Railways' use of photography to promote the export of Canadian goods and to attract potential immigrants. (Osborne 2003)

Image worlds

Let us look at an example of marketing photography, where an understanding of the context within which images are produced helps us to perceive the extent to which commercial interests affect photographic practice. In *Image Worlds*, David Nye gives us a detailed exploration of the context of production, dissemination and historical setting of General Electric's photographs between 1900 and 1930 (**Nye 1985**). David Nye notes how commercial photographers do not strive for uniqueness (as does the artist photographer), but rather for a solidity of a predictable character. In spite of their documentary appearance, Nye notes the contrast between the images

DAVID NYE (1985) **Image Worlds: Corporate Identities at General Electric 1890–1930**, Cambridge, MA:
MIT Press

produced by a socially concerned documentary photographer and a commercial photographer, even when the subject is the same. He compares two photographs of Southern textile mills, one by Lewis Hine, the other by a photographer working for General Electric. While Hine emphasises the people and children in the mills who work in potentially dangerous environments, the commercial photographer's image stresses machinery, electrification and technical progress (Nye 1985: 55–6).

Nye notes how, by the beginning of the twentieth century, the management of General Electric discovered the need to address four distinct groups – engineers, blue collar workers, managers and consumers. Their desire to say different things to different groups affected the production of images for the company's various publications. While the *General Electric Review* (a company-sponsored scientific journal) used photographs which emphasised the machines, the publications for workers employed images which concentrated on the idea of the corporation as community.

Nye not only notes the varying sorts of photographs for different publications, but also the changing production of images over time. While images from 1880 to 1910 expressed a sense of relationship between workers and managers (they were often photographed together), images after this date present a picture of a workforce which was much more highly controlled by management. Nye details how by the 1920s General Electric had 82,000 workers in their employment, in contrast to 6,000 in 1885. The burgeoning workforce made management's role more important, and the artisanal skills of the previous era had also all but disappeared. Labour unrest began to increase during the 1910s. In 1917, partly in response to these conflicts, General Electric began to publish a magazine called Works News which was distributed to all blue collar workers twice a month. The paper did not address the general workforce, but was tailored to each site. The covers of the magazine produced a new kind of photographic image not previously used by the company. They featured individual skilled workers photographed from head to toe and engrossed in a piece of interesting work. This kind of image was repeated on the cover of nearly every issue of Works News (Figure 5.16), and did not represent the reality for most of General Electric's employees; but, since these workers were individualised and isolated, the generalisation was only implicit. These kinds of images hardly existed inside the magazine, which concentrated instead on the workers - as a community which went on holiday, played in sports teams and participated in other forms of recreation. The style of the cover photographs had a history in Lewis Hine's work a decade earlier. He had aimed to represent and give dignity to 'real men' in difficult work. In adopting this style, the General Electric photographers were simply using it as a representational strategy to define the image world of the General Electric plant. It is only through an appreciation of the context of the image that we can understand the intent in the production of images by Hine and the General Electric photographer as different, and

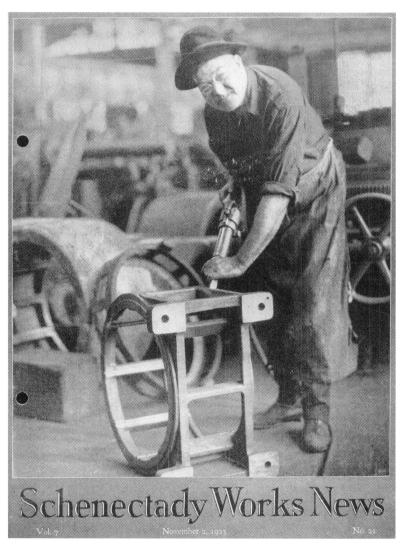

5.16 Schenectady Works News General Electric 2 November 1923

Images which represented individual workers engrossed in a piece of interesting work dominated the cover of Works News during the 1920s. It did not represent the reality for most workers, but presented images which gave a certain dignity and harmony during a period fraught with conflicts can therefore appreciate the different meanings of the image. The production of meaning is a process. As Marx noted in *Grundrisse*:

It is not only the object that production creates for consumption . . . [It] also gives consumption its precise nature, its character, its finish. . . . Hunger is hunger, but the hunger that is satisfied by cooked meat eaten with a knife and fork is a different hunger from that which bolts down raw meat with the aid of hand, nail and tooth. Production thus produces not only the object but also the manner of consumption, not only objectively but also subjectively.

(Marx quoted in Slater 1983: 247)

For General Electric the process of production and conditions of production changed in 1917, with the success of the Bolshevik Party in Russia and the ensuing Russian Revolution in October 1917, an event which shook the world. New images of dignified workers emerged as a result. General Electric borrowed and absorbed this new language to control and mollify their own work force.

CASE STUDY: BENETTON, TOSCANI AND THE LIMITS OF ADVERTISING

The case of Toscani's Benetton advertising enables us to draw together a number of strategies for considering commercial photography which have been suggested in this chapter. We can recognise the way in which spectacle works, the value of giving due importance to economic and social contexts, the value of exploring the language of particular advertisements and their reception, as well as the limits of advertising photography and advertising in general. Toscani's relationship with Benetton is also a rare example of an advertising photographer who gained an almost celebrity status and became named in the art world through his imagery for Benetton.⁷ Yet his attempt to use advertising as a means to speak beyond the limits of the spectacle also brought an end to his relationship with the clothing firm.

In 1984, when Toscani joined Benetton, the United Colors campaign was initiated. The image of young people from around the world wearing Benetton clothing suited the newly international interests of the clothing firm. In 1978, Benetton's export market was 26 per cent of its total sales, but by 1981 its export share had increased to 40 per cent of its total output. By 1983, export sales exceeded domestic sales. In 1986 the Benetton Group was finally launched on the stock exchange. During the mid-1980s, therefore, the company changed from being an Italian (and family) company, to becoming an international player for world markets (Belussi 1987: 12–22). Toscani's imagery provided the company

⁷ Benetton imagery was shown in *The Globe* exhibition which toured the UK in 1989. The image of the new-born baby was also shown in an exhibition of images of motherhood at Boymans-van-Beunigen Museum, Rotterdam, Holland.

L. BACK AND V. QUAADE (1993) 'Dream Utopias, Nightmare Realities: Imagining Race and Culture within the World of Benetton', **Third**

with an image of global consumption. In typical multinational fashion it ignored the 'third world' realities of globalisation which are characterised by the exploitation of third world workers for the benefit of increased consumption in the West and the elites of third world nations. As Back and Quaade indicated these images of international harmony were constructed within a 'grammar of race' (Back and Quaade 1993: 65). These images carefully constructed within the confines of the studio also promoted ideologies of capitalism and imperialism at the moment when the Soviet Union was collapsing. In March 1987 for example, an advertisement made up of two double page spreads depicted a Russian boy, dressed in red Benetton clothing and sporting Soviet regalia (Figure 5.17a), and a young American girl called Stacey Reynolds in denim clothing (Figure 5.17b) (The Face, March 1987). 'Stacey' was obviously a mythic character since two different American girls are given this name in Benetton advertisements. Toscani says different things about America and the USSR through the models' poses and regalia. The Soviet boy stands straight, and salutes us with a stern expression on his face. In his left hand, he carries a paper rocket in army camouflage colours - perhaps a reference to the arms race. In contrast, the American girl smiles at us gently and carries a model of the Statue of Liberty. Symbolically, we have the gentle America presented as the upholder of liberty, contrasted with the stern and uncompromising USSR that is presented as responsible for the build up of arms. In another image, a Chinese boy, dressed in blue, carries a copy of Chairman Mao's 'Little Red Book'. The book is upside down. Other Benetton advertisements also indicate support for imperialist ideology (Ramamurthy 2003: 219-20). The advertisements represent the ideological interests of the company: 'Our international image and the substance of our company are the same - a global group open to the world's influences and engaged in a continuing guest for new frontiers' (Benetton 1993).

The contradiction in Benetton's images of global harmony can be seen by exploring their context of production. Benetton's business success rests on their 'flexibility in manufacturing', which allows the company to respond quickly to changes in fashion trends. Through a computerised network that links retailers with the Benetton headquarters, Benetton is immediately made aware of fast-selling items, which can then be reproduced according to demand. This entails a large amount of subcontracting, a system that encourages unskilled 'shell making' in the Third World where labour is cheap, small workshops with non-unionised labour, and homeworking which is notorious for being badly paid (Mitter 1986: 112–15; Phizacklea 1990: 14–16). Much of Benetton's success in world markets is linked to the establishment of the multifibre agreement, which limits clothing imports from the Third World for the benefit of European manufacturers.

Shock advertising: ahistoricism and ambiguity

In 1989, Toscani, aware that his images were being read ambiguously, discarded the slightly sugary image of children smiling sweetly for a series of bold images

5.17a & b USSR, Benetton and America, Benetton, 1987

which played on contrasts, particularly that of skin colour. Before 1989, Benetton's images still seemed to relate to the genre of studio fashion photography. Benetton clothes and other accourrements of fashion were worn by the models, who were positioned in a shallow space. After 1989, this relationship collapsed and the clothes ceased to be represented at all. Back and Quaade (1993) have described the 1989 to 1991 phase as that of 'racialisation and ambiguity'. The notion of racial essences continued; but beyond this, racist imagery and history were evoked. This series included the image of a black woman nursing a white child. It created uproar in America, as well as discontent in Britain. The image clearly echoed slave relations, where black slave mothers nursed white children. The image also dehumanised the black woman through the way it was cropped - she is a headless unidentifiable 'Other'. This image has visual references to the photograph of a torso of a Dahomey woman by Irving Penn, Her headless body is totally **objectified** and dehumanised, and is presented for consumption to the predominantly white viewer - she cannot even look back (see Penn 1974: 39).

Images, like everything else, are historically based and although they change in meaning according to their context, they cannot avoid the meanings and symbolisms from the past. This is part of their context. Historical interpretation, however, was dismissed as individual interpretation by Benetton. Following the storm over this and other advertisements in the United States, Benetton's sales figures fell in America, but only for a short while. Controversy eventually seemed to increase sales. As Vittoria Rava, Benetton's advertising manager, of the time commented: 'we believe our advertising needs to shock – otherwise people will not remember it' (Graham 1989).

Pseudo-documentary and the courting of controversy

The controversy of Benetton images (and their sales) increased as Benetton discarded the constructed fantasy image of advertising for the seeming realism of photodocumentary. This third phase of advertising has been described as experimentation with 'pseudo-documentary' whose overriding theme is 'a fetishisation of images of abject catastrophe' (Back and Quaade 1993: 74). The new campaign included a photograph of David Kirby dying from AIDS, an African soldier holding a human femur behind his back, a burning car in an Italian street, an albino Zulu girl being shunned by others and an image of poor black people scrambling into a waste lorry. In using these images, Toscani defied the boundaries of photographic genres, in which the 'reality' of the documentary image stands in stark contrast to the fantasy world of advertising. The collapsing of these genres, however, caused outrage. The photograph of the man dying from AIDS, the Zulu girl and the fire-bombed car had all been published earlier in documentary contexts, but as has been noted above, the production of meaning is a process, and that process is affected by the photograph's context. In using controversy to increase consumer awareness the company sometimes exploited the quandaries of magazine editors. Elle magazine, for example, accused Benetton of deliberately sending advertisements to magazines just before printing deadlines. On one occasion Elle were forced to leave a double page of the magazine blank. The page however explained why, giving Benetton more publicity. On another occasion, Benetton refused to substitute the advertisement of an albino Zulu girl being shunned by other girls for the New Yorker. The paper was running a piece about Malcolm X and racial tension in the same issue. They did not want viewers to think they were mixing advertising and editorial. Benetton argued that pulling the ad would set up 'a dangerous precedent' (Savan 1990: 47). Yet during the LA riots of 1992, Benetton withdrew their billboards of a burning fire-bombed car from the streets of LA, of their own accord. Suddenly Benetton seemed to care about the new meanings which their images could create. They replaced this image with one of people of various ethnic backgrounds smiling broadly. Benetton exploited the free publicity of the news cameras again. CNN sent a camera crew to document the event. Fred Bacher commented on Benetton's approach: 'What I find offensive about the ads is not their extreme violence; it's their trendy ambiguity. Benetton's ads are not constructed to help their consumers form ideas about social issues' (Bacher 1992: 45-6). Toscani revelled in the 'trendy ambiguity' as interviews with him make clear (Blood on the Carpet 9/1/2001 BBC 2). Lorella Pagnucco Salvemini has discussed Benetton's shock strategies in her recent book United Colors: The Benetton Campaigns (Salvemini 2003).

In reading these 'pseudo-documentary' images, we must remember that Benetton did not just add their green logo. These photos were cropped and touched up, in a similar way to which a commercial photographer might enhance the image of a cake to give it greater visual appeal. The original black and white photo of Kirby was hand-coloured by Benetton. One interesting fact about Benetton's use of documentary images is that until 1995 they were always in fantastic colours, despite the rich black and white documentary tradition. Benetton's shock tactics have been explored by Pasi Falk who describes them as the Benetton-Toscani effect (Falk 1997). These images can be viewed on a variety of websites and Benetton publications such as *Global Vision* (1993).

Toscani, the spectacle and the market

In the mid 1990s, Toscani seemed invincible in his constant innovation and use of shock tactics for Benetton campaigns. His use of this strategy can be traced back to the influence from his father, a journalist who taught Toscani the power of shock and scandal to sell photographs. Toscani applied this to the fashion image and influenced a whole genre of fashion photography that now exploits shock imagery. See, for example, recent images by Diesel and Christian Dior. But in his last year at Benetton, Toscani photographed an issue that was too close to his heart. He could not adopt the 'trendy ambiguity' of his previous campaigns in photographing men on death row in America. He found himself unable to twist this issue into the spectacle and drama of 'the permanent

PASI FALK (1997) 'The Benetton-Toscani Effect — Testing the Limits of Conventional Advertising' in Mica Nava et al. (eds) **Buy This Book**, London: Routledge. opium war'. Toscani tried to use his images to voice his abhorrence of the death penalty and to raise concerns about miscarriages of justice. The reaction and consequent campaign by those in support of execution, which included one family whose son had been murdered, was to lose Benetton a contract with Sears department store for 100 Benetton stores. On this occasion, when ambiguity was removed and when Toscani tried to attack the conservative ideologies of America, Benetton lost revenue and enormous potential revenue. The campaign ended, as did the relationship between Benetton and Toscani a few months later. The experience highlights beautifully the limitations of advertising and its inevitable ideological position of upholding hegemonic ideas and ideals. Issues can be used to enhance and decorate the spectacle but cannot be seriously discussed. The key interest of advertising is profit. As Luciano Benetton articulated after the incident: 'Campaigning is not my subject, I am an entrepreneur.' (Blood on the Carpet 9/1/2001 BBC 2.)

CHAPTER 6

On and beyond the white walls

Photography as art

LIZ WELLS

247 Introduction

The status of the photograph as art

251 Early debates and practices

The complex relations between photography and art Realism and systems of representation Photography extending art Photography claiming a place in the gallery

259 The modern era

Modernism and Modern Art
Modern photography
Photo-eye: new ways of seeing
Case study: Art, design, politics: Soviet
Constructivism
American formalism
Case study: Art movements and intellectual
currencies: Surrealism

273 Late twentieth-century perspectives

Conceptual art and the photographic Photography and the postmodern New constructions Women's photography Questions of identity Identity and the multi-cultural

284 Photography within the institution

Appraising the contemporary Curators and collectors Internationalism: festivals and publishing The gallery as context Case study: Landscape as genre

6.1 Karen Knorr, Analytical Inquiry into the Principles of Taste, from Country Life

On and beyond the white walls

Photography as art

INTRODUCTION

Photography is significant as a means of visual communication. But the history of photography as art focuses not so much on photographic communication as upon photographs as objects, reified for their aesthetic qualities. It follows that such histories typically focus on pictures, and on the works of specific practitioners. Thus, the story of photography as art has tended to be presented as a history of 'great', or 'master' (*sic*), photographers. Such accounts not only divorce photography as fine art from the larger history of photography with its ubiquity of practices, but also rarely engage with broader political issues and social contexts.

In this chapter we use 'Art' to refer to fine art practices relating to the Arts establishment (galleries, museums, public and private sponsorship, auction houses . . .) by contrast with more general understandings of photography as an 'art' or expressive skill. The position of photography in relation to the gallery is complex; on the one hand, photographic media (photography, photodigital, photovideo) may be used by artists, possibly in conjunction with other media, as a means of expression; photographic pictures or series may be made primarily for gallery viewing. Photography is thus contextualised as art through being shown in galleries, museums, and artists publications. Photomedia are also used by artists in contexts beyond the gallery, for instance,

1 The term 'Art' is used to indicate focus upon Arts institutions and gallery exhibition. This follows Raymond Williams' distinction between 'art' as creative skill and 'Art', used in Britain since the early nineteenth century to refer to the Art establishment, a network of galleries, museums, funding organisations, publishing and festivals (Williams 1976). The notion of Art as a specialised field of practice has been criticised variously, for instance, in Soviet Constructivism, or, more recently, in postmodern practices such as publishing imagery on the internet, exhibiting on (advertising) hoardings, or organising community-based arts projects.

2 Community arts as a movement (for instance, in Britain in the 1970s/80s) challenged what was perceived by some as elitism in the arts establishment through taking art to people – on housing estates, in schools, to public fairs, and so on – and through encouraging wider participation in arts events and practices.

made in other contexts, such as documentary or fashion, may later be taken up by galleries or museums. Collections at major institutions such as MOMA, New York or the Victoria and Albert Museum in London clearly illustrate this.

This chapter considers debates relating to the status of photography as fine

as billboard art, or within community arts.² On the other hand, imagery

This chapter considers debates relating to the status of photography as fine art. In particular, it discusses photography, the art gallery, and the market for photography as art. The first section focuses on nineteenth-century debates and practices, noting that from its very inception photography was conceptualised in terms of both its apparent ability to accurately transcribe from reality and its expressive potential. This acts as historical context for the principal concern of the chapter which is twentieth-century photography considered in the context of Western modern, and postmodern art movements. In modernism, the emphasis was upon photography as a specific medium with particular qualities or attributes. Postmodern theory loosened the focus on the formal, viewing the photographic as a particular language or sign system. Finally, the chapter notes gallery systems, and the internationalism of contemporary art within which photographic media are now ubiquitous. As with any overview, a word of caution is appropriate: this discussion should be taken as a starting point for fuller exploration of sets of debates, not as a comprehensive compendium. The chapter includes three case studies: on Soviet constructivism, Surrealism as an art movement, and Landscape. Each directly illustrates points made; they were also chosen in part as examples of the interrelation of history, politics, intellectual debate and art, and in part to offer summary introduction to materials not necessarily easily accessible. Photographs relating to land and landscape are used as illustration throughout. This focus allows more immediate comparison of form, content and subject-matter than would be the case with a random compilation of images. Landscape was selected also to contrast with the emphasis on people (in personal albums, in the streets, or as 'body') in previous chapters.

MIKE WEAVER (1989a) **The Art of Photography**, London: Royal Academy of Arts.

3 The title references a description (attributed to Lincoln Kirstein, poet, critic, curator and founder of the New York City Ballet) of Walker Evans work as 'tender cruelty' linking photography within the gallery to social documentary. Documentary uses of photography were emphasised in this exhibition which, in common with many shows, brought work originally made for other purposes into the gallery.

The status of the photograph as art

In 1989, 150 years after Fox Talbot's announcement of 'photogenic drawing' (the calotype), the Royal Academy, London, mounted its first ever photography exhibition, *The Art of Photography*. Arguably this represented the acknowledgement by the Arts establishment in Britain that had been sought, variously, throughout photography's history. The first major photography show at the Tate (Tate Modern, London), titled *Cruel and Tender*, was not until 2003.³ Photography has fared better elsewhere with, for instance, a long-established collection at Museum of Modern Art, New York.

Historically, tension between the photograph as document and the personal expressivity of art has been at the heart of debates as to the status of the photograph as art. Photographs have been exhibited right from the inception of photography. In Britain they were included in the Great Exhibition

of 1851, and the Royal Society of Arts organised its first show of photography in 1852.⁴ In the nineteenth century, there were no mass media of the sort taken for granted now, so exhibition was one of the prime ways of communicating information about artistic, scientific and technological innovations. But, from very early days, critics and practitioners disagreed as to the status of photography as art.

This debate begs the question as to what is meant by 'art'. Definitions here have been variously contested. For aesthetic philosophers post-renaissance art relates to the sensual, the beautiful and the refined; thus, questions of taste are centrally related to expressive practices. Here, the artist is characterised as a special sort of 'seer', or visionary of 'truth', poetically expressed. In the case of photography, the artist is viewed as transcending 'mere recording' of events, offering a unique perspective on or insight into people, places, objects, relationships, circumstances. But taste involves judgement and judgement may be exercised by few - albeit, in certain political scenarios, ostensibly on behalf of the many. For example, in Britain - as elsewhere in Europe traditionally it had been the aristocracy and the upper classes who exercised hegemonic influence through their power of patronage although, particularly since the mid-nineteenth century, city museums and galleries opened their collections to the public. Now, increasingly, influence and judgement falls to curators, critics, arts educators, and the world of the media, as well as private buyers whose investment in the work of particular artists may be instrumental in supporting the possibility of the artist making further work. In the USA the arts establishment greeted and promoted modern art from Europe (and, indeed, immigrant artists from Europe) especially in the period before and during the Second World War, thus influencing emergent critical categories, such as criteria for appreciation of formalism or of abstract expressionism.

Many critics, including the influential American curator and historian Beaumont Newhall, have based claims for photography on formal and expressive qualities which accord with the Western, post-Renaissance tradition. Such claims stem from connoisseurship; that is, valuation of the sensitive and the precious. They are not necessarily intended to assert parity of status with older media such as painting or sculpture, but they do reinforce the notion of the photograph potentially offering a special form of perception both through its ability to capture and freeze a moment in time and through artistic sensibilities. In the nineteenth century, when photography was first announced and developed, art and technology - the expressive and the mechanical - were viewed as distinct. This distinction characterised the reception of photography and attitudes towards it. But photography also conformed to aesthetic conventions in terms of composition and subject-matter, highlighting particular features in order to stress their significance. For many photographers, it was creative potential along with its apparent accuracy of transcription that was the source of fascination with the medium.

4 The 1851 exhibition, a celebration of British achievements, was held at the purpose-built Crystal Palace, London. The Royal Society of Arts is also London-based.

See also ch. 1, pp. 50–2 for a discussion of Beaumont and Nancy Newhall, and their *The History of Photography*.

However, they did not necessarily see themselves as artists. For instance, British photographers such as Julia Margaret Cameron or Lady Clementina Hawarden, whose work might now be viewed as Art, and who certainly hold a central place within museum collections, did not themselves make this claim. As historian Margaret Harker notes, combination printing, using two or more 'negatives' (glass plates) in order to achieve particular pre-visualised results, was common from the 1850s. This could be viewed as an artist's approach to using the medium. Yet she affirms that the first attempt to promote photography as *fine art* was not made until a Camera Club exhibition in Vienna in 1881 (Harker 1979). By contrast, Aaron Scharf, in relation to the Paris photography exhibition of 1855, describes photographers including Durieu, Nadar and Bayard as '"immigrants" to the Fine Arts' (Scharf 1974: 140). As we see, there is disagreement between historians as to when photography was first viewed as an art which not only reflects debates conceptualised in terms of art versus technology but is also influenced by differing national contexts and attitudes.

Thus, we should distinguish between claims made by photographers for themselves, or for particular movements, and claims made at a later stage by historians, critics and curators. For instance, Soviet revolutionary artists aimed to take work out from the gallery into everyday social life, viewing art as both an essential tool in the re-education of the mass of the Russian people and as 'art for the people'. Nowadays, retrospectives of this work are curated for galleries, spaces which the Soviet artists would surely have viewed as bourgeois and elitist! Likewise, as already noted, early twentieth-century documentary, originally destined for publications in social surveys, magazines or books, now takes pride of place within the gallery and the archive. Peter Galassi, as curator of an exhibition of highlights from the photography archive at the Museum of Modern Art in New York, distinguishes between photography intended as Art and 'vernacular' photography, noting the differing lineages of work now included within the same collection (Galassi 1995). This distinction over-simplifies a complex history. It may be useful as a means of classification for museums and archives which, since the late twentieth century, have become increasingly prominent - and curators increasingly influential - in both the conservation of images and their interpretation. However, precisely because of the influence of the museum in constructing what are inevitably selective histories of the medium, over-simplified categorisation has become a source of concern for academics.

Noting a number of moments of transition in the late nineteenth and early twentieth centuries in which photography was central to art movements, critic, **Peter Wollen** argues that:

For photography to be an art involves reformulating notions of art, rejecting both material and formal purism and also the separation of art from commerce as distinct semiotic practices that never interlock.

(Wollen 1982: 188)

PETER WOLLEN (1978)
'Photography and Aesthetics',
Screen 19(4), Winter, reprinted
in Reading and Writings,
London: Verso and New Left
Books, 1982.

Writing in the 1930s, Walter Benjamin likewise argued that the 'aura' associated with the uniqueness of the work of fine art, such as a painting, should wither in favour of the photograph, which he welcomed as a more democratic – or less exclusive – medium because of possibilities for mass reproduction (Benjamin 1936). Here it is the anti-elitist potential of photography which is being stressed.

EARLY DEBATES AND PRACTICES

The complex relations between photography and art

Understanding the relationship between photography and painting in the nineteenth century involves a number of interconnected considerations. Photography in Britain and France was initially heralded for its technical recording abilities. With few exceptions, the emphasis was upon picture-taking rather than picture-making — to echo a distinction made by Margaret Harker (Harker 1979). She suggests that the development of the art of photography in the late 1850s can partly be accounted for through the increasing involvement of people trained as artists. They brought with them a concern for form and composition and, in particular, the use of light. She notes that the use of photographs as illustrations for poetry or literature, or as picture narrative and allegory, also dates from the late 1850s. Mary Warner Marien argues that what she terms High Art Photography:

orchestrated separate media. High Art photographs blended theater, printmaking, and painting with photography. Actors or other players were posed singly or in a *tableau vivant*. Interestingly, specific paintings were only occasionally replicated in High Art Photography. For the most part, these images rendered original conceptions, illustrating religious or moral precepts often in the manner of maudlin genre painting and popular Victorian prints. By partaking in the established didactic function of the fine arts, High Art photographers attempted to skirt objections to the medium's inartistic verisimilitude.

(Warner Marien 1997: 87)

In this section we consider first the influence of the transcriptive qualities of photography within changing nineteenth-century fine art practices; second, photography democratising Art; and third, photography, aesthetics and Western Art. In the following section we discuss pictorialism, and claims for the photograph as fine art made by photographers at the turn of the century. Writing on *Art and Photography* **Aaron Scharf** (1974) emphasises uses of photographs by artists; for example, as reference notes. Only in the later chapters on twentieth-century Art movements does he acknowledge the

MARY WARNER MARIEN (1997)
'Art, Photography and Society',
Ch. 3 of Photography and its
Critics, A Cultural History,
1839–1900, Cambridge/New
York: Cambridge University
Press.

AARON SCHARF (1974) **Art and Photography**,

Harmondsworth, Pelican Books,
revised edition.

VAN DEREN COKE (1972) **The Painter and the Photograph**, New Mexico: University of New Mexico Press.

5 This was clearly indicated in sketches, photographs and tear sheets from the collection at the Paris Bibliothèque Nationale exhibited at the Maison de Balzac as part of *Mois de la Photo*, 1990.

Key archives: Paris: Musée d'Orsay for French nineteenthand early twentieth-century art. Examples are held in many national or metropolitan collections; for instance, The National Gallery, London has a section on a nineteenth-century French paintings (including one version of Manet's The Execution of the Emperor Maximilian).

photograph as art in its own right. As both **Van Deren Coke** and Aaron Scharf have indicated, a number of artists used photographs as study devices, eliminating the need to pay for models or to spend long periods of time sketching. For some, these photographic 'sketches' ultimately took over as works in their own right. For example, the French caricaturist, Nadar, first used photography as the basis for satirical portraiture, later acknowledging the photographs themselves.⁵ Photography also allowed painters to extend their range of references, returning from both urban 'public' spaces and rural 'open' spaces with photographic notes to support paintings made in the studio. Photographs could be used as research notes, or as models for painting. For instance, Aaron Scharf notes that Manet used photographs of the Mexican emperor, and of soldiers, when working on his paintings of the emperor's execution. Scharf also includes two examples, a riverscape and a seascape, by the French realist painter, Gustave Courbet, which seem to be based directly upon contemporary photographs (Scharf 1974: 127).

Realism and systems of representation

Courbet and Manet were prominent among artists associated with nineteenth-century Realism within which photography was implicated as an aid to painting. Discussing the implications of Realism as an historical movement in painting and in literature, in France and elsewhere, Linda Nochlin has suggested that the degree of social change experienced during the Industrial Revolution in Britain from the late eighteenth century, and the political revolutions in France, induced artists to explore everyday social experience (Nochlin 1978). Noting the dominance of Realism as a radical movement from about 1840 until 1870 to 1880, she suggests that there are a number of associated ambiguities including, crucially, the issue of the relation between **representation** and 'reality', itself a problematic concept. She argues that:

The commonplace notion that Realism is a 'styleless' or transparent style, a mere simulacrum or mirror image of visual reality, is another barrier to its understanding as an historical and stylistic phenomenon. . . . Realism was no more a mere mirror of reality than any other style and its relation *qua* style to phenomenal data . . . is as complex and difficult as that of Romanticism, the Baroque or Mannerism. So far as Realism is concerned, however, the issue is greatly confused by the assertions of both its supporters and opponents, that Realists were doing no more than mirroring everyday reality. . . . These statements derived from the belief that perception could be 'pure' and unconditioned by time or place.

(Nochlin 1978: 14)

Central to her approach is the contention that perception is culturally conditioned.

Paris underwent massive architectural and cultural change in the first half of the nineteenth century, becoming, in effect, the first modern city. Modes of vision, and subject-matter appropriate for Art, were up for debate. Writing at that time, French poet and philosopher, Baudelaire, argued that the painter of 'modern life' should focus on the contemporary, upon the movement and change which had revolutionised everyday experience. He was among the first critics to support Realism's challenge to previous aesthetic convention through the introduction of everyday subjects and ordinary people into pictures, and through the use of less 'finished' styles of painting than those expected or in keeping with the conventions of the French Academy of Art. Yet he made no particular connection between Realism and photography, dismissing the latter as an inferior form of artistic expression due to its mechanical nature. Thus his view of the potential and limitations of the camera seems in line with that, for instance, of critics who dismissed Courbet's series of large-scale pictures of the rural community in Ornans on a number of grounds, including not only the everyday content of the image but also, as one critic put it, its appearance as 'a faulty daguerreotype'. Photography, in a whole range of practices, was central to changing ways of seeing, albeit inheriting rather than subverting formal codes of picture-making.

Aesthetic conventions reflect broader sets of ideas. For instance, from the Renaissance to the early twentieth century, Western Art used perspective as the principal system of visual organisation. Perspective involves a single, central viewing point. It has been argued by some critics that this system, in prioritising one central viewing position, reaffirms individualism (that is, the emphasis on the individual which emerged within entrepreneurial capitalism). In other words, a particular political philosophy is reflected and reaffirmed through image-making conventions. In photography, focus, which refers to the use of the camera lens to give a 'sharp' image of objects which may be in differing parts of the picture, interacts with perspective to support ways of seeing based upon geometric mapping of space. That camera optics conform to the rules of perspective meant that photographic notes could support composition in painting. As film theorist, Bill Nichols, has suggested, 'Renaissance painters fabricated textual systems approximating the cues relating to normal perception better than any other strategy until the emergence of photography' (Nichols 1981: 52). Indeed, as has been noted, one of the claims made was that the photograph had the technical ability to reproduce from actuality with more accuracy than any other form of representation. As such, photography, itself a part of scientific and technological development, seemed to fit within the spirit of modernity, as well as offering realist possibilities for representing aspects of modern life.

Photography extending art

Photography provoked artists to re-examine the nature and potential of paint as a particular medium. Artists used cameras as a method of note-taking, in

daguerreotype Photographic image made by the process launched by Louis-Jacques-Mandé Daguerre in France in 1839. It is a positive image on a metal plate with a mirror-like silvered surface, characterised by very fine detail. Each one is unique and fragile and needs to be protected by a padded case. It became the dominant portrait mode for the first decades of photography, especially in the United States.

DOROTHY KOSINSKI (1999) The Artist and the Camera, Degas to Picasso. Yale University Press.

See Photography archives, pp. 344–5, for further museums, galleries and archives.

calotype Photographic print made by the process launched by William Henry Fox Tallbot in England in 1840. It involved the exposure of sensitised paper in the camera from which, after processing, positive paper prints could be made. Not much used in England in the early days, because it was protected by Fox Talbot's own patents, but its use was developed in Scotland, especially by David Octavius Hill and Robert Adamson.

PETER GALASSI (1981) **Before Photography**, New York: MOMA.

MARK HAWORTH-BOOTH (1992) **River Scene, France**, Los Angeles, CA: J. Paul Getty Museum.

COLIN FORD (2003) Julia Margaret Cameron: 19th Century Photographer of Genius, London: National Portrait Gallery. effect, a substitute for the sketchbook; but also as a means of exploring the physical and social world. Photography appeared to be more successful than painting in capturing likenesses. It also had a sense of instantaneity which painting lacked. It has been suggested that photography encouraged the Impressionist painters to experiment with manners of painting which could also capture a sense of the moment, and the passage of light. It is a truism that photography 'released' painting from its responsibility for literal depiction, allowing it to become more experimental. The developing relationship between the two media was considerably more symbiotic.

Photography encroached very directly upon genres of painting such as portraiture, not only taking over some of the work of painters, but extending the compass of the work. For instance, while few could afford the time and cost of sitting for a painted portrait, the professional studio photographer could offer a similar service much more cheaply. As such, portraiture became more generally available. Both high street studios and the touring 'jobbing' photographer were common from the mid-nineteenth century (see ch. 3). This did not prevent a continuing hierarchy; the painted portrait was still commissioned by the wealthy and the aristocracy. But it did allow a greater number of people the status of seeing themselves pictured.

Another respect in which photography may be said to have extended fine art was in its role as the re-presenter of art objects. It was no longer necessary to travel to Florence to see paintings commissioned by the Medicis, or to Egypt to contemplate classical architecture and artefacts; you could attend slide talks, or visit an exhibition, and view reproductions. Virtual reality, with its possibilities of seemingly travelling around a painting or sculpture, viewing it from every possible angle, now makes the 2D black and white photograph appear highly limited as a means of showing an object. But, at the time, the possibility of seeing photographs of art was highly radical. Among the first illustrated art histories was an 1847 limited edition book of Spanish Art which included 66 **calotypes** by Fox Talbot (Scharf 1974: 160).

Photographs also mirrored drawing and painting in making pictures in accordance with established formal conventions. *Before Photography*, **Peter Galassi**'s comparative study of photographs and paintings within the same genres, draws our attention to continuities in aesthetic convention including compositional similarities. Likewise, in a more detailed manner, **Mark Haworth-Booth** has examined the construction of *River Scene*, *France* by Camille Silvy, which was a combination print involving staging people within the rural setting (Figure 6.2). Not only does its composition echo traditional aesthetics, but the image replicates the romantic pastoral familiar within eighteenth- and early nineteenth-century landscape painting.

Indeed, staged photographs depicting idealised or mythical scenes became common from the 1850s onwards. Among earlier examples is the work of Julia Margaret Cameron (**Ford** 2003). She invited friends, family and servants

to pose for her, either for portraits or as actors within her dramatic scenarios. Since she moved in Victorian middle-class circles, this legacy includes portraits of well-known artists, writers and intellectuals, including Alfred Lord Tennyson and Charles Darwin, many of whom visited her at her home, Dimbola Lodge, at Freshwater on the Isle of Wight where Tennyson also kept a house. Her tableaux, staged using friends, servants and local people as actors or characters, have particular significance. Cameron's photography coincided with, and in some respects echoes, Pre-Raphaelite Art in Britain.⁶ Through mythologising the past, arguably, the Pre-Raphaelites offered a conservative response to modernity. Cameron likewise staged mythical scenes, referencing the seasonal and the cyclical, using costumes and titles to emphasise the poetic. Continuity rather than change was emphasised, and there is no hint of the modern metropolis in her work.

Julia Margaret Cameron was one of a number of serious 'amateurs' who figure prominently in the history of photography in Britain. Others were

6 The Pre-Raphaelites were a group of British artists of whom Dante Gabriel Rossetti (the son of an Italian refugee), William Holman Hunt and John Everett Millais were the most famous. Taking nature as their primary subject, they sought to retrieve what they viewed as a simplicity and sincerity in art which had been lost in the Renaissance. Examples of their work may be found in many English municipal galleries (the most extensive collection is in Birmingham City Art Gallery).

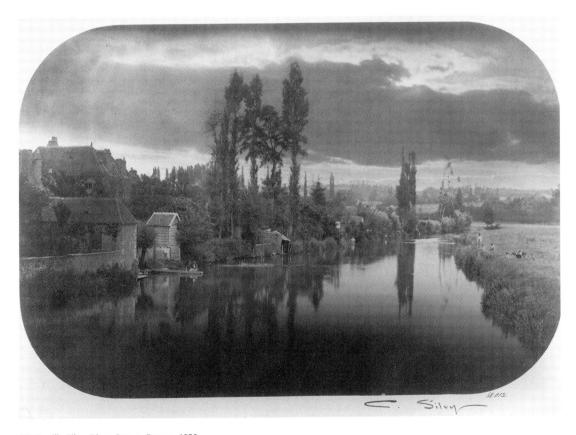

6.2 Camille Silvy, River Scene, France, 1858Two exposures combined to create the idealised rural scenario

MIKE WEAVER (ed.) (1989b) British Photography in the Nineteenth Century: The Fine Art Tradition, Cambridge: Cambridge University Press. A collection of essays on major photographers of the Victorian era.

more professional, in the sense that photography was their source of income. For instance, Swedish painter-photographer, Oscar Rejlander, set up a commercial studio in Victoria, London. But he became known for his allegorical compositions, in some cases on a scale equivalent to paintings. For example, 'The Two Ways of Life', involving a number of models playing roles that contrasted the religious (charity) with the debauched (gambling), was nearly three feet (one metre) wide. It was made from 30 separate photographs, entailing pre-visualisation on a grand scale. Such work reflected Victorian preoccupations, including religion, class and morality. This particular picture must have accorded with social concerns acceptable to the Establishment – it was purchased by Queen Victoria in 1857.

Thus pictures made by Victorian photographers reflected conventions and tensions in other areas of Victorian Art. Indeed, photography itself impacted on such tensions and aesthetic developments. There was an emerging schism between those preoccupied with the realist concerns of nineteenth-century industrialisation and those with more expressive aspirations.

Photography claiming a place in the gallery

In 1892 a number of photographers seceded from the Photographic Society of Great Britain – which in the 1870s and 1880s had emphasised the science and technology of photography, offering no support for the progress of photography as art. Led by Henry Peach Robinson, they formed the Linked Ring Brotherhood (which did include a few women). Robinson suggested:

It must be admitted by the most determined opponent of photography as a fine art that the same object represented by different photographers will produce different pictorial results and this invariably not only because the one man uses different lenses and chemicals than the other but because there is something different in each man's mind which somehow gets communicated to his fingers' ends and thence to his pictures.

(Harker 1988: 46)

Retrospectively labelled 'pictorialist', typically their imagery was soft focus, with metaphoric connotations, often drawing upon traditional fable and allegory (Figure 6.3). Again, the Pre-Raphaelites may have been one source of influence. Defining pictorial photography, Mike Weaver notes the aim:

to make a picture in which the sensuous beauty of the fine print is consonant with the moral beauty of the fine image, without particular reference to documentary or design values, and without specific regard to personal or topographical identity.

(Weaver 1986: Preface)

MARGARET HARKER (1979) The Linked Ring: The Secession Movement in Photography in Britain, 1892—1910, London: Heinemann.

NAOMI ROSENBLUM (1997) **A World History of Photography**, London, New York and Paris: Abbeville Press, Ch. 7 on Pictorialism.

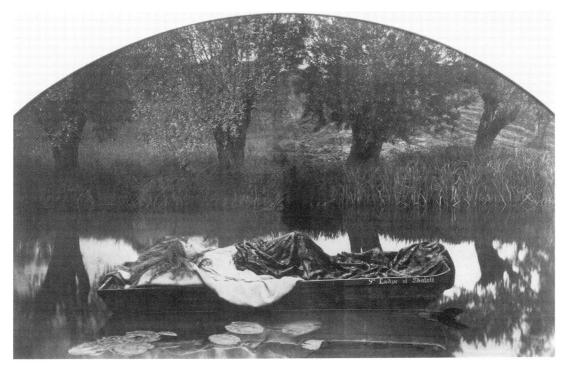

6.3 Henry Peach Robinson, *The Lady of Shalott*, 1860–1861 A Medieval tale interpreted allegorically

Membership of the Linked Ring was international, with photographers in other secessionist movements in Europe and the USA joining by invitation. In France the first exhibition of the newly formed Photo-Club of Paris was held in 1894; in Germany Hamburg became the centre for art photography. The Photo-Secession in New York, which was founded by Alfred Stieglitz (a member of the Linked Ring) was not established until 1902. Its objectives echoed the emphasis on the expressive potential of the medium which characterised the European movements. However, membership was restricted to Americans. Margaret Harker suggests that this was to facilitate the raising of standards within American photography to exceed those in Europe. Indeed, Europe was a source of influence on American art (the Armory show, a major exhibition of new work from America and Europe, particularly France in 1913, included work by over 300 artists). Stieglitz organised a number of exhibitions of work by European painters, introducing the Impressionists to New York and bringing what he considered to be the best in European Art to America.7 He also founded and edited Camera Work, published from 1903 to 1917, described by Aaron Scharf as 'undoubtedly one of the most influential journals ever published to be concerned equally with art and photography' (Scharf 1974: 240).

7 The Impressionists, midto late nineteenth century, include Monet, Cezanne, Pisarro, Bonnard, Morisot, Renoir, Van Gogh and Sisley. Relatively informal technique seemed to offer a vision of the world which was both instantaneous and subjective. Their concern to find ways of painting which reflected light, movement and speed echoed an emphasis on modernity and immediacy by critics such as Baudelaire, although the subject-matter treated by many of the artists was rural or natural rather than urban. The most extensive collection is in the Musée D'Orsay, Paris, but most major art collections (including the Metropolitan Museum of Art, New York and the National Gallery, London) offer examples.

Given the complexity of the relation between photography and painting, and the extent to which photographers since the mid-century had sought 'artistic results', why was there such emphasis on photography as art at the end of the century? One factor is that secessionism coincided with the development of technologies such as roll film and the box camera, which allowed the casual amateur to take photographs. Serious amateurs, in claiming artistic status, were also marking a distinction between themselves and the newly emerging mass market in photography.

Furthermore, dissent within photography, represented by the various secessionist groups, echoed dissent more generally within the arts. The end of the nineteenth century witnessed the challenge posed by the Impressionists in painting, naturalism in theatre and, indeed, the birth of cinema. It also witnessed the development of lithographic techniques necessary for the mass reproduction of photographs in print. It was an era of considerable change, characterised by tension, debate and dissent. The pictorialists claimed the photograph as fine art, but this claim coincided with a more general challenge to dominant aesthetics. Pictorialism appears conservative now; to many people it probably already seemed overly traditional then.

English photographer, Peter Henry Emerson became known for picturing life in East Anglia. Emerson's emphasis was upon what he termed 'Naturalistic Photography', which was the title of his book published in 1889. He

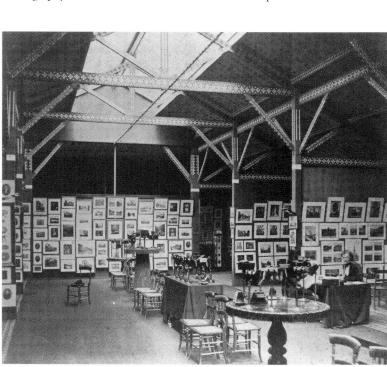

8 Naturalism in painting now refers to close observation and detailed study of external appearances. Naturalism in late nineteenth-century theatre referred to drama in which social environment was depicted as the primary influence on characters, actions and events. Key dramatists include the Scandinavians Henry Ibsen and August Strindberg.

6.4 Thurston Thompson, Exhibition Installation, 1858

Installation shot of the fifth exhibition of the Photographic Society of London, 1858. Photographs were framed and matted but crowded in blocks, some so high or low as to render them difficult to see.

advocated realism and 'truth-to-nature' as opposed to the impressionist or the idealistic. For this reason he has been viewed by some critics as a forerunner of modern photography, although others see his work as too picturesque. Indeed, his concern with composition and differential focusing, including soft focus where appropriate, would have allowed him a place within Pictorialist circles had he so desired. Well-documented disputes with H.P. Robinson were probably the main cause of his exclusion.

Aside from illustrated talks, the exhibition was the principal space for public display for all photographs. 11 Claiming photography as high art did not mean seeking different forms of display so much as claiming different cultural significance. Relevant historical research to date is limited, but it should not be assumed that the Victorian gallery operated like the contemporary gallery. For instance, gallery display conventions emphasised quantity of work, rather than the singularity of the specific image. Paintings, prints and photographs were hung floor to ceiling, with little regard to size or frames (Figure 6.4). Since it would be almost impossible to view those hung at floor or ceiling level, certain parts of the wall were, in effect, pride of place. An example of this may be found in the Round Room at Birmingham Museum and Art Gallery, England, which has been hung to demonstrate the style of the gallery in 1885 (although with only about 50 paintings rather than nearly 90, as originally). The legacy - and difficulties - of this style of hanging may also be seen annually, particularly in the print sections, at the British Royal Academy Summer Show. Galleries were not painted white, and lighting was limited, in contrast to the visibility standards of the late twentieth century. Just seeing monochrome images must have been difficult, let alone discerning the detail of resolution and tonal contrast for which the Pictorialists strived. Indeed, the Pictorialists were instrumental in introducing changes to the gallery, emphasising the presentation of the picture. Photographer Frederick Evans is credited with the introduction of mounts in more muted colours in order not to distract from the delicacy of detail and imagery achieved through the various photographic printing and toning processes. Photographs were framed more uniformly and less heavily than previously; more wall space was allocated to each picture, and the hanging space restricted to the central area of the wall, not too high or too low. Although the concentration of photographs would surprise viewers accustomed to late twentieth-century gallery conventions, this represented new standards of display at the time.

- 9 Defining 'picturesque', Margaret Harker notes 'emphasis on acute observation and appreciation of scenery; an understanding of proportion and perspective in landscape; and the conception of architecture at one with its natural environment (not to be considered in isolation)' (Harker 1979: 27).
- 10 Emerson remained in the Photographic Society and is credited with responsibility for Royal acclaim, hence the change of title to the Royal Photographic Society (RPS). Paradoxically, perhaps, the RPS became the major archive for nineteenth-century British Pictorialism, holding work by many of those who led the secessionist challenge to the Photographic Society. The collection is now housed at the National Museum of Photography, Film and Television (NMPFT) in Bradford, Yorkshire, UK.
- 11 Books of photographs date from the very early days with Henry Fox Talbot's *The Pencil of Nature* or Anna Atkins' use of photographic illustrations in her studies of flora. Each image had to be separately hand printed, so books could only be produced in limited editions.

THE MODERN ERA

Modernism and Modern Art

The Modern Movement in the twentieth century has often involved painters and sculptors in an exploration of the idea that art has a purely Key galleries/collections: in Britain, Tate Modern, Tate Britain, London; Tate Liverpool; The Tate, St Ives, holds a collection of English Modernism. In North America collections include MOMA, New York; San Francisco Museum of Modern Art. Check museum and gallery websites for information on their collections.

formal language in which meaning is conveyed by shape, texture, colour and size. This exploration has been in a shifting dialogue with the traditional subjects of art, such as landscape, the figure and still life.

(Tate Gallery, St Ives, Cornwall, 1995)

In his essay 'When Was Modernism', cultural critic Raymond Williams noted that the idea of the modern began to take on what he terms 'a favourable and progressive ring' in the mid-nineteenth century (Williams 1989). He adds that, in its more specific use, 'modern' soon developed into a categorisation of a number of art movements broadly located between the 1890s and the 1940s, so that by 1950 it was possible to contrast 'modern art' with 'contemporary art'. 'Modernism' increasingly came to refer to avantgarde art movements within which the emphasis was on the specific medium (paint, marble, bronze, photography . . .) and on experiments in forms of expression. Williams cited a number of factors which contributed to making the early twentieth century a key era of artistic change. These included the growth of publishing: he noted that the Futurists, Surrealists, Cubists, Constructivists and others announced the birth of their new art movement through manifestos published in magazines or journals. There were also sociopolitical factors: the dislocation of artists caused by war and revolution contributed a sense of art movements as international as artists migrated within Europe or to North America, spreading ideas and making work which suggested new ways of seeing. This further supported the notion of the artist as somehow outside of modern society and therefore in a position to offer a particular perspective on it. This was now new; since the Renaissance it had been common for artists to travel to work and study in major centres such as Rome, Florence, Paris, Berlin. Arguably study abroad induces a more particular sense of, and perspective on, 'home', further enhancing the fetishisation of artistic sensibilities. For instance, Bill Brandt was born in London, but studied in Paris (1929-31) with Man Ray, who himself was American. On his return from Paris Brandt made a number of studies which collectively investigated Englishness, including his well-known contrast between lifestyles 'upstairs' and 'downstairs' and pictures of stately homes and parks (Figure 6.5).

The influential American critic Clement Greenberg wrote extensively on the subject of Modernism, taking the position that art is autonomous from its social context of production. In 1939, Greenberg had distinguished between avant-garde art, and 'kitsch', by which he meant the popular and the commercial 'product of the industrial revolution which urbanised the masses of Western Europe and America and established what is called universal literacy' (Greenberg 1939: 533). For him the avant-garde was the historical agency which functioned to keep culture alive in the face of capitalism. At this point in his development as a critic, Greenberg acknowledged the social and historical contexts in which the experience of art occurs, asserting that

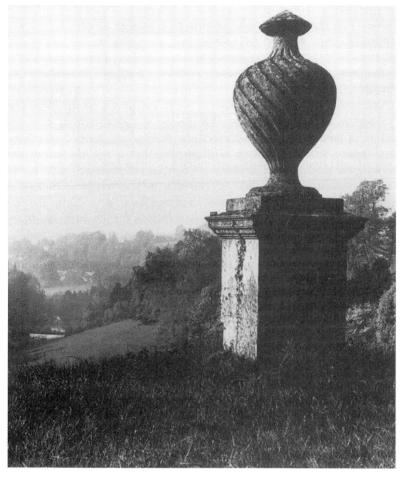

6.5 Bill Brandt, *Prior Park, near Bath, 1936*Straight photography used with great compositional effect to describe the contours of the park, and of the sculptural urn in the foreground

the avant-garde was a type of political engagement. He particularly emphasised medium, and method of expression, arguing that:

the essence of Modernism lies . . . in the use of the characteristic methods of a discipline to criticise the discipline itself, not in order to subvert it but in order to entrench it more firmly in its area of competence.

(Greenberg 1961: 308)

Greenberg condemned the literal in painting. His unequivocal support for abstract art contributed to the international respect accorded to American

Abstract Expressionism (including painters such as Mark Rothko and Jackson Pollock). By contrast, he welcomed it in photography:

The art in photography is literary art before it is anything else: its triumphs and monuments are historical, anecdotal, reportorial, observational before they are purely pictorial. . . . The photograph has to tell a story if it is to work as art.

(Greenberg 1964: 131)

In his view the photograph was transparent, documentary, and marked by speed and ease (relative to painting): 'All visible reality, unposed, unaltered, unrehearsed, is open to instantaneous photography' (Greenberg 1964). This view clearly prioritised **straight photography**, by then well established in American documentary, over American photographic **formalism** which, as we shall see, in its mid-century heyday, was experimental and more gallery oriented.

Modern Art came to occupy a relatively autonomous, arguably elitist position which remained unchallenged until the 1960s (see **Arnason** 1988). The internationalism of Modern Art rests on this notion of autonomy. If art is viewed as *not* context-specific it can be assumed that it communicates regardless of national and cultural differences. Artist-critic Victor Burgin has commented sardonically on such assumptions:

Art is an activity characteristic of humanity since the dawn of civilisation. In any epoch the Artist, by virtue of special gifts, expresses that which is finest in humanity. . . . The visual artist achieves this through modes of understanding and expression which are 'purely visual' – radically distinct from, for example, verbalisation. This special characteristic of art necessarily makes it an autonomous sphere of activity, completely separate from the everyday world of social and political life. The autonomous nature of visual art means that questions asked of it may only be properly put, and answered, in its own terms – all other forms of interrogation are irrelevant. In the modern world the function of art is to preserve and enhance its own special sphere of civilising human values in an increasingly dehumanising technological environment.

If these beliefs sound familiar – perhaps even self-evident – it is because they long-ago became part of the received common-sense we in the West learn at our mother's knee.

(Burgin 1986: 30)

Modern photography

Nowadays modern photography is central to the archive. Historical connoisseurship has created a canon of photographers whose imagery is now highly regarded. This was not always the case. As is suggested elsewhere in this

H.H. ARNASON (1988) **A History of Modern Art**,
London: Thames and Hudson.
This revised and updated third
edition includes photography.

book, the main impetus in photography for most of this century was in documentary and photojournalism, studio portraiture and commercial art. From about 1905 (towards the end of Pictorialism) photography had little visibility in the art gallery in Britain. The work of British photographers – such as Bill Brandt and George Rodgers, whom we now celebrate – was not made initially for gallery exhibition, nor was it necessarily widely known. Bill Brandt's now famous collection *Perspective of Nudes* was not published until 1961. Photography fared better elsewhere in Europe and in the USA; as we shall see, it was central to Surrealism, and also to American formalism and thus included in a number of exhibitions.

Broadly speaking, modern photography sought to offer new perceptions, literally and metaphorically, using light, form, composition and tonal contrast as the central vocabulary of the image. As Peter Wollen, noted:

During the 1910s the pictorialist paradigm began to crack. It moved, however, not towards greater intervention, but towards less. The straight print triumphed, shedding at the same time its *fin-de-siècle* aesthetic pretensions and overcoming its resistance to photography of record. Not only was the gum process rejected but also softness, darkness, blurriness and *flou* altogether. Following the crucial innovations of Strand and Sheeler, ambitious photography accepted illumination and sharpness. The way was cleared by the new machine aesthetic of modernism, which gave fresh confidence to the photographer and validated clarity and precision . . . pictorialism transmuted into a new modernist photography of geometrical compositions, machine forms, hard-edge design and clear delineation of detail.

(Wollen 1982: 180-1)

Wollen also observed that this was the era when the pictorial and the documentary came together under the influence of new principles of composition. Photographers such as Florence Henri (France) or Paul Strand (USA) seem to have echoed the Cubists in their concern with form. In the case of many of Strand's more famous photographs people are depersonalised to the extent that they become anonymous figures in the cityscape (see, for instance, Wall Street, or Central Park, both 1915/1916). Wollen engages with the aesthetic implications of this new photography, arguing that the camera as machine does not in itself make the photograph more objective (and therefore less amenable to the expression of particular perceptions), 'it simply substitutes discovery for invention in the traditional categories of classical aesthetics' (Wollen 1982: 182). Here it is the process of realisation of the image which is at stake. Put more bluntly: creativity resides in the artist, not in the technology.

Photographers move geographically and aesthetically over a lifetime, changing their style and subject-matter, their work reflecting differing political contexts. Photography figured extensively within European avant-garde

Key collections include:
The Print Room, Victoria and
Albert Museum, London;
George Eastman House,
Rochester, USA; Center for
Creative Photography,
University of Arizona, Tucson;
MOMA, New York. Use
www.google.com, or similar
search engines, to explore and
locate work from the period.

movements of the 1910s to 1930s, but in ways which did not necessarily pose images as art or lead to gallery exhibition. Reconstruction in Europe, subsequent to both the First World War and the Russian Revolution, offered obvious social and political context and a sense of immediacy. Photomontage was commonly used as a means of offering direct political comment or more general reflection on social change. For instance, Herbert Bayer's montage of hands and eyes within an urban setting might be interpreted in terms of supplication, or of constant surveillance, as well as referencing the hand and eye, observation and crafting, central to art (see the frontispiece to this book, p. xx).

Discussing photography and architecture in Europe between the wars, Ian Jeffrey describes 1920s photographic modernism in Europe as engaged with social totalities and worthy of respect, 'premised on selflessness, transcending local and even national affiliations' (Jeffrey 1991: 60). By contrast, he notes more archaic subject-matter in the 1930s, with more romantic focus on secret worlds and marginalised people within the city. The imagery of Krull, Atget, Brassai can be viewed as more conversational, in a classic documentary manner, less experimental and less inclined to celebrate the promise of a new social order so eagerly supported in the first half of the 1920s. In effect, reminding us of the changing European political circumstances, Jeffrey proposes that optimism in the 1920s was superseded by a retreat into romanticism in the 1930s and, crucially, that this can be discerned in the shifting subject-matter and style of the image. Furthermore, work was made for publication in the then popular picture press (see ch. 2, p. 70), not for the gallery. The formal concerns and documentary subject-matter of the period were only later taken up by museums and art galleries.

Photo-eye: new ways of seeing

Shifting political circumstances were specifically reflected in the fortunes of the German Bauhaus (1919-33), which was founded in Weimar under the leadership of Walter Gropius. It moved to Dessau in 1925, by which time Herbert Bayer, photographer and typographer, was a key influence; and to Berlin in 1932, before disbanding in consequence of the election of Hitler's National Socialists. 12 The Bauhaus was a clear response to the destruction and dereliction witnessed during the First World War. 'Bauhaus' literally means 'house for building'. Although multi-disciplinary, and concerned to integrate art, design, and social purpose, architecture came to be the central concern. Taking the notion of reconstruction as the central tenet, Bauhaus theorists emphasised the relation between form and function, and stressed what they saw as a potential unity of art, design and the everyday (see Rowland 1990; Willet 1978). László and Lucia Moholy-Nagy were perhaps the best-known photographers associated with the Bauhaus. They stressed ways in which use of light, mechanical reproduction and the possibility of sensitive printing expressed the machine aesthetic of the Modern Age. In

12 Many Bauhaus theorists were exiled to the United States where they formed The Chicago Art Institute.

JOHN WILLETT (1978) The New Sobriety, Art and Politics in the Weimar Period, London: Thames and Hudson. parallel with the Soviet emphasis upon photo-eye as the modern method of communication, Moholy-Nagy emphasised the relation between the mechanical nature of the camera, form, angle of vision, the use of light, and visual perception, arguing that photography enhances sight in relation to time and space (Moholy-Nagy 1932). Their radical approach was not uncontroversial. For instance, Frankfurt School theorist, Walter Benjamin, expressed impatience with such experimentation, accusing the 'new objectivity' photographers of the Bauhaus of making the world artistic rather than making art mundane. ¹³ As already noted Benjamin was interested in photography as a democratic means of mass communication; he opposed formalism and abstraction because, he argued, experimentation in visual languages tends to be exclusive, and therefore elitist. The Bauhaus theorists viewed radicalism in photography in different terms. Like Benjamin, they opposed the reification of the individual artist. Unlike Benjamin, they stressed aesthetic experimentation, viewing this as central to new (and contemporary) modes of expression.

The following case study briefly considers the example of Soviet Constructivism in which art was seen as playing a role in building a new post-revolutionary society.

13 The Frankfurt School of Social Research included philosophers, aestheticians, and social scientists. variously concerned with politics and culture, and influenced by the writings of Marx and Hegel. Theodore Adorno, Walter Benjamin, Erich Fromm, Jürgen Habermas, Max Horkheimer, Herbert Marcuse were all associated Many members ended up in exile in the USA having escaped the Nazis. Benjamin committed suicide in 1940, whilst waiting to cross from occupied France to Spain (his companions made the journey the next day).

CASE STUDY: ART, DESIGN, POLITICS: SOVIET CONSTRUCTIVISM

A brief background

Discussing experimentation in Russian art from the 1860s to the early 1920s, Camilla Gray traces a number of strands within Russian Modern Art, ranging from spiritual interest in medieval icon painting to a realism which mirrored developments in other parts of Europe (Gray 1962). In the mid-nineteenth century, 'The Wanderers' – a group of Russian painters who, like their contemporaries in France, had broken from the Russian Art Academy – committed themselves to developing art which was about the everyday. Links with Paris, Munich and Vienna, especially immediately after the failure of the 1905 Revolution, led to a number of major exhibitions in Moscow and St Petersburg wherein Russian artists showed alongside their Western European contemporaries. By the time of the 1917 Revolution there was an identifiable avant-garde which, in the paintings of Malevich, Popova, El Lissitzky, paralleled Cubism in France in exploring the surface of the canvas and the nature of artistic language.

Experiments in the social role of art

The success of the 1917 Revolution led to a new political context, one in which the nature and social role of art was hotly debated. A number of artists, led by Malevich, stressed the formal and spiritual supremacy of art in itself. A Russian form of Modernism! Others emphasised proletarian culture advocating a social

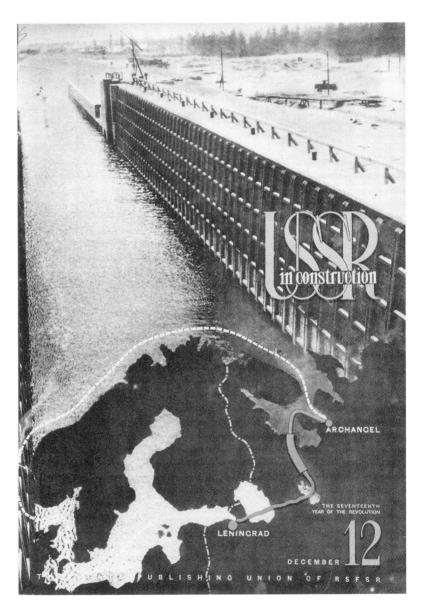

6.6 Alexander Rodchenko, White Sea Canal, from USSR in Construction 12, 1933One example of the geometric style and the commitment to a new angle of vision, literally and metaphorically, which characterised Constructivism

role for artist-workers in the vanguard of Revolutionary change (see **Phillips** 1989; **Solomon-Godeau** 1991). The new situation encouraged a radical aesthetic. Painter-photographer Alexander Rodchenko asserted that:

Art has no place in modern life. It will continue to exist as long as there is a mania for the romantic and so long as there are people who love beautiful lies and deception. . . . Every modern cultured man must wage war against art, as against opium. . . . Photograph and be photographed.

(Rodchenko 1928)

For Rodchenko and the other Constructivists, new art involved, first, the depersonalisation of practice, that is, taking art out of the realm of individual artistic expression; second, logical laboratory study of form and composition; third, analysis of rules governing the nature of artistic communication. Photography as a technological medium seemed particularly appropriate. Art set out to renegotiate itself as a type of practice which was utilitarian in foregrounding design and function, and selfless from the point of view of the artist. As such it represented the socialist ideals of the Revolution. Soviet Constructivism flourished for about a decade, before being superseded by Socialist Realism with its focus on glorification of the worker, the peasant and 'heroes' of the Revolution.

Constructivist photography

The Constructivist saw photography as a popular form which, through its usage in posters, magazines and publishing, could be at the forefront of taking new ideas to the people. Emphasising art's post-Revolutionary responsibilities, Rodchenko stated that he was fed up with 'belly button' shots, by which he meant photographs composed conventionally, shot from waist level through cameras with their viewfinder on top. 14 He argued for full exploration of the geometry of the image which would, literally and metaphorically, engineer a new angle of vision (see Figure 6.6). Indeed, for Rodchenko photography was the true modern art. He argued that, unlike painting and sculpture, which he viewed as outdated, photography could express the reality of post-Revolutionary society. Thus, in Soviet Constructivism, the issue was not one of photography attempting to claim status as Art, but rather of a democratisation of artistic practices in the service of social and cultural revolution within which photography, by its enquiring nature and its ubiquity, could play a leading role.

American formalism

Concern with form and precision can be seen at its extreme in what became characterised as American formalism, for example, in the work of the West Coast f/64 Group, founded in 1932 by a number of American photographers, including Edward Weston, Imogen Cunningham and Ansel Adams, which was so-titled precisely to stress visual clarity. Their approach emphasised

CHRISTOPHER PHILLIPS (ed.) (1989) Photography in the Modern Era: European Documents and Critical Writings 1913–1940, New York: MOMA.

ABIGAIL SOLOMON-GODEAU (1991) 'The Armed Vision Disarmed: Radical Formalism from Weapon to Style' in Photography at the Dock: Essays on Photographic History, Institutions and Practices, Minneapolis: University of Minnesota Press.

14 Cameras were very different then to the light digital cameras of today, made to fit in pockets or handbags, although the legacy can be seen in the design of medium and large format cameras still in use. They were commonly designed with a viewfinder on top so the photographer looked down; the camera would be steadied at waist or 'belly button' - level. Examples can be viewed in most museums of the history of photography.

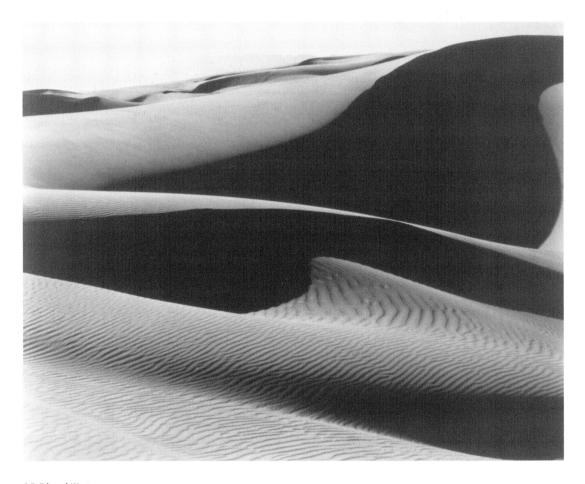

6.7 Edward Weston, Dunes, Oceano Photographic seeing with

Photographic seeing with emphasis on the rhythm of form.

15 f/64 references smallness of aperture and thus symbolises intent to maximise depth of field.

16 The work of these photographers, and other American photographers of the era, has been extensively published in histories of photography as well as in monographs or biographic essays on individual photographers.

photography as a specific type of medium with its own optical, chemical and consequent aesthetic properties. This approach became – and remains – highly influential; it was mirrored in the work of East Coast photographers such as Harry Callahan and Minor White. Here European influences are also relevant; for instance, in 1946 Callahan went to teach for Moholy-Nagy at the 'New Bauhaus' in Chicago. 16

The specificity of photographic seeing was commented upon by curator John Szarkowski in his discussion of the properties of photography wherein he suggested that the facticity of photographs, detail, framing, exposure time and vantage point (literally, point of view) come together in the image (Szarkowski 1966). Ansel Adams, who himself had studied music, famously drew an analogy between music and photography wherein he likened the negative to the score, or composition, and the print to performance, that is, interpretation. For Edward Weston, the trademark of photography lies in

precision of definition, the fine detail that can be recorded, in the continuity of tonal gradings (black to white), and in the qualities of the surface of the paper used for the print. He himself defined his approach as both abstract and realist, emphasising the observational basis of the photograph and the aim of the photographer to reveal the nature of the world inhabited. Edward Weston's visual poetics emerged from concentration on tone and shape, although he claims concern with the subject of the image. Beaumont Newhall stressed the interdependence of the technological and the aesthetic in Weston's work, noting his insistence upon pre-visualisation of the image. Weston sought clarity of form and extolled the camera for its depth of focus and its ability to see more than the human eye. The formalists were not exclusively concerned with a more abstract aesthetic; for example, Weston made portraits of family and friends throughout his life, and the photographer, Tina Modotti, is also known for her documentation of the Mexican revolution.

Unlike other photographic movements of the time, formalism sought gallery exhibition. Indeed, work by these photographers is now highly prized (and priced) and is included in all major photography archives as examples of one of the most significant photography movements of the twentieth century.¹⁷

Formalism could be defined as a tendency in American art, one that was taken up by the Art establishment. It was not announced as an art movement; rather the label is retrospective. The following case study considers photography in relation to a specific art movement, one which was constituted through manifestos – namely Surrealism. Intellectual currencies which informed Surrealism, its multidisciplinary nature, and subsequent comments and reappraisals, are noted. The case study offers an example of ways in which photography within specific broader movements may be analysed and contextualised. It also draws attention to the emphasis on aesthetic radicalism which typified Modern movements.

CASE STUDY: ART MOVEMENTS AND INTELLECTUAL

CURRENCIES: SURREALISM

What was Surrealism?

In pursuing academic analysis it is always relevant and interesting to trace links between the general intellectual climate of any era and aesthetic developments. Surrealism took the idea of the individual psyche as its theoretical starting point, thus particularly reflecting the psychoanalytic work of Sigmund Freud. Surrealism emphasised artistic processes whereby the imaginary can be recorded through automatic writing or drawing which would thus offer insights into the world of 'thought' and therefore disrupt taken-for-granted perceptions and

17 Curiously, the influential photographer and curator, Alfred Stieglitz never showed Edward Weston's work in New York in his Madison Avenue gallery, named An American Place, which he ran from 1929 to 1946. However, in the second half of the twentieth century almost all major historical surveys or gallery overview exhibitions give prominence to the work of the American Formalists. The individual photographers are featured in a number of monographs so their work is easily found in bookshops and libraries.

18 Surrealists included André Breton (founder), Antonin Artaud, Luis Bunuel, Claude Cahun, Jean Cocteau, Salvadore Dali (later expelled from the movement because of his support for General Franco and the Spanish Right), Max Ernst, René Magritte (in Belgium where there was a separate Surrealist group), Lee Miller, and painter-photographer, Man Ray. Surrealism was championed in Britain by Roland Penrose.

19 Held in London at the New Burlington Galleries in Burlington Gardens; that is,

in a modern gallery.

frames of reference. For the Surrealists, the artist was the starting point or material source of what was to be expressed. Freud had distinguished between the Id, the **unconscious** instinctual self, and the Ego, the largely conscious socialised self. Likewise, Surrealists distinguished between 'thought' and 'reason', and aimed to bypass what they saw as the **repressive** nature of reason in order to express natural desires.¹⁸

Surrealism has been regarded as attempting to replicate the world of dreams. This is premised directly on Freud's dream theory wherein he argued that analysis of the manifest content of dreams offers perception on subjective responses to experience. However, this is to oversimplify, as the aims of Surrealism were complex and, to some extent, changed over time. They included a direct attack on the nature of art; many of the early Surrealists had also been involved in the First World War anti-art movement, Dada (Ades 1974). Both Dada and Surrealism were interventionist in challenging what was happening in the gallery. For instance, Marcel Duchamp placed a urinal in the gallery claiming that the location made it 'Art'.

French poet André Breton described 'A desire to deepen the foundations of the real; to bring about an ever clearer and at the same time ever more passionate consciousness of the world perceived by the senses' (Breton 1978: 115). In the late 1920s, Surrealists, led by Breton, called for adherence to Marxist dialectical materialism and to the ideal of revolution. This caused splits in the Paris-based group. But fundamentally, Surrealism was premised on challenging philosophical distinctions between interior experience and exterior realities. The radicalism of Surrealism lay in its aims: to disorient the spectator; to push towards the destruction of conventional ways of seeing; and to challenge rationalist frameworks. Surrealist aesthetics were not based on intention to shock, as has sometimes been suggested, although this was sometimes the effect.

Fine art movements transcend national boundaries, albeit reflecting particular national features. It is necessary to take into account the interplay between that which characterises specific social and political circumstances, and more general international contexts. For instance, the first Surrealist Manifesto was published in Paris in 1924, but the first International Surrealist Exhibition in Britain did not take place until 1936, by which time, arguably, the movement had lost its more experimental edge. ¹⁹ Furthermore, a number of the original Paris-based group became members of the Communist Party. In Britain, with Roland Penrose as the key Surrealist artist and exponent, the emphasis was more on visual form and psychoanalytic references than on political revolution.

Surrealist photography

How does lens-based imagery, including photography, fit within Surrealism? For Dali, the mechanical nature of the camera was liberating: 'photography sets imagination free', he claimed. Breton stated:

The invention of photography has dealt a mortal blow to the old modes of expression, in painting as well as in poetry, where automatic writing, which appeared at the end of the nineteenth century, is a true photography of thought.

(Breton 1978: 7)

He also noted approvingly that 'belief in an absolute time and space seems to be vanishing', a reference to the photograph's ability to picture the past, or the geographically distant, and welcomed the fact that 'today, thanks to the cinema, we know how to make a locomotive arrive in a picture' (1978: 7). Despite

6.8 Lee Miller, Portrait of Space, near Siwa, Egypt, 1937

An example of a Surreal juxtaposition of interior/exterior to achieve a dreamlike effect. Mirrors frequently feature, referencing reflection and also the self as source of angst, trauma and, artistic creativity. Possibly the inspiration for Magritte's Le Baiser

photomontage The use of two or more originals, perhaps also including written text, to make a combined image. A montaged image may be imaginative, artistic, comic or deliberately satirical.

rayographs, solarisation
Aesthetic techniques associated
in particular with the work of
Man Ray and Lee Miller.
Solarisation involves brief
exposure to light during printing
thereby altering tonal contrast.
Rayographs or photograms are
cameraless photographs, made
by placing objects on
photographic paper then
exposing to light.

ROSALIND KRAUSS AND JANE LIVINGSTON (1986) **L'Amour Fou**, London: Arts Council of Great Britain.

IAN WALKER (2002) City Gorged with Dreams, Manchester University Press.

RUDOLF E. KUENZLI (1991)
'Surrealism and Misogyny' in
Mary Ann Caws, Rudolf Kuenzli
and Owen Raaberg Surrealism
and Women, Cambridge, MA:
The MIT Press.

the involvement of artists such as Herbert Bayer, previously associated with the Bauhaus, where the emphasis was on observation, rather than on interiority, Surrealist photography clearly differed both in principle and in vision from the formalist 'new objectivity' of the Bauhaus or of Soviet Constructivism. Stressing the imagination as the source of insight on experience, the Surrealists used **photomontage**, double exposure, **rayographs**, or **solarisation**, in order to produce disorienting imagery. Key Surrealist artist-photographer, Man Ray, remarked that he painted that which cannot be photographed and photographed that which cannot be painted. The realism associated with the photograph was utilised, more-or-less playfully, as a tactic to contribute to the Surrealist provocation of new insight as objects, persons or locations were rendered in unexpected conjunctions or distortions or particular motifs doubled within the image.

Critical reappraisals

Debates relating to (photographic) representation of the real, distortions, and emergent surreal effects, have figured within critical reappraisal of the movement. Some critics, including Rosalind Krauss, focused on taken-for-granted realism of the photographic as the source of the coup d'oeuil effect which often operated to disorient the spectator. Krauss notes metaphoric effects: 'we see with a shock of recognition the simultaneous effect of displacement and condensation, the very operations of symbol formation, hard at work on the flesh of the real' (Krauss and Livingston 1986: 19). In this formulation the shock emanates from the refusal of the transcriptive realism expected of photography. lan Walker has argued that this position is problematic as it rests on a distrust of 'straight' photography, with its claims to authenticity as source of authority, and reflects a binary opposition between art and documentary still current in North America in the 1980s (Walker 2002). He suggests that in Europe documentary has never been polarised from other areas of practice such as Surrealism and argues that critical focus on a Surrrealist realism concerned with photography of the city (in their case, Paris) can contribute to more comprehensive evaluation of the import of Surrealist photography.

Feminism also contributed to reappraisal of Surrealism, drawing both on debates about patriarchal attitudes in psychoanalysis and, more specifically, through new art history. Women figured in Surrealism as artists but, until recently, their position and contribution has been largely ignored (see Chadwick 1985, 1998). Reinstatement has focused attention on the work of many women Surrealists, including photographers Lee Miller and Claude Cahun. Indeed, allegedly Lee Miller 'discovered' solarisation by opening a darkroom door, not realising that Man Ray was printing.

The feminist critique drew attention to the role of woman as muse. Considered from a feminist perspective, the expression of unconscious desires, central to Surrealist imagery, seems merely an excuse for male heterosexual fantasy. 'Woman' is objectified. The distorted or fragmented female figure is a

common motif. Hans Bellmer's female dolls most obviously degrade and violate woman through her disfiguration or dismembering. Surrealists viewed such imagery as an expression of innate but repressed desire, but also used this to challenge bourgeois boundaries of permissibility and drew attention to the violence of war (ch. 4, p. 186 and Figure 4.11). Such images were thus simultaneously revolutionary and, in the light of feminist analysis, misogynistic.

LATE TWENTIETH-CENTURY PERSPECTIVES

The American and European Avant-garde art movements of the 1960s emphasised idea and process over the conventions of painting and sculpture. The war in Vietnam, the civil rights movement in America, the development of feminist politics and theory, and the student protests of 1968, were reflected in works that were challenging to the status quo, to ideas about the artist as apolitical and working alone, and to art institutions.

(Comment and Commitment: Art and Society 1975–1990, Tate Gallery, London 1995)

A number of shifts occurred in the second half of the twentieth century which had ramifications for gallery practices. From the 1960s onwards the image world of the media became increasingly influential within art practices. Second, as art retreated from Modernist preoccupations with form and medium, it once again engaged with social and political landscapes so that national and international developments such as civil rights movements, feminism, war, first world/third world relations figured as themes. Third, postmodern theory became a source of influence upon conceptual and interpretative processes, that is, the making and the reading of pictures.

Conceptual art and the photographic

Photography in the 1960s was centrally implicated in the expansion of the mass media, including fashion shots, album covers for long-playing (33½) records, photojournalism (the *Sunday Times* colour supplement was launched in 1962). Two parallel developments in the 1960s and 1970s contributed to shifting the position of photography in the gallery. First, pop artists such as Andy Warhol (USA), Roy Lichtenstein (USA), David Hockney and Richard Hamilton (both British) started to use the photographic in order to reference and comment on lifestyles and consumerism.²⁰ But, unlike now, with photomedia (chemical or digital, still or time-based) taken for granted as media of artistic expression, photography then was still seen as inherently different (commercial, popular, documentary) from more established art forms such as painting and sculpture. This was no doubt in part because, to echo

20 Pop Art in the 1960s essentially commented upon evidence of transformation into a consumerist society. Artist Richard Hamilton described Pop Art as popular, transient, expendable, low cost, mass produced, young, witty, sexy, gimmicky, glamorous and big business.

Roland Barthes, many elements within their pictures were déià-lu ('already read'). But this was the whole point. Raymond Williams has suggested that in the 1960s the two dimensions of the modern, radical aesthetics and technological change, came together in the pictures of artists whose work engaged with the revolution in mass culture consequent upon developments in technology and communications such as television (Williams 1989). Indeed, photography arguably contributed to creating a more visually sophisticated audience than had previously obtained: 'that painters have used photographs does not legitimise photography; on the contrary, such cross-pollination has primarily helped painting remain a vital and effective medium' (Coleman 1979: 121). Through Pop Art the photographic gained a presence in the gallery (see Alloway (1966) for an account of British Pop Art). Second, in Conceptual Art the photographic became accepted as a valid medium of artistic expression. It was in the 1970s that American Art magazines, including Artforum and Art in America, took photography into their remit. As phototheorist, John Roberts, has argued:

Photography was the means by which conceptual art's exit from Modernist closure was made realisable as *practice*. Yet photography itself was of little interest to most conceptual artists, producing a situation in which critical agency is given to the photographic image without photography becoming theoretically self-conscious as a medium. Photography, then, had an indirect function: it allowed conceptual art to reconnect itself to the world of social appearances without endorsing a *pre*-Modernist defence of the pictorial.

(Roberts 1997: 9)

Modernist theory had focused on the medium. By contrast, Conceptual Art stressed ideas. Artists were concerned to draw attention to the manner or vocabulary of expression; also, to contexts of interpretation, that is, the influence of the situation within which the spectator responds to the image or art object. Indeed, in a number of instances artists placed a statement about an art object in the gallery, thereby focusing attention on the idea, rather than the object (which might never have been actually made). From recent (post-modern) theoretical perspectives the notion of explicitly requiring spectator interpretation comes as no surprise. But, at the time, Conceptual Art, especially in its more critical or political forms, constituted a challenge to the Art establishment (see Harrison and Wood 1993; also Green 1984). In conceptual photography the characteristics of the medium could be used as a part of the means of expression of an idea. Thus, for instance, Keith Arnatt's sequence of digging himself into a hole in the ground (Figure 6.9) is obviously, at one level, a metaphoric reference to the well-known phrase. But the documentary idiom secures a sense that this event literally did take place through demonstrating the sequence of moments in time.

JONATHAN GREEN (1984) 'The Painter as Photographer' in **American Photography**, ch. 9, New York: Harry N. Abrams.

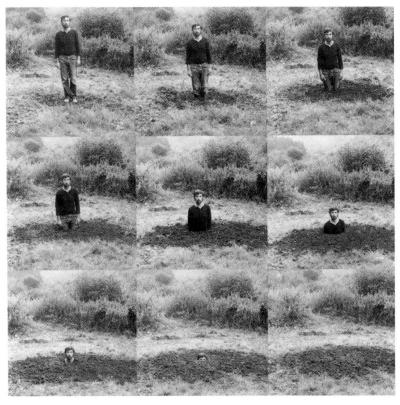

6.9 Keith Arnatt, Self Burial, TV Interference Project, 1969Photograph on paper, 467 × 467cm. The humour of the piece of work emanates from the realism attributed to photography. One way of testing the implication of choice of specific medium, and therefore the implied comment on the nature of the medium, is to imagine what interpretational shift might occur if the sequence had been, say, painted

Conceptualism challenged the dominance of abstract formalism. It was not that it denied the significance of form. Rather, form was brought into play differently with a view to social, political, metaphysical, or simply humorous, comment. However, as photography became accepted within Conceptual Art, so attention came to be paid to photographs (pictorialist, formalist and documentary) and to photography history. In effect, Conceptual Art offered photography a bridge into the gallery.

This era featured other challenges which, although incorporating some of the aesthetic characteristics of formalism, took for their starting point ideas which were anchored socially (rather than aesthetically). For instance, the 'new topographics' photographers, including Lewis Baltz (USA) and Bernd and Hilla Becher (Germany), explored the act of looking, as well as topographic features, through the detailed mapping of industrial edifices or locations.²¹ In the Becher's work similar images are blocked next to one

21 The term 'new topographics', used in the 1970s, refers back to nineteenth-century topographical work, especially the photographic charting of the American West.

another, thereby bringing into question the degree of detailed discrimination involved in day-to-day perceptions. Clearly this work drew on the emphasis upon detailed seeing typical of, for instance, the f/64 group. But the new topographics, in charting the industrial landscape, implied a social and environmental questioning which did not figure in American formalism. Land art also dates from this period. Here, the photograph is the record, and the final product, of an engagement with or intervention within the rural. Work by British artists, including Hamish Fulton, Richard Long and Andy Goldsworthy, has become well known not through direct experience of the results of their investigations and interventions, but through their photographs. A sculptural intervention ameliorates, deteriorates, and becomes reabsorbed within the environment; a journey takes place in specific time. Ultimately only the picture remains.

Photography and the postmodern

From the 1970s onwards there were significant developments in art practices founded in the new centrality of critical ideas to the visual arts, and in what was often referred to as the 'return to the figurative'. Of course the figurative had never entirely disappeared. The 'return' was more a question of a regeneration of interest in the representational on the part of curators and critics, now moving beyond modernist preoccupations with the specificity of each medium. New art also posited questions of representation. By the 1980s art had ceased to be self-obsessed, was looking outward beyond the boundaries of the gallery, taking on contemporary issues and making a range of references that ruptured modernist assertions of the autonomy of art.

Critical theorist, Douglas Crimp, suggested that photography contributed centrally within this challenge to the museum and gallery:

From the parochial perspective of the late-1970s art world, photography appeared as a watershed. Radically reevaluated, photography took up residence in the museum on a par with the visual arts' traditional mediums and according to the very same art-historical tenets. New principles of photographic connoisseurship were devised; the canon of master photographers was vastly expanded; prices on the photography market skyrocketed. Counterposed against this reevaluation were two coincident developments: a materialist history of photography and dissident photographic practices . . . taken together and brought into relation, they could tell us something about Postmodernism, a term coming into wide use at just that time.

(Crimp 1995: 2)

Thus, from the 1970s on, emphasis upon conceptual ideas and critical practices contributed to creating a place for the photographic within the gallery. Furthermore, photography contributed to the regeneration of art practices.

The sources of this shift are complex. First, the radicalism of 1968 in Europe heralded a Left cultural agenda in the 1970s. This underpinned critical interrogation of dominant cultural practices. Examples may be found in the work of Victor Burgin and Mary Kelly, both of whom, notably, wrote about photographic practices as well as making photographic work. Second, and as a part of this, modern theory had begun to be questioned across many realms of academic enterprise, from the scientific to the aesthetic. In art theory this questioning took off earlier in North America than it did in Europe. Thus a further influence was new American art, including photographically based work by artists such as Cindy Sherman and Barbara Kruger. (See Nairne 1987, ch. 4; Kruger 1983, 1990; Sherman 1997.) Fourth, developments including community arts, performance art and 'happenings' signified a broadening of art practices. This widening definition of what constituted art contributed to photography breaching the art gallery which, as already noted, occured around this time. In addition, in Britain, there were energetic claims from within the documentary movement for the artistic integrity of the medium, and such claims were further fuelled by the commercial success of leading British 1960s photographers.

Art education reflected the changes. For instance, in England in the 1970s there was a move to consolidate art schools within the newly established polytechnics and to upgrade courses from diploma to degree status. This involved changing the erstwhile 'liberal studies' agenda to a more purposeful critical appraisal of art history. Art school graduates, who subsequently formed the new generation of gallery curators, were increasingly well informed and interested in exhibiting a greater range of ideas-based work. Not only had photography moved into the art gallery but, more broadly, critical ideas moved on to the agenda in photography education; an agenda that was increasingly influenced by then radical feminist perspectives and critiques. A number of new degrees in photography became established wherein 'theory' meant thinking about photography semiotically, and in relation to questions of identity, gender and representation.²² By the 1990s, the implications of the digital were also central to the agenda (see ch. 7). Although this varies according to the priorities of particular universities, by contrast with many educational institutions elsewhere in Europe and in North America, British photography education continues to emphasise the interrelation of theory and practice.

Developments do not proceed in an orderly and coherent fashion. Whilst digitally produced work takes its place alongside the straight photograph and constructed imagery, the relative lack of photographs in a number of major museum collections indicates that photography is still seen by some as a lesser art. The corollary of the new emphasis upon ideas and critiques was that, from the mid-1980s, *straight* photography found itself positioned ambiguously. On the one hand, museums established photography sections but on the other hand it became more difficult to retain the space within the contemporary

22 The most prominent example was at the Polytechnic of Central London in the 1980s. Tutors then included Victor Burgin and Simon Watney, both of whom have published extensively on art and culture.

23 For instance, the Museum of Modern Art, New York has a number of galleries permanently dedicated to photography; the V&A, London, opened a permanent space for photography exhibition in 1998. Some museums are entirely dedicated to audiovisual media, including photography; these include the National Museum of Photography, Film and Television in Bradford, Yorkshire, England. See list of archives for further information (p. 344).

gallery.²³ The foothold established in the 1970s came to seem precarious. This was expressed partly in the practical issue of scale. Photography galleries had been designed to accommodate the standard-format image. A number of the newer photo-media galleries, which were larger scale (often converted from disused industrial buildings), became key institutions within the new debates. The standard photograph became harder to show, smaller pictures being dwarfed within cavernous warehouse – now, gallery – spaces (many of which have subsequently embraced video installation and digital experimentation).

More particularly, the position of photography changed partly as a consequence of fashion and the focus on the postmodern. Since the 1970s lens-based media, including photography, video, slide projection and installation have been absorbed within broader fine art practices. Furthermore, by the 1990s irony, parody and pastiche increasingly featured within the armoury of the artist. It is no accident that a key exhibition of contemporary British photography at the Victoria and Albert Museum in 1988 was titled Towards a Bigger Picture. The double meaning of the title referred in particular to the extension of photography within art practices and to diversity of subjectmatter. But it also referenced conceptual understanding of ways in which scale contributes to the claim for place within the gallery. For example, very small-scale work, carefully mounted and framed, inherits the sense of the precious associated with miniature painting. It demands close-up and detailed looking. Preciousness is emphasised if individual works are hung with space between them. By contrast, large-scale photographic works claim the status traditionally accorded to academic painting and other art made for public spaces. They assert their presence and, therefore, the significance of their theme or subject-matter. Such pictures engage with contemporary myth in ways which echo the ideological and political involvements typical of classical painting.

New constructions

Discussing pluralism in American art in the 1970s, critic Corinne Robins comments on the increasing eclecticism of photography, noting:

Photographers concentrated on making up or creating scenes for the camera in terms of their own inner vision. To them, reportage as such had become the job of the video artist, who had the heritage of *cinéma vérité* behind him [sic]. To the 1970s camera people, realism belonged to the earlier history of photography and, as seventies artists, they were embarked on a different kind of aesthetic quest. It was not, however, the romantic symbolism of photography of the 1920s and 1930s, with its emphasis on the abstract beauty of the object, that had caught their attention, but rather a new kind of concentration on narrative drama, on the depiction of time changes in the camera's fictional moment.

The photograph, instead of being presented as a depiction of reality, was now something created to show us things that were felt rather than necessarily seen.

(Robins 1984: 213)

Central to the postmodern is an emphasis on construction, the forging, staging or fabrication of images. Pictures are preconceived by the artist. Constructed photography includes photomontage, staged imagery, imagetext works, slide-tape installations, photographs derived from land art; indeed, any photographic imagery wherein the conceptual engineering of the artist is clearly evident. Artists as divergent in concerns as Bernard Faucon, Andreas Gursky, Mary Kelly, Peter Kennard, Barbara Kruger, Richard Long, Mari Mahr, Cindy Sherman, Susan Trangmar, Jeff Wall and Joel-Peter Witkin all fall within this broad category. The notion of construction derives from two sources: first, the idea that art can intervene politically, as in the example of the Soviet Constructivists or of the German monteurs. Second, in postmodern terms, 'construction' directly relates to deconstruction theory and practices. Both approaches refuse to take the world at face value. Constructed imagery in effect critiques what Grundberg has defined as 'concentration on the literal surfaces of things and on subject matter that seems to speak for itself' (Grundberg 1990a: 82).

For instance, in the example of Karen Knorr's series *Country Life*, made in the late 1980s, countryside becomes a setting for reflections upon bourgeois taste and lifestyle (Figure 6.1, p. 246). This is obviously a staged image (we would not just come across this scene and capture it photojournalistically). The images use the **indexical** qualities of the photographic – that is, the way in which the photograph draws upon actuality – as part of its vocabulary of expression, but only a part of it. It invites the spectator to actively *read* the image and implicates questions of **identity** through its reference to the English landscape, aesthetic philosophy and patriarchy (in that judgement of taste is invested in a young, well-attired man). The title is used to indicate the critical reading intended, in effect acknowledging the **polysemic** nature of imagery.

There are a number of methods whereby the interpretive latitude of an image may be contained. These include photomontage, sequencing and image-text techniques. We also have to take account of factors beyond the image itself. The mounting and framing of pictures – whether single images, or series, or sequences – is not neutral. Framing contributes to the rhetoric of the image through delineating the edge of the picture, that which is put into the frame. It also acts as a margin between the work and the wall on which it hangs. The established convention in post-Renaissance Art of framing paintings means that the frame also signifies the special status of a picture. However, the meaning of the frame is ambiguous: from the point of view of the gallery wall it is a part of the picture, but from the point of view

fabrication The crafting of images which have been staged or appropriated and adjusted for the camera. The term is more common within American photography than European, referencing the craft base of the medium. It stands by contrast with 'constructed' imagery, which inflects the directorial approach in more political terms through referencing both Soviet Constructivism and theories of deconstruction.

staged images Described by American critic A.D. Coleman as 'falsified documents', this refers to the creating of a scene for the camera (as in staging within theatre).

image-text Pictures within which visual imagery and written text are juxtaposed in order to effect a play of meaning between them.

of the picture it dissolves into the wall. In relation to the single image, this ambiguity is relatively clearly comprehended. Within sequences, or blocks of images, the play of the frame is more complex: the frame not only plays between the setting and the image, but also interacts with other frames within the grouping of pictures.

Written text commonly accompanies both single pictures, and series, groups or sequences. Written text includes titles, captions, artists' statements, poetry, or forewords which accompany an exhibition or book publication. Titling, and the signature of the artist, contribute to the claim for the status of the image as Art. Titles may be cryptic, or metaphoric, operating to extend resonances, or they may be primarily descriptive. For instance, a title such as *Rome, 1975* or *Waiting Room* specifies place or type of location. However, the caption does not simply anchor; writing constitutes a further signifier within the complex interaction of discourses with which the spectator engages. For instance, the title *Rome* at the very minimum means something different to an Italian than to someone of another nationality. Titles, or captions, simultaneously anchor, and become implicated in, play of meaning. The refusal of a title, as in *Untitled*, is likewise not neutral. This implies that the image is to 'speak for itself'.

Writing operates complexly. This is often particularly so in constructed imagery within which text is montaged as an integral element. Here the verbal is articulated not only as a poetic reference but also as a visual element. Colour, handwritten or typographic style, placing, scale, prominence – all contribute to how we read the overall piece. Likewise, artists' statements do not simply contextualise, or determine a position from which the work is to be read, although, of course, they do offer this. If an artist is viewed as a special sort of seer, offering particular insights into the world of experience, then his or her statement contributes to this claim for authority.

Women's photography

The mere mention of the phrase 'women's art' sends shivers down the art establishment spine – more radical feminists on the war-path! Feminism, advocacy of women's rights on the ground of equality, is usually misinterpreted to mean exclusively female, probably radical and, more than likely, shaven-headedly lesbian. It's curious how this misconception perpetuates!

(Libby Anson, Untitled #7, Winter 1994/1995)

The resurgence of feminism in the 1970s challenged the patriarchal establishment. This challenge included a set of questions about women, representation and art, which led to critical work on three key fronts. First, examination of ways in which women have been represented in Western art. Within patriarchy, active looking has been accorded to the male spectator.

'Woman' becomes the object of his gaze. Although this does not only concern 'the nude', the representation of naked women for visual consumption formed one obvious focus for accusations of sexism in visual culture. It was argued that the term 'nude', central to the visual arts tradition, lent a guise of respectability to the practice of naked women being objectified for fantasy libidinous gratification. Second, feminist art historians pursued the archaeological project of rediscovering and drawing attention to the work of artists. previously ignored or marginalised. women in art schools, galleries and publishing asserted a right for space devoted to contemporary women artists. The revolution took several forms. In art education the art history curriculum was brought under scrutiny, and various guises whereby sexism figured in the studio were challenged. Alongside this, the demand was made that galleries and publishers should examine their record in exposing the work of women artists - and set out to rectify it. Protests were mounted against exhibitions showing work deemed offensive to women.

Question: Do women have to be naked to get into the

Metropolitan Museum of Art?

Answer: Less than 5% of the artists in the Modern Art

sections are women, but 85% of the nudes are

female - Guerilla Girls

This revolution obviously influenced photography, itself forging space in the gallery. Three projects stand as key examples. They relate, respectively, to the diverse history of photography, modern aesthetics and postmodern gallery-based practices. First, in Women Photographers: The Other Observers 1900 to the Present, writer-curator Val Williams traced and surveyed a range of British work, from high street studio portraiture to fashion photography, from the documentary and photojournalistic to the snapshot, and to contemporary feminist practices. The purpose was to expose the names and work of women photographers, previously hidden from history, and to demonstrate the diversity of practices within which they had been active. This exhibition, with its broad remit, opened in 1986 at the National Museum of Photography, Film and Television; significantly, a photography organisation (as opposed to an art gallery). It contrasts with the second example, Constance Sullivan's selection, also entitled Women Photographers, which takes an international approach (albeit with some emphasis on North American artists) and more specifically recuperates women as artists in terms of the precepts and principles of modern photography. From the point of view of considering photography and the art gallery in the context of contemporary, postmodern practices, the third example, Shifting Focus, curated by Susan Butler, was of central import for both its focus upon contemporary work made for the gallery and its internationalism. Most significantly, Shifting Focus posited the

Key resources: IRIS International Centre for Women in Photography, www.staffs.ac.uk/ ariadne; Women in Photography International, www.WOMEN IN PHOTOGRAPHY.org

VAL WILLIAMS (1986) Women Photographers: The Other Observers 1900 to the Present, London: Virago (second edition published as The Other Observers: Women Photographers 1900 to the Present). This was researched and curated for the National Museum of Photography, Film and Television in Bradford, Yorkshire as a touring show with accompanying book, although it is the text which has become the classic introduction to the recuperation of a range of types of work by women.

CONSTANCE SULLIVAN (ed.) (1990) Women
Photographers, London:
Virago. This book concentrates on high-quality reproduction of photographs by women

historically, with a view to

reclaiming their work for the canon.

SUSAN BUTLER (1989)
Shifting Focus, Bristol/
London: Arnolfini/Serpentine.
The catalogue comments
internationally on contemporary
work by women.

Also DIANE NEUMAIER (ed.) (1996) **Reframings, New American Feminist Photographies**, Philadelphia: Temple University Press.

24 Examples include John Coplan's imaging of the male body (Tate collection), Paul Reas' exploration of his relationship with his father (included in *Who's Looking at the Family*, Barbican Gallery, London, 1994) and David Lewis' appraisal of the black body within anthropology (*The Impossible Science of Being*, The Photographers' Gallery, 1995).

DAVID A. BAILEY and STUART HALL (eds) (1992) **Ten/8** 2(3), **Critical Decade**.

question: What happens when women look? If, traditionally, women have been the object of the gaze, the viewed rather than the viewer, the represented rather than the author of representation, what happens when she takes a more active role? Butler was concerned to explore ways in which, in exercising the right to look, women alter the terms of visual culture which, as feminist art historians have argued, was premised upon unequal viewing relations.

It is now commonplace for exhibitions to include work by women artists. But perhaps the strength and confidence of women's work is best testified by the shift to more specifically themed exhibitions, for example, self-portraiture, war, the family, lesbian identity. The presence of women photographers in the gallery is now taken for granted. Furthermore, the shift in focus has influenced new themes within the work of male photographers.²⁴

The influence of women's photography within the gallery thus goes beyond simply securing a rightful place for work by women. Feminist theory posed a more fundamental critique of aesthetic conventions and practices. This has led to determined retrieval of the terms of visualisation. As American artist, Barbara Kruger, asserted in one of her renowned photomontages, 'we will not play nature to your culture'. Thus women's photography moved beyond critiques of representation to exploration of relations of looking and questions of identity.

Questions of identity

Poststructuralist thinking opposes the notion that a person is born with a fixed identity. . . . It suggests instead that identities are floating, that meaning is not fixed and universally true at all times for all people, and that the subject is constructed through the unconscious in desire, fantasy and memory.

(Bailey and Hall 1992: 20)

One of the functions of art is to explore and comment upon individual and social worlds of experience. Historically art has been understood as contributing to the myths and discourses which inform ways of making sense of and responding to cultural phenomena. From medieval church frescos to academic history paintings artists have told stories which help us to interpret our world of experience. Stories – such as the religious or the historical – help us to locate ourselves within sociopolitical hierarchies.

Psychoanalytic theory suggests that images, through offering points of identification, offer fantasy resolutions for subjective angst. Identification, in this context, refers to processes whereby the individual subject assimilates an aspect, property or attribute of that which is seen, and is transformed, wholly or partially, after the model which the other – in this instance the image – provides. Personality is constituted through such imaginary identifications. Thus art may be seen as feeding our need for a clear sense of identity and

of cultural belonging. This is a continuous process of apprehension and reassurance, since identity is neither uniform nor fixed, and is constantly subject to challenge and shift. In other words, any sense of self-location acquired through the contemplation of the photographic image is temporary. Indeed, desire for reassurance may be one of the factors propelling us to keep on looking at images.

The emphasis on the body in 1990s gallery art seemed also linked to issues of identity in a changing world wherein communications are increasingly virtual and global. Cyberculture, with its related dislocation of place and location, seemingly enhanced curiosity about actual physical space and presence. For example, Boris Mikaihlov's lifesize pictures of people caught in the effluent of the post-Soviet economy have attracted international attention not only because of their photographic realism but also because of a type of exoticism of degradation. Rineke Djikstra's photographs of bullfighters stained with blood or of naked women who have just given birth, with their babies (Plate 6) tell of real physical exertion in an era of prosthetics. Cindy Sherman's more recent masquerades, perfomances which take the body as a starting point for construction of the image, arguably link to similar concerns.

Identity and the multi-cultural

Issues of identity are of double relevance to people who see themselves as outside of dominant culture, if not marginalised by it. For instance, in Britain, in the early 1980s context of Thatcherism, and inner-city racial tension, key exhibitions and initiatives included *Reflections of the Black Experience* (curator, Monika Baker, Brixton Art Gallery, 1986); as a primarily documentary show, it offered evidence not only of the diversity of black experience in Britain but also of the presence of good black photographers. The Association of Black Photographers, later Autograph, was formed soon after this to promote the work of black photographers across a range of fields. Meanwhile, *D-Max* (curator, **Eddie Chambers**) showed work by British Afro-Caribbean photographers made for the gallery.

Racism, the post-colonial context and the desire to explore ethnic difference, mean that questions of identity figure centrally in black art. Obvious avenues of exploration include the dislocated family, diaspora, internationalism, and media representation of 'the Other'. Exhibitions which explored such themes included *Disrupted Borders*, which connected work from widespread parts of the world – including Finland, India, North America – all of which in some way engaged questions of cultural integration or marginality (Gupta 1993); and *Mirage*, which included work, in a range of media, by black artists from Europe and North America (Bailey, ICA, 1995). A number of British-based photographers became prominent within new Black art practices. These include Ingrid Pollard, whose work posed questions of history and heritage, and David A. Bailey, whose 1987 series on the family album was the subject of the following evocative description:

EDDIE CHAMBERS (1999) 'D-Max: An Introduction' in **Run Through the Jungle**, Annotations 5, London: INIVA

SUNIL GUPTA (ed.) (1993) **Disrupted Borders**, London: Rivers Oram Press Key resources in Britain: Institute of International Visual Arts (INIVA), London, an umbrella organisation coordinating multicultural initiatives; African and Asian Artists Slide Library, University of East London. Against the background of a 'Made in England' clock and a montage of snapshots, a family album is displaced by a Black magazine which in turn is displaced by the screaming headlines of a tabloid newspaper. As the clock ticks on, marking the shifting historical context, the changing assemblages of images address the contradictions between private and public representations of race.

(Gilane Tawadros in Haworth-Booth 1988: 41)

British explorations of post-colonial identity typically interlinked the political and personal. Two themes predominated: first the legacy of colonialism; and second what it is to be British, regardless of ethnic identity, given 'New Europe'.

Post-colonial preoccupations are clearly marked in Black art, but likewise figure within Scottish and Irish art. To take an example: black artist David Lewis pictured the map of Africa as a chessboard for a game played by European players (*D-Max*). Scottish artist Ron O'Donnell depicted a map of Scotland with a noose round the Highlands (*I-D Nationale*, Portfolio Gallery, Edinburgh, 1993). The point is similar. Likewise in North America, Afro-American photographers have been concerned to trace particular heritage(s) exploring visual iconography as well as personal and political histories. For example, Stephen Marc's project, 'Awakened in Buffalo' traces escape routes for slaves seeking freedom by reaching the Northern States or Canada; his related series, 'Soul Searching' which is digitally montaged, acknowledges his African American heritage and identity by including himself somewhere in each picture. The story is told; the aesthetic allows the particular personal resonance to be incorporated.

In North America, the end of the twentieth century also witnessed developing interest in Latin American photography. This partially reflects increasing Hispanic population and influences, especially in the southern states of the USA. But the interest in what the *New York Times*, in reviewing *Image and Memory* by **Watriss and Zamora**, described as 'vast national subconscious made visible and waiting to be fathomed', begs more complex explanation. Arguably it also reflects neo-colonial concerns with identity; Latin America geographically is both the closest threat to the USA's political supremacy and also offers the nearest exotic from the point of view of commerce, travel and fascination with other cultures. Research, exhibition and publishing of historical and contemporary photography from Central and South America feeds this fascination in the US.

WENDY WATRISS and LOIS ZAMORA (eds) (1998) Image and Memory: Photographs from Latin America 1866–1994, Austin: University of Texas Press.

Drawing from the more than 1,000 images exhibited at Houston's FotoFest in 1992, this book documents the work of 50 photographers from 10 countries. The photographs range from the opening of the Brazilian frontier in the 1880s to documentary images from El Salvador's recent civil war to works of specifically aesthetic and experimental nature.

PHOTOGRAPHY WITHIN THE INSTITUTION

Questions of national identity are not only reflected in art practices but also in the centrality of the gallery and museum within many nations and cultures. This is particularly marked in what has come to be referred to as 'heritage industries'. Funding for arts, both for the contemporary gallery and for heritage institutions such as museums, in most nations is a mixed economy drawing upon private, commercial and public resources - in some cases, including regional or national lottery funding as well as state subsidy.²⁵ (Even in major national institutions exhibition organisers often rely on private or commercial sponsorship as well as revenue from admission tickets and sales such as postcards and catalogues.) In Britain the 1970s and 1980s were characterised not only by the extension of provision for photography collections and exhibitions, but also by an increase in major institutions located away from London.²⁶ By the mid-1980s there were over 2,000 museums and galleries in the United Kingdom, with new ones opening at the rate of one a fortnight. Discussing The Heritage Industry, Robert Hewison argued that 'in the twentieth century museums have taken over the function once exercised by church and ruler, they provide the symbols through which a nation and a culture understands itself' (Hewison 1987: 84). Museums have become key patrons of art, influencing priorities and pricing within the art market. Given the monumental dimensions of some new centres, for instance, the Pompidou Centre, Paris, or the Tate Modern in London, not to mention MOMA, New York, or San Francisco Museum of Modern Art, galleries also influence the conceptual scale of imagery. The photograph has been used extensively within the expanding museum to both document and celebrate the history. It has also been implicated in critiquing this 'heritage industry' (Taylor 1994: 240ff.).

Appraising the contemporary

Any attempt to overview recent photo-based art is fraught with difficulty, not only because of diversity of form and subject-matter but also because of the lack of the benefit of hindsight. In addition, previous distinctions between photography galleries, and galleries which include photographically produced work within their collection seem increasingly unclear as all galleries now host photography, photo-video and digital installation. Remaining photography galleries may have a narrower remit in terms of focus upon the particular medium (whether chemically or digitally based), but a much broader cultural remit in, potentially, displaying and interrogating all aspects of photography as visual communication, historically and now. Outside the mainstream, in community arts, the emphasis has been not so much on exhibition or publication but on the darkroom as workshop and on ways in which photographic seeing can contribute to self-esteem and the fostering of social and political perceptions. Schools-based initiatives and community workshops offered innovative collaborations (among the best known was the Cockpit in London in the 1980s). Projects often took the form of workshops for teachers or community workers, who then take back ideas to their schools or local areas. Some of these projects owed their roots to high profile initiatives such as international festivals whose organisers were concerned not to overlook the locality in which they are based.

25 Funding arrangements and the relative balance of the various sources of income differ according to national fiscal and cultural policies. It is not possible to offer a full overview here.

26 Other developments in Britain included the opening of the Photographers' Gallery in London, 1971, and of Impressions Gallery, York, in 1972. Stills Gallery, Edinburgh, was set up in 1977, and the Association of Welsh Photographers, later Ffotogallery, Cardiff, in 1978. Plans to establish the National Museum of Photography, Film and Television (NMPFT) in Bradford, as a branch of the Science Museum. were announced in 1980. Also in 1980 the Royal Photographic Society (RPS) moved its library and archive from London to Bath; later to NHPG. Bradford. The Scottish Photography Archive, part of the National Galleries of Scotland, was established in 1984 and, by 1995, included over 20,000 photographs. In 1998 the V&A opened the Canon Photography Gallery dedicated to exhibitions of the art of photography.

27 In viewing exhibitions, you should take into account particular relations set up between the work of different photographers and consider how this contributes to interpretation. One obvious question: What work is hung at the entrance point? Does this indicate a central theme or preoccupation?

BRETT ROGERS (ed.) (1994)
Documentary Dilemmas:
Aspects of British
Documentary Photography
1983–1993, London: British
Council. This exhibition was
curated for an international
tour, and included work by John
Davies, Anna Fox, Julian
Germain, Paul Graham, Anthony
Haughey, Chris Killip, John
Kippin, Karen Knorr, Martin Parr,
Ingrid Pollard, Paul Reas, Paul
Seawright and Jem Southam

Three Perspectives on Photography, London: Arts Council, 1979; Shocks to the System, London: The South Photography, then, is situated both within the gallery system and beyond it. Likewise, publishing and marketing of photography books and magazines may be in association with gallery initiatives, or may be part of a more mainstream concern with media arts and media education on the part of publishers. It follows from this ubiquity that the task of researching and mapping contemporary developments in photo-based art is daunting. Furthermore, critical evaluation of contemporary exhibition practices is limited by the fact that it is not possible to visit and view all shows, and catalogues often say little about the impact of how each show was hung within particular gallery spaces.²⁷

Indeed, as Mary Kelly has argued, that there is a sense in which the gallery itself, although of central symbolic significance, is less important in the history of artistic production than catalogues, books, reviews, and other accompanying, more permanent, forms of reproduction of work (Kelly 1981). Exhibitions are ephemeral. It is published reviews, catalogues or books, rather than the shows themselves, which reach the wider audience. Thus, in order to consider changing thematic or aesthetic concerns in recent years, we need to seek out books, press and journal reviews, exhibition catalogues and websites.

Furthermore, curators may be caught up in the fashionable, so an overview of exhibitions does not necessarily tell everything about contemporary developments – although it might say quite a lot about the politics of the gallery. For instance, as **Brett Rogers** suggested in her introduction to *Documentary Dilemmas*,

Ignored by the art world which favours big pictures and high prices, and outstripped by technology that gives the edge to television and digital developments, documentary photography has also come under harsh scrutiny from post-modern critics, who question its tendency to separate and exploit certain groups of people, serving up the poor as exotic fare for voyeuristic consumers.

(Rogers 1994: 5)

She went on to suggest that this has led to the ignoring of new rhetorical strategies in use within documentary, including fill-in flash, colour, scale, captioning, sequencing, and the use of text within the image. Trends within curatorship, criticism and, indeed, the international Art market, marginalise some areas of practice. Any attempt to define trends and developments should acknowledge this.

That noted, comparison of particular exhibitions may be indicative. For instance, in 1979 The Arts Council of England and Wales mounted *Three Perspectives on Photography*, a show of recent British photography, at the Hayward Gallery, on London's South Bank. This exhibition makes an interesting contrast to the 1991 Arts Council show, *Shocks to the System. Three*

Perspectives on Photography was organised as three different groups of work, each separately curated, thus acknowledging diversity of approaches. In so doing it appeared radical at the time. Section One, on 'Photographic Truth, Metaphor, and Individual Expression' included series of photographs – each captioned - by six (male) photographers. Stylistically the images reflected a modernist emphasis on photographic seeing. But Paul Hill, in his introduction to the section, stressed the expressive and metaphoric dimensions of the photograph, opposing any simple equation of believability with truth. Indeed, suggesting that the photograph should be understood as a symbol for that which is depicted, he drew attention to what would now be termed the semiotics of the image. Of even more significance retrospectively are the two following sections: 'Feminism and Photography' and 'A Socialist Perspective on Photographic Practice'. Neither of these topics would figure in so blunt a way by the 1990s. Feminist perspectives, on the whole, have been taken on board, some might say diluted through incorporation. By contrast, socialism had been marginalised, and would be a distinctly unfashionable exhibition title! By 1991, a decade later, nothing so succinct as three perspectives could be claimed. The imagery included in Shocks to the System was largely made during, and influenced by, the Thatcher decade. Here it was not Left art which was emphasised so much as a range of different visual methods of drawing attention to subjective and political issues and complexities, often employing humour or parody. The show was multicultural, and reflected the diversity which by then obtained in gallery photographic practices.

Curators and collectors

Major museums not only maintain archives but also purchase contemporary work, thereby, in effect, supporting photographers. Curators may commission new work for particular shows as a part of their responsibility for conceiving and organising photography exhibitions which tour nationally and internationally - and, increasingly, feature as websites as well as physical entities. Museums and galleries exhibitions are 'hired' by other galleries; it is not uncommon for shows to be 'on the road' for two years. Normally they are curated by one or more people, whose role includes researching the exhibition concept, the selection (or commissioning) of work, planning how the work will be hung within the exhibition space, and writing a significant part of any accompanying book or catalogue. The power of the curator, operating regionally, nationally or, increasingly, internationally, has come into question in recent years. Of course curators take initiatives which contribute to the exposure of work. But they may also regularly favour certain artists, or types of work, at the expense of others. Furthermore, it has been suggested that curators often act more as 'creators', putting together theme exhibitions which, however relevant and interesting, serve as much to advance themselves as to showcase the work of artists.

Bank Centre, 1991. The latter catalogue includes 37 photographers represented by one photograph, and a minibiography. Two further shows -About 70 Photographs, ed. CHRIS STEELE-PERKINS, curated from the Arts Council collection in 1980, and GERRY BADGER and JOHN BENTON-HARRIS, Through the Looking Glass, London: Barbican Art Gallery, 1989 - also demonstrate something of the diversity of practices within mainstream gallery photography in the 1980s. Both include straight photography alongside more conceptual works.

28 For example, in 1995, prior to auction, a collection of paintings and photographs by Man Ray was exhibited at the Serpentine, one of London's higher profile public galleries for contemporary art.

SANDY NAIRNE (1987) 'Value, Commodity and Criticism' in State of the Art, Ideas and Images in the 1980s, London: Chatto & Windus The archive, the critic and the curator interact with the international market for both contemporary and historic photographic work. International auction houses, such as Christie's or Sotheby's, note the influence of exhibitions (and events, such as the death of an artist) on auction prices. Considering places in which the validation and valuation of art occurs, **Sandy Nairne** noted the key influence of the private gallery, the private collector, the public museum and the art magazine (Nairne 1987).

Commercial art dealers scrutinise trends in order to maintain their position in a competitive market. In Britain, the market for both old and contemporary photography is a relatively new phenomenon; a response, perhaps, to both the renewal of interest in the photograph in the 1970s and 1980s and the increasing emphasis upon private commercial practices which characterised 1980s Thatcherism. But 'collection' as a commitment on the part of particular individuals or businesses is not new. Indeed, royal patronage for artists, since the Renaissance, has taken precisely this form. The key purchasers may now be media stars and entrepreneurs rather than European aristocracts, but patronage through payment for ownership of the art object persists. As Walter Benjamin suggested in 1931, 'The most profound enchantment for the collector is the locking of individual items within a magic circle in which they are fixed as the final thrill, the thrill of acquisition, passes over them' (Benjamin 1931b: 62).

Internationalism: festivals and publishing

The 1980s witnessed a burgeoning of international photography festivals. The first such international festival was established as an annual meeting place and showcase for photography at Arles, France, in 1970. Others, such as Houston (biennial since 1986) and Rotterdam (more or less biennial since 1988), have been loosely based upon the same model involving some thematic focus, a number of lectures and events, opportunities for lessexperienced or less-established photographers to show their portfolio to known photographers, critics and curators and, in certain instances, some form of schools- and community-based spin-off. Another major European festival is the biennial Paris Mois de la Photo which, since 1980, has taken place throughout the city. Fotofeis, the biennial Scottish International Festival of Photography, ran from 1993 to 1997. England has no regular, large-scale international festival, although there have been a number of one-off themed festivals; for instance, the 1994 Signals Festival of Women's Photography and the Photo '98 Year of Photography and the Digital Image. Contemporary Photography Fairs, commercial enterprises, increasingly feature as do photography auctions. Photographic work has also increasingly featured in major international arts event such as Venice Biennole or Documenta, Germany.

The purpose of festivals is to offer a focus, meeting place and showcase for work. As such they contribute to raising the profile of photography nationally and internationally. Along with gallery exhibitions, photography magazines and books, they profile trends and the work of particular photographers. But festivals require attendance and participation. This contrasts with photography publishing which, in principle, can attain widespread distribution through bookshops (although few bookshops stock much other than a few more popular titles by 'household name' photographers). It is photography journals and magazines (and contemporary art journals and websites) which trace debates and developments, and shape history, through featuring the work of particular photographers, discussing contemporary issues, and reviewing shows and books (see list, pp. 348–9).

The gallery as context

Galleries are particular sorts of meeting places, often including coffee bars and/or bookshops. Arguably, the gallery network not only offers visual pleasures but also operates to reassure a certain sense of intellectual and cultural elitism. Part of the pleasure of looking at pictures lies in discussing images, in sharing responses. This assumes and reaffirms biographical and cultural similarities in terms of class, gender, ethnicity, education and interest or involvement in the Arts. Sociologist Terry Lovell has suggested that 'the discerning of aesthetic form itself must be seen as a major source of pleasure in the text – the identification of the "rules of the game", and pleasure in seeing them obeyed, varied and even flouted' (Lovell 1980: 95). Galleries have specific profiles in relation to this, sometimes operating overtly as a site of political engagement. For instance, organisations such as Camerawork in East London and Side Gallery, Newcastle, UK, both of which were prominent in the 1980s, were founded in socialist commitment.

Indeed photography has been used in a range of contexts to challenge dominant aesthetics, usually with some commitment to political empowerment. Central to the politics of representation is the question of whose experience is validated. As we have seen, this motivated the work of many contemporary women and black artists particularly in the 1980s and early 1990s. The political role and significance of the contemporary gallery is complex. There is a sense in which curator, critic, audience and artist are all complicit in perpetuating an exclusive system which functions hegemonically in ways which seem relatively detached from economic imperatives. On the other hand, the private collector, and the public museum and gallery, along with commercial sponsorship and public subsidy, exercise a significant degree of economic influence on developments within the arts.²⁹

29 See for instance Stuart Alexander, 'Photographic Institutions and Practices' in Michel Frizot (1998) A New History of Photography, Cologne: Könemann.

CASE STUDY: LANDSCAPE AS GENRE

I make landscapes, or cityscapes as the case may be, to study the process of settlement as well as to work out for myself what the kind of picture (or photograph) we call 'landscape' is. This permits me also to recognize the other kinds of picture with which it has necessary connections, or the other genres that a landscape might conceal within itself.

(Jeff Wall, 1995)

In ending this chapter with a brief historical overview of one genre of practice, we not only trace historical developments but also draw attention to ways in which clusters of themes and concerns, none of which are exclusive to any specific genre, come together to characterise a particular genre.

Genre

Developed within film studies to reference clusters of movies of a similar sort (such as the Western, melodrama, film noir), the term 'genre' refers to types of cultural product. But genre is not simply a classification. Genres carry with them specific sets of histories, practices, ideological assumptions and expectations, which shift over time to take account of changing cultural formations. We have chosen the example of landscape, but the principal point about change and continuity can be examined in relation to any chosen genre.

Landscape as genre

There is a key distinction between 'land' and 'landscape'. In principle, land is a natural phenomenon, although most land, especially in Europe, has been subjected to extensive human intervention (creating fields, planting crops, shoring up the coastline, and so on). 'Landscape' is a cultural construct. It dates from seventeenth-century Dutch painterly practices, but became central to English painting and also became a method for artists and topographical draughtsmen to explore territories elsewhere. The eighteenth-century English landscape painting did not simply echo the Dutch, but re-articulated the genre to incorporate the increasing emphasis on technological achievement (Bright 1990) – a clear example of accommodation to particular cultural circumstances!

Landscape can be defined as vistas which encompass both nature and the changes which humans have effected in the natural. Broadly interpreted, this includes sea, fields, rivers, gardens, buildings, canals, and so on. It thus encompasses emblems of property ownership (such as fences), or of industrialisation (such as mines or factories). Typically, English landscape pictures rarely depict work or, if they do so, romanticise the rural labourer. For the aristocracy, landed gentry and nineteenth-century industrialist, land ownership symbolised hereditary status or entrepreneurial success. As John Berger has argued, landscape paintings operated to reassure this status (Berger 1972a).

Jeff Wall's landscapes (Plate 11) are staged images, usually shown as large lightboxes, which reflect upon landscape as a genre within fine art. His digitally assembled pictures are meticulously staged in accordance with standard conventions of perspective and the 'golden rule' (strictly applied this refers to the one-third/two-thirds horizontal division of the canvas between sky and land/water, designed to induce a sense of harmony). Often they reference traditional landscape imagery, for instance, the woodcuts of Japanese artist, Hokusai. But Wall's images always include the unexpected; in A Sudden Gust of Wind it is the uncontrollable effect of the wind as papers are thrown into the air. The gesture interrupts the serenity otherwise implied.

Landscape photography

In considering landscape as an example of a genre within photography, we are concerned first to identify typical aesthetic and sociopolitical characteristics of landscape imagery; and second to explore ways in which the genre has accommodated change, reinvented and reinvigorated itself over time. Landscape photography has largely inherited the compositional conventions of landscape painting. Typically, landscape photographs are a lateral rectangle – it is no accident that 'landscape format' has come to describe photographs where the width is greater than the height. Compositionally, the 'golden rule' of one-third/two-third horizontal proportions is usually obeyed, as are the rules of perspective.³⁰

Landscape photography is founded as much in the documentary endeavours of travelling photographers, at home and abroad, as in the gallery. Thus there are two key lines of inheritance within the genre: on the one hand, straight photographs, topographical in intent, on the whole echoing the composition of the classic landscape painting, and, on the other hand, more pictorial images constructed in accordance with a preconceived idea, be it poetic, mythological or critical import. As with all genres, landscape also reflects new aesthetic ideas; for instance, Surrealist dreamlike states (Figure 6.8, p. 27) or the Constructivist compositional radicalism based on the ideal of a new angle of vision (Figure 6.6, p. 266).

Historical development and change

By the nineteenth century, 'landscape' also stood as an antidote for the visual and social consequences of industrialisation, offering a view of nature as therapeutic, a pastoral release from commerce and industry. Art movements such as Romanticism and Pictorialism reflected such changing attitudes: ignoring ways in which the industrial actually impacted on the visual environment. Romanticism in painting reified the rural idyll, albeit emphasising the spiritual and the metaphysical. This reification is reflected in photographs of the time, for instance, early mountainscapes. On a less **sublime** scale, pastoral imagery such as Camille Silvy's *River Scene, France* (Figure 6.2, p. 255) made from two separate exposures and using people as models, offers a carefully staged myth about the calm, leisure and pleasure of the countryside. There are several

30 As with all genres, there are exceptions. Aside from constructivist experiments, exceptions might include more metaphoric imagery, dealing, for instance, in landscape and memory, or pictures shot close-up which draw upon the conventions of still life as well as landscape.

31 In idealist philosophy, dating from Plato, emphasis is on measured behaviour, on civilisation as an imposition of order. The term 'measure' is useful here as it implies caution or restraint, whilst also implying mathematical principles. In classical, i.e. Renaissance art, this is expressed through the principles of composition, perspective, and proportion (including relations between the vertical and the horizontal).

examples of seascapes, for instance, by Gustave le Grey (also French) wherein combination printing has, similarly, been used to effect pleasing scenes; for instance, clouds above serene waters. Both invite the viewer to reflect upon the rural or seascape and both reflect idealist notions of harmony.³¹

As we have seen, such stagings are taken further in Pictorialism, within which people were frequently depicted in close relation to what was perceived as 'natural' environment, with no stated documentary or topographic location. Thus, for instance, *The Lady of Shalott* is re-presented by Henry Peach Robinson as a picturesque tale (Figure 6.3, p. 257). Here landscape becomes the background against which a story is staged.

Unlike most of Europe, the American West is characterised by vast open spaces. Nineteenth-century pioneers, such as Carleton Watkins, whose work is now central to the photography archive, were employed to chart land prior to its opening up by, in this case, the laying of the Pacific Railroad. Mary Warner Marien notes the differing cultural contexts within which European and American landscape photography developed:

Where English and European amateurs might craft an antimodern, picturesque photograph that lamented the decline of an agriculturally based society, Watkins synthesized a soaring sublime based on wilderness. . . . The viewer of his photographs is often flung out over and above dizzying, deep chasms. The immediate sensation is one of transcendence and invincibility, a feeling profoundly different from the quiet reflection and nostalgic passivity evoked by much European amateur landscape photography. Indeed, a sense of the sublime, vested in natural wonders like Niagara Falls and Yosemite but transferable to human works like the railroad, is characteristic of nineteenth-century American cultural life.

(Warner Marien 1997: 95-6)

New aesthetics

Modern landscape photography has been particularly associated with American photographers, including Ansel Adams, Imogen Cunningham, Minor White and Edward Weston, who subscribed to the notion of pure photographic seeing. Modern photographers stressed the aesthetic and spiritual dimensions of landscape, producing elegant and elegiac abstract imagery. Edward Weston's images, in which the sharpness of the realisation of the photograph is tempered with the rhythm of form, offer prototypical examples (Figure 6.7, p. 268).

Genres typically are characterised by continuity through change, by an ability to re-form in order to incorporate new aesthetics and circumstances. Landscape is no exception. Now fences, the railway, brick walls, motorways, pylons, signs and hoardings have all, variously, become rendered as a part of traditional imagery and myth. Of course, 'translations' are involved: landscape photographs are often monochrome, the countryside represented in terms of shape and tonal gradings. The fundamental point is that the photograph re-inflects subject-

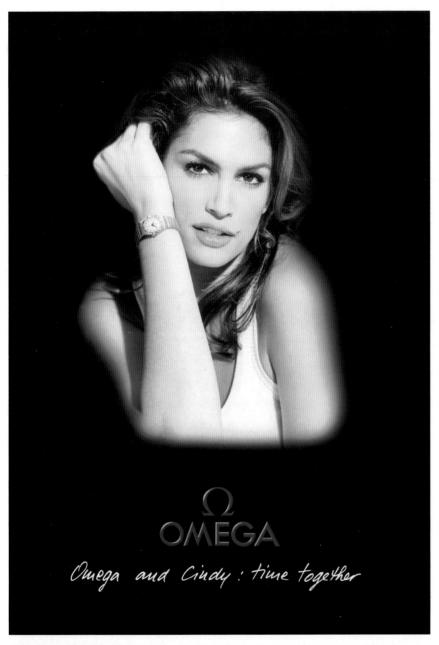

Plate 8 Advertisement for Omega watches, 'Omega and Cindy, time together', 1999. Courtesey of Omega SA, Zurich

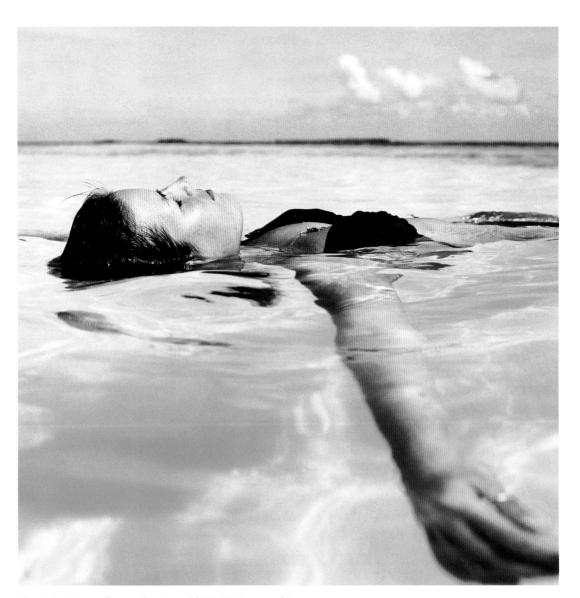

Plate 9 Stock image of woman floating, no. bf0378-001. Courtesy of Getty Images

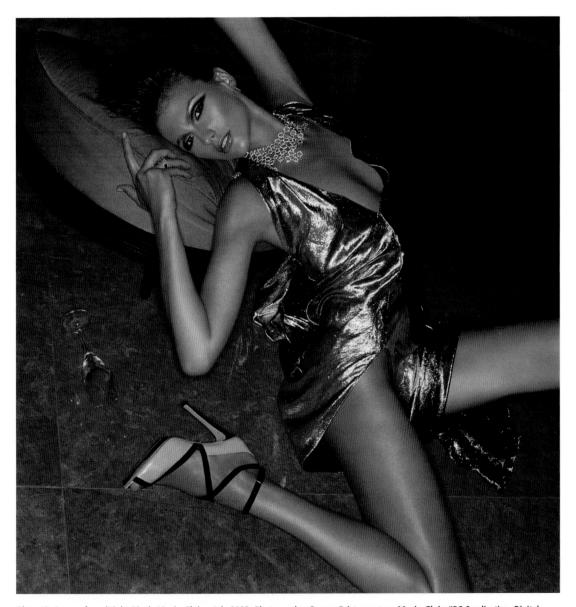

Plate 10 A page from 'Night Diva', Marie Claire, July 2003. Photographer Darren Feist, courtesy Marie Claire/IPC Syndication. Digital manipulation is used to heighten the image of women's sexual availability

Plate 11 Jeff Wall, A Sudden Gust of Wind (After Hokusai), 1993 transparency in lightbox 90 x 148.5 in.

Courtesy of the artist and Tate Publishing © Tate, London 2003

Plate 12 Ingrid Pollard, from Pastoral Interludes, 1987, hand-tinted gelatin silver print, 20 x 24 in. Courtesy of the artist

Plate 13 Marte Aas, from the series Common Green, no. 7, 1999, original size 39.4 x 59.1 in. C print on aluminium. Courtesy of the artist

Plate 14 Susan Derges, 'Larch', from *The Streens*, 2002, 58 x 24 in. Courtesy of the artist

matter in terms which reflect current cultural currencies. In this sense, the modernist landscape, with its emphasis on aesthetics, was one moment in the regeneration of the genre. The focus upon more obviously intrusive cultural elements, or industrial legacies, for instance, in the work of British photographers, Ray Moore or John Davies, offers another.³²

The modern and the postmodern

Analysis of aesthetic and ideological change involves engagement with broad socioeconomic and political circumstances as well as with aesthetics. But genre analysis is always best pursued through comparison of specific examples. For instance, in this chapter there are two compositionally somewhat similar squareformat photographs, by Bill **Brandt** (Figure 6.5, p. 261) and Karen Knorr (Figure 6.1, p. 246). Both use photographic techniques and conventions to effect a sense of harmony. Yet they are different in import. Brandt's image is a documentary statement, the location is given. Knorr's, through the presence of the man and the book, and the caption, offers a conceptual comment upon English culture, one which provokes critical interpretation. The difference between the modern aesthetic, and the postmodern critique, is marked.

Landscape and heritage

A number of contemporary photographers, in Britain including Keith Arnatt, John Davies, John Kippin, Ingrid Pollard and Jem Southam, engage in critical terms with notions of landscape, commenting, for example, on the legacy of industrialisation whether it be rural industry such as tin-mining (Southam) or the Northern industrial landscape (Davies), or on the implicit racialisation of pastoral imagery (Pollard). Fay Godwin's work on land, access and property rights offers a further significant example. Landscape imagery reflects and reinforces particular ideas about class, gender, race and heritage in relation to property rights, accumulation and control (see Taylor 1994; Wells 1994). Several contemporary photographers have made it their business to question this. The contrast between this type of contemporary emphasis and the nineteenth-century idyllic image is obvious from a comparison of the work of Pollard (Plate 12), with Silvy or Peach Robinson.

Such concerns are culturally specific in a range of respects. For instance, Norwegian landscape photography tends to dramatise the mountains and fjords of the north. Nineteenth and early twentieth-century Norwegian landscape painting and photography is clearly influenced by the Kantian sublime (best typified by German painter Casper David Friedrich). The Norwegian mountain became a national icon – especially prominent at the turn of the twentieth century when Norway was seeking independence from Swedish rule. In effect the mountain for Norwegians became an equivalent to the Wordsworth country of the Lake District for Englishness. Thus when contemporary Norwegian photographers focus upon a more ordinary, everyday landscape such as lands used for recreation close to urban and suburban spaces, there is an implicit

32 Work by most of the photographers mentioned in this section can be found in monographs published under their name, or in exhibition catalogues published variously.

The Land: 20th Century Landscape Photographs, also by Bill Brandt, was exhibited at the Victoria and Albert Museum in 1975. cyanotype (blueprint), ferric ammonium citrate and potassium ferricyanide are applied to a surface and dried. An object or negative is placed on the treated surface, then

exposed to the sun.

33 It has not been possible to include full publication references for all the artists named in this chapter. Most university library catalogues offer search facilities by keyword, in this instance, the name of the artist. Many dealers, galleries and museums have websites offering information on artists and their work, sometimes including book and magazine references.

questioning of myths of Norwegianess (Plate 13). The iconic is culturally specific; it follows that art which challenges established attitudes to some extent relies upon audience familiarity with particular national themes and aesthetic histories.

Many artists working with land and landscape are less concerned with the overtly sociopolitical, working in terms which echo earlier formalist preoccupations but which may also reflect current ecological curiosities and concerns. Within a few years of the foundation of photography in the nineteenth century, Anna Atkins was using the **cyanotype** process to make detailed images of flora and fauna. Artists continue to use photograms and other contact printing methods to register nature. For example, using natural and artificial light, Susan Derges places sensitised paper below the surface of water to register the effects of reflection of plants and trees and the movement of, for instance, grains of earth or sand in rivers or waves breaking on the seashore (Plate 14). Others have critically explored issues of perception, subjectivity and the gaze, employing a range of tactics to dis-locate our sense of ourselves in relation to space depicted.³³

Thus genres are defined not by uniformity, but by clusters of characteristic themes, formal and aesthetic concerns, and ideological preoccupations. They are revitalised through aesthetic experimentation and through new issues, often typifying attitudes and discourses characteristic of particular eras. As can be seen from the various examples of landscape included in this chapter, a range of factors and questions are in play when discussing specific fields of practice. It is productive to analyse genres in terms both of specific historical traditions within visual culture and of contemporary issues and aesthetics.

CHAPTER 7

Photography in the age of electronic imaging

MARTIN LISTER

297 Introduction

Box A: Digital encoding

Box B: Digital simulation

Box C: Digitising photographs: the initial implications

Box D: Analogue and digital

304 A 'post-photographic' era?

A new way of seeing and the end of the 'Cartesian dream'?

308 Walter Benjamin and the precedent of the age of mechanical reproduction

The end of photography as we know it? Digitisation and the commodification of images Post-photography, postmodernity and language

317 Technological change and cultural continuity

Photography's promiscuity: its historical interface with other technologies, sign systems and images Case study: War and surveillance Case study: Popular entertainment

327 Photodigital: taking stock

Remembering photography's nature Our belief in photography's realism The force of the indexical image The reception of digital images Does digital photography exist? Photo-realism versus post-human vision

7.1 David Bate, Six Simulations of Liberty, 2003

Photography in the age of electronic imaging

INTRODUCTION

Since the first edition of this book was published in 1997, digital image technology has been ever more widely assimilated into photographic practice and many other areas of art, design and media. Recent critical thought reflects a much more complex interplay between photography and digital image technologies (or even 'post-photography') than was envisaged in most of the earlier attempts (between the late 1980s and the mid-1990s) to gauge and understand what the digital meant for the photographic. Nevertheless, there is a rich history of debate in this earlier work, and it gave rise to some challenging and still influential ideas, not least those of a new 'post-photographic' era, the 'end' of photography as we have known it, of an 'image revolution' of profound historical importance, and a crisis for photographic truth. In some ways, debates about these ideas continue. There will be readers for whom these are met for the first time, and others who are unaware of their history. Hence, this chapter, in this third edition of the book, retains some of the material which dealt with these ideas in previous editions. This is to be found in the sections entitled A 'post-photographic' era? and Technological change and cultural continuity. A number of the boxed sections which explain issues such as digital encoding, simulation, the manner in which the implications of digitisation for photography were initially conceived, and the 'analogue and digital' have also been retained. However, there is a new Introduction and a lengthy new section, Photodigital: taking stock. This updates the chapter by discussing the new, and more nuanced, directions in which thinking about photography's relationship to the now older 'new' image technologies has taken. As always, however, the sense of more recent thinking depends to some degree upon knowing what it is taking issue with. This is a further reason for retaining some of the history of critical responses and efforts have been made to cross-reference new and old material, sometimes in the text itself and by use of the margin notes.

Two decades have passed since it became technologically possible to produce images which have the appearance of traditional chemical photographs by digital means. Two fundamental technological developments were involved. First, the digitisation of existing analogue photographs by scanners and the registering of images with a digital camera. In either case, an image that was made with an optical lens comes to exist as an electronic file instead of, or as well as, a material, analogue artefact. (See Box A: Digital encoding.) Second, the ability to produce photo-realistic images and simulate photographs using 3-D computer graphics systems. (See Box B: Digital simulation.)

The technology made possible:

- (i) The transfer of traditional photographs from their basis in a material surface etched by light and chemicals to a set of numerical values, stored as a set of electronic impulses. The traditional photographic image was fixed – its digital version was mutable.
- (ii) The registration of the information received through an optical lens directly as a set of numerical values.
- (iii) The production of images that looked like photographs generated from data and knowledge – where no human eye, looking through a viewfinder, had directed a lens at an actual object in the physical world, opened a shutter and traced its image.
- (iv) The circulation of such images of all kinds, ancient, archived or contemporary photographs, as electronic data packages through telecommunications systems.

[For a more detailed list see Box C: Digitising photographs: the initial implications.]

Over the period, 'digital imaging' has developed into a major industry, and has become a taken for granted part of the media landscape. For many photographers, digital technologies and processes are now an essential part of their post-production practices, and have blurred the edges between older specialisms, especially between photography, typographic and graphic design, editorial work, and still and moving image production. For others, digital technologies have all but replaced **analogue** technologies: optical lenses are replaced by digital and virtual cameras, films by discs, 'wet' physical darkrooms and optical enlargers by computers and software. At a consumer level, digital cameras, memory cards, scanners, writable CDs and associated software have largely replaced the mechanical camera and film on the shelves of high street photographic retailers. Even the snapshots once pasted into the

BOX A DIGITAL ENCODING

The encoding of the 'message without a code' (Barthes 1977b: 36) – the conversion of original analogue photographs to digital images.

Digital technology facilitates the introduction of a matrix of tiny manipulable elements at the physical base of the photographic image. This amounts to an 'infection' of the stable analogue photographic image by an intrinsically fluid and malleable digital code.

The material basis of the chemical photograph, the photographic emulsion, is a granular structure of silver halides dissolved in gelatin and spread onto a plastic or acetate base. This emulsion holds the nearest thing there is to a photographic 'mark': the tiny light-sensitive grains of silver, the constituent bits out of which an image is configured. This material basis of the photograph has long been industrially produced. It is put in place by workers in the factories of Kodak, Ilford, Fuji or Agfa. The individual photographer has never had access to this level of signification, except to control the degrees of contrast which various intensities of light reflected from an object in the real world bring about within this granular field. It is this sense, that something pre-exists the photographer's intervention in the forming of an image, that underpins our belief in the chemical photograph's special claim to veracity.

The computer with its immaterial field of binary switches has unlocked this inaccessible level of signification. Chemical grain can be scanned by a set of linked Charge Coupled Devices to become digital pixel. Digital pixel can also be made to mimic chemical grain. In short, a code has been imported into, has translated and reconfigured, the granular field of the chemical photograph. With this code in place the photographic image (now strictly speaking the 'photographic' image) becomes manipulable to a fine degree.

0 1 2 3 4 5 6 7 8 9 10 11

i	1	1	1	10	11	1	1	1	1	1	1	1	1	1	1	1	1	9	8
ï	1	1	1	10	11	1	1						1				2	8	9
ï	1	1	1	10	11	1	1								1	1	4	8	10
ï	1			10											1	1	4	8	10
ï	1	1	1	10	11	1	1	1	1	1	1	(4)	1	1	1	1	5	8	10
ï	1	1	1	10	11	1	1	1	1	1	1	1		1	1	1	5	8	8
ï	0	0	0	10			0	0	0	0	0	1	1	0	0	0		8	
0	2	2	2	10	11	2	3	3	4	4	5	5	7	7	7	7	6	8	8
3	5	9	8	10	11	7	7	7	7	8	8	8	7	6	6	6	6	8	8
1	9	9	6	10	11	7	7	8	8	8	8	8	6	5	5	5	6	8	8
0	9	9	6	10	11	7	8	8	8	8	8	8	3	5	6	4	6	8	8
ō	7	6	6	10	11	6	7	7	8	6	6	6	4	3	2	2	5	8	8
4	3	8	7	10	11	5	4	3	2	2	2	2	2	2	2	4	8	8	8
6	4	12	2	10	11	2	2	2	2	2	3	2	2	2	7	9	8	8	8
2	2	2	2	10	11	2	2	2	2	2	2	12	5	7	9	9	7	8	8
è	2	2	2	10	11	2	2	12	2	4	2	8	9	9	10	9	8	7	8
2	2	2	2	10	11	12	2	2	2	2	5	7	9	10	11	9	10	9	1
2	2	2	2	10	81	12	2	12	2	12	7	9	9	9	18	11	10	9	7
2	2	5	7	9.2	8	2	12	2	12	7	9	9	9	10	11	11	11	10	1
	9	17	5	2	13	2	12	12	2	8	9	9	10	11	11	11	11	11	10

7.2 A three-stage illustration of the principle of digitising a photograph

The tones or colours of the chemical photograph which are represented by a seamless and random grain are divided into a grid of small picture elements (pixels). Each area of the grid is then assigned a number which corresponds to the brightness of a grey scale or to the three primary colours. Changes in resolution, definition and contrast can be achieved by changing the value of these pixels, and even the configuration of the image can be invisibly altered by removing or adding pixels

BOX B DIGITAL SIMULATION

The simulation of photographs: the production of images which have the appearance of a chemical photograph but which are constructed from information which is processed within the computer.

This use of computers represented a dramatic assault on the notion of photographic causality: the sense that photographs are caused by the objects and the lights that make those objects visible. This is the manner in which digital technology is being used to generate images, which have a photographic appearance, from pure data. The images which are constructed in this way have no traditional photographic referent. Such a 'photograph' may be based on knowledge of, but not caused by, the action of light reflected by a particular object. But what it does refer to is other photographs. In fact the whole motivation in the generation of many such images is that they carry the authority and information of a photographic image (and in the way that a photograph carries such information). Given this aim, the continuity of photographic codes between chemical and digital photographic production is strong.

Such 'object-based' systems work by using the computer to define the geometry of an object and then to render its surfaces by the application of algorithms which simulate the object's constructed surface according to information about viewpoint, location, illumination, reflection, etc. This ability of the computer to construct objects in space is in direct line with the perspectival geometry of the Western pictorial tradition. This has its roots in the work of fifteenth-century painter mathematicians and art theorists of the early Italian Renaissance, such as Leon Battista Alberti, Piero della Francesca and Paolo Ucello.

In this sense, the computer's simulation of photographic images shares much with the constructed perspectival views of early Renaissance painters. They both construct views of the physical world which are centred on the eye of a spectator in a given position, and they do so by organising information about objects, spaces, and the behaviour of light which is the result of observation, data and its rigorous conceptual systematisation.

traditional family photo-album are now often stored electronically and displayed on the TV or PC screen. In film production, synthetic, computer-generated images are now seamlessly integrated with traditional cinematographic footage. However, images that have their source in a camera lens pointed at objects and events in the world and with a destination in the ink on a printed page are clearly as numerous and culturally important as ever. It is the processes that intervene between these two points that are digital, electronic and interactive, and frequently involve telecommunications networks for exchanging work in progress and as a means of distributing and exhibiting images.

WILLIAM J. MITCHELL (1992)
The Reconfigured Eye:
Visual Truth in the Postphotographic Era, Cambridge,
MA: The MIT Press.

An early account of the technology in question was **William Mitchell**'s detailed 1992 analysis, *The Reconfigured Eye: Visual Truth in the Post-Photographic Era.* His account of the emergence of digital imaging techniques begins with the 1950s construction of a mechanical drum scanner which traced the variations in tonal intensity on the surface of a photograph, converting them into binary digits which could be stored in the memory of an early form

BOX C DIGITISING PHOTOGRAPHS: THE INITIAL IMPLICATIONS

- A shift in the location of photographic production: from the chemical darkroom to the 'electronic darkroom' of the computer.
- The outputting of single photographic originals in an expanded range of ways, from 'hardcopy' through transparencies and varying forms of print, to the computer and TV screen, and websites.
- An unprecedented ease, sophistication and invisibility of enhancing and manipulating photographic images.
- The entry of photographic images into a global information and communications system as they become instantaneously transmissible in the form of electronic pulses passing along telephone lines and via satellite links.
- The high speed transmission of news images which are no longer containable within territorial and political boundaries.
- The conversion of existing photographs and historical archives into digital storage banks which can be accessed at the screens of remote computer terminals.
- The potential of the new information and image networks for greatly extending the practices of military and civil surveillance.
- The unprecedented convergence of the still photographic image with previously distinct media: digital audio, video, graphics, animation and other kinds of data in new forms of interactive multimedia.

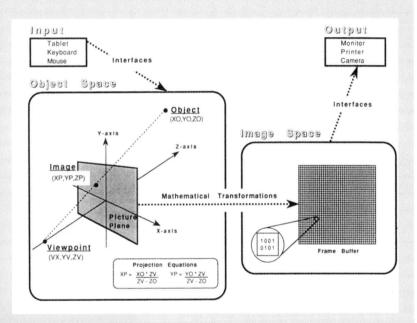

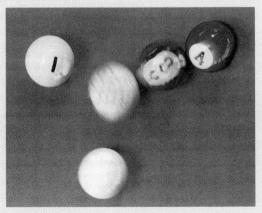

7.3 (above) Diagrammatic representation of the concept of a 'virtual camera'

7.4 (left) Computer-generated image of billiard balls

This image of impacting billiard balls is a computer simulation of 'photographic seeing'. These particular balls do not exist and neither does the room which is reflected on their surfaces. They are constructed mathematically and their surfaces are rendered according to the computer's 'knowledge' of the action of light upon specified kinds of surface, over a given distance and from a certain position and source, etc. The balls are represented in movement as if photographed with a shutter speed of 1/250 of a second. The realism to which this computergenerated image aspires is the 'look' of a photograph; realism equals the signifying means of the photographic image

See Wombell, P. (ed.) (1991) for an early recognition of these factors of computer (Mitchell 1992: 3). During the following three decades, largely driven by space exploration programmes, the need to transmit data over vast distances and to process it into pictorial form, led to sophisticated image processing systems (1992: 11-13). Mitchell points to the end of the 1980s as the moment when these technologies fed into the production of inexpensive 'point and shoot' digital cameras which then appeared on the consumer market. At the same time the personal computer began to have the processing power, memory, and storage capacity needed for image processing work. In the early 1990s interactive CDs became widely available and laser scanners for digitising images from existing photographs became popular and affordable computer peripherals. The result was that, 'the means to capture, process, display, and print photograph-like digital images - which had hitherto been available in only a few specialised scientific laboratories and print shops - now fell within reach of a wide community of artists, photographers, and designers' (1992: 18). Mitchell likens this moment to an earlier one (in the 1880s) when George Eastman introduced the Kodak 'Brownie' box camera (see chapter 3) laying the basis for a mass, popular practice of domestic photography: 'the burgeoning technology of digital imaging suddenly spawned a mass medium' (1992: 17).

A range of critical issues were soon raised by the emergence of 'digital imaging' and a new 'digital photography' and it was widely sensed that this was a moment of special significance in the history of media and visual representation. Its importance for visual culture was compared to the invention of photography itself (Mitchell 1992: 20) or the formulation of pictorial perspective in the fifteenth-century Renaissance (Crary 1993: 1). Depending upon the viewpoint of the practitioner or theorist it was a moment either to be celebrated as a release from the constraints of photographic representation (Ascott 1996: 165–73) or conversely, a moment of cultural panic in which the values and practices of photography were seen to be threatened (Ritchen 1990a, 1990b).

These stark terms in which the challenge of digital imaging technology for photography was initially posed often meant that sight was lost of the fact that there is no single thing called photography but – instead – there are many 'photographies' (Tagg 1988: 14–15). Two implications of the technological changes that we have traced above are that (i) the digital encoding or registering of a photograph means that it is open to alteration or manipulation to an unprecedented degree and (ii) that images of a photographic appearance, but which have no referent in the world, can be constructed by computers. These two possibilities seemed to strike at the heart of certain kinds of photography – documentary, photojournalism and related forms of 'straight' photography where photographic realism, photography's truth value, and its use as evidence and testimony, are particularly high (see also chapter 2). However, the new ability to manipulate and synthesise photo-

BOX D ANALOGUE AND DIGITAL

Traditionally, images were analogue in nature. That is, they consisted of physical marks and signs of some kind (whether brush marks, ink rubbed into scored lines, or the silver salts of the photographic print) carried by material surfaces. The marks and signs are virtually inseparable from these surfaces. They are also continuously related to some perceivable features of the object which they represent. The light, for instance, cast across a rough wooden table top, becomes an analogous set of tonal differences in the emulsion of the photograph. A digital medium, on the other hand, is not a transcription but a conversion of information. In short, information is lodged as numbers in electronic circuits. It is this feature of digitisation which has meant that images can now exist as electronic data and not as tangible, physical stuff. Some of the key differences can be set out as follows:

Analogue

transcription: the transfer of one set of physical properties into another, analogous, set

continuous: representation occurs through variations in a continuous field of tone, sound, etc.

material inscription: signs inseparable from the surface that carries them

medium specific: each analogue medium bounded by its materials and its specific techniques

Digital

conversion: physical properties symbolised by an arbitrary numerical code

unitised: qualities divided into discrete, measurable and exactly reproducible elements

abstract signals: numbers or electronic pulses detachable from material source

generic: one binary code for all media, enabling convergence and conversion between them

Digitisation is also the effective precondition for the entry of photographic images into the flow of information which circulates within the contemporary global communications network. It is their translation into a numerical code that now enables them to be electronically transmitted. For the above reasons, questions have arisen about the place of images in time and space, where they can be said to actually exist, about how and where they are stored when in electronic form, how and by whom they can be accessed, used, owned and controlled.

For a full discussion of the analogue/digital distinction see: TIMOTHY BINKLEY (1993) 'Refiguring Culture' in P. Hayward and T. Wollen (eds) Future Visions: New Technologies of the Screen, London: BFI.

graphic image elements could hardly be experienced as a threat to advertising, art, or fashion photography. These are kinds of photography where an enhanced ability to manipulate the 'real' is sought after and welcomed; cases where celebration would be appropriate.

A 'POST-PHOTOGRAPHIC' ERA?

With the coining of the term 'post-photographic era' in the early 1990s, a decisively historical and epochal dimension was given to the thinking about the impact of new image technologies upon photography (Wombell 1991: 150, Mitchell 1992).

Thinking of the wider significance of digital image technology for media and visual culture, the art historian Jonathan Crary spoke of 'the rapid development in little more than a decade of a vast array of computer graphics techniques' as bringing about 'a transformation in the nature of visuality probably more profound than the break that separates mediaeval imagery from Renaissance perspective' (Crary 1993: 1). While Crary himself asked questions about the completeness of this 'break', this was a bold claim and one which did not go unchallenged **Robins 1995**).

However, by the early 1990s, there was a feeling abroad that the period of some 150 years in which photography had been central to visual culture was approaching its end. In many ways photography has been broadly understood as part of a longer tradition of visual representation in the West, variously as the industrialisation, the mechanisation and the democratisation of perspectival images and the privileged, centred, position these afford the human viewer. At the same time, photography (and film) have also been credited with enabling new ways of seeing the world and changing the very cultural status of images. Photography was also associated with truth, realism, and evidence. Finally, photography was closely connected to commodification; it had turned appearances of every kind into commodities, to be mass produced, bought and sold on an unprecedented scale and was an essential part of marketing the goods, services, and values of consumer culture.

The claims that a 'post-photographic' era was upon us did more than encourage a wave of speculation about what it might hold and how it would be different from the late nineteenth- and twentieth-century culture centred upon photography. They also led to a renewed interest in the emergence of earlier image and communication technologies and the claims that accompanied them (Marvin 1988; Boddy 1994). They continue to bring about a new kind of interest in the early histories of photography, film, radio and television as a way of researching the historical grounds for speculating about the direction of current changes in media, including photographic, technologies (Punt 1995; Slater 1995b, Huhtamo 1996). In the sections that follow, each of these factors, raised by the concept of 'post photography' and

K. ROBINS (1995) 'Will Images Move Us Still?' in M. Lister (ed.) **The Photographic Image in Digital Culture**, London and New York: Routledge.

1 A recent example of this renewed interest in the history of photography understood as a technology in general and an image technology in particular is Patrick Maynard's book *The Engine of Visualisation* (1997).

which preoccupied theorists and critics of the photodigital in the first half of the nineties, will be discussed. The issues of cultural continuity are discussed in the section Technological change and cultural continuity.

In a parallel development, much interest arose in the history of the computer, especially the manner in which it came to be applied to image-making, as the machine which is credited with this epochal transformation (**Darley 1990, 1991,** Manovich 1996, Veltman 1996, Mayer 1999).

A new way of seeing and the end of the 'Cartesian dream'?

Mitchell suggests that as new image technologies unsettled older, established attitudes and beliefs in the status of images, they looked set to take us beyond the historically specific (and therefore temporary) limits of photographic 'seeing' in a progressive movement which was in tune with a postmodern age. Had the application of the computer and digitisation to image-making brought an age of ('false') innocence to an end? A false innocence belonging to the 150-year period during which chemical photographs provided us with images that we could comfortably regard as

causally generated truthful reports about things in the real world, and which could be confidently distinguished from more traditionally crafted images, which seemed notoriously ambiguous and uncertain human constructions.

(Mitchell 1992: 225)

The once fixed and stable images of photography 'served the purposes of an era dominated by science, exploration, and industrialisation'. This historical period was drawing to an end as we entered a 'post-photographic era' and had to face a new challenge to the fragile distinctions we were used to making between the imaginary and the real or, as Mitchell puts it, 'the tragic elusiveness of the Cartesian dream' (1992: 225).

The reference is to the seventeenth-century philosopher René Descartes and the 'Cartesian' tradition in Western philosophy which bears his name. This has generally come to stand for a search for certain and objective knowledge through the exercise of scientific reason; for a disinterested and rational method of enquiry untainted by the feelings and subjectivity of the observer. The attainment of such certain knowledge by an abstract reason exercised by a 'disembodied' mind is the 'Cartesian dream' to which Mitchell referred.

By the early nineteenth century such a search for scientific knowledge had taken a fiercely empirical turn and had been extended to the study of the social as well as the natural world within the social philosophical framework known as **positivism**. This was characterised by an exclusive concern

A. DARLEY (1991) 'Big Screen, Little Screen: The Archaeology of Technology', Ten-8 2(2) Digital Dialogues.

A. DARLEY (1990) 'From Abstraction to Simulation: Notes on the History of Computer Imaging' in P. Hayward (ed.) Culture, Technology, and Creativity in the Late Twentieth Century, London: John Libbey and Co Ltd.

See: Post-photography, postmodernity, and language, in this chapter (pp. 316–17).

See also: Photodigital: taking stock, later in this chapter, for further discussion of the Cartesian world-view and its concept of the viewer or 'humanist subject' (pp. 327ff).

for empirically verifiable and measurable facts. A connection between this 'positivist' method and the birth of photography has been frequently noted. As John Berger put it,

The camera was invented in 1839. Auguste Comte was just finishing his Cours de Philosophie Positive. Positivism and the camera and sociology grew up together. What sustained them all as practices was the belief that quantifiable facts, recorded by scientists and experts, would one day offer man such total knowledge about nature and society that he would be able to order them both.

(Berger and Mohr 1982: 99)

As real as this historical link with positivist social science may have been, photography has never been exclusively contained within positivism's framework or limited to such uses.

It is, however, an aspect of photography's history which was thrown into sharp relief by the concept of post-photography and the apparently radical contrast between the mechanical process and optical realism of analogue photography and a new digital 'age of electro**bricolage**'.

The new constructed or 'virtual' visual 'spaces' of computer-generated imagery which were emerging, were radically different from the 'mimetic capacities of film, photography, and television' (Crary 1993: 2). Photography depended upon 'a point of view static, or mobile, located in real space' while the techniques of computer imaging were relocating, 'vision to a plane severed from a human observer' (ibid). As the new image technologies became 'the dominant models of visualisation', Crary suggested that:

Most of the historically important functions of the human eye are being supplanted by practices in which visual images no longer have any reference to the position of an observer in a 'real' optically perceived world.

(1993: 2)

Both Mitchell and Crary sketched out a scenario in which seeing and representing the world through a camera lens, from a definite position in space, were giving way to new forms of vision and image.

A vision in which older lens-based images are either converted into electronic data or new images are constructed directly from data which simulate the appearance of a photograph. These images can be infinitely changeable, as they continually circulate within global telecommunication networks, available for convergence with one another and other 'abstract visual and linguistic elements' (Crary 1993). Further, these images do not necessarily refer to anything that is empirically verifiable as 'real' but to ensembles of concepts, and to other images and data.

See, for example, Digitisation and the commodification of images, later in this chapter.

bricolage A process of improvisation in which various elements and 'bits and pieces' are joined together to make something. In French a bricoleur is a handyman, and bricolage refers to DIY. The term was adapted for use within digital imaging by adding the prefix 'electro'.

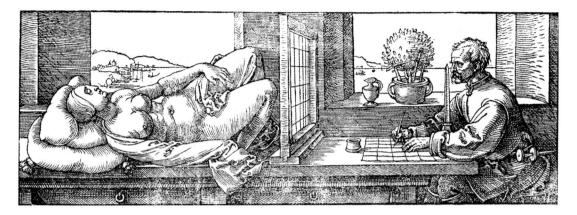

7.5 Albrecht Dürer, 'Draughtsman drawing a nude', 1538

Dürer depicts one of many apparatuses in the history of art through which the appearance of the world was organised in relation to the position of the observer. It is an apparatus and a way of seeing which is later embodied in the camera. It also, as Lynda Nead observes, already positions the female as the object of the male gaze (Nead 1992: 11)

It is not difficult to see how, on this way of thinking, the traditional handme-down, Cartesian framework for thinking about how we observe the external world was deemed to have become hopelessly inadequate. Faced with Crary's vision of the new image technologies, the question no longer seemed to be 'can an observer see clearly from their position?', but whether we, as observers, could continue to have any fixed or secure position from which to see anything that is material and stable! New possibilities for vision and visualisation were opening up, as the computer extended the realm of what the visual sense encompasses. On the one hand, we (or perhaps, given the globally and locally uneven distribution of technologies and information circuits, 'some of us', would be more accurate) were now able to 'see' distant planets, the inside of a beating heart, a molecule that is a concept, we could move through buildings which had not been built, we could window-shop in cyberspace. On the other hand, the qualities and formal means of images were undergoing certain kinds of change; this was probably most remarkable in terms of the spectacular extremes of scale and detail, of focus and viewpoint, of subtle and dramatic kinds of juxtaposition, in the degree of fragmentation and fusion, and in the transformation and mutation of images that we were coming to regularly see in the cinema, in advertisements on our television screens, and in websites and computer games. There was a scrambling, to an unprecedented degree, of the real and the imagined.

However, as Crary argued, we would not get far in understanding this newly 'precarious' position within a shifting scenario of images and imaging technologies if we failed to see it in a historical context (for there were precedents of sorts) and did not take account of the forms of social and cultural power which drive and shape such developments (Crary 1993: 2).

See: Technological change and cultural continuity (pp. 317ff.).

WALTER BENJAMIN AND THE PRECEDENT OF THE AGE OF MECHANICAL REPRODUCTION

WALTER BENJAMIN (1936) 'The Work of Art in the Age of Mechanical Reproduction' in H. Arendt (ed.) (1970) **Illuminations**, Glasgow: Fontana/Collins.

Many art and photographic historians were quick to see how these developments echoed Walter Benjamin's classic account of the impact of photography upon the handmade image in his 1936 essay 'The Work of Art in the Age of Mechanical Reproduction'. Here, we take note of his influential ideas on photography, especially his concept of an 'age' of mechanical reproduction and why they immediately found echoes in the idea of a new 'post-photographic era'.

The parallel was so compelling that a good deal of the earlier writing which dealt with the significance of digital imaging for visual culture explicitly played with Benjamin's original title (including the title of this chapter itself). Articles and scholarly papers with titles which echoed Benjamin's abounded; transposing the 'Mechanical Age' to the electronic, the cybernetic, the digital, the post-photographic age, era, or culture. The newspaper pastiche 'Mute', which reports on new media and related techno-cultural issues, once sported the banner, 'The Work of Art in the Age of Post-Mechanical Reconstruction!' (Nichols 1988; Virilio et al. 1988; Grundberg 1990b; Malina 1990; Jukes 1992).

Why? Benjamin, writing over 60 years ago, offered two basic sets of propositions about the epochal significance of film and photography as means of mechanically reproducing images.

The first concerned the power of a new image technology, photography, to **reproduce** autographic images. A second set concerned the particular ways that the camera – still and moving – represented the contemporary world itself. These two sets of propositions were rapidly transposed in efforts to think about the impact of digital technology upon photography.

Benjamin pointed out that mechanical reproduction substituted 'a plurality of copies for a unique existence' (Benjamin 1939: 223). These were not copies in the sense of fakes (they could not be passed off for the original) or imperfect handmade copies, but were the outcome of an independent technical process. Through this process, images which had previously existed in one place at one time could now be seen simultaneously by a variety of new audiences in a diverse range of situations. Knowledge of the work was no longer restricted to being in the presence of the original. The images were no longer dependent upon their original contexts for their meaning and became open to multiple interpretations and readings. They could also be put to new uses. For instance, it became possible to compare and connect images that were previously separated in space and time. Reproduction created a new kind of portable cultural object (Lury 1992: 396) which was free from the controlled environments and rituals of the church, the civic state, and the aristocratic cultures in which the unique handpainted image had been predominantly produced and used.

Now, it was the photographic image itself which was subject to a similar process as it was converted, reproduced or simulated in digital form, stored electronically, and transmitted by telecommunications networks. Hence, the question arose as to whether a second 'electronic' or 'digital' revolution in visual culture was taking place which would usurp the role that photography had in the 'age of mechanical reproduction' and which Benjamin first described.

Benjamin's second set of propositions concerned the camera itself. He recognised that photography developed as a part of the scientific and technological endeavours of nineteenth- and early twentieth-century industrial capitalism. The physical context of this development was the nineteenth-century city. He stressed the way that urban experience was newly characterised by speed, rapid change and a fragmentation of everyday experience. This was brought about by new transport and communications systems, by the industrial division of labour on the production line, and by the separation of leisure and work in a wage labour economy. Benjamin argued that a rapid succession and juxtaposition of shifting viewpoints and experiences confronted the city dweller in their everyday lives. The new industrial and urban environment bombarded him or her with an unprecedented level of physical and psychological shocks (Benjamin 1939).

Benjamin sees the camera and its images as making this bewildering environment possible to contemplate. He points to the way that still photography renders faithfully the plethora of everyday detail that would normally be overlooked. He points to factors such as the way in which the photographic camera can put the 'eye' in places that it could not otherwise be, or the way in which the shutter freezes action not perceivable by the eye alone. With movie film the speed of human and mechanised action was slowed down. Through editing, a range of shots, frames and actions, matching the bewildering viewpoints of the city dweller, could be put together in a coherent narrative. Benjamin suggests that, in this period, a kind of 'optical unconscious' was revealed by the camera, just as, through psychoanalysis, 'the instinctual unconscious' was discovered.

So, in Benjamin's view, photography, and then cinematography, were particularly suited to depict the changed environment of industrial societies and, moreover, they could reach mass urban audiences rather than small elites. They represented a new way of organising perceptions within the dramatically changed environments of early twentieth-century cities. In his 1988 essay, 'Postmodernism and Consumer Society', Fredric Jameson had proposed that our perceptual skills and habits were again lagging behind our apprehension of a new kind of urban environment, represented most clearly in the new forms and spaces of postmodern hotels and shopping centres.

My implication is that we ourselves, the human subjects who happen into this new space, have not kept pace with that evolution . . .

[of postmodern architectural space] . . . we do not yet possess the perceptual equipment to match this new hyperspace . . . in part because our perceptual habits were formed in that older kind of space I have called the space of high modernism.

(Jameson 1993: 198)

Jameson makes it clear that he sees himself as following in Benjamin's footsteps when making this point (Jameson 1993: 202). Similarly, albeit in the sphere of visual representation rather than architectural space, it was argued that we were moving rapidly into a time where the new means of digital and electronic imaging were coming to supersede those of the age of mechanical reproduction. As they did, it was suggested that new kinds of perception were being born, which were adjusting to a world in which significant global economic, technological and cultural change was taking place on a scale that was likened to that of late nineteenth- and early twentieth-century industrialisation itself.

Although interested in film rather than still photography, **Bill Nichols** investigated the idea of such a parallel in his 1988 essay, 'The Work of Culture in the Age of Cybernetic Systems' (1988: 27). Here, following Jameson (1984), he drew up three parallel lists of the technological, legal and cultural features of three stages of capitalism – the entrepreneurial, monopoly and multinational. With more emphasis on social and economic processes, David Harvey (1989: 174–9) has also reproduced a number of charts which represent the changes that have been seen to take place in the transition from industrial capitalism to present conditions, variously described as 'late capitalist', 'disorganised capitalist', 'postmodern', 'post-industrial' and 'post-Fordist'. In a much reduced form the kinds of change which are pointed to in this way of thinking are as follows:

the mechanical camera
the photograph
industrialism
the modern era
modernism
rationalism/positivism

the electronic computer
the digital image
a 'post industrial age'
postmodernity
'postmodernism'
structuralism/post-structuralism

The end of photography as we know it?

A fear for the demise of photographic truth was one of the initial responses to digital image technology. Traditional claims about photography's truth value have rested upon the causal relationship between the photographic image and the real world. In realist theories, photography was primarily defined by its technical basis: the way in which light reflected by an object or event in the real world is registered on the film emulsion (or, in the case of video,

BILL NICHOLS (1988) 'The Work of Culture in the Age of Cybernetic Systems', **Screen** 29(1), Winter.

on electromagnetic tape). The photograph was understood as an **index** or trace of what had caused it. But it has long been clear that this aspect of the photo-mechanical process has only a small part to play in the meanings that a photograph has. (For discussions of realist theories of photography and their fallacies see Snyder and Allen 1975; Snyder 1980.) Subsequently, the ambiguously complex meanings of photographs have been understood to be the result of complex technological, cultural, ideological and psychological processes in which **indexicality** is but one element.

Despite this recognition, in the early thinking about digital technology's impact upon photography this **indexical** quality was frequently stressed above all others, especially in the polarised debates of the kind which saw photography as 'old, bad and limited' versus the digital as 'new, good and open-ended'.

Such positions and debates short-circuited much of what has long been understood about photographic representation. They diverted attention from the whole range of decisions, conventions, codes, operations and contexts which constitute photographic meaning. However, even where such illinformed oppositions were avoided, there was still a sense in which many practitioners felt that the ethics and politics of photographic representation were under threat. This was the position taken by Fred Ritchin, a photographer and teacher of photojournalism, who claimed that 'the new malleability of the image may eventually lead to a profound undermining of photography's status as an inherently truthful pictorial form' (Ritchin 1990b: 28; my emphasis). This, however, is not the only way in which the issues were conceived. Martha Rosler, an artist and critical theorist, argued that they could not be posed in terms of photography's essential or inherent truth value. Her thinking on the matter proceeded by stressing that 'Any familiarity with photographic history shows that manipulation is integral to photography' (1991: 53; my emphasis).

In the face of what she saw as 'slightly hysterical' pronouncements that 'photography as evidence of anything is dead', Rosler wanted to remember a more complex history of photography in which contradictions abound and its objective realism is not an essential quality of the medium. Instead, as we shall see, she argued that photographic truth is based upon a set of historically and culturally specific beliefs about photographs as documents. (See also Kember 1998 and the discussion in the sections Remembering photography's nature and Our belief in photography's realism.)

More recently, Batchen (2001: 138–9, and see also Manovich 2003: 245) has made the point even more strongly when he states that, 'the history of all photography is a history of image manipulation'. We hardly need to look to the usual and more obvious examples of combination printing, photomontage and the like, to see the force of this point. So-called 'straight photography' is no exception even though it is the basis of several industries

In more recent thinking about the photodigital the issue of indexicality has been seen as far more complex, more carefully distinguished from questions of photographic truth, and recognised as a factor in our reception of digital as well as traditional photographic images. (See: Photodigital: taking stock, where this is discussed.)

F. RITCHIN (1990a) In Our Own Image: The Coming Revolution in Photography, New York, Aperture; (1990b) 'Photojournalism in the Age of Computers' in C. Squiers (ed.) The Critical Image Seattle: Bay Press, pp. 28–37.

M. ROSLER (1991) 'Image Simulations, Computer Manipulations, some Considerations', **Ten-8 2(2)**, **Digital Dialogues**. which rely upon an exclusive stress on the mechanical nature of photography and the lack of subjective intervention this is thought to guarantee (journalism, surveillance, medicine, science).

'Straight photography' is frequently assumed to be some kind of photographic norm from which other, more overtly manipulative, photographic processes deviate. However, 'Digital technology does not subvert "normal" photography because "normal" photography never existed' (Manovich 2003: 245). The very process of producing a single photographic image – the passage from the brief opening of the camera's shutter trained on an object or event in the physical world to a completed and exhibited or reproduced print – is already a complex process within which a great deal of mediation takes place. When seen as a whole, each moment in this process (camera position, camera angle, focal length of lens, control of light, use of filters, length of exposure, nature of film emulsion, the method of development, the craft of printing) is a moment of choice between options, an intervention in how the photographic image will relate to a notional direct and unmediated recording of the photographed object.

As one of the 'classic' American 'straight' photographers, Edward Weston, observed some 40 years ago when digital imaging was hardly on the horizon,

within the limits of his medium, without resorting to any method of control that is not photographic (i.e., of an optical or chemical nature), the photographer can depart from literal recording to whatever extent he chooses.

(Edward Weston, (1964) 'Seeing Photographically', The Encyclopaedia of Photography, Vol. 18)

We will first attend to Ritchin's thoughts on the issue which express some widespread concerns relating to the professions of documentary and photo-journalistic practice in particular. (See also chapter 2.)

For Ritchin (1990a), the choices the photographer makes at the point of exposure (which could now be digitally altered in retrospect), together with subsequent editorial and post-production manipulations, were so greatly extended by the use of computers that ethical problems arose 'with the greatest urgency' (1990a: 29). He argued that traditional manipulations of photographs were somehow held in ethical check and were usually undertaken without 'damaging the image's integrity'. New digital image technologies meant that an 'editor has the ability to reach into the guts of a photograph and manipulate any aspect of it', much in the way that texts can be edited and the writer's meanings subtly but effectively altered.

Ritchin, whose thinking is haunted by an Orwellian nightmare of a future digital dystopia (1990a: 3), searched for strategies which would enable photo-journalists to ward off the digital undermining of their vocation. However, he was too keenly aware of the **semiotic** complexities and the politics of

photojournalism to be able to seek reassurance in any simple idea of photographic realism. He recognised that the genre of documentary photography has long been the subject of critical debate, and that naive reflection theories have for some time ceased to inform most documentary photographic education and practice (1990b: 28). And, given this history of critical debate, Ritchin then sees 'the application of computer technology to photography' as a second challenge to what he calls 'photography's putative capacity for reliable transcription'.

Ritchin entertained two responses to this second challenge. First, he plays with the idea of securing a protected category of stable, verifiable images, whose trustworthy status would, in some way, be officially accredited. One can imagine some kind of 'kite mark' or official caption stating that this is a 'certificated' chemical photograph or an 'ethically manipulated' digital photograph (1990b: 28–37). With this suggestion Ritchin came close to occupying a defensive, rearguard position that William Mitchell foresees for photojournalists:

Protagonists of the institutions of journalism, with their interest in being trusted, of the legal system, with their need for provably reliable evidence, and of science, with their foundational faith in the recording instrument, may well fight hard to maintain the hegemony of the standard photographic image.

(Mitchell 1993: 7)

Second, Ritchin (1990b) avoided basing his defence of photojournalism on any form of technological veracity and shifted it to the ground of authorship. In fact, Ritchin's best argument was based upon his view that there should be some parity between the photojournalist and the journalist who writes, where the authority of the writer's report is based upon the reputation of the author and the institutions for which they work. Finally then, Ritchin seemed to accept that the value of the photographic image in a digital age would not be secured by tracing its truthfulness to its origins in a photo-chemical process. Rather, it must rest on the conscience and reputation of the photographer who made the image. In this one respect, he came close, as we shall see, to sharing Martha Rosler's argument.

Overall, Ritchin cast the difficulty for photojournalism in a digital age as a largely personal and ethical problem – a problem for individual photographers and picture editors as they were pitched into a situation where truth and integrity became ever harder to defend against what he saw as an inherently unscrupulous and deceitful digital technology.

Digitisation and the commodification of images

We have seen how Fred Ritchin argued that a kind of photographic integrity was at stake as digital image technology dramatically increased the possibilities of image manipulation. Yet, at the same moment, Martha Rosler reminded us of the part that photography itself has played in creating a market in illusions throughout the twentieth century, she offered a view of the fragility and partialness of the 'modern' idea of photographic truth. In doing so, she pointed to a history in which photography brought about a condition where we 'prefer the sign to the thing signified, the copy to the original, fancy to reality, the appearance to the essence' (Rosler 1991: 61).

In this essay, 'Image Simulations, Computer Manipulations: Some Considerations', Rosler has no time for the opposition between photographic truth and digital manipulation which was becoming central to much discussion about 'post-photography'. She warned that 'critical considerations of the possibilities of photographic manipulation tend to end with the tolling of the death knell of *truth*. This discussion will not end that way' (Rosler 1991: 53). The manipulation which Rosler saw as integral to photography itself is shown by any familiarity with photographic history from the very earliest uses of multiple negatives by photographers like Oscar Rejlander.

In Rosler's thinking, any sense of there being a crisis of photography's truth value is to fundamentally mistake what is going on. She agreed that we may no longer look at photographs 'as ways of communicating facticity, but that doesn't amount to asserting that "truth is dead" or that "photography is used up" (Rosler 1991: 53). For we are mistaken if we think that the changes which are taking place are simply or primarily caused by the new technologies, or that some kind of essential 'nature of photography' was undergoing change. She argued that we needed to look at wider cultural factors and recognise that our ideas and beliefs about photographs, as well as many other things, were changing.

Rosler stressed the importance of understanding that the straight photography of documentary and journalism is a genre. It has its own history, a politics, and institutional frameworks (of the press and broadcasting) which lend it its special, if contestable, authority. The term 'straight photography' points us to a way of making photographs in which evident artifice, construction and manipulation are avoided as a matter of principle. It does not, and cannot, mean an unmediated, uncrafted photograph or an image which is not the result of intention and shaping by the photographer. The very choice to work in this way, to avoid dramatic and rhetorical artificial lighting, for example, to resist any setting up and orchestration of the subject, or the many manipulations and devices of the darkroom, is itself the outcome of working with ideas and making choices within a wider set of possibilities.

The question was not how accurately or objectively photographs represent the appearance of reality but whether they, or any other kinds of image, can be used to 'tell the truth' about a reality whose appearance can itself be an illusion. In seeing the issue this way, Rosler points to the openly manipulative, alternative traditions of photography, represented by the **photomontages** of the Dadaists and John Heartfield. Theirs was a way of using

photography that sought to prise open and dismantle appearances in order to point to the social realities that their surfaces do not reveal. In her essay, Rosler sees these political photomontages as sharing with the early practitioners of photography, those who used multiple negatives to overcome the limitations of orthochromatic film, a search for a 'truer truth, one closer to conceptual adequacy' (Rosler 1991:54). If, then, manipulation is recognised as integral to photography, it is best embraced and consciously directed.

If we want to call up more hopeful or positive uses of manipulated images, we must choose images in which manipulation is itself apparent, not just as a form of artistic reflexivity but to make a larger point about the truth value of photographs and the illusionistic elements in the surface of (and even definition of) *reality*. . . .

Here we must make the requisite bow to Brecht's remark about the photo of the exterior of the Krupp works not attesting to the conditions of slavery within.

(Rosler 1991: 58)

Rosler argued that the 'identification of photographs with objectivity is a modern idea' and it is one that may be passing together with many other certainties of the modern age, such as a belief in progress. The meanings that images carry, whether photographic or digital, are not 'fully determined by the technologies used in their production', but they are shaped by the ideas and beliefs that are invested in and brought to them. Further, 'the questioning of photographic truth' is part of a 'more general cultural delegitimisation [that] is at work in industrial societies' (Rosler 1991: 63). Rosler has in mind Guy Debord's theory of a 'society of the spectacle' in which the cultural industries of capitalist societies, which centrally included photography, have turned the very look of the world, its appearance, into a type of marketable commodity (Debord 1970). This was the material basis for a far-reaching change in the status of images, and it is one that substantially took place across the late nineteenth and the first half of the twentieth century, prior to the emergence of digital image technologies.

Images, then, had already been severed from any simple equation with 'truth' in the earlier history of the mass production of images, advertising, cinema, propaganda, popular visual culture and spectacular entertainment. The question of the truth value of images or the reliability of the evidence which they provide does not simply rest on the kind of technology which was used to produce them, whether mechanical, electronic or digital. The use of photographs for propaganda purposes, argued Rosler, 'neither began nor will end with the electronic manipulation of photographic imagery'. Rosler's approach, (first published in the late 1980s), strongly anticipates elements in the work of Kember (2003) and Manovich (2003) which are discussed in the section: Photodigital: taking stock.

It was William Mitchell who made the connection between 'post-photography' and 'postmodernity' most explicitly when he stated that 'The tools of digital imaging are felicitously adapted to the diverse projects of our postmodern era' (Mitchell 1992: 7). This is because, argues Mitchell, the digital medium 'privileges fragmentation, indeterminacy, and heterogeneity' and 'emphasises process or performance' rather than 'a kind of objective truth' which has previously been assured by traditional photography's 'quasi-scientific procedure and closed, finished perfection'. In describing digital images with words like 'fragmentation', 'indeterminacy' and 'heterogeneity', Mitchell echoes closely the language of postmodern social and cultural theory. Steven Best and Douglas Kellner, for example, characterise postmodern patterns of thought as rejecting 'modern assumptions of social coherence and notions of causality in favour of multiplicity, plurality, fragmentation, and indeterminacy' (Best and Kellner 1991: 4).

JACQUES DERRIDA (1930–) French poststructuralist philosopher and Paris-based professor, born in Algeria. He is centrally concerned with the deconstruction of texts, particularly literature. His focus is on the fluidity of language, the unfixity of meaning, and on play between words. Key works include Of Grammatology (1967), Writing and Difference (1967) and The Truth in Painting (1978).

Post-photography, postmodernity and language

The idea that digital images are essentially more provisional, mutable, hybrid and 'in process' than the fixed images of photography together with the way in which digital image software could be used to dismantle, alter, and construct photographs, led to a number of analogies being drawn between digital imaging, post-photography, and poststructuralist theories of language.

A software application, such as Adobe Photoshop, is a **heuristic** tool for understanding and rehearsing photographic codes and qualities. Within a few hours' use, such a program allows the user to explore many of the manipulations and conventions which are part of the practice of photography. In this way, digital imaging software can be a means of *understanding* photographic representation and the nature of photographic 'language'. Digital technology became a critical tool which could demonstrate in practice what had been argued in theory for some three decades: that photographic images are themselves special kinds of constructions. This 'deconstructive' project was itself fully in line with aspects of postmodern cultural practice which emerged strongly in the 1980s and were associated with a self-conscious and playful use of language and style – whether visual, literary or architectural – and set out to reveal their manner of operation.

Further, an analogy can be drawn between the open-endedness of the digitised image and poststructuralist theories of language and meaning drawn from the philosopher Jacques Derrida's ideas about the nature of language and meaning. The emphasis in such theories is upon the polysemic nature of signs (their capacity to mean more than one fixed thing) and their indeterminacy (the way that language and sign systems are always 'in process' because they are being continually modified and nuanced as they are written and spoken in differing social contexts). They never reach a final destination of fixed, settled meaning; that is, any kind of 'closure'. In the realm of visual images, digital technology was then seen as deconstructing the singular, fixed images of photography (their objectivity and closure) and in this process, we were being released from the grips of a worn-out and ailing photographic tradition and its outmoded mission. It is Mitchell, again, who introduces this idea when he sees digital technology as being able to,

expose the aporias in photography's construction of the visual world, to deconstruct the very ideas of photographic objectivity and closure, and to resist what has become an increasingly sclerotic tradition.

(Mitchell 1992: 8)

More recently, in a complete reversal of this argument, similar 'Derridean' ideas have been used by Geoffrey Batchen to suggest that photography

is itself a digital process. Photographs are a special kind of sign; they are indexical signs, signs which are caused by the objects they represent (see p. 331 'The force of the indexical image') but they are nevertheless signs (Batchen 1997: 215). Poststructuralist theories of language insist that it is in the nature of linguistic signs that they are unstable. Any particular sign has the meaning(s) it does because it has a relation of difference to other signs; another way of saying this is that its meaning derives from what it is not; any sign entails others, and is always referring beyond itself to others which are not present.

Whenever a sign brings something to mind or calls up its presence, it therefore relies on something that is absent. If we think of photographs in such poststructuralist semiotic terms we may override our preoccupation with the photograph's special indexical status and we are returned once more to see how a photograph's meaning arises from an unstable, relational play of signs. Batchen concludes that this is tantamount to recognising that photography itself is a digital process; it signifies through a system of signs playing across a field of presences and absences, positives and negatives, '0's and '1's.²

TECHNOLOGICAL CHANGE AND CULTURAL CONTINUITY

If much of the initial thought about the place of photography in an age of electronic imaging was based upon ideas of historical ruptures, breaks and radical change, not only in the means of producing images, but also in culture at large, these ideas did not go unchallenged. Media theorists and historians argued that such a view failed to take enough account of photography's history in particular, and the kind of relationship that new technologies have to cultural change in general. They argued that such claims place too much emphasis on the evident technological difference between photographic and digital processes. A preoccupation and fascination with technological difference obscured important elements of continuity in the cultural meaning and uses of technologies. (See also Photodigital: taking stock, p. 327 for some further outcomes of this tendency.)

Rather than simply see a break between the 'old' chemical technology and the 'new' electronic and digital one, these critics argue that we also have to see how both are shaped and developed by powerful social and cultural forces which run through nineteenth- and twentieth-century Western culture. The difference between analogue and digital image technologies is only one factor within a much larger context of continuities and transformations. In short, in order to assess the significance of new image technologies we also have to look at how images are used, by whom, and for what purposes.

This reversal, the use of a similar set of propositions about the nature of language, first (in the early 1990s) to argue for the novelty and difference of post-photography from traditional photography (Mitchell 1992) and then some seven years later (Batchen 1997) to argue for a fundamental identity between the digital and the photographic, chimes well with the changing times. For as we suggest in the last section of this chapter, much recent thinking about the photodigital attends far more to their interplay than to their simple difference.

2 For his account of this argument and also his ideas about the different relation that photographic and digital images have to time, see GEOFFREY BATCHEN (1997)

Burning with Desire,
Cambridge, MA: The MIT

Press, pp. 207-16. In making the argument that photography is 'a digital process', Batchen references the work of Jacques Derrida (1976) Of Grammatology, trans. Gayatri Chakravorty Spivak (Baltimore, MD: The Johns Hopkins University Press). Derrida's work is difficult and an approach to it may be made through the chapter on poststructuralism in J. Sturrock (1986) Structuralism, Fontana, and the chapter on Derrida in J. Sturrock (ed.) (1979) Structuralism and Since: from Levi-Strauss to Derrida, Oxford: Oxford

University Press.

KEMBER, S. (1998) Virtual Anxiety: Photography, new technologies and subjectivity, Manchester and New York: Manchester University Press. For instance, a major use of new image technologies is to be found within medicine, where they are being used to make the interior of the living body visible. Some writers have stressed the way in which such new, non-invasive, medical imaging techniques can be seen as liberatory and wholly benign (Stafford 1991). However, in her study of the way in which these technologies are being used to produce and construct images of the body within medical science, **Sarah Kember** argues that the highly mediated images of CAT scans and Magnetic Resonance Imaging have their antecedents in nineteenth-century medical photography. For Kember, 'there is in fact no clear separation between photo-mechanical and electronic imaging in the context of the surveillance and classification of the body' (Kember 1995a: 95–6). Both, she argues, participate in the gendered power relations of an increasingly technologised, masculine medical science which seeks to dominate the female body with its connotations of the 'natural' and 'maternal'.

In order to see the kinds of cultural continuity which run through technological change, we have to pay attention to the institutions and social sites in which new image technologies are being applied, and to the established cultural forms and practices which are being extended and transformed through such use. These sites are predominantly ones in which the photographic image has long been put to work: in the production of news, in the making of art, in advertising, in military and civil surveillance, in the production of spectacle and entertainment, education and pornography, to name only the more obvious ones.

Before looking more closely at two examples of such sites and uses, we will note a number of more general ways in which the use of digital technology can be seen as an acceleration or intensification of photographic processes that have a lengthy history. To see, in fact, that digital technologies are used to continue and build upon photographic forms.

Photography's promiscuity: its historical interface with other technologies, sign systems and images

Throughout its history, photography has always enjoyed a complex relationship with other text-based or visual information media.

(Bode and Wombell 1991: 4-5)

The new digital media, in their interactive, multimedia forms, were immediately celebrated for their capacity to generate **polysemic** meanings which involve the viewer's active participation. The two main bases for this were the capacity of digitisation to bring about, first, a convergence of previously separate media and, second, an 'interactive' relationship between the viewer and the text.

The first wave of critical responses to digital image technology over-whelmingly valued this capacity to produce layered and open-ended images which are always in creative process. By being included within digital multi-media fomats, photographic images were newly exposed to multiple contexts of sound, other images, speech and text, etc. Multiple, alternative, radical and unexpected meanings were then seen to be the result of this new kind of complex of messages. Moreover, such meanings could now be discovered or created by the viewer (or 'user') as they interact with material which is structured with their participation in mind.

In this celebration of 'new' media, an opposition was often made, or implied, with an idea of an older 'pure' photography which was an 'automatic' source of fixed, singular and stable meaning (Robins 1991: 56-60; Lister 1995b: 8-11). The evident technological difference between photographic, camera-based processes on the one hand, and digital, computer-based processes on the other, also became the basis for constructing different intellectual and creative conceptions of practice, production and, in particular, of what is involved in viewing or using images. There are, indeed, differences to be thought about, as there were between the traditional practices of working with still or moving images, or between making 'silent' and 'talking' movies. However, it is an altogether different matter to jump to the conclusion that the convergence of older media brought about a completely novel and unprecedented situation. There was also a danger here that 'convergence' was assumed to be an inevitable achievement of the technology, rather than a matter of how it is used, what it is used for, and whether, in any particular case, it is of value to use it.

The degree to which these factors of convergence and interactivity tended to be seen as entirely new features of 'digital' art, media and communications was dependent upon failing to take into account a number of factors. When such factors are included in our thinking, the frequently made opposition between the photographic and the digital turns instead into a picture of the latter extending and building upon some key aspects of the former. This is important to remember; otherwise, two difficulties arise.

First, the degree to which digital image production draws upon the received conventions and codes of older media is lost to sight. 'Codes' are not just a matter of routine practice or 'know-how', but have ideological weight. This means that there is a danger that a rich resource can, in fact, be drawn upon, but without an informed, critical awareness of the politics of representation which have been developed around these practices. Second, the euphoric over-evaluation of digital 'culture' which was achieved by means of simple and ahistorical oppositions, placed photographic culture in a poor light and obscured its continuing power and complexity (Robins 1991: 56–7).

See ch. 5 for a fuller discussion of codes, pp. 210–12.

Three features of photographic culture will indicate how the meanings and uses of photographs, in a pre-digital period, have involved issues of convergence and relationships with other media. (For a discussion of the limits of the current opposition between ideas of the 'passive' viewer of photographs and the 'interactive' user of digital multimedia, see Lister 1995b.)

- Mass-produced, mediated and hybrid 'photographic images' have circulated throughout the twentieth century. This has depended upon a convergence of photography with print, graphic, electronic and telegraphic technologies. As John Tagg put it, 'the era of throwaway images' began in the 1880s with the introduction of the half-tone plate. It was this interface of the chemical photograph with print technology which 'enabled the economical and limitless reproduction of photographs in books, magazines and advertisements, and especially newspapers' (Tagg 1988: 56). In 1903 the telegraphic transmission of half-tone images became possible and the *Daily Mirror* launched a photo-telegraphy service as early as 1907 (Harvie et al. 1970).
- Photographic images have seldom been met in isolation. They are embedded and contexted in other signifying systems, primarily, those of the written or spoken word, graphic design and the institutional connotations of power, authority, neutrality or glamour. As Barthes (1977a: 15) puts it, the photograph is at the centre of 'a complex of concurrent messages'. In a newspaper these are the text, the title, the caption, the layout, and even the title of the newspaper or publication itself: a photograph can change its meaning as it passes from the page of the conservative to the radical press. Photography as an element in a complex of 'concurrent messages' pre-dates the technological convergence of the new hybrid media.
- The sheer number of photographs circulating in the world, and the frequency with which we meet them, is also a basis of their *intertextuality*. None is free-standing. Each one is a small element in a history of image production and a contemporary 'image world'. Within this environment, the photographic image gains its meaning by a continual borrowing and cross-referencing of meanings between images. The still photograph quotes a movie, the cinematographer adopts the style of an advertising photographer, the music video mimics an early silent movie.

We can now consider this argument for continuities of use and cultural meaning between pre- and post-digital photography by looking at two brief case studies. They are chosen from many possible ones. Whilst not discussed here, equally strong examples can be found in the production of erotica and pornography (Graham 1995), and the relationship of digital image culture to domestic snapshots (Slater 1995b).

The Daily Mirror

THE MORNING JOURNAL WITH THE SECOND LARGEST NET SALE.

Registered at the G.2.0, as a Newsgopes.

SATURDAY, APRIL 20, 1912

One Halfpenny.

ONE OF THE THOUSANDS OF TRAGEDIES WHICH MADE THE TITANIC WRECK THE MOST HORRIBLE IN THE WORLD'S HISTORY.

7.6 Front page of the Daily Mirror, 22 April 1912

An early use of a screened photograph printed with text

CASE STUDY: WAR AND SURVEILLANCE

From the original watchtower through the anchored balloon to the reconnaissance aircraft and remote sensing-satellites, one and the same function has been indefinitely repeated, the eye's function being the function of a weapon.

(Virilio 1989: 3)

The remote digital video cameras, sensors and image processors used in modern warfare have taken over and extended an historic role of photography. Paul Virilio clearly has in mind that an early use of photography was the mounting of a camera in a balloon for the purpose of aerial reconnaissance. In this way vision and its record were placed in the service of military intelligence; it was given a new vantage point and power. This has been built upon ever since, as a sequence of new image technologies has been harnessed to, and often developed for, military surveillance purposes. With the contemporary use of satellites, remote sensing technology, digital enhancement of images, and the establishment of global information networks, this early means of lifting a mechanical eye above the enemy has continued to develop. A point has been reached where the entire planet is 'becoming encapsulated by whole networks of orbital devices whose eyes, ears, and silicon brains gather information in endless streams' which produce a kind of 'portrait of what is happening on planet earth painted electronically in real time' (Robins 1991: 72).

In the nineteenth century, portable, if cumbersome, darkrooms were trundled out to war. As early as the 1850s Fenton was commissioned by the British government to photograph the Crimean War, and Brady worked the battlefields of the American Civil War. By the First World War, photography played a key part in reporting war and and providing propaganda for the public at home. In 1991 the Gulf War revealed the scale and depth to which technologies of surveillance and so-called 'information' technologies had reached. The domestic television set became the mesmerising end point of an electronic image chain which started with a digital camera travelling on the nose of a smart bomb (Druckery 1991). Immersed in real-time simulations, pilots attacked by computer and video, functioning 'as components in the virtual domain of the military technological system' disembodied and dislocated from material reality. Visual surveillance systems have become simulation systems. The gathering of data and intelligence was converted into a real-time digital image of war which paralleled an awful reality that few of us in the West could know or, mercifully, experience.

A highly selective and orchestrated spectacle of this war, at least partly derived from the same material, was relayed to the domestic television set. When Paul Virilio called this war 'the first totally electronic war', we can, as Ian Walker (1995) has pointed out, take this phrase 'in two ways, to describe how the war

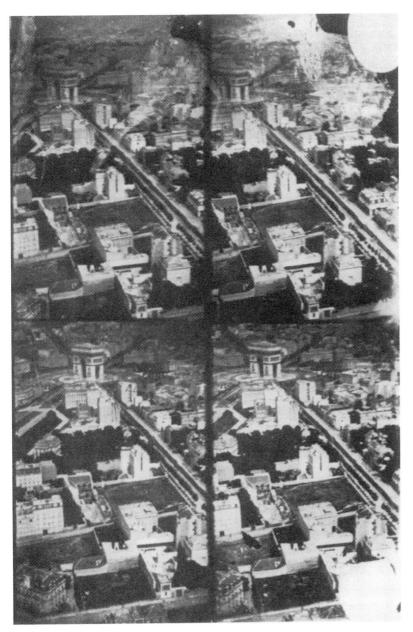

7.7 Nadar (Gaspard Felix Tournachon), The Arc de Triomphe and the Grand Boulevards, Paris, from a Balloon, 1868.

A (civil) example of how, within 20 years of its invention, the camera was airborne and pointing to its usefulness as a tool of intelligence gathering and surveillance

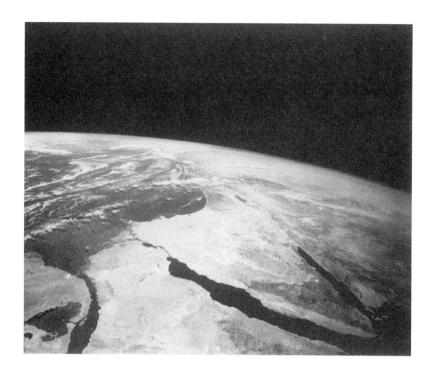

7.8 NASA, Johnson Space Center, Houston, Texas. STS-52 'Earth View (Sinai Peninsula)'.

7.9 Press photographer photographing the Gulf War in progress. Access to the war action is confined to a video screen at a military briefing.

7.10 Sophie Ristelhuber, Fait, 1992

Photograph from the exhibition and book *Aftermath*. Still photography was practically and officially made almost impossible during the 1991 Gulf War, but Sophie Ristelhuber's camera offers an alternative and critical view of the aftermath of the events 'in considered retrospect' (Walker 1995)

was fought and how it was represented. At many points these two aspects came together, as 'the most potent images were those taken by the military themselves' which were then relayed on through the world's media. The journalists and war correspondents, like the rest of us, saw the war mainly on television. Photographers were reduced to taking pictures of military personnel pointing to video monitors at prearranged press briefings. However, the 'invisibility' of the Gulf War and the highly mediated nature of the images received is squarely in the tradition of 'self censorship [imposed] in the name of social cohesion' which has been part of war reporting and photojournalism from the Great War to the Falklands (Taylor quoted in Walker 1995).

Ian Walker has also argued that in this new context, where the photographer is removed from the scene of cybernetic warfare and its electronic reporting, photography continues to play a role in offering us a view of events 'in considered retrospect' (Walker 1995). Considering Sophie Ristelhuber's photographs of the aftermath of the Gulf War, Walker agrees with Taylor that it is ill-informed simply to oppose photography's old role as reportage to its recent displacement and deconstruction by digital image technology. He points instead to the range of political and aesthetic strategies which an artist like Ristelhuber brings to their use of photography. He then suggests that the future of the medium may lie in such critical-artistic interventions and not in the traditional genre of documentary photography and photo-reportage.

CASE STUDY: POPULAR ENTERTAINMENT

Photography was . . . only one of many instruments, institutions, and practices designed to engage, astonish and entertain the eye; only one of a vast array of machines for the production of spectacle.

(Neale 1985: 23-4)

7.11 Viewers at a Panorama

Source: Buck Morss (1991) The Dialectics of Seeing: Walter Benjamin and the Arcades Project, Cambridge, MA: The MIT Press, p. 82.

7.12 Photograph of a contemporary games arcade.

While we may not associate the still photograph with spectacular effect, Steve Neale reminds us that the stereoscope was one of the most popular ways of viewing photographs in the nineteenth century. Projected images for entertainment (both painted and photographic) as in the Phantasmagoria, and other environments in which transparent and backlit images were presented to audiences (the Diorama, the Eidophusikon) were very much part of the culture in which photography emerged.

All of these machines were united by their '"astonishing" capacity for realism and painstakingly detailed representation'. With their use of light and movement, they lured and manipulated the spectator's gaze. With the coming of electricity and mechanical music towards the end of the nineteenth century these luminous photographic entertainments became the technical and cultural antecedents of cinema, which, in one of its earliest forms – Edison's Kinetoscope – was an arcade machine designed to be used by individual viewers (Neale 1985).

More recently, two major popular forms which digital image technology has taken are those of the console-based interactive computer game for domestic use, and the 'coin-op' arcade game (Haddon 1993). By 1995, the magazine CD Rom Today reported that the gross US turnover for computer games had equalled that of the Hollywood movie industry (Dewdney and Boyd 1995). The interactivity which is central to the design and use of personal computers has major roots in the arcade game, the 'earliest form of interactive software to find a mass market' (Haddon 1993). The imagery of interactive CD-Rom also strives for the high resolution of the photographic image in combination with full motion video and stereo sound. These are held in audio-visual structures, exhibited on luminous screens, which invite the individual viewer to navigate in and out of parallel or forking narrative paths which frequently draw upon a range of traditional narrative genres borrowed from cinema or television.

In these ways digital CD-Rom can be understood as a developed electronic version of many preceding forms of visual entertainment which has, as one of its roots, these nineteenth-century forms of photographic entertainment and spectacle (Dewdney and Boyd 1995).

PHOTODIGITAL: TAKING STOCK

We have seen in the previous pages that the earlier, and still influential, attempts to gauge the significance of digital imaging for photography focused upon the differences between the analogue and the digital image, and between practices of representation (photography) and simulation (computer graphics) as the key issues. They argued that shifts from analogue/representation to digital/simulation were the visual expression of an underlying shift from a modern to a postmodern world and the loss of the kind of world-view that photography had provided since the mid-nineteenth century. A new

post-photographic era in visual culture was being ushered in, in which we could no longer cling to our fragile if tenacious belief in the truth and evidential value of photographs. At the same time a range of historical antecedents had been brought to light which pointed to cultural continuities in the uses of photography which cut across its many technological developments.

It now seems clearer than ever that the 'logic' of digital photography contains a tense relationship between continuity and discontinuity. While digital image technology may be replacing the photographic apparatus it is also playing a part in continuing and even raising the value of the photographic image so that thinking in terms of absolute differences between the two hardly makes sense. We can see a more complex interplay taking place. By any account we are faced with a situation which cannot be reduced to simply thinking in terms of the replacement of one medium or image technology by another. As Lev Manovich puts it,

'The logic of the digital photograph is one of historical continuity and discontinuity. The digital image tears apart the net of semiotic codes, modes of display, and patterns of spectatorship in modern visual culture – and, at the same time, weaves this net even stronger. The digital image annilhilates photography while solidifying, glorifying and immortalizing the photographic.'

(Manovich: 2003: 241)

On this note, the rest of this chapter will consider more recent challenges and refinements to the ideas considered in earlier sections of the chapter as it is now possible to think through what has occurred in more measured and nuanced ways. We now find a situation where the digital has:

- continued to make us puzzle over the source of photography's realism;
- renewed an interest in photography's indexical nature:
- given rise to a new interest in the identity of the viewer of 'post-photography';
- required us to think about the reception, rather than the production, of digital photographs;
- led us to question, in the light of practical experience and use, the earlier abstract thinking that was brought to bear on the analogue/digital difference:
- suggested grounds for conceiving of a 'post-human' vision (replacing an earlier preoccupation with the resonance between 'post-photography' and the postmodern).

Remembering photography's nature

It has been a remarkable aspect of the emergence of digital image technology that it has led us to reappraise how we have understood photography and to revisit old questions and debates about its realism. Sarah Kember (1998: 17) points to a conundrum which is one of the main reasons for this:

Computer manipulated and simulated imagery appears to threaten the truth status of photography even though that has already been undermined by decades of semiotic analysis. How can this be? How can we panic about the loss of the real when we know (tacitly or otherwise) that the real is always already lost in the act of representation?

Why then, does computer manipulated and simulated imagery appear to threaten a practice that is already recognised as one of mediation and manipulation? In the section Digitisation and the commodification of images, we met Rosler's argument that manipulation was integral to photography as seen in the very earliest uses of multiple negatives by photographers like Oscar Rejlander and in the openly manipulative, alternative traditions of photography, represented by photomontage and the work of the Dadaists and John Heartfield. Subsequently, Manovich has asserted that 'Digital technology does not subvert "normal" photography because "normal" photography never existed' (Manovich 2003: 245). Batchen (2001: 137) also argues that photography is nothing if not a history of manipulated images.

In different ways, both Kember (1998: 17) and Batchen (2001: 139–43) have argued that a tenacious belief in photography's realism is due to a strong historical investment in the idea. We must look to the history of image making and the 'way of seeing' that it embodied that we traced earlier in this chapter (A new way of seeing and the end of the 'Cartesian dream?').

Our belief in photography's realism

We saw earlier that photography is part of a **scopic regime** that is far wider and has a much longer history than itself. We must now consider the cultural identity of the 'viewer' who sees in this manner. At the centre of this history of Western visuality stands the humanist self. This is a conception of the human subject who, amongst other things, is understood to be the rational centre of the world and the prime agent in seeking its meaning and establishing its order. We described this humanist subject as one who has searched for certain and objective knowledge through a disinterested and rational method of enquiry.

In her own reflection on the question, Kember stresses that this subject and this scopic regime are part of a larger scientific system and mode of enquiry, 'fashioned in Enlightenment philosophy and by Cartesian dualism and perpectivalism' (1998: 23). It is a system in which the viewer is understood as a centred, knowing subject coaxing information from a passive supine nature. However dominant this rational-scientific system and the centred humanist subject became over a period of some 500 years she reminds us that this position was always unstable and gendered. It was gendered because

The particular questions raised by digital technologies for documentary photography are discussed in more detail in chapter 2.

The concept of a 'scopic regime' is Martin Jay's. See Jay, M. (1992) 'Scopic Regimes of Modernity' in Lark, S. and Friedman, J. (eds) *Modernity and Identity*, Oxford: Blackwell.

typically the 'knowing subject' was figured as male and 'supine nature' as female – see Figure 7.5). It was unstable, because it was a system that depended upon (and was simultaneously troubled by) a desire to exercise power and control over nature and over others. Seen in this context we can understand that our 'panic' about the computer's threat to photography's realism does not actually take place at the level of the image itself. It is cultural panic over the potential loss of our centred, humanist selves, with our 'dominant and as yet unsuccessfully challenged investments in the photographic real' (Kember 1998: 18). The perceived threat is to our subjectivity, where a more fundamental fear is triggered which concerns, 'the status of the self or the subject of photography, and about the way in which the subject uses photography to understand the world and intervene in it' (1998: 18).

Digital photography (or digital imaging) has clearly shown us that even if the mechanical camera and chemical film are no longer involved, a practice and a form of image production persists that can be called photographic (or at the very least post-photographic). We have now seen that the value of photography depends upon more than its technology or the way it 'looks' but also upon our historical, cultural and psychic investment in it as a way of seeing and knowing. It affords us a position, an identity, a sense of power, and it promises to meet our desires. So, as Batchen (2001: 140) suggests, photography is more than its machines, it is also an 'economy of photographic desires and concepts'. At the centre of this economy is a desire to be securely placed as observers in relation to objects which interest us. For over 150 years we have gone to photography to give us reports on nature, to produce knowledge of others, to arrest time, to document and remember, to bring the spatially distant closer (to travel in space). Overall, we have looked to photography to provide a picture of a reassuring world in which every thing appears to stay in its time, space and place (Kember 1998: 2). As long as such interests and projects are pursued by human beings, then surely 'a photographic culture of one sort or another will (. . .) endure despite the fact that computers may replace cameras and film' (Batchen 2001: 141).

Kember's account of photographic realism as part of a long humanist investment, and Batchen's concept of a 'photographic economy' which contains a set of enduring human desires and concepts, remind us why the single most important medium in modern visual culture cannot simply be swept aside by technological change. However preoccupied we have become with the technological and signifying differences between photography and digital imaging we are also called to think about the strength of the human (humanist) values which will direct our use of either. Yet, as we shall see below, arguments are now made which suggest that a new kind of vision and new kinds of images may displace photography precisely because the old, settled concept of the human as absolutely different and other to technology is, itself, under attack.

The force of the indexical image

We dealt earlier with the over-played idea that realism is more a property of some kinds of photograph than of (some kinds) of digital image, an idea that was at the centre of many early estimations of their difference. Photography's indexical quality also played a part in those earlier comparisons, in that the photograph was seen to have a fixed and mechanically guaranteed link with what it depicts while the digital image tended toward the artificial, the constructed and simulacral. Much was also made of its novel 'immateriality' in the sense that a photograph could exist as an electronic file. (See Box D Analogue and digital.)

The value that we have traditionally placed on the indexical nature of the mechanical and chemical photograph is an important part of the 'photographic economy' we have just discussed. It is also a quality that is closely associated with beliefs in photography's realism but which needs thinking about in an entirely different way. The resources to do this have been to hand for some time (Barthes: 1980) but it is the puzzles thrown up by digital image technology's relationship to photography that have sent us back to think again. A compelling feature of chemical photography is the manner in which a photograph is caused by the light travelling from an object; in other words, that it is an image that is caused by what it represents; as the footprint is to the foot. In making the same point, photographs have been described as being like stencils off the real (Sontag: 1979). However, these 'stencils' or traces are ones in which any reality content or verisimilitude has been transcribed, manipulated, enhanced, suppressed or emphasised by the mediating processes of photography yet they remain traces or indexes, nevertheless. Such traces could be in fact quite minimal in terms of verisimilitude or information about what they represented, being little more than smudges and marks on paper which we struggle to decipher.

While it plays a part in forming our beliefs in photography's realism, photography's indexicality is, in fact, something quite different from realism. The indexical quality of a photograph has more to do with a sense of presence than realism. It testifies to the being or existence of something that was once before the camera. The photographic negative was once, as it were, in touch with the object it depicts. Clearly, this indexical quality of a photograph can coexist alongside its mediations. The ideas that a photograph constructs and leads us to have about some-thing, (or person, or event) through its mediations and codes, whether they are 'true' or 'realistic' or not, can be accompanied by a powerful sense that this thing 'has been', does or did exist (Batchen 2001: 139). Hence, even given the theoretical knowledge and critical understanding we may have about the impossibility of photographic representations capturing the 'real', we nevertheless 'sense' the real in a photograph. We 'feel' the presence of the real. This indexical quality is a characteristic of the photographic image which resists and is untouched by

our very understanding that what is before us in a photograph, is very far from a simple reality or truth (Kember 1998: 31).

Traditional photographs are material, and usually portable objects. In considering photography's indexical proximity to the 'real', it is important also to think about this materiality. A photographic print is both like a 'stencil' and is a physical object itself. Photographs frequently take the form of small things we have and keep, which we can carry with us and look at in the absence of what they depict. Putting photographic indexicality and materiality together we get a powerful mix; we see the photograph as something which it is as important to hold, touch, feel and check for as it is to see, and which we sense has literally touched something that exists but is absent or has existed but is no more. This is the photograph as a modern kind of fetish; it stands in for or displaces something lost or unattainable but desired (Kember 1998: 210).

However, digital photographs can also be indexes in both a technical way and, possibly more importantly, in how they are received and valued. We will consider this below as part of a wider discussion of the reception of digital images.

The reception of digital images

In ch. 1 (pp. 30–3), it was noted that in his book *Camera Lucida*, Roland Barthes was interested in the act of looking at photographs rather than their production. He was interested in the meaning or indeed, the feelings, we have about photographs which remain of people once known to us, after their death. In thinking about photography this way we move to consider the reception, rather than the production of photographs; and to reflect on our felt experience of images rather than the analysis of their signifying means. When we do this, the difference between the chemical and the digital photograph again ceases to be important.

The significant differences between the purely photographic and the digitally registered photograph lie in the way it was 'taken', registered or transmitted, not simply the way it looks. Hence, in thinking about 'pre' and 'post' digital photography we are not always faced with evident and visible differences in the images themselves. This is because of the capacity of the new image technologies to register, carry, mimic, or simulate photographic images in increasingly undetectable ways. Over the last decade of 'digital photography' this has become more and more clearly the case. Far from always being used to produce images of a montage-like heterogeneity, digital imaging technology is just as likely to be used to make images that are as traditionally coherent in their pictorial unity and exhibit the pictorial values of traditional, chemical photographic prints. Similarly, in the case of the impact of digitisation on archive images, picture libraries and image banks, the critical issues are ones of access, transmission and the use of images which continue to look like photographs.

This is the aspect of photography famously explored by Barthes in Camera Lucida — where he runs counter to his own influential, intellectual semiotic analysis of photography to ask, 'What does my body know about photography?'.

Jay David Bolter and Richard Grusin (1999: 105-12) extend this point when they observe that digital photographs are intended to be received by their viewers as photographs. It matters not whether an image was captured by the photosensitive cells of a digital camera (clearly a form of indexical registration), or, perhaps more surprisingly, was a conventional photograph that is subsequently scanned by a computer and altered, or is a combination of two digitised photographs and computer generated elements. All of these images address us as photographs. Digital photographers want us to regard their images 'as part of the tradition of photography' (Bolter and Grusin 1999: 105). These are all images that are advertised or presented to us as photographs. They are all intended to be part of the tradition of photography. When we see any of these images we see, phenomenologically, a photograph; an image that has all the marks of a photograph and calls us to read it as a photograph, that depends for its sense on the capacity of viewers to read photographs. Further, Bolter and Grusin argue, digitising the light that comes through the lens of a digital camera is no more or less artificial then the chemical process of traditional photography. A photograph's tonal values may be altered by the algorithms contained within a piece of computer software or by the length of time it is immersed in chemicals. It is a cultural judgement to say that one of the images is more true than the other. In short, 'whether the image is mechanically or digitally produced is irrelevant' (Kember 1998: 11).

It is also the case that many photographs do not operate, or are not valued, as indexes (even if they are). It is quite possible to 'read' photographs as other than evidence of concrete things that existed in a specific time and place. As Manovich observes, 'A photograph as used in an advertising design . . . does not say . . . this hat was in a room on May 12'. Rather it simply represents 'a hat' or 'a beach' or 'a television set' without any reference to time and location (Manovich 2003: 245). Thought about this way the difference between certain kinds of photographs and paintings, let alone digital images, no longer holds.

Does digital photography exist?

Another kind of criticism of earlier ideas about the revolutionary impact of digital imaging upon photography has emerged. It again qualifies the degree of difference between them, and it flows from a continuing suspicion of arguments that are based upon abstract principles and technical differences. In the mid-1990s, Manovich and others (see Robins 1995, Lister 1995b, Kember 1998), pointed out the flaw of restricting the discussion of digital technology's effect upon photography to its technical means alone. They objected, in particular, to the habit of inferring cultural consequences directly from technological differences. In 'The Paradoxes of Digital Photography' Manovich pointed out that two key points of difference between photography and digital imaging, which were made much of by Mitchell (1992: 4–6), while correct

in technical principle, have no cultural significance (Manovich 2003: 242). These differences were:

- (i) that there is no hierarchy between a digital original and its copy;
- (ii) that the information encoded in a photograph is indefinite and continuous while in a digital image it is precise and definite. Enlarging a photograph reveals more information (if at the loss of resolution) while enlarging a digital image reveals none.

Neither, observes Manovich, matter in practice. In the first case, due to the file compression used in storing and sending digital images, (a necessary and normal practice in digital production now central to the economy of new media) loss of data and degradation of the image routinely occurs as files are copied and circulated. Practically, it makes no sense to say that digital technology makes the 'flawless replication of data' (ibid: 243) possible and that a digital image has no original or copies. In the second case, the high resolution capable by modern scanners means that the amount of information or detail contained in a digital image records, 'much finer detail than was ever possible with traditional photography' (ibid: 243). Effectively, it surpasses human interest in that detail or our cultural need for it. This is a good case of abstract theory being correct in its own terms while shedding little light on practice. Mitchell's 'differences' may be correct in principle but, 'if we consider concrete digital technologies and their uses, the difference disappears. Digital photography simply doesnt exist' (Manovich 2003: 242).

Photo-realism versus post-human vision

So far, in 'taking stock' of more recent thinking on the photodigital, we have noted a marked tendency to refute, or at least minimise the earlier claims for a radical difference. Finally, we turn to note another line of thought which, arguably, paints a more revolutionary picture than any of the thinking we have met so far in this chapter.

The computer is a kind of universal machine; it can assume the function of many other machines, including the camera, a machine that takes photographs. This capacity may be distributed across the silicon chips that compute the operations of a digital camera, which itself is connected as a 'peripheral' to the processing power in a PC, and to others such as scanners, printers and data-projectors. There may then be an optical lens trained upon the world of physical things but it is deeply enmeshed in digital technology. In the case of the simulation of photographic images by 3–D computer graphics software this optical relationship to 'things' in the world is replaced by knowledge of their physics and of photography (its optics) stored in the computer and its software. The computer knows what something in the physical world would look like if it were photographed. This last point alerts us to the fact that whatever else computer generated 'photographs' represent

they also, always represent or refer to, the look of photographs (Batchen 2001: 140). Digital images become signs for photographs, which, as we discussed above, are themselves, signs of the 'real'.

A good example of this is now found in the employment of computer graphics in contemporary cinema. 3-D computer graphics as it is used in contemporary cinema has realist goals. In many cases, the aim is to make a fantastic proposition appear realistic. The standard of realism it seeks is 'photorealism' – the look of something when photographed. As Allen (1998: 127) observes:

In cases where a real-life equivalent is clearly impossible, such as the morphing effects in *Terminator 2*, the pictorial quality of the effect must be sophisticated and 'photo-realistic' enough to persuade the audience that if, for example, a tiled floor transformed into a human figure in real life, it would look exactly like its screen depiction does.

To achieve the seamless integration of computer simulated scenes with cinematography of real scenes, the clinical images produced by the computer are deliberately degraded and rendered 'photographic' by closely guarded algorithms which are the industry's stock in trade (Manovich 2003: 247). These add 'noise' to the pristine computer image in the form of distinctive photographic qualities: areas of soft focus, depth of field, lens flare and halation, added to ensure the 'reality' of the image. If computer graphics succeeds in creating realist illusion it does so by borrowing 150 years of photographic history in which time we have come to accept the images of photography and film as images of the real (ibid: 246). In this aspiration of computer graphics to be photo-realistic the photographic image is newly valued as the very sign of reality at the same time as it is, in part, displaced in the technical production of the movie (ibid: 246–8).

But what of the computer simulated images themselves? If not adjusted to match the look of photographs, they are photo-unrealistic in their hyperreality, and free from the limitations of human and camera vision. '(W)hose vision is this?' asks Manovich (2003: 248). His answer is that they are representations of a cyborg vision; the vision of a hybrid human-machine. Indeed, it is argued that Manovich's 'cyborg body to come' is with us already, as Batchen recognises, when he points to digitisation, prosthetic and cosmetic surgery, cloning, genetic engineering, artificial intelligence and virtual reality as signs that the old category of 'the human' may no longer be with us in any settled way.

As such, they are representations of a future vision, when human sight will be augmented by computer graphics. Even the gaps and imperfections of computer images are not 'unreal' because they are the images of another kind of body than the organic human one – they are of a cyborg body yet to come. In the 1930s Walter Benjamin claimed that 'evidently a different nature

For a more detailed discussion of these developments see New Media: A Critical Introduction, pp. 137–59, Lister et al. (2003). See the section: Walter Benjamin and the precedent of the age of mechanical reproduction

See also: Hayles, N. Katherine (1999) How We Became Posthuman: Virtual Bodies in Cybernetics, Literature, and Informatics. Chicago and London, University of Chicago Press, and Lury C. (1998) Prosthetic Culture: Photography, Memory and Identity, London and New York: Routledge.

opens itself to the (photographic) camera than opens to the naked eye' (Benjamin: 1970a: 238). Now we may need to entertain that computer simulated images are not less or more real than those of photography, they are a representation of a different reality or, in Benjamin's terms, 'nature'.

In considering the idea that different realities open themselves up to the human eye, the camera, and now the computer, we are yet again returned to the Cartesian or humanist scopic regime we discussed earlier in this chapter. We must now entertain the idea that we live amidst large shifts in how we understand the world and our place within it. Ones in which the very security of our traditional distinctions between nature and culture and human and technological are dissolving.

Glossary

KEY TERMS

aesthetic Pertaining to perception by the senses, and, by extension, to the appreciation or criticism of beauty, or of art. Thus 'aesthetics' references the criteria whereby we judge a work of art. Such criteria primarily include formal conventions (composition, tonal balance, and so on). Aesthetic philosophy is concerned with systems of principles for the appreciation of the beautiful, including the beautiful in art.

analogue A form of representation, such as a painting, a chemical photograph or video tape, in which the image is composed of a continuous variation of tone, light or some other signal. Similarly, a gramophone record is an analogue medium for reproducing sound or music. Analogue representation is based upon an unsegmented code while a digital medium is based upon a segmented one in which information is divided into discrete elements. The hands of a traditional (analogue) clock which continuously sweep its face, in contrast to a digital clock which announces each second in isolation, is a common example of the difference.

art Imagery created principally for exhibition in galleries, museums, or related contexts. In this book we use 'Art', to refer to 'high art' and related gallery and funding systems and institutions.

autographic A generic term applied to all of those processes – drawing and painting being the main ones – in which images are made by the action and coordination of the eye and hand, and without mechanical or electronic intervention. Autographic images are authored wholly by physical and intellectual skill, or as a general field of (artistic) practices.

carnivalesque A concept developed by the Russian theorist Bakhtin to describe the taste for crude laughter, bad taste, excessiveness (particularly of bodily functions) and

offensiveness. It celebrates a temporary liberation from recognised rules and hierarchies and is tolerated because, once people have been allowed to let off steam, those norms can be re-established.

code Used here in the **semiotic** sense to refer to the way in which signs are systematically organised to create meaning – the Morse code is one simple example. Cultural codes determine the meanings conveyed by various cultural practices, say, the way people dress or eat their meals; photographic codes control the way meanings are conveyed in a photograph – for example, the details that give a news photograph its sense of authenticity, or a wedding photograph the right sort of dignity. Cultural codes are centrally examined in chapter 5.

See semiotics

commodity Something which is bought and sold. The most commonly understood forms of commodity are goods which have been manufactured for the marketplace, but within capitalism other things have also been commodified. Natural resources and human labour have also been metamorphosed into commodities.

commodity culture A term increasingly used to describe the culture of industrial capitalism. Within today's culture everything, even the water we drink, has become a product to be bought and sold in the marketplace. Commodity culture also infers the naturalisation of this system to the extent that we cannot imagine another way of living.

construction This refers to the creating or forging of images and artefacts. In photography this particularly draws attention to the deliberate building of an image, rather than its taking from actuality, through **staging**, **fabrication**, **montage** and **imagetext**. The term also reminds us of Soviet Constructivism, which emphasised the role of Art in the building of a new social order and used industrial elements, putting them together as work. It also draws upon theories of **deconstruction**.

deconstruction A radical poststructuralist theory, centred upon the work of French literary theorist, Jacques Derrida, which investigates the complexity and, ultimately indeterminable, play of meaning in texts. Derrida's focus is literary, but the analysis may be extended to the visual.

discourse The circulation of an idea or set of ideas. Photography is one of the many media – including newspapers, books, conversation, television programmes, and so on – which constitute contemporary discourses.

See ideology

epistemology A branch of philosophy concerned to establish by what means knowledge is derived. It is concerned with questions such as what it is possible to know and how reliable is knowledge. In the present context, questions can be asked about what kind of knowledge images provide, and how they do it.

fantasies The term 'fantasy' usually refers to stories, daydreams and other fictions. It is sometimes distinguished from 'phantasy', which is a more technical term from

psychoanalysis referring to **unconscious** processes. This book draws on both meanings, especially when discussing writers and photographers influenced by psychoanalytic thought.

See unconscious

fetishism The substitution of a part for the whole; or use of a thing to stand in for powerful but repressed forces. In Freudian theory fetishism refers to the displacement and disavowal of sexuality. Fascination or desire are simultaneously denied, and indulged through looking at an object or image which stands in for that which is forbidden. Thus a photographic image of a fragment of a woman's body may stand in for woman as object of sexual desire.

See objectification, psychoanalysis, voyeurism

formalism The prioritisation of concern with form rather than content. Focus on composition and on the material nature of any specific medium.

gaze This has become a familiar term to describe a particular way of looking at, perceiving and understanding the world. It was brought into currency by writers on cinema, concerned to analyse the response of the audience as voyeurs of the action on the screen. The voyeuristic gaze is used to describe the way in which men often look at women, as well as the way in which Western tourists look at the non-Western world. More recently, discussions have focused on the implications of a 'female gaze'.

hegemony Dominance maintained through the continuous negotiation of consent by those in power in respect of their right to rule. Such consent is underpinned by the possibility of coercion.

See ideology

heuristic An educational strategy in which students (or researchers) are trained to find things out for themselves.

historicisation Used (in chapter 7) to refer to the process by which events or other phenomena are given a place in an historical narrative. Photography may be defined by the position that it occupies in a larger historical schema or an unfolding over time of technologies and practices.

identity A person's identity is their sense of self and the different contexts within which that selfhood is constructed. It can never be given one simple, coherent description. For example, the national identity into which one is born may well clash with the cultural identity of the community in which one chooses to live; or a gay identity, based on sexuality, may clash with a religious identity based on strict rules governing sexual behaviour.

ideology This term is commonly used in two differing but interconnected ways. In this book it is used primarily to refer to a system of bodies of ideas which may be abstract, but which arise from a particular set of class interests. The term is also commonly used to refer to ideas which are illusory, whose purpose is to mask social and economic relations which actually obtain. For instance, the idea that children need their mother

at home (which was common in the 1950s) masked the economic relations of patriarchy whereby married women were rendered financially dependent upon their husbands.

index One of three kinds of sign defined by American semiotician, C.S. Peirce. The indexical sign is based in cause and effect, for example, the footprint in wet sand indicates or traces a recent presence. The other two types of sign are the iconic (that which is based in resemblance), and the symbolic, or sign proper (that which is entirely conventional).

indexicality This term refers to a cluster of qualities and ideas about photographs which are associated with their indexical nature (see **index** above); in other words, the manner in which a photograph can be understood to be a chemical trace or imprint, via the passage of light, of an existing (or once existing) physical object. For example, ideas that photographs are closely related to memory, the past, presence and absence, and death. Or, that they are tangible evidence of a thing's existence. A further meaning is that the 'taking' of a photograph can be thought of as 'pointing' to something in the world.

See semiotics

mimetic representation Based upon imitation, upon showing rather than telling, a concept central to traditional post-Renaissance art theory.

See representation

modernism In everyday terms 'modern' is often used to refer to contemporary design, media or forms of social organisation (as in 'the modern family'). But 'modern' also frequently refers to the emphasis upon modernisation from the mid-nineteenth century onwards, and, more particularly, to Modern movements in art and design from the turn of the twentieth century. It is essentially a relative concept (modern by contrast with . . .); its precise usage depends upon particular contexts. In this book we distinguish between three terms: modernism, sets of progressive ideas in which the modern is emphasised and welcomed; and modernity, social, technological and cultural developments. The term 'Modernism' is used in chapter 6 to refer to particular emphasis on form and materiality in modern art. Throughout the book a distinction is made between the modern, and the postmodern or contemporary.

See postmodern

objectification It is often argued that photography objectifies people by turning them into things or objects to be looked at thereby disempowering them.

See voyeurism

ontological Ontology is a branch of philosophy. It concerns the study of how things exist and the nature of various kinds of existence. It involves the logical investigation of the different ways in which things of different types (physical objects, numbers, abstract concepts, etc.) are thought to exist.

the Other A concept used within **psychoanalysis** and **identity** theory, and within post-colonial theory, to signify ways in which members of dominant groups derive a

sense of self-location partly through defining other groups as different or 'Other'. Thus, within patriarchy, the male is taken as the norm, and woman as 'Other'; that is, not male. Similarly, in racist ideologies, whiteness is taken for granted, therefore blackness is seen as Other.

See identity, psychoanalysis

phenomenology A philosophical movement founded by Edmund Husserl in the early twentieth century in which the focus is on perception and consciousness, upon what the senses and the mind notice.

polysemic A property of signs is that they can have many meanings, depending on their context and the interests of their readers. Hence the frequent use of captions, or words within the image, to help anchor meaning.

positivism As is implied in the roots of the term itself, positivism stresses that which is definite or positive, i.e. factually based. Positivism, with its associated emphasis upon logical deduction and empirical research methods, including the social survey, is associated with the Victorian period in Britain, although its roots lie in earlier, eighteenth-century philosophy.

postmodern Literally 'after the modern', the postmodern represents a critique of the limitations of modernism with its emphasis upon progress and, in the case of the arts, upon the materiality of the medium of communication. Philosophically, postmodernism has been defined as marking the collapse of certainty, a loss of faith in explanatory systems, and a sense of dislocation consequent on the global nature of communication systems and the loss of a clear relation between signs and their referents.

poststructuralist At its most simple, this means 'after Structuralism', also implying critical thinking that contests and goes beyond Structuralist theory and method, rejecting the idea that all meaning is fundamentally systematic. In this book it is used to refer to a group of theories which stress the way that the human 'self' and the meaning made of the world is constructed through the languages (including visual languages) which we use. Poststructuralist thinking challenges the idea that there is a fixed and stable human subject who can have certain knowledge.

See identity, structuralism

private and public spheres We lead our lives within two distinct modes, a 'private' sphere, which is made up of personal and kinship relations and domestic life, and a 'public' sphere, made up of economic relations, work, money-making and politics. The 'private' sphere tends to be controlled by moral and emotional constraints, the 'public' sphere by public laws and regulations. This distinction, although contested by feminist writers, underlies the way the terms 'private' and 'public' are used in this book, especially in chapter 3.

psychoanalysis The therapeutic method established by Sigmund Freud, which involves seeking access to traumatic experiences held in the **unconscious** mind.

See repression, unconscious

representation This refers to ways in which individuals, groups or ideas are depicted. Although this seems obvious, the use of the term usually signals acknowledgement that images are never 'innocent', but always have their own history, cultural contexts and specificity, and therefore carry **ideological** implications.

repression Unpleasant or unwelcome thoughts, emotions, sensations are 'repressed' when they are forced into the **unconscious**. The phrase 'the return of the repressed' means that such emotions surface into the conscious world in different form.

See psychoanalysis, unconscious

reproduction The production by machine of many identical copies. The process of mass production when applied, through photography, print technology, and electronic recording to the copying of visual images or music. As this process has become increasingly sophisticated, the reproduction of original works of art has reached a stage where the reproduction is, for almost all intents and purposes, as good as the original. Where it does not, and cannot, replace the original autographic work is in bearing the traces and marks of its maker. Such originals have been spoken of as having an 'aura' (Benjamin) due to our sense of their being unique and of having a history. There are, broadly, two schools of thought about the impact of reproduction on original images. One deplores the 'cheapening' of unique originals through reproduction; the other celebrates the process as a way of democratising visual and aural culture. Whatever the case, photography is a technology which has reproducibility built in. A negative is produced precisely to be able to make infinite numbers of prints, each, in principle, being identical. The phenomenon of the 'artist' photographer's proof, or 'original' print, is therefore an ironic twist and an example of the political economy triumphing over technological determinations. Digital technology now renders distinctions between 'original' and 'reproduction' irrelevant.

scopophilia The human drive to look or observe; in Freudian theory the fundamental instinct leading to **voyeurism**.

See fetishism, voyeurism

semiology see semiotics

semiotics The science of signs, first proposed in 1916 by linguist Ferdinand de Saussure, but developed in particular in the work of Roland Barthes (France) and C.S. Peirce (USA). Semiotics – also referred to as semiology – is premised upon the contention that all human communication is founded in an assemblage of signs – verbal, aural and visual – which is essentially systematic. Such sign systems are viewed as largely – or entirely – conventional; that is, consequent not upon 'natural' relations between words or images and that to which they refer, but upon arbitrary relations established through cultural convention. The sign proper has two aspects, signifier and signified. The signifier is the material manifestation, the word, or pictorial elements. The signified is the associated mental concept; that is, conventionally associated with the specific signifier. While separable for analytic purposes, in practice the signifier and the signified always go together.

See code

social and economic history History may be written in many ways. Economic history deals with changes in work patterns and the ways in which human societies have sustained themselves. Social history deals with the organisation of societies – marriage, education, child-rearing and the like. A history of photography is normally seen as part of art history or, more broadly, of cultural history. In chapter 3 it is suggested that we can understand personal photography better if we consider it within a social and economic context. Chapter 5 takes the social and the economic as the primary context for understanding commercial uses of photography.

straight photography Emphasis upon direct documentary typical of the Modern period in American photography.

structuralism Twentieth-century theoretical movement within which stress is laid upon analysis of objects, cultural artefacts and communication processes, in terms of systems of relations rather than as entities in themselves.

technological determinism This refers to the proposition that technological invention alone determines new cultural formations. The notion has been criticised primarily on the grounds that new technologies arise from research enterprises driven largely by economic imperatives and perceived social or political needs. Technological developments may be seen as an effect of cultural desires as well as a major influence within cultural change.

teleology Arguments and explanations in which the nature of something is explained by the purpose or 'end' which it appears to have. In this view photography, and then cinema, may be understood as being caused by a human desire to achieve ever more comprehensive illusions of reality and are seen as striving towards a future achievement.

unconscious In **psychoanalysis**, that which is **repressed** from the individual's conscious awareness yet gives rise to impulses which influence our behaviour. Freud insisted that human action always derives from mental processes of which we cannot be aware.

See repression, psychoanalysis

voyeurism Sexual stimulation obtained through looking. In photography voyeurism refers to the image as spectacle used for the gratification of the (hitherto construed as male, heterosexual) spectator.

See fetishism, objectification, psychoanalysis

For a comprehensive definition and discussion of *technical* terms in photography see: Baldwin, G. (1991) *Looking at Photographs: A Guide to Technical Terms*, California: The Paul Getty Museum and London: British Museum Press.

For fuller discussion of various contributions to twentieth-century debates, including Barthes, Benjamin, Foucault and Freud see:

Lechte, John (1994) Fifty Key Contemporary Thinkers, London: Routledge.

Photography archives

Work by many photographers, historical and contemporary, is kept under proper conservation conditions in specific archives (or collections). Researching images – perhaps for an extended essay or dissertation – may mean that you want to look at original prints. Here we list some key archives which may be of help to you. However, you should always phone, fax or e-mail in advance to check that the work that interests you is available and to make a viewing appointment. Most archives have some materials reproduced on their website (NB website addresses below, correct July 2003). Also see www.musee-online.org/asppages/PageMenu.asp?MT=20 for international listings of museums concerned with photography.

KEY PUBLIC ARCHIVES IN BRITAIN (Tel: +44)

National Museum of Photography, Film and Television, Pictureville, Prince's View, Bradford, West Yorkshire BD5 0TR Tel: (0)870 7010200, www.nmpft.org.uk Includes the collection of the Royal Photographic Society

National Portrait Gallery, Charing Cross Road, London WC1 Tel: (0)207 306 0055, www.npg.org.uk For photographic portraiture archives and exhibitions

Scottish National Portrait Gallery, 1 Queen Street, Edinburgh EH2 1JD. Tel: (0)131 556 8921, www.nationalgalleries.org For portraiture archives

Victoria and Albert Museum, South Kensington, London SW7 Tel: (0)207 938 8500, www.vam.ac.uk Holds the National Collection of the Art of Photography

Also see www.24hourmuseum.org.uk

OTHER ARCHIVES

- Barnardo's Photographic and Film Archive, Tanners Lane, Barkingside, Ilford, Essex 1G6 1OG. Tel: (0)208 550 8822 x345, www.barnardos.org.uk
- The Documentary Photography Archive, 56 Marshall Street, New Cross, Manchester N4 5FU. Tel: (0)161 832 5284, www.gmcro.co.uk/photography/DPA/dpa.htm
- IRIS, Women's Photography Archive, Staffordshire University Tel: (0)1782 294721, www.staffs.ac.uk/ariadne
- Jo Spence Memorial Archive, 152 Upper Street, London N1 1RA Tel: (0)207 359 9064 National Sound Archive, British Library, 96 Euston Road, London NW1 2DB. Tel: (0)207 942 2000, www.bl.uk/collections/sound-archive/nsa.html Interviews with contemporary photographers
- The Women's Library, Old Castle Street, London E1 7NT. Tel: (0)207 320 2222, www.thewomenslibrary.ac.uk Includes the Fawcett Library (women's rights)

Many organisations, including newspapers and commercial companies, maintain their own archives. However, access to these may be limited, by appointment only or based on payment of search fees. Among the foremost such collections are:

- Hulton Getty Picture Collection, Unique House, 21–31 Woodfield Road, London W9 2BA. (0)207 579 5777, www.hultongetty.com Archives include *Picture Post, Express, Evening Standard*
- Mary Evans Picture Library, 59 Tranquil Vale, London SE3 0BS Tel: (0)208 318 0034, www.mepl.co.uk

Most city libraries include photography in their local history collections. Sometimes this covers major bodies of work; for example, Edinburgh City Libraries house a large collection of calotypes by Hill and Adamson.

ARCHIVES IN THE USA (Tel: +1)

- International Museum of Photography and Film, George Eastman House, 900 East Avenue, Rochester, New York 14607–2298 Tel: (585) 271 3361, www.eastman.org Work by over 10,000 photographers
- New York Public Library Photography Collection, 42nd Street at Fifth Avenue, New York, NY 10018 Tel: (212) 930 0837, www.nypl.org/research/chss/spe/act/photo/photo. htm Work by over 2,000 photographers

Collections with holdings of over 1,000 photographers

- Art Institute of Chicago, 111 South Michigan Avenue at Adams Street, Chicago, IL 60603 Tel: (312) 443 3600, www.artic.edu/aic/index.html
- Center for Creative Photography, University of Arizona, Tucson, AZ 85721 Tel: (520) 6217968, www.library.arizona.edu/branches/ccp/home.html
- Colorado Historical Society, 1300 Broadway, Denver, Colorado 80203. Tel: (303) 866 3682, www.coloradohistory.org Holds 500,000 photographic images
- Harry Ransom Humanities Research Center, University of Texas at Austin, PO Drawer 7219, Austin, TX 78713 Tel: (512) 471 8944, www.hrc.utexas.edu/collections/photography Houses five million photographs
- Getty Center for the History of Art and the Humanities, 1200 Getty Center Drive, Los Angeles, CA 90049 Tel: (310) 458 9811, www.getty.edu/art/collections/collection_types/c260.html Archive of 1.5 million images

- The Library of Congress, Prints and Photographs Division, 101 Independence Avenue, SE, Washington DC 20540–4840 Tel: (202) 707 5000, www.loc.gov/acq/devpol/colloverviews/photography.html Over fifteen million prints and photographs including early daguerreotypes
- J. Willard Marriott Library, University of Utah, Salt Lake City, UT 84112 Tel: (801) 581 7200, www.lib.utah.edu/spc/photo/hp2.html
- Metropolitan Museum of Art, New York (Department of Photographs), 1000 Fifth Avenue at 82nd Street, New York NY 10028 Tel: (212) 535 7710, www. metmuseum.org/collections/department.asp?dep=19
- Museum of Fine Arts, 1001 Bissonnet Street, Houston, Texas TX 77005 Tel: (713) 639 7300, www.mfah.org/main.asp?target=collection
- Museum of Modern Art, 11 West 53rd Street, New York, NY 10019 Tel: (212) 708 9400, www.moma.org/collection/depts/photography Has been collecting photographs since 1930 and holds over 25,000 works from 1840 to now. A large gallery is devoted to permanent collections where vintage prints of the great photographers are housed. Contemporary photographs are also held. (MOMA is closed until 2005, the collection temporarily relocated to MOMA, QNS)
- Museum of New Mexico (photographic archives), 133 Washington Avenue, Santa Fé, NM 87501. Tel: (505) 476 5002, www.museumofnewmexico.org/photos.html
- National Museum of American History, Smithsonian Institute, 14th Street and Constitution Ave, NW, Washington DC 20560 Tel: (202) 357 2700, www.american history.si.edu/csr/index.htm
- New Orleans Museum of Art, 1 Collins Diboll Circle, City Park, New Orleans, LA 70124 Tel: (504) 488 2631, www.noma.org/html_docs/photo.html
- San Francisco Museum of Modern Art, 151 Third Street, San Francisco, CA 94103 Tel: (415) 357 4000, www.sfmoma.org/collections/collections_photography.html
- University of New Mexico, Albuquerque, NM 87131 Tel: (505) 277 0111, www.unm.edu/~falref/html/guide-call-photo.html
- Visual Studies Workshop, 31 Prince St, Rochester, New York 14607 Tel: (585) 442 8676, www.vsw.org/research/researchcenter.html

For smaller archives, and for listings of photographers included in the collections listed above, see Andrew H. Eskind (ed.) (1996) *Index to American Photographic Collections*, compiled at the International Museum of Photography at George Eastman House, Rochester, 3rd edn. New York: G.K. Hall & Co.

See also *USA Photography Guide* (1998 3rd edn, Tucson/Munich: Nazraeli Press) for details of galleries, publishers, associations, museums and collections, and courses.

There are several major commercial collections with online presence, including Getty Images, 122 South Michigan Avenue, Suite 900, Chicago, IL 60603. Tel: (800) 644 7781, www.hultongetty.com.

Hulton/Archive, 75 Varick Street, New York, NY10013. Tel: (800) 876 5115, www.hulton getty.com.

ARCHIVES ELSEWHERE (ENGLISH-LANGUAGE-BASED)

Australia (Tel: +61)

Collections of photography are held at:

Art Gallery of New South Wales, The Domain, Sydney, NSW 2000 Tel: (2) 9225 1700, www.artgallery.nsw.gov.au/collection

LaTrobe Library, State Library of Victoria, 328 Swanston Street, Melbourne, Victoria 3000 Tel: (3) 9639 7006, www.statelibrary.vic.gov.au/slv/pictures

Mitchell Library, State Library of New South Wales (major photography collection), Macquarie Street, Sydney, NSW 2000 Tel: (2) 9273 1414, www.sl.nsw.gov.au/picman/about.cfm

National Gallery of Australia, Parkes Place, Canberra, ACT 2601 Tel: (2) 6240 6502, www.nga.gov.au/Home/index.cfm (Art collection including photography)

National Gallery of Victoria, 180 St Kilda Road, Melbourne, Victoria Tel: 9208 0222, www.ngv.vic.gov.au/collection

National Library of Australia, Canberra. ACT 2600 Tel: (02) 6262 1266, www.nla. gov.au/pict Queensland Art Gallery, Melbourne St. South Brisbane, Queensland 4101 Tel: (7) 3840 7333, www.gaq.qld.gov.au/collection/areas.htm#pdp

Canada (Tel: +1)

Canadian Museum of Contemporary Photography, 1 Rideau Canal, PO Box 465, Station A, Ottawa, Ontario K1N 9N6. Tel: (613) 990 8257, www.cmcp.gallery/ca Over 158,000 images by Canadian photographers

National Gallery of Canada, 380 Sussex Drive Box 427, Station A, Ottawa, Ontario K1N 9N4 Tel: (613) 990 1985, www.national.gallery.ca An international collection of almost 20,000 photographs ranging from early photography to the contemporary

New Zealand (Tel: +64)

Alexander Turnbull Library, POB 1467, Wellington 6000 Tel: (4) 474 3000, www.natlib. govt.nz/en/using/2atl.html Some 846,000 photographs

Auckland Museum, Private Bag 92018, Auckland 1 Tel: (9) 309 0443, www.akmu-seum.org.nz/web/ Contemporary collection of Robin Morrison photographs

National Archives, 10 Mulgrave Street, PO Box 12–050, Wellington Tel: (4) 499 5595, www.archives.govt.nz Over 200,000 photographs

For listings of all major and regional photograph collections in New Zealand see *Directory* of New Zealand Photograph Collections, 1992, available from The National Library Shop, POB 1467, Wellington. Email: atl@natlib.govt.nz

South Africa (Tel: +27)

Bensusan Museum of Film and Photography. in MuseuMafricA, at 121 Bree Street, Newtown, Johannesburg. Historical collection, with particular reference to South Africa.

Note: for other European archives see H. Evans and M. Evans (compilers) (1992) Picture Researcher's Handbook: An International Guide to Picture Sources and How to Use Them, London: Chapman and Hall. See also European Photography Guide 7, Göttingen: European Photography 2001 which includes information for over 2,000 individuals and institutions in 32 European countries and also information on magazines and journals, grants, awards, festivals and fairs, auctions and bookstores.

KEY BRITISH MAGAZINES AND JOURNALS

Autograph, The Association of Black Photographers (founded 1988), quarterly. www. autograph.abp.co.uk

British Journal of Photography, London (founded 1854), weekly. Focus on commercial photography. www.bjphoto.co.uk

History of Photography, Oxford (academic journal, founded 1977), quarterly. www. tandf.co.uk/journals/tf/03087298.html

Portfolio, Portfolio Gallery, Edinburgh, biannual. www.portfoliocatalogue.com

Source, Belfast, first issue Summer 1992, quarterly. www.source.ie

Camerawork, London (until 1985). Concerned with social and political issues.

Creative Camera, London, (until 2001) published six times a year. Contemporary gallery-based photography.

Ten/8, Birmingham (until 1992; titled Ten.8 in the two final issues).

KEY NORTH AMERICAN MAGAZINES AND JOURNALS

Afterimage, Visual Studies Workshop, Rochester, NY. Issues in photography and video. www.vsw.org/afterimage/index.html

Aperture New York/San Francisco, quarterly since 1952. Themed issues and portfolios. (Also for photography books.) www.aperture.org/magazines.html

Blackflash, The Photographers Gallery, Saskatoon, Saskatchewan, Canada. Three yearly.

Journal of photo-based and electronic-art production. www.blackflash.ca/About/
about.htm

Border Crossings; Winnipeg, Manitoba, quarterly. An interdisciplinary arts review featuring articles, book reviews, artist profiles, and interviews covering the full range of the contemporary arts in Canada and internationally. www.bordercrossingsmag.com

Canadian Art, Toronto, Ontario, quarterly. Visual arts in Canada. Includes critical profiles of new artists and established art world figures. www.canadianart.ca/

CV Photo, Montreal, Quebec, quarterly. Richly illustrated magazine, photographic work, essays. www.cvphoto.ca/

October, The MIT Press, Cambridge, MA, quarterly since 1976. Academic journal: art, criticism, theory and history. http://mitpress.mit.edu/catalog/item/default.asp?ttype= 4&tid=18

Parachute, Montreal, quarterly. Contemporary art including photography. Bilingual. /www.parachute.ca

Visual Anthropology Review, published by the American Anthropological Association. Debates on documentary and anthropology. etext.Virginia.EDU/VAR/

OTHER MAGAZINES AND JOURNALS

Published in English or with translation

Camera Austria, contemporary photography. Quarterly. www.camera-austria.at European Photography, Göttingen, Germany, founded 1980. Twice yearly. www. european-photography.com

Flash Art International, European Art magazine, firt published as Flash, 1996. Quarterly. www.flashartonline.com

Katalog, Denmark. Quarterly journal of photography and video, founded 1988. www. brandts.dk/katalog/

NZ Journal of Photography, New Zealand Centre for Photography, POB 27–344, Wellington, articles about NZ photography and portfolios of images. Quarterly http://nzcp.wellington.net.nz/nzjp.htm

Photofile, Australian Centre for Photography, Sydney, founded 1983. Thrice yearly. www.acp.au.com/photofile/photofile.shtml PhotoVision, Spain, founded 1981, biannual. www.photovision.es

WEBSITES

Dealing with photography and digital media. These are just a few of what is now a huge range of sites. You should also use keyword searches, to ensure you find the most up-to-date sites.

ADAM www.adam.ac.uk

The Art, Design, Architecture & Media Information Gateway is a searchable catalogue of Internet resources internationally selected and catalogued by professional librarians in UK Higher Education (under reconstruction, July 2003).

ADAWEB http://www.adaweb.com

A website which aims to provide contemporary artists (visual artists, as well as composers, movie directors, architects, choreographers, etc.) with a station from which they can engage in a dialogue with users of the internet.

CHANNEL http://www.channel.org.uk/interface/start.html

Channel shows new artists' work and experimental projects. It aims to test the possibilities of digital arts practice and to cut across traditional media boundaries and spaces (under reconstruction, July 2003).

CTHEORY http://www.ctheory.net

Ctheory is an international journal of theory, technology and culture. Articles, interviews and key book reviews in contemporary discourse are published weekly as well as theorisations of major 'event-scenes' in the mediascape.

IRIS – Women Photographers http://www.staffs.ac.uk/ariadne Features images, writing and information on women photographers.

LEONARDO — Electronic Almanac http://mitpress.mit.edu/e-journals/LEA/home.html Leonardo Electronic Almanac (LEA). An electronic journal dedicated to providing a forum for those who are interested in the convergence of art, science and technology. Includes: profiles of media arts facilities and projects; profiles of artists using new media; feature articles comprised of theoretical and technical perspectives; an on-line gallery exhibiting new media art.

MUTE http://www.metamute.com/

On-line version of the London-based journal of digital art and media critique.

PHOTOGRAPHY IN NEW YORK www.photography-guide.com/ National and international listings of art photography exhibitions and events.

SCREENING THE PAST http://www.latrobe.edu.au/www/screeningthepast/index.html An international electronic journal of visual media and history. Covers photography, film, television and multimedia.

ZONEZERO http://www.zonezero.com/

ZoneZero is dedicated to photography and its journey from the analogue to digital world. It aims to carry an ongoing debate on all the issues surrounding the 'representation of reality' and other subjects relevant to the transition from analogue to digital image-making. It aims to promote an understanding of where, in the context of the digital age, the tradition of the 'still image' is headed. Carries extensive online exhibitions of photography. Has a special interest in Latin American work.

Bibliography

- Ades, Dawn (1974) Dada and Surrealism, London: Thames and Hudson
- Agee, J. and Evans, W. (1939) *Let Us Now Praise Famous Men*, New York: Random House Alexander, S. (1998) 'Photographic Institutions and Practices' in Michel Frizot *A New History of Photography*, Cologne: Könemann
- Allen, M. (1998) 'From Bwana Devil to Batman Forever: technology in contemporary Hollywood cinema, in Steve Neale and Murray Smith (eds) *Contemporary Hollywood Cinema*, London, Routledge
- Alloula, Malek (1987) *The Colonial Harem*, Manchester: Manchester University Press Alloway, Lawrence (1966) 'The Development of British Pop' in Lucy R. Lippart (ed.) *Pop Art*, London: Thames and Hudson
- Arnason, H.H. (1988) *A History of Modern Art*, London: Thames and Hudson, third edition (updated and revised to include photography)
- Arts Council (1972) From Today Painting is Dead, London: Arts Council
- (1975) The Real Thing, An Anthology of British Photographers 1840–1950, London: Arts Council
- —— (1979) Three Perspectives on Photography, London: Arts Council
- —— (1987) Independent Photography and Photography in Education, London: Arts Council
- —— (1991) Shocks to the System, London: The South Bank Centre
- Ascott, R (1996) 'Photography at the Interface', in T. Druckery (ed.) *Electronic Culture: Technology and Visual Representation*, New York: Aperture
- Axelmunden, V.H. *et al.* (eds) (1996) 'Photography after Photography: Memory and Representation in the Digital Age', Amsterdam: OP17 and Munich: Siemens Kulturprogramm
- Bacher, Fred (1992) 'The Popular Condition: Fear and Clothing in LA', *The Humanist*, September/October
- Back, L. and Quaade, V. (1993) 'Dream Utopias, Nightmare Realities: Imagining Race and Culture within the World of Benetton', *Third Text* 22
- Badger, Gerry and Benton-Harris, John (eds) (1989) *Through the Looking Glass,* London: Barbican Art Gallery

- Badmington, Neil (2000) Posthumanism, New York: Palgrave
- Bailey, David (1988) 'Re-thinking Black Representations', Ten/8 31
- (1989) 'People of the World' in P. Wombell (ed.) The Globe: Representing the World. York: Impressions Gallery
- Bailey, David and Hall, Stuart (eds) (1992) Ten/8 2(3), Critical Decade
- Baker, Lindsay (1991) 'Taking Advertising to its Limit', The Times, 22 July, p. 29
- Bakhtin, Mikhail (1984) *Rabelais and His World*, Bloomington: Indiana University Press Baldwin, Gordon (1991) Looking at Photographs: A Guide to Technical Terms, California: The J. Paul Getty Museum and London: British Museum Press
- Barrett, M. and McIntosh, M. (1982) *The Anti-Social Family*, London: Verso
- Barthes, Roland (1973) *Mythologies*, London: Granada (first published 1957), republished in London by Grafton Books, 1986
- (1977a) 'The Photographic Message' in S. Heath (ed.) *Image, Music, Text*, London:
- (1977b) 'The Rhetoric of the Image', in S. Heath (ed.) op. cit.
- —— (1977c) 'The Third Meaning', in S. Heath (ed.) op. cit.
- —— (1984) Camera Lucida, London: Fontana, first published in French, 1980; previous English publication 1981, New York: Hill and Wang
- Batchen, Geoffrey (1990) 'Burning with Desire: The Birth and Death of Photography', Afterimage, January
- —— (1997) Burning With Desire, Cambridge, MA: The MIT Press
- —— (2001) 'Ectoplasm' in *Each Wild Idea: Writing: Photography: History*, Cambridge, MA and London: The MIT Press.
- —— (2003, [1998]) 'Photogenics' in Wells L. (ed.) 'The Photography Reader', London and New York, Routledge.
- Bate, David (1993) 'Photography and the Colonial Vision', Third Text 22
- —— (2001) 'Blowing it: Digital Images and the Real', DPICT, no. 7, April/May
- Baudelaire, Charles (1859) 'The Salon of 1859', reprinted in P.E. Charvet (ed.) (1992)

 Baudelaire, Selected Writings on Art and Artists, Harmondsworth: Penguin
- Baudrillard, Jean (1983) 'The ecstasy of communication' in H. Foster (ed.) *The Anti-Aesthetic* Washingtion DC: Bay Press
- —— (1995) *The Gulf War Did Not Take Place*, Bloomington, Indiana: Indiana University Press
- Bazin, André (1967) 'The Ontology of the Photograph' in What is Cinema? Volume 1, Berkeley, Los Angeles and London: University of California Press
- Becker, K. (1991) 'To Control our Image: Photojournalists Meeting New Technology' in P. Wombell (ed.) *PhotoVideo: Photography in the Age of the Computer*, London: Rivers Oram Press
- Bede, C. (1855) Photographic Pleasures, London
- Beloff, Halla (1985) Camera Culture, Oxford: Blackwell
- Belussi, Fiorenza (1987) Benetton: Information Technology in Production and Distribution: A Case Study of the Innovative Potential of Traditional Sectors, SPRU, University of Sussex
- Benetton (1993) Global Vision: United Colors of Benetton, Tokyo: Robundo
- Benjamin, Walter (1931a) 'A Short History of Photography' in (1979) *One Way Street*, London: New Left Books. Also published as (1972) 'A Short History of Photography', Screen 13(1)
- —— (1931b) 'Unpacking My Library' in *Illuminations*, London: Jonathan Cape, 1970; Fontana, 1973/1992. Originally published in *Literarische Welt*, 1931
- (1936) 'The Work of Art in an Age of Mechanical Reproduction' in Hannah Arendt (ed.) *Illuminations*, London: Fontana. Revised edition 1992. Originally published in *Zeitschrift für Sozialforschung* 5(1), 1936

- —— (1938) 'The Paris of the Second Empire in Baudelaire', in Charles Baudelaire: A Lyric Poet in the Era of High Capitalism, London: Verso, 1985
- —— (1939) 'Some Motifs in Baudelaire' in Hannah Arendt (ed.) *Illuminations*, London: Fontana
- Benson, S.H. (n.d.) Some Examples of Benson Advertising, S.H. Benson Firm
- Berger, John (1972a) Ways of Seeing, Harmondsworth: Penguin
- —— (1972b) 'The Political Uses of Photomontage' in *Selected Essays and Articles, The Look of Things*, Harmondsworth: Penguin
- Berger, J. and Mohr, J., *Another Way of Telling*, London and New York: Writers Publishing Cooperative Society Ltd
- Bernstein, B. (1971) Class, Codes and Control, Vol. 1, Theoretical Studies Towards a Sociology of Language, London: Routledge & Kegan Paul
- Best, S. and Keller, D. (1991) *Postmodern Theory: Critical Interrogations*, London: Macmillan
- Bezencenet, Stevie (1982a) 'What is a History of Photography?', Creative Camera 208, April
- —— (1982b) 'Thinking Photography', Creative Camera 215, November
- Bhabha, H. (1990) 'Novel Metropolis', New Statesman and Society, 9 February
- Binkley, T. (1993) 'Refiguring Culture' in P. Hayward and T. Wollen (eds) Future Visions: New Technologies of the Screen, London: BFI
- Bishton, D. and Rearden, J. (eds) (1984) 'Black Image Staying On' Ten/8 16
- Blood on the Carpet (9/1/2001) Blood, Sweaters and Sears, BBC2
- Boddy, W. (1994) 'Archaeologies of Electronic Vision and the Gendered Spectator', Screen 35(2): 105–22
- Bode, S. and Wombell, P. (1991) 'Introduction: In a New Light' in P. Wombell (ed.)

 PhotoVideo: Photography in the Age of the Computer, London: Rivers Oram Press
- Boffin, T. and Fraser, J. (1991) Stolen Glances: Lesbians Take Photographs, London: Pandora Press
- Bolter, Jay David and Grusin, Richard (1999) 'Digital Photography' in *Remediation: Understanding New Media*, Cambridge, MA and London: The MIT Press.
- Bolton, Richard (ed.) (1989) The Contest of Meaning, Cambridge, MA: The MIT Press
- Bourdieu, P. (1965/1990) Photography: A Middle Brow Art, London: Polity Press
- Braden, Su (1978) Artists and People, London: Routledge & Kegan Paul
- Brandt, Bill (1961) Perspective of Nudes, London: The Bodley Head
- Braun, Marta (1992) *Picturing Time: The Work of Etienne-Jules Marey (1830–1904)*, Chicago, IL: University of Chicago Press
- Breton, André (1978) What is Surrealism? Selected Writings in F. Rosement (ed. and introduction), London: Pluto Press
- Bright, Deborah (1990) 'Of Mother Nature and Marlboro Men: An Inquiry into the Cultural Meanings of Landscape Photography' in Richard Boston (ed.) *The Contest of Meaning*, Cambridge, MA: The MIT Press
- —— (ed.) (1998) *The Passionate Camera: Photography and Bodies of Desire*, London and New York: Routledge
- Brittain, D. (ed) (1999) Creative Camera: 30 Years of Writing, Manchester: Manchester University Press
- Brookes, Rosetta (1992) 'Fashion Photography' in J. Ash and E. Wilson (eds) *Chic Thrills: A Fashion Reader*, London: Pandora
- Brown, Beverley (1981) 'A Feminist Interest in Pornography: Some Modest Proposals' in Parveen Adams and Elizabeth Cowie (1990) *The Woman in Question*, London and New York: Verso
- Buck-Morse, S. (1991) The Dialectics of Seeing: Walter Benjamin and the Arcades Project, Cambridge, MA: The MIT Press

- Burgess, N. (2001) 'From Golden Age to Digital Age', DPICT, no. 7, April/May
- Burgin, Victor (ed.) (1982) Thinking Photography, London: Macmillan
- —— (1986) 'Re-Reading Camera Lucida' in The End of Art Theory: Criticism and Postmodernity, London: Macmillan
- —— (1991) 'Realising the Reverie', Ten/8 2(2), Digital Dialogues
- Butler, Susan (1985) 'From Today Black and White is dead', in D. Brittain (ed.) (1999) Creative Camera, Manchester: Manchester University Press
- —— (1989) Shifting Focus, Bristol: Arnolfini, and London: Serpentine
- Butt, Gavin (1998) Men on the Threshold: The Making and Unmaking of the Sexual Subject in American Art 1948–1965, Unpublished Ph.D. Thesis, University of Leeds
- Campany, David (ed.) (2003) Art and Photography London and New York: Phaidon
- Carlebach, M.L. (1992) *The Origins of Photojournalism in America*, Washington DC: Smithsonian Institute
- Carr, E.H. (1964) What is History?, Harmondsworth: Penguin
- Cartier-Bresson, H. (1952) The Decisive Moment, New York: Simon and Schuster
- Cartwright, Lisa (1995) Screening the Body: Tracing Medicine's Visual Culture, Minneapolis and London: University of Minnesota Press
- Chadwick, Whitney (1985) Women Artists and the Surrealist Movement, London: Thames and Hudson
- —— (1998) Mirror Images: Women, Surrealism and Self-Representation, Cambridge, MA: The MIT Press
- Chambers, Eddie (1999) 'D-Max: An Introduction' in *Run Through the Jungle*, Annotations 5, London: INIVA
- Chanan, M. (1996) The Dream That Kicks, London: Routledge
- Chester, Gail and Dickey, Julienne (eds) (1988) Feminism and Censorship: The Current Debate, Bridport, Dorset: Prism Press
- Christian, J. (1990) 'Paul Sandby and the Military Survey of Scotland' in N. Alfrey and J. Daniels (eds) *Mapping the Landscape*, University of Nottingham
- Clark, Kenneth (1956) The Nude, Harmondsworth: Penguin, 1960
- Clarke, Graham (1997) The Photograph, Oxford: Oxford University Press
- Coe, B. (1989) 'Roll Film Revolution' in C. Ford (ed.) *The Story of Popular Photography*, Bradford: Century Hutchinson Ltd/National Museum of Photography, Film and Television
- Coe, B. and Gates, P. (1977) The Snapshot Photograph: The Rise of Popular Photography 1888–1939, London: Ash and Grant
- Coke, Van Deren (1972) *The Painter and the Photograph*, New Mexico: University of New Mexico Press
- Coleman, A.D. (1979) Light Readings, New York: Oxford University Press
- Cooper, Emmanuel (1990) Fully Exposed: The Male Nude in Photography, London: Unwin Hyman
- Corner, John and Harvey, Sylvia (1990) 'Heritage in Britain', Ten/8 36
- —— (eds) (1991) Enterprise and Heritage, London: Routledge
- Craik, Jennifer (1994) 'Soft Focus: Techniques of Fashion Photography' in *The Face of Fashion*, London: Routledge
- Crary, Jonathan (1993) *Techniques of the Observer: On Vision and Modernity in the Nineteenth Century*, Cambridge, MA: The MIT Press
- Crawley, G. (1989) 'Colour Comes to All' in C. Ford (ed.) *The Story of Popular Photography*, Bradford: Century Hutchinson Ltd/National Museum of Photography, Film and Television
- Crimp, Douglas (1995) On the Museum's Ruins, Cambridge, MA: The MIT Press
- Crimp, Douglas and Rolston, Adam (1990) AIDS DemolGraphics, Seattle: Bay Press

- Csikszentmihalyi, M. and Rochberg-Halton, E. (1992) *The Meaning of Things: Domestic Symbols and the Self*, Cambridge: Cambridge University Press
- Curtis, Neal (1999) 'The Body as Outlaw: Lyotard, Kafka and the Visible Human Project', Body and Society Vol. 5 (2–3): 249–66
- Darley, A. (1990) 'From Abstraction to Simulation: Notes on the History of Computer Imaging' in P. Hayward (ed.) *Culture, Technology, and Creativity in the Late Twentieth Century*, London: John Libbey and Co. Ltd
- —— (1991) 'Big Screen, Little Screen: The Archaeology of Technology', *Ten/8* 2(2), *Digital Dialogues*
- Davidoff, L. and Hall, C. (1976) 'The Charmed Circle of Home' in J. Mitchell and A. Oakley (eds) *The Rights and Wrongs of Women*, Harmondsworth: Penguin
- Davis, S. (1995) 'Welcome Home Big Brother', Wired Magazine, May
- Debord, Guy (1970) The Society of the Spectacle, Detroit: Black and Red
- Deitch, Jeffrey (1992) Post Human, Amsterdam: Idea Books
- Delpire, Robert and Frizot, Michel (1989) Histoire de Voir, Paris: Photo Poche
- Dentith, Simon (1995) Bakhtinian Thought: An Introductory Reader, London: Routledge Devlin, Polly (1979) Vogue Book of Fashion Photography, London: Condé Nast
- Dewdney, A. (1991) 'More Than Black and White: The Extended and Shared Family Album' in J. Spence and P. Holland (eds) Family Snaps: The Meanings of Domestic Photography, London: Virago
- Dewdney, A. and Boyd, F. (1995) 'Television, Computers, Technology and Cultural Form' in M. Lister (ed.) *The Photographic Image in Digital Culture*, London and New York: Routledge
- Doy, Gen (1996) 'Out of Africa: Orientalism, race and the female body', *Body and Society*, Vol. 2, no. 4, pp. 17–44
- Drake, M. and Finnegan, R. (eds) (1994) Studying Family and Community History: 19th and 20th Centuries, Vol. 4, Sources and Methods: A Handbook, Cambridge: Cambridge University Press and the Open University Press
- Druckery, T. (1991) 'Deadly Representations or Apocalypse Now', *Ten/8* 2(2): 16–27, *Digital Dialogues*
- Dubin, Steven C. (1992) Arresting Images: Impolitic Art and Uncivil Actions, London and New York: Routledge
- Durand, R. (1999) 'The Document, or the Lost Paradise of Authenticity', *Art Press* 251 Dworkin, Andrea (1981) *Pornography: Men Possessing Women*, London: The Women's Press
- Eastlake, Lady Elizabeth (1857) 'Photography', Quarterly Review, April, reprinted in Beaumont Newhall (ed.) (1980) Photography: Essays and Images, London: Secker and Warburg
- Eco, Umberto (1979) The Role of the Reader: Explorations in the Semiotics of Texts, London: Hutchinson
- —— (1987) Travels in Hyperreality, London, Picador
- Edwards, Elizabeth (ed.) (1992) *Photography and Anthropology 1860–1920*, New Haven, CT: Yale University Press
- Edwards, Steve (1989) 'The Snapshooters of History', Ten/8 32
- Elias, Norbert (1994) *The Civilising Process: Vol 1, History of Manners*, Oxford: Blackwell Ellis, J. (1991) *Visible Fictions: Cinema, Television, Video*, London and New York: Routledge
- Enos, Katherine (1997/1998) 'Crash & Pornography Culture', www.pomegranates.com Evans, C. and Thornton, M. (1989) *Women and Fashion: A New Look*, London: Quartet Evans. Jessica (ed.) (1997) *The Camerawork Essays*, London: Rivers Oram Press
- Ewing, William (1991) 'Perfect Surface' in *The Idealising Vision: The Art of Fashion Photography*, New York: Aperture

- —— (1994) The Body, London: Thames and Hudson
- —— (1996) Inside Information: Imaging the Human Body, London: Thames and Hudson Falconer, J. (2001) India: Pioneering Photographs 1850–1900, London: The British Library Falk, Pasi (1997) 'The Benetton-Toscani Effect Testing the Limits of Conventional Advertising' in Mica Nava, Andrew Blake, Iain MacRury and Barry Richards (eds) Buy this Book, London: Routledge
- Felman, S. and Laub, D. (1992) *Testimony: Crises of Witnessing in Literature, Psycho-analysis and History*, London: Routledge
- Ferguson, Russell (1992) 'A Box of Tools: Theory and Practice' in R. Ferguson *et al.* (eds) *Discourses: Conversations in Postmodernism, Art and Culture*, Cambridge, MA: The MIT Press
- Fisher, Andrea (1987) Let Us Now Praise Famous Women, London: Pandora
- Ford, C. (1989) *The Story of Popular Photography*, Bradford: Century Hutchinson Ltd/National Museum of Photography, Film and Television
- —— (2003) Julia Margaret Cameron: 19th Century Photographer of Genius, London: National Portrait Gallery
- Foster, Hal (1993) Compulsive Beauty, Cambridge, MA and London: The MIT Press
- (1996) 'Obscene, Abject, Traumatic', October 78, Autumn
- Frank, R. (1959) The Americans, New York: Grove Press
- Freedman, Jim (1990) 'Bringing it all Back Home: A Commentary on Into the Heart of Africa', Museum Quarterly, February
- Friedberg, Anne (1993) Window Shopping: Cinema and the Postmodern, Berkeley: University of California Press
- Freud, Sigmund (1905) 'Three Essays on Sexuality', in Vol. 7 of Sigmund Freud (1953–1964) Standard Edition of the Complete Works, trans. James Strachey, London: Hogarth Press
- —— (1927) 'Fetishism', in Vol. 7 of Sigmund Freud (1953–1964) op. cit.
- Freund, Gisele (1980) Photography and Society, London: Gordon Fraser
- Frizot, Michel (ed.) (1998) A New History of Photography, Cologne: Könemann (originally published in French, 1994)
- Gabriel, T. (1995) 'The Intolerable Gift', unpublished conference paper, London: BFI Galassi, Peter (1981) *Before Photography*, New York: MOMA
- (1995) American Photography 1890–1965, New York: MOMA
- Gamman, Lorraine and Makinen, Merja (1994) Female Fetishism: A New Look, London: Lawrence and Wishart
- Gasser, Martin (1992) 'Histories of Photography 1839–1939', History of Photography 16(1), Spring
- Geraghty, C. (1991) Women and Soap Opera: A Study of Prime Time Soaps, Cambridge: Polity Press
- Gernsheim, Alison (1981) Victorian and Edwardian Fashion, A Photographic Survey, New York: Dover (originally published 1963, revised edition)
- Gernsheim, Helmut and Gernsheim, Alison (1965) A Concise History of Photography, London: Thames and Hudson
- (1969) The History of Photography from the Earliest Use of the Camera Obscura in the Eleventh Century up to 1914, 2 vols., London and New York: McGraw-Hill (first edition, 1955)
- Gidal, T.N. (1973) Modern Photojournalism, New York: Macmillan
- Giebelhausen, Joachim (1963) *Techniques of Advertising Photography, Munich: Nicolaus Karpf*
- Gillis, J. (1997) A World of Their Own Making: A History of Myth and Ritual in Family Life, Oxford: OUP

- Goddard, Angela (1998) *The Language of Advertising: Written Texts*, London: Routledge Godfrey, Tony (1998) *Conceptual Art*, London: Phaidon
- Goffman, Erving (1979) Gender Advertisements, London: Macmillan
- Goldberg, Vicki (ed.) (1981) *Photography in Print*, Albuquerque: University of New Mexico
- Goldman, Robert (1992) Reading Ads Socially, London: Routledge
- Graham, B. (1995) 'The Panic Button (In Which our Heroine Goes Back to the Future of Pornography)' in M. Lister (ed.) *The Photographic Image in Digital Culture*, London and New York: Routledge
- Graham, Judith (1989) 'Benetton "Colors" the Race Issue', Advertising Age
- Graham-Brown, Sarah (1988) Images of Women: The Portrayal of Women in Photography of the Middle East 1860–1950, London: Quartet Books
- Gray, Camilla (1962) *The Russian Experiment in Art*, London: Thames and Hudson Green, D. (1994) 'Classified Subjects', *Ten/8* 14: 30–7
- —— (ed.) (2003) Where is the Photograph? Brighton: Photoforum and Maidstone: Photoworks
- Green, Jonathan (1984) 'The Painter as Photographer', *American Photography*, New York: Harry N. Abrams
- Greenberg, Clement (1939) 'Avant-Garde and Kitsch', in *Art and Culture*, Boston, MA: Beacon Press, 1961. Reprinted in C. Harrison and P. Wood (eds) (1992) *Art in Theory* 1900–1990. Oxford: Blackwell
- —— (1961) 'Modernist Painting' reprinted in F. Frascina and J. Harris (eds) (1992) Art in Modern Culture, London: Phaidon
- —— (1964) 'Four Photographers', as reprinted in *History of Photography* 15(2), Summer 1991
- Green-Lewis, Jennifer (1996) Framing the Victorians, Photography and the Culture of Realism, Ithaca and London: Cornell University Press
- Grey, C. (1991) 'Theories of Relativity' in J. Spence and P. Holland (eds) Family Snaps: The Meanings of Domestic Photography, London: Virago
- Griffiths, P.J. (1971) Vietnam Inc., New York: Macmillan
- Grundberg, Andy (1986) 'Veins of Resemblance' in P. Holland, J. Spence and S. Watney (eds) *Photography/Politics: Two*, London: Comedia
- —— (1990a) 'On the Dissecting Table' in Carol Squiers *The Critical Image*, London: Lawrence and Wishart
- —— (1990b) 'Photography in the Age of Electronic Simulation' in Crisis of the Real, New York: Aperture
- Gupta, Sunil (1986) 'Northern Media, Southern Lives' in P. Holland, J. Spence and S. Watney (eds) *Photography/Politics: Two*, London: Comedia
- —— (1990) 'Photography, Sexuality and Cultural Difference', Camerawork Quarterly 17(3)
- (ed.) (1993) Disrupted Borders: An Intervention in Definitions of Boundaries, London: Rivers Oram Press
- Haddon, L. (1993) 'Interactive Games' in P. Hayward and T. Wollen (eds) Future Visions: New Technologies of the Screen, London: BFI
- Hall, C. (1979) 'Early Formation of Victorian Domestic Ideology' in S. Burman (ed.) Fit Work for Women, London: Croom Helm
- Hall, Stuart (1988) 'The Work of Art in The Electronic Age', Block 14
- —— (1991) 'Reconstruction Work: Images of Post-War Black Settlement' in J. Spence and P. Holland (eds) Family Snaps: The Meanings of Domestic Photography, London: Virago
- —— (1993) [1980] 'Encoding/Decoding' in S. Durring (ed.) The Cultural Studies Reader, London: Routledge

- —— (ed.) (1997) Representation, Cultural Representations and Signifying Practices, London: Sage/Open University
- Hamilton, P. and Hargreaves, R. (2001) *The Beautiful and the Damned: The Creation of Identity in Nineteenth Century Photography*, London: Lund Humphries in association with The National Portrait Gallery.
- Hannavy, J. (1975) Roger Fenton of Crimble Hall, London: Gordon Fraser
- Hardy, B. (1977) 'Bert Hardy', Camerawork 8
- Harker, Margaret F. (1979) The Linked Ring: The Secession Movement in Photography in Britain 1892–1910, London: Heinemann
- —— (1988) Henry Peach Robinson, Oxford and New York: Blackwell
- Harrison, Charles and Wood, Paul (1993) 'Modernity and Modernism Reconsidered', Chapter 3 of Paul Wood, Francis Frascina, Jonathan Harris and Charles Harrison Modernism in Dispute, London: Yale University Press and the Open University Press
- Harrison, Martin (1991) Appearances: Fashion Photography Since 1945, London: Jonathan Cape
- Harvey, D. (1989) The Condition of Postmodernity, Cambridge, MA: Blackwell
- Harvie, C. et al. (1970) Industrialisation and Culture 1830–1914, London: Macmillan and the Open University Press
- Haworth-Booth, Mark (ed.) (1975) The Land: Twentieth Century Landscape Photographs, selected by Bill Brandt, London: Gordon Fraser Gallery
- —— (ed.) (1988) British Photography: Towards a Bigger Picture, New York: Aperture
- —— (1992) River Scene, France, Los Angeles, CA: J. Paul Getty Museum
- (1997) Photography: An Independent Art, London: V&A Publications
- Hayles, N. Katherine (1999) How We Became Posthuman: Virtual Bodies in Cybernetics, Literature, and Informatics, Chicago and London: University of Chicago Press.
- Hayward, P. (1993) 'Situating Cyberspace: The Popularisation of Virtual Reality' in P. Hayward and T. Walker (eds) Future Visions: New Technologies of the Screen, London: BFI
- Heiferman, Marvin (1989) 'Everywhere, All the Time, for Everybody' in Marvin Heiferman and Lisa Phillips (eds) *Image World*, New York: Whitney Museum of Art
- Heim, M. (1995) 'The Design of Virtual Reality' in Mike Featherstone and Roger Burrows (eds) *Cyberspace, Cyberbodies, Cyberpunk: Cultures of Technological Embodiment,* London, California and New Delhi: Sage
- Heron, Liz and Williams, Val (1996) *Illuminations: Women Writing on Photography from the 1850s to the Present*, London and New York: I.B. Tauris
- Hershkowitz, R. (1980) *The British Photographer Abroad: The First Thirty Years*, London: Robert Hershkowitz Ltd
- Hewison, Robert (1987) The Heritage Industry, London: Methuen
- Higonnet, A. (1998) Pictures of Innocence: The History and Crisis of Ideal Childhood, London: Thames and Hudson
- Hiley, M. (1983) Seeing Through Photographs, London: Gordon Frazer
- Hill, Paul and Cooper, Thomas (1992) Dialogue with Photography, Manchester: Cornerhouse Publications
- Hirsch, J. (1981) Family Photography: Context, Meaning and Effect, New York: Oxford University Press
- Hirsch, M. (1997) Family Frames: Photography, Narrative and Postmemory, Cambridge, MA: Harvard University Press
- Hoggart, Richard (1957) The Uses of Literacy, Harmondsworth: Penguin, 1959
- Holland, P. (1991) 'The Old Order of Things Changed' in J. Spence and P. Holland (eds) Family Snaps: The Meanings of Domestic Photography, London: Virago
- —— (1992) What is a Child?, London: Virago

- —— (1997) 'Press Photography' in A. Briggs and P. Cobley (eds) Introduction to Media, London: Longman
- —— (2004) Picturing Childhood: the Myth of the Child in Popular Imagery, London: I.B.Tauris
- Holland, P. and Dewdney, A. (eds) (1992) *The Child, Seen but Not Heard?*, Bristol: Watershed Media Centre. Exhibition catalogue
- Holmes, Oliver Wendell (1859) 'The Stereoscope and the Stereograph', *Atlantic Monthly* 3, reprinted in B. Newhall (ed.) (1980) *Photography: Essays and Images*, London: Secker and Warburg
- Honey, N. (1992) Entering the Masquerade: Girls from eleven to fourteen, Bradford: National Museum of Photography, Film and Television
- Hopkinson, T. (1962) In the Fiery Continent, London: Victor Gollancz
- Horne, Donald (1984) The Great Museum: The Re-presentation of History, London: Verso
- Howard, F. (1853) 'Photography Applied to Fine Art', Journal of the Photographic Society, London
- Hudson, D. (1972) Munby, Man of Two Worlds, London: John Murray
- Huhtamo, Erkki (1996) 'From Kaleidoscope to Cybernerd: Notes Toward an Archeology of Media' in T. Druckery (ed) *Electronic Culture: Technology and Visual Representation*, New York: Aperture
- Hurley, Jack (1972) Portrait of a Decade: Roy Stryker and the Development of Documentary Photography in the Thirties, Baton Rouge: Louisiana State University Press
- Hutchison, Robert (1982) *The Politics of the Arts Council*, London: Sinclair Browne lles, Chrissie and Roberts, Russell (eds) (1997) *In Visible Light*, Oxford: Museum of Modern Art
- Isherwood, C. (1939) Goodbye to Berlin, Harmondsworth: Penguin Books
- Isherwood, S. (1988) The Family Album, London: Broadcasting Support Services
- Jameson, Fredric (1984) 'Postmodernism or the Cultural Logic of Late Capitalism', New Left Review 146, July/August
- —— (1991) Postmodernism, Or, the Cultural Logic of Late Capitalism, London: Verso
- (1993) 'Postmodernism and Consumer Society' in A. Gray and J. McGuigan (eds) Studying Culture, London, New York, Melbourne and Auckland: Edward Arnold
- Jay, Martin (1992) 'Scopic Regimes of Modernity' in S. Lash and J. Friedman (eds), Modernity and Identity, Oxford: Blackwell
- —— (1993) Downcast Eyes: The Denigration of Vision in Twentieth Century French Thought, San Francisco: University of California Press
- Jeffrey, Ian (1981) Photography, A Concise History, London: Thames and Hudson
- —— (1982) 'Some Sacred Sites', Creative Camera 215, November
- —— (1991) 'Morality, Darkness and Light: The Metropolis in Pictures' in Martin Caiger-Smith Site Work, London: The Photographers' Gallery
- Jhally, Sut (1990) Codes of Advertising, London: Routledge
- Jukes, P. (1992) 'The Work of Art in the Domain of Digital Production', *New Statesman and Society*, 17 July: 40–1
- Kalogeraki, K. (1991) 'My Father's Land' in J. Spence and P. Holland (eds) Family Snaps: The Meanings of Domestic Photography, London: Virago
- Kellner, Douglas (2003) Media Spectacle London, Routledge
- Kelly, A. (1979) 'Feminism and Photography' in P. Hill, A. Kelly and J. Tagg *Three Perspectives on Photography*, London: ACGB
- Kelly, Mary (1981) 'Reviewing Modernist Criticism', Screen 22(3)
- Kember, S. (1995a) 'Medicine's New Vision' in M. Lister (ed.) The Photographic Image in Digital Culture, London and New York: Routledge

- —— (1995b) 'Surveillance, Technology and Crime: The James Bulger Case' in M. Lister (ed.) *The Photographic Image in Digital Culture*, London: Routledge
- —— (1998) Virtual Anxiety: Photography, New Technologies and Subjectivity, Manchester and New York: Manchester University Press.
- (2003) 'The Shadow of the Object: photography and realism' in Liz Wells (ed.) The Photography Reader, London and New York. Originally published in 1996 in Textual Practice, 10/1 pp. 145–63
- Kemp, Martin and Wallace, Marina (2000) Spectacular Bodies: The Art and Science of the Human Body from Leonardo to Now, Hayward Gallery Publishing, London
- Kendrick, Walter (1987) *The Secret Museum: Pornography in Modern Culture,* New York: Viking republished in 1996 by University of California Press
- Kenyon, D. (1992) Inside Amateur Photography, London: Batsford
- Kern, Stephen (1983) *The Culture of Time and Space 1800–1918*, Cambridge, MA: The MIT Press
- Kipnis, Laura (1992) '(Male) Desire and (Female) Disgust: Reading Hustler' in Lawrence Grossberg et al. (eds) Cultural Studies, London and New York: Routledge
- Klein, Naomi (2001) No Logo, Flamingo
- Kosinski, Dorothy (1999) The Artist and the Camera, Degas to Picasso, New Haven, CT: Yale University Press
- Kotz, Liz (1998) 'Aesthetics of Intimacy' in Deborah Bright (ed.) *The Passionate Camera: Photography and Bodies of Desire*, London and New York: Routledge
- Kozloff, Max (1979) *Photography and Fascination*, USA New Hampshire: Addison House —— (1987) *The Privileged Eye*, Albuquerque: University of New Mexico Press
- Kracauer, Siegfried (1960) 'Photography', Chapter 1 of *Theory of Film*, Oxford: Museum of Modern Art
- Krauss, Rosalind (1981) 'A Note on Photography and the Simulacral', October, Winter, reprinted in Carol Squiers (ed.) (1991) The Critical Image, Seattle: Bay Press and London: Lawrence and Wishart
- (1986) The Originality of the Avant-Garde and Other Modernist Myths, Cambridge, MA: The MIT Press
- Krauss, Rosalind and Livingston, Jane (1986) L'Amour Fou, London: Arts Council of Great Britain
- Kruger, Barbara (1983) We Won't Play Nature to your Culture, London: Institute of Contemporary Arts
- (1990) Love for Sale: The Words and Pictures of Barbara Kruger, New York: Harry N. Abrams, Inc.
- Kuenzli, Rudolf E. (1991) 'Surrealism and Misogyny' in Mary Ann Caws, Rudolf Kuenzli and Owen Raaberg *Surrealism and Women*, Cambridge, MA: The MIT Press
- Kuhn, A. (1991) 'Remembrance' in J. Spence and P. Holland (eds) Family Snaps: The Meanings of Domestic Photography, London: Virago
- —— (1995) Family Secrets: Acts of Memory and Imagination, London: Verso
- Lalvani, Suren (1996) *Photography, Vision, and the Production of Modern Bodies,* Albany: State University of New York Press
- Lemagny, Jean-Claude and Rouille, André (1987) A History of Photography, Cambridge: Cambridge University Press
- Landau, P.S. and Kaspin, D. (eds) (2002) 'Images and Empires: Visuality in Colonial and Post-Colonial Africa', Berkeley, CA: University of California Press.
- Lange, Dorothea (1960) 'The Assignment I'll Never Forget' in Beaumont Newhall (ed.) (1980) *Photography: Essays and Images*, London: Secker and Warburg
- Langford, M. (2001) Suspended Conversations, the Afterlife of Memory in Photographic Albums, Montreal: McGill-Queens University Press

- Lavin, Maud (1993) Cut with the Kitchen Knife: The Weimar Photomontages of Hannah Höch, New Haven, CT: Yale University Press
- Leiss, W., Kline, S. and Jhally, S. (1986) *Social Communication in Advertising*, Toronto: Methuen
- Leslie, Esther (2002) Hollywood Flatlands; Animation, Critical Theory and the Avant-Garde, London: Verso
- Lewinski, J. (1978) The Camera at War, London: W.H. Allen
- Lewis, B. and Harding, D. (eds) (1992) Kept in a Shoebox: The Experience of Popular Photography, Bradford: Yorkshire Art Circus/National Museum of Photography, Film and Television
- Linkman, A. (1993) *The Victorians: Photographic Portraits*, London: Tauris Parke Books Linkman, A. and Warhurst, C. (1982) *Family Albums*, Manchester: Manchester Polytechnic. A fully illustrated exhibition catalogue with an introduction
- Lipton, Eunice (1980) 'The Laundress in Nineteenth Century French Culture', Art History, Vol. 3, No. 3, pp. 215–313, abridged version in Francis Frascina and Charles Harrison (1983) Modern Art and Modernism: A Critical Anthology, HarperCollins
- Lister, M. (ed.) (1995a) *The Photographic Image in Digital Culture*, London and New York: Routledge
- —— (1995b) 'Introductory Essay' in M. Lister (ed.) *The Photographic Image in Digital Culture*, London and New York: Routledge
- Lister, M., Dovey, J., Giddings, S., Grant, I., Kelly, K. (2003) New Media: A Critical Introduction, London and New York: Routledge
- Lloyd, J. (1985) 'Old Photographs, Vanished Peoples and Stolen Potatoes', *Art Monthly* 83, February
- Lovell, Terry (1980) 'Is art a form of knowledge?' *Pictures of Reality*, ch. 5.3, London: BFI
- Lury, Celia (1992) 'Popular Culture and the Mass Media' in R. Bocock and K. Thompson (eds) Social and Cultural Forms of Modernity, Cambridge: Polity Press
- —— (1998) 'Prosthetic Culture: Photography, Memory and Identity' London and New York, Routledge.
- Lyons, Nathan (1966) *Photographers on Photography*, Englewood Cliffs, NJ: Prentice Hall
- Lvotard, Jean-François (1985) 'Argument' Camerawork 32, Summer
- McCauley, Elizabeth Anne (1994) *Industrial Madness: Commercial Photography in Paris* 1848–1871, New Haven, CT, and London: Yale University Press
- McClintock, A. (1995) Imperial Leather: Race, Gender and Sexuality in the Colonial Conquest, London: Routledge
- McCullin, Don (2003) Don McCullin, London: Jonathan Cape
- Macdonald, G. (1979) Camera: A Victorian Eyewitness, London: Batsford; based on a Granada television series
- McGrath, R. (1984) 'Medical Police', Ten/8 14: 13-18
- Machin, David (2004) 'Building the world's visual language: The increasing global importance of image banks in corporate media' *Journal of Visual Communication* 3(3)
- Magli, Patrizia (1989) 'The Face and the Soul' in M. Feher *et al.* (eds) *Zone 4: Fragments* for a History of the Human Body, Part Two, Cambridge, MA: Zone and The MIT Press
- Makela, Tapio (1997) 'Photography, Post-Photography', Creative Camera, April/May
- Malina, R.F. (1990) 'Digital Image Digital Cinema: The Work of Art in the Age of Postmechanical Reproduction', *Leonardo*, Supplemental Issue: 33–8
- Mann, S. (1992) Immediate Family, London: Phaidon

- Manovich, L. (1996), 'The Automation of Sight: From Photography to Computer Vision', in Druckery (ed.) *Electronic Culture: Technology and Visual Representation*, New York: Aperture.
- —— (2001) 'The Synthetic Image and its Subject', in The Language of New Media, Cambridge, MA, London: The MIT Press
- —— (2003) [1995] 'The Paradoxes of Photography' in L. Wells (ed.) *The Photography Reader*, London and New York: Routledge.
- Martin, R. (1991) 'Unwind the Ties That Bind' in J. Spence and P. Holland (eds) Family Snaps: The Meanings of Domestic Photography, London: Virago
- Marvin, C. (1988) When Old Technologies Were New, New York: Oxford University Press Mayer, Paul A. (1999) Computer Media and Communication, Oxford and New York: Oxford University Press
- Mavor, C. (1996) Pleasures Taken: Performances of Sexuality and Loss in Victorian Photographs, London: I.B. Taurus
- Mayhew, H. (1861) London Labour and the London Poor, reprinted 1967, London: Frank Cass
- Mayle, Peter (1983) *Thirsty Work: Ten Years of Heineken Advertising*, London: Macmillan Maynard, P. (2000) [1997] *The Engine of Visualization: Thinking Through Photographs*, Ithaca: Cornell University Press
- Mayne, R. (1986) The Street Photographs of Roger Mayne, London: V&A Museum Mellencamp, Patricia (1992) High Anxiety: Catastrophe, Scandal, Age and Comedy, Bloomington: Indiana University Press
- Metz, Christian (1985) 'Photography and Fetish', October 34, Autumn
- Meyer, Moe (ed.) (1994) The Politics and Poetics of Camp, London: Routledge
- Miller, Mark (1994) Spectacle: Operation Desert Storm and the Triumph of Illusion, New York: Poseidon Press
- Minto, C.S. (1970) Victorian and Edwardian Scotland from Old Photographs, London: Batsford
- Mitchell, W.J. (1992) The Reconfigured Eye: Visual Truth in the Post-photographic Era, Cambridge, MA: The MIT Press
- Mitter, Swasti (1986) 'Flexibility and Control: The Case of Benetton' in Common Fate Common Bond; Women in the Global Economy, London: Pluto
- Moholy-Nagy, László (1967) Painting, Photography, Film, London: Lund Humphries
- Montoussamy-Ashe, Jeanne (1985) Viewfinders: Black Women Photographers, New York: Dodd, Mead
- Morris, Roderick C. (1992) 'The Best Possible Taste', Spectator, 15 February
- Morrish, J (2001) Business 2.0, April edition, Bizjournals, Seattle
- Mulvey, Laura (1975) 'Visual Pleasure and Narrative Cinema' in Screen 16 (3) 6-18
- —— (1981) 'Visual Pleasure and Narrative Cinema' in T. Bennett *et al.* (eds) *Popular Television and Film*, London: BFI and the Open University. Also in Mulvey, L. (1989) *Visual and Other Pleasures*, London: Macmillan
- Musello, C. (1979) 'Family Photography' in J. Wagner (ed.) *Images of Information*, London: Sage
- Myers, Kathy (1986) *Understains: Sense and Seduction in Advertising*, London: Comedia (1990) 'Selling Green' in Carol Squiers (ed.) *The Critical Image: Essays on Contemporary Photography*, Seattle: Bay Press
- Nairne, Sandy (1987) State of the Art, Ideas and Images in the 1980s, London: Chatto & Windus
- Nead, L. (1992) *The Female Nude: Art, Obscenity and Sexuality*, London and New York: Routledge
- Neale, S. (1985) Cinema and Technology: Images, Sound, Colour, London: Macmillan

- Neumaier, Diane (ed.) (1996) Reframings, New American Feminist Photographics, Philadelphia: Temple University Press
- Newhall, Beaumont (1982) [1937] *The History of Photography*, New York: MOMA, fifth edition, revised and enlarged
- Nichols, Bill (1981) Image and Ideology, Bloomington: University of Indiana Press
- —— (1988) 'The Work of Culture in the Age of Cybernetic Systems', Screen 29(1), Winter
- Nochlin, Linda (1978) Realism, Harmondsworth: Penguin
- Nye, David (1985) *Image Worlds: Corporate Identities at General Electric 1890–1930*, Cambridge, MA: The MIT Press
- Ohrn, Karen Becker (1980) *Dorothea Lange and the Documentary Tradition*, Baton Rouge: Louisiana State University Press
- Olalquiaga, Celeste (1992) Megalopolis: Contemporary Cultural Sensibilities, Minneapolis: University of Minnesota Press
- O'Reilly, John (1998) 'Death is Probably the Last Pornographic Issue Left', *The Guardian*, 2 February
- Osborne, Brian S. (2003) 'Constructing the State, Managing the Corporation, Transforming the Individual: Photography, Immigration and the Canadian National Railways, 1925–30' in J. Schwartz & J. Ryan (eds) *Picturing Place: Photography and the Geographical Imagination*, London: I.B. Taurus
- Parr, M. (1986) *The Last Resort: Photographs of New Brighton*, Stockport: Dewi Lewis Publishing
- —— (1995) *Small World: A Global Photographic Project, 1987–1994,* Stockport: Dewi Lewis Publishing
- Parr, M. and Stasiak, J. (1986) 'The Actual Boot': The Photographic Post-card Boom 1900–1920, Bradford: A.H. Jolly (Editorial) Ltd/National Museum of Photography, Film and Television. Exhibition catalogue
- Penlake, R. (1899) Home Portraits for Amateur Photographers, London
- Penn, Irving (1974) Worlds in a Small Room, London: Studio Vista
- Petro, Patrice (ed.) (1995) Fugitive Images, Bloomington: Indiana University Press
- Phaidon (1997) The Photography Book, London: Phaidon
- Phillips, Christopher (ed.) (1989) *Photography in the Modern Era: European Documents and Critical Writings 1913–1940*, New York: MOMA
- Phizacklea, Annie (1990) 'The Benetton Model' in *Unpackaging the Fashion Industry:*Gender, Racism and Class in Production, London: Routledge
- Pinney, C. (1997) Camera Indica: The Social Life of Indian Photographs, London: Reaktion Books
- Piper, K. (1991) 'Fortress Europe: Tagging the Other' in P. Wombell (ed.) *PhotoVideo: Photography in the Age of the Computer*, London: Rivers Oram Press
- Pollock, Griselda (1977) 'What's Wrong with "Images of Women"?', reprinted in R. Parker and G. Pollock (eds) (1987) Framing Feminism, London: Pandora Press
- (1990) 'Missing Women Re-Thinking Early Thoughts on Images of Women' in Carol Squiers (ed.) The Critical Image: Essays on Contemporary Photography, Seattle: Bay Press
- Posner, Jill (1982) Spray it Loud, London: Routledge
- Price, D. (1983) 'Photographing the Poor and the Working Class', Framework 22 (22), Autumn
- Price, Mary (1994) The Photograph: A Strange, Confined Space, Stanford, CA: Stanford University Press
- Prochaska, David (1991) 'Fantasia of the Phototheque: French Postcard Views of Senegal', *African Arts*, October

- Pryce, W.T.R. (1994) 'Photographs and Picture Postcards' in M. Drake and R. Finnegan (eds) *Studying Family and Community History: 19th and 20th Centuries*, Cambridge: Cambridge University Press and the Open University Press
- Pultz, John (1995a) *The Body and the Lens: Photography 1839 to the Present*, New York: Harry N. Abrams, Inc
- —— (1995b) Photography and the Body, London: Weidenfeld & Nicolson
- Punt, Michael (1995) 'The Elephant, the Spaceship and the White Cockatoo: An Archaeology of Digital Photography' in M. Lister (ed.) *The Photographic Image in Digital Culture*, London and New York: Routledge
- Quartermaine, P. (1992) 'Johannes Lindt: Photographer of Australia and New Guinea' in M. Gidley (ed.) *Representing Others: White Views of Indigenous Peoples*, Exeter: University of Exeter Press
- Rabinowitz, Paula (1994) They Must be Represented: The Politics of Documentary, London: Verso
- Rahir, Patrick (2003) 'Pan-European security body slams TV for turning war into entertainment', 1 April, Agence France Presse
- Ramamurthy, A. (2003) Imperial Persuaders: Images of Africa and Asia in British Advertising, Manchester: Manchester University Press
- Ray-Jones, T. (1974) A Day Off: An English Journal, London: Thames and Hudson
- Richards, Thomas (1990) Commodity Culture in Victorian Britain, London: Verso
- —— (1993) The Imperial Archive: Knowledge and the Fantasy of Empire, London: Verso
- Ride, P. (1997) 'Photography and Digital Art', Creative Camera, April/May
- Riis, J.A. (1918) The Making of an American, New York: Macmillan
- Ritchen, F. (1990a) *In Our Own Image: The Coming Revolution in Photography*, New York: Aperture
- (1990b) 'Photojournalism in the Age of Computers' in Carol Squiers (ed.) *The Critical Image,* Seattle: Bay Press
- Roberts, John (1993) *Renegotiations: Class, Modernity and Photography*, Norwich: Norwich Gallery, Norfolk Institute of Art and Design
- —— (ed.) (1997) The Impossible Document: Photography and Conceptual Art in Britain 1966–1976, London: Camerawords
- (1998) The Art of Interruption: Realism, Photography and the Everyday, Manchester: Manchester University Press
- Robertson, G., Mash, M., Tickner, L., Bird, J., Curtis, B. and Putnam, T. (eds) (1994) Travellers' Tales: Narratives of Home and Displacement, London: Routledge
- Robins, Corinne (1984) *The Pluralist Era: American Art 1968–1981*, New York: Harper & Row
- Robins, K. (1991) 'Into the Image: Visual Technologies and Vision Cultures' in P. Wombell (ed.) *PhotoVideo: Photography in the Age of the Computer*, London: Rivers Oram Press
- —— (1995) 'Will Images Move Us Still?' in M. Lister (ed.) *The Photographic Image in Digital Culture*, London and New York: Routledge
- Rodchenko, Alexander (1928) 'Against the Synthetic Portrait, for the Snapshot', published in the Moscow journal Novy LEF: New Left Front of the Arts in C. Phillips (ed.) (1989) Photography in the Modern Era: European Documents and Critical Writings 1913–1940, New York: MOMA
- Rodgerson, Gillian and Wilson, Elizabeth (eds) (1991) *Pornography and Feminism: The Case Against Censorship*, London: Lawrence and Wishart
- Rogers, Brett (ed.) (1994) Documentary Dilemmas: Aspects of British Documentary Photography 1983–1993, London: British Council
- Rosenblum, Naomi (1994) A History of Women Photographers, New York, London, and Paris: Abbeville Press

- —— (1997) A World History of Photography, New York, London, and Paris: Abbeville Press (previous editions, 1984, 1989)
- Rosler, Martha (1989) 'In, Around and Afterthoughts (on Documentary Photography)' in Richard Bolton (ed.) *The Contest of Meaning: Critical Histories of Photography*, Cambridge, MA: The MIT Press
- —— (1991) 'Image Simulations, Computer Manipulations, Some Considerations', *Ten-8 2(2), Digital Dialogues*
- Rowland, Anna (1990) *The Bauhaus Source Book*, Chapter 6, 'Graphics', Oxford: Phaidon
- Royal Photographic Society (1977) Directory of British Photographic Collections, London: Heinemann
- Ruby, Jay (1995) Secure the Shadow: Photography and Death in America, Cambridge, MA and London: The MIT Press
- Ryan, James R. (1997) *Picturing Empire: Photography and the Visualisation of the British Empire*, London: Reaktion Books
- Said, Edward (1985) Orientalism, London: Penguin (first published 1978)
- Salvemini, Lorella Pagnucco (2003) *United Colours: The Benetton Campaigns*, Scriptum Editions
- Sampson, A. (1983) *Drum: An African Adventure and Afterwards*, London: Hodder and Stoughton
- Savan, Leslie (1990) 'Logo-rrhea', Voice, 24 November, New York
- Scharf, Aron (1974) Art and Photography, Harmondsworth: Pelican, revised edition
- Schildkrout, Enid (1991) 'The Spectacle of Africa Through the Lens of Herbert Lang', African Arts, October
- Segal, Lynne and Macintosh, Mary (eds) (1992) Sex Exposed: Sexuality and the Pornography Debate, London: Virago
- Sekula, Allan (1978) 'Dismantling Modernism, Reinventing Documentary (Notes on the Politics of Representation)' in J. Liebling (ed.) *Photography: Current Perspectives*, Rochester, New York: Light Impressions Co.
- Sherman, Cindy (1986) 'The Body and the Archive', October 39, reprinted in Richard Bolton (ed.) (1989) The Contest of Meaning: Critical Histories of Photography, Cambridge, MA: The MIT Press
- —— (1991) 'Reading an Archive' in Brian Wallis and Marcia Tucker (eds) *Blasted Allegories*, Cambridge, MA: The MIT Press
- —— (1997) Retrospective, London: Thames and Hudson
- Slater, D.R. (1983) 'Marketing Mass Photography' in H. Davis and P. Walton (eds) Language, Image, Media, Oxford: Blackwell
- —— (1991) 'Consuming Kodak' in J. Spence and P. Holland (eds) Family Snaps: The Meanings of Domestic Photography, London: Virago
- —— (1995a) 'Photography and Modern Vision: The Spectacle of "Natural Magic"' in C. Jenks (ed.) *Visual Culture*, London: Routledge
- (1995b) 'Domestic Photography and Digital Culture' in M. Lister (ed.) *The Photographic Image in Digital Culture,* London and New York: Routledge
- —— (1997) Consumer Culture and Modernity, Cambridge, MA: Blackwell
- Smith, L. (1998) The Politics of Focus: Women, Children and Nineteenth Century Photography, Manchester: Manchester University Press
- Snyder, Joel (1980) 'Picturing Vision', Critical Enquiry 6, Spring: 499–526
- —— (1994) 'Territorial Photography' in W.J.T. Mitchell (ed.) Landscape and Power, London: University of Chicago Press
- Snyder, J. and Allen, N.W. (1975) 'Photography, Vision, and Representation', Critical Enquiry 2, Autumn: 143–169

- Solanke, A. (1991) 'Complex Not Confused' in J. Spence and P. Holland (eds) Family Snaps: The Meanings of Domestic Photography, London: Virago
- Soloman, J. (1995) 'Interrogating the Holiday Snap' in J. Spence and J. Soloman What Can a Woman do with a Camera?, London: Scarlet Press
- Solomon-Godeau, Abigail (1991a) Photography at the Dock: Essays on Photographic History, Institutions and Practices, Minneapolis: University of Minnesota Press
- —— (1991b) 'Who is Speaking Thus?' in A. Solomon-Godeau op. cit.
- —— (1991c) 'Reconsidering Erotic Photography: Notes for a Project of Historical Salvage' in A. Solomon-Godeau op. cit.
- Sontag, Susan (1979) On Photography, Harmondsworth: Penguin
- —— (2002) *On Photography*, Harmondsworth: Penguin. A new edition with an introduction by John Berger.
- Spence, J. (1987) Putting Myself in the Picture, London: Camden Press
- —— (1991) 'Soap, Family Album Work . . . and Hope' in J. Spence and P. Holland (eds) Family Snaps: The Meanings of Domestic Photography, London: Virago
- —— (1995) *Cultural Sniping*, London: Routledge
- Spence, J. and Holland, P. (eds) (1991) Family Snaps: The Meanings of Domestic Photography, London: Virago
- Spence, J. and Soloman, J. (eds) (1995) What Can a Woman do with a Camera?, London: Scarlet Press
- Spender, H. (1978) 'Humphrey Spender: M.O. Photographer', Camerawork 11
- Squiers, Carol (ed.) (1990) The Critical Image, London: Lawrence and Wishart
- —— (1992) 'The Corporate Year in Pictures' in R. Bolton (ed.) *The Contest of Meaning: Critical Histories of Photography*, Cambridge, MA: The MIT Press
- (2003) 'Class Struggle: The Invention of Paparazzi Photography and the Death of Diana, Princess of Wales' in Carol Squires (ed.) Over Exposed: Essays on Contemporary Photography, New York: The New Press
- Stafford, B.M. (1991) Body Criticism, Imaging the Unseen in Enlightenment, Art and Medicine, Cambridge, MA: The MIT Press
- Stallabrass, J. (1997) 'Sebastiao Salgado and Fine Art Photojournalism', New Left Review No. 223
- Stallybrass, Peter and White, Allon (1986) *The Politics and Poetics of Transgression*, Ithaca and New York: Cornell University Press
- Stanley, J. (1991) 'Well, Who'd Want an Old Picture of me at Work?' in J. Spence and P. Holland (eds) Family Snaps: The Meanings of Domestic Photography, London: Virago
- Stapely G. and Sharpe, L. (1937) *Photography in the Modern Advertisement,* London, Chapman and Hall
- Steele-Perkins, Chris (ed.) (1980) *About 70 Photographs*, London: Arts Council of Great Britain
- Stein, S. (1981) 'The Composite Photographic Image and the Composition of Consumer Ideology', *Art Journal*, Spring
- —— (1983) 'Making Connections with the Camera: Photography and Social Mobility in the Career of Jacob Riis', Afterimage 10(10)
- —— (1992) 'The Graphic Ordering of Desire: Modernisation of a Middle-Class Women's Magazine 1919–1939' in R. Bolton (ed.) The Contest of Meaning: Critical Histories of Photography, Cambridge, MA: The MIT Press
- Stokes, Philip (1992) 'The Family Photograph Album: So Great a Cloud of Witnesses' in Graham Clarke (ed.) *The Portrait in Photography*, London: Reaktion Books
- Stott, W. (1973) Documentary Expression and Thirties America, Oxford: Oxford University Press

- Strand, Paul (1917) 'Photography', Camera Work 49/50, reprinted in B. Newhall (1982) The History of Photography, New York: MOMA
- —— (1980) Photography: Essays and Images, London: Secker and Warburg
- Stryker, Roy (1972) in Peninah R. Petruck (ed.) *The Camera Viewed: Writings on Twentieth-Century Photography*, New York: E.P. Dutton
- Sullivan, Constance (ed.) (1990) Women Photographers, London: Virago
- Swingler, S. (2000) 'Victorian/Edwardian women as photographers and keepers of the family album' in Liz Wells, Kate Newton and Catherine Fehily (eds) Shifting Horizons, London: I.B. Tauris
- Szarkowski, John (1966) 'Introduction' from The Photographer's Eye, NY: MOMA
- —— (1989) Photography Until Now, New York: MOMA
- Tabloid Tales 3/6/2003) Anthea Turner BBC1
- Tagg, John (1988) The Burden of Representation: Essays on Photographies and Histories, London: Macmillan
- Taylor, Janelle S. (2000) 'Of Sonograms And Baby Prams: Prenatal Diagnosis, Pregnancy, and Consumption', Feminist Studies, Summer
- Taylor, John (1994) A Dream of England: Landscape, Photography and the Tourist's Imagination, Manchester: Manchester University Press
- Taylor, Mark C. (1997) *Hiding*, Chicago, IL, and London: University of Chicago Press
- Thomas, Alan (1978) The Expanding Eye: Photography and the Nineteenth Century Mind, London: Croom Helm
- Thomas, Deborah Willis (1985) Black Photographers 1840–1940: An Illustrated Bio-Bibliography, New York: Garland
- Thompson, F.M.L. (ed.) (1990) *The Cambridge Social History of Britain 1750–1850*, Vol. 2, *People and Their Environment*, Cambridge: Cambridge University Press
- Thomson, J. (1877) Street Life in London, n.p.n.
- Tietjen, Friedrich (2003) 'Experience to see Jeff Wall's photo works: modes of production and reception', *Jeff Wall. Photographs,* Vienna: Museum Moderner Kunst Stiftung Ludwig
- Townsend, Chris (1998) Vile Bodies: Photography and the Crisis of Looking, Munich and New York: Prestel-Verlag and Channel Four Television Corporation
- Trachtenberg, A. (1982) The Incorporation of America, New York: Hill and Wang
- (1989) Reading American Photographs, New York: Hill and Wang
- Tucker, Anne (1973) The Woman's Eye, New York: Knopf
- —— (1984) 'Photographic Facts and Thirties America' in David Featherstone (ed.) Observations: Essays on Documentary Photography, Carmel, CA: Friends of Photography
- Turner, Peter (1987) History of Photography, London: Hamlyn
- Urry, J. (1990) The Tourist Gaze: Leisure and Travel in Contemporary Societies, London: Sage
- Van Schendel, W. (2002) 'A Politics of Nudity: Photographs of the 'Naked Mru' of Bangladesh', *Modern Asian Studies*, 36, 2
- Vance, Carole S. (1990) 'The Pleasures of Looking: The Attorney General's Commission on Pornography versus Visual Images' in Carol Squiers (ed.) *The Critical Image: Essays on Contemporary Photography*, Seattle: Bay Press
- Vanhaelen, A. (2002) 'Street life in London and the organization of labour', *History of Photography*, Autumn.
- Veltman (1996) 'Electronic Media: The Rebirth of Perspective and the Fragmentation of Illusion', in Druckery (ed.) Electronic Culture: Technology and Visual Representation', New York, Aperture.
- Virilio, P. (1989) War and Cinema, London: Verso

- Virilio, P., Baudrillard, J. and Hall, S. (1988) 'The Work of Art in the Electronic Age', Block 14
- Waldby, Catherine (2000) The Visible Human Project; Informatic Bodies and Posthuman Medicine. London and New York: Routledge
- Walker, Ian (1995) 'Desert Stones or Faith in Facts' in M. Lister (ed.) *The Photographic Image in Digital Culture*, London and New York: Routledge
- —— (2002) City Gorged with Dreams, Manchester: Manchester University Press
- Walkerdine, V. (1991) 'Behind the Painted Smile' in J. Spence and P. Holland (eds) Family Snaps: The Meanings of Domestic Photography, London: Virago
- Wall, Jeff (1995) 'About Making Landscapes' in Lynda Morris (ed.) (2002) Jeff Wall, Norwich: Norwich Gallery and Birmingham: Article Press
- Ward, Dick (1990) Photography for Advertising, London: Macdonald Illustrated
- Warner Marien, Mary (1988) 'Another History of Photography', *Afterimage*, October: 4–5
- (1991) 'Toward a New Prehistory of Photography' in Daniel P. Younger (ed.) Multiple Views, Albuquerque: University of New Mexico Press
- —— (1992) 'Women in the Victorian Family Album', Creative Camera, May
- —— (1997) Photography and Its Critics, A Cultural History, 1839–1900, Cambridge and New York: Cambridge University Press
- —— (1999) 'Parlour Made', in David Brittain (ed.) Creative Camera: 30 Years of Writing, Manchester: Manchester University Press
- —— (2002) Photography, a Cultural History London: Laurence King Publishing Ltd.
- Watney, S. (1991) 'Ordinary Boys' in J. Spence and P. Holland (eds) Family Snaps: The Meanings of Domestic Photography, London: Virago
- Watriss, Wendy and Zamora, Lois (eds) (1998) Image and Memory: Photographs from Latin America 1866–1994, Austin: University of Texas Press
- Weaver, Mike (1982) Photography as Fine Art, London: Thames and Hudson
- --- (1986) The Photographic Art, London: Herbert
- —— (1989a) *The Art of Photography*, London: Royal Academy of Arts/New Haven, CT: Yale University Press
- (1989b) British Photography in the Nineteenth Century: The Fine Art Tradition, Cambridge: Cambridge University Press
- Weernink, Wim (1979) La Lancia: 70 Years of Excellence, London: Motor Racing Publications
- Wells, Liz (ed.) (1992) 'Judith Williamson, Decoding Advertisements' in M. Barker and A. Beezer (eds) *Reading into Cultural Studies*, London: Routledge
- —— (ed.) (1994) Viewfindings, Women Photographers: 'Landscape' and Environment, Tiverton, Devon: Available Light
- Werge, J. (1890) The Evolution of Photography, London
- Weski, T. (2003) 'Cruel and Tender', in E. Dexter and T. Weski (eds) *Cruel and Tender*, London: Tate Publishing
- West, Nancy Martha (2000) Kodak and the Lens of Nostalgia, Virginia: University of Virginia Press
- Wilkinson, Helen (1997) '"The New Heraldry": Stock Photography, Visual Literacy and Advertising in 1930s Britain', Journal of Design History, 10(1)
- Willett, John (1978) The New Sobriety, Art and Politics in the Weimar Period, London: Thames and Hudson
- Williams, Linda (1995) 'Corporealized Observers: Visual Pornographies and the Carnal Density of Vision' in Patrice Petro *Fugitive Images*, Bloomington: Indiana University Press
- Williams, Raymond (1974) *Television, Technology and Cultural Form*, London: Fontana —— (1976) *Keywords*, London: Fontana

- —— (1979) 'The Arts Council', Political Quarterly, Spring
- —— (1980) 'Advertising the Magic System' in Problems in Materialism and Culture, London: Verso
- —— (1989) 'When Was Modernism' in *The Politics of Modernism*, London: Verso
- Williams, Val (1986) Women Photographers. The Other Observers, 1900 to the Present, London: Virago (revised edition 1991, The Other Observers. Women Photographers from 1900 to the Present)
- —— (1994) Who's Looking at the Family?, London: Barbican Art Gallery. Exhibition catalogue and introduction
- —— (1998) Look at Me: Fashion and Photography in Britain, 1960 to the Present, London: British Council
- Williamson, Judith (1978) Decoding Advertisements: Ideology and Meaning in Advertising, London: Marion Boyars
- —— (1979) 'Great History that Photographs Mislaid' in P. Holland, J. Spence and S. Watney (eds) Photography/Politics: One, London: Comedia
- Willis, A-M. (1990) 'Digitisation and the Living Death of Photography' in P. Hayward (ed.) Culture, Technology, and Creativity in the Late Twentieth Century, London: John Libbey and Co. Ltd
- Winship, Janice (1987a) 'Handling Sex' in R. Betterton (ed.) Looking On: Images of Femininity in the Visual Arts and Media, London: Pandora
- —— (1987b) Inside Women's Magazines, London: Pandora
- Wollen, Peter (1982) [1978] 'Photography and Aesthetics', as reprinted in *Readings and Writings*, London: Verso and New Left Books; originally published in *Screen* 19(4) Winter (1978)
- Wombell, P. (1991) *PhotoVideo: Photography in the Age of the Computer*, London: Rivers Oram Press
- Ziff, T. (1991) 'Taking New Ideas Back to the Old World' in P. Wombell (ed.) *PhotoVideo: Photography in the Age of the Computer*, London: Rivers Oram Press

Index

Note: Page numbers in **bold** indicate illustrations. Page numbers followed by (m) indicate marginal text.

Abbott, Berenice 34 abstract art 249, 261-2 abstractions, embodied 46 accuracy 13-15, 35, 85, 253 actuality 29, 92, 253, 279 Adams, Ansel 267, 268, 292 Addison, Graeme 99 Adobe Photoshop 189, 316 advertising: Benetton 212, 239-44, 241; Carte D'Or 216, 217; children 142; colonialism 120; commodity spectacle 204-8; context 235-44; cosmetics 172, 220; desire 205-6, 209-10, 216; Fiat 236; grammar 208-14, 218, 240; Jack Daniels 218, 219; Kodak 140-2, 141, 147; Lancia 235-6; limits 239-44; Omega watches 208-10; Saab 186, 187-8, **188**; semiotics 235; shock 240-2; stock images 202-3, 204, 206, 207, 210; Toblerone 188; women 172 aesthetics: art history 43-4; conventions 249, 253; feminist theory 282; machine 263;

perspective 253; queer 180;

status of photography 12;

Surrealism 270; and technologies 12-24: theory 36; twodimensional 17 Afghanistan 89 African Drum see Drum Afro-American photographers 284 age: of electronic imaging 295-336; global 109-11, 196, 239-40, 306 ageing 161 ahistoricism 240-2 AIDS 161-3, 177, 242 albums: beyond family 117, 154; electronic media 298, 300; hybridity 150-1, 157; Kocharian 150-1, **152-3**, 156; Kodak Brownie 142, 143; Lockwood 145; multi-cultural identity 283-4; Onslow 129; and portraits 126-31; Wilson 120, 121, 122, 123, 132 Algerian postcards 225 alienation 34 allegories 14, 256 Allen, M. 335 Alloula, Malek 224, 226 Amateur Photographer 124 amateur photography 115, 139, 140

ambrotype (collodion) 87 America see United States American Civil War 87-8, 322 American formalism 262, 267-9 American Indians 85 American innocence 20-1 American landscape photography American Radical Feminists 175 Americanness 45-6 analogue photography 298, 306 analogue-digital comparison 27, 303, 317 Analytical Inquiry into the Principles of Taste 246 ancient Greece 176-7, 186 Anglo-American Corporation of South Africa 212-14 animation 189 Annan, Thomas 76, 79, 133 Anson, Libby 280 anthropological photography 55-6, 58, 228-9 anthropological types 82-3 anthropometric system 165 anti-pornography campaigns 174-6 appearance: authenticity 42; disruption 94; facts 100; ontology

18: social encounters 164; truth 26. 71-2 Appearances: Fashion Photography since 1945 exhibition 222 Appert, E. 71 'Arabia behind the veil' 230-2 The Arc de Triomphe 323 arcade games 326, 327 archives: curators and collectors 287-8; digital images 109-10: disciplinary power 166; heritage industry 55-6, 62-3; key 252: modern photography 262-4: police 164-5, 165, 166, 184; see also stock images Aristotle 49 Armory show 257 Arnatt, Keith 274, 275, 293 art: commercial dealers 288; Conceptual 273-4; definitions 247, 249; education 277, 281; history 25, 43-4; objects 254; for the people 250; photo-based 285-7; photography as 245-94; photography extending 253-6; postmodernism 276-8: practices 276-8; social role 265-7; or technology 13-17; theories 33-4; truth 249 Art in America magazine 274 Art and Photography (Scharf) 251-2 The Art of Photography (Weaver) 54 Artforum 274 Arts Council of England and Wales 286-7 Association of Black Photographers (Autograph) 283 Atget, Eugène 34, 264 Atkins, Anna 294 attention arresting 31-2 auction houses 288 audio-visual technologies 73-4 aura 18, 23, 251 Australia 83 authenticity: appearance 42; being there 19–20; documentary 71–3; indicators 42; London Poor 80; observable 18; paparazzi photographs 200; realism 29 authorship 23, 313 autobiography 119 Autograph (Association of Black Photographers) 283

autographic images 29, 308 automaton-like images of women 186 autonomy of modern art 262 avant-garde 186, 260, 263–4, 265, 273

Bacher, Fred 243 Back, L. 240, 242 Bahktin, Mikhail Mikhailovich 173(m), 179 Bailey, David A. 282, 283-4 Bailey, Jim 97, 99 Bailey's of Bournemouth 135 Barnardo, Dr T.J. 71-2, 80 Barthes, Roland 26(m), 30(m); act of looking 332; attention arresting 32; Camera Lucida 26, 30-1, 46, 118, 332; commodity culture 208: concurrent messages 320; corpses 189-90: déià-lu 273-4: denotation-connotation 202, 210; food advertising 216; fugitive testimony 12, 59; history and photography distinction 12; image as text 30-3; myth of community 40; Mythologies 30; phenomenology 32-3; photography of something 22, 74, 331; The Pleasure of the Text 30; S/Z 30; second-order semiological system 210-11 Batchen, Geoffrey: belief in realism 329; cyborg with us already 335; digital process 316-17; founding of photography 50; image manipulation 311-12: photographic economy 330; social imperative 13 Bate, David 109-10, 296 Baudelaire, Charles 13-14, 13(m), Baudrillard, Jean 22(m), 74-5, 196 Bauhaus 264-5, 268, 272 Bayer, Herbert xx, 264, 272 Bazin, André 18 Beard, Richard 126-7 beauty 16, 27, 43 Becher, Bernd and Hilla 275-6 Bede, Cuthbert 119, 128, 131,

Before Photography (Galassi) 254

being there 19-20, 149

belief in realism 314, 329-30, 331-2 Bellmer, Hans 186, 187, 273 Beloff, Halla 46-7, 102 belonging, cultural 282-3 Benetton 212, 239-44, 241 Benjamin, Walter 17(m); age of mechanical reproduction 308; aura 17-18, 23, 251; camera and naked eye 336; collector enchantment 288; elitism 265; materialist analysis 34: optical unconscious 19, 309; perception expansion 182 Berger, John 170, 215, 221, 290, 306 Bernstein, Basil 118 Bertillon, Alphonse 165, 166, 184 beyond the domestic 117, 123-5, 154 Beyond the Family Album exhibition 154 beyond spectacle 239-44 Bezencenet, Stevie 53 billiard balls 301 Billy Durm 219 Birmingham Museum and Art Gallery, England 259 Birth Defects feature 203 birth photographs 189-92, 203, 283 black Britons, 1950s 149 Black country chain-makers postcard Black Panther magazine 47 black and white images 212-14, 218 black women 54-5, 242 Blackpool postcards 135 blue collar workers 237-8 Bluebell Fairy 155 Bode, S. 318 body: classical 173, 176-7, 179, 186, 191; colonialism 84-5; corrective transformation 184; digital malleability 187-9; distorted 188-9; embodied observers 180; female 46, 220; femininity and cut-upness 220; fragmentation 220; grotesque 173, 174; identity 283; language 219; as machine 185-6; manipulations by science 163;

medical surveillance 18; of native peoples 83-4; nudes 173, 176-7, 281, 307; photographic in crisis 161-4; physique photos 160, 179: Picasso 220; politics 161-2; subject as object 159-92; technological 180-9; see also nudes; nudity of native peoples Boffin, Tessa 107 Bohemia Venezolana 47 Boltanski, Christian 157-8 Bolter, Jav David 333 Bond, Edward and May 136, 137 Bourdieu, Pierre 158 Bourdin, Guy 221 bourgeois culture 197 Bournemouth postcard 135 Box Brownie 115, 142, 143, 302 box cameras 142, 258, 302 Brady, Matthew 87-8, 322 branded concepts 202, 204 branding, concept 222 Brandt, Bill 103, 260, 261, 263, 293 Braun, Marta 180-1 Breton, André 270-1 bricolage 306 Bright, Deborah 175 British Journal of Photography 15 brochures, tourist 227 Brookes, Rosetta 221-2 Bruger, Barbara 282 Buck-Morss, S. 326 Bulger, James 156 The Burden of Representation (Tagg) 58, 105-6 Burgin, Victor 26(m), 33-5, 33(m) 194, 216; autonomy of modern art 262; postmodernism 277 Burson, Nancy 167-8, 168 Butler, Susan 108, 281-2 Butt, Gavin 176-7 Cahun, Claude 272 calotype 123, 128, 132, 248, 254

Cahun, Claude 272
calotype 123, 128, 132, 248, 254
Camera Club exhibition, Vienna 250
Camera Lucida (Barthes) 26, 30–1,
46, 118, 332
Camera Work magazine (19031917) 20, 257
cameras: box 115, 142, 143, 258,
302; camera obscura 49; detective
132; digital 298, 302; everyday
details 309; Instamatics 147, 198;

as machine 263; as mechanical eve 180-3; polaroid 134; sales 143-4: society of spectacle 196; viewfinders 267; virtual 301, 301 Camerawork magazine (20th century) 61, 91, 104 Camerawork organization, London 150, 289 Cameron, Julia Margaret 130, 250, 254-5 camp 176-7, 179-80 Campany, David 75 Canadian National Railway 236 canon 25, 52, 55 Capa, Robert 88 capitalism: avant-garde 260-1; Benetton 240; commodity culture 195-6; fetishism 172; genres 197; individualism 173; perspective 253; photographic growth 196-7; radical photographic movements 106, 150; stages 310 captions 42, 209, 280 Carlebach, Michael L. 87 carnivalesque 148, 173, 174 Carr, E.H. 11-12 Carte D'Or 216, 217 Carter, Jennifer Ransom 147 cartes-de-visite 128, 142, 197 Cartesian dream 305-7, 329 Cartier-Bresson, Henri 73, 88 Cartwright, Lisa 183 case studies: Benetton 239-44; La Cicciolina 177-80, 178; Landscape as genre 248, 290-4; Lange's Migrant Mother 37-47, 38, 40; Omega and Cindy: Time Together 208-9; popular entertainment 326-7: Soviet constructivism 248, 265-7: Surrealism 248, 269-73; Tourism, Fashion and The Other 223-35; war and surveillance 322-5 castration anxiety 171 CAT (computed axial tomography) scans 318 catastrophe images 242-3 categorical photography 58-60 CD Rom Today 327 CD Roms 302, 327 celebrity magazines 157, 200-1 censorship 163

Chambers, Eddie 283

change 56-7, 196, 310, 317-22; historical 291-2 cheesecake, technicolour 178-9 children 117, 142, 146, 154-6 China 124 Chinese baby 199 choices, photographers' 312, 314 Christianity 33, 191 chronophotographic studies 182, 184 La Cicciolina case study 177-80, 178 cinematography 309 Clarke, Graham 39, 53-4 class: body 172-4; classlessness 17; conflict 21; cultural politics 107; documentary 93-4, 108; FSA project 96-7; see also bourgeois culture: middle classes; working classes classical body 173, 176-7, 179. 186, 191 classifications 82-3, 164, 165, 166 classlessness 17 Close No. 118 High Street 76 Coca-Cola 95, 212 Cockpit, London 285 codes: cultural and photographic 149: digital image production 319; homoerotic desire 176; iconic 29-30; indexical 29-30; messages without 32-3, 299; personal photography 158; semiology 29; story-telling 30; structuralism 30 Coe, Brian 118, 140 Coke, Van Deren 252 collections 202, 248, 260, 263 collectors 287-8 collodion 87 colonialism 59, 82-6, 120; colonialised subjects 223-4; postcards 224, 225, 232, 232; see also imperialism colour photography 108-9, 243 colour printing 142 colour supplements 70-1, 147, 201, 202-3 combination prints 250, 254, 292 commercial art dealers 288 commercial photography 56, 60, 146-7, 201-4, 236-7 commodification 211, 304, 313-15

commodity culture 193-244 commodity eroticisation 170 commodity fetishism 172, 206-7 communication theory 35-6 community: arts 248, 277, 285; communal meanings 150-1; corporations as 237; histories 150; myths of 40 Company magazine 229 competitions 80 complexity, semiotic 312-13 composite portraiture 166-7 composition 15, 263, 291 computed axial tomography (CAT) 183, 184 computers: computer-generated composites 168; 3-D graphics systems 298; manipulation 74; personal 302; universal machine 334; visual compass 307; see also digital imaging concept branding 222 Conceptual Art 273-6 A Concise History of Photography (Gernsheim) 51 concurrent messages 320 conflict 21, 204 connoisseurship 249 connotation 72, 202, 210; connotative truth 72; stock photography 210 constitution of meaning 18, 29-30 construction: of documentary 89-97; identity 154; (in)visibility 104-5; photography 279; see also postmodernism; Soviet Constructivism consumer culture 110-11 consumer empowerment 148 consumer magazines 147 contemporary art 260 contemporary debates 24-37 contexts: communication theory 35-6; evidence 43; FSA project 42; galleries as 289; images 235-44; institutions 60-3; interest in 24; meaning creation 212-14: uses 28; of viewing 43 continuity, discontinuity 328 control: image reproduction 41-2: social 164-5; of workforce see General Electric controversy courting 242-3

conventions: aesthetics 249, 253; authentic documentary 72-3; commodity culture 197; digital image production 319; fashion photography 221; high street studios 197-8; mood transfer imaging 211; perspective 291 convergence 73, 319-20 Cooper, Emmanuel 176 Cooper, Thomas 52 copies and originals 21-2, 23, 110, 128, 308 Corbis 202-3 corporate media 201-4 corpses 189-91 cosmetic advertisements 172, 220 Coubert, Gustave 252 Country Life series (Knorr) 246, 279 coup d'oeuil 272 Courbet, Gustave 253 Craik, Jennifer 220-3 Crary, Jonathan 180, 304, 306, 307 Crawford, Cindy 208-9, 210-11 Crimean War 86-7, 322 Les Crimes de la Commune (Appert) 71 criminal types 59, 165, 165-6, Crimp, Douglas 61, 276 crisis, photographic body in 161-4 criticism, theory and practice 35-6 cross-dressing 177 cultural...: belonging 282-3; continuity 317-22; politics 106-9; significance of digital images 333-4; spaces 100; theory of the body 163 culture and usage 13 culture-nature distinction 336 Cunningham, Imogen 267, 292 curators 250, 287-8 cyanotype process 294 cyberculture 283 cyborgs 163, 189, 335

D-Max exhibition 283
Dada 94, **185**, 186, 270, 314–15, 329
Daguerre, Louis-Jacques-Mandé 13, 48, 49, 126
daguerreotypes 15, 49, 126, **127**, 197, 253
Daily Illustrated Mirror 142
Daily Mirror 92, 142, 320, **321**

Dali, Salvador 270
Das schöne Mädchen 185
data loss 334
Davidoff, Leonore 147–8
Davies, John 293
de Saussure, Ferdinand 29
death penalty 243–4
death photography 132, 189–92,

190 debates: ontological 18, 25, 31, 74; and practices 251-9; priority debate 49; thinking about photography 11-63 Debord, Guy 195-6, 201, 315 decentered subject 21 decisive moment 73 decoding 210, 211-12, 235-6 deconstruction 279, 316 decorum 173 deeds without a name 148-57 defamiliarisation 34 déjà-lu (already read) 273+4 democratisation 16, 18, 251, 267 Dennett, Terry 117 denotation-connotation 202, 210 Derges, Susan 294 Derrida, Jacques 316(m) Descartes, René see Cartesian dream desire: advertising 205-6, 209-10, 216; disgust 173, 174; economy of 330; homoerotic 176-7; objects of 168-77; Omega watches 209-10; production 161; repression 270 detail 102-3, 307, 309, 334 detective cameras 132 determinism, technological 13 Devlin, Polly 221 Dewdney, Andrew 157 Diana, Princess of Wales 199-200 difference 161, 164-8 differentiation, universe of 23 digital cameras 298, 302 digital imaging 299; analogue comparison 27, 29, 36, 303, 317; continuity-discontinuity 328; cultural significance 333-4: digitisation 298, 301, 313-15; encoding 299; home photographers 116; implications 23, 277, 301; interactivity and convergence 319; malleability

157, 187-9, 311; photography

evidence 35, 43, 56-7, 311, 333 distinctions 29, 36; Eastlake, Lady Elizabeth 15-17, Exhibition Installation (Thompson) photojournalism 109-10; and real 15(m) Eastman, George 115, 138, 139-40, 73-5; reception 332-3; as signs exhibitions, comparison of 335; simulation 300; see also contemporary 286-7 Eastman Kodak Image Bank 202 computers Exit Photography Group 108 eclecticism 278-9 Dijkstra, Rineke 191-2, 283 exotic 123-4, 169, 223-35 Diorama 327 Eco, Umberto 18, 30, 34 experience 270, 282, 332-3 economic history 116 disavowal 171, 172 economy: of desire 330; exploitation 92, 156, 196, 240 disciplinary power 166 expressionism, abstract 249, 261-2 discourse 116 photographic 330 expressivity 248-9 education 89-90, 277, 281 disgust 173, 174 Edwards, Elizabeth 58 extension of art 253-6 dislocated signs 21 eve: mechanical 180-3; naked 336; dispossessed 156 Edwards, Steve 222-3 photo-eye 19, 86, 264-5 Eggleston, William 108 Disrupted Borders exhibition 283 Eidophusikon 327 disruptions 19, 94, 148 f/64 group 267-8, 276 Eisenstein, Sergei 189 distorted bodies 188-9 fabrication 279 electrobricolage 306 document, photograph as 17-18 The Face of Fashion (Craik) 220-1 electronic imaging age 295-336 documentary: authenticity 71-3; The Face magazine 222 electronic revolution 309 commercial photography 236-7; faces 59, 172 electronic war 322-3; see also Gulf construction of 89-97; critique facts: appearances 100; carrier 16; 103-6; definition 17; education communication 17; documentary Elias, Norbert 173 89-90; ethics 72-3; gender of genre 90; facticity 314; FSA elitism 265 photographers 93; global age project 95-6; photo-eye 19; social 109-11; humanism 44; landscape Elle 234, 243 embodied abstractions 46 75-8 photography 291; lesbian 107; Fait 325 embodied observers 180 new cultures, new spaces 99-103; embodying social difference 164-8 Falk, Pasi 243 personal photographs 118; and family photographs: children 117, Emerson, Peter Henry 258 photojournalism 69-75; 146; commercial images 146-7; empire, imaginative geography of postmodern critics 286; pseudocommunal meanings 150-1; 85-6 242-3; realism 107; rhetorical feminism 148; groups 130; empiricism 57, 305-6 strategies 286; subjective 103; empowerment of consumers 148 histories 151; holidays 146; theory 103-6; truth 33-4 home-based idyll 144-6; Kodak enchantments for collectors 288 Documentary Dilemmas (Rogers) 140; post-family 157-8; post-war encoding 211-12, 299, 334 286 144; rereading 150; stories 150-1 encounters 164 domestic...: beyond the 123-5; fantasy 116, 125-6, 155, 226, 281, end of history 21 digital cameras 302; hyperrealism 282-3 end of photography 297 158; ideal 120, 144, 156 Enlightenment philosophy 21, 329 Farm Security Administration (FSA) domesticity 117, 120 37, 41-5, 68, 94-7 Enos, Katherine 175 dominant reading 212 fashion photography 220-35, 243 entertainment, popular 326-7 'Draughtsman drawing a nude' 307 enticement 28-9 femininity 220, 221 dreams 270, 291; Cartesian 305-7, feminism: aesthetics theory 282; environmental questioning 276 329 American Radical Feminists 175; equality of photographer and Drum 97-9, 98 art education 277; on crosssubject 41 Duchamp, Marcel 270 dressing 177; documentary Duncan, M.C. 115, 116, 117 erotic imagery 168-9, 176-7, 221, 106-7; family 148; image and 224 Dunes, Oceano 268 eroticisation of commodities 170 memory 154; incorporation 287; Durand, Regis 111 the Other 83; pornography Dürer, Albrecht 307 ethics 27, 28, 72-3, 313 174-6; psychoanalysis 272; eugenics 167 Dust Storm 96 Surrealism 272 Evans, C. 221 Dworkin, Angela 172, 175 Feminists Against Censorship 175 events: photographs 137-8, 150; of Fenton, Roger 86-7 the spectacle 201-2 e-mail 23 Ferguson, Russell 24 the everyday 106-9, 309 earth view (NASA) 324

ferrotypes 134 Frizot, Michel 53 global age 109-11, 196, 212, festivals 288-9 FSA see Farm Security 239-40, 306 fetishism 35, 170-2, 189, 242-3, Administration Godwin, Fay 293 332; commodity fetishism 172, fugitive testimony 12, 59 Goffman, Erving 218-19 206-7 function and form 264-5 'Golden Age of Hollywood' 234 Fiat 236 golden rule 291 fiction and fantasy 125-6 Gabriel, Teshome 149 Goldman, Robert 211 figurative, return to 276 Galassi, Peter 250, 254 graffiti 212, 220 film 103, 219, 223, 300 galleries: claiming a place in 256-9: grammar: of advertisements film stars 172 as context 289: family 208-14, 218; of race 240 film studies 25, 103-4 photography 157-8; key 260; grand narratives 21 fine art: photography status national identity 284: Grav. Camilla 265 248-51; see also art postmodernism 276; Victorian Great Exhibition, London 205, First World War 88, 143-4, 264, 259; women artists 281 248-9 322 Galton, Francis 166, 167 great masters approach: art history A Fish Stall 81 Gasser, Martin 48-9 25; challenges 54-5; FSA 94; Fisher, Andrea 44-5 Gates, Paul 118, 140 Gernsheim 51-2; histories of fixing the image 49-50 gay cultural forms 177 photography 49-50, 247; flash 147 gaze: camera 67; function 46; irrelevance 23; Newhall 51-2; flat death 31 mobile technologies 182-3; popular photography 55 flattening 171, 172, 179 objectification 169-70, 281; Greece, ancient 176-7, 186 floating in the sea 203-4 tourist 123; voyeuristic 219; see Green, Jonathan 274 foetal ultrasound scans 183 also looking Greenberg, Clement 180, 260-2 food photography 216 gender: amateur photography 140; Griffiths, Philip Jones 89 Ford, Colin 118, 254-5 documentary photographers 93; Gropius, Walter 264 forgetting 158 gendered images 44-5; gendered grotesque body 173, 174 form 211, 264-5, 275 subject 329-30; histories of Grundrisse (Marx) 239 formalism 249, 262, 267-9 photography 54-5; medical Grusin, Richard 333 formalist-constructivism 34 science 318; representations 35. Guerilla Girls 281 Foster, Hal 186 218-20; Spence 161 Gulf War 74-5, 198, 322-3, 324, Foucault, Michel 58(m), 104-5, Gender Advertisements (Goffman) 325 165-6, 184 218-19 Gupta, Sunil 283 Fox, Sue 191 General Electric 236-9. 238 Fox Talbot, William Henry 13, 48, General Electric Review 237 Hackney Flashers 106, 150 49, 123, 130, 248; Spanish Art generic props 201–2 half-tone plates 320 book 254 genetics 163 Hall, Stuart 149, 208, 211-12, 218, fragmentation 171, 220, 223, 273, genres: capitalism 197; concept 290; 282 307 history 53-4; landscape as 248, Hamilton, Richard 273 frames 48, 279-80 290-4; merging 75; straight handbooks of methods 49 France see Paris photography 314; and usage hands 219-20, 264 Frank, Robert 100 41 - 2hanging 259, 286 Frankfurt School of Social Research geography, imaginative of empire Hans Bellmer with first Doll 187 265 85-6 happenings 277 Fraser, Jean 107 geometric mapping 253 happy memories 144, 156 fraud 71 geometrical composition 263 Hardy, Bert 91 Frederick, Mrs Christine 215-16. geometry of the image 19, 267 harem image 169, 229-30, 232 Gernsheim, Helmut and Alison Harker, Margaret 250, 251, 256, French Academy of Art 253 42-3, 50(m), 51-2 257 French colonial postcards 225, 232 Getty Images 202, 203-4 Harrison, Tom 90-1 Freud, Sigmund 33(m), 35, 170-2, ghettoisation 61-2 Hart, Edith Tudor 104 269-70 Giebelhausen, Joachim 207-8 Harvey, David 310 Friedlander, Lee 102, 103 Gilbreth, Frank 184, 185 Haworth-Booth, Mark 53, 54 Frith, Francis 86, 123 glamour 198-201, 206, 208-9 Heartfield, John 314-15, 329

hegemony 173, 208, 214-20, 244 Hello! magazine 157 Helm, James 130 Henri, Florence 263 Herbello, Fran 162 heritage industry: archives 55-6, 62-3; landscape 293-4; national identity 284-5; showing the past 63, 110, 124; viewpoints 125 Hewison, Robert 63, 285 High Art Photography 251 Higonnet, Anne 158 Hill & Knowlton 198-9 Hill, Paul 52 Hine, Lewis 81-2, 237 Hiroshima 156 Hirsch, Julia 150, 151 Hirsch, Marianne 148, 151 historic sites 86 history: ahistoricism 240-2; black women 54-5; community 150; end of 21: from below 150; image banks 202; photograph as image 49; of photography 48-55; guestions 11–12; radical history movement 150; through autobiography 119 History of Photography (Gernsheims) The History of Photography (Newhall) 50-1 hobbyists 17, 115, 130 Höch, Hannah 185 Hockney, David 273 Hogg, Jabez 127 Hoggart, Richard 178-9 Holland, Patricia 117 Holmes, Oliver Wendell 21-2 Holocaust 116, 149-50, 156 home: in and beyond 120-48; commercial imagery 146-7; digital photography 116; family idyll 144-6; ideology of 146; mobility 146: see also domestic...; family photographs homoerotic desire 176-7 homosexuality 175, 176, 177; see also lesbian photography; queer photography Hopkinson, Tom 99 Horlicks 206 Horne, Donald 62-3 Hovis 218

Howard, F. 15
Hulton Picture archive 202, 204
human–technical distinction 336
humanism 36, 39, 44
Hurley, Jack 42
Hustler 172, 173–4
Huxley, T.H. 59
hybridity 85–6, 150–1, 157
hyperreality 158, 196, 335

I-D 222 iconic codes 29-30 iconic signs 45 icons 46-8, 146 idealist philosophy 292 ideals, domestic 120, 144, 156 identity: body 283; construction 154; Country Life series 279; fashion 222-3; multi-cultural 283-4; personal photography 119: post-colonial 284; poststructuralism 282; questions 279, 282-3 ideology: Benetton 240; of the body 186; change 196; commodification 211: conservative 244; focus 36; FSA 44-5; of home 146; imperialist 240: looking 35; maintenance 208: personal photographs 118; power 105-6 illusions 193-244, 314, 315 Illustrated 70 Illustrated London News 70, 87 Illustrierte 70 Image Worlds (Nye) 236-9 images: analysis 37-48; banks 201-4; contexts 42, 43-4, 235-44: force of indexical 331-2; geometry of 19; as icon 46-8; image-text 42-3, 279; reality 24, 314-15; as text 30-3

immigrants 156–7 immobility of the body 182 imperialism: Benetton 240; domesticity ideal 120; imaginative geography of empire 85–6; information 82; the Other 58; social change 57; see also colonialism

imaginary, real distinction 305, 307

imaginative geography of empire

85-6

Independent, South African miners 213 index, photograph as 311 indexical...: actuality 279; codes 29-30; force of 331-2; quality 279, 311; signs 45, 74, 317; status 36: truth 311 indexicality 28 'Indian summer' 233 individualism 33, 139, 173, 253 industrial age 15, 252, 291, 293 industrial relations 236 informality and intimacy 132-3 information 21, 82 innocence, American 20-1 instability of signs 317 Instamatics 147, 198 instant vision 51 integral manipulation 311, 314, 315, 329 integrity 312, 313-14 intellectual currencies, Surrealism 269-73 interactivity 302, 319-20, 327 internationalism 288-9 interpretation 36, 274, 279-80 intertextuality 320 interventions 26, 133, 183-5, 270, 279 intimacy and informality 132-3 inventions 48 Irish art 284 Italian Radical Party 178, 179

Impressionists 254, 257, 258

Jack Daniels whiskey 218, **219**Jacobs, Joseph 167
Jameson, Frederic 22, 309–10
Jay, Martin 329
Jeffrey, Ian 53, 54, 264
Jernigan, Joseph 184 *The Jewish Type* **167**Jhally, Sut 235
jobbing photographers 15, 134–5, 254

Kellner, Douglas 196 Kelly, Angela 106–7 Kelly, Mary 277, 286 Kember, Sarah 318, 329 Kempadoo, Roshini 86 Kent cigarettes 212 Kenyon, Dave 127, 142

Kinetoscope 327 Kipnis, Laura 172, 173-4, 179 Kippin, John 293 kitsch 177, 180, 191, 260 Klein, William 102-3 Knorr, Karen 246, 279, 293 knowledge 62, 85, 184 Kocharian, Ursula 150-1, 152-3, 156 Kodak: advertising 140, 141, 147; Box Brownie 115, 142, 143, 302; Eastman Kodak Image Bank 202; family holidays 146; happy memories 144, 156; Instamatics 147, 198; Kodak and the Lens of Nostalgia (West) 118; mass market 138-44; nostalgia 118, 124-5; working classes 138-44 Kodaland, supersnaps 144-8 Korean war 88 Kozloff, Max 28-9 Kracauer, Siegfried 18, 18m Krauss, Rosalind 23, 272 Kruger, Barbara 277 Kuhn, Annette 154, 155

Kerouac, Jack 100

labour: conditions 57, 237; conflict 204; relations 216-18, 236-9, 238; stock images 204; strikes 236; unrest 237; see also work: workers; working classes The Lady of Shalott 257, 292 1 Lafayette, Louisiana 102 Lalvani, Suren 197 Lancia 216-17, 235-6 land 290 land art 276, 279 landscape: commercial uses 56; documentary 291; as genre 248, 290-4; and heritage 293-4; historical change 291-2; land distinction 290; modern and postmodern 293; new aesthetics 292 - 3Lange, Dorothea 37-48, 38, 40, 94 language 219, 248, 316-17 lantern slides 133 laser scanners 302 Latin American photography 284

Levitt, Helen 101 Lewinski, Jorge 88 Lewis, David 284 liberties taken 221 Lichtenstein, Roy 273 Life 70, 88, 198 light 251, 254, 333 likeness 254 limits of advertising 239-44 Lindt, Johannes 83 linearity disruption 19 Linked Ring Brotherhood 256-7 Lipton, Eunice 169 literalness 261-2 literary criticism 25 Literary Studies 103-4 Livingston, Jane 272 Lloyd, Jill 83 Lockwood, Frank 145 locomotion studies 180-1, 183-4, Lodgers in a Crowded Tenement 79 London Labour and London Poor (Mayhew) 58, 79, 80 London Stereoscopic Company 86.

125
Lonely Metropolitan (Bayer) xx
Look 70
looking 35, 163, 280–1, 332; see
also gaze
Lovell, Terry 289
La Lumière 13
Lyotard, Jean François 21

McCauley, Elizabeth Anne 197

McCullin, Don 89

Machin, David 201-2 machines: aesthetic 263, 264-5; body as 185-6; camera as 263; universal 334; see also mechanical... Madge, Charles 90-1 magnetic resonance imaging (MRI) 183, 184, 318 Magnum Photos 88 males: body as machine 186; body objectification 220; knowing subject 329-30; photographers 53; see also classical body malleability 157, 187-9, 311 Man Ray 260, 270, 272, 288 Manet, Édouard 252

manipulation: amateur photography 139; computer 74; digital images 302, 304; integral 311-12, 314, 315, 329; meaning 94; photomontage 314-15; press images 109-10; truth opposition Manovich, Lev 187, 328, 329, 333-4, 335 Mao, Chairman 240 mapping 56, 59, 253 Mapplethorpe, Robert 163, 176 Marey, Etienne-Jules 180-1, 182, 183-4, 185 marginalisation 281, 287 Marie Claire 220, 229, 230-2, 232-3, **233**, **234** market: of illusions 314; and spectacle 243-4 marketing photography 235-44 Marks & Spencer 220 Marx, Karl 172, 206-7, 239 Marxism 21, 34, 270 mass culture 274 mass market, Kodak 138-44 Mass Observation 90-2 mass tourism 111 materialist analysis 34 materiality 332 Mayhew, Henry 58, 79, 80 meaning: archives 62; communal 150-1; complexity 310-11; constitution 18, 29-30; contexts 212-14; creation 208; fixed and stable 319; formal structures 211; framing 214; manipulation 94; polysemic 318-19; poststructuralism 25; production 25-6, 30, 211, 239, 242-3; reception 28, 29; styles 212-14; technology 315; transfer 211-12; viewers 211 mechanical...: drum scanners 300, 302; expressive distinction 249; eye 180-3; reproduction age 308-17; see also machines medical imaging techniques 183, 317-18 medical surveillance 18 mega-spectacles 196 memento mori 189 memory: childhood 155-6; fantasy 155; forgetting 158; happy

legitimacy 163

Lemagny, Jean-Claude 53

lesbian photography 107, 177

collections 248; exhibitions 50-2, Nichols, Bill 253, 310 memories 144, 156; Holocaust Nièpce, Nicephore 49 54, 108; galleries 278 116, 149-50, 156; indoors 147; Nietzsche, Friedrich 33 photographs 27; popular 59-60 museums 61-2, 276, 284; see also Nochlin, Linda 252 under individual museum names Men Greeting in a Pub 92 non-Western photography 53 mutoscopes 180 messages 32-3, 210-11, 299, 320 non-Western world, tourism 227-8 Muybridge, Edward 180-1 Metz, Christian 171 normal photography 329 Myers, Kathy 214 Mewes, George 205, 206 Mythologies (Barthes) 30 Norwegian landscape 293-4 middle classes 124-5, 133, 174 nostalgia 118, 124-5 myths 40, 211, 282 migrant artists 260 note-taking with camera 251-2, Migrant Mother (Lange) 37-48, 38, Nadar (Gaspard Felix Tournachon) 40, 94 Nova 222 323 migrants 95, 156 nudes 173, 176-7, 281, 307 Nairne, Sandy 288 military uses 56-7, 67; see also war nudity of native peoples 83-4 naked eye 336 photography Nye, David 236-9 narrative 21, 156-7 Miller, Lee 270, 271, 272 NASA, earth view 324 Mirage 283 objectification 168-72, 220, 242 National Endowment for the Arts Mitchell, William 33-4, 300-1, 305, objectivity 15, 26-7, 78 306, 313, 316 175 - 6objects: art objects 254; of desire National Geographic image mobile phones 182 168-77; portable 308; subjects as collection 202 mobility 146, 182 159-92 National Museum of Photography, modern art 259-62 observability 18 Film and Television 281 modern photography 262-4, 293 observers 180, 281 naturalistic photography 14, 179, modernism 18-21, 57, 248, 260, O'Donnell, Ron 284 206, 215, 258-9 264 Ohrn, Karin Becker 43, 69 nature: culture distinction 336; modernity 57, 119 OK magazine 157, 200-1 different reality 336; of modes: of representation 68; of Omega and Cindy: Time Together vision 253 photography 328-9 case study 208-9, 210 Nazism 167, 186 Moholy-Nagy, Lázló and Lucia 20, On Photography (Sontag) 26, 27 Neale, Steve 326 34, 264-5 Onslow, R. Folev 129 MOMA see Museum of Modern negotiated reading 212 ontological debates 18, 25, 31, networks 21 Art 74 new aesthetics 292-3 monochrome 109, 292 oppositional reading 212 Montage (Wombell) 227 new art history 25 optical effects 132 New Bauhaus 268 montages 67, 132, 209, 226 optical unconscious 19, 309 new constructions 278-80 Montoussamy-Ashe, Jeanne 54 A New History of Photography orbital devices 322 Morque series 191 originals and copies 21-2, 23, 110, (Frizot) 53 Morocco 226, 233-4 308 The New Housekeeping (Frederick) Morocco 1990 226 the Other: Benetton advertisements mortuary photographs 191 215, **215** 242; colonial 83, 223-35; new technologies: impact 12-13; motherhood 44-5 exotic/primitive 223-35; fashion see also digital imaging; mounting 259 photography 229-35; feminism technology MRI see magnetic resonance 83; identity 283; imperialism 58; new topographics 275 imaging psychoanalysis 83; tourism New York c. 1940 101 Mrs Lewis Waller with a Kaffir Boy 223-35; workers as 79 New York Public Library 61 ownership 227-8 New Yorker 243 multi-cultural identity 283-4 Newhall, Beaumont 48, 48(m), multifibre agreement 240 paint 253-4 50-2, 249, 269 Mulvey, Laura 172 painted portraits 132, 254 news reporting 142; see also Munby, Arthur 81, 81-2(m) panopticons 126 photojournalism muse, woman as 272-3 panoramas 326 newsworthiness 198 Museum of Modern Art (MOMA): paparazzi 198-201 Newton, Helmut 221 aesthetic attention 61; art and parasitism 204, 212-14 vernacular distinction 250; Next Directory 222-3

pleasure, voyeurism and eroticism

The Pleasure of the Text (Barthes)

170 - 2

Paris: Commune 71; modes of vision 253; Photo-Club 257; photography exhibition (1855) Parr, Martin 109, 110-11 past 63, 110, 124, 149 patriarchy 58, 280-1 patronage 288 Peapell, Lily 114 Penlake, Richard 115, 132 Penn, Irving 223, 229, 242 Penrose, Roger 270 Penthouse 173-4, 179 perception 182, 252-3, 310 performance arts 277 personal computers 302 personal histories 151 personal photography 113-58 perspective 17, 253, 291 Phantasmagoria 327 phenomenology 32-3 philosophy: aesthetics 249; Cartesian 305, 329; Enlightenment 21, 329; idealist 292; phenomenology 32-3; Western 24 photo fits 168 photo-based art appraisal 285-7 Photo-Club of Paris 257 photo-eye 19, 86, 264-5 photo-realism 334-6 Photo-Secession, New York 257 photo-telegraphy 320 photodigital, taking stock 317, 327-36 photogenic drawing see calotype The Photograph (Clarke) 53-4 photographers: Afro-American 284; choices 312, 314; gender 53, 93; home digital 116; jobbing 15, 134-5, 254; postcards 136-7; subjects relation 41, 78; travelling 135-6; women 54, 154-5, 281 photographic...: body in crisis 161-4; economy 330; message 210-11; modernism 264; portraits 15; truth 18, 310, 311 Photographic Advertising Archive stock images 207 Photographic Advertising Ltd. 206 The photographic craze 124 Photographic Pleasures (Bede) 131

Photographic Society 126 Photographic Society of Great Britain 256 photographs: as art 248-51; of art 254; as document 17-18; as image 49; in itself 31 Photography: A Concise History (Jeffrey) 53 Photography: An Independent Art (Haworth-Booth) 53 photography...: as art 245-94; criticism 35; and the modern 18-21; postmodern 248; of something 22, 74, 331 Photography, A Cultural History (Warner Marien) 52-3 Photography, A Short Critical History (Newhall) 48 Photography and Anthropology (Edwards) 58 The Photography Book 52 Photography Until Now (Szarkowski) 54 photojournalism: authorship 313: documentary relation 70-3; evidence 35; fashion photography 223; glamour 198-201; global age 109-11; historic 57; issues and definitions 69-75; paparazzi 198-201; Second World War 144; self-censorship 325; semiotic complexities 312-13; see also war photography photomontage 67, 132, 185, 186, 272, 314-15 phrenology 59, 164-5, 166-7 physiognomy 59, 164-5, 166-7, 186 physiognotrace 13 physiology 180 physique photos 160, 179 Physique Pictorial 160 Picasso, Pablo 220 pictorialism 14, 17, 258, 263, 292 Picture Post 70, 91, 92, 99, 144, 198 picturesque 259 picturing ourselves 90-4 Pierce, C.S. 29-30, 45, 74 plasmatic 189 Plato 292 play of the frame 279-80

Playboy 173-4, 179

30 - 1point of view 253, 268, 306 Polaroid Land camera 134(m) police archiving system 59, 164-5. **165**, 166, 184 politics: documentary 93-4, 103; implications 42; intervention 279; photomontages 314-15; politicised exhibitionism 154-5: postmodern construction 279; power 19; of representation 94, 289; repression in the domestic 123; Soviet Constructivism 265 - 7Pollard, Ingrid 283, 293 Pollock, Griselda 220 polysemia 318-19 Pop Art 273, 274 popular...: entertainment case study 326-7; memory 59-60; photography 55-6, 113-58 pornography 67, 126, 168-9. 172-6, 178-9 portable cultural objects 308 Portrait of Space 271 portrait studios 127, 137, 254 portraiture 126-31, 132, 166-7, 196-8, 254 poses 127, 177 positivism 14, 24, 305-6 Possession (Burgin) 194, 216 post-colonial identity 284 post-colonialism 85-6 post-family 157-8 post-human vision 334-6 post-mortem photography 190-1, post-photography 157-8, 304-7, 308, 316-17, 330 postcards: Bailey's of Bournemouth 135; Black country chain-makers 138; Blackpool studio 135; colonial 224, 225, 225, 232, 232; erotic 224; photographers 136-7; popular photography 55; sales postmodernism 21-4; architectural space 309-10; Art 247; art practices 276-8; documentary 286; galleries 276; landscape 293; language or sign system 248,

316-17; museums and galleries 276; new constructions 278-80; original and copies 23, 110; photography 276-8; postphotography 316-17; practice 276-8; representation 276; theory poststructuralism 25, 282 Poverty in London 104 power: colonialism 85; digital manipulation 109-10; ideology 105-6; of photography 105-6; political 19; power/knowledge 85; relations 58; science 105; Visible Human Project 184; voyeurism 170 PR companies 198-9 practice: early debates 251-9; legitimacy 163; ownership 227-8; postmodern 276-8; signification 34: theory and criticism 35-6 Pre-Raphaelites 255, 256 pre-visualisation 269 precursors of photography 12-13 preferred reading 212 prerequisites of realism 58 presence 29, 36, 283, 308, 317, 331-2 Pretty Polly tights 220 Price, Mary 26, 28 primitive Other 223-35 printing, colour 142 prints: combination 250, 254, 292; industry 123; quality concerns Prior Park, near Bath 261 priority debate 49 production and consumption 239 progress and civilisation 85 proliferation 196 propaganda 322 props 177-8, 178, 201-2 provenance 55-6, 59 pseudo-documentary 242-3 pseudo-realism 242-3 psychoanalysis: childhood memory 154; fantasy resolutions 282-3; feminism 272; the Other 83; photography theory 25; semiotics 30, 33; voyeurism and fetishism 170-1 public narratives 156-7

publishing 260, 286, 288–9 Pultz, John 46, 161 *punctum* 32

Quaade, V. 240, 242 Quartermaine, Peter 83 queer photography 175, 177, 179–80

Rabinowitz, Paula 47 race: anthropological types 82-3, 167-8; anti-Semitism 167; colonial history 86: difference 161; Galton 166, 167; grammar of 240; identity 283; phrenology 166-7; physiognomy 59, 166-7, 186; racialisation 242; racism 283; representation 35; scientific appraisal 59 radical history movement 150 Radical Party, Italy 178, 179 radicalism 106, 150, 175, 252, 291 rationality 24, 232-3 rayographs 272 readers 70-1, 117-18, 149 reading: digitally morphed bodies 189; dominant 212; evidence 333: the image 29-33; institutions and contexts 60-3; methods 211-12; Migrant Mother 46: of photographs 24; semiological methods 210-11 real: and digital 73-5; imaginary distinction 305, 307; photographs as sign of 335; stencils off the

realism: belief in 314, 329–30, 331–2; critical reflections 26–9; hyperrealism 158; naturalism 206; photo-realism 334–6; photography 310–11; popular entertainment 327; post-human vision 334–6; prerequisites 58; pseudo 242–3; representation 252–3; semiotics 312–13; sexual morality 179; simulacrum 252; Sontag 28; Surrealism 272; see also authenticity reality: black and white 214;

eality: black and white 214; concept 252; different nature of 336; experience distinction 270; illusion 315; intervention 183; ontology 18; signification 46 reason-thought distinction 270 reception: digital images 332-3; global 109, 212; meaning 28, 29 recognition, shock 32 The Reconfigured Eye (Mitchell) 300-1 reference 28; Barthes 31; computer constructed 302-3; digital images 306: Jameson 22; referential characteristics, usage and interpretation 36; Sontag 33; to the world 73 Reflections of the Black Experience exhibition 283 Rejlander, Oscar Gustav 80, 133, 256 religious fundamentalism 163, 175, representation: accuracy 35; democratic 16; gendered 218-20; hegemony 214-20; mechanical reproduction 308; modes 68; of ourselves 106; photography 17; politics of 94, 289; postmodernism 276; realism 252 - 3repression 123, 270 reproduction: age of mechanical 17-18, 308-17; control of 41-2; see also copies and originals rereading family pictures 150 respectable women 174 restricted codes 118 return to the figurative 276 revolutions: electronic 309; political 252-3, 264 Reynolds, Stacey 240 rhetoric 25, 286 Richards, Thomas 82 Riis, Jacob 77-8, 79, 133 Ristelhuber, Sophie 325, 325 Ritchin, Fred 311, 312-14 ritual photographs 151 River Scene, France 254, 255, 291 Roberts, John 44-5, 107, 274 Roberts, Pam 130 Robins, Corinne 278-9 Robins, K. 304 Robinson, Henry Peach 256, 257, 259, 292, 293 Rodchenko, Alexander 94, 266, 267 Rodgers, George 88, 263 Rogers, Brett 286

roll film 258 Sekula, Allan 59, 60, 62, 73, 165, 265-7; semiotics 30; surveys Rosenblum, Naomi 41, 43, 53, 54 167-8 75-8; types 168-9 Rosler, Martha 69, 93, 311, 313, Self Burial 275 social science theory 25 314, 329 self-censorship 325 socialism 287, 289 Rothstein, Arthur 72, 94, 96 self-scrutiny 119 Socialist Realism 267 Rouille, André 53 semiology 103-4, 210-11 society of the spectacle 15, Royal Academy, London 54, 248, semiotics: advertisements 235; 195-208, 220-3; see also 259 Burgin 34-5; complexities popular entertainment Royal Photographic Society 126, 130 312-13; exploration 149: Society of the Spectacle (Debord) Royal Society of Arts, London 249 meaning constitution 18, 29-30; 195-6, 201 Ruby, Jay 190-1 photojournalism 312-13; sociology 306 rules for ritual photographs 151 psychoanalysis 30, 33 solarisation 272 Rushdie, Salman 198 sensationalism 199-20 Solomon-Godeau, Abigail 42, 69, Russell, William 86-7 Serrano, Andres 163, 176, 191 169-70, 267 Russian...: Futurism 34; Modern Art sexism 281 sonograms 183 265; Revolution 264; see also sexual morality 179 Sontag, Susan 26-8, 26(m), 28, 33, Soviet Constructivism; Soviet sexual politics 36, 163, 177 Sharpe, L. 205 South African miners 213, 213-14 Ryan, James R. 85, 86 Sherman, Cindy 161, 277, 283 Soviet Constructivism 247, 248, Shifting Focus (Butler) 281-2 265-7, 272, 279, 291 S/Z (Barthes) 30 shock: advertising 240-2; fashion Soviet Union 240, 241, 250, 265 Saab 9-3 advert 186, 187-8, 188 photography 243; recognition 32; space: absolute 271; dislocation 19; Said, Edward 224 and scandal 243-4; Shocks to the feminised 46; geometric mapping St Mary's School, Manchester System exhibition 286-7; 253; neutral of studio 229; new 134 Surrealism 272 cultural 99-103; and presence sales 134, 143-4 Side Gallery, Newcastle 289 283; time-space 19; urban Salgado, Sebastião 66, 109 sight augmentation 335-6 309-10; virtual visual 306 Sampson, Anthony 97-8 signatures 280 Spanish Civil War 88 Sao Paulo Construction 66 signification 34, 36, 46, 210-11 spectacle, society of 193-244 Saunders, Nick 157 signifiers 169 speed 309 scale 278, 285, 307 signs: digital images of photographs Spence, Jo 117, 119, 154-5, 156, scanners 116, 183, 298, 300, 302 335; dislocated 21; iconic 45; Scharf, Aaron 250, 251-2, 257 indexical 45, 74, 317; instability Spender, Humphrey 91-2, 92 Schenectady Works News 238 317; postmodernism 248. Squiers, Carol 214 Schicchi, Riccardo 177, 178, 180 316-17; of the real 335; symbolic staged images 279, 291 Schmidt, Joachim 158 Stallabrass, Julian 105-6 school photos 133, 134 silhouettes 13 Staller, Ilona see La Cicciolina science: body manipulations 163; Silvy, Camille 254, 255, 291, 293 Stapely, G. 205 eugenics 167; images 183-5; similarities, universal 39-40 statistics 59 interventions 183-5; management Simmel, Georg 164 status 12, 36, 248-51 technique 184; power 105; race Simpson, O.J. 196 Stein, Sally 78, 215, 216 appraisal 59; scientific theory 25; simulacra 22, 110, 252 stencils of the real 331 taxonomic imperative 82; of work simulation 300, 322, 327 stereoscopes 86, 125-6, 169, 180, 184 Six Simulations of Liberty 296 181, 327; slides 125 scopic regime 36, 329 sketches 252 stereotypes 214 scopophilia 170, 219 Slater, Don 106, 116, 139, 148, Stieglitz, Alfred 257, 269 Scottish art 284 227, 235 stock images 202-3, 204, 206, 207, seascapes 292 sleep, death as 190, 190-1 210 Seawright, Paul 89 slippages 30-1 Stokes, Philip 31-2 secessionism 258 slums 133 stolen images 200-1 Second World War 88, 144 social...: control 164-5; facts 75-8; Stott, William 90 second-order semiological system history 33, 55-63, 116; relations straight photography: 1980s 277-8;

concealment 215-16; role of art

accuracy 14-15; colour work 108;

210-11

documentary 69, 262; genre 314; as norm 312; prized 17 Strand, Paul 20-1, 263 street photography 68, 135-6, 136 strikes, 1970s 236 Stryker, Roy 39, 42, 44, 94 studios: high street 55, 197-8; neutral space 229; portrait 127, **137**. 254 studium 32 styles and meaning creation 212-14 subjective documentary 103 subjects: colonialised 223-4; decentered 21; humanist centred 329-30; male knowing 329-30; as objects 159-92; photographer relation 41, 78 sublime 291, 292, 293 Sullivan, Constance 55, 281 Sunday Times Magazine 202-3 supersnaps 144-8 Surrealism 186, 223, 248, 263, 269-73, 291 surveillance 18, 58, 59, 105, 166, 322-5 surveyors and surveyed 65-111 surveys 57, 58, 75-8 Sutcliffe, Frank Meadow 80, 81 Swift, Willie 133 symbolic codes 29-30 symbolic signs 45 Szarkowski, John 48, 54, 268 Taadros, Gilaine 284

tableaux 130, 254-5 tabloids 199-200 Tagg, John: capitalism 196-7; criminals 165-6; denoted messages 210; modernity 119; power relations 58; representation 105-6; throw-away era 320 taste, principles 246 Tate Gallery, St Ives 260 Tate Modern, London 248 Taylor, Frederick Winslow 184 Taylor, John 124 Taylorism 184, 186 technical-human distinction 336 techno-scientific ideal body 184 technology: and aesthetics 12-24; or art 13-17; bodies 180-9; change 317-22; consequences

333-4; determinism 13; history of photography 48-9; landscape 290 television 274, 322, 325 Ten/8 magazine 61, 104 testament 37-40, 302, 304; see also evidence testimony, fugitive 12, 59 text 30-3, 42-3, 100, 214, 279; see also captions theory: of art 33-4; critique of documentary 103-6; of photography 25-6; practice and criticism 35-6; role 24-5 Thinking Photography (Burgin) 26, third world 53, 227-8, 240 Thomas, Alan 57, 76-7 Thomas, William 84, 84 Thompson, Thurston 258 Thomson, John 79-80 Thornton, M. 221 thought-reason distinction 270 Three Perspectives on Photography exhibition 286-7 throw-away era 320 time 19, 31, 271 The Times 86-7, 123 tintypes 134 titles 280; see also captions Toblerone advertisement 188 topographics, new 275 Toscani, 239-4 tourist industry 62-3, 86, 125, 146; case study 223-35 tourists: gaze 123; photographs 228; view of the world 124 Tournachon, Gaspard Felix (Nadar) 323 Towards a Bigger Picture exhibition 278 Townsend, Chris 163 trace 27, 104, 311 Trachtenberg, Alan 82, 87-8 traditional garb 228-32 tranguility stock image 203-4 transcription capacity 251-2, 313 transfer of meaning 211-12 transparency 34, 262 traumatic memory 154-7 travel photography 86, 110-11, 135 - 6truth: appearance 26, 71-2; to actuality 29; art 249; and beauty

16; connotative 72; digital images 302–3; documentary 33–4; indexicality 311; manipulation 314; photographic 18, 310, 311; real 332; truer 315; truth-to-nature 259; uses 315
Tucker, Anne 39–40, 54
Turbeville, Deborah 221
Turner, Anthea 200–1
twenty-first century 148–57
types: classification 164; criminal 59, 165–6, 165; race 82–3, 167–8; social 168–9

unconscious, optical 19, 309 United Colors campaign 239 United States (US): New Right 175, 176: see also American... universal machines 334 universal similarities 39-40 universe of differentiation 23 unreliability 59, 118 urban spaces 309-10 Urry, John 85, 123 users: contemporary 148-9; personal pictures 117-18; users-readers distinction 117-18 uses: constructivist 267; contexts 24, 28: and genre 41-2; mapping 56, 59: medicine 317-18; military 56-7; realism 27, 28; social 16; testimony 302, 304; truth 315 USSR. Benetton and America 241 utopianism 182, 185-6, 189

values 20 Van Schendel, W. 84 Vance, Carole S. 163, 176 vanishing point 17 vantage point 268 veracity 42 vernacular photography 250 Vertov, Dziga 181 Victoria and Albert Museum, London 53, 222, 248, 278 video 310-11 Vienna Camera Club exhibition 250 Vietnam war 89 viewers, active production of meaning 211 'Viewers at a Panorama' 326 viewfinders 267 viewing: contexts 43; point 253

viewpoints 19, 124, 125
violence 156
Virilio, Paul 322
virtual...: cameras 301, **301**; reality 254; visual spaces 306
visibility 104–5, 183, 184
Visible Human Project 184
vision: compass of computer 307; post-human 334–6
visual anthropology 55–6
Vogue 221, 229, 234
The Vogue Book of Fashion
Photography 222
voyeurism 91, 170–2, 219
Vu 70

Walker, lan 272, 322, 324
Walkerdine, Valerie 155, **155**, 156
Wall, Jeff 290, 291
Waller, Mrs Lewis **84**war photography 86–9, 198, 273, 322–5; see also individual wars
Warhol, Andy 273
Warner Marien, Mary 49–50, 52–3, 57–8, 251, 292
Watkins, Carleton 292

Watney, Simon 34 Watriss, Wendy 284 ways of seeing 19-20, 34, 182-3, 260, 305-7 Weaver, Mike 54, 256 Wells, Liz 235 Weski, Thomas 108 West, Nancy Martha 115, 118 Weston, Edward 267, 268-9, 268, 292, 312 White, Minor 292 White Sea Canal 266 Willett, John 264 Williams, Linda 174, 180 Williams, Raymond 13, 260, 274 Williams, Val 54, 93, 143, 222, 281 Williamson, Judith 208, 211, 216-18, 235-6 Wilson, Sir Arnold 120, 121, 122, 123, 132 Winship, Janice 219-20 Wollen, Peter 250, 263 Wombell, Paul 226-7, 227, 318 women: automaton-like images 186; colonialist exoticism 224-5:

fragmented 171, 273; hands 219-20; hobbyists 17, 130; Instamatic cameras 147: Kodak advertisements 140-2; labourers 81; as muse 272-3; objectification 168-70; photographers 54. 154-5; photography 280-2 Women Photographers: The Other Observers (Williams) 281 Women Photographers (Sullivan) 281 Wong, H.S. 199 work 227, 290; see also labour 'The Work of Art in the Age of Mechanical Reproduction' (Benjamin) 308 workers: blue collar 237-8; exploitation 92; FSA 94-7; the Other 79; photographing 79-82; see also General Electric; labour working classes 133-44, 177 workplace photography 136-7 Works News 237 workshops 285

Zamora, Lois 284

A library at your fingertips!

eBooks are electronic versions of printed books. You can store them on your PC/laptop or browse them online.

They have advantages for anyone needing rapid access to a wide variety of published, copyright information.

eBooks can help your research by enabling you to bookmark chapters, annotate text and use instant searches to find specific words or phrases. Several eBook files would fit on even a small laptop or PDA.

NEW: Save money by eSubscribing: cheap, online access to any eBook for as long as you need it.

Annual subscription packages

We now offer special low-cost bulk subscriptions to packages of eBooks in certain subject areas. These are available to libraries or to individuals.

For more information please contact webmaster.ebooks@tandf.co.uk

We're continually developing the eBook concept, so keep up to date by visiting the website.

www.eBookstore.tandf.co.uk

300TLEDGE STUDY GUIDE

WORK SMARTER, NOT HARDER!

It's a simple fact - everyone needs a bit of help with their studies. Whether you are studying for academic qualifications (from A-levels to doctorates), undertaking a professional development course or just require good, common sense advice on how to write an essay or put together a coherent and effective report or project, Routledge Study Guides can help you realise your full potential.

Our impressive range of titles covers the following areas:

- Speaking
- Science
- Doctorate

- Study Technique
- English
- MBA

- Thinking
- History
- Research

- Writing
- Mathematics
- Politics

Available at all good bookshops or you can visit the website to browse and buy Routledge Study Guides online at:

www.study-guides.com www.study-guides.com www.study-guides.com www.study-guides.com www.study-guides.com